W9-CEW-143

# Radiation Protection

# RADIATION PROTECTION

## A Guide for Scientists and Physicians

## Third Edition

Jacob Shapiro

Harvard University Press, Cambridge, Massachusetts, and London, England

10 9 8 7 6 5 4 3 2
This book is printed on acid-free paper, and its binding materials have been
chosen for strength and durability.

**Library of Congress Cataloging in Publication Data**

Shapiro, Jacob, 1925–
  Radiation protection : a guide for scientists and physicians /
Jacob Shapiro.—3rd ed.
      p.   cm.
  Includes bibliographical references.
  ISBN 0-674-74586-8
  1. Ionizing radiation—Safety measures.   2. Radioactive
substances—Safety measures.   3. Radiation—Dosage.   I. Title.
  [DNLM: 1. Radiation Protection.   WN 650 S529r]
RA569.S5   1990
616.07′57′0289—dc20
DNLM/DLC
for Library of Congress                                                89-26860
                                                                        CIP

To my grandchildren—Arielle, Shlomo Yohai, Shira, Tehilla, David, Yitzhak, and Avital

To their parents—Jean, Robert Moshe, Aviva, and Josh

To my wife, Shirley

And to great grandparents Bella and Mollie

# Preface

This manual explains the principles and practice of radiation protection for those whose work in research or in the field of medicine requires the use of radiation sources. It provides the information radiation users need to protect themselves and others and to understand and comply with governmental and institutional regulations regarding the use of radionuclides and radiation machines. It is designed for a wide spectrum of users, including physicians, research scientists, engineers, and technicians, and it should be useful also to radiation safety officers and members of radiation safety committees who may not be working with the sources directly. The organization of the material was guided by my experience in conducting courses and seminars in radiation protection over many years for workers in the research laboratories at Harvard University and its affiliated hospitals.

The field of radiation protection, as taught to specialists, draws heavily on radiation physics and calculus. A large number of workers who require training in radiation protection, however, have minimal experience in these subjects and their schedules are usually too full to allow for the luxury of extended reviews of mathematics or physics. Thus, this manual is designed to obviate the need for reviews of atomic and radiation physics, and the mathematics has been limited to elementary arithmetical and algebraic operations.

After a brief historical prologue, the text introduces the major concepts in radiation protection and develops these in the context of the working materials of the radiation user. The central role of the energy imparted by ionizing particles in characterizing radiation exposure is explained and the ways in which radiation levels are evaluated and controlled are illustrated through

examples of actual radiation sources.  Brief reviews are presented of radiation units, standards, and the significance of various radiation levels, followed by some simple calculations in radiation protection and supplementary material for users of x-ray machines in medical practice and research. Next are detailed explanations of radiation dose calculations, radiation measurements, and practical aspects of radiation protection.  The book ends with a detailed discussion of the two subjects that are essential to obtaining perspective on the risk and significance of exposure to radiation: the results of studies of the effects of radiation exposure of human populations, and the radiation exposure experience of the population both from man-made sources and from natural sources.  It is my hope that the material presented in this part will give individuals who must make benefit-risk decisions a firm foundation for making responsible and ethical judgments regarding the irradiation of other persons, whether these persons are associates working in radiation areas, members of the general public who have no connection with the user, or patients who are undergoing medical diagnosis and treatment.

The practice of radiation protection in the 1990s will see some significant changes in the United States.  The Nuclear Regulatory Commission (NRC) is requiring implementation by January 1, 1993, of a major revision of the standards for radiation exposure laid out in the Code of Federal Regulations (10CFR20).  The revised standards will incorporate the system of radiation dose limitation presented in 1977 by the International Commission on Radiological Protection (ICRP).  In addition, the NRC recently revised its regulations for medical users in 10CFR35.

In this third edition, the section on the practical aspects of the use of radionuclides has been rewritten to take into account the new regulations. The ICRP system expresses radiation exposures in terms of a quantity that evaluates risk, the "effective dose equivalent" or the "weighted dose equivalent."  This concept has been adopted as the basis for the proposed revised limits in 10CFR20.  It allows for the summing of multiple doses of non-uniform and differing radiation patterns, either from external radiation or from localized uptakes of radioactivity in the body.  This is done by expressing partial-body doses in terms of equivalent whole-body doses on the basis of comparable risks of producing fatal disease.  Although this system has the advantage of simplicity and standardization, its value as a measure of individual and population exposure for scientific and epidemiological purposes is, at best, very tenuous.  Estimates of the biological effects of radiation exposure as a function of type of radiation, exposure rate and fractionation, age at exposure, and many other factors are always subject to change. Given the uncertainty of quantities based on biological effectiveness, it is unfortunate that the concept of the effective dose equivalent is being given a central position in scientific documents, such as the reports of the United Nations Scientific Committee on the Effects of Atomic Radiation (UNSCEAR), thus encouraging its use as a scientifically rigorous

method for evaluating radiation exposure. To extend the use of a concept primarily suited for regulatory purposes to evaluation of the harm or risk to exposed individuals and populations is much too simplistic.

The Environmental Protection Agency (EPA) is addressing what appears to be a major public health radiation problem, the high levels of radon gas that exist in a significant fraction of homes in the United States. These findings have given rise to huge expenditures of effort in monitoring for radon and in conducting remedial programs and have also had legal implications in real estate transactions. The detailed discussion of the radiation dose from radon in the second edition thus has even greater significance at the present time.

Medical radiation continues to be a source of significant exposure as physicians make increased use of the powerful diagnostic tools available in radiology and nuclear medicine. The question of where the line should be drawn between benefit and risk will be an open one for the foreseeable future. Malpractice litigation and other legal considerations have become crucial factors in decisions on the use of ionizing radiation for diagnostic purposes, decisions which should be based strictly on medical considerations. Recent data on doses of radiation in medical practice and recommended exposure guides have been added to this edition.

The United States is grappling with the problem of converting from the traditional units in radiation protection to the Standard International (SI) units. No doubt a full transition will be made in time, but at present the NRC is retaining the traditional units (with SI units in parentheses) in the revised regulations while the National Council on Radiation Protection and Measurements (NCRP) is using the SI units with the traditional units in parentheses. Most of the values in this book are given in the traditional units but the reader will also find examples of the SI units. Conversion from one set of dose units to the other is very simple—it requires multiplication or division by a factor of 100. Some may feel strongly about the use of one or the other set, but the simple conversion factor should give little difficulty in living with both sets of units.

The ICRP, the Advisory Committee on the Biological Effects of Ionizing Radiation of the National Academy of Sciences, and the United Nations Scientific Committee on the Effects of Atomic Radiation continue to issue reports on the current state of knowledge of the effects of radiation. Risks from gamma radiation may be three or more times as great as previously thought, according to a reanalysis of the Hiroshima-Nagasaki dosimetry and longer follow-up times, and these new risk estimates have been included in this edition of the text. The NCRP recommends that the quality factor (a measure of the relative hazard of energy transfer by different radiation particles) be doubled to 20 for neutron radiation and the ICRP concludes that we need to be more cautious in controlling exposure from this source; the NRC, however, is still retaining the quality factor of 10 at this printing.

I regret the rejection of the roentgen as a unit of radiation exposure in the revised 10CFR20. The great advantage of the roentgen is its correspondence with the rad, one of the measures of absorbed dose: *one roentgen,* as measured in an air ionization chamber, results in an absorbed dose to tissue of (very nearly) *one rad,* or *0.01 gray.* This correspondence is lost when Standard International units are used—an exposure of one coulomb per kilogram, as measured in an air ionization chamber, corresponds to a dose of 37.6 grays to tissue.

It is a pleasure to acknowledge the assistance of William Shurcliff and Dade Moeller in the genesis of *Radiation Protection.* I am grateful to the many individuals who offered advice and assistance on various portions of the work, including James Adelstein, John Baum, Bengt Bjarngard, Robley Evans, Abraham Goldin, Robert Johnson, Kenneth Kase, Samuel Levin, James McLaughlin, Frank Osborne, Joseph Ring, Kenneth Skrable, John Villforth, and Michael Whelan. I also thank Kate Schmit, my editor for this edition at the Harvard University Press, for her assistance and interest. Finally, I am happy to express my appreciation to my daughter, Jean, my wife, Shirley, and my nephew, Mark Shapiro, for editorial comments regarding some of the personal views expressed here, and to my son, Robert, for stimulating me to think of a personal statement.

# Contents

# Tables

# Guide to the Use of This Manual

Part I introduces the various radiation particles from a historical perspective. It also presents some basic definitions and concepts in atomic structure and radioactivity. It was written primarily to give an overall view of the varieties of ionizing particles in nature and need not be studied in detail (except for figs. 1.1 and 1.2).

Part II comprises the core material of the manual. Sections 1–5 and 8–13 constitute a primer on radiation protection for all users of radiation sources. The central role of the energy imparted by ionizing particles in producing damage is introduced and the energies and properties of radiation particles are presented along with descriptions of the main sources. In this way readers may associate the facts and principles of radiation protection with the specific radiation sources of concern to them.

The particles considered first are beta particles and gamma photons, since they are the types of particles of interest to most users of radiation. Special attention is given to the distinction between the direct role of beta particles in imparting dose and the indirect role of gamma photons in liberating beta-like particles (that is, high-speed electrons) which in turn produce a dose. The sections on the properties of beta particles and gamma rays are followed by brief discussions of radiation protection measures for external sources of these particles. Subsequent sections introduce the concepts of doses from external and internal sources and discuss the significance of dose levels in terms of radiation standards, biological effects, and natural background levels. The section on internal sources includes recommendations on protection against internal contamination.

Separate sections cover positrons, alpha particles, protons, neutrons, x rays, and high-energy particles from accelerators. Readers may omit those sections that do not cover the ionizing particles they encounter in their

work.   Part II concludes with some simple calculations for evaluating radiation hazards.

The material in Part II can be used to provide basic information for new radiation users prior to receiving practical training in working with specific radionuclides or other radiation sources.   Without further formal training, such individuals would have to work under supervision.   Individuals planning to work independently with radiation sources or to administer radiation to human beings must also study Parts III–VI.

Part III gives details on dose calculations.   A discussion of calculation methods is given in Sections 1–4.   Detailed dose calculations for some specific nuclides are given in Section 5, and these may be studied selectively according to the interests of the reader.   Part IV covers the details of detection instruments and their use in making some of the more common radiation measurements.   Part V presents practical information, primarily for users of radionuclides.   The last part, Part VI, is concerned with the public health implications of the large-scale use of radiation in medicine and technology.

## Problem Assignments and Laboratory Exercises

Readers who need to demonstrate adequate training in radiation protection must be proficient in the mathematics and calculations basic to the use and measurement of radioactivity and must be trained in radioactivity measurement, standardization, and monitoring techniques and instruments.   A set of problems is presented in Appendix II, and the reader should begin solving them soon after beginning his reading of Part III.   In addition, he should perform a series of laboratory exercises.   The design of the particular experiments will depend on the availability of equipment, and no detailed experimental write-ups were prepared for this manual.   However, much of the measurement data given in figures and tables in Parts II and IV of the text are presented as obtained in the laboratory, along with schematics of the equipment used.   A suitable laboratory program can be completed by using the tables and curves as models and designing the laboratory exercises to give comparable measurements and data presentation.

## Supplementary Reference and Reading Material

One of the most useful compilations of data in radiation protection is the United States Public Health Service publication, *Radiological Health Handbook*. It also contains an excellent glossary.   A selected bibliography, listing handbooks and texts that cover the field of radiation protection in depth, is given at the end of the manual.

## Use of the Manual in a Formal Training Program

Guidelines for training of radiation users in radiation protection are given by various professional and governmental bodies.   They vary depending on the magnitude of the radiation hazards to the user and whether the purposeful

irradiation of human beings is involved. The recommendations of the U.S. Nuclear Regulatory Commission (NRC) often serve as a guide in preparing training programs because of the responsibilities and authority of this organization in the control of the use of radionuclides and their extensive experience in developing and offering training programs. Training programs are discussed in Part V, Section 2.

The Nuclear Regulatory Commission recommends 40 hours of training in radiation protection for physicians applying for licenses for uptake, dilution, and excretion studies using radionuclides as part of a general training program in basic radioisotope handling techniques. It requires that the general training include a working knowledge of (a) radiation physics and instrumentation; (b) radiation protection; (c) mathematics pertaining to the use and measurement of radioactivity; (d) radiation biology; and (e) radiopharmaceutical chemistry. In addition, it requires supervised clinical experience in the use of the types and quantities of radionuclides for which the application is made, or equivalent experience.

This manual was written in part for the training program in the safe use of radionuclides in research conducted by the Harvard University Health Services. This program was initiated in 1962 by me and Dr. E. W. Webster of the Department of Radiology of the Harvard Medical School. It includes 10 two-hour sessions of formal lectures and laboratory demonstrations; problem assignments; and a final examination. The program provides training for investigators who want authorization to work independently with radionuclides under the broad specific license for the use of radionuclides in research and development granted to Harvard University by the NRC. However, all technicians working with radionuclides under supervision are required to attend the first three sessions. The material in Part II relating to radionuclides is presented in the first session, and selected portions of Part V are covered in the second session. The third session is a demonstration covering calibration, shielding monitoring, and decontamination.

The course is also offered as a self-paced option. Students study the material in three stages. They must complete a problem set and take a one-hour examination for each stage. They must also attend the three lecture sessions and the laboratory demonstration session given to all users of radionuclides and an instrumentation laboratory given as part of the complete lecture course.

Although it covers in 20 hours of formal instruction the areas specifically referred to by the NRC in its application form NRC-313M for a byproduct materials license, the program is not designed to meet all the training requirements for a license for the medical use of radionuclides (see Part V, Section 2).

# Transition to SI Units in Radiation Protection

The special name for the unit of absorbed dose in the International System of units (SI) is the gray (Gy), which is equal to 1 joule per kilogram (J/kg). The name for the SI unit of activity is the becquerel (Bq), with the unit reciprocal second ($sec^{-1}$). The gray was adopted at the 1975 meeting of the General Conference on Weights and Measures (a diplomatic conference responsible for the international unification and development of the metric system).

The sievert (Sv) was approved in 1979 by the General Conference on Weights and Measures as the special name for the dose equivalent. The sievert is equal to the gray multiplied by the quality factor (Q) and other modifying factors (N). It is a term based on biological considerations as well as on physical quantities.

Students will need to have facility in using both traditional and SI units. Most of the numerical data in this text are presented in traditional units because they are still in common use in the United States, but the reader should make a mental note of the corresponding values in SI units. Since the gray and the rad differ by a factor of 100, it is easy to switch mentally from one to the other.

The following suggestions should be helpful in mastering both sets of units.

a. Read *1 rad* as *1 centigray* or *10 milligrays* (1 rad = 1 cGy = 10 mGy).

b. Read *1 rem* as *1 centisievert* or *10 millisieverts* (1 rem = 1 cSv = 10 mSv).

c. Read *1 mrad* as *10 µGy*.

d. Think of the nominal value of the absorbed dose from the radiation background as both 100 mrad/yr and 1 mGy/yr. Similarly, consider the background dose equivalent as approximately 100 mrem/yr or 1 mSv/yr.

e. Think of the occupational limit for whole body dose as both 5 rem/yr and 50 mSv/yr.

# Radiation Protection

# Part I

# Historical Prologue

## In the Beginning

Although our society has been concerned for some time with the potential radioactive contamination of the environment resulting from the technological exploitation of nuclear energy, the fact is that the universe is and always has been permeated with radiation, and at the present time there are about one billion rays traveling through space for every elementary particle of matter. The remarkable set of circumstances involving the interaction of radiation and matter has a history of some ten billion years. Some of our most fascinating theories attempt to explain how we arrived at the present point in time and space in the universe, and how to account for its continuing expansion and very low temperature (only two degrees above absolute zero!). If we trace our universe from the present back into antiquity, we find that the further back we go, the smaller and denser and hotter it was, until eventually we come to the moment of birth—time zero—and the initial cosmic fluid.

How did it all begin? Perhaps, say some, with a great big bang. At any rate, there was created the initial or primordial fluid, an indescribably complex "soup" consisting almost completely of extremely energetic material particles traveling at speeds very close to the speed of light. A very small number were nonmaterial in nature. The density and temperature of the primordial fluid were extremely high (initial temperature $10^{33}$ degrees; density $10^{94}$ g/cm$^3$), and particle energies were of the order of $10^{27}$ million electron volts.[1]

1. These numbers are so high that we must describe them by numbers expressed as powers of 10, where the power gives the number of zeroes in the number, for example, $10^4 = 10,000$. More will be said about units of energy and their significance later, but for the moment we may note that the energies associated with radiations from radionuclides are commonly under 2 million electron volts (MeV) and are insignificant compared to the energies at creation.

**Table 1.1.** Classification of elementary particles.

| Hadron family | Lepton family | Photon family |
|---|---|---|
| mesons (135–548) | electrons (0.511) | radiowaves |
| baryons | muons (105.65) | microwaves |
|   nucleons: neutrons (939.5) | tau particles | infrared light |
|   and protons (938.2) | electron neutrinos (0) | visible light |
| hyperons (1115–1675) | muon neutrinos (0) | ultraviolet light |
| | tau neutrinos | x rays |
| | | gamma rays |

*Note:* Numbers in parentheses are the masses of the particles in MeV. Each material particle listed has an antiparticle of identical mass and, for charged particles, opposite charge. The antiparticles have been omitted for simplicity. The only stable particles are the proton, the electron, the muon neutrino, the electron neutrino, and the photons. The neutron has a half-life of 710 sec. The half-lives of the other unstable particles range from $10^{-6}$ sec to less than $10^{-14}$ sec.

The various types of particles in the primordial fluid could be grouped by modern classification schemes into one of three families.[2] The families and their members are given in table 1.1. The great majority of particles in the primordial fluid belonged to the hadron family and comprised a vast number of species. The only significant members of this family remaining on earth at the present time are the neutrons and protons, the basic constituents of the nuclei of atoms. The other members of the hadron family, the hyperons and mesons, may be found occasionally in the atmosphere as a result of the inter- actions of cosmic radiation, and are being created and studied throughout the world through the operation of high-energy accelerators. There was a very small fraction of material particles belonging to the lepton family. The most famous member of this family is the electron, the third basic constituent of atoms, and the agent for holding atoms together in molecules. Also included in the lepton family are muons, which may be found in the cosmic radiation at sea level; the tau particle discovered only recently; and their respective neutri- nos, which are very common but have no significance with regard to radiation effects. The third family, but also insignificant at time zero, consisted of pho- tons, bundles of energy but nonmaterial in nature. We shall be very much concerned later on in our studies of protection from ionizing radiation with two members of this family, x rays and gamma rays.[3]

Each material particle at the beginning existed in one of two states, which we denote as matter and antimatter. Although both forms are equally stable when apart, they annihilate each other and their matter is transformed into

2. Much of the material on the nature of the creation and evolution of the universe was taken from Harrison, 1968. An excellent book on the subject is Weinberg, 1977.

3. Actually the terms x ray and gamma ray represent the same kinds of photons and refer only to two basically different ways in which these photons are produced.

photons and neutrinos when they come into contact, except at very high temperatures.   So at time zero, the universe was densely populated primarily with very energetic hadrons, and the temperature was so high that matter and antimatter could coexist without annihilation.

Starting from the moment of birth, the temperature began dropping, the variety of hadron species decreased, and finally the temperature reached a point where matter and antimatter annihilated each other on contact.   By one ten-thousandth of a second, the temperature was down to $10^{12}$ °K, the density down to $10^{14}$ g/cm³, most of the hadrons had annihilated each other, and the way was clear for the dominance of the leptons.   The leptons remained in ascendancy for about 10 seconds, and their era terminated with the annihilation and decline of the electrons.   By this time the density was down to 10,000 g/cm³, and the temperature was $10^{10}$ °K.

The energy from the decline and annihilation of the electrons was inherited by the radiation photons, leading to the introduction of the radiation era.   The universe was flooded with photons for about one million years, during which the temperature and density continued to drop as the universe expanded. "Matter was like a faint precipitate suspended in a world of dense brilliant light."[4]

Although the relatively small number of neutrons and protons remaining were capable of combining with each other and forming stable configurations such as heavy hydrogen nuclei (neutron + proton) and helium nuclei (2 neutrons + 2 protons), this was prevented by the presence of the very energetic photons, which had enough energy to break any bonds that were established. But as the radiation era progressed, the mean photon energy dropped below the binding energy of the nucleons, and heavy hydrogen and helium built up. These continued to attach neutrons and protons, and thus the heavier nuclides were also created.

As the universe expanded, the radiation density dropped more rapidly than the density of matter.   When the temperature had dropped below 3000 °K, protons and electrons were able to combine, and atoms of matter began to appear.   By the time the mean density of the expanding universe had dropped to $10^{-21}$ g/cm³, one million years after time zero, matter began to emerge as the dominant constituent of the universe.

From then on, matter aggregated into celestial structures: galaxies, stars, and planets.   About $10^{80}$ nucleons were available in the universe from which to form these structures.   There were still $10^9$ photons and neutrinos for every neutron or proton, and the photon and neutrino densities were each of the order of 1000/cm³.

### The Discovery of Radiation

We shall dispense with the billions of years of evolution that resulted in the establishment of the solar system, the origin of life, and the emergence of

4. Harrison, 1968.

modern man.  It took our own species *Homo sapiens* at least 25,000 years to reach a level of knowledge and understanding prerequisite to discovery of the existence of energetic radiations in the universe.  The first clues (in the latter half of the nineteenth century) arose out of experiments with electrical discharges in vacuum tubes, known as Crookes tubes.  The discharges were produced by applying high voltage across the electrodes in the tubes.  The observations, for example, light emitted by gas in the tube and the production of fluorescence in the glass envelope, were attributed by Thomson in 1897 to the effects of high-speed negatively charged particles, which he called electrons.  In 1895, Roentgen, experimenting with Crookes tubes, identified penetrating radiations that also produced fluorescence and which he named x rays.  And in 1896, Becquerel discovered that penetrating radiations, later classified as alpha, beta, and gamma rays, were given off by uranium, and thus opened up a new field of study of radioactive substances and the radiations they emit.  Thus, by 1900, man had begun to discover and experiment with high-energy radiations of the kind that had dominated the universe some ten billion years earlier.

At about the same time, the work of Planck in 1900 and Einstein in 1905 showed that many kinds of radiation, including heat radiation, visible light, ultraviolet light, and radiowaves, which had previously appeared to be transmitted as continuous waves of energy, were actually emitted as discrete bundles of energy called photons.  Most of these arose from the vibrations of electrons in matter, and they differed only in the energies of the photons.  In time, it was learned that gamma radiation, emitted from the nuclei of atoms, and x rays, produced by the acceleration of electrons (outside the nucleus), were also made up of photons, but of much higher energies.

The discovery of the new particles and rays led to intense experimentation on their properties and their interactions with matter.  Energetic alpha particles emitted by radioactive materials were directed by Rutherford against thin gold foils.  Through analysis of the scattering pattern, he deduced in 1911 that the atom was composed of a tiny central core, or nucleus, containing all the positive charge and almost all the mass of the atom, and a nearly empty surrounding region containing the light, negatively charged electrons, in sufficient number to balance out the inner positive charge.  The nucleus of the hydrogen atom, consisting of a single particle with a charge equal in magnitude and opposite in sign to that of the electron, was recognized as a fundamental building block of the nuclei of all complex atoms.  It was named the proton (from the Greek *protos,* which means "first").  With the development of the theory of the atomic nucleus composed of protons and other elementary particles, it was possible to visualize how certain types of nuclei could disintegrate and emit particles.

The emitted particles had very high energies, and the source of the energies would have been a puzzle if not for the formulation by Einstein in 1905 of the mass-energy equation.  This equation expressed in quantitative terms his con-

clusion that matter could be converted into energy according to the relationship $E = mc^2$, where $E$ was the energy, $m$ the mass, and $c$ the velocity of light.  If $m$ was expressed in kilograms, and $c$ was expressed in meters per second, the equivalent energy $E$ was given in a unit of energy known as the joule.  When it later became possible to determine the masses of individual particles in an instrument known as the mass spectrograph, the relationship between mass and energy was verified experimentally.  Whenever a particle was emitted from a nucleus with high energy, it was found that the mass of the nucleus decreased not only by the rest mass of the particles emitted but by an additional mass that was equivalent to the energy carried by the particle, as given by Einstein's equation.

Rutherford bombarded many elements with the energetic particles from various naturally radioactive materials.  In 1919 he found that, when alpha particles bombarded nitrogen nuclei, energetic protons were released.  He had, in fact, produced the first man-made nuclear transformation, by forcing an alpha particle into the nitrogen nucleus, resulting in the emission of one of its fundamental constituents, the proton.  The residual atom was deduced to be oxygen.  In 1932 Chadwick identified the other basic particle in the nucleus: the neutron.  He had ejected it from the nucleus of a beryllium atom by bombarding it with alpha particles.  The neutron, unlike the proton, did not have an electrical charge.

The discovery of the neutron gave very strong support to the concept of the atomic nucleus as consisting solely of neutrons and protons, packed very closely together (fig. 1.1).  Certain combinations of neutrons and protons are stable.  They comprise the nuclei of isotopes of elements that retain their identity indefinitely, unless disrupted by nuclear collisions.  Other combinations of neutrons and protons do not give stable nuclei.  The nuclei eventually undergo a nuclear transformation through spontaneous disintegration processes that result in the alteration of the neutron proton ratio (fig. 1.2).  Some nuclides go through several disintegration processes before finally attaining a stable neutron-proton ratio.

### The Development of a Radiation Technology

After the discovery of the neutron, major developments in nuclear research came in rapid succession: discovery of uranium fission in 1939, and the recognition of the possibility of releasing enormous amounts of energy; achievement of the first self-sustaining fission reaction in a reactor in 1942; explosion of nuclear fission devices in 1945; production of thermonuclear explosions in 1952; commissioning of the first nuclear-powered submarine, the *Nautilus,* in 1954; and the development of high-energy accelerators with energies up to $10^6$ MeV in the seventies.  The result of these developments some ten billion years after the hadron era was the creation of an extensive radiation technology concerned with the production of energetic radiations for research, medical treatment, and industrial use.

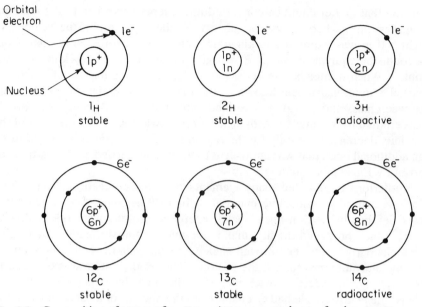

**Fig. 1.1**  Composition of atoms of matter.  Atoms are made up of a dense core, consisting of positively charged protons and uncharged neutrons, surrounded by an extended cloud of negatively charged electrons.  In the lighter elements, the cores of stable atoms contain approximately equal numbers of neutrons and protons.  In the neutral atom, the surrounding electrons are equal in number to the protons.  The number of protons in the nucleus is called the *atomic number*, symbol $Z$.  The number of protons plus neutrons is called the *mass number*, symbol $A$.  Atoms characterized by their atomic number and their mass number are called *nuclides*.  Nuclides with the same number of protons but differing numbers of neutrons are called *isotopes*.  All isotopes of a particular element have almost identical chemical properties.  Some nuclides are *radioactive*, that is, each atom eventually undergoes spontaneous disintegration, with the emission of radiation.  The figure shows isotopes of hydrogen (H) and carbon (C).  The superscript affixed to the symbol gives the mass number.

## The Need for Radiation Protection

The development of a radiation technology left its occupational casualties—physicists, radiologists, radiation chemists—researchers who investigated the properties and uses of these energetic radiations without appreciating their capacity for destructive effects in living matter.  But man soon recognized the harm that energetic radiations could cause when exposure was uncontrolled, and he has worked diligently since to further his understanding of the biological effects of radiation and to establish acceptable limits of exposure.

The development of the nuclear reactor and the production of large amounts of artificial radioactivity created the potential for injury on an unprecedented scale.  Governments realized that extraordinary measures were necessary to

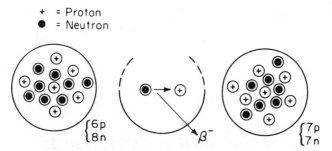

+ = Proton
● = Neutron

**Fig. 1.2A** Decay of the carbon-14 nucleus.

The carbon-14 nucleus contains 6 protons and 8 neutrons.

It is not stable. The ratio of neutrons to protons is too high.

The ratio is changed by the spontaneous transformation of one of the neutrons into a proton and the emission of an energetic beta particle (negative) from the nucleus.

The average lifetime of the nucleus is 8250 years.

The resultant nitrogen-14 nucleus (7 protons, 7 neutrons) is stable.

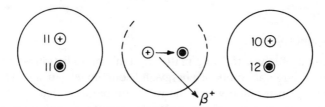

**Fig. 1.2B** Decay of the sodium-22 nucleus.

The sodium-22 nucleus contains 11 protons and 11 neutrons.

It is not stable. The ratio of protons to neutrons is too high.

The ratio is usually changed by the spontaneous transformation of one of the protons into a neutron and the emission of an energetic positron (positive beta particle) from the nucleus.

The average lifetime of the nucleus is 3.75 years.

The resultant neon-22 nucleus (10 protons, 12 neutrons) is stable.

protect radiation workers and the public from excessive exposure to radiation. The result, as every user of radionuclides knows, was the enactment of extensive legislation, the establishment of regulatory bodies and licensing mechanisms, the setting of standards of radiation exposure, and the requirement of training of radiation workers to conform with accepted practice in working with radiation and radionuclides.

# Part II

# Principles of Radiation Protection

## 1. Energy and Injury

The production of injury to living matter by ionizing radiation is the result of the transfer of large amounts of energy indiscriminately to individual molecules in the region through which the radiation passes. These large energy transfers cause disruptions of the molecular structure, and when the molecules affected are essential for the normal functioning of a cell, the cell in turn suffers injury or dies. Thus, the imparting of energy by ionizing radiation to living matter may be characterized in general as a harmful process, and the greater the energy imparted, the greater is the injury produced.

Because the transfer of energy plays the key role in the production of injury by ionizing radiation, all measurements and calculations to evaluate the hazard from ionizing particles have, as their initial object, the determination of the energy imparted by the ionizing particles to the region of concern. Studying the production of injury in terms of excessive energy absorption by living tissue is not unique. For example, energy transfers have been studied in detail in connection with injury from automobile accidents and other events involving transfer of mechanical energy to the body. One common interaction that produces injury, the penetration of a bullet through the body, provides an instructive analog to penetration by an ionizing particle. Like the ionizing particle, a bullet or other missile that penetrates the body imparts its energy in a way that destroys body tissues; that is, the energy cannot be used constructively (as the energy from food can) to meet the body's energy needs for the performance of work. The bullet fired from a gun carries kinetic energy by virtue of the motion of its mass, and on entering the body, it dissipates its energy as it tears apart the tissue through which it penetrates (fig. 2.1a). As it

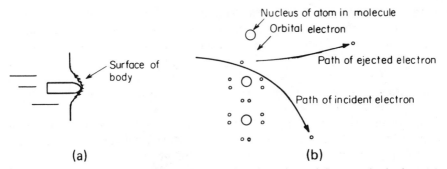

**Fig. 2.1** Ways in which energy is imparted and produces injury to the body. (*a*) Incident bullet expends energy by tearing up body tissue. Bullet slows down and will come to rest if all its energy is imparted. (*b*) Incident charged particle (high-speed electron) flies past one of the atoms constituting a molecule. The electric field of the rapidly moving electron exerts impulsive forces on the orbital electrons and imparts energy to them. If an electron is ejected from the atom as a result, this may break up the molecule.

loses kinetic energy, it slows up and may be stopped in the body. In this case, the kinetic energy of the bullet is completely absorbed. If it should pass through the body, only a part of its energy is deposited, the rest of it being carried away by the emergent missile.

Ionizing particles are also missiles that possess energy and can penetrate into a medium, but the individual particles are so small that we must consider their actions in terms of collisions with individual atoms (fig. 2.1b). These actions, of course, are much more subtle than the tearing apart of tissue produced by large missiles. The most drastic chemical effect that can be produced on a molecule by energy transfer is to completely remove an electron, that is, to ionize the molecule. Ionizing radiation consists of particles that have sufficient energy to produce ionizations of atoms and molecules with which they interact. The ionization can result in a breakup of a molecule or engender other deleterious changes that ordinarily would not occur.

The region affected by the action of a single ionizing particle or ray is small, the damage caused to the person is insignificant, and the risk of induction of any serious delayed effects, such as malignancy, is extremely low. However, the damage produced by successive particles accumulates, accompanied by some repair for certain types of particles and by no repair for others, and if enough energy is imparted, the consequences can become serious. To prevent these consequences from developing, limits are set on radiation exposure from ionizing particles. The limits are derived from epidemiologic and laboratory data on the relationship between the energy imparted to the body and injury produced, and, in essence, they specify the maximum energy that can be permissibly imparted by ionizing particles to critical regions in the body.

The effects produced by ionizing particles depend not only on the amount of

energy imparted to the body but also on the location and extent of the region of the body exposed and the time interval over which the energy is imparted. These and other factors must be taken into account in specifying maximum exposure levels.

While the human body can sense and take measures to protect itself from injury from most physically destructive agents—heat, noise, missiles, and so on—it cannot sense exposure to radiation except at levels that are invariably lethal. Thus we see how important it is to understand how to anticipate radiation problems through calculations and analyses and how to use radiation instruments to monitor the emissions from radiation sources.

## 2.   Directly and Indirectly Ionizing Particles

We noted in the previous section that ionizing particles produce damage in matter by ionizing the atoms of which the matter is constituted as they penetrate. The particles that can produce these ionizations are divided into two classes—directly ionizing particles and indirectly ionizing particles. Thus ionizing radiation is defined as follows:

*Ionizing radiation is any radiation consisting of directly or indirectly ionizing particles or a mixture of both.*

*Directly ionizing particles are electrically charged particles having sufficient kinetic energy to produce ionization by collision.* They include electrons, protons, alpha particles, beta particles, etc.

*Indirectly ionizing particles are uncharged particles which can liberate directly ionizing particles or can initiate a nuclear transformation.* They include neutrons, gamma rays, neutral mesons, etc.

There are very basic differences between directly and indirectly ionizing particles in their modes of interaction with matter. The clue to the differences can be seen from their definitions. The directly ionizing particles are *charged* material particles and produce ionizations at small intervals along their path as a result of impulses imparted to orbital electrons. The impulses are exerted *at a distance* through electrical forces between the charged particles and orbital electrons. Indirectly ionizing particles *are not charged,* and therefore penetrate through a medium without interacting with electrons, until, by chance, they make collisions (with electrons, atoms, or nuclei), which result in the liberation of energetic charged particles. The charged particles that they liberate are directly ionizing, and it is through them that ionization and damage in the medium are produced. Thus the basic damage is done by charged, directly ionizing particles, even when the incident radiation is indirectly ionizing.

The charged particles possess the energy required to produce ionizations by virtue of their mass and motion. (Remember the classical expression for the kinetic energy of a moving body: K.E. $= \frac{1}{2}mv^2$; kinetic energy equals one-half the product of the mass and the square of the velocity.) As the particles im-

part energy to the medium through which they penetrate, they lose kinetic energy until they are finally stopped.  The more energy they have to start with, the deeper they penetrate before they are stopped.  The charged particles emitted from radionuclides have a limited energy range and are stopped in a relatively short distance, usually less than a few millimeters in the body.

### 3.  Beta Particles—A Major Class of Directly Ionizing Particles

Carbon-14, tritium, sulfur-35, calcium-45, phosphorous-32, strontium-90— these names are familiar to investigators who use radioisotopes as tracers in research.  All these radionuclides have in common the characteristic that they emit only one type of ionizing particle—a beta particle ($\beta^-$).  Beta particles comprise one of the most important classes of directly ionizing particles. They are actually high-speed electrons which are emitted by nuclei of atoms as a result of energy released in a radioactive decay process involving the transformation of a neutron into a proton (fig. 1.2).  The energy of the beta particle may have any value up to the maximum energy made available by the transformation.  The energy difference between this maximum and the actual energy of the beta particle is carried off by another particle, known as the neutrino.  The neutrino has virtually no interaction with matter and is thus of no interest from a radiation-protection point of view.

Electrons with velocities and energies comparable to those possessed by beta particles are widely used in technology.  The electrons are usually energized in special machines by applying a high positive voltage between the source of electrons and a collecting terminal (fig. 2.2).  One widespread appli-

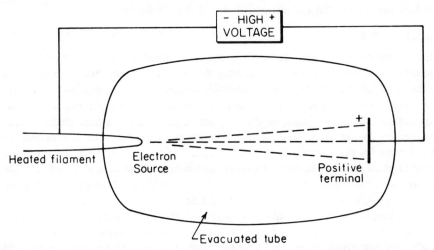

**Fig. 2.2**  Use of high voltage to produce energetic electrons.  The electrons are attracted toward the positive terminal and reach it traveling at high speed.  The tube is evacuated in order that electrons will not collide with gas molecules and lose their energy.

cation of high-speed electrons is in a television tube. High-voltage sources of the order of 20,000 volts are used. We say the electrons reaching the positive terminal acquire energies equal to 20,000 electron volts (20,000 eV). When they strike the fluorescent screen of the TV tube, their energy is partly converted into light, producing the picture we see.

In x-ray machines, electrons are energized with much higher voltages. For example, they acquire 70,000–115,000 eV of energy in medical diagnostic machines, and millions of electron volts in some therapy machines. When they strike the heavy metal targets (usually tungsten) in the x-ray tubes, their energy is partly converted into x-ray photons, which are then used to produce x-ray pictures or destroy a cancer. The high-speed electrons emitted by radionuclides have energies within the range covered above, that is, between a few thousand to a little over 2 million eV, and serve to trace the presence of the nuclei from which they are emitted.

### 3.1   Properties of Some Common Beta-Emitting Radionuclides

Let us examine some radionuclides that emit only beta particles. Properties of beta emitters that are most commonly used in research at universities are given in table 2.1. It is not surprising that the radioactive isotopes that trace carbon and hydrogen, carbon-14 and tritium, are most popular, because of the basic role of these elements in chemical and biological processes. We have included strontium-90 because its decay product, yttrium-90, which is always present with strontium-90, gives off the most energetic beta particle found among the common radioactive nuclides. Hence, this radionuclide is often used as a source of penetrating beta radiation. Let us examine table 2.1 in detail, discussing the quantities listed and their values.

### 3.1.1   Half-Lives

Each beta particle given off by a radioactive source results from the transformation or decay of an atom of that source to an atom of another element. The rate at which the atoms undergo transformations, and consequently, the rate of emission of beta particles, is directly proportional to the number of radioactive atoms present. Thus, as the number of radioactive atoms in the source decreases owing to the radioactive transformations, the rate of emission of beta particles decreases. When half the atoms in a sample have decayed, the rate of emission of beta particles is also cut in half. The time in which half the atoms of a radionuclide are transformed through radioactive decay is known as the half-life of the particular radionuclide.

A radionuclide that is frequently used to demonstrate the nature of radioactive decay is indium-116 ($^{116}$In). This is produced from indium-115, which is a naturally occurring, nonradioactive metal, by the absorption of neutrons, and suitable neutron sources are usually available at research or educational institutions. Figure 2.3 shows the counting rate of a sample of $^{116}$In as a function of time, as measured with a Geiger-Mueller counter. The data are plotted on

**Table 2.1.**    Properties of some commonly used beta emitters.

| Property | Beta emitter | | | | |
|---|---|---|---|---|---|
| | $^3$H | $^{14}$C | $^{45}$Ca | $^{32}$P | $^{90}$Sr |
| Half-life | 12.3 yr | 5730 yr | 163 d | 14.3 d | 28.1 yr |
| Maximum beta energy (MeV) | 0.0186 | 0.156 | 0.257 | 1.71 | 2.27[a] |
| Average beta energy (MeV) | 0.006 | 0.049 | 0.077 | 0.70 | 1.13[b] |
| Range in air (ft) | 0.02 | 1 | 2 | 20 | 29 |
| Range in unit density material (cm) | 0.00052 | 0.029 | 0.06 | 0.8 | 1.1 |
| Half value layer, unit density absorber (cm) | — | 0.0022 | 0.0048 | 0.10 | 0.14 |
| Dose rate from 100 beta particles/cm$^2$-sec (mrad/hr)[c] | — | 56 | 33 | 11 | 11 |
| Fraction transmitted through dead layer of skin (0.007 cm) | — | 0.11 | 0.37 | 0.95 | 0.97 |
| Dose rate to basal cells[d] of epidermis from 1 $\mu$Ci/cm$^2$ (mrad/hr) | — | 1,400 | 4,000 | 9,200 | 17,000[e] |

a. From the $^{90}$Y decay product. $^{90}$Sr emits 0.55 MeV (max) beta. See part III, section 5.3.

b. From $^{90}$Sr (0.196) + $^{90}$Y (0.93).

c. Parallel beam (Jaeger, 1968, p. 14).

d. Calculated from Healy, 1971, fig. 1. The dose is from beta particles emitted in all directions equally from contamination on surface of skin. Basal cells are considered to be 0.007 cm below surface.

e. From $^{90}$Sr (7700) + $^{90}$Y (8900). Data for half-lives and maximum and average beta energies taken from MIRD, 1975.

semilogarithmic graph paper and fall on a straight line. No matter when the measurement (count) is made, the counting rate decreases with a half-life of 54 minutes. Each radionuclide has a unique half-life.

From table 2.1 we see that the half-lives of commonly used radionuclides cover a wide range. The maximum half-life shown is 5730 years for carbon-14. The minimum half-life is 14.3 days for phosphorous-32. A source of phosphorous-32 would have half the number of atoms and would disintegrate at half the initial rate in about two weeks. After several months the disintegration rate or activity would be negligible.[1] On the other hand, the activity of a source of carbon-14 remains essentially unchanged over many years.

Half-lives of radionuclides cover a much wider range than those listed in table 2.1. Half-lives shorter than $10^{-6}$ seconds are given in listings of radionuclides. Examples of long-lived radionuclides are uranium-238, 4.5 billion

1. Methods for evaluating the radioactivity remaining after any decay period are given in section 13.4 of this part and in section 1.3 of part III.

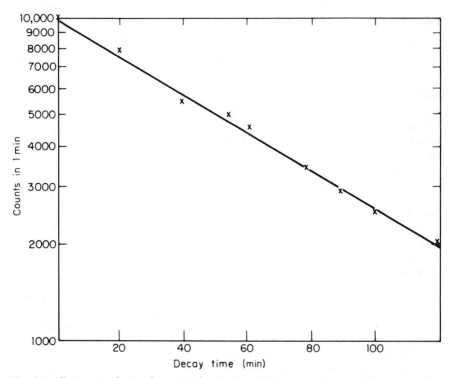

**Fig. 2.3**   Decrease of counting rate of an indium-116 source after an arbitrary starting time.   Measurements were made with a G-M counter.   Each count was taken for one minute, starting 30 seconds before the time recorded for the count.   When plotted on semilogarithmic paper, the results of the measurements fall close to a straight line drawn as a best fit, with a half-life of 54 minutes.   They do not fall exactly on the line because of statistical variations in the number of disintegrations in a fixed counting interval (see part IV, section 6).

years, and potassium-40, 1.3 billion years.   These radionuclides were created very early in the life of the universe, but approximately 79 percent of the $^{238}$U and 99 percent of the $^{40}$K have been lost by decay since creation because of their radioactivity.

### 3.1.2   Maximum and Average Energies of Beta Particles

The energies of the beta particles given off in radioactive decay of the various radionuclides listed in table 2.1 are expressed in terms of both a maximum energy and an average energy.   The maximum energies range from 0.018 million electron volts (MeV) for tritium to 2.24 MeV for strontium-90 (from the yttrium-90 decay product).   The tritium betas are very weak, the maximum energy of 0.018 MeV, or 18,000 electron volts, being less than the energies of electrons hitting the screens of most TV tubes.   Average energies are given for the beta sources, because, as stated earlier, the nature of beta decay is

such that any individual beta particle can have any energy up to the maximum given by $E_{max}$. However, only a very small fraction of the emitted beta particles have energies near the maximum, and most of them have much lower energies. The frequency with which energies below the maximum are carried by the beta particles is given by energy spectrum curves which have characteristic shapes. Energy spectra for tritium and carbon-14, low-energy beta emitters, and for phosphorous-32, a high-energy beta emitter, are shown in fig. 2.4. Energy spectra of the type shown in fig. 2.4 can be used to determine the

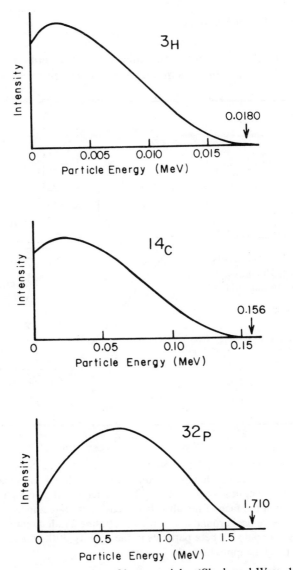

**Fig. 2.4**   Distributions of energies of beta particles (Slack and Way, 1959).

fraction of the beta particles emitted in any energy range by simply determining the fraction of the area under the curve that lies between the energy points of interest.

Values for the average energies of the beta particles from the radionuclides in table 2.1 are listed under the values of the maximum energies. In general, the average energy is about one-third the maximum. As we shall see later, the average energy is a basic quantity in determining the energy imparted to tissue by beta emitters and in evaluating the dose from concentrations of these radionuclides in the body.

### 3.1.3   Range of Beta Particles

If absorbers of increasing thickness are placed between a source of beta particles and a detector, the counting rate falls off steadily until no net count can be detected (fig. 2.5). The maximum thickness the beta particles will penetrate is

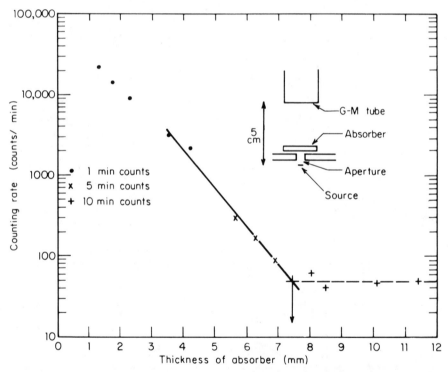

**Fig. 2.5**   Count rate from $^{32}$P beta source as a function of absorber thickness. The thickness is expressed in millimeters of unit density material and includes an air and detector window thickness of 0.08 mm. The diameter of the beta particle beam was limited to 1 mm at the face of the absorber. The count rate appears to level off to a value slightly above background due to the penetrating x radiation produced by acceleration of the energetic $^{32}$P beta particles in the vicinity of the nuclei of the absorber atoms. The range is approximately 7.4 mm.

called the range. The ranges of beta particles from the radionuclides in table 2.1 are given for air and for a medium of unit density. Range is specified for a general medium of unit density because the penetration of the beta particles is primarily determined by the mass of matter that is traversed, and does not depend strongly on other atomic characteristics such as atomic number.[2] For different media, the thickness that will provide the same mass in the path of the particle, and consequently the same amount of attenuation of the beta particles, is inversely proportional to the density of the material. Thus, if we know the range in a medium of density equal to 1, the range in any other medium can be determined by dividing by the density.[3]

> *Example 1:* Calculate the minimum thickness of the wall of a glass test tube required to stop all the beta particles from $^{32}$P.
> From table 2.1, the range of $^{32}$P beta particles in unit density material is 0.8 cm. The density of the glass is 2.3 g/cc. The maximum range in glass is 0.8/2.3 = 0.35 cm. This is the minimum thickness required. (Most of the beta particles would be stopped by a much smaller thickness. See section 4.1.4.)

Note that the range of the beta particles is very dependent on $E_{max}$. Beta particles from $^{32}$P ($E_{max} = 1.71$ MeV) require 0.8 cm at unit density (or 6 m of air) to stop them, while the very weak betas from tritium ($E_{max} = 0.018$ MeV) are stopped by less than 0.00052 cm at unit density (6 mm of air). A useful "rule of thumb" is that the range in centimeters at the higher energies is approximately equal to the energy in MeV divided by two.

The ranges of beta particles give us an idea of the hazards of the various radionuclides as *external* sources of radiation. For example, the beta particles from tritium are stopped by only 6 mm of air or about 5 $\mu$m of water. These particles cannot penetrate the outermost layer of the skin, which contains no living tissue; hence such particles present no hazard when they originate outside the body. They can produce injury only if they originate from tritium inside the body, through either ingestion or inhalation, by diffusion through the skin, or entrance through breaks in the skin. They cannot be de-

---

2. Frequently the range is expressed in terms of the density thickness, defined as the mass per unit area presented by a sample of a given thickness. The units are usually in mg/cm². For a medium of density $\rho$ g/cm³, the range in mg/cm² is 1000$\rho$ times the range in cm.

3. We should expect that the ranges for unit density material would also apply to water and to soft tissue, since both have densities equal to 1. However, water provides somewhat better attenuation than do other media for equivalent intercepting masses. The reason is that penetrating electrons lose their energy primarily by colliding with electrons in the medium, and it is easy to verify that water has more electrons per gram (because of the hydrogen content) than do other absorbers. However, for our purposes, we can ignore the extra effectiveness of water and use the range and attenuation data in table 2.1 for all materials, bearing in mind that if a high degree of accuracy is required, special data for the medium in question will have to be used.

tected by G-M counters because they cannot penetrate through the window of the counter, even if the window is very thin.

In contrast to the tritium beta particles, the highly energetic particles from $^{32}$P will penetrate as much as 8 mm into the body. They are among the most penetrating beta particles used in tracer work, and special care must be taken in working with them. Because of their penetrating power, they are readily detected with G-M counters designed for general radiation monitoring.

### 3.1.4   Absorption of Beta Particles at Penetrations Less Than the Range

The range for a given source of beta particles is a limiting distance, a thickness of material that no beta particle emitted from a source can penetrate. Actually, most of the beta particles emitted by a source are absorbed in distances considerably less than the range. It turns out that over distances that are a minor fraction of the range, the rate of loss of particles is almost constant. Thus we can introduce a concept called the half-value layer, which is the distance in which half the particles are absorbed. Half-value layers have been included in the data presented in table 2.1. Although the maximum range of $^{32}$P beta particles is 0.8 cm, about half the beta particles are absorbed in the first 0.1 cm, half of those penetrating the first 0.1 cm in the second 0.1 cm, and so on. Also shown in the table are attenuation values for beta particles in the dead layer of the skin, where the thickness of the dead layer is taken as 0.007 cm, a value generally assumed for the thinner portions of the skin. We note that only 11 percent of the $^{14}$C beta particles can penetrate this dead layer, while 95 percent of the more energetic $^{32}$P particles can pass through.

An approximate formula for the half-value layer for beta particles in unit density material as a function of energy $E$ in MeV is:[4]

$$\text{HVL} = 0.041 \; E^{1.14} \text{ cm}. \tag{3.1}$$

### 3.2   Protection from External Beta Particle Sources—Time, Distance, and Shielding

Three key words are often emphasized when proper working procedures with radiation sources are reviewed. These are *time, distance,* and *shielding.* The *time* refers to the principle that the working time while being exposed to the radiation from the source should be no longer than necessary. Obviously, the longer the time one is exposed to a source, the greater will be the number of particles incident on the body and the greater the dose. It is necessary to emphasize minimum working times because the worker cannot feel the presence of the radiation or any discomfort from it which would remind him to limit his working time.

4. Evans, 1955, pp. 625–629. The HVL values given by this formula differ from the values in table 2.1. The data in table 2.1 are based on dose measurements (see Hine and Brownell, 1956), while equation 3.1 describes results obtained in counting beta particles.

*Distance* refers to the desirability of keeping as much distance as possible between the source and the worker.   Distance is very effective in reducing the intensity of the radiation particles incident on the body from small sources. The actual relationship follows the inverse square law; that is, for point sources, the intensity varies inversely as the square of the distance from the source.   Thus, if we use a distance of 10 cm from a source as a reference point, a distance of 100 cm will be 10 times as far, and the intensity of beta particles incident on the skin will be $1/(10)^2$ or $\frac{1}{100}$ the intensity at 10 cm.   At 1 cm, the ratio of distance to the distance at 10 cm is $\frac{1}{10}$.   The ratio of intensities is now $1/(\frac{1}{10})^2$, or 100 times the intensity at 10 cm.   The effect of distance is illustrated in fig. 2.6.   The extra distance provided by use of tweezers or tongs produces a tremendous lowering in exposure compared to holding a source in the hands.   Distance also exerts some protective effect through the interposition of air between the source and worker, but except for the low energy beta emitters, this effect is generally small at normal working distances.

*Shielding* thicknesses greater than the range stop all beta particles.   However, a complication in the shielding of beta sources arises from the fact that when beta rays strike a target, a fraction of their energy is converted into much more penetrating x radiation called *bremsstrahlung* (see p. 69).   The efficiency of x-ray production increases sharply with increasing atomic number of the target and energy of the beta particles.   For this reason, plastic is to be preferred over steel and lead to minimize x-ray production when shielding ener-

**Fig. 2.6**   Effect of the inverse square law in reducing intensity of beams of particles. As used here, the intensity is equal to the number of particles crossing unit area per unit time (that is, particles/cm²-sec) at the indicated location.   It is arbitrarily taken to be 100 at a distance of 10 cm.   Attenuation in the medium is neglected.

getic beta emitters.  Only a few millimeters are sufficient to stop the beta particles from all commonly used sources.

We have discussed protection from external beta particle sources in rather general terms.  However, the protection measures that are instituted for any specific situation should be commensurate with the hazard.  The investigator should not become overconcerned with weak sources that may present trivial radiation hazards.  The ability to evaluate the amount of protection needed will be acquired after subsequent material on the doses from sources of different activities and their meaning has been studied.  However, it should be reiterated that beta activity is so easy to shield and protect against that complete protection can almost always be obtained with minimal inconvenience, loss of time, or expense.

## 4.   Characteristics of Indirectly Ionizing Particles

Indirectly ionizing particles have no charge.  As they pass through matter, they do not lose their energy as charged particles do, through applying impulses to nearby electrons.  Instead, they proceed without any interaction until they undergo a chance encounter with one of the elementary components of the medium through which they pass.  The component may be an atom, an electron, or the nucleus of an atom—we shall not be concerned with the nature of the interaction—and as a result of this encounter, energy is transferred from the indirectly ionizing particle to a directly ionizing particle, such as an electron (fig. 2.7).  The electron is liberated from the atom as the result of the

**Fig. 2.7**  Imparting of energy to body by indirectly ionizing particles.  Indirectly ionizing particle shown is a gamma photon.  It penetrates without interaction until it collides and transfers energy to an electron.  The electron is ejected and leaves behind a positively charged atom.  The electron continues to ionize directly as it travels through the medium.  The gamma photon may transfer all its energy and be eliminated or may be deflected, in which case it transfers only part of its energy and travels in a different direction at reduced energy.  The dots represent potential sites for collision.

energy transfer and proceeds to ionize in the manner characteristic of directly ionizing particles as discussed previously. Thus, the net result is that indirectly ionizing particles liberate directly ionizing particles deep within a medium, much deeper than the directly ionizing particles could reach from the outside.[5]

Examples of indirectly ionizing particles are gamma rays, x rays, neutrons, and neutral mesons. Gamma rays are the most important class of indirectly ionizing particles encountered by users of radionuclides.

## 5. Gamma Rays—A Major Class of Indirectly Ionizing Particles

Gamma rays are electromagnetic radiations emitted by radioactive nuclei as packets of energy, called photons, and often accompany the emission of beta particles from the same nuclei. They have energies over the same range as that found for beta particles, that is, from a few thousand electron volts up to several million electron volts. Unlike beta particles, which slow down as they lose energy and finally become attached to an atom, gamma rays of all energies travel with the speed of light. We are quite familiar with other types of electromagnetic radiation, which are classified according to the photon energy. For example, radio wave photons have energies between $10^{-10}$ and $10^{-3}$ eV, infrared photons between $10^{-3}$ and 1.5 eV, visible light between 1.5 and 3 eV, and ultraviolet light between 3 and 400 eV.[6] X-ray photons have energies between approximately 12 eV and the upper limit that can be produced by man-made electronic devices, which has reached billions of electron volts.

Gamma rays lose energy through chance encounters that result in the ejection of electrons from atoms.[7] The gamma ray may lose all of its energy in an encounter, or only part. If only part of its energy is removed, the remainder continues to travel through space, with the speed of light, as a lower-energy photon. On the average, the higher the energies of the gamma photons, the higher are the energies of the liberated electrons.

Because gamma rays are indirectly ionizing particles and travel through a medium without interaction until they undergo a chance encounter, every

5. We refer here to directly ionizing particles in the energy range emitted by radionuclides. Particles with very high energies, such as found in cosmic rays or emitted by high-energy accelerators, will penetrate deeply into matter.

6. A photon will ionize an atom if it has enough energy to remove an electron from the atom. A minimum of 13.5 eV of energy is required to ionize a hydrogen atom. Ionization potentials, expressed in volts, for the outermost electrons of some other elements are as follows: carbon, 11.2; nitrogen, 14.5; oxygen, 13.6. There are no sharp boundaries between the ultraviolet and x-ray regions. The classification of a photon as ultraviolet or x ray in the region of overlap generally depends on the nature of the source or method of detection.

7. Gamma photons with energies greater than 1.02 MeV may also undergo a reaction in the vicinity of an atomic nucleus, known as pair production, in which a portion of the photon energy (1.02 MeV) is used to create two electrons of opposite charges and the remaining energy is divided as kinetic energy between the two particles. However, this interaction is important only at high photon energies and for high atomic number materials. From the standpoint of radiation protection, it is of minor significance for gamma photons from radionuclides.

gamma ray has a finite probability of passing all the way through a medium through which it is traveling.  The probability that a gamma ray will penetrate through a medium depends on many factors, including the energy of the gamma ray, the composition of the medium, and the thickness of the medium.  If the medium is dense and thick enough, the probability of penetration may be practically zero.  However, with a medium of the size and density of the human body, gamma rays emitted inside the body by most radionuclides have a good chance of emerging and being detected outside the body.  For this reason, suitable gamma-ray emitters are powerful tools for studying body function.

It is important to keep in mind that it is the electrons to which the energy is transferred by the gamma photons that actually produce the damage in the medium (by subsequent ionization and excitation of the atoms).  Once a photon liberates an electron, the subsequent events depend only on the properties of the electron and not on the gamma photon that liberated it. The ejection by a photon of an energetic electron, say with an energy of 1 MeV, from an atom, is only a single ionization.  The electron, in slowing down, will produce tens of thousands of ionizations and excitations, and the damage produced will depend on the number and spatial distribution of these ionizations and excitations, rather than on the single ionization produced by the gamma photon (see section 9.1).

## 5.1   Energies and Penetration of Gamma Rays from Some Gamma-Emitting Radionuclides

Data for three gamma-emitting radionuclides are presented in table 2.2.  The radioiodine isotopes listed are probably used more than any other radionuclide in medical diagnosis and therapy, because of their unique value in diagnosis and treatment of conditions of the thyroid gland.  We need not discuss the data on half-lives and beta energies, since we have already covered the significance of these quantities in the previous section on beta particles.  We may note, however, that the gamma rays are generally emitted along with directly ionizing particles and that both types of particles may have to be considered when sources of gamma rays are being evaluated.

Unlike beta particles, which are emitted at all energies up to a maximum characteristic for the radionuclide, gamma rays are emitted at discrete energies.  The nuclides chosen for table 2.2 provide examples of high-, intermediate-, and low-energy gamma emitters, where the energy classification is roughly indicative of the relative effectiveness of lead shielding in attenuating the gamma rays.  The gamma rays from cobalt-60 are of relatively high energy.  The listing of a 100-percent value with each photon energy means that each disintegration of a $^{60}$Co nucleus, which entails the emission of a beta particle, is also accompanied by the emission of two gamma photons of 1.17 and 1.33 MeV energies.

It has been noted that photons, in contrast to beta particles, have a defi-

**Table 2.2.**   Properties of some beta-gamma emitters.

| Property | Beta-gamma emitter | | |
|---|---|---|---|
| | $^{125}I$ | $^{131}I$ | $^{60}Co$ |
| Half-life | 60 d | 8.1 d | 5.3 yr |
| Maximum beta energy (MeV) | — | 0.61 | 0.31 |
| Average beta energy (MeV) | 0.020[a] | 0.188 | 0.094 |
| Gamma energies (MeV) | 0.035 (6.7%)[b] | 0.364 (82%) | 1.17 (100%) |
| | 0.027 – .032[c] (140%) | 0.637 (6.5%)[d] | 1.33 (100%) |
| Gamma half-value layer | | | |
| lead (cm) | 0.0037 | 0.3 | 1.1 |
| water (cm) | 2.3 | 5.8 | 11 |
| Dose rate from 100 photons per cm²-sec (mrad/hr) | 0.020 | 0.065 | 0.22 |
| Specific gamma ray constant, $\Gamma$ (R/hr per mCi at 1 cm) | 0.7 | 2.2 | 13.2 |

a. Internal conversion and Auger electrons (see fig. 2.8).

b. Percent of disintegrations resulting in emission of photons.

c. X rays.

d. Also 0.723 (1.7%), 0.284 (5.8%), 0.080 (2.58%), 0.030 (3.7%, x rays).   Energies taken from MIRD, 1975.

nite probability of passing through any shield, and this probability can be calculated accurately.  The shielding effectiveness of a material for photons is commonly expressed in terms of the thickness required to reduce the intensity of the photons by a factor of two.  This thickness is called the half-value layer.[8]  The photons from $^{60}Co$ have relatively high penetration, as indicated by the values for the half-value layers in lead and water listed in table 2.2 of 1.1 cm and 11 cm respectively.  It takes 1.1 cm of lead and 11 cm, or 10 times this thickness, of water to provide an attenuation of one-half.  Since lead is 11.4 times as dense as water, water is slightly more effective than lead on a mass basis at these energies.

While two gamma energies are usually associated with the decay of iodine-131, the spectrum is quite complex.  A 0.364 MeV photon is emitted in 82 percent of the beta disintegrations and a 0.637 MeV photon in 6.5 percent, but small percentages of photons with higher and lower energies are also emitted.  The $^{131}I$ photons have a much lower penetration in lead than the photons from $^{60}Co$, since a half-value layer is only 0.3 cm.  The thickness

8. Note the analogy between half-value layer and half-life (introduced in section 3.1.1).  See sections 5.3 and 13.4 for methods of using these concepts in attenuation and decay calculations.

of water required is 5.8 cm, or 19 times as great. Thus the lead is much more effective relative to water at these energies than at $^{60}$Co energies.

The gamma photons emitted in $^{125}$I decay are of low energy. They do not accompany beta decay, but are emitted in a decay process known as electron capture. In this transformation (fig. 2.8), an electron in the innermost orbit of the atom is captured by the nucleus, and the energy made available by this reaction is equal to 0.035 MeV. In 6.7 percent of the disintegrations, this energy is emitted as a 0.035 MeV gamma photon. The rest of the time, it causes the release of electrons, known as internal conversion electrons, from the shells surrounding the nucleus.

Electron capture and internal conversion processes are always accompanied by the emission of x rays[9] from the inner shells of the atom. About 1.4

9. Photons originating in the inner orbits of the atom are called x rays, and photons originating in the nucleus are called gamma rays, although they are identical if of the same energy.

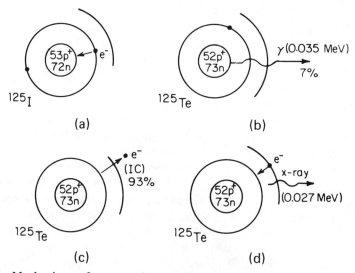

**Fig. 2.8**  Mechanisms of energy release during electron capture, as illustrated with $^{125}$I. (*a*) Nucleus captures electron, usually from innermost shell, producing 0.035 MeV excess energy in resulting tellurium-125 nucleus. (*b*) In 6.7 percent of the disintegrations, a 0.035 MeV gamma photon leaves the atom. (*c*) In 93 percent of the disintegrations, an electron is ejected from one of the inner shells in a process known as internal conversion. The energy of the internal-conversion electron is equal to the difference between 0.035 MeV and the energy required to remove it from the atom. The energies required for removal from the two innermost shells are 0.032 MeV and 0.005 MeV. (*d*) The vacancies left by electron capture and internal conversion are filled by the transfer of electrons from the outer shells. The energy made available by the transfer is emitted as x-ray photons characteristic of $^{125}$Te or is used to eject additional orbital electrons known as Auger electrons.

x rays with energies between 0.027 and 0.032 MeV are emitted per disintegration of the $^{125}$I nucleus.   Note that, for this radionuclide, there is very little difference in energy between the gamma rays and x rays.

Lead is extremely effective in attenuating the low-energy photons emitted by $^{125}$I.   It takes only 0.0037 cm of lead to reduce them by a factor of 2. Water is much less effective, requiring 2.3 cm, or 620 times the thickness of lead, for the same degree of attenuation.

### 5.2   Attenuation Coefficients of Gamma Photons in Different Materials

The attenuation of photons traversing a medium depends on the probability that the gamma photons will interact with the atoms, electrons, or nuclei as they pass through.   There are several mechanisms by which the photons can interact, and the probabilities of the interactions depend in various ways on the energy of the photons and on the atomic number of the atoms in the medium.   The attenuation resulting from the interactions is expressed quantitatively in terms of an attenuation coefficient, designated by the symbol $\mu$. This is the probability of an interaction per unit distance.   If we consider a very small distance of value $x$ in the medium, then the product of $\mu x$ gives the probability of interaction in the distance $x$, *provided $\mu x$ is much smaller than 1*.   (If $\mu x$ is not much smaller than 1, the probability of interaction is $1 - e^{-\mu x}$, as determined by methods of the calculus.)

Attenuation coefficients can be determined experimentally for a given material by interposing increasing thicknesses of the material between the gamma source and a detector.   The setup and data from an attenuation measurement are shown in fig. 2.9.   Special precautions must be taken so photons that are not completely absorbed but only scattered at reduced energy in another direction are not intercepted by the detector.

Attenuation coefficients for different materials and energies of gamma photons are given in table 2.3.   Let us consider the data for a 1 MeV photon, which is representative of fairly energetic photons emitted by radionuclides.   We note that the attenuation coefficient or probability of interaction of this photon per centimeter of travel through lead is 0.776.   The probability of interaction per centimeter of penetration through water is 0.0706. Note that specifying a probability per centimeter of 0.776 is *not* equivalent to saying the probability of interaction in 1 cm is 0.776.   This can be seen from the following stepwise calculation in evaluating the penetration of a beam of gamma photons through 1 cm of lead.

Suppose 10,000 photons are incident on the lead, as shown in fig. 2.10. Since the probability of interaction per centimeter is 0.776, the probability per millimeter is one-tenth this, or 0.0776.   Let us assume that this is in fact also the probability of interaction in a millimeter, though we shall see shortly that this is not quite correct.   We then calculate that the number of photons that interact is the incident number times the probability that an individual photon will interact, or $10,000 \times 0.0776 = 776$.   Then 9224 photons will

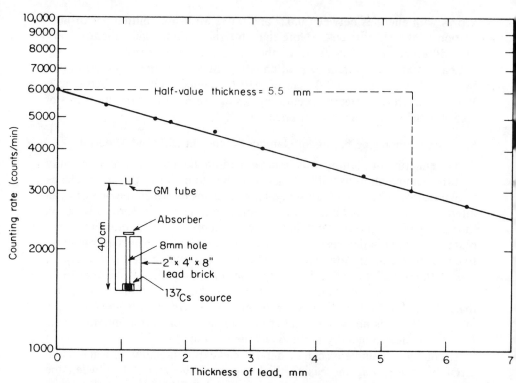

**Fig. 2.9** Attenuation of photons (from cesium-137) in lead. Each count was taken for two minutes. The collimator provides an incident beam of photons that is perpendicular to the absorber, and the large distance from absorber to detector minimizes the detection of photons that are scattered in the absorber. A configuration that minimizes the detection of scattered photons is known as "good geometry."

**Table 2.3.** Photon attenuation coefficients.

| Energy (MeV) | $\mu(cm^{-1})$ | | | |
|---|---|---|---|---|
| | Water | Iron | Lead | Concrete |
| 0.01 | 4.99 | 1354. | 1453 | 62.3 |
| .1 | 0.168 | 2.69 | 59.4 | 0.400 |
| 1 | .071 | 0.469 | 0.776 | .150 |
| 10 | .022 | .235 | .549 | .054 |
| 100 | .017 | .340 | 1.056 | .055 |

*Sources:* Hubbell, 1969; Storm and Israel, 1970. Coherent scattering is not included (for discussion, see Jeger et al., 1968, p. 197).

*Note:* The densities of the above materials, in g/cc, are as follows: water, 1; iron, 7.87; lead, 11.35; concrete, 2.35.

**Fig. 2.10**   Estimate of transmission of photons through successive layers of attenuating material.   The total absorber thickness of 1 cm was divided into 10 fractions, each 1 mm thick.   The attenuation coefficient is 0.0776/mm.

emerge from the first millimeter without interaction.   The number of these that will interact in the second millimeter is evaluated as $0.0776 \times 9224 = 716$, and 8508 photons emerge.   If we carry this through 10 mm, we calculate that the number emerging is $(0.9224)^{10} \times 10,000$, or 4459.   If we had used the value of 0.776 as the probability of interaction in 1 cm, we would have calculated the number interacting as 0.776 per centimeter times 10,000, or 7760, leaving 2240 photons penetrating, a result considerably different from the previous calculation.   Even the answer using the stepwise calculation is not completely accurate.   The correct answer is obtained by subdividing the absorber into infinitesimally small elements through the use of calculus.   (The probability of penetration of a photon through a thickness $x$ is $e^{-\mu x}$ and thus the probability of interaction within the distance $x$ is $1 - e^{-\mu x}$.   The probability of interaction in 1 cm determined by this method is $1 - e^{-\mu}$, or $1 - e^{-0.776} = 0.54$.   The number of photons that interact is thus 5400, and the number that emerge is 4600, which is still almost 10 percent greater than the stepwise calculation.   The number emerging could also be obtained directly by multiplying 10,000 by $e^{-0.776} = 10,000 \times 0.46 = 4600$.)

A frequently tabulated quantity is the attenuation coefficient divided by the density, or the *mass attenuation coefficient*.   The attenuation coefficient for a given material when it is part of a mixture or compound is then obtained by multiplying the mass attenuation coefficient by the density in the mixture.

The attenuation coefficient of each constituent is determined separately and all are added to give the total attenuation coefficient for the medium.

*Example 2:*   Calculate the attenuation coefficient of silica sand for 0.1 MeV photons.   Assume the sand has a porosity of 30 percent and is all quartz ($SiO_2$, sp gr = 2.63).

The mass attenuation coefficients at 0.1 MeV for Si and O are 0.173 and 0.152 cm²/g respectively. The density of the sand is $0.70 \times 2.63 = 1.84$ g/cm³. The Si ($A = 28.1$) and O ($A = 16$) constitute 47 and 53 percent by weight of $SiO_2$ with densities in sand of $0.47 \times 1.84 = 0.86$ and $0.53 \times 1.84 = 0.98$ g/cm³. Thus the attenuation coefficients are: $\mu(Si) = 0.173$ cm²/g $\times 0.86$ g/cm³ $= 0.149$ cm$^{-1}$; $\mu(O) = 0.152$ cm²/g $\times 0.98$ g/cm³ $= 0.149$ cm$^{-1}$. The total attenuation coefficient, $\mu_t = 0.298$ cm$^{-1}$. The corresponding half-value layer = 2.33 cm.

## 5.3  Calculation of Attenuation of Gamma Photons by the Half-Value Layer Method

We noted in section 5.1 that the transmission of photons can be described in terms of a half-value layer (HVL),[10] the thickness for which gamma photons have a 50 percent probability of penetration without interaction. Shielding calculations can be made very readily with the use of half-value layer data for the attenuating medium. Thus, if 100 gamma photons are incident on a half-value layer of a material, on the average, 50 gamma photons will penetrate without interaction, that is, they will emerge as if no attenuating medium had been present.

Of the 50 percent that penetrate through the first half-value layer, only half on the average get through a second half-value layer, or only a quarter of the incident photons get through 2 half-value layers without interaction, and so on. The fraction of gamma photons that penetrates a medium as a function of its thickness in half-value layers is shown in table 2.4.

10. There is a very simple relationship between the attenuation coefficient ($\mu$) and the half-value layer: $HVL = 0.693/\mu$. This relationship is derived as follows: Since, by definition, the half-value layer is that value of $x$ for which $e^{-\mu x} = 0.5$, $x = -\ln 0.5/\mu = 0.693/\mu$.

**Table 2.4.**  Powers of one-half for attenuation and decay calculations, $(1/2)^n$.

| n | .0 | .1 | .2 | .3 | .4 | .5 | .6 | .7 | .8 | .9 |
|---|---|---|---|---|---|---|---|---|---|---|
| 0 | 1.000 | 0.933 | 0.871 | 0.812 | 0.758 | 0.707 | 0.660 | 0.616 | 0.578 | 0.536 |
| 1 | 0.500 | .467 | .435 | .406 | .379 | .354 | .330 | .308 | .287 | .268 |
| 2 | .250 | .233 | .217 | .203 | .190 | .177 | .165 | .154 | .144 | .134 |
| 3 | .125 | .117 | .109 | .102 | .095 | .088 | .083 | .077 | .072 | .067 |
| 4 | .063 | .058 | .054 | .051 | .047 | .044 | .041 | .039 | .036 | .034 |
| 5 | .031 | .029 | .027 | .025 | .024 | .022 | .021 | .019 | .018 | .017 |
| 6 | .016 | .015 | .014 | .013 | .012 | .011 | .010 | | | |

*Note:* n is the number of half-value layers or half-lives. In 2.6 half-lives, the activity or number of atoms will be reduced to 0.165 of the original value. In 2.6 half-value layers, the number of photons will be reduced to 0.165 of the number entering the shield.

Using semilog graph paper, it is easy to prepare a curve giving the relationship between fraction penetrating and half-value layers, as shown in fig. 2.11. Because radioactive decay follows the same mathematical relationships as radiation attenuation, both table 2.4 and fig. 2.11 can be used for solving decay problems and have been labeled accordingly. Values of half-value layers for different materials may be found in radiation-protection handbooks (NCRP, 1976, Report 49, table 28; BRH 1970, pp. 163–164).

*Example 3:* Determine the attenuation of the gamma photons from a cesium-137 source in a container shielded with 3 cm lead.

The HVL of these gamma photons is 0.55 cm. The number of HVL in the shield is $3/0.55 = 5.45$. Thus the attenuation provided by the shield as determined from the HVL curve is 0.023.

**Fig. 2.11** Semilogarithmic plot of penetration of photons against thickness in half-value layers, or fraction remaining in radioactive decay as a function of time in half-lives. The graph is constructed by drawing a straight line between the points (a) Attenuation Factor = 1 at 0 half-value layers, and (b) the AF for some other number of half-value layers. To obtain the AF for larger values than plotted, multiply the values of AF for a combination of half-value layers that add up to the thickness of interest. Use AF for 10 HVL = 0.000978 ≈ 0.001. Example: to determine AF for 13.9 HVL, multiply AF for 10 and 3.9 (from graph) to get 0.001 × 0.067 = 0.000067.

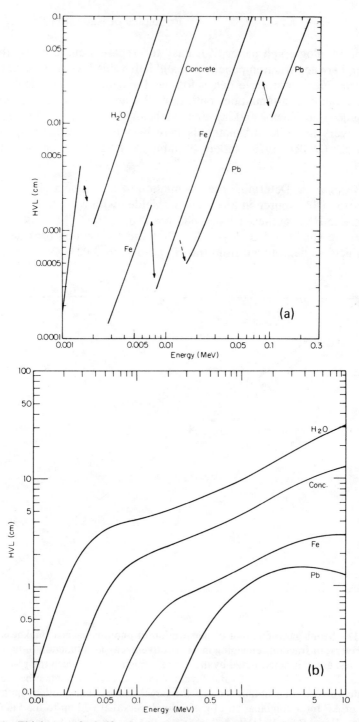

**Fig. 2.12** Thickness of a half-value layer of commonly used attenuating materials as a function of energy. The values are based on "good geometry" conditions, that is, no scattered radiation gets to the detector, whether from within the attenuating medium or from surrounding surfaces. Densities of materials (g/cc): $H_2O = 1$; Fe = 7.85; Pb = 11.3; concrete = 2.36.

*Example 4:* What is the thickness of lead needed for a shielded container to reduce the gamma photons emerging from the source in the previous problem to 0.012 of the unshielded value?

From the HVL curve, the number of HVL required is 6.4. Multiplying by the thickness of a single HVL, we obtain a required thickness of 6.4 × 0.55 = 3.52 cm.

Figure 2.12 gives the half-value layer as a function of photon energy for several materials. The values given by the curves are for "good geometry" conditions; that is, they give the attenuation if the scattered radiation is not significant at the detector. The augmenting of photons at a point as a result of scattering in a large shield is illustrated in fig. 2.13. Besides removing or deflecting radiation originally headed toward a detector from a source, the shield scatters toward the detector some radiation that was originally traveling in a direction away from the detector. As a result, the radiation falls off more slowly than under "good geometry" conditions and the effective half-value layer is increased. Experimentally determined values for the half-value layer as obtained with large area shields should be used in shielding problems, since they describe actual shield attenuation more accurately than the "good geometry" coefficients. There are times, however, when the fall-off may not be describable in terms of a single value for the half-value layer. When relevant experimental data are not available, or when the problem is too complex to be treated by half-value layer concepts, the actual procedure is to make a calculation using the "good geometry"

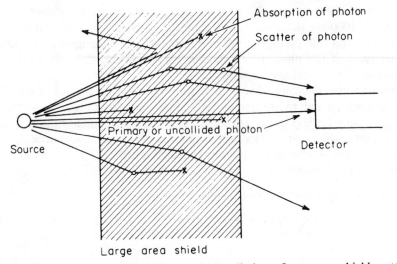

**Fig. 2.13** Illustration of buildup of secondary radiation. Large area shield scatters toward detector some of radiation originally traveling away from detector and thus gives less attenuation than is measured in "good geometry" experiment (fig. 2.9).

values, and increase the results by a factor that takes account of the increase due to scattering. This factor is generally known as the "buildup factor" and its use is described in texts on radiation shielding (Morgan and Turner, 1967, chap. 9).

### 5.4   Protection from Gamma Sources—Time, Distance, Shielding

The three key words—*time, distance,* and *shielding*—introduced in connection with protection from beta particles apply equally well to protection against gamma photons. Short working times and maximum working distances are as effective in reducing exposure from gamma photons as from beta particles. As with beta particles, the degree by which the intensity from a small source is reduced at increasing distances is obtained by the inverse-square law. Because gamma photons are so much more penetrating than beta particles, they require more shielding, the amount depending, of course, on the size of the source. If large gamma sources are to be handled, thick shields are required; often special manipulators and lead glass windows are used.

We must keep in mind one basic difference between beta and gamma shielding. Beta particles are directly ionizing and have a maximum range. Thus a shield built to stop beta particles from a particular radionuclide will stop the particles from any source consisting of that nuclide, regardless of the source strength.[11] On the other hand, a gamma shield always allows a fraction of the gamma photons to get through, since they are indirectly ionizing. The fraction decreases, of course, as the thickness of the shield increases.

Suppose the fraction of gamma photons that penetrate a shield is 1 percent. If 1000 are incident, 10 will penetrate, and if 100 are incident, 1 will penetrate, on the average. These numbers may be insignificant. On the other hand, if $10^{15}$ photons are incident on the shield, $10^{13}$ will get through. This could have serious consequences.

With gamma photons, as with all indirectly ionizing particles, a shield that is just thick enough to provide protection for one level of activity will not be thick enough for levels that are significantly higher. The protection offered by a gamma shield must always be evaluated in terms of the source strength, and no shield should be trusted until its adequacy has been verified for the source to be shielded.

### 6.   Some Additional Directly Ionizing Particles[12]

The electron is the most common but not the only directly ionizing particle encountered by radionuclide users. For our purposes, the other particles

---

11. There may still be a secondary effect from bremsstrahlung.

12. Material in this section on particles not encountered by the reader may be omitted in a first reading.

may be characterized by their charge and their mass when they are at rest. Because they are so small, it is not convenient to express their mass in grams. Instead, we shall express their mass relative to the electron mass (an electron has a mass of $9.1 \times 10^{-28}$ g) or in terms of the energy equivalent of their mass. We often express the mass in terms of the energy equivalent because it is possible for the rest mass of a particle to be converted into an equivalent amount of energy and vice versa. The equivalence is given mathematically by Einstein's equation, Energy = mass × (velocity of light)$^2$. The rest mass of an electron is 0.51 MeV.

### 6.1 The Positron—The Electron Counterpart from the World of Antimatter

The electron with a single negative charge has a counterpart in another particle, with the same rest mass, but with a single positive charge. This positive electron is called a positron. When apart from the electron, the positron is stable. However, the positron ultimately combines with an electron in an interaction which results in the annihilation of both, and their rest mass appears as two 0.51 MeV photons. The electron and positron are called antiparticles. Each elementary particle is accompanied in nature by an antiparticle, identical in mass, but opposite in electric charge and some other intrinsic properties. The contact of a particle and its antiparticle results in the complete destruction of the matter of both, and its transformation to the energy of photons.

Although the antiparticle, the positron, does not normally exist on earth, it is created in some forms of radioactive decay, as well as in reactions involving high-energy radiations. For example, sodium-22 and fluorine-18 are positron emitters and are much used in tracer studies. The positrons have the same ranges in matter as electrons of the same energies because they undergo similar collision processes. Since the positron must ultimately vanish through annihilation with an electron, positron emitters can be traced not only through the direct ionization of the positrons but also through the characteristic 0.51 MeV gamma photons emitted subsequent to annihilation.

### 6.2 The Alpha Particle—A Particle with High Linear Energy Transfer and High Capacity for Producing Damage

In the preceding section we noted that the positron has charge and rest mass equal to that of the electron and thus has the same range as an electron with the same amount of energy. There are other directly ionizing particles which have much greater masses. These particles have lower velocities than equally energetic electrons and much shorter ranges in matter. One of these heavy particles is the alpha particle.

The alpha particle is an energetic helium nucleus, consisting of two neutrons and two protons. It is therefore heavier than the electron by a factor of over 7300 and has double the charge. It is commonly emitted in the radio-

active decay of the heaviest nuclides in the periodic table.   Examples of naturally occurring alpha emitters are uranium, thorium, radium, and polonium.   A man-made alpha emitter, plutonium, is likely to be the main component of fuel in the nuclear power plants of the future.

The alpha particles emitted by these nuclides possess kinetic energies ranging between 4 MeV and 9 MeV.   The corresponding velocities are between 1.4 and $2.1 \times 10^9$ cm/sec.   They are much less than the velocities of beta particles in the same energy range, which are quite close to the speed of light.

Because of their slower speeds, the alpha particles spend more time than beta particles in the vicinity of the atoms they pass and exert much larger impulses on the orbital electrons.   The impulses are increased still more because their charge and the electrical forces they exert are twice as great as those of electrons.   As a result the rate at which alpha particles impart energy to the medium along their path is much greater than that of beta particles.

The rate at which charged particles impart energy locally to a medium is known as the linear energy transfer, commonly abbreviated as LET.[13]   LET values for charged particles as a function of their energies and velocities are given in table 2.5.   Note how LET increases at lower energies (and speeds).

The range of charged particles is, of course, intimately connected with the LET.   The ranges of the high LET alpha particles are much smaller than the ranges of electrons with comparable energies.   An alpha particle with an energy of 5 MeV, typical for alpha particles emitted from radionuclides, travels a distance of 44 $\mu$m in tissue compared to a distance of 3350 $\mu$m for a 1 MeV electron.

The damage produced in living tissue by absorption of a given amount of energy is generally greater as the distance over which this energy is imparted decreases, that is, as the LET increases.   In addition, the ability of the body to repair radiation damage is less as the LET increases and is believed to be essentially zero at LET values characteristic of alpha particle penetration.   As a result, for certain effects, the relative effectiveness of energy imparted by the short-range alpha particles has been found to be as much as 20 times as great as an equivalent amount of energy transferred by beta particles.   We shall see how this effect is taken into account in establishing exposure limits in a later section.

Alpha particles have long had a reputation for being especially hazardous.   They represent the main source of energy from radium and thorium isotopes responsible for the production of bone cancers (in persons making

13. In some analyses, only a portion of the LET value is considered, that part which imparts energy less than a stated amount (frequently 100 eV) to electrons.   Electrons given higher energies, referred to as delta rays, are not considered part of the track.   However, this distinction is not productive in radiation-protection applications.   For a detailed discussion of linear energy transfer and its use to specify the quality of radiation, see ICRU 1970, Report 16.

**Table 2.5.**  Transfer of energy per centimeter in water by energetic charged particles (linear energy transfer).

| Particle | Mass[a] | Charge | Energy (MeV) | Velocity (cm/sec) | LET (MeV/cm) | Range (microns) |
|---|---|---|---|---|---|---|
| Electron | 1 | −1 | 0.01 | $0.59 \times 10^{10}$ | 23.2 | 2.5 |
| | | | .1 | $1.64 \times 10^{10}$ | 4.20 | 140 |
| | | | 1.0 | $2.82 \times 10^{10}$ | 1.87 | 4,300 |
| | | | 10.0 | $3.00 \times 10^{10}$ | 2.00[b] | 48,800 |
| | | | 100.0 | $3.00 \times 10^{10}$ | 2.20[c] | 325,000 |
| Proton | 1835 | +1 | 1.0 | $1.4 \ \times 10^{9}$ | 268 | 23 |
| | | | 10.0 | $4.4 \ \times 10^{9}$ | 47 | 1,180 |
| | | | 100.0 | $1.3 \ \times 10^{10}$ | 7.4 | 75,700 |
| Alpha | 7340 | +2 | 1.0 | $0.7 \ \times 10^{9}$ | 1,410[d] | 7.2 |
| | | | 5.3[e] | $1.6 \ \times 10^{9}$ | 474 | 47 |

*Sources:* ICRU, 1970, Report 16 (protons and electrons); Morgan and Turner, 1967, p. 373 (alpha particles); Etherington, 1958, pp. 7–34 (ranges for alpha particles, tissue values used).

a. Mass is taken relative to the electron mass.

b. An additional 0.20 MeV/cm is lost by emission of photons.

c. An additional 2.8 MeV/cm is lost by emission of photons.

d. Includes only energies imparted locally.  About 24 percent of the total energy lost by the alpha particle is imparted to electrons in amounts greater than 100 eV per collision.  These electrons are considered to lose their energy away from the track, and their energy loss has not been included in the local energy loss of the alpha particle.

e. Energy of alpha particle from $^{210}$Po.

radioluminescent dials), and from radon gas associated with the production of lung cancers (in uranium miners).  However, because of their short range, alpha particles emitted by radionuclides cannot penetrate through the dead outer layer of the skin and thus do not constitute an external hazard. They can cause damage only if the alpha-emitting radionuclides are ingested or inhaled and the alpha particles are consequently emitted immediately adjacent to or inside living matter.

### 6.3  The Proton—Another Directly Ionizing Particle with High Linear Energy Transfer

We here complete our review of important directly ionizing particles with a discussion of the proton.  This particle occurs naturally as the sole constituent of the nucleus of the hydrogen atom and can be found in higher numbers in the nuclei of the other elements.  The atomic number of an element, which defines its position in the periodic table and is uniquely associated with its identity, is equal to the number of protons in the nucleus.

Protons show evidence of internal structure—they are lumpy.  The lump-

iness has been associated with still more elementary entities inside the proton, given the name of quarks (Robinson, 1978).

The proton has a mass that is 1835 times the mass of the electron and has a single positive charge (charge of opposite sign to that of the electron, but of the same magnitude). Protons with energies less than a few MeV travel at velocities that are low compared to the velocities of electrons of comparable energies. As a result they impart energy at a high rate as they pass through matter (high LET). Values of linear energy transfer and ranges are given in table 2.5.

The proton is not emitted in spontaneous radioactive decay of the nuclei of the elements, as are the other directly ionizing particles discussed previously (electrons, positrons, and alpha particles). It must be given a minimum amount of energy, through a nuclear collision by another ionizing particle (that is, high-energy photon), before it can be expelled.

The human body contains an extremely large number of single protons as the nuclei of hydrogen atoms. When the body is irradiated by neutrons (section 8) most of the incident energy is initially imparted to these nuclei, which, in turn, become the major means (as energetic protons) for transferring the neutron energy to the body tissue.

### 7.   The Neutron—A Second Important Indirectly Ionizing Particle[14]

The neutron is a very common particle, since it is a basic constituent of the nucleus along with the proton. It is almost identical to the proton in mass and size, but it carries no charge. Normally it remains locked in the nucleus along with the proton. The number of neutrons and protons is a characteristic number for any given nuclide and is known as the mass number.

### 7.1   Sources of Neutrons

There are no significant naturally occurring neutron emitters. A naturally occurring nucleus that is unstable because of an excess of neutrons relative to protons will change the ratio by the transformation of a neutron into a proton within the nucleus and the emission of a beta particle rather than through the emission of a neutron. Radionuclides that emit neutrons can be produced artificially, but all except one have half-lives that are too short to be useful. The only nuclide source of neutrons that has practical possibilities is californium-252. This is a transuranium isotope with a half-life of 2.65 years that undergoes 1 decay by fission for every 31 decays by alpha-particle emission. The fission of each nucleus is almost always accompanied by the emission of a small number of neutrons, which vary for each individual fission. The average number of neutrons emitted per fission of $^{252}$Cf is 3.76.

Aside from the fission of $^{252}$Cf, the only way to produce neutron sources is

---

14. Readers who do not encounter neutrons in their work should omit this section in a first reading and continue on to section 8.

through nuclear reactions, that is, the bombardment of nuclei with projectiles to produce various products.   Suitable projectiles for producing neutrons can be obtained with radiation machines or from some radionuclides. The most common reaction using radionuclides is the bombardment of beryllium with alpha particles.   The alpha particles must have an energy greater than 3.7 MeV to initiate the reaction.   Suitable alpha particle sources are polonium-210, radium-226, plutonium-239, and americium-241. The energy spectrum of neutrons from an americium-beryllium source is shown in fig. 2.14.

The most powerful sources of neutrons are nuclear-fission reactors.   Approximately 2.5 neutrons are emitted per fission of uranium-235 and can cause further fissions.   As a result, a self-sustained fission reaction can be maintained.   The fission process releases a tremendous amount of energy, approximately 200 MeV per fission, and it is because of this outstanding energy release capability that fissionable material has become such a valuable fuel for power plants.

Strong neutron sources are provided by radiation machines known as neutron generators.   A reaction which is much used is the bombardment of a tritium target with deuterons (deuterium nuclei) having energies in the 150,000 eV range.   The neutrons produced have energies of 14 MeV. These neutron generators are available at a cost within the budgets of many educational and scientific institutions.

The variety of reactions that can produce neutrons increases as the energy of the bombarding particles increases.   Neutrons are produced in abundance around high-energy accelerators, as secondary radiations resulting from the interactions of the primary particles with shielding and other material in the environment.   The protection of personnel from exposure to

N(E)

2      4      6      8      10

Neutron energy (MeV)

**Fig. 2.14** Energy spectrum of neutrons emitted by Am-Be neutron source (Geiger and Hargrove, 1964). N(E) gives the relative number of neutrons emitted per MeV of energy range, and the area under the curve between any two energies gives the relative number of neutrons in that energy range.

these neutrons represents one of the more difficult problems in radiation protection.

## 7.2   Neutron Collisions

In considering the actions of neutrons as they penetrate a medium, it must be borne in mind that the neutron carries no charge and has a mass only slightly larger than that of the proton. Its mass equals 1.00867 atomic mass units (AMU),[15] while that of the proton equals 1.00728 AMU. Because the neutron is not charged, it does not lose its energy in direct, closely spaced ionizations as do charged particles such as protons. It is not electromagnetic like gamma photons and therefore does not undergo interactions with the electrons in the medium. A neutron travels through a medium without interaction until it collides with an atomic nucleus. The collision (involving two material objects) is governed by the laws of conservation of momentum and energy. The maximum energy transfer that can result occurs when neutrons collide with the nuclei of hydrogen atoms (that is, protons), which are of almost equal mass. The amount of energy transferred depends also on the directions of recoil of the proton and the neutron after the collision. If the proton is ejected directly forward, it will receive all the energy of the neutron, which in turn will come to rest. The maximum energy that can be transferred to an atom heavier than hydrogen decreases as the atomic mass increases. The maximum fractional transfer to a target with atomic mass $M$ is equal to $4M/(M + 1)^2$ which equals 1 for collisions with hydrogen ($M = 1$), and 0.28 for collisions with carbon ($M = 12$). The maximum energy transfer occurs only a small fraction of the time, and on the average the energy transferred is half the maximum.

The energetic recoil atom becomes charged quickly and penetrates as a directly ionizing particle. Because of its large mass, it travels at a relatively low speed and loses energy at a high rate; that is, its ionization is characterized by high linear energy transfer. Energy from recoil atoms represents the most important mechanism by which neutrons produce damage in tissue. Hydrogen atoms receive most of the energy from neutrons traveling through tissue and produce most of the damage as recoil protons. This is because of the abundance of hydrogen and the high probability of the interaction of neutrons with the hydrogen nuclei, relative to other nuclei present. Other damage is produced from carbon and oxygen recoils, while a fraction is from gamma rays and protons released by the capture of low-energy neutrons in the nitrogen.

Collisions between neutrons and the light elements found in tissue at neutron energies of a few MeV and lower (generally characteristic of neutron exposure) are elastic; that is, the kinetic energy of the colliding bodies is

---

15. This scale is chosen so that the neutral carbon-12 atom has a relative mass exactly equal to 12 (equivalent to $1.6604 \times 10^{-24}$ g).

conserved during the collision.   In heavier elements, some of the kinetic energy of the neutron may be transferred to the internal energy of the nucleus. In this case, referred to as an inelastic collision, the kinetic energy which can be imparted to the atom will be reduced.   The excited nucleus will release the energy of excitation in the form of a gamma photon or other particles. Inelastic collisions have significance in the attenuation of neutrons but do not play an important role in the production of damage in living matter.

### 7.3   Attenuation of Neutrons

The concepts of the attenuation coefficient and the half-value layer used in the discussion of the attenuation of gamma photons (sections 5.2, 5.3) also apply to the attenuation of neutrons.   Since attenuation of neutrons of energies less than a few MeV is most effectively accomplished with hydrogen, the attenuation coefficient of hydrogen is of special interest and is shown as a function of energy in fig. 2.15.   The value applies to a medium in which the hydrogen density is 1 $g/cm^3$.   To determine the attenuation from the hydrogen content in any other medium, calculate the hydrogen density in that medium in g/cc and multiply it by the attenuation coefficient in fig. 2.15.   Convert the coefficient to the half-value layer by the relationship: half-value layer = 0.693/attenuation coefficient.   Calculate the total number of half-value layers for the thickness under consideration and evaluate the attenuation produced, for the number of half-value layers obtained, in the usual manner.

> *Example 5:* Calculate the attenuation due to the hydrogen in a water shield, 1.5 m thick, for 8 MeV neutrons.
>
> Water consists of 11 percent hydrogen by weight; that is, the density of hydrogen is 0.11 g/cc.   From fig. 2.15, the attenuation coefficient of hydrogen is 0.68 $cm^{-1}$ at unit density, and 0.075 for a hydrogen density of 0.11.   The HVL for the hydrogen in water is 0.693/0.075 = 9.25 cm.   The number of HVL contributed by the hydrogen in the shield is 150/9.25 = 16.2.   The attenuation is $(1/2)^{16.2}$ or $1.3 \times 10^{-5}$.

When we are dealing with a complex energy spectrum, such as the one characterizing neutrons produced in fission, the problem can become very complicated, since the attenuation coefficient varies with the energy.   It is sometimes possible to use a single value of the attenuation coefficient for the energy distribution considered.   A single coefficient which can be used for the whole spectrum is called a removal attenuation coefficient.   Values of the removal coefficient for fission neutrons are presented in table 2.6.   They apply to a density of 1 $g/cm^3$, and the value for a substance in any given shielding material may be obtained by multiplying the value in table 2.6 by the density of the substance in this material.   The number of half-value layers contributed by the substance in the shield may then be determined by

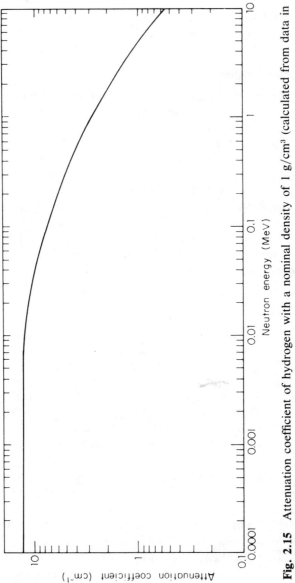

**Fig. 2.15** Attenuation coefficient of hydrogen with a nominal density of 1 g/cm³ (calculated from data in Hughes and Schwartz, 1958).

**Table 2.6.**  Removal attenuation coefficients for fission neutrons in attenuating medium with a density of 1 g/cc.

| Element | Removal coefficient (cm$^{-1}$) |
|---------|---------------------------------|
| Iron | 0.020 |
| Hydrogen | 0.602 |
| Oxygen | 0.041 |
| Calcium | 0.024 |
| Silicon | 0.295 |

*Source:* NBS, 1957, Handbook 63.

dividing the shield thickness by the half-value thickness.  The removal coefficient concept applies only if the shield contains an appreciable amount of hydrogen (hydrogen atoms >20 percent) or if the last part of the shield is hydrogenous.[16]

When a shield is composed of several materials, the total attenuation produced by all the materials is obtained by determining the number of half-value layers contributed by each of the materials and adding them.  An attenuation factor is calculated for this total number of half-value layers.[17]

> *Example 6:* Calculate the attenuation provided by a water shield 1 m thick for fission neutrons.
>
> From table 2.6 the attenuation coefficient of hydrogen is 0.11 × 0.602, or 0.066 cm$^{-1}$, and the HVL is 0.693/0.066 = 10.5 cm.  Thus the number of HVL in 1 m is 100/10.5 = 9.5.  The oxygen has a density of 0.89 g/cm$^3$ in the water.  The attenuation coefficient for oxygen in water is 0.041 × 0.89, or 0.0365, and the HVL is 19 cm.  The number of HVL contributed by the oxygen in the 1 m water shield is 5.25.  The total number of HVL is 14.75 and the attenuation factor is 3.7 × 10$^{-5}$.

Neutron attenuation problems are concerned with neutron energies down to the average energies of the surrounding atoms, that is, energies of neutrons in thermal equilibrium with their surroundings.  At normal room temperature, 20°C, these neutrons, known as thermal neutrons, have a most probable energy equal to 0.025 eV.  Thus, neutrons from 0.025 eV up are significant in shield penetration and dose evaluation.  The consideration of neutron shielding is not terminated with the loss of neutron energy, because all neutrons are eliminated through absorption by the nucleus of an atom

16. Price, Horton, and Spinney, 1957, pp. 175 ff.; NCRP, 1971a.

17. Shield engineers determine the attenuation from the total number of relaxation lengths, $\mu x$, and the value of e$^{-\mu x}$ (see Price, Horton, and Spinney, 1957).

after they are slowed down. The nuclear absorption of a neutron results in the release of a substantial amount of energy, generally of the order of 7 MeV. This energy usually appears as very penetrating gamma photons,[18] and so we have the unhappy situation, from a shielding point of view, of removing the kinetic energy of neutrons by attenuation, only to get more energy back after absorption of the thermal neutron in the form of energetic gamma photons. Neutron attenuation problems are almost always followed by gamma attenuation problems.

Neutron shields always terminate in hydrogenous material, so if lead or some other high atomic number element is needed for additional gamma shielding, it should precede the hydrogenous material. In this way the gamma shielding also has maximum effectiveness as neutron shielding and the attenuation is determined with the use of removal coefficients. The design of shields for both gamma photons and neutrons is a complex problem beyond the scope of this text. For details, see shielding texts and handbooks (Rockwell, 1956; Price, Horton, and Spinney, 1957; and Jaeger, 1968).

The concepts of time, distance, and shielding, discussed previously in connection with protection from gamma photons, apply equally to neutrons.

## 8.   The Absorbed Dose—A Measure of Energy Imparted to a Medium

In previous sections we presented the properties of directly and indirectly ionizing particles, and described the manner in which they imparted energy to a medium. We also emphasized the key role (in damage production) of energy imparted. We now consider how energy imparted is determined and the units in which it is expressed (ICRU 1980, Report 33).

### 8.1   The Pattern of the Imparted Energy in a Medium

The ionization patterns produced by various particles incident on a medium such as water are shown in fig. 2.16. Beta particles are depicted as continuously producing ionization (from the moment they enter the medium) along a tortuous path marked by occasional large-angle scatterings as well as smaller deflections. The large-angle scatterings occur when the beta particles pass close by an atomic nucleus and encounter strong electrical forces. These large-angle scatterings do not produce ionization, but they cause the beta particle to emit x-ray photons. There are also side tracks of ionization caused by high-speed electrons (known as delta rays) that are ejected from the orbits of atoms. The depths of penetration of individual beta particles vary depending on their energy and the degree of scattering. The maximum penetration is equal to the range of the beta particles in the medium. The particles impart their energy as excitations as well as ionization of the atoms in the medium.

Alpha particles are shown traveling in a straight line and stopping in a much shorter distance than beta particles. The ionizations, always closely

---

18. This is known as *radiative capture*.

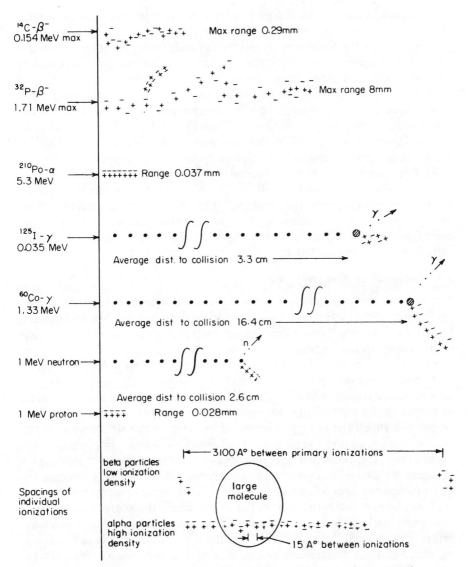

**Fig. 2.16**  Ionization patterns produced by various particles in tissue (not drawn to scale).

spaced, become even more closely spaced near the end of the range.  The spacings of the individual ionizations of alpha and beta particles in comparison to the dimensions of a large molecule are compared at the bottom of the figure.

Gamma photons are shown as proceeding without interaction until there is a collision in which a high-speed electron is ejected from an atom.  The ejected electrons may have energies up to the maximum energy of the

gamma photon, minus the energy required to eject the electrons from their shells. The maximum-energy electrons result from complete absorption of the photon, and the lower-energy electrons result from partial loss of the energy of the photon in a scattering. The scattered gamma photon proceeds until it undergoes further interactions.

Photons of two energies are shown for comparison. The gamma photon from cobalt-60 on the average travels a longer distance (16.4 cm) than the lower-energy gamma photon from iodine-125 (3.3 cm) between interactions. The electrons ejected by the $^{60}$Co photons are also more energetic, on the average, and travel greater distances before being stopped.

Fast neutrons are shown to proceed without interaction until there is an elastic collision with a nucleus followed by recoil of the nucleus and scattering of the neutron at reduced energy. The recoil nucleus, because of its large mass, has high linear energy transfer and short range. A track of the most important recoil nucleus in tissue, the proton, is shown diagrammatically under the neutron track.

### 8.2    Definition of Absorbed Dose

The basic quantity that characterizes the amount of energy imparted to matter is the absorbed dose. The mean absorbed dose in a region is determined by dividing the energy imparted to the matter in that region by the mass of the matter in that region.

From the discussion of patterns of ionization presented in the last section, it is obvious that such patterns can be quite nonuniform throughout a region, and therefore the absorbed dose is different in different parts of the region. A proper application of this concept requires a knowledge not only of the manner in which the energy is imparted but also of the significance of this manner with regard to the production of injury to tissue. In evaluating absorbed dose, the radiation protection specialist must select the critical region in which he wishes to evaluate the energy imparted. He may average the energy imparted over a fairly large region. If the energy pattern is very nonuniform, he may select that part of the region where the energy imparted is a maximum to obtain a maximum dose. If the region where the dose is a maximum is very small, he may decide that the dose in that region is not as significant as a dose determined by considering a larger region. We shall examine the various possibilities in later examples.

### 8.3    The Rad and the Gray — The Special Units of Absorbed Dose

Absorbed doses are expressed in units of rads or grays,[19] or in prefixed forms of these units such as the millirad (mrad, 1/1000 rad), the microrad ($\mu$rad, $10^{-6}$ rad), etc.

---

19. The rad is the traditional unit of absorbed dose. The gray was adopted as the basic unit of absorbed dose in the International System (SI) of units. The conversion is 1 gray = 100 rad;

The gray is equal to 1 joule per kilogram (1 J/kg).

The rad is equal to $62.4 \times 10^6$ MeV per gram.

The millirad is equal to 62,400 MeV per gram.

Harmful levels of radiation dose are generally expressed in terms of rads; for example, over a hundred rads must be imparted in a short period over a substantial portion of the body before most individuals will show significant clinical symptoms (Saenger, 1963, p. 66). The millirad is used in specifying levels of permissible dose rates. Occupational exposure to radiation is not allowed to produce absorbed dose rates in excess of a few mrad per hour, on the average.

## 9. The Dose Equivalent—The Basic Quantity in Radiation Protection

Although the injury produced by a given type of ionizing radiation depends on the amount of energy imparted to matter, some types of particles produce greater effects than others for the same amount of energy imparted. For example, for equal absorbed doses, alpha particles produce more injury than protons do, and these in turn produce more injury than beta particles do. The damage produced increases as the distance over which a given amount of energy is imparted decreases. The effectiveness of one ionizing particle relative to another may also vary considerably depending on many other special circumstances, including the particular biological material which is irradiated, the length of the time interval in which the dose is delivered, the type of effect considered, the delay prior to appearance of the effect, and the ability of the body to repair the injury.

If we knew the dose in rads required to produce a given degree of injury by every kind of particle, this information would suffice for purposes of radiation control. Obviously such information does not exist, nor is it ever likely to be completely developed. Because of the general policy of strict control of radiation exposure, there are relatively few documented instances of injury to humans from excessive radiation exposure, and these instances provide only some rough estimates on the relative harm of the different particles.

Studies on animals are very useful in providing information on the effectiveness of the different particles in producing damage. The experiments serve primarily to determine the effects of the particles on the animals, and extrapolation to man introduces many uncertainties. Accordingly, the specialist in radiation protection is usually forced to use some physical measure

---

that is, they are related numerically as fractions are to percentages. In general the traditional units are used here except when it is more convenient to express a quantity in SI units. The standard definition of the rad is 100 erg per gram. We have expressed it in MeV per g, since this form simplifies the dose calculations for ionizing particles, whose energies are generally given in MeV. The handbook value for the electronic charge is $1.602 \times 10^{-19}$ C which gives a conversion factor of $62.42 \times 10^6$ MeV/g-rad.

of the way different ionizing particles impart their energy to matter to gauge their relative effectiveness in producing injury to humans.

### 9.1   The Quality Factor—A Measure of the Relative Hazard of Energy Transfer by Different Particles

The physical measure for gauging the relative effectiveness of equal absorbed doses from different particles in producing injuries is the linear energy transfer, or LET.[20]   The higher the LET of the radiation, the greater the injury produced for a given absorbed dose.

The factor expressing the relative effectiveness of a given particle based on its linear energy transfer is known as the *quality factor*.   Values of quality factor as a function of LET are assigned primarily on the basis of animal experiments.

In a given radiation exposure situation there also may be other factors which are known to modify the effect of the energy imparted to the matter, for example, the distribution of dose.   If these factors are known, they may be included in the evaluation along with the quality factor, as *modifying factors*.

When the absorbed dose is evaluated for purposes of radiation protection, it must be multiplied by the quality factor and other modifying factors that may be justified.   The resultant quantity is known as the *dose equivalent* (ICRU 1980, Report 33; ICRU 1976, Report 25).   The dose equivalent is designed to express on a scale common to all ionizing radiations the irradiation incurred by exposed persons; that is, it is intended to correlate with the injury produced as a result of the radiation exposure.

### 9.2   The Rem and the Sievert—The Special Units of Dose Equivalent

When the absorbed dose in rads is multiplied by the quality factor and other modifying factors, the result is the dose equivalent expressed in rem.   The sievert has the same relationship to the gray in SI units.

$$\text{rems} = \text{rads} \times \text{QF} \times \ldots$$
$$\text{sieverts} = \text{grays} \times \text{QF} \times \ldots$$

Values of the quality factor are given in table 2.7.   Doses produced by electrons, positrons, and x rays are arbitrarily assigned a QF of 1.   The QF is as high as 20 for alpha particles and heavy recoil nuclei and were recently doubled for neutrons by the NCRP (1987) to give them a range between 6 and 20.

Standards for radiation protection are given in terms of the rem unit.   For all practical purposes, doses expressed as rads may be compared to limits given in terms of rem when dealing with beta particles, x rays, and gamma photons.   It is much more complicated to convert absorbed doses to dose equivalents for neutrons, protons, and alpha particles, since the radiation

---

20. See section 6.2, where the LET was introduced in connection with the penetration of alpha particles.   Values of LET for different particles are given in table 2.5.

**Table 2.7.**    Quality factors.

1. X rays, electrons, and positrons of any specific ionization

$$QF = 1$$

2. Heavy ionizing particles

| Average LET in water (MeV/cm) | QF |
|---|---|
| 35 or less | 2 |
| 35 to 70 | 2 to 4 |
| 70 to 230 | 4 to 10 |
| 230 to 530 | 10 to 20 |
| 530 to 1750 | 20 to 40 |
| 1750 and above | 40 |

For practical purposes, a QF of 20 is often used for fast neutrons and protons up to 10 MeV, alpha particles, and other multiply charged particles.

The following values for quality factors may be used for neutrons when the neutron energy spectrum is known:

| Neutron Energy (MeV) | QF |
|---|---|
| Thermal | 5 |
| 0.0001 | 4 |
| 0.01 | 5 |
| 0.1 | 15 |
| 0.5 | 22 |
| 1.0 | 22 |
| 10 | 13 |

*Source:* NCRP, 1987.

field must be known well enough to determine its LET characteristics. Generally, it is not practical to obtain the data, and the value 20 is normally assigned to high LET radiation of unknown energy. Efforts are being made to develop instruments that can measure the LET directly. Such instruments would obviate the difficult technical problem of determining the specific energy characteristics of the particles involved.

There are situations where available biological data may indicate that the quality factor as based on LET does not express accurately the relative effectiveness of a particular radiation field for the effect of interest. Under these circumstances, the biological data must take precedence and be used in deciding on maximum permissible exposure levels.[21]

21. In radiobiology, the experimentally determined ratio of an absorbed dose of the radiation in question to the absorbed dose of a reference radiation required to produce an identical biological effect in a particular experimental organism or tissue is known as the RBE (relative biological effectiveness). The term RBE was originally used as a multiplication factor of "rads" to give "rem," but this practice is no longer employed.

### 10.   The Roentgen—A Special Unit for Radiation Exposure

One of the most common methods of measuring x and gamma radiation is to measure the charge they produce by ionizing air. The quantity that expresses the ionization produced by x rays interacting in a volume element (for example, 1 cc) in air is known as the exposure. The unit in which exposure is expressed is the roentgen (R). It is used for x and gamma ray measurements in the energy range from a few keV to a few MeV.

The roentgen was originally defined as the amount of x or gamma radiation that produces 1 esu of charge per cc of dry air at 0 °C and 760 mm pressure. It is defined currently in equivalent units as $2.58 \times 10^{-4}$ coulombs/kg air. It turns out that this amount of radiation imparts an amount of energy equal to $5.4 \times 10^{7}$ MeV per g of air, or 0.87 rad to air. A roentgen of x radiation in the energy range 0.1–3 MeV also produces 0.96 rad in tissue (ICRU, 1962). Thus, for most purposes values of exposures in roentgens can be considered essentially numerically equal to absorbed doses in rads to tissue irradiated at the same point, or to dose equivalents in rem.

### 11.   The Significance of External Radiation Levels

Having introduced units for expressing radiation levels, we may now consider the significance of specific values of these levels. It is convenient to separate radiation exposure into two categories: exposure to radiation from sources external to the body and exposure to radiation from radionuclides incorporated inside the body. We shall consider external radiation levels here and deal with the significance of internal emitters in the next section.

Values of radiation levels for various situations of interest are presented in table 2.8. The table ranges from the very low levels encountered normally as radiation background, through levels defined for purposes of control of radiation exposures, and up to levels that can produce severe injury. The values selected are given in the units in which they were reported in the literature, but all numerical values given in the table may be expressed as rem for x, gamma, or beta radiation.

The background levels, given as four entries in group I, table 2.8, are due to gamma radiation from radioactive materials in the earth, such as radium and potassium-40, and cosmic radiation coming down through the atmosphere. The levels are expressed in terms of the exposure accumulated over a period of one year to allow comparison with radiation protection standards.

Note that the background level on the earth's surface increases by a factor of about 2 from 88 milliroentgens (mR) per year to 164 mR per year in going from sea level to 10,000 feet altitude as a result of the increased intensity of cosmic radiation. The mass of air contained in the atmosphere is equivalent to a shield of water 10.3 m (34 ft) thick, and attenuates appreciably the cosmic radiation incident upon it. This shielding effect is lost, of course, when

**Table 2.8.**   Significance of external radiation levels (excluding neutrons).

| Exposure | Significance |
|---|---|

### I

| | |
|---|---|
| 88 mR/yr, continuous whole body (0.011 mR/hr) | Background radiation, sea level, out of doors, New York City |
| 76 mR/yr, continuous whole body | Radiation inside wooden house at sea level, NYC |
| 164 mR/yr, continuous whole body | Background radiation, altitude of 10,000 ft (ground level) |
| 4,400 mR/yr, continuous whole body | Exposure at cruising altitude of supersonic transport (60,000 ft) |

### II

| Current | Proposed revision* | |
|---|---|---|
| 1,250 mrem/qr | 5,000 mrem/yr EDE | Occupational exposure limit for whole body |
| 125 mrem/qr | 100 mrem/yr EDE | Whole-body limit for members of public |
| 15,000 mrem/yr | Depends on EDE (max. 50 rem/yr) | Single tissue or organ limit if not covered separately |

### III

| | |
|---|---|
| <2 mrem in an hour and <100 mrem in any 7 consecutive days | Unrestricted area.  No control or sign required |
| >2 mrem in an hour or >100 mrem in any 7 consecutive days | Control of area required |
| >5 mrem in 1 hour to major portion of body | Radiation area sign required |
| >100 mrem in 5 days to major portion of body | Radiation area sign required |
| >100 mrem in 1 hour to major portion of body | High radiation area sign required |

### IV

| | |
|---|---|
| 1 R, major portion of bone marrow | Risk of fatal leukemia is about 1 in 10,000 |
| 1 R, whole body | Risk of eventual appearance of fatal solid cancer about 1 in 1,500 |
| 10 R, whole body | Elevated number of chromosome aberrations in peripheral blood; no detectable injury or symptoms |
| 100 R, reproductive system | Dose for doubling spontaneous mutations |
| 100 R, single dose, whole body | Mild irradiation sickness |
| 350 R, single dose, whole body | Approximately 50% will not survive |

* As of this printing the revised limits have been proposed but not enacted. EDE = effective dose equivalent.

**Table 2.8.** (continued)

| Exposure | Significance |
|---|---|
| 400–500 R, low energy x ray, local | Temporary loss of hair |
| 500–600 R, single dose, locally to skin, 200 keV | Threshold erythema in 7–10 days, followed by gradual repair; dryness and dull tanning. |
| 2000 R locally to skin from 1 MeV x ray at 300 R/day | Threshold erythema |
| 600–900 R, locally to eye | Radiation cataract |
| 1,000–2,500 R, local, at 200–300 R/day | Treatment of markedly radiosensitive cancer |
| 1,500–2,000 R to skin, single dose, 200 keV | Erythema, blistering, residual smooth soft depressed scar |
| 2,500–6,000 R, local, at 200–300 R/day | Treatment of a moderately radiosensitive cancer |
| V | |
| 900 mR[a] | Mean exposure per dental film per examination in 15–29 yr age group (1970) |
| 27 mR | Mean exposure per chest x ray (PA, radiographic, 1970) |
| 500 mR | Mean exposure per chest x ray (photofluorographic, 1964) |
| 5,000 mR/min[b] | Output from properly operating fluoroscope without image intensifier |

a. 400 mR and less per exposure practical.
b. Less than 2,000 mR/min with image intensifiers.

we travel at high altitudes. The increase is dramatic at altitudes at which a supersonic transport would be flown (up to 26,000 mR/year). Even this level is much less than the level which would be produced during periods of solar flares.

The levels on the ground vary considerably from place to place, depending on altitude, composition of soil, pressure, solar activity, and so on. The levels in buildings can be appreciably higher or lower than the levels out-of-doors, depending on the materials of construction. One measurement of the radiation level inside a wooden building is given in table 2.8. The level is 12 mR per year less than it would be out-of-doors.

There is a small contribution to the environmental radiation dose from neutrons, not shown in table 2.8. Typical annual doses are 0.35 mrad at sea level, 8.8 mrad at 10,000 ft and 192 mrad at 60,000 ft. The dose equivalent (in mrem) is about 10 times as high on the basis of current quality factors used by the NRC but could be over 20 times as high if proposed revisions in the quality factor for neutrons are adopted.

The entries in group II list exposure limits promulgated by the U.S. Nuclear Regulatory Commission in the Code of Federal Regulations, Title 10, Part 20 (10CFR20). Since the limits are used for regulating purposes, they are expressed as dose equivalents, in units of mrem. We note that the maximum level for occupational exposure is 1,250 mrem/quarter (5000 mrem/yr) to the whole body. If only the hands are exposed, higher levels are allowed, amounting to 18,750 mrem/quarter. Technically, a radiation worker could receive his whole quarterly dose at one time without exceeding the standards for exposure, provided he received no additional exposure for the remainder of the calendar quarter in question. In practice, exposure is usually controlled on a weekly basis; that is, the individual's exposure should not exceed 100 mrem/week. The regulations do allow for higher quarterly exposure levels for the whole body if the cumulative previous dose is below a certain level. Operations that could result in the higher exposure rates should be carefully reviewed for dose reduction possibilities. Regardless of limits, doses to individuals should be kept as low as reasonably achievable (ALARA policy).

The maximum level for individuals under 18 years of age and other individuals nonoccupationally exposed is 10 percent of the occupational level, or 125 mrem/quarter for the whole body. The occupational exposure of pregnant women should be so limited that the unborn child does not receive a dose greater than 500 mrem during the entire gestation period. To prevent excessive exposure of the fetus before pregnancy is recognized, fertile women should be employed only in situations where the annual dose accumulation is unlikely to exceed 2 or 3 rems and is acquired at a more or less steady rate.

The NRC is requiring implementation by January 1, 1993, of a revised 10CFR20 with many significant changes. The quarterly limits will be dropped in favor of annual limits, and a new approach to setting limits will combine both internal and external exposure. The limit for individual members of the public will be reduced by a factor of 5, to 100 mrem/yr. Some examples are included in table 2.8.

Group III deals with the posting of areas to warn individuals that significant radiation exposure is possible. Signs are required if the general radiation level exceeds 5 mrem in 1 hour, or 100 mrem in 5 days. Control of the area is required if the level exceeds 2 mrem in an hour or 100 mrem in any seven consecutive days. If the level is less than 2 mrem in an hour, the area is considered unrestricted. Under these conditions occupants do not need to be warned that radiation is present. For example, if an individual occupies an apartment building adjacent to an x-ray machine operated by a doctor or dentist, he does not need to be told of the presence of radiation from that machine provided it does not exceed the limits for an unrestricted area. Of course, the more restrictive condition that the quarterly dose is not to exceed 125 mrem also applies. If the level is in excess of 100 mrem or more in 1 hour, the area is considered a high radiation area, and regulations specify special control measures.

Group IV describes some of the effects produced in individuals who are exposed to radiation.  The cumulative levels generally associated with occupational exposure are in the roentgen or rad range, and the effects to the worker of most concern at these levels are the risks of producing leukemia or other cancers.  There appears to be some consensus that the risk of leukemia is of the order of 1 in 50,000 per rad to the whole body.  The chances of any individual's getting leukemia seem to diminish appreciably 10 years after exposure.  A major fraction of the bone marrow has to be affected to give this level of risk.  Thus, the chance of any individual's getting leukemia at the control levels of exposure, which must average out to less than 5 rad per year, is very small.  However, the laws of statistics ensure that if the risk figures are correct, and if enough individuals are exposed, some cases of leukemia will be produced.

Data on the risk of production of cancers other than leukemia are very meager, but some authorities have speculated that the risk of cancers in sensitive organs may be comparable to the risk of leukemia.  If the whole body receives the same radiation dose, the combined risk of the eventual appearance of all other cancers may be as high as ten times that of leukemia.  The cancer risk does not peak until more than 20 years after exposure.  The risk estimates may be high, since they are based on the extrapolation of results observed after acute doses of many tens of rads in radiation therapy to doses imparted occupationally at a much lower rate.  However, in the absence of other data, the values are applied for radiation-protection purposes.

Another area of concern is genetic damage.  In assessing the effects of radiation, the concept of doubling dose is helpful.  The doubling dose for a population is the dose to the childbearing segment of the population that is believed to double the number of mutations that would occur normally in the offspring of unexposed parents.  Both the rate at which new mutations arise in each generation "spontaneously" and the dose required to double this rate are numbers that are very difficult to derive.  The United Nations Scientific Committee on the Effects of Atomic Radiation (UNSCEAR, 1977) estimates that, in every million births, over 14,000 (1.4 percent) produce children with genetic disease as a result of dominant gene mutations and chromosome aberrations.  Perhaps 400 of the births carry dominant gene mutations that arose "spontaneously" in the preceding generation (ICRP, 1966, Report 8).  A dose of 100 rad, imparted as an acute dose to the whole parental generation, might double this incidence.  An additional 7000 (0.7 percent) births carry chromosome aberrations, which must have arisen in the preceding generation, since these are not transmitted to future generations because of the severity of their consequences.  The effectiveness of x rays or gamma photons in producing chromosome aberrations is unknown but is believed to be very low for low dose rates.  There is reason to believe on the basis of animal experiments that the effect of 100 rad, imparted at the low dose rates characteristic of occupational exposure, is probably less than

an acute exposure. Animal experiments also indicate that the effect is considerably reduced if there is a delay of several months between exposure and conception. The problem of the total genetic harm that might be caused, including the subtle effects of recessive mutations, over many generations, is extremely complex and may never be resolved satisfactorily. Accordingly, regardless of the standards that may be set, the only acceptable policy with regard to the exposure of large numbers of individuals is to keep the dose to the gonads to a minimum, well below the dose from natural background radiation. As far as any individual worker exposed below occupational limits is concerned, the risk of any genetic harm to offspring conceived after exposure is extremely small (ICRP, 1966, Report 8, sect. 11.1, p.50). However, if a substantial dose is incurred by a worker in a short time period, it may be prudent to allow the lapse of several months prior to conception.

The higher levels shown in group IV produce directly observable effects. Note the high levels that are used in radiation treatment of cancer. The individual can survive the high exposure because the volume exposed is small. There may be significant risk of cancer induction at a later period from doses imparted at these levels, but if radiation treatments can arrest or cure a cancer that cannot be treated by other techniques, the immediate benefit is more important than any possible later effects.

The entries in group V give levels associated with diagnostic x rays, the major source of radiation exposure of the population outside the natural background. The dose imparted in taking an x ray has decreased tremendously over the years with improvements in film and x-ray equipment. It may be noted, for example, that the lower limit of exposure from a chest x ray using modern techniques is of the order of 10 percent of the annual exposure from natural background radiation to the same region. On the other hand, even a properly operating fluoroscope can produce exposure rates of the order of 5000 mR/min. Additional information on medical x-ray exposures is given in section 14 and part VI.

## 12.   Exposure from Internal Radiation Sources

To this point we have discussed the imparting of dose to the body from radiation incident upon it from the outside. Our major concern has been with the properties of the radiations and their manner of imparting dose, and we have not considered the characteristics of the source. However, we shall now consider radiation exposure resulting from the introduction of radioactive materials into the body through inhalation, ingestion, or medical procedures. We must introduce a new quantity which describes the rate at which the radioactive materials undergo nuclear disintegrations. Knowing the disintegration rate, we can then determine the rate at which radiations are emitted during the course of these disintegrations and evaluate the dose produced when they interact and impart energy to matter.

## 12.1    The Activity—A Quantity for Describing the Amount of Radioactivity

The basic event that characterizes a radioactive nuclide is the transformation of its nucleus into the nucleus of another species. This transformation is known as decay, and there may be several modes of decay for a given nuclide. The number of nuclear transformations occurring per unit of time is called the activity. As an example, consider the decay scheme for bismuth-212, shown in fig. 2.17. This nuclide undergoes alpha decay in 36 percent and beta decay in 64 percent of its disintegrations. A quantity of $^{212}$Bi that undergoes 100 nuclear disintegrations per minute has an activity of 100/min and emits 36 alpha particles and 64 beta particles per minute. Gamma photons accompany 72 percent of the alpha decays and 16 percent of the beta decays.[22]

## 12.2    The Curie, and the Becquerel—Special Units of Activity

The activity of radioactive material is generally expressed in terms of the curie or fractions of a curie. The SI unit for activity is the becquerel.

$$1 \text{ curie} = 2.22 \times 10^{12} \text{ disintegrations/minute.}$$
$$1 \text{ millicurie} = 2.22 \times 10^{9} \text{ dis/min.}$$
$$1 \text{ microcurie } (\mu\text{Ci}) = 2.22 \times 10^{6} \text{ dis/min.}$$
$$1 \text{ picocurie (pCi)} = 2.22 \text{ dis/min.}$$
$$1 \text{ becquerel (Bq)} = 1 \text{ dis/sec.}$$

22. Very few radionuclides decay like $^{212}$Bi, by emitting both alpha and beta particles. This example was chosen primarily because of its value in illustrating the meaning of activity as contrasted to particle emission rate.

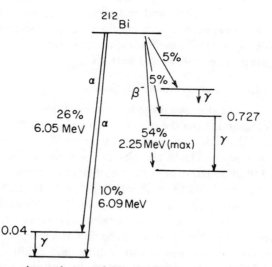

Fig. 2.17   Disintegration scheme of bismuth-212. Energy released from alpha decay, $Q_{\alpha} = 6.21$ MeV. Energy released from beta decay, $Q_{\beta} = 2.25$ MeV.

It is important to recognize that the unit of activity refers to the number of disintegrations per unit time and not necessarily to the number of particles given off per unit time by the radionuclide. For example, 1 $\mu$Ci of $^{212}$Bi undergoes $2.22 \times 10^6$ transformations per minute but gives off $2.22 \times 10^6 \times 0.36$ alpha particles per minute, $2.22 \times 10^6 \times 0.64$ beta particles per minute, and $2.22 \times 10^6 \times 0.36$ gamma photons per minute. The rate of emission of a particular type of ionizing particle can be equated to the activity only when that particular particle is given off in each disintegration.

The range of activities found in radiation operations varies tremendously, from microcurie and submicrocurie quantities in laboratory tracer experiments to hundreds of megacuries (millions of curies) inside the fuel elements of nuclear power plants. The distribution of microcurie quantities of most radionuclides is not regulated, since these small amounts are not considered hazardous as sources external to the body. On the other hand, nuclear reactors require very tight governmental regulation because of the potential for serious radiation exposures in the event of reactor accidents.

### 12.3   Significance of Levels of Radioactivity inside the Body

The dose from radiation emitted by radioactive materials inside the body is evaluated in accordance with the same principles as for radiation from sources outside the body. We must determine the energy imparted per unit mass by radiations emitted by the radioactive materials, and we use the same units that we used for absorbed dose, MeV/g. Maximum levels for activities of radionuclides inside the body are set by requiring that they do not result in doses to critical regions in excess of those specified for external sources of radiation.[23] The limits are generally expressed in microcuries.

Although the maximum body burdens of radionuclides are established on the basis of dosimetry calculations, an important benchmark for maintaining perspective on internal exposure is the natural radioactivity of the body. The body contains several radionuclides, most of which have always been contaminants in air, water, and food, and others which have appeared only in recent years as the result of fallout from the testing of nuclear weapons. Some of the radionuclides present in the body are shown in table 2.9.

The main source of radioactivity is from the radioactive isotope of potassium, potassium-40. There are 1.12 radioactive atoms of $^{40}$K for every 10,000 nonradioactive atoms of potassium. There is of the order of 140 g of potassium in an adult who weighs 70 kg, and 0.0169 g consists of the $^{40}$K isotope. This amount of $^{40}$K disintegrates at the rate of 266,000 atoms per minute. Of every 100 disintegrations, 89 result in the release of beta particles with maximum energy of 1.33 MeV, and 11 result in gamma photons with an energy of 1.46 MeV. All of the beta particles and about 50 percent of the

---

23. Exceptions are the bone-seekers. Because of the extensive epidemiologic data obtained for radium, it has been possible to establish limits for this nuclide based on human exposure. Limits for other bone-seekers are set by consideration of the energy imparted and the LET relative to radiations resulting from radium in the body.

**Table 2.9.**   Radioactive materials in the body.

| Radionuclide | Body content in 70 kg man | | Annual dose (mrad) |
|---|---|---|---|
| | (picocurie) | (dis/min) | |
| $^{40}$K | 120,000 | 266,000 | 18 (whole body) |
| $^{14}$C | 87,000 | 193,000 | 1 (whole body) |
| $^{226}$Ra | 40 | 89 | 0.7 (bone lining) |
| $^{210}$Po | 500 | 1,110 | .6 (gonads) |
| | | | 3 (bone) |
| $^{90}$Sr (1973) | 1,300 | 2,886 | 2.6 (endosteal bone) |
| | | | 1.8 (bone marrow) |

*Sources:* UNSCEAR, 1977; NCRP, 1975, Report no. 45 ($^{90}$Sr).

energy of the gamma rays are absorbed in the body, giving annual doses of 16 mrad from the beta particles and 2 mrad from the gamma rays.

The $^{40}$K that decays is not replenished, and presumably all the $^{40}$K that exists on earth today was produced at the time that the earth was created. The reason all this activity has not decayed completely over the 10 billion years of the earth's existence is the long half-life of the potassium, 1.26 billion years. Other naturally occurring radionuclides that are still present because of their long half-lives are uranium-238, uranium-235, thorium-232, and a whole series of radioactive decay products.

The second most active radionuclide in the body is carbon-14. The half-life of this nuclide is 5,730 years, so obviously whatever $^{14}$C was formed at creation is no longer with us. The $^{14}$C is continuously being produced in the atmosphere by the reaction of the cosmic ray neutrons with the nitrogen in the air. In this reaction, the nitrogen absorbs a neutron and releases a proton, yielding $^{14}$C. The total content of $^{14}$C in the body of an adult undergoes about 193,000 beta disintegrations per minute; the dose from absorption of the weak 0.156 MeV beta particle amounts to only 1 mrad per year. Thus we see that although there are 0.67 times as many $^{14}$C as $^{40}$K disintegrations in the body, the dose rate from $^{14}$C is only 5 percent of the dose rate from $^{40}$K because the energy of the beta particle from $^{14}$C is so much less.

The other three radionuclides in the table deposit primarily in bone. $^{226}$Ra and $^{210}$Po are alpha emitters and the dose in mrad is multiplied by 20 to give the dose equivalent in mrem. $^{210}$Po imparts about 60 mrem and $^{226}$Ra (plus its decay products) about 14 mrem a year to bone cells. The $^{90}$Sr activity in bone is the result of fallout during the testing of atomic bombs.

Selective irradiation of the lungs occurs from inhalation of the radioactive noble gases, radon-222 and radon-220 (thoron) and their radioactive decay products, all of which are always present in the atmosphere. These gases are alpha emitters and along with their decay products, which also impart most of their energy as alpha radiation, produce annual average doses to the

lungs of the order of 34 mrad. (UNSCEAR, 1977, p. 79). Most of the dose (30 mrad) is from $^{222}$Rn and its decay products. Because the exposure is from alpha particles, the dose equivalent is twenty times as high, and thus the lung is the organ that receives the highest radiation exposure from natural sources. A detailed discussion on the nature of the dose from radon and its decay products is given in part III, section 5.6.

### 12.4   Maximum Permissible Concentrations in Air and Water

Protection measures for the prevention of excessive internal doses from radioactive materials are based on the specifications of a maximum permissible intake of the radioactivity by the body. The intake, in turn, is regulated by setting maximum limits for the concentration of radioactivity in air and water. Current NRC occupational limits are set so that, on the basis of calculations using the best data for uptake and retention in the body, the maximum annual doses to any organ in the body will not exceed 5 rem to the red bone marrow, head and trunk, gonads, and lenses of eyes, and 15 rem to other single organs. For people nonoccupationally exposed, the dose must not exceed one-tenth the occupational value. When a large segment of the public is exposed, the intake is further limited, so that the average dose to the population is reduced by an additional factor of 3. New limits based on the "effective dose equivalent" are scheduled to go into effect in 1991 or 1992 (see part VI, section 1). Values for current and proposed limits are given in table 2.10.

### 12.5   Protection from Radioactive Contamination

When we considered protection from radiations emitted by radiation sources, we emphasized *distance* and *shielding* as measures for attenuating the radiation to permissible levels. When we deal with radioactive contamination, the problem is to prevent the contamination from entering the body. This can occur through inhalation, ingestion, absorption through the unbroken skin, or penetration through abrasions, cuts, and punctures. The protective measures needed are similar to those used with any other contaminant that presents an internal hazard and are probably familiar to any person trained to work in the laboratory.

It is general practice to handle significant quantities of radioactive material in a hood to prevent release of these materials to the working environment. The velocity of the air flowing into the hood should be between 100 and 150 linear feet per minute. Gloves should be worn and forceps used to handle sources. Hands should be washed and monitored for contamination after working with these materials. A generally cautious attitude with common sense precautions should provide adequate protection in most working situations. Of course, as the amount of the active material handled increases, the measures must become more stringent. A detailed discussion of protec-

**Table 2.10.**   Concentration guides for radionuclides (in pCi/cc).

| Radionuclide | In air, occupational | | In air, environmental | | In water, environmental | |
|---|---|---|---|---|---|---|
| | Current | Revised | Current | Revised | Current | Revised |
| HTO water | 5 | 20 | 0.2 | 0.1 | 3000 | 1000 |
| $^{14}CO_2$ gas | 50 | 90 | 1 | 0.3 | | |
| $^{14}CO_2$ soluble | 1 | 4 | .1 | .003 | 800 | 30 |
| $^{32}P$ soluble | .07 | .4 | .002 | .001 | 20 | 9 |
| $^{131}I$ soluble | .009 | .02 | .0001 | .0002 | .3 | 1 |
| $^{125}I$ soluble | .005 | .03 | .0008 | .0003 | .2 | 2 |
| $^{226}Ra$ soluble | .00003 | .0003 | $3 \times 10^{-6}$ | $9 \times 10^{-7}$ | .03 | .06 |
| $^{90}Sr$ soluble | .001 | .002 | $3 \times 10^{-5}$ | $6 \times 10^{-6}$ | .3 | .3 |
| $^{228}Th$ insoluble | $6 \times 10^{-6}$ | $7 \times 10^{-6}$ | $2 \times 10^{-7}$ | $2 \times 10^{-8}$ | 10 | .2 |
| $^{239}Pu$ soluble | $2 \times 10^{-6}$ | $7 \times 10^{-6}$ | $6 \times 10^{-8}$ | $2 \times 10^{-8}$ | 5 | .02 |

*Sources:* Current: CFR, 1987; Revised: NRC, 1988. The limits are those promulgated by the U.S. Nuclear Regulatory Commission and include those currently in effect and a proposed revision set to be implemented in 1991 or 1992. The revised limits are based on the use of the effective dose equivalent (see part VI, section 1). The revised environmental limits are based on an effective dose equivalent limit of 0.1 rem, reduced from imparted doses on which current limits are based of 0.5 rem for the whole body or 1.5 rem for critical organs in individual members of the public. The derived concentrations were reduced by another factor of 2 to take into account age differences in sensitivity in the general population.

tive measures for individuals working with radioactive materials is given in part V.

Questions always arise as to what levels of radioactivity require use of a hood, or a glove box, or gloves. We shall not attempt to specify protection measures for various levels of activity. However, every person beginning work with radioactive materials should take strict precautions, even at low levels. In this way he will obtain valuable training and experience. As proper habits are formed, the worker will gain an appreciation of the hazards involved. In time he will accumulate enough experience to select the essential precautions and to avoid the application of excessive control measures.

We cannot overemphasize the need always to utilize radiation monitoring equipment for hazard control. Instruments are the only means of evaluating the presence of radioactivity. Because the worker cannot sense the presence of radioactivity, he cannot be sure that he is in fact working with low amounts when he thinks he is. There are instances, for example, of errors in shipment of radioactive material, of errors in purchase orders of microcuries being read as millicuries, and of unexpected contamination of shipping containers. In planning any protection program, the worker must be aware of the possibilities of such errors and take such reasonable measures as are necessary to insure that he will be protected.

### 13.   Some Simple Calculations in Radiation Protection

It is often useful to be able to make a simple estimate of dose.   Following are a few elementary calculations utilizing "rules of thumb."

### 13.1   Dose from Beta Particles

The higher-energy beta particles, in penetrating through water or water-equivalent thicknesses, lose energy at the rate of about 2 MeV per centimeter.[24]   This characteristic enables us to make a rough calculation of the dose rate from a beam of beta particles incident upon the body.

> *Example 7:* What is the dose rate at the point where a beam of energetic beta particles is incident upon the body, if, over an area of 1 cm², 100 beta particles are crossing per second?
>
> Consider a thin layer of tissue, say 0.1 cm, and assume the tissue is equivalent to water, density = 1 g/cm³.   At an energy loss of 2 MeV/cm, a beta particle deposits 0.2 MeV in the layer and 100 beta particles/cm² deposit 20 MeV in a volume 1 cm² × 0.1 cm = 0.1 cm³, with a mass of 0.1 g.   The energy deposited per unit mass is 20/0.1 = 200 MeV/g.
>
> $$\text{Dose rate} = \frac{200 \text{ MeV/g-sec}}{62,400 \text{ MeV/g-mrad}} = 0.0032 \text{ mrad/sec};$$
>
> 0.0032 mrad/sec × 3600 sec/hr = 11.5 mrad/hr.

As a rough rule of thumb, we may use the relationship 100 beta particles/cm²-sec = 10 mrem/hr.   This relationship holds only for high-energy beta particles.   The dose rate increases appreciably at lower energies because the rate of energy loss increases.   Value of the dose rate in mrad/hr from 100 beta particles per cm²-sec incident on the skin are given in table 2.1 for various radionuclides, and it can be seen that the actual values range from 11 for ⁹⁰Sr to 56 for ¹⁴C.   However, the beta particles undergo greater attenuation in the dead layer of the skin at lower energies and the net result is to bring the dose rate to the basal cells of the epidermis for the various energies to within about 30 percent of 10, for a nominal dead layer thickness of 0.007 cm.

These relationships are useful in estimating the dose if some activity contaminates the surface of the skin.

---

24. The energy loss of 2 MeV per centimeter is a *differential* expression, that is, it is the *limit* of the ratio of the energy loss to the thickness ($\Delta E/\Delta x$) as the thickness gets very small.   It is *not* the energy loss in 1 centimeter (that is, a 0.5-MeV beta particle loses energy over a small distance at the rate of approximately 2 MeV/cm, but obviously it will not lose 2 MeV in 1 cm; it will lose approximately 0.02 MeV in 0.01 cm).   See the end of section 5.2 for additional discussion on differential losses as applied to the attenuation of radiation.

*Example 8:* What is the dose rate to the cells under the dead layer of the skin if a square centimeter of surface is contaminated with 1 $\mu$Ci of $^{32}$P?

The microcurie emits $3.7 \times 10^4$ beta particles per second, half of which are emitted in the direction of the skin. To simplify the problem, assume that all the beta particles are incident perpendicular to the surface and deposit energy at a rate characteristic of high energy beta particles, that is, 2 MeV/cm. Using the results of example 7, and assuming 95 percent penetrate the dead layer, the dose rate is $(3.7 \times 10^4 \times 0.5 \times 0.95 \times 11.5)/100 = 2021$ mrad/hr.

However, the situation is much more complicated. The beta particles enter the skin at all angles and have longer path lengths in the sensitive layer of the skin than at perpendicular incidence. Also, even the higher-energy beta emitters emit a large fraction of low-energy beta particles which impart more than 2 MeV/cm to tissue. The actual dose rate turns out to be 9200 mrad/hr, almost five times as high as the simple calculation (Healy, 1971).

In any event, beta contamination on the surface of the skin can produce high local dose rates and must be monitored carefully.

The following example illustrates how an end-window Geiger-Mueller detector[25] can be used to estimate the dose rate from beta particles.

*Example 9:* A thin end-window G-M counter yields a counting rate of 30,000 counts/min when positioned over a source of beta particles. Estimate the dose rate at the window of the detector, if the window has a diameter of 2.54 cm. Assume every beta particle that passes through the window produces a count.

The cross-sectional area of the window is 5 cm². If we assume there is no attenuation in the window, then the number of beta particles incident on 1 cm² of the counter window per second is $30,000/(60 \times 5)$, or 100. From the results of example 7, an incident beam of 100 energetic beta particles per cm² per second produces a dose rate of approximately 11.5 mrem/hr.

Thus, a counting rate due to beta particles of 30,000/min when obtained with an end-window G-M tube with a window diameter of 2.54 cm, is indicative of a dose rate of approximately 11.5 mrem/hr. The maximum allowable dose to the extremities is 1500 mrem/week, so the hands could be in this beta field for about 140 hours without exceeding occupational exposure limits.

The dose rate due to a localized beta source falls off with distance as a re-

25. See part IV, section 1.1 for description of G-M tube.

sult of increased separation and increased attenuation by the air. Because of the strong dependence of air attenuation on energy, a simple expression for the dose rate is not possible, but an upper estimate may be made by neglecting air attenuation over a few centimeters. This is a reasonable assumption for the high-energy beta emitters. The expression for the dose rate at a distance from a source of a given activity is[26] dose rate in mrad/hr = $\dfrac{338,000 \times \text{activity in mCi}}{(\text{distance in cm})^2}$.

> *Example 10:* An investigator is evaporating a solution containing 100 $\mu$Ci of $^{32}$P in a small beaker. What is the dose rate 10 cm above the bottom of the beaker after the solution is evaporated to dryness?
>
> $$\text{Dose rate} = \frac{338,000 \times 0.1}{10^2} = 338 \text{ mrad/hr.}$$

The example illustrates the high dose rates that are possible near a beta source. The dose rate is much less when the activity is in solution, since most of the beta particles are absorbed in the solution.

When beta emitters are taken into the body it is necessary to evaluate the dose rate imparted to organs in which they are incorporated. The average dose rate can be evaluated readily by assuming, because of the short range of the beta particles, that all the beta energy emitted in an organ is absorbed in the organ.[27] Thus the calculation of the average absorbed dose per beta particle is done by determining the average beta energy emitted per gram.

> *Example 11:* If iodine is swallowed, about 30 percent ends up in the thyroid gland, which has a mass of 20 g in an adult. What is the initial beta dose rate to the thyroid gland of a person who ingests 100 $\mu$Ci of $^{131}$I? The average energy per disintegration of the beta particles from $^{131}$I is 0.188 MeV.
>
> Of 100 $\mu$Ci ingested, 30 $\mu$Ci deposits in the thyroid. The rate at which beta energy is imparted to the thyroid is:
>
> $$30 \ \mu\text{Ci} \times \frac{3.7 \times 10^4 \text{ dis}}{\mu\text{Ci-sec}} \times \frac{0.188 \text{ MeV}}{\text{dis}} = 2.09 \times 10^5 \frac{\text{MeV}}{\text{sec}}.$$
>
> The dose rate is:
>
> $$\frac{2.09 \times 10^5 \text{ MeV}}{20 \text{ g-sec}} \times \frac{3600 \text{ sec}}{\text{hr}} \times \frac{1 \text{ mrad-g}}{62,400 \text{ MeV}} = 600 \frac{\text{mrad}}{\text{hr}}.$$

---

26. This expression is derived from the results of example 6, that is, 100 betas/cm²-sec equals 11.5 mrad/hr.  There are 2.94 × 10⁶ betas/cm²-sec at 1 cm from a 1-mCi source (see part III, section 3.2.2).

27. A detailed treatment of the dose from internal emitters is given in part III, section 1.

The average time the radioiodine is in the thyroid is about 10 days. The total dose imparted to the thyroid is thus of the order of 144 rads following ingestion of 100 $\mu$Ci. An additional 10 percent is added to the dose from gamma photons emitted by the $^{131}$I.

## 13.2   Exposure Rate and Dose Rate from Gamma Photons

A useful rule of thumb gives the exposure rate (to an accuracy of about 20 percent between 0.07 and 4 MeV) at a distance from a point[28] source of gamma photons. The exposure rate is proportional to the rate of emission of gamma photons from the source and their energy and decreases inversely as the square of the distance. The formula is:

$$\text{Exposure rate in mR/hr} = \frac{6AEn}{d^2}. \tag{13.1}$$

$A$ = activity of source in millicuries,
$E$ = photon energy in MeV,
$n$ = number of photons of energy $E$ per disintegration,
$d$ = distance from source to dose point in feet ($d$ may be expressed in centimeters if the coefficient 6 is changed to 5000).

The factor $n$ is needed if the photon of energy $E$ is not emitted with each disintegration. If photons of several energies are emitted, the contribution of each must be determined separately and the values added.

The numerical value of the exposure rate given by equation 13.1 may also be considered equal to the dose rate to tissue in mrad/hr and to the dose equivalent rate in mrem/hr.[29]

> *Example 12:* Iodine-131 emits gamma photons of two energies: 0.36 MeV in 87 percent of the disintegrations and 0.64 MeV in 9 percent of the disintegrations. What is the exposure rate at 2 ft from a 10 mCi source of $^{131}$I?
>
> We calculate the contribution to the exposure rate separately for each of the photons.
>
> $E_1$ = 0.36        $n_1$ = 0.87
> $E_2$ = 0.64        $n_2$ = 0.09
>
> $$\text{Exposure rate from 0.36 MeV photons} = \frac{6 \times 10 \times 0.36 \times 0.87}{4}$$
>
> $$= 4.7 \text{ mR/hr.}$$
>
> $$\text{Exposure rate from 0.64 MeV photons} = \frac{6 \times 10 \times 0.64 \times 0.09}{4}$$
>
> $$= 0.86 \text{ mR/hr.}$$

28. A source may be considered to be a point source if the distance to the source is large compared to the dimensions of the source.

29. Review sections 9 and 10 for the discussion of the distinctions between these quantities.

The total exposure rate is 4.7 + 0.86 = 5.6 mR/hr. This may also be expressed as a dose rate of approximately 5.6 mrad/hr to tissue.

For purposes of calculating exposures from gamma-emitting nuclides in medical applications, the source strength is often characterized by a constant known as the specific gamma ray constant $\Gamma$. This gives the exposure rate in R/hr at 1 cm from a 1 mCi source. With the use of $\Gamma$, the exposure rate for a given source activity $A$ (mCi) at any other distance $d$ (cm) may be obtained. The formula is

$$\text{exposure rate} = \frac{\Gamma A}{d^2}.$$

*Example 13:* What is the exposure rate at 61 cm (2 ft) from a 10 mCi source of $^{131}$I? $\Gamma$ for $^{131}$I = 2.18 R/mCi-hr at 1 cm.

$$\text{Exposure rate} = \frac{2.18 \times 10}{(61)^2} = 0.0059 \text{ R/hr} = 5.9 \text{ mR/hr}.$$

This is in good agreement with the result obtained by "rule-of-thumb" in example 12. As stated previously, the numerical value may also be expressed as tissue dose in mrad/hr or dose equivalent in mrem/hr for radiation protection purposes.

### 13.3   Reduction of Dose Rate by Both Distance and Shielding

When the exposure or dose rate from a small shielded source is to be evaluated at a point, both distance and attenuation by the medium must be taken into account. We have already looked at examples for treating these effects separately. To evaluate their combined effect, the exposure or dose rate is first calculated on the basis of distance alone, neglecting the shielding effect of the medium. The half-value layers between the source and the dose point are then evaluated, and the exposure or dose rate is reduced by the attenuation factor given for the number of half-value layers encountered.[30]

*Example 14:* Calculate the exposure rate at a point 10 cm from a 10 mCi $^{60}$Co source housed in a lead container which is 2.5 cm thick (see table 2.2 for data).

The approximate formula for exposure rate without attenuation is $6AEn/d^2$. Since $d$ is expressed in feet, we must convert distance in centimeters to feet: $d = 10$ cm = 0.238 ft. We must add the contributions of the two photons given off with each disintegration.

$E \times n = 1.33 \times 1 + 1.17 \times 1 = 2.5$ MeV.

$$\text{Exposure rate} = \frac{6 \times 10 \times 2.5}{(0.328)^2} = 1390 \text{ mR/hr}.$$

---

30. See the end of section 5.3 for comments on cases where the half-value-layer concept is not applicable.

Next we determine the attenuation provided by 2.5 cm of lead. This thickness equals 2.27 half-value layers. From fig. 2.11, the attenuation factor is 0.205.

The exposure rate (neglecting buildup)[31] is then $1390 \times 0.205 = 285$ mR/hr. We could also say the dose rate to tissue is approximately 285 mrad/hr.

## 13.4   Correction for Radioactive Decay

The decay of radioactivity with time follows exactly the relationship for attenuation by a medium as a function of distance penetrated. This may be inferred from the similarity between the concepts of half-value layer and half-life. One refers to the distance (in an absorbing medium) required to attenuate the radiation by a factor of two; the other refers to the time in which the radioactivity decreases by a factor of two. The fall-off at the same multiples of half-value layers and half-lives is also identical, and for this reason we have shown the data in table 2.4 and fig. 2.11 as applying to both half-value layers and half-lives.

*Example 15:* An isotope user acquired from a national laboratory in June 1971 a surplus $^{60}$Co source whose activity was given as 9 curies on January 1956. The source was shielded with 2 in. of lead. What is the tissue dose rate the user could expect at 12 in. from the source? (Use data in table 2.2 and fig. 2.11.)

The dose rate at 1 ft, uncorrected for shielding or decay, is given approximately by equation 13.1 (in rads/hr if activity is in curies):

$6 \times 9 \times 2.5/1^2 = 135$ rads/hr.

Half-value layers $= \dfrac{2.54 \times 2}{1.1} = 4.62$; Attenuation factor $= 0.040$;

Half-lives $= \dfrac{15.5}{5.25} = 2.95$; Fraction remaining $= 0.13$.

The corrected dose rate (neglecting buildup) =
$$135 \times 0.040 \times 0.13 = 0.702 \text{ rad/hr} = 702 \text{ mrad/hr.}$$

## 13.5   Shielding of Large or Complex Sources[32]

The calculation of the attenuation of a shield for complex sources follows an approach different from that used in the previous section. Flux densities are calculated at the dose point of interest for photons at each of the energies emitted by the source. They are then converted to dose rates by flux density–dose rate (or exposure rate) conversion factors, and the dose rates are summed. Flux density to exposure rate conversion factors are shown as a function of energy in fig. 2.18.

31. The buildup factor is about 2; see Morgan and Turner, 1967.
32. This section should be omitted in a first reading. For a thorough treatment, see Jaeger et al., 1968.

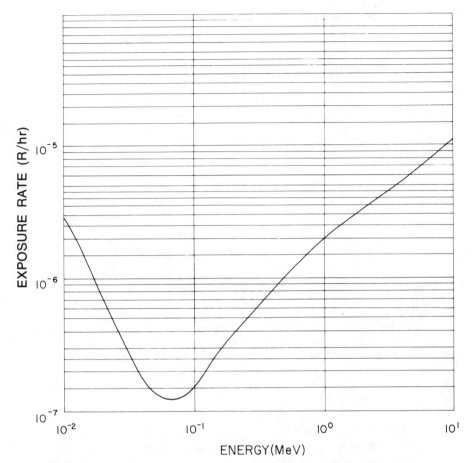

**Fig. 2.18**   Exposure rate from 1 photon/cm²-sec.   Source: Rockwell, 1956.

When the source is of such large dimensions that the distance from the dose point to different points in the source varies considerably, or when there is appreciable attenuation within the source, we can no longer treat it as a point source.   We must break it up into subdivisions, chosen so that the distance from the dose point varies little over each subdivision.   We evaluate the contribution to the dose rate from each subdivision separately and then add the results.   The use of computers makes it possible to define the source elements as small as needed for the desired accuracy.   However, useful estimates often can be made with rather large source elements.

*Example 16:*   A tank filled with an aqueous solution of $^{60}$Co with a total activity of 3 curies is to be stored behind a lead shield, 4 cm thick, as shown in fig. 2.19.   Calculate the tissue dose rate at points 32 cm and 64 cm from the center of the tank.

**Fig. 2.19** Method of subdividing large source for dose calculations. For simplicity the problem is presented as two-dimensional. The source is subdivided into 6 elements of equal volume, and the activity in each element is considered to be concentrated at the center of the element. The distances are drawn to scale so that the dimensions can be taken directly from the diagram. The use of smaller subdivisions would give greater accuracy.

All dimensions are drawn to scale in the figure. The tank is subdivided into 6 sources of equal volumes as shown. Therefore, each source has an activity of 0.5 curies. Distances to the dose point $A$ and distances traveled by the gamma photons in the lead and water are taken off the figure and listed in table 2.11. The half-value layers in lead and water traversed by the photons from each source are calculated and summed and attenuation factors calculated. The flux density without attenuation is evaluated for each source and then multiplied by the attenuation factor. The flux density is converted to exposure rate, and the result is multiplied by a buildup factor to account for scattered radiation. The total exposure rate is obtained by summing the contributions from the subdivisions. It is equal to 2183 mR/hr at 32 cm and 670 mR/hr at 64 cm by a similar calculation.

Note that the exposure rate at 64 cm from the center of the tank is 0.31 times the exposure rate at 32 cm, whereas it would be only 0.25 times as high if it fell off as the inverse square law with distances referred to the center of the tank. When source dimensions are significant compared to the distance, the dose rate falls off more slowly than

**Table 2.11.**   Organization of calculations of dose rate from
large source (fig. 2.19).

| Source point | Distance to A (cm) | Distance in H₂O (cm) | Distance in Pb (cm) | No. of HVL, H₂O | No. of HVL, Pb | No. of HVL, H₂O + Pb | AF |
|---|---|---|---|---|---|---|---|
| 1 | 32 | 10 | 5 | 0.91 | 4.55 | 5.46 | 0.0227 |
| 2 | 46 | 27 | 4.5 | 2.45 | 4.09 | 6.54 | 0.0108 |
| 3 | 24 | 8 | 4 | 0.73 | 3.64 | 4.37 | 0.0484 |
| 4 | 40 | 24 | 4 | 2.18 | 3.64 | 5.82 | 0.0175 |
| 5 | 32 | 10 | 5 | 0.91 | 4.55 | 5.46 | 0.0227 |
| 6 | 46 | 27 | 4.5 | 2.45 | 4.09 | 6.54 | 0.0108 |

| Source point | Distance squared (cm²) | Flux density at A (cm²-sec)⁻¹ | Exposure rate (mR/hr) | Buildup factor | Exposure rate including buildup (mR/hr) |
|---|---|---|---|---|---|
| 1 | $1.02 \times 10^3$ | 65,530 | 154 | 2.2 | 339 |
| 2 | $2.12 \times 10^3$ | 15,000 | 35 | 2.4 | 85 |
| 3 | $5.76 \times 10^2$ | 247,400 | 581 | 2.0 | 1162 |
| 4 | $1.6 \times 10^3$ | 32,204 | 76 | 2.3 | 174 |
| 5 | $1.02 \times 10^3$ | 65,530 | 154 | 2.2 | 339 |
| 6 | $2.12 \times 10^3$ | 15,000 | 35 | 2.4 | 85 |
| | | | | Total: | 2184 |

*Note:* Data for HVL are taken from table 2.2 and exposure rates from fig. 2.18. An average energy of 1.25 MeV/photon is used. (A more accurate calculation would require separate calculations for the 1.18 and 1.33 MeV photons from ⁶⁰Co.) Buildup factors to correct for scattered radiation are taken from table 9 of NCRP, 1964, Report 30, which gives buildup factor for point isotropic source. To use table 9 the half-value layers given above are converted to relaxation lengths ($\mu x$) by dividing by 1.44. Since we have a shield of two materials, the number of HVL in the sequence of material was obtained by adding the values for the separate materials and a buildup factor determined for the summed HVL, assuming the medium was the last material in the sequence, that is, lead. This is a simplified and approximate method. See Jaeger et al., 1968, for a more accurate calculation.

the inverse square because the radioactivity is not all at the same distance. The rate of falloff is further decreased over the inverse square as the distance from the tank in fig. 2.18 increases because the gamma photons go through a shorter slant distance in the attenuating medium.

When one wishes to calculate the thickness of shielding required to attenuate the dose rate from a complex of sources to a specified value, the calculation in example 16 is repeated for two or more assigned thicknesses. The

assigned thicknesses should preferably bracket the thickness required.  The calculated dose rates are plotted on semilog graph paper as a function of thickness, and a best fit is drawn between the points (straight line for two points).  The thickness required for the desired dose rate is then read from the graph.

## 14.   X Rays—Radiation Made by Machine

The origin of the x-ray machine can be traced to the discovery by Roentgen in 1895 that electrons striking surfaces within an electron tube at high speed generated a penetrating radiation, which he called x radiation.  The radiation was detected accidentally when a paper screen washed with barium-platino-cyanide lit up brilliantly in a darkened room in the vicinity of the electron tube, which was covered with a closely fitting mantle of thin black cardboard.

It was soon found that, because of their ability to penetrate matter, x rays could be used to produce pictures of the interior of objects, and, over the years, x-ray machines were developed that could show the interior of objects in great detail.  Our concern here is primarily with the use of x rays in examinations of the internal structure of the human body, that is, with photon energies less than 150,000 eV.  Because x rays are so valuable in the diagnosis and treatment of disease and injury, they are used routinely in medical and dental practice, and as a result they are responsible for most of the exposure of the public to ionizing radiation, outside of exposure due to the natural radiation background.

In this section, we shall consider the ways in which x rays are used to provide diagnostic information, the dose to the subject that results from such use, and measures for minimizing exposure of both subject and operator.  The discussion applies, of course, not only to medical x-ray equipment but also to all other kinds of x-ray machines.

### 14.1   Production of X Rays

At about the time x rays were discovered by investigators making observations on high-speed electrons in electron tubes, persons working with radioactive material discovered that these materials also emitted penetrating radiations; they called these radiations gamma rays.  The penetrating rays emitted by the radioactive material were detected through the unexpected blackening of photographic film developed following storage in a container near the source of the radiation.  The names x and gamma ray were assigned to these radiations before their fundamental properties were determined, and it was later found that both types of radiation consisted of photons of electromagnetic radiation and that in fact x rays and gamma photons of the same energy were identical.  Thus, the difference in names reflected only the difference in origin of the radiations, rather than any difference in their nature.

We have already seen how gamma photons arise from transitions in the nuclei of the atoms of radioactive substances.  On the other hand, x rays are produced in processes that take place outside the nucleus.  These processes involve interactions between high-speed electrons and the atom.

There are two different mechanisms through which x rays are produced. These are illustrated in fig. 2.20.  The most important mechanism, from the point of view of the use of x rays in radiography, is through a violent acceleration of the electron, resulting in a sharp deflection, as it interacts with the electrical field around the nucleus.  Such acceleration results in the emission of photons of x radiation.  These are indirectly ionizing and therefore consti-

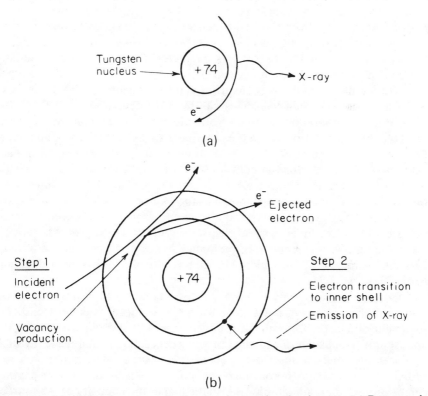

**Fig. 2.20**  Methods of x-ray production by electron bombardment.  (*a*) Bremsstrahlung production by acceleration of bombarding electrons.  Electrons accelerated (shown here as a change of direction) near the highly charged nucleus of a heavy element may lose all or most of their energy through the emission of photons (called bremsstrahlung, meaning "braking radiation").  (*b*) Characteristic x radiation production by deexcitation of atom energized by bombarding electron.  Step 1: Incident energetic electron ejects orbital electron from inner shell of atom, leaving atom in excited state.  Step 2: Electron from outer shell drops to vacant shell, resulting in emission of characteristic x-ray photon.

tute a penetrating radiation, in contrast to the directly ionizing electrons from which they arise (see section 5).   The photons are generally referred to as bremsstrahlung (braking radiation), because the electrons lose energy and slow down in the process of emitting the radiation.   All the kinetic energy of the electron may be converted into an x ray, but this occurs only rarely. Most of the time, only part of the energy is converted.   The result is a continuous spread of energies in the x rays produced, up to the maximum energy of the electron.   In commerical x-ray units, the x rays are produced by bombarding a target with electrons that receive their energy by acceleration through a high voltage.

The second mechanism of x-ray production is through transitions of electrons in the inner orbits of atoms.   These orbital transitions produce photons of discrete energies given by the differences in energy states at the beginning and end of the transitions (fig. 2.20).   Because of their distinctive energies, the photons produced are known as characteristic x rays.   Characteristic x rays can be produced only if electron vacancies are created in the inner orbits of atoms to which outer electrons can be transferred.   There are several ways in which such vacancies can be produced.   One is through the bombardment of an atom with energetic electrons which may result in the ejection of other electrons from the innermost shells.   This can be an important source of x rays in an x-ray tube, although the main source is from acceleration of the electrons in collisions with the target, as discussed in the previous paragraph.   Vacancies can also be produced by gamma rays through an absorption process known as the photoelectric effect.   There are two forms of radioactive decay that also create vacancies followed by x-ray emission: internal conversion and electron capture.   These processes are responsible for the development of radionuclide x-ray sources for use in radiography.   The manner in which they give rise to x rays is shown diagrammatically in fig. 2.21.

Although there are many physical processes that result in the production of x rays, the process of most value for medical purposes is electron bombardment of a target through the use of the x-ray tube.   The reason for the almost universal use of this method of x-ray generation is that the x-ray tube produces the smallest and most intense x-ray source.   The closer an x-ray source can be made to approach a point source, the sharper is the image that can be produced in radiography.   Also the higher the intensity of the source, the shorter is the exposure time required.

## 14.2   Diagnostic Radiology

When an x ray is taken of a person, the part of the body studied is exposed to photons that emanate as rays from the tube target.   The fraction of the x-ray photons in an incident ray that penetrates through any portion of the object irradiated depends on the energy of the photons and the type and thickness of material in the path of the ray.   If a photographic plate is placed behind the object radiated, and then developed, the darkening is proportional to the

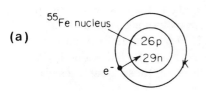

**(a)**

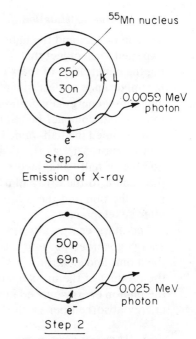

|  |  |
|---|---|
| Step 1 | Step 2 |
| Capture of K electron | Emission of X-ray |

**(b)**

|  |  |
|---|---|
| Step 1 | Step 2 |
| Ejection of K electron | Emission of X-ray |

**Fig. 2.21** Radionuclide sources of x rays. (a) X-ray production by electron capture. Step 1: Electron is captured from innermost (K) shell by iron-55 nucleus, converting proton in nucleus into neutron and producing a manganese-55 atom with an electron missing in the K shell. Step 2: Innermost orbit of manganese-55 atom is filled by transition of electron from outer shell, accompanied by emission of an x ray. The most favored transition is from the closest shell, and gives rise to an 0.0059 MeV x ray. (b) X-ray production by internal conversion. The example used is the isomer of tin-119, a metastable state of the nucleus that is more energetic than the ground state by 0.089 MeV. It reverts to the stable state with a half-life of about 250 days by releasing this energy. Step 1: The 0.089 MeV released in reverting to the ground state is imparted to one of the inner electrons and ejects it from the atom as an internal conversion electron. Step 2: The vacant shell is filled immediately by another electron, a process accompanied by the emission of an x ray. Internal conversion electrons from the next (L) shell are followed by 0.004 MeV x rays. (A process that competes with internal conversion is the emission of 0.089 MeV gamma photons following deexcitation of the nucleus.)

amount of radiation intercepted and absorbed by the plate, and this produces an image related to the internal structure of the object being examined.

It should be noted that the reason x-ray pictures are produced is that a variable fraction of the x-ray energy is absorbed as the x rays penetrate through the body. This absorbed energy produces a dose distribution in the irradiated person and thus provides the potential for producing injury coincidental with its use in promoting the health of the patient.

## 14.3   X-Ray Attenuation in the Body

We can understand the nature of the image formed and the dose distribution imparted to an object that is examined with x rays by looking at data describing the penetration of the x rays through matter.   Two quantities of particular importance in describing the behavior of x rays are the half-value layer and mass energy-absorption coefficient.   Values of these quantities for muscle and compact bone are presented in table 2.12.

We defined the half-value layer in connection with gamma photon attenuation (section 5.1), as the distance in which half the photons interact.   The number of half-value layers traversed by a beam of photons traveling from the source to the x-ray film determines how many of the photons actually reach the film and therefore the degree of darkening that will be produced after development.

The mass energy-absorption coefficient gives the fraction of the photon energy absorbed per unit mass of the medium as a result of interaction with the atoms and electrons.   When a beam of photons is incident on a medium, the product of the mass energy-absorption coefficient in units of $cm^2/g$ and the photon energy carried in 1 $cm^2$ of the cross-section of the beam gives the energy absorbed per gram.[33]   This can be converted readily into rads.

33. The mass energy-absorption coefficient should not be confused with the mass attenuation coefficient (section 5.2), which gives the *photons interacting* per unit mass of medium rather than the *energy absorbed*.   The mass attenuation coefficient is used in the calculation of the number of photons that reach a point, while the mass-energy absorption coefficient is used to calculate the absorbed dose at a point once the photons get there.

**Table 2.12.**   X-ray attenuation data for muscle and compact bone.

| Photon energy (MeV) | Half-value layers | | Mass energy-absorption coefficient | |
|---|---|---|---|---|
| | Muscle (cm) | Compact bone (cm) | Muscle ($cm^2/g$) | Compact bone ($cm^2/g$) |
| 0.01 | 0.13 | 0.019 | 4.87 | 19.2 |
| .02 | 0.95 | 0.14 | 0.533 | 2.46 |
| .03 | 2.02 | .41 | .154 | 0.720 |
| .04 | 2.78 | .78 | .070 | .304 |
| .05 | 3.19 | 1.15 | .043 | .161 |
| .06 | 3.54 | 1.45 | .033 | .10 |
| .08 | 3.84 | 1.88 | .026 | .054 |
| .10 | 4.09 | 2.14 | .026 | .039 |
| 1.00 | 9.90 | 5.58 | .031 | .029 |
| 10.00 | 31.3 | 16.3 | .016 | .016 |

*Source:* Attix and Roesch, 1968, vol. I, chap. by R. D. Evans.   Half-value layers calculated from data in reference by using density of 1 for muscle and of 1.85 for compact bone.   The data are for good geometry (see section 5.2 and fig. 2.9).

*Example 17:* A beam of $10^{10}$ photons, all with the same energy of 0.05 MeV, is incident on tissue. The beam diameter is 7.62 cm. (*a*) What is the dose to the tissue at the point of incidence? (*b*) What would be the dose to bone from the same beam?

(*a*) The cross-sectional area of the beam is 45.7 cm². Thus the number of photons passing through 1 cm² (called the fluence) = $10^{10}/45.7 = 2.19 \times 10^8$ photons/cm². The photon energy passing through 1 cm² = $0.05 \times 2.19 \times 10^8 = 1.10 \times 10^7$ MeV/cm². From table 2.12 the mass energy-absorption coefficient in muscle for 0.05 MeV photons is 0.043 cm²/g. The energy absorbed per gram = $1.10 \times 10^7 \times 0.043 = 4.73 \times 10^5$ MeV/g. The dose is

$$\frac{473,000 \text{ MeV/g}}{62,400 \text{ MeV/g-mrad}} = 7.56 \text{ mrad.}$$

(*b*) The mass energy-absorption coefficient for 0.05 MeV photons is 0.161 cm²/g in bone compared to 0.043 cm²/g in muscle. Therefore the dose imparted by the radiation is $0.161/0.043 = 3.74$ times as much. The dose to the bone is thus $3.74 \times 7.56 = 28.3$ mrad.

The values of half-value layer and mass energy-absorption coefficients depend on the energy of the photon and the composition of the medium, in particular on the atomic numbers of the atoms in the medium. We note that the half-value layer data presented in table 2.12 vary tremendously over the energy range covered. The attenuation presented by the chest of an adult, which is equivalent to a thickness of about 10 cm of muscle, is equal to 10.5 half-value layers for 20-keV photons and 2.8 half-value layers for 60-keV photons. Since most of the energy in a diagnostic x-ray beam is carried by photons with energies below 60 keV, almost all the energy directed against the body is absorbed within the body. The actual dose imparted to any region exposed to a given x-ray intensity depends on the mass energy-absorption coefficient and, as we have seen from example 17, is several times higher in bone than in adjacent tissue at diagnostic x-ray energies.

### 14.4  Effects of Photon Energy Distribution on Image Formation and Absorbed Dose

Let us consider in detail what happens when a beam of x-ray photons is used to take an x ray. The paths of individual photons are shown in fig. 2.22. The photons that penetrate without interaction will produce a pattern on the film that models the amount of matter through which they had to penetrate to reach the photographic plate. The less the amount of matter of a given type in any particular direction, the higher the intensity of the emergent beam and the greater the darkening produced in the film. A radiologist adjusts exposure conditions to provide a darkening with a normal pattern that is optimum to him for showing up small changes in the penetrating radiation produced by abnormalities in the tissue that is traversed. The amount of x-ray energy

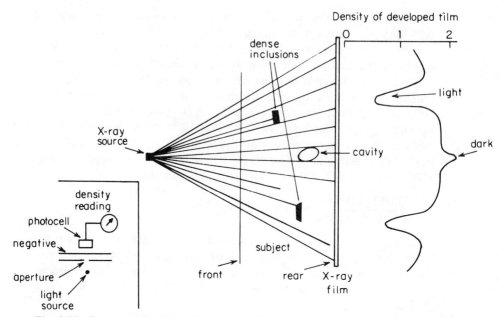

**Fig. 2.22** Image production with x rays. The x rays that reach the film interact with the emulsion and produce a latent image, which is brought out by development. The amount of darkening at any point in the developed image is a measure of the radiation exposure at that point. The darkening, generally referred to as the density, is measured with a densitometer. This is an instrument that measures the transmission of a small beam of light through the negative (see insert) with a photocell. The density is defined as the common logarithm of the ratio of the reading for unexposed film to the reading for exposed film. The figure illustrates the density at various portions of the negative. Note that the density is low in the region where the incident radiation is intercepted by the inclusion and increases when a cavity has been introduced. A density of 1 means that the light transmission is 1/10 the light transmission through an unexposed part of the film.

required to produce a response on the film that satisfies the radiologist determines the exposure to that portion of the body of the patient that is adjacent to the film. Data on density versus exposure for x-ray films are given in fig. 2.23.

In considering the exposure[34] and resulting dose to the patient, we must

34. Note the use of two terms in this paragraph to describe the level of x radiation: exposure and dose. Exposure refers to the ionization produced by the x rays in a special medium, air. Dose refers to the absorption of x-ray energy in unit mass of the region actually exposed to the x rays. At diagnostic x-ray energies, the absorption of photons is much greater in a material like calcium than in soft tissue, which has a much lower average atomic number. Thus the dose in calcium would be much larger than in tissue, for a quantity of x rays that produced a given exposure in air. When a small mass of soft tissue is contained in a calcium matrix (such as, the Haversian cells in bone), the dose to the tissue is essentially the same as that to the

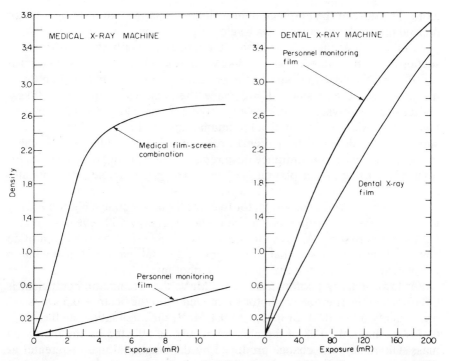

**Fig. 2.23**   Relationship between photographic density and radiation exposure.  The densities generally acceptable in diagnostic radiology range between 0.25 and 2, corresponding to a range of transmitted light between 56 percent and 1 percent of the incident light.   Note the high sensitivity of the medical x-ray film used with an intensifying screen as compared to the dental and personnel monitoring films.   The image in the film-screen combination is produced mainly by the light emitted from the intensifying screen rather than from the direct interaction of the ionizing radiation with the photographic emulsion, as in the dental x-ray film.   (For a detailed discussion of the radiologic image and the retrieval of information, see Ter-Pogossian, 1967.)   The data were obtained with Gaevert x-ray film mounted in a cassette with par-speed intensifying screen (using a medical x-ray machine); Kodak ultra-speed dental x-ray film (using a dental x-ray machine); and Kodak type 2 personnel monitoring film.   The films were covered with 2 in. of polyethylene during exposure.   The dental machine was operated at 85 kVp.   The densities of the films exposed to the medical x-ray machine did not vary appreciably between 75 and 115 kVp at a given exposure.

examine the exposure over the entire region of the body traversed by the x-ray beam rather than at the film alone.   The dose to soft tissue is highest at the point the photons enter the body and decreases steadily to the point of

surrounding bone, rather than that which would be evaluated if the whole volume were composed of soft tissue.   The evaluation of the enhancement of the dose to soft tissue when it is near bone or other material of higher atomic number is complex, and the reader is referred to Attix and Roesch, 1968, for details.

exit.   The dose at the entrance point is higher than the exit dose by a factor depending on the number of half-value layers through which the radiation penetrates.   Thus, in the case of the 10-cm thickness of tissue considered in section 14.3, the attenuation of 20-keV photons (10.5 half-value layers) is $(1/2)^{10.5}$ and the dose to tissue on the entrance side is over two million times the dose on the exit side.   If we make the same calculation for 60-keV photons (2.8 half-value layers), we find the entrance dose is seven times as high as the exit dose.[35]   Since a minimum number of photons (with a corresponding exit dose to the patient) are required to provide an acceptable radiographic image, the entrance dose required for a given procedure can be reduced by using higher photon energies.   The gains increase dramatically as the thickness to be traversed increases (that is, for heavier patients).

However, a very important factor to consider in selecting a photon energy is the effectiveness with which a given photon energy will reveal an abnormality in the tissue.   As an example, consider the effect on the beam of an abnormal mass of tissue that introduces additional mass with a thickness equivalent to 0.5 cm into the path of the photons.

For lower-energy photons, say 0.030 MeV, the attenuation coefficient is 0.34/cm and the fraction of photons removed from the beam in 0.5 cm is approximately $0.5 \times 0.34$, or 0.17.   At 0.1 MeV, the attenuation coefficient is 0.161/cm and only 0.08 of the photons would be affected by the increased mass. Obviously, the change produced by the additional mass is greater at the lower energies.   The results with lower energies are even better when examining higher atomic number materials, such as bone.   Hence, we conclude that lower-energy photons provide better contrast and more detail in the image.

While the use of higher tube voltages results in lower entrance doses for a given film exposure, the gain is offset somewhat by the greater penetrating power of the higher-energy x rays.   This consequence is particularly noteworthy in the case of dental x rays, since the film is placed within the mouth and the tissue behind the film is also exposed to the radiation.   Now, one of the measures of the overall damage produced by an x-ray exposure is the total energy imparted by the ionizing radiation in the entire volume irradiated.   This is generally referred to as the integral absorbed dose.   The irradiation of additional tissue behind the film by more penetrating radiation, increasing the integral absorbed dose, may be more detrimental than the higher skin dose produced at the lower energies, unless the region behind the film is shielded.

35.   The calculations using the half-value layers given in table 2.12 are based on "good geometry," that is, neglect of the scattered radiation that builds up as the photons penetrate through the medium (see section 5.3 and fig. 2.13).   The effect of the buildup of the scattered radiation is to increase the half-value layer.   The extent of the increase depends on the area of the beam and the thickness penetrated.   Attenuation calculations which include the effect of the scattered radiation can be quite complicated, and it is often much simpler to make measurements of the effective half-value layer for specific radiation conditions (HPA, 1961).

Even when the film is located outside the body, as in medical x rays, the lowering of the entrance dose at higher voltages is offset somewhat because of the increased penetration. The total energy imparted to the tissue in the path of the incident beam is proportional to the product of the entrance dose and the half-value layer, when most of the energy is absorbed in the body. If the entrance dose is halved by going to a higher energy, but at the same time the half-value layer is doubled, the total energy imparted to tissue is approximately the same. In certain cases it may be difficult to make an accurate evaluation of the relative hazards of high localized doses versus total energy imparted to the irradiated region, especially when the localized doses are not high enough to produce apparent effects in tissue. However, the major consideration in adjusting the dials of an x-ray machine is to produce an x-ray image to the satisfaction of the radiologist, and imaging equipment should be sensitive enough to make consideration of the fine details of dose distributions primarily of academic interest. In any event, the radiologist should be aware of the doses associated with various settings and should check that the entrance doses associated with his procedures do not depart appreciably from the lowest values that produce satisfactory results.

To this point, we have not taken into account the fact that x rays are never produced at a single energy but rather are produced over a whole range of photon energies up to the maximum energy given by the high voltage setting of the machine. For the lowest energy part of the spectrum, the attenuation of the photons is so great that these photons contribute very little, if anything, to the image. All they do is produce very high doses at the point where they enter the body and for a short distance along their path. Obviously, the numbers of these photons in the beam should be minimized, and we shall present in a later section the measures that are instituted to accomplish this.

## 14.5  A Description of an X-Ray Machine

The modern medical x-ray machine is engineered to enable the operator to define precisely the region of the subject that is irradiated and to prevent unnecessary exposure of either the operator or the subject. Let us examine the main components of an x-ray machine and their specifications for the production of x-rays.[36] A schematic of an x-ray unit is given in fig. 2.24.

*A. Source of Electrons.* This is a tungsten filament which is heated with an electric current to approximately 2000 °C to emit electrons. The temperature is sufficiently high to produce incandescence. The greater the filament current, the higher is its temperature, and the greater are the number of electrons emitted. The x-ray machine comes equipped with a milliampere (mA) meter that gives the current emitted from the filament. One milliampere is equal to $6.25 \times 10^{15}$ electrons/sec. Dental x-ray tubes generally op-

---

36. Details and guidance on the selection of commercial x-ray equipment are given in Thompson, 1978.

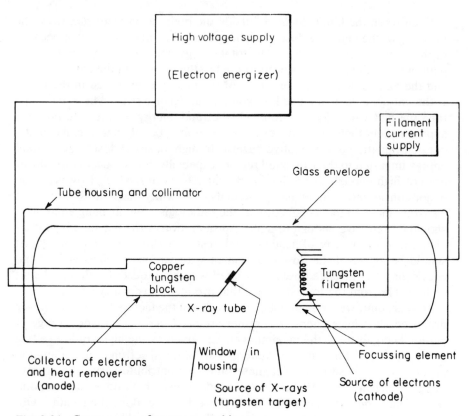

**Fig. 2.24**   Components of an x-ray machine.

erate between 5 and 15 mA, and medical x-ray tubes for radiography be-
tween 50 and 1000 mA.

*B. High Voltage Supply.*   This gives energy to the electrons emitted by
the source by accelerating them in an electric field.   The higher the voltage,
the higher the energy achieved by the electrons.   The energy of the elec-
trons is specified in terms of the voltage through which they are acceler-
ated.   If the voltage is adjusted to 75,000 V, the electrons receive energies
specified as 75,000 electron volts (75,000 eV).   A 250,000-volt machine pro-
duces electrons with energies of 250,000 eV.   In radiation therapy, it is de-
sirable to use high-energy x rays in treating some conditions, and special ma-
chines called betatrons are commercially available that can accelerate the
electrons to energies as high as 20 MeV.

It is expensive to provide a constant voltage for an x-ray machine, and
satisfactory performance at much lower cost is obtained in diagnostic ma-
chines with an alternating voltage.   In this case, the electrons possess a
range of energies that follow the form of the applied voltage.

*C. Target, Including Focusing System.*   The energetic electrons from the source are made to collide with a suitable target, such as tungsten, set in molybdenum or copper to conduct heat away.   Source and target are enclosed in a sealed tube that is held under high vacuum so the electrons accelerated by the applied high voltage will not collide with gas molecules and lose energy or be deflected.   The collisions of the electrons and their deflections in the vicinity of the target atoms result in the production of the useful x-ray beam.

The electrons are focused by appropriate shaping of the electrical field at the same time they are accelerated to the target so they will strike the target within as small an area as practicable.   The smaller the source of x rays the sharper the image produced.

Results of the measurement of the spectrum of photons emitted by one x-ray machine are given in fig. 2.25.   The high voltage on the machine was 0.1 million volts, and the target was tungsten.   Note the peak at 59,000 eV caused by the characteristic radiation from tungsten (see section 14.1).   The photons contributing to the peak constituted approximately 7.5 percent of the total number of photons emitted by a full wave rectified machine at 100,000 V and 2.5 mm Al total filtration (Epp and Weiss, 1966).   At 90,000 V they contributed only 1.4 percent.   For machines with a more constant wave form, such as a 3-phase, 12-pulse machine, the contribution of characteristic photons is several times higher.

Only a small fraction of the energy carried by the electrons incident on the target is converted into radiation.   The fraction is given approximately by the product: electron energy(MeV) × atomic number of target × $10^{-3}$.   This formula holds for electron energies up to a few MeV.

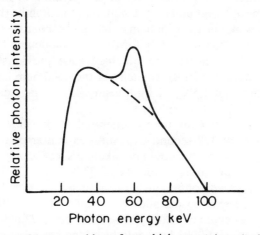

**Fig. 2.25**   Spectrum of bremsstrahlung from thick target (constant potential tube, 100,000 V).   Peak at 59 keV is due to characteristic tungsten K-radiation (ICRU, 1962).

As an example, consider the collision of 0.10 MeV electrons with a tungsten target. The atomic number of tungsten is 74. The fraction of energy converted is $0.1 \times 74 \times 10^{-3} = 0.0074$. Less than 1 percent of the electron energy is converted into radiation. The fraction of electron energy which is not converted and emitted from the target as x-ray photons is absorbed in the target and converted into heat. Targets are designed to accept and dissipate this highly localized heat through the use of features such as rotating anodes and water or oil cooling systems.

The operation of x-ray tubes must be restricted by limitations on tube current, operating time, and frequency of exposures to prevent damage from overheating. The limitations are supplied by the tube manufacturer as maximum heat storage capabilities and special performance and rating charts. There are separate limits for single exposures, a rapid series of exposures or short-term continuous operation of the machine, and long-term operation.

The limits for a single exposure are set to prevent local melting of the target surface. They are given in rating charts which specify the maximum exposure time with given tube current and voltage settings. For example, the rating chart for a Machlett Dynamax "64" x-ray tube with a 0.6 mm (diameter) focal spot, full-wave three-phase rectification and high-speed anode rotation specifies a maximum of 0.1 seconds exposure at 100 kVp and 3300 mA. A maximum exposure time of 3 sec is allowed if the focal spot is 1.2 mm. The limits for a rapid series of exposures or short-term continuous operation are established to prevent excessive temperatures of the anode, particularly at the tube seal or at bearings. The limits for long-term operation, say over a period of an hour, are determined by overall heating of the tube to prevent damage to the glass, insulation, and so on.

The accumulation of heat as a result of operation of the machine is described in terms of "heat units": the number of heat units (hu) is equal to the product of the peak kilovolts, milliamperes, and seconds. Limits in terms of heat units are specified separately for the tube anode and for the tube housing. The specifications for the Machlett tube previously described are 200,000 hu anode heat storage capacity at the maximum anode cooling rate of 54,000 hu/min and 1,500,000 hu housing heat storage capacity.

> *Example 18:* An x-ray tube is operated at 70,000 V and 200 mA. A rapid series of 1/2-second exposures is contemplated. What is the maximum number that could be taken in succession without exceeding the anode heat storage capacity of 72,000 hu? How long could the tube be operated continuously at these settings?
>
> Each 1/2 sec exposure adds $70 \times 200 \times 0.5 = 7,000$ hu. A total of 10 exposures could be taken without exceeding 72,000 hu. For continuous operation, 14,000 hu would be added per second, and the operating time would have to be limited to 5 seconds.

Over a longer period, credit can be taken for loss of heat units through cooling, and thermal characteristics charts are supplied with tubes showing the actual accumulation of heat units as a function of time. Housing-cooling charts are also supplied that show the loss of heat units through cooling as a function of time when the machine is not operating.

Medical x-ray machines are designed to give satisfactory cooling for normal operational settings and patient loads. However, one can conceive of situations in which a diagnostic tube would be operated for periods considerably in excess of recommended limits. For example, an inexperienced radiation protection inspector might convince a medical practitioner of the desirability of measuring exposure rates around his x-ray machine. If neither individual were aware of operating limits, interest in the making of accurate and detailed measurements could lead to long operating times resulting in destruction of the tube—a result that could hardly produce a favorable association with radiation protection in the mind of the owner of the x-ray machine.

*D. Collimator.* When human beings are x rayed, the beam must be confined to the region under examination. There is no reason to expose tissue unnecessarily to radiation. Accordingly, modern x-ray machines have special collimators which can be adjusted to limit the beam to the area being studied. In dental x-ray machines, it is not practical to use adjustable collimators, and standard practice is to collimate the beam merely so its diameter is less than 3 inches at the patient's face.

One standard type of collimator for dental x-ray machines is the pointer cone. The collimation is done with a diaphragm located at the end of the cone that screws onto the machine. The cone itself does not produce any collimation but serves to assist the dentist or dental technician to position the x-ray tube so it is at the proper distance from the face and the beam is aimed correctly.

The pointer cone is falling into disuse because it scatters radiation to parts of the face and body not under examination. It is being replaced by the open cone, which is a long cylinder, open at the end to reduce the scattered radiation.

*E. Filter.* We have already mentioned that the x rays emitted from the x-ray tube target include many low-energy photons that do not penetrate enough to contribute to the image but can impart appreciable dose to the subject. The dose from these useless photons can be reduced through the use of selective absorbers, or filters, which are relatively transparent to the higher energy photons, that is, those that actually produce the picture. For example, the addition of 2 or 3 mm aluminum attenuates 30 KeV photons by a factor of about 2 while attenuating 60-KeV or higher energy photons by less than 20 percent. The actual thickness and material of the filter needed depend on the voltage of the x-ray machine. Radiation protection standards

specify a minimum filter thickness equivalent to 2.5 mm of aluminum for diagnostic x-ray machines operated above 70,000 V peak.

*F. Tube Housing.* All the components previously described are incorporated within a tube housing that prevents the radiation not emitted in the direction of the subject from irradiating the surrounding area. Radiation protection standards specify that the leakage from the housing of a diagnostic machine is not to exceed 100 mR in 1 h at 1 m from the target when the tube is operated at any of its specified ratings.

The amount of radiation actually emitted from an x-ray machine depends on a variety of factors, including operating current and voltage, filtration, absorption in the walls of the tube, and so on. It is important to have data on the exposure rates in the vicinity of the machine in order to know the dose imparted to the patient or to the operator for various procedures. The appropriate data are obtained by measurements around the machine under actual operating conditions, but estimates of the exposure rate from a machine under given operating conditions can often be obtained from tables. The data for any given set of conditions can be extrapolated to other conditions on the assumption that the exposure rate is directly proportional to the number of electrons hitting the target per second (that is, the tube current), and to the square of the electron energy (measured by the peak voltage). The voltage wave form is also a factor in determining the radiation output for given voltage and current settings. A 3-phase or constant-potential machine produces approximately twice the exposure rate of a full-wave machine. The drop-off of the dose in the direct (or useful) beam with distance from the target follows the inverse square law, with an additional loss as a result of attenuation in the air.

Approximate outputs of x-ray machines are given in radiation protection handbooks. Outputs of radiographic machines are generally expressed in terms of roentgens per 100 milliampere-seconds or milliroentgens per milliampere-second of machine operation at various operating voltages and distances. Outputs of fluoroscopes are given in terms of roentgens per milliampere-minute. Data on outputs of diagnostic radiographic x-ray equipment are given in fig. 2.26.

From the data in fig. 2.26, the exposure incurred in taking an x ray is estimated as follows: Obtain the distance from the x ray target to the skin, the milliampere setting, the voltage, and the duration of the exposure. Determine the milliampere-seconds (mAs) from the product of the current and time. Read the exposure for 1 mAs and the appropriate filtration and kVp. (If the filtration is not known, use a nominal value of 2.5 mm Al.) Multiply the exposure by the actual mAs used. If the distance is different from the distance given in the figure, also multiply the exposure by the factor, (distance in figure)$^2$/(actual distance)$^2$. If the high voltage is outside the range in the figure, also multiply the exposure by the factor, (actual voltage)$^2$/(vol-

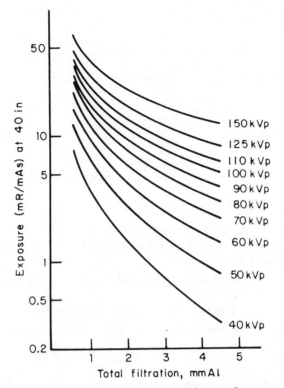

**Fig. 2.26** Exposure rates from diagnostic x-ray equipment for a target-skin distance of 40 in. Values are for a full-wave rectified single-phase machine. The exposure rates would be about 1.8 times higher if a multiple-phase high-voltage supply (approximately constant potential) were used. The values should also be increased by about 70 percent for fluoroscopic units, since at the low milliamperage the full-wave rectified waveform becomes quite similar to that for a constant potential (McCullough and Cameron, 1971). For comparison, the output of a dental unit at 20 cm is 140 mR per mAs for 70 kVp, 1.5 mm Al and 90 kVp, 2.5 mm Al (NCRP, 1968, Report 33, Table 6). The rates in the figure apply to a point in air away from any scattering objects. They would be 20 to 40 percent higher at the surface of the body because of backscatter (Johns, 1969, p. 27).

tage in figure)[2]. The value for the exposure is given for the condition in which surrounding surfaces do not scatter any significant radiation to the point. However, radiation will scatter from within the body of the patient. The total exposure at the surface including backscatter is obtained by multiplying the exposure in the absence of backscattering by the backscatter factor (BSF). The BSF is a function of the size of the field, the radiation energy, and the material of the scattering surface. Some values are given in table 2.13.

**Table 2.13.** Backscatter factors.

| | Backscatter factor | |
|---|---|---|
| kVp | 8″ × 10″ field | 14″ × 17″ field |
| 40 | 1.16 | 1.16 |
| 60 | 1.27 | 1.27 |
| 80 | 1.34 | 1.35 |
| 100 | 1.38 | 1.40 |
| 130 | 1.41 | 1.45 |
| 150 | 1.42 | 1.46 |

*Source:* Trout, Kelley, and Lucas, 1962.

> *Example 19:* A modern community health care center reported the fol-
> lowing exposure conditions for a chest x ray: Target-patient distance,
> 6 ft; current, 300 mA; peak voltage, 114,000 V; exposure time,
> 1/120 sec; filtration (aluminum), 3 mm. Estimate the exposure to the
> patient from a chest x ray.
>
> From fig. 2.26, exposure is 10 mR per mAs at 40 in.
>
> 6 ft = 72 in. mA-sec product for x ray = (1/120) × 300 = 2.5 mAs.
>
> Exposure = 10 mR × 2.5 mAs × $\dfrac{(40 \text{ in})^2}{(72 \text{ in})^2}$ = 7.7 mR.

This value is the exposure in air with the patient absent. The exposure at
the surface of the patient would be increased about 40 percent because of
backscatter (Johns, 1969, p. 27).

A detailed discussion of organ doses from medical x rays is given in part
III, section 6, and part VI, section 4.3.1.

### 14.6  Mammography

X-ray mammography is a technique developed for the detection of breast
cancer. This involves the identification of small abnormalities, including
areas of calcification in soft tissue, and requires the use of low-energy
photons. X-ray tubes for screen-film mammography operate typically at 28
kVp (for the cranio-caudad view) and at 40–50 kVp for xeromammography
(NCRP, 1986). Low-energy photons are attenuated rapidly, and entrance
exposures must be much higher than would be needed using conventional x-
ray technique.[37] The dose is increased further if film is used alone rather

---

37. A tungsten targeted Machlett Hd50D tube for mammography (inherent filtration
0.7 mm Al) has an output at 40 kVp and 75 cm typical target tissue distance of 438
mR/100 mAs (Baxt et al., 1976). Typical mAs values are 1000 if film (Kodak M) is used and 400
if Xerography is used. High voltage settings vary from 28–46 kVp depending on the view and
size of the breast.

**Table 2.14.**    Exposures (in roentgens) in mammographic examinations.

| View | 1976 data | | 1985 data | |
|---|---|---|---|---|
| | Screen film | Xerox | Screen film | Xerox |
| Cranio-caudad | 1.1–2.1 | 1.1–1.3 | 0.345 | 0.890 |
| Medial-lateral | 1.8–3.0 | 1.1–1.6 | | |
| Axillary | 6.9–8.2 | 2.3–2.8 | | |
| Total | 9.8–13.3 | 4.5–5.7 | | |

*Notes:* Exposures measured in air at skin distance. Range covers small to large breast. 1985 values are average for medium breast (5 cm compressed), no grid. Use of grid doubles exposure. Mean gland dose (1985) is 60 mrad for screen film, no grid. From Baxt et al., 1976; CRPCRD, 1988.

than in high-sensitivity film-screen combinations to get as sharp an image as possible. Thus mammography examinations can result in skin exposures of many roentgens.[38] Considerable development work has been done on methods to reduce these exposures. Special mammographic units are available which use an x-ray tube with a molybdenum target and molybdenum filtration. Xeromammography, in which the film is replaced by a positively charged selenium plate similar to that used in a Xerox machine, used to require exposures of about half the dose required for those of conventional mammography, but now it requires higher exposures. The results of studies of radiation exposure to the breast are given in table 2.14. Rare earth screen-film combinations have reduced the exposure per examination dramatically, to the mR range. However, the various systems produce images that differ significantly in quality, and the radiologist's preference is the major factor in determining the patient dose.

### 14.7  Computed Tomography: Taking Cross Sections with X Rays

Each point on a conventional radiographic image represents the penetration of x rays from a point source through the various media encountered on the way to the film, and is thus the composite effect of the different media along the path of the beam. It often requires consummate skill on the part of the radiologist to piece together the actual anatomical detail from the two-dimensional image presented on the film. Frequently two or more views are taken, typically at 90° to each other, to help identify features that may be superimposed and therefore obscured in a single view, but some subtle abnormalities may be impossible to detect. In 1972, largely through the

38. Surveys show wide variations in the doses imparted to patients. At twenty-nine breast cancer screening clinics, the skin exposures (6 cm thick breast) ranged from 3.5 to 5.5 R (Wooten, 1976) for conventional film radiography, and 0.2 to 3.4 R when low-dose film-screen combinations were used.

development work of Godfrey N. Houndsfield at Electro-Music, Inc. (EMI) in England, the first x-ray machine based on computed tomography made its appearance.  It involved mating x-ray scanning and digital computer technology.  This development has been called as revolutionary as the original discovery of x rays by Roentgen.  A diagram of an advanced type of scanner is given in fig. 2.27 (Swindell and Barrett, 1977).  The scan is made on a slice through the body 3 to 5 mm thick.  Each element of area in that slice is traversed by pencils of x rays entering from more than 100 different angles. The attenuation presented by the slice to all these rays is measured with a battery of about 300 electronic detectors, each only a few mm in diameter. Corresponding data are obtained for all the elements of area in the slice, and the data are incorporated into a series of simultaneous equations from which one can solve for the density of every element of the slice.  The results are then plotted by computer to give an accurate rendition of the cross section through which the tomograph is taken.  Commercially available equipment can perform a scan in a few seconds and accurately measure the attenuation coefficients of biologic materials with a precision of 0.5 percent and a spatial resolution of approximately 2–5 mm.

Doses are difficult to specify because of the complex motions and the geometry of the beam.  The exposure dose for a complete head scan study is between 1 and 2.5 roentgens and compares in value to a single skull film (McDonnel, 1977).  Since a complete skull series includes about seven

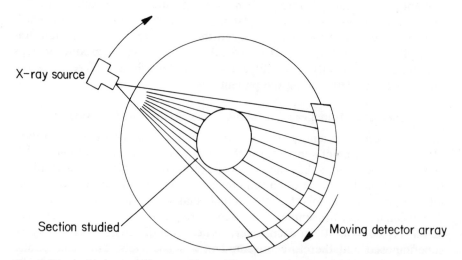

**Fig. 2.27**  A third-generation machine.  The x rays are formed into a fan of pencil beams that encompasses the section of interest.  With the source-detector assembly rotating uniformly about the patient, the required set of exposures is obtained by flashing the x-ray tube on at the appropriate angular positions.  In some recent versions only the source moves.  *Source:* Swindell and Barrett, 1977.

films, the CT dose is less than in film radiography.  Body scans include perhaps four to six slices per patient and deliver about 3 roentgens per scan, although this varies considerably among different machines.  The results of one study on dose variations are shown in table 2.15 (McCullough and Payne, 1978).  The values shown are maximum surface dose values and are for single scans.  Because of overlap between scans of adjacent slices, actual doses are higher by factors of 1.2 to almost 2.  Several of the rotate-translate geometry scanners had, in addition to a "normal" operating mode, a higher accuracy (lower noise) mode which entails slowing down the scanner, thereby increasing the scan time.  This produces a higher photon input to the detectors, but also results in considerably increased radiation doses by as much as a factor of 4.  The doses in the "high-accuracy" mode have been measured as high as 56 rad and are also shown in table 2.15.  McCullough and Payne reported that physicians at the institutions studied appeared to be ignorant of the high doses delivered under these conditions or felt that the increased clinical yield was worth the larger patient dose.

The regulation of Computed Tomography falls under the diagnostic x-ray standard, published in the Code of Federal Regulations, Title 21, Part 1020.30 (21CFR1020.30), but this was not designed for the control of a beam that has a spatial extent of the order of millimeters at distances of the order of a meter from the source, and special standards and considerations will have to be developed.

### 14.8   Technical Approaches for Minimizing the Doses Required to Record an X Ray

The simplest approach to obtaining a permanent record of the information carried in a beam of photons that has penetrated through a subject is to intercept the beam with a photographic emulsion.  The dose required to produce a satisfactory image on film has been reduced greatly over the years as the sensitivity of photographic emulsions to x rays has been increased.

The dose required to produce an x ray can be reduced by an order of magnitude over that required using x-ray emulsions alone by using ultrafast photographic film sandwiched between phosphors that fluoresce on being exposed to x rays.  The primary record of the image carried in the x-ray beam is made on the phosphor, and the light produced by the phosphor in turn produces an image on the adjacent film.

Methods for minimizing dose in photographic recording systems are obvious.  Increase the sensitivity of the emulsions to either the x radiation or the light, depending on the system used; increase the light output from the fluorescent screen; find faster developers for the film.  The fastest film-screen combinations can produce radiographs with a skin dose to the patient of only a few millirads.  However, the quality of the image obtained with the most sensitive techniques is not as good as that obtained with some of the slower

**Table 2.15.** Single-scan patient doses in CT scanning.

| CT unit | Study | kVp | mA (a) or mAs (b) | Scan time (sec) | Max. surface dose in single scan (rad) |
|---|---|---|---|---|---|
| *a.* Rotate-Translate (180° scan angle) | | | | | |
| EMI CT-5005 | head | 140 | 28 | 26 | 2.4 |
| | | | | 73 | 9.6, "high-accuracy" |
| | body | 140 | 28 | 25 | 3.0 |
| | | | | 73 | 12.0, "high accuracy" |
| Delta 50 | head | 120 | 30 | 120 | 1.8 |
| | body | 120 | 30 | 150 | 1.4 |
| Delta 50 FS | body | 140 | 35 | 20 | 2.4 |
| | | | | 36 | 4.8, "high accuracy" |
| *b.* Rotary (360–390° angle) | | | | | |
| Delta 2020-P | head | 130 | 160 | 2 | 5.6 |
| | body | 130 | 40–200 | 2 | 1.5–6.5, typical values |
| | | | 1600 | 16 | 52, maximum possible value |
| GE CT/T-7800 | head | 120 | 100–300 | 4.8 | 0.5–1.5 |
| | body | 120 | 100–300 | 4.8 | 0.9–2.6 |
| | | | 1152 | 9.2 | 9.2, max. possible value |
| GE CT/T-8800-P | body | 120 | 200–300 | 4.8 | 1.7–2.6 |

*Source:* McCullough and Payne, 1978.

*Note:* Doses in the patient will be about 40–70 percent of the listed maximum surface dose. For rotate-translate scanners scanning through 180°, the minimal surface dose is 20–25 percent of the listed maximum value. In scanners rotating through 360° or more, one can expect the surface dose to be reasonably uniform unless a large amount of overscanning is present. Because of overlap between scans of adjacent slices patient doses are higher by factors of 1.2 to almost 2.

methods, and so the choice of the film cannot be made on dose considerations alone.

If the cost or complexity of the recording system is not a factor, it is possible to use electronic recording and data processing systems to minimize dose still further and to increase the amount of information extracted from the beam. Examples of sophisticated electronic readout systems include:

(a) Image intensifier tubes with fast photographic film. Image intensifier tubes are electronic devices which amplify the light signal by transforming the pattern of light photons to a pattern of electrons, accelerating the electrons to high speeds, and producing another light image of greater intensity than the original by directing the more energetic electrons against a fluorescent screen. The resulting image may then be recorded on fast film (16, 35, or 70 mm).

(b) Image intensifier tubes with television recording. The recording of the output of an image intensifier tube on videotape by a television camera provides the most sensitive system for taking x rays. Radiographs of the trunk can be made with less than 1 mR of exposure.

(c) Image enhancement of grossly underexposed radiographs with flying spot scanner. The x ray is deliberately underexposed to reduce the patient dose. The desired information is still in the image but requires processing by special electronic techniques to extract it from the negative. The negative is scanned by a very narrow light beam and the resultant pattern is processed by a computer programmed to provide the desired information. This technique has been employed extensively in the study of aerial photographs for military purposes and, in principle, can be used effectively in radiography.

The methods of image intensification apply to fluoroscopy as well as radiography. The recording of the image on TV tape is especially powerful for fluoroscopy, since it provides a permanent record for continued study with a minimum of exposure. Certainly as resources become available, the "one-time" viewing of fluorescent screens by the physician in fluoroscopy should be replaced by permanent records on TV tape.

The use of pulsed methods provides even more dramatic reductions in dose (Miller and Baker, 1973). The fluoroscope is pulsed briefly and the x-ray image is converted to a television frame which is electronically stored on a magnetic disc (expensive and extremely delicate) or a silicon image storage tube (inexpensive, reliable, but image not permanent). It is then instantly replayed as a frozen image over the television monitor with the x-ray beam off. It can also be photographed on a remote TV monitor (Sashin et al., 1973). The rate of pulsing the fluoroscope can be tailored to the dynamics of the study. A rapidly changing process can be examined with more frequent pulses than one changing slowly. For example, barium enema studies of certain segments of the G-I tract characterized by little motility require exposures only every second or so to provide adequate information

concerning the flow of contrast medium.    Radiation exposures can be matched to the detail and contrast needed (to the extent that these are determined by photon statistics).    If only gross structure is of interest (such as in x rays of the G-I tract of a child to search for a swallowed safety pin), much fewer photons (and much lower exposures) are needed than in the search for a possible tumor in the breast.

The possibilities for electronic processing are unlimited.    Stored images taken previously can be superimposed on live images.    In selective catheterization procedures, electronic radiography has resulted in a much lower radiation dose, reduced procedure time, and reduced amounts of injected radiopaque contrast as compared to conventional fluoroscopy, which can give patient exposures as high as 100 R.    There are corresponding substantial reductions in the exposures of radiologists and cardiologists, who receive as much as 5 R/yr occupational exposure in the course of performing these examinations with conventional fluoroscopy.

Extremely low dose systems for medical radiography are being developed based on x-ray techniques used for screening baggage at airports.    The patient is scanned with a fine (that is, 1 mm) beam and the transmitted photons are detected with a collimated NaI scintillator.[39]    The data are processed and stored by means of a mini-computer, and the contrast and magnification can be adjusted upon displaying the image.    The entrance exposure required to x ray humans is about 0.3 mR and the exit exposure is less than 0.03 mR. This is between 100 and 1000 times smaller than the exposure required using screen-film radiography.    The system does not have the resolution of the conventional radiography systems and the exposure time is much longer, so it has limited applicability in medical radiography at present.

It is obvious that the amount of radiation required to produce a suitable image cannot be reduced indefinitely.    The limit would be zero exposure, and one cannot take an x-ray picture without an x-ray beam.    For meaningful results, a minimum number of x-ray photons must penetrate through the patient.    The actual number depends on the size of the area that is examined and the minimum contrast that is acceptable.    The problem is discussed in texts on medical x-ray physics (Ter-Pogossian, 1967; Hendee, Cheney and Rossi, 1977).

### 14.9    Protection of the Patient in X-Ray Diagnosis

The first element in a program to protect the patient is to maintain the x-ray machine in proper operating condition through a continuing quality control program involving measurements of output, beam quality, collimator performance, timer operation, and so on.    (BRH 1974; Hendee et al., 1977). The remaining elements are concerned with minimizing patient dose and

---

39. Medical systems of this type are being produced commercially for clinical evaluation by American Science and Engineering, Inc. of Cambridge, Mass.

avoiding the taking of unnecessary x rays. The following recommendations are basic to good practice in radiology from the viewpoint of radiation protection.

1. Minimize field size with accurate collimators. Do not expose parts of the body that are not being examined. (An additional safety measure, but not a substitute for adequate beam collimation, is to use leaded cloth or other shielding material to protect the gonads and possibly other regions not being examined.) Use film larger than the required x-ray field to verify that collimation is being done properly.

2. Use maximum target-patient distance. This decreases the difference between dose at the entrance side relative to the exit dose because of differences in distances to the target. (As an example, it can be easily verified from the inverse square law that when the x-ray film is 1 ft from the point where the beam enters the body, the entrance dose for a 3 ft separation between the target and film is over 6 times the entrance dose for a 6 ft separation.)

3. Make sure that proper filtration is used.

4. Use a setting for the high voltage that will give minimum absorbed dose consistent with a satisfactory picture.

5. Use the fastest film/screen combinations and shortest exposures that give satisfactory results.

6. Pay careful attention to processing procedures to allow minimum exposures (that is, by using full strength developer, proper temperatures, and so on).

7. Use fluoroscopy only when radiography cannot give the required information. Use image intensification in fluoroscopy.

8. Use all the planning necessary to prevent faulty pictures and the need for retakes. Retakes are a major source of excessive x-ray exposure.

9. Do not prescribe the x ray unless it is necessary.[40]

A decision by a physician to forgo prescribing an x-ray examination takes a certain amount of courage in our society, considering his vulnerability to a malpractice suit in the event a diagnosis is missed. It is much safer for him to continue past practices of routinely prescribing x-ray examinations even if he honestly and justifiably believes a clinical diagnosis can be made without their use. Yet the weighing of benefit vs. risk to the patient in prescribing x rays would most certainly result in the elimination of some x-ray examinations and the curtailment of unnecessarily extensive ones (ICRP, 1970, Publication 16). Fortunately, public awareness and concern over the effects of radiation on the fetus has resulted in a sharp curtailment of examinations of pregnant women. Children and even adults, if somewhat less sensitive, are also entitled to the same conservative approach. An example of guidelines for reaching a decision on the prescription of an x-ray examination of a

40. See Gilkey and Manny (1978) and Phillips (1978) for criteria for the prescription of x rays.

woman of childbearing age is given in fig. 2.28. When pregnancy is discovered following an x-ray examination, the question may arise as to whether the pregnancy should be terminated. There are no definite rules. The opinion of the NCRP is that the decision should properly be left to the patient, with arguments and recommendations supplied by the physician. The most sensitive period in the development of the fetus is considered to be between the 10th day and the 10th week postconception. The risk is considered to be negligible at a fetal dose of 5 rads or less. This is well above the level usually received by the fetus in diagnostic procedures (NCRP, 1977, Report 54).

In January 1978 a Presidential memorandum entitled, "Radiation Protection Guidance to Federal Agencies for Diagnostic X Rays," was issued (Carter, 1978). It was based on a report prepared by the Interagency Work-

---

I. Is the examination of the abdomen or pelvis an *elective* procedure for the patient under consideration?

   A. No. ☐ Go to II.

   B. Yes. ☐ Go to IV.

II. Is the patient pregnant?

   A. No. There is no chance of an unsuspected pregnancy. ☐ Proceed with the examination. Advise patient to avoid the risk of pregnancy until after two months after the examination.

   B. Yes, or pregnancy cannot be ruled out. ☐ Advise the patient that medical judgment indicates that the need for the examination outweighs the possible slight risk to the embryo or fetus. Go to III.

III. Can the examination be modified so as to reduce the dose to the uterus (embryo or fetus if present)?

   A. No. ☐ Proceed with the examination.

   B. Yes. ☐ Proceed with the modified examination.

IV. How many days after the onset of the last menses would the examination be performed?

   A. 0–14 days. ☐ Proceed with examination. Advise the patient to avoid pregnancy for two months.

   B. 15 days or more. ☐ Postpone examination until menstruation ensues. If patient proves to be pregnant, postpone the examination until term.

**Fig. 2.28** Example of a decision tree that might be employed in scheduling or postponing elective examination of the abdomen or pelvis of a woman of childbearing capacity. An elective examination is one that is not of immediate importance to the patient's health and can be postponed to term if the patient should prove to be pregnant, without significant risk to the health of the patient or her conceptus (NCRP, 1977, Report 54).

ing Group on Medical Radiation (EPA, 1976). The memorandum noted that exposure due to medical uses of ionizing radiation presented a significant and growing source of exposure for the U.S. population and that exposure could be reduced by practices such as avoiding the prescription of clinically unproductive examinations and minimizing the number of radiographic views required. The memorandum contained a set of twelve recommendations which were developed cooperatively by the Environmental Protection Agency and the Department of Health, Education, and Welfare over a period of three and one-half years. While the recommendations were directed to Federal facilities, under the authority possessed by the President, they were distributed by the Bureau of Radiological Health to a broad spectrum of people and organizations in the private sector interested in diagnostic x-ray protection. It was felt that the public health would benefit if the private medical community would consider the Presidential recommendations as indices of ways to improve medical and dental x-ray practices. The recommendations were not considered as the definitive approach to x-ray protection but as a basis for continuing efforts in promulgating voluntary guidance to educational programs for improving radiological health care.

The recommendations covered the qualifications of persons authorized to prescribe x rays, indications for the prescription of x rays, training of persons operating the equipment, equipment design and performance standards, and quality assurance programs for effecting the objectives of the program. Examples of examinations that were not to be performed routinely included:

($a$) chest and lower back x-ray examinations in routine physical examinations or as a routine requirement for employment,

($b$) tuberculosis screening by chest radiography,

($c$) chest x rays for routine hospital admission of patients under age 20 or lateral chest x rays for patients under age 40 unless a clinical indication of chest disease exists,

($d$) chest radiography in routine prenatal care,

($e$) mammography examinations of women under age 50 who neither exhibit symptoms nor have a personal or strong family history of breast cancer,

($f$) full mouth series and bitewing radiographs in the absence of clinical evaluation in preventive dental care.

A set of Entrance Skin Exposure Guides (ESEG) were given as indicators of maximum exposures to be imparted where practicable in certain routine non-specialty examinations (see table 2.16, which also gives 1988 values).

At a national conference on referral criteria for x-ray examinations (BRH, 1978a) factors underlying the overutilization of radiological examinations were identified as excessive radiation per film, excessive films per examination, excessive examinations per patient, lack of radiological screening of requests, and defensive medicine. Retakes because of faulty films were said

**Table 2.16.**   Entrance skin exposure guides (ESE) for medical x rays.

| Examination (projection) | ESE 1976 (mR) | ESE 1988 (mR) | |
|---|---|---|---|
| | | 200 speed | 400 speed |
| Abdomen (A/P), Grid | 750 | 490 | 300 |
| Lumbar Spine (A/P) | 1000 | 450 | 350 |
| Full Spine (A/P) | 300 | 260 | 145 |
| Cervical Spine (A/P) | 250 | 135 | 95 |
| Skull (Lateral) | 300 | 145 | 70 |
| Chest (P/A), No grid | | 15 | 5 |
| Grid | | 25 | 15 |
| Mammography, No grid | | ESE 345 mR, MGD 60 mrad | |
| Grid | | ESE 690 mR, MGD 135 mrad | |
| Dental (bitewing), 75 kVp (1988) | 700 | 100–140, E speed | |

*Sources:* EPA 1976; CRCPD 1988.

*Note:* Entrance skin exposure determined by the Nationwide Evaluation of X-Ray Trends program (NEXT) for a patient having the following body part/thickness: head/15 cm, neck/13 cm, thorax/23 cm, abdomen/23 cm, and foot/8 cm. Values are given in air, without backscatter. MGD = mean glandular dose in mammography.

to be responsible for about 27 million additional films per year.   It was suggested that routine skull examinations in headache or vertigo without physical signs could be limited to a single film for screening.   The periodic upper gastrointestinal series on the patient with healed duodenal ulcer frequently was unnecessary, since the clinical course might accurately depict the patient's response to treatment.   There was little justification for routine "screening" x rays, unless specifically applied to high-risk groups.   Defensive x rays, a consequence of the malpractice mores of the era, comprised a significant percentage of the 271 million examinations per year (Abrams, 1978).   The actual risks in terms of subsequent biological effects incurred by the population from diagnostic x rays are uncertain.   However, the proceedings of a recent symposium on subsequent effects demonstrated an increased awareness of the potential risks of the medical uses of ionizing radiation and "the need to ensure that members of the medical profession, who do not necessarily think in terms of radiological protection, are made aware of current thinking in this important field" (Weeks and Kobayashi, 1978).

Maximum patient doses from diagnostic x rays are regulated by the state of Illinois through a Radiation Protection Advisory Council (consisting of seven professionals, including health physicists, medical and dental licensed practitioners, and industrial executives).   Routine intraoral radiography is limited to an incident exposure of 100 mR per radiograph with a recommended limit of 500 mR.   Limits are also set for medical radiographs: 1400 mR per radiograph maximum and 100 mR per radiograph recommended limit measured at the tabletop (Lanzl, 1976).

## 14.10   Radiation Levels around X-Ray Machines

The installation and operation of an x-ray machine must be such as to provide adequate protection for both operating personnel and any individuals in the vicinity of the machine.[41]  This is accomplished by providing shielding where necessary to attenuate the radiation traveling in unwanted directions or by restricting the occupancy of specified regions.  After a radiation machine has been installed and shielded, radiation surveys are made to insure that the radiation levels are below the limits specified by radiation advisory groups or governmental agencies.  If there is a reasonable possibility that exposures can be received in the course of using the machine that are in excess of 25 percent of the occupational dose limits (that is, in excess of 0.3 rem/quarter for whole body radiation), personnel monitoring devices must be worn (see part V, section 5, for a discussion of personnel monitoring).

The radiation produced at any point by an operating x-ray machine may consist of one or more of the following components:

(a) Useful beam.  This consists of photons coming directly from the target and through collimating devices that define the region of the patient to be irradiated.

(b) Scattered radiation.  Since the useful beam in a properly designed machine is limited to the region of the patient being examined, the scattered radiation originates primarily in the body of the patient.  This radiation can also undergo subsequent scattering from the walls and other objects in the examination room.

(c) Leakage radiation.  This is radiation which penetrates the x-ray tube housing and collimator and is not part of the useful beam.  It is, of course, attenuated very markedly by the tube housing and collimating devices.

The degree of protection required by an operator of an x-ray machine varies considerably, depending on the radiation procedure being performed.  Only low radiation levels are found in the vicinity of a dental x-ray machine because of the small size of the beam and the small amount of scatter produced.  It is possible for the operator of a dental x-ray machine to stand in the same room with the patient and take pictures without exceeding his allowable exposure if he positions himself properly.  However, because of the low energy of dental x rays, they are very easily shielded, and any operator who has any significant work load should be protected by a thin lead screen.

Medical diagnostic x-ray machines create larger environmental levels than dental x-ray machines relative to the dose at the film because the larger beams used produce more scattered radiation.  The x-ray equipment must

41. Detailed recommendations are given in Reports 35, 34, and 33 of the National Council on Radiation Protection and Measurements, listed in the Selected Bibliography at the end of the book.  Users of radiation emitting machines should keep abreast of the latest recommendations published by advisory committees on radiation protection.

be installed in rooms with adequate shielding, and the radiographer must stand behind protective barriers during radiographic procedures. Needless to say, the radiographer must not expose any part of his body to the direct beam. Most of the severe consequences of exposure to radiation developed in operators who deliberately allowed parts of their own bodies to be irradiated by the useful beam. Many dentists developed atrophy and cancer in exposed fingers as a result of holding the film in the patient's mouth while taking x rays, a folly that is no longer practiced.

When a patient must be held in position by an individual during radiography, the individual holding the patient must be protected with appropriate shielding devices, such as protective gloves and apron and should be positioned so that no part of his body encounters the useful beam (preferably as far from the edge of the useful beam as possible). The task of restraining a child should be assigned to the patient's parent.

Fluoroscopic examinations pose a problem in radiation protection because the examining physician often stands close to the patient and the useful beam. The results of a survey made during operation of a conventional fluoroscope are presented in fig. 2.29. By far the highest exposure rate (3.6

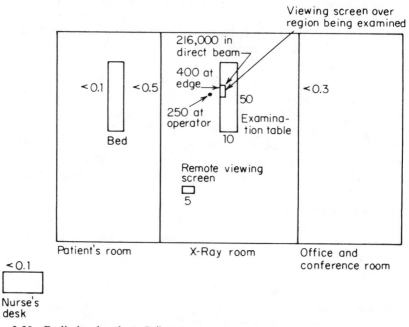

**Fig. 2.29** Radiation levels (mR/hr) measured during fluoroscopy in hospital x-ray examination room. X-ray tube is under examination table and beam is directed upward through patient to viewing screen. Operating conditions, 90 kVp, 3 mA; all dose measurements made with condenser ion chambers (R. U. Johnson, personal communication).

R/min) was in the useful beam.   Thus the most important precaution an op-
erator of a fluoroscope unit can take is not to expose any unshielded part of
his body to the useful beam.   With the use of image intensifiers, it is possible
to locate the viewing screen remotely from the patient if proximity to him is
not required.   However, some diagnostic procedures require that the physi-
cian or other medical personnel perform operations on the patient during the
exposure.   The potential for receiving high occupational exposures from re-
peated examinations of this type are great, and special control measures are
required.   Detailed monitoring of physicians' hands or other critical regions
should be employed to prevent overexposure.   The monitoring results
should be appraised continually to develop procedures or shielding tech-
niques for lowering the dose as much as feasible.

The maximum environmental levels occur in the vicinity of machines used
for therapy.   The doses imparted to the patient are high and the leakage and
scattered components are correspondingly high.   The operator must always
remain in a shielded booth or outside the shielded treatment room while
operating a therapeutic x-ray machine.

### 14.11   Shielding the X-Ray Beam

X-ray shielding is based on principles the same as those for gamma shielding
discussed in section 5.3.   To specify the correct thickness of shielding, it is
necessary to know the half-value layer for the x rays of interest.   Generally,
one determines this value for the highest energy at which the machine will be
operated.   Although half-value layers may be calculated theoretically, the
calculation is complicated because of the complex nature of the x-ray spec-
trum.   Also, the half-value layer depends on the width of the beam and other
factors contributing to scatter of radiation in the attenuating medium.   Ac-
cordingly, it is desirable to select values for half-value layers and other at-
tenuation coefficients that were determined for conditions similar to those
encountered in a specific design problem.   Values of experimentally deter-
mined half-value layers are given in table 2.17.

**Table 2.17.**   Half-value layers for diagnostic x rays.

| Tube voltage | Lead (mm) | Concrete[a] (cm) |
|---|---|---|
| 50,000 | 0.06 | 0.43 |
| 70,000 | .17 | .84 |
| 100,000 | .27 | 1.6 |
| 125,000 | .28 | 2.0 |

*Source:* NCRP, 1976, Report 49.

[a] The half-value layer will vary in different kinds of concrete and is given for illus-
trative purposes only.

X-ray shielding is usually designed to limit the maximum exposure which could be received by a person over a period of a week at specified dose points to 0.1 R in controlled areas and 0.01 R in uncontrolled areas. The evaluation of the exposure produced by a machine is based in practice on specification of the output and three other factors: the workload, $W$, defined as the degree of use of the machine and usually expressed in milliampere minutes per week; the use factor, $U$, defined as the fraction of the workload during which the radiation under consideration is pointed in the direction of interest; and the occupancy factor, $T$, defined as the factor by which the workload should be multiplied to correct for the degree of occupancy of the area in question while the machine is emitting radiation. The product of the output specified for the distance from the target to the point of interest and the three factors, $W$, $U$, $T$ is divided by the permissible weekly dose to give the attenuation factor required, and the shield thickness is then calculated in the usual way from the number of half-value layers required to produce the desired attenuation. For convenience of the shield designer, the protection handbooks contain tables for determining shield thicknesses at an installation operated at a given kilovolt peak. The thicknesses (usually for lead and concrete) are given as a function of the product $WUT$ and the distance from the tube target to the occupied area. Typical values of $W$, $U$, and $T$ are also given for use as guides in planning shielding when complete data are not available (NCRP, 1970, Report 34).

> *Example 20:* Determine the thickness of lead required on the floor of a radiographic installation directly above a waiting room for the following conditions: $kVp = 150$; $W = 200$; $U = 1$; $T = 1/16$. The distance from the source is 7 ft.
>
> $WUT = 12.5$ NCRP Report 34 (1970) specifies a lead thickness of 1.5 mm if no credit is taken for attenuation by the materials of construction of the floor. The floor thickness may be converted to number of half value layers and subtracted from the number of half-value layers represented by 1.5 mm of lead to give the actual number of half-value layers and thus the thickness of lead recommended for the floor.

It may be necessary to provide shielding of scattered radiation as well as of the direct beam. An exact calculation of scattered radiation is very complex, and generally, empirical factors are used for determining the dose scattered from a surface. One approximate relationship commonly used is: Scattered dose at one meter from scatterer = $1/1000 \times$ incident dose at scatterer for a beam with a cross section 20 cm × 20 cm. Since the scattered radiation is proportional to the cross-sectional area of the beam, for beam areas other than 400 cm², a correction may be made by multiplying the estimate of scatter by the ratio (actual area)/400.

The attenuation coefficients used in determining the thickness of shielding

for scattered x rays in diagnostic installations are usually taken to have the same values as those given for the useful beam. The scattered radiation is less penetrating for x rays generated at voltages greater than 500 kV, and the reader is referred to the handbooks for design data.

## 14.12 Comments for Users of X-Ray Diffraction Machines

X-ray diffraction machines are designed for routine analytical work and, in theory, do not present any radiation hazards to the user if simple precautions are observed. However, they make use of beams of extremely high intensity, and although the direct beams emanating from the machines have diameters generally not exceeding a centimeter, they can produce severe and permanent local injury from only momentary irradiation of the body (Weigensberg et al., 1980). The direct beams also generate diffuse patterns of scattered radiation in the environment; although this radiation does not present a hazard of serious accidental exposures, it can produce harmful somatic or genetic effects to individuals exposed over an extended period of time. The magnitude and extent of radiation fields found typically around x-ray analytical instruments are illustrated in fig. 2.30.

Note that two principal modes of operation are shown, diffraction and fluorescence. In diffraction, the primary beam from the target of the x-ray tube emerges from the machine through a collimator and strikes the sample, which diffracts it in a characteristic manner. The diffraction pattern is measured with a photographic film or a radiation counter. In fluorescence, the primary radiation beam strikes the sample inside a shielded enclosure, and only scattered radiation and secondary radiation excited in the sample as a result of the irradiation emerges from the machine for analysis. Consequently, external levels are much lower in the fluorescence mode than in the x-ray diffraction mode.

The greatest risk of acute accidental exposures occurs in manipulations of a sample to be irradiated by the direct beam in diffraction studies. Exposure rates of the order of 10,000 R/sec can exist at the tube housing port. Erythema would be produced after an exposure of only 0.03 sec, and in 0.1 sec severe and permanent injury could occur. The fingers, of course, are the parts of the body most likely to receive these high exposures. Environmental levels near the machine from scattered radiation can also be quite high, perhaps a few hundred millirems per hour. Maximum occupational exposures for a three-month period would be attained within a few hours at these exposure rates.

Modern x-ray diffraction machines incorporate shielding and safety features to prevent both acute local accidental exposures and chronic long-term irradiation of the body. Operators should be fully cognizant of the protective devices incorporated into their machines and the possibilities for failure or malfunction. Operators working with older machines must be especially careful of the possibilities of receiving excessive amounts of radiation.

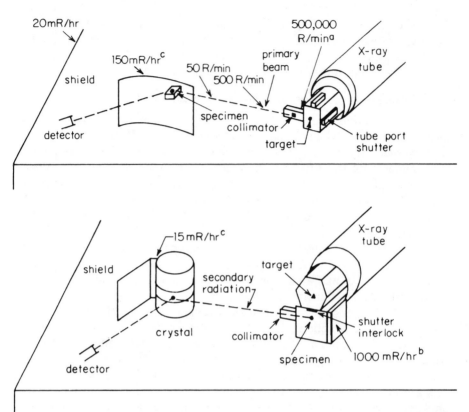

**Fig. 2.30**   Radiation fields around x-ray analytical equipment.   In x-ray diffraction studies, the intense primary beam passes through an open area before striking the sample.   In x-ray emission (fluorescence) studies, the primary beam and sample are completely enclosed and shielded; only scattered and secondary fluorescence radiation emerge to open areas.   Note that typical exposure rates around the fluorescence setup are orders of magnitude lower than around the x-ray diffraction setup.   The figures for exposure rates are based on published data and the author's experience. (For additional survey results, see McLaughlin and Blatz, 1955.)   Points identified on diagram are: (*a*) at tube port with shutter open; (*b*) at specimen chamber when tube not seated properly or sample holder removed and shutter interlock not completely effective; and (*c*) in vicinity of shielding.

It is very important that x-ray diffraction machines be surveyed for excessive radiation levels on a regular schedule, at intervals not exceeding a year.   They should also be surveyed every time a modification in measurement techniques affecting the radiation pattern is introduced.   All measurements, except those of the extremely localized and intense direct beam, can be performed satisfactorily with an ionization-chamber type of survey meter equipped with a thin window for the low energies encountered in x-ray ana-

lytical work. Photographic film works well for delineating the direct beam and for searching for other small intense beams that may penetrate through holes in the shielding. The exposure due to the direct beam is usually measured with a small condenser-type ionization chamber (R meter) or a lithium-fluoride thermoluminescent detector. A Geiger counter is a very effective instrument for searching for excessive scattered radiation that must then be evaluated accurately with dose or exposure measuring devices.

The need for personnel monitoring is debatable when well designed instrumentation is used routinely, but personnel monitoring is necessary when machines are used in experimental configurations. The effectiveness of film badges and other personnel monitoring devices for monitoring the primary beam is limited because of their small size. When film badges are used, they should be worn on the wrist to monitor the region most vulnerable to exposure. When high exposures to the fingers are possible, it is very desirable to supplement the standard personnel dosimeters with finger monitors. The detectors may be incorporated into a ring or merely taped to the fingers.

When excessive radiation levels are found around x-ray analytical equipment, they can be easily reduced because of the very low energies of the x-ray photons. Any convenient structural material can be used. Frequently a thin sheet of steel, copper, or brass will suffice. Essentially complete attenuation of the highest intensities normally encountered can be accomplished with a thickness as small as 3 mm brass, or the equivalent.

Following is a list of safety recommendations applicable to persons working with analytical x-ray equipment (Lindell, 1968).

1. Warning signs, labels, and lights should be used at working stations.

   a. Labels bearing the words "Caution Radiation—This equipment produces radiation when energized" should be attached near any switch which energizes a tube. They should contain the radiation symbol and be colored magenta and yellow.

   b. Highly visible signs bearing the words "Caution—High Intensity X-Ray Beam" or other appropriate warning should be placed in the area immediately adjacent to each tube head.

   c. Warning lights which are lit whenever the tube is delivering x rays should be placed at tube on-off switches and at sample holders. The installation of the lights should be "fail-safe," or two lights should be installed in parallel to provide a warning even if one of the bulbs burns out.

2. Shutters should be used that cannot remain open unless a collimator is in position.

   The only equipment failures that have been reported as resulting in radiation injury have involved defective shutters over the tube head ports. Accordingly, even when shutters are provided, they must be inspected and monitored regularly.

3. Shutter interlocks should be used to cut off the beam when samples are changed.

Modern fluorescence instrumentation comes equipped with shutters that prevent the beam from entering the sample chamber when samples are removed. However, there are reports of poorly designed shutters that allow significant amounts of radiation to leak through. Accordingly, the presence of these shutters cannot be taken as prima facie evidence of effective radiation protection, and they should be monitored routinely.

4. No repair, cleaning work on shutters and shielding material, or other nonroutine work that could result in exposing anyone to the primary beam should be allowed unless it has been positively ascertained that the tube is completely deenergized.

5. Active educational and indoctrination programs in radiation protection should be conducted for users of the x-ray equipment.

The most frequent causes of radiation accidents leading to severe tissue injury have been due to human error, involving either carelessness or ignorance on the part of the operator in performing adjustments or repairs when the tube was energized. Well-planned formal training and indoctrination sessions will help reduce human-error accidents. Lack of training programs is evidence of neglect of responsibilities by the user and the owner of the x-ray equipment.

6. Equipment should be secured so it cannot be used or approached by unauthorized personnel.

The most obvious method of preventing unauthorized use is by locating the equipment in a locked room which cannot be entered except by authorized users. If equipment must be located in unrestricted areas, appropriate barricades should be installed and a key required to turn on the equipment.

## 15.   Particle Accelerators—The Universal Radiation Source

The x-ray machines described in the last section actually represent a special class of particle accelerator. In x-ray machines, electrons are accelerated to energies which produce x rays suitable for radiology. The energies delivered by the machines range from a few thousand electron volts to several million electron volts, depending on the application. Other particles, such as protons and deuterons, can also be accelerated in special machines and have various technological and medical applications.

In physics research, particles at the highest energies attainable are the basic experimental tool in studies on the nature of matter, energy, and nuclear forces. Very large and complex machines are needed to produce the energies desired, and present designs are looking toward 1000 billion elec-

tron volts.  The field of science which is concerned with the development and use of these machines is known as high-energy physics, and the growth of this field has generated specialists in radiation protection concerned with protection of personnel from the new and energetic particles produced.

Because particle accelerators increase the velocities of particles through the application of electrical forces, only charged particles can be accelerated.  These particles may then be used directly for various applications, or they may be used to collide with atoms or nuclei to produce other particles.  We have already cited the x-ray machine as the most common application of the latter procedure, where a small fraction of the energy of directly ionizing electrons is converted to the energy of indirectly ionizing photons.  This is a process that takes place outside the nucleus of the atom.  In other procedures, charged particles are given enough energy so they can penetrate into the nucleus.  Their capture results in the release of a considerable amount of nuclear binding energy, usually of the order of 7 or 8 MeV that, in addition to their own kinetic energy, is available to initiate further reactions.

## 15.1  History of Particle Accelerators

The potential for learning about the structure of the nucleus by bombarding it with energetic particles gave much impetus to the development of machines for accelerating suitable projectiles.  The first machines used simple electrical circuits to produce high voltages, the most successful of which was the voltage-doubling type of circuit developed by Cockroft and Walton.  The voltage source was made up of electrical transformers, condensers, and rectifier tubes in an arrangement that resulted in the production of up to 700,000 volts.  The first nuclear reaction induced by artificially accelerated particles was obtained with this machine.  Protons were accelerated through 150,000 volts and used to bombard a lithium target.  The lithium target was split into two alpha particles, each of which carried over 8 MeV, as a result of the nuclear energy released in the process.

The maximum voltages attainable with the Cockroft-Walton circuit were limited, and the next step came with the development of the Van de Graaff electrostatic generator.  This utilized a moving belt to deliver electrical charge to a sphere whose voltage increased with the accumulation of charge up to a maximum limited by the ability of the insulators to support the voltage without breaking down.  From initial generators of 1.5 million volts, the technology developed to the point where the machines could generate potentials up to 10 million volts.  The Van de Graaff generator is the favored accelerator in its energy range because of the accuracy and precision of particle energies obtainable by this means.

The next step forward in the production of higher energies came with the development of the cyclotron.  An ingenious method was invented for imparting very high energies to particles without the use of corresponding high voltages.  The particles were made to go around in a circle and each half

revolution they passed through a high voltage which gave them an increment of energy. The circular orbit resulted from the imposition of a magnetic field perpendicular to the plane of motion of the particles. By use of bigger magnets, the particles could be accelerated to higher energies. Typical cyclotrons have diameters of 60 inches and accelerate protons to about 10 MeV. A diagram of a cyclotron is given in fig. 2.31.

The basic cyclotron design could not be used when the velocities of the particles approached the speed of light, and most of the energy imparted to the particles served to increase the mass rather than the speed. The synchrocyclotron, by gradually reducing the frequency of the accelerating field, overcame the problems of acceleration at higher energies. The 184 in. synchrocyclotron at Berkeley produced proton energies up to 350 MeV.

The attainment of higher energies was prevented by the cost of the construction and operation of the massive magnets required to keep the particles traveling in the circular orbit. The magnet for the cyclotron at Berkeley weighed 4000 tons. A new principle was needed if further progress toward higher energies was to be made. The solution to this problem was the development of the synchrotron. The single magnet and radiofrequency field

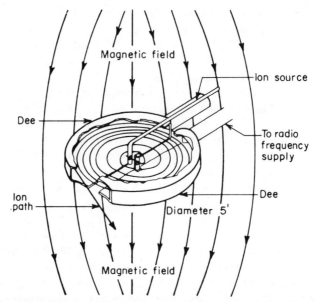

**Fig. 2.31** Simplified diagram of the cyclotron. Paths of the charged particles (ions) introduced at the center are bent into near-circles by the verticle magnetic field. A rapidly alternating horizontal electric field applied between hollow electrodes (dees) accelerates the particles each time they complete a half circle and cross the gap between the electrodes. This causes the particles to travel in ever-widening orbits until they are extracted by deflecting electrodes and aimed at an externally placed target. The dees are enclosed in a vacuum chamber (Kernan, 1963).

were replaced by a large ring consisting of a sequence of magnets for bending the beam and radiofrequency fields for accelerating it.   This arrangement allowed the establishment of the very large orbits required to contain the energetic particles with deflecting magnets of practical sizes.   A portion of the ring of the proton synchrotron at the Fermi National Accelerator Laboratory in Batavia, Illinois is shown in fig. 2.32.   This machine accelerates protons to 500 billion electron volts (500 GeV).   The proton orbit has a diameter of 2000 meters.   Work is proceeding on the production of colliding beams of high-energy nucleons.   The use of two beams of particles hurtling at each other at the speed of light instead of single beams colliding with a stationary target increases very substantially the energy available for the production of reactions, allowing exploration of a new range of phenomena in particle physics.

Electrons traveling in a circular orbit emit electromagnetic radiation and lose energy that must be made up by supplying additional power.   Radiation losses impose a practical limit on the maximum energy that can be attained.   These losses are eliminated by accelerating the electrons along a straight line, but the distance of travel required to attain the desired energies at first discouraged the serious consideration of a linear accelerator.   However, this and other obstacles were finally surmounted, and in 1966 the Stanford Linear Accelerator came into operation.   This two-mile long machine accelerates electrons in a straight line to energies of 20 billion electron volts.   The electrons are accelerated by traveling electric fields that accompany them and continuously impart energy to them.

It appears that as long as scientists demonstrate their ability to build more powerful and energetic particle accelerators and can use them to push forward the frontiers of knowledge, society will support them in their endeavors.   Just when a terminal point based on maximum attainable energy will be reached is an open question, but as long as high-energy research is pursued, the frontiers of high-energy research will constitute one of the frontiers of research in radiation protection.

## 15.2   Interactions of High-Energy Particles

The collisions made by ionizing particles with energies less than a few MeV are fairly uncomplicated, at least from the viewpoint of energy transfer to the medium in which they travel.   Gamma photons give rise to electrons of relatively short range which dissipate their energy close to the point of origin.   Neutrons collide with and impart energy to the nuclei of atoms, energizing them into projectiles with very short ranges.   In those cases where neutrons enter into the nucleus, they liberate additional nuclear energy, which is generally released from the nucleus in the form of gamma photons of moderate energy.   Neutron reactions can also result in the emission of charged particles that lose their energy locally.

Both neutrons and gamma photons may either disappear completely after

**Fig. 2.32** A portion of the main ring of the 500 GeV accelerator at the Fermi National Accelerator Laboratory (Fermilab) in Batavia, Illinois. The dominant elements shown are the bending magnets. Underneath the bending magnets, next to the floor, is a ring of superconducting magnets, which is now under construction. There are 774 bending magnets, each 20 ft long, plus other magnets whose function is to hold the protons together in the vacuum pipe; altogether there is a total of over 1000 magnets. The bending magnets require an excitation current of about 5000 A to provide the 18 kG magnetic field to keep the fully accelerated protons in the circle (Sanford, 1976). Protons are accelerated to 8 GeV before entering the ring, where they acquire 2.8 MeV of energy each time they make a revolution. Thus they encircle the ring 176,000 times and travel a distance of $1.1 \times 10^6$ km while being accelerated to 500 GeV. This distance, which is traversed in 3.5 seconds at nearly 50,000 revolutions per second, is 2.9 times the distance to the moon. The normal beam flux is $2 \times 10^{13}$ protons per pulse. Beams are received every 10 sec from the injector and are used for 1 second at full energy. Since $10^{13}$ protons/sec represents a current of 1.6 uA, a $2 \times 10^{13}$/sec beam of 500 GeV protons contains 1.6 MW of beam power.

individual interactions or continue on at reduced energies. In any event, we have seen how the reduction of the intensity of neutrons or gamma photons of any given energy in a medium can be specified rather simply in terms of the half-value layer concept.

As the energies of the interacting particles increase, more complex interactions occur. Gamma photons at high energies become readily materialized in the vicinity of the nuclei of atoms into high-energy electrons and positrons (a process known as pair production). The energetic charged particles so produced lose their energy in turn by radiating high energy photons, as well as by ionization. The result is the creation of what is known as an electromagnetic cascade, a continual shuttling back and forth of energy between material and photon forms that results in deep penetration of the radiation energy in a medium. The photons in the cascade also undergo reactions with nuclei that result in the ejection of considerable numbers of neutrons.

High-energy material particles undergo complex nuclear interactions that result in the transfer of a tremendous amount of energy within the nucleus and the emission of a variety of particles, primarily high-energy protons (with long ranges) and neutrons, but sometimes heavier fragments. The high-energy protons and neutrons are ejected as a result of a series of collisions of individual particles within the nucleus in a process known as an intranuclear cascade. This cascade process begins to be important above 50 MeV. When the energies of incident particles exceed 400 MeV, production of mesons begins to compete with other processes.

After the cascade process, some energy remains distributed in the nucleus, and this produces what may be described as a nuclear boiling process, with the subsequent "evaporation" of low-energy neutrons and protons.

The nuclear interactions undergone by high-energy protons occur at separate points. In between the nuclear collisions, the protons continue to lose energy continuously by ionization in the manner characteristic of directly ionizing particles.

### 15.3 Shielding High-Energy Particles

Because of the many complex interactions that occur when high-energy particles penetrate matter, including the production of very penetrating secondary radiations, a shielding design is a very difficult problem. The simple

---

Obviously the acceleration and handling of such a beam must be done with great care. Completion of the superconducting ring with its 1000 magnets will enable acceleration to 1000 GeV (1 TeV). Work is underway to produce colliding beams at 1000 GeV (Wilson, 1977). The effects produced in the accelerator with colliding beams would require energies of about one million GeV if observed through collisions with protons at rest, and a synchrotron capable of producing such energies would encircle the whole United States. (Photo courtesy of Fermilab Photo Unit.)

half-value layer concept which was effective for the lower energies discussed previously is generally not applicable at these high energies. Many of the data for the design of accelerator shields are obtained from measurements in actual shield configurations of the falloff of dose with distance through a shield. From such experimental data, curves on the attenuation of high-energy radiations through different materials are prepared. An example of attenuation measurements is given in fig. 2.33.

One of the major difficulties in providing accelerator shielding is the extended nature of the sources of high-energy radiation. The accelerating particles cover very large distances in these machines. For example, in one 6 GeV electron synchrotron design, each particle travels a distance of 1400 miles as it makes 10,000 turns around the orbit within an evacuated pipe. The large circulating currents produce very high radiation sources whenever the electrons collide with the walls of the pipe or the surrounding magnets and other equipment. It is not always practical to provide sufficient shielding to protect against continuous exposure from all possible sources of radiation from a misdirected beam, and control of radiations from these machines includes dependence on the ability of the accelerator designer and operator to confine the beam to its orbit.

In practice, the main sources of exposure to personnel working near accelerators occur not during operation of the machine but from activation by the beam of the materials of construction. The radiation levels from production

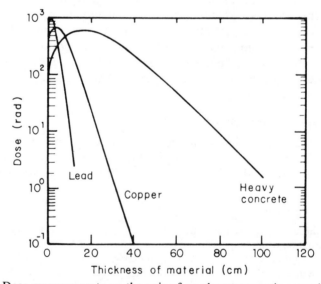

**Fig. 2.33** Dose measurements on the axis of an electromagnetic cascade produced by a beam of $5 \times 10^9$ 6300 MeV photons. Measurements were made with an air-filled ionization chamber (Bathow et al., 1967).

of radioactive nuclides can become quite high and pose a real problem when work has to be done on the activated components.   The technical problem of specifying the degree of shielding required is not difficult, since the sources are radioactive nuclides. The major problem is to install shielding adjacent to the radioactive components in a manner that will provide the required radiation protection and still allow close and intricate operations.

# Part III

# Radiation Dose Calculations

In order to evaluate the hazard of a radiation exposure, it is necessary to determine the energy imparted to critical tissue in the person exposed. The quantity of interest is the absorbed dose, and it is determined in practice by evaluating the energy imparted to a definite mass of tissue. If the dose is imparted by high LET radiations, it must, in addition, be converted to the dose equivalent by multiplying by the appropriate quality factor, to enable comparison with permissible limits.

In our treatment of dose calculations, we shall evaluate absorbed dose in terms of MeV of energy imparted to a gram of tissue. We shall express the absorbed dose in units of rads or millirads:[1]

1 rad = $62.4 \times 10^6$ MeV per g;
1 mrad = 62,400 MeV per g.

One factor that complicates dose calculations is that the dose generally is not uniform over the body. If the radioactive material is inside the body, it may be taken up selectively in different organs and tissues. If the source of radioactivity is at a distance from the region of interest, it will have a different effect on different parts of the region, depending on their distance from the source and on attenuation of the radiation by matter between the source and the dose point.

When the dose pattern is nonuniform, we may have to exercise some judgment in making the dose evaluation. Shall we determine the maximum dose that any point gets? Suppose only a very small region gets a high dose, for

1. The concepts of absorbed dose and the rad unit are introduced in part II, section 8.

example, the region near a highly localized source of beta particles. Under these circumstances, is it more realistic to obtain an average dose over a critical region?[2]

Generally speaking, we shall be concerned with situations where it is accepted practice to average the dose over a fairly large region, say over an organ. We would not usually average over an area smaller than 1 cm², or a volume smaller than 1 cm³. We shall, however, consider examples where it is preferable, on the basis of available data, to average the dose over smaller regions. In particular, we shall discuss doses from tritiated precursors of nucleic acids that tend to concentrate in the chromosomes of cells. Here the dose is calculated by averaging the energy imparted over the volume of the nucleus rather than the whole cell. We shall, however, consider another situation involving extremely localized exposures—the dose from highly radioactive particles in the lungs—where there is little experimental or theoretical basis for averaging and interpreting the exposure.

### 1. Dose from Beta-Emitting Radionuclides inside the Body

The fact that beta particles have very short ranges in tissue, of the order of millimeters or less, simplifies considerably the calculation of the dose from beta particles emitted by radionuclides in the body. We can assume that the beta particles impart their energy essentially at the point where they are emitted. This means that the rate at which beta particle energy is imparted per gram is equal to the rate at which the energy is emitted per gram in the medium containing the radioactive material.[3]

To calculate the dose, we first determine the initial dose rate, that is, the rate at which the energy is imparted to unit mass of tissue where the radionuclide has been taken up.[4] Then we calculate the dose over a specific time interval, that is, day, month, quarter year, or the entire period the material is in the body. The calculation of the dose is complicated somewhat because in most cases the initial dose rate decreases over a period of time as a result

2. These questions are discussed in several publications of advisory committees on radiation protection. In particular, see ICRP, 1977, Publication 26, par. 32–34; ICRP, 1969, Report 14; and NCRP, 1971, Report 39, pp. 78-9. Most controlled radiation exposures are in the range where the effect is considered proportional to the dose, and under these conditions, it is justifiable to consider the mean dose over all cells of uniform sensitivity as equivalent to the actual dose distribution.

3. The rigorous definition of absorbed dose is the limit of the quotient of the energy imparted divided by the mass of the region under consideration as the mass approaches zero; that is, it refers to a value at a point. This is the sense in which it is generally used with reference to exposure from external sources of radiation, as in exposure to x rays. However, in considering internal emitters, we will use the term to refer to average doses over an extended region. It would be more precise, but also unnecessarily wordy, to continually use the term average organ dose or average whole-body dose.

4. Anatomical and physiological data for calculating doses may be found in ICRP, 1975, Report 23.

of the turnover of the radionuclide in the tissue and its physical decay. We shall first see how to calculate the initial dose rate and then how this is used to evaluate the absorbed dose over an extended period.

## 1.1   Calculating the Initial Dose Rate

The following steps are followed in calculating the initial dose rate from radioactivity in a tissue or organ:

1. Select the region where the dose rate is to be determined.

2. Determine the activity in the region, expressed in terms of $\mu$Ci. Divide by the mass of matter in the region to give the concentration in $\mu$Ci/g.

3. Determine the energy emitted per second per gram of matter. For beta emission, this also essentially equals the energy imparted per second per gram to the medium.

4. Convert to dose rate in appropriate units, for example, rad/hr or mrad/hr.

> *Example 1:* Calculate the initial dose rate to the body from the inges-
> tion of 10 mCi of tritiated water.
> Mass of region irradiated (body water): 43,000 g.
> Concentration: 10,000 $\mu$Ci/43,000 g = 0.232 $\mu$Ci/g.
> Energy emitted /sec-g: 0.232 $\mu$Ci/g × 37,000 dis/sec-$\mu$Ci
> $$\times\ 0.006\ \text{MeV/dis} = 51.5\ \text{MeV/sec-g}.$$
> Dose rate:
>
> $$\frac{51.5\ \text{MeV/sec-g}}{62,400\ \text{MeV/g-mrad}} = 0.000825\ \text{mrad/sec} = 2.98\ \text{mrad/hr}.$$

The following formula is readily derived for the dose rate due to the emis-
sion of beta particles at a constant rate (assuming the beta particle energy is locally absorbed):

$$\text{Dose rate} = 51\ CE_\beta\ \text{rad/day}. \tag{1.1}$$

$C$ = Concentration of beta emitter ($\mu$Ci/g).
$E_\beta$ = average energy (MeV) emitted per disintegration.

A concentration of 1 $\mu$Ci/g of a radionuclide that emits one beta particle per disintegration, with an average beta-particle energy of 1 MeV produces a dose rate of 51 rad/day. If only half the disintegrations resulted in beta-particle emission, and the average energy per beta particle were 0.2 MeV, the beta dose rate per day would be 51 × 1 × 0.2 × 0.5, or 5.1 rad/day.

## 1.2   Dose Calculations for a Decaying Radionuclide

If the initial dose rate remains constant, the total dose equals the product of the initial dose rate and the time interval. An initial dose rate of 3 mrad/hr will give 30 mrad in 10 hr and 300 mrad in 100 hr. For many situations,

however, the dose rate does not remain constant over the period of interest. If a radionuclide is giving off radiation, it means it is losing atoms through radioactive decay. If it is losing atoms, there are fewer remaining to decay. The less remaining, the less the rate at which they are decaying. When half the atoms have disappeared, the remaining atoms will decay at half the initial rate.

How do we calculate the total dose when the activity of a nuclide is decreasing over the period in which we are interested? We must determine the total number of disintegrations during that time period and then calculate the total dose from the total number of disintegrations in the same way we determined the initial dose rate from the initial disintegration rate. In the case of simple radioactive decay, that is, when the activity is decaying with a constant half-life, the calculation of the total disintegrations from the initial disintegration rate can be derived very simply from the analysis of basic radioactive decay relationships.

### 1.3   Some Relationships Governing Radioactive Decay

A radioactive substance is continuously losing atoms through decay and loses the same fraction of its atoms in any particular time period. Thus, if a particular radionuclide loses 10 percent of its atoms in a day, we will find it will lose 10 percent of its remaining atoms in the next day, and so on.

We call the fraction of the atoms which undergo decay per unit time the decay constant and give it the symbol $\lambda$.

$\lambda$ = decay constant.

For example, iodine-131 undergoes decay at the rate of 8.6 atoms per hundred atoms per day, or $8.6/24 = 0.36$ atoms per hundred atoms/hr. $\lambda = 0.086/\text{day} = 0.0036/\text{hr}$.

Note that 0.086/day is an instantaneous rate. If we start with 100,000 iodine atoms, they will begin to decay at the rate of $0.086 \times 100,000$ or 8600/day. This does not mean that we will have lost 8600 atoms by the end of the day. The reason is, of course, that the actual rate of loss is only 8600/day when all the 100,000 atoms are present. As the number of atoms decreases, the absolute rate of loss decreases, even though the fractional or relative rate of loss remains constant. At the end of a day, the actual number of atoms that have decayed is equal to 8300; 91,700 remain, and they decay at the rate of $0.086 \times 91,700 = 7900/\text{day}$.

We can express the fact that the number of atoms that decay per unit time is proportional to the number of atoms present in equation form:

Disintegrations/unit time = decay constant × number of atoms
 or activity

$$A \quad = \quad \lambda N$$

(Using calculus notation with disintegrations/unit time given by $dN/dt$, $dN/dt = -\lambda N$. The negative sign reflects the fact that the number of atoms decreases with time.)

If the number of atoms is doubled, the activity doubles. Halving the number of atoms halves the activity.

Since the disintegrations result in the emission of radiation that we can detect, we can determine the disintegration rate at any time by simple counting and by using suitable factors for converting counting rates to activity. If we know the activity we know the number of atoms in the sample.

$$\text{Number of atoms in sample} = \frac{\text{activity}}{\text{decay constant}}$$

$$N = \frac{A}{\lambda}$$

*Example 2:* Calculate the number of $^{131}$I atoms in a sample, if their disintegration rate is 300/min ($\lambda = 0.000060$/min).

$N = 300/0.000060 = 300/6 \times 10^{-5} = 5 \times 10^6$ atoms.

Eventually, of course, all the radioactive atoms will disintegrate. Thus $N$ gives the total number of disintegrations that will be undergone by the sample during its life.

Replacing $N$ by the total disintegrations, we can write:

$$\text{Total disintegrations} = \frac{\text{activity}}{\lambda}.$$

We can introduce a new term, the average life, $T^a$, defined by the relationship

$$\text{Total disintegrations} = \text{initial activity} \times \text{average life}$$
$$N = AT^a$$
$$T^a = 1/\lambda.$$

For $^{131}$I, $\lambda = 0.00006$/min.,

$$T^a = \frac{1}{0.00006/\text{min}} = 1.67 \times 10^4 \text{ min} = 11.6 \text{ days}.$$

An $^{131}$I solution with an initial disintegration rate of 300/min will undergo $300 \times 1.67 \times 10^4$, or $5 \times 10^6$ disintegrations before all the iodine is lost by decay.

We have already introduced the concept of half-life, $T^h$. It can be shown that the half life is 0.693 times the average life.[5]

5. If $N_0$ = number of atoms at a time $t = 0$, integration of $\frac{dN}{dt} = -\lambda N$ gives the number of atoms $N$ at any time $t$ as $N = N_0\, e^{-\lambda t}$. In one half-life ($T^h$), $N/N_0 = 0.5 = e^{-\lambda T^h}$. $T^h = -\ln 0.5/\lambda = 0.693/\lambda = 0.693\, T^a$.

$T^h = 0.693\ T^a$,
$T^a = 1.44\ T^h$,
$N = 1.44\ AT^h$.

When samples have long half-lives, it would take a long time for essentially all the disintegrations to occur. Suppose we wanted to know the number of disintegrations occurring over a short period of time, for example, in order to evaluate the dose imparted over that time.

We calculate the number of disintegrations occurring over a period of time by determining the number of atoms remaining at the end of the period and subtracting from the initial number of atoms. The number remaining equals the fraction remaining at the end of the time period times the initial number. The fraction of atoms remaining is evaluated by converting the time period to half-lives and using graphs or tables to convert from half-lives to fraction remaining (part II, table 2.4 or fig. 2.11).

There are other ways of presenting the fraction remaining versus time relationship, for example: $f = e^{-\lambda t}$, $f = e^{-0.693t/T^h}$, or $f = (1/2)^n$, where $n$ is the number of half-lives.

Note that the decay of the activity follows the same relationship as the decay of the number of atoms, since both are directly proportional to each other.

> *Example 3:* What is the fraction of $^{131}$I atoms or fractional activity remaining after 6 days?
>
> $T^h = 8.1$ days. Elapsed half-lives $= 6/8.1 = 0.74$.
> $f = 0.59$ (part II, fig. 2.11).

> *Example 4:* How many atoms of $^{131}$I in the sample of example 2 decay during the 6-day period?
> The number of atoms decayed $=$ initial number $-$ number left.
>
> $N_d = N - fN = N(1 - f)$.
>
> The initial number of atoms is $5 \times 10^6$. At 6 days, the fraction 0.59 remains, or $0.59 \times 5 \times 10^6 = 2.95 \times 10^6$ atoms.
> Atoms decayed $= 5 \times 10^6 - 2.95 \times 10^6 = 2.05 \times 10^6$. An alternate calculation is $5 \times 10^6 (1 - 0.59) = 2.05 \times 10^6$.

Since the activity is the quantity that is known rather than the number of atoms, it is more useful to write $N$ as $A\ T^a$ and the equation for the number of atoms decayed in a given time period becomes $N_d = A\ T^a\ (1 - f)$.

## 1.4 Relationships Involving Both Radioactive Decay and Biological Elimination

The loss of atoms of a radionuclide from a region may be due not only to physical decay but also to biological elimination of the nuclide from the

region.  The total rate of loss of atoms is the sum of the rates of the loss from physical decay and biological elimination.

We introduce a biological decay constant given by $\lambda_b$ and call the total fractional rate of loss by all mechanisms, the effective decay constant, $\lambda_e$.

$$\begin{array}{ccc} \text{Effective fractional} \\ \text{rate of loss} \\ \lambda_e \end{array} = \begin{array}{c} \text{Fractional rate from} \\ \text{physical decay} \\ \lambda_p \end{array} + \begin{array}{c} \text{Fractional rate from} \\ \text{biological elimination} \\ \lambda_b \end{array}$$

*Example 5:* Phosphorous-32 undergoes physical decay at the rate of 4.85 percent per day.  In addition, it is eliminated biologically at the rate of 1.44 percent per day.  What is the effective decay constant?

$\lambda_e = 0.0485 + 0.0144 = 0.0629/\text{day}.$

The total loss rate is 6.29 percent per day.

As a result of biological elimination, the effective average life of the radioactive atoms in the tissue is less than the physical average life.

Just as the physical average life, $T_p^a = \dfrac{1}{\lambda_p}$, we can write

effective average life, $T_e^a = \dfrac{1}{\lambda_e} = \dfrac{1}{\lambda_p + \lambda_b}$

effective half-life, $T_e^h = \dfrac{0.693}{\lambda_p + \lambda_b} = \dfrac{T_p^h T_b^h}{T_p^h + T_b^h}.$

For phosphorus-32:

$$T_p^a = \frac{1}{0.0485} = 20.6 \text{ days,}$$

$$T_b^a = \frac{1}{0.0144} = 69.5 \text{ days,}$$

$$T_e^a = \frac{1}{0.0629} = 15.9 \text{ days,}$$

$$T_e^h = 0.693 \times 15.9 = 11.0 \text{ days.}$$

We can now calculate the total number of disintegrations in a time period if there are both physical decay and biological elimination.  We calculate it in the same manner as we did when we had only physical decay, but use the effective average life instead of the physical average life.  Thus the total number of disintegrations that can occur in a region is given by the product of the initial activity and the effective average life of the activity in the region.

*Example 6:* The initial disintegration rate of a phosphorous-32 sample is 10,000 per minute.  Calculate the total number of disintegrations expected.

Initial disintegration rate, expressed as disintegrations per day
$$= 1440 \times 10{,}000 = 1.44 \times 10^7.$$
Total disintegrations $= 15.9 \times 1.44 \times 10^7 = 22.9 \times 10^7.$

The number of disintegrations over a specific time interval is given by the product of the total disintegrations for complete decay times the fraction of the total that occurs during the time interval.   The fraction that occurs is determined by subtracting the fraction of atoms remaining from 1.

Disintegrations $=$ Initial Activity $\times T_e^a \times (1 -$ fraction remaining).

The fraction remaining is calculated using the effective decay constant, or the number of effective half-lives elapsed during the period of interest.

*Example 7:* If the initial activity of $^{32}$P is 10,000 dis/min, how many disintegrations would occur in 31 days?

$T_e^h = 11.0$ days, so number of effective half-lives $= 31/11.0 = 2.82$.
From fig. 2.11, the fraction remaining $= 0.14$.
Disintegrations in 31 days $= 22.9 \times 10^7 (1 - 0.14) = 19.7 \times 10^7.$

## 1.5   Absorbed Beta Dose over a Period of Time

The disintegrations evaluated in section 1.4 are accompanied by radiations that are responsible for the dose to the patient over the period of interest. Since the dose and disintegrations are directly related to each other, the same formula can be used to calculate total dose as was used to calculate total disintegrations by merely substituting initial dose rate for initial disintegration rate.

*Example 8:* Suppose the initial dose rate to the bone marrow from phosphorous-32 is calculated to be 100 mrad/hr.   What is the dose imparted in 31 days?

The initial dose rate $= 100 \times 24 = 2400$ mrad/day.
The total dose $=$ Initial dose rate $\times T_e^a,$
$$= 2400 \text{ mrad/day} \times 15.9 \text{ days} = 38{,}200 \text{ mrad}.$$
The dose in 31 days $= 38{,}200 (1 - 0.14) = 32{,}900$ mrad $= 32.9$ rads.

The following formula for the beta dose in a given time is readily derived:[6]
$$D = 73.8 \, C \, E_\beta T_e^h \, (1 - f). \tag{1.2}$$

$D =$ absorbed dose in rads,
$C =$ concentration in $\mu$Ci/g,
$E_\beta =$ average beta energy per disintegration in MeV,
$T_e^h =$ effective half-life in days,
$f =$ fraction remaining at end of time period.

6. The factor 73.8 comes from multiplying $3.20 \times 10^9$ (dis/day per $\mu$Ci) $\times 1.44$ (conversion from half-life to average life) $\times \dfrac{1}{62.4 \times 10^6}$ (conversion from MeV/g to rad).

When radioactive substances follow complex pathways in the body, it may not be possible to describe the variations in regions of interest in terms of a single half-life.   Sometimes the variation can be approximated as the sum of two or more components, each decaying with a characteristic half-life, and it is still possible to use the equations given in this section (see section 5.5).   If the simple decay relationships do not apply, however, it may be necessary to obtain detailed data on the accumulation and elimination as a function of time, and from these data to determine the total number of disintegrations during the period of interest (Smith, Brownell, and Ellett, 1968), and hence the dose (see section 5.2).

## 2.   A Closer Look at the Dose from Beta Particles

Our treatment of beta dose from a source distributed in tissue was based on local absorption of the beta particle energy averaged over the tissue in which the beta particles were emitted.   We did not need to concern ourselves with the specific details of the distribution of the source and the penetration of the beta particles after emission.   However, there are instances where the manner in which the beta particles impart their dose after emission from a source must be considered for a proper evaluation of the dose.   Examples of cases requiring such analysis include the use of beta plaques for radiotherapy and the evaluation of injury from irradiation of the skin from contamination deposited on it.

### 2.1   Beta Particle Point Source Dose Functions

The dose from beta particle sources may be evaluated with the use of basic equations known as beta particle point source dose functions.   These functions give the dose as a function of distance from a point source of beta particles.   They are derived either by experimental or by theoretical methods.   The general equations are quite complex and are given by Hine and Brownell (1956).   With these dose functions, one can determine the dose distribution from any arbitrary source configuration.

### 2.2   Evaluation of Beta Particle Dose from the Fluence and Stopping Power

Dose calculations are often made by first evaluating a quantity known as the fluence.   The fluence at a point irradiated by a beam of particles is calculated by dividing the total number of particles in the beam by its cross-sectional area.   If, at the point of interest, beams of particles are incident from many directions, then the fluence must be evaluated for each direction separately, and the results summed.

> *Example 9:* Particles are incident upon a point from three different directions, as illustrated.   Beam A has a cross-sectional area of 5 cm² and consists of a total of 1000 particles.   Beam B has a cross-sectional

area of 2 cm² and consists of a total of 500 particles. Beam C has a cross-sectional area of 1 cm² and consists of a total of 100 particles. What is the fluence at point *P*?

The fluence is 1000/5 contributed by A, + 500/2 contributed by B, + 100 contributed by C, or 550 particles/cm².

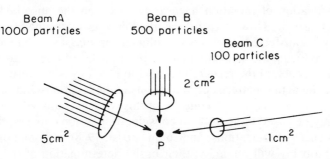

Beam A
1000 particles

Beam B
500 particles

Beam C
100 particles

2 cm²

5 cm²

1 cm²

P

Note that the fluence refers to an accounting of particles over a period of time. Frequently, we are concerned with irradiation per unit time, in which case we use a quantity known as the flux density. The flux density at a point is the number of particles passing per unit time, per unit area of the beam. For example, if the 1000 particles carried by Beam A pass a point in 2 seconds, then the flux density is $1000/(5 \times 2)$, or 100 per cm² per second. The calculation of the flux density at various distances from a point source is described in section 3.2.2.

If the fluence is multiplied by the rate at which the particles impart energy per centimeter of travel through the medium, the result is the energy imparted per unit volume. If the energy imparted per unit volume is divided by the density, the result is the energy imparted per unit mass, or the absorbed dose. The rate at which beta particles lose energy per unit distance in a medium is called the stopping power. For the energies emitted by beta particle sources, almost all of the stopping power is due to ionization and excitation. The stopping power may also result from loss of energy by radiation, but this occurs to an appreciable degree only for electrons at higher energies, such as are attained in accelerators.

*Example 10:* The linear stopping power for 1 MeV electrons in water is 1.89 MeV/cm.[7] What is the dose at the point where a beam of 1 MeV electrons enters a water medium, if the beam contains 10,000 electrons/cm² (that is, fluence = 10,000/cm²)?

The initial rate of loss by the electrons in 1 cm² of the beam is

7. At a rate of loss of 1.89 MeV/cm, a 1 MeV particle would travel a distance of 1/1.89 cm before coming to rest if the value of the stopping power remained constant as the energy of the particle decreased. The distance traveled is less than this value, since the stopping power increases as the particle slows down.

10,000 × 1.89 = 18,900 MeV/cm. The energy lost per unit volume at the point of incidence is 18,900 MeV/cm³. The energy imparted per gram (obtained by dividing by the density of 1 g/cm³) = 18,900/1 = 18,900 MeV/g. The absorbed dose in mrad = 18,900/62,400 = 0.302.

The evaluation of radiation hazards is based on the absorbed dose for practical reasons. However, the absorbed dose is determined by averaging the energy transferred over gross volumes or masses, while the actual damage-producing mechanisms involve the transfer of energy to individual molecules. Much of the research in radiation biology is concerned with determining the actual patterns of ionizations and excitations and interpreting their significance. As a consequence of this work, the analysis of radiation effects may be based ultimately on consideration of ion clusters, delta rays, time sequences of ionizations, and so on (Rossi, 1968), although operational surveys probably will retain, as their basis, determination of the mean energy imparted per gram of tissue.

### 3.   Calculation of the Absorbed Dose from Gamma Emitters in the Body

In considering the dose from beta emitters distributed uniformly throughout an organ, we were able to assume that the energy carried by the beta particles was locally absorbed, because of their short range. As a result, if we knew the energy released per gram, we could equate this to the energy absorbed per gram, and thus calculate the absorbed dose.

When we deal with gamma photons, the situation is different. The photons are indirectly ionizing, in contrast to the directly ionizing beta particles. Upon leaving a nucleus, they travel in a straight line without any interaction until there is a collision with an atom or one of its external electrons. No matter what distance is considered, there is a finite probability that a photon can travel that distance without making a collision, but the probability is less as the amount of material in the path of the photon increases. On the average, the distance traveled by gamma photons in tissue before their first collision is measured in centimeters.

The collision of the photon gives rise to an energetic electron that actually imparts the dose to the tissue and that, because of its short range, is considered as locally absorbed.

### 3.1   Dose Rate from a Point Source of Photons—The Specific Dose-Rate Constant for Tissue

Calculation of the dose within the body from gamma emission throughout the body is more complicated that that for beta particles because the dose is imparted over an extended distance from the source. The dose to tissue at a given point depends on both the distance to the source and the attenuation in the intervening medium. If we exclude the attenuation factor, we can write

for the dose rate from a point source of gamma photons an expression of the form

$$DR = \Gamma_{tis}\, A/r^2 \tag{3.1}$$

where we shall denote $\Gamma_{tis}$ as the specific dose rate constant for tissue.[8]  $A$ is the activity of the source, and $r$ is the distance.

The point source, to which the equation above applies, is, of course, a mathematical idealization.  All actual sources have finite dimensions.  The "point source" equation applies to a source when the relative distances to various parts of the source from the dose point of interest do not vary appreciably, and attenuation within the source is negligible.  A few milliliters of radioactive liquid in a test tube may for all practical purposes be considered a point source if the dose is to be evaluated 10 cm from the test tube.  On the other hand, if the test tube is being held in the hand, the contributions to the dose to the fingers vary greatly for different parts of the source.  When it is possible to represent sources of radiation as point sources, the calculations are simplified considerably.

### 3.2   Evaluation of the Specific Dose Rate Constant

The constant $\Gamma$ for use in the equation above is determined by calculating the absorbed dose rate for the flux density of photons produced at a distance of 1 cm from a source which has an activity of 1 mCi.

### 3.2.1   Calculation of the Absorbed Dose Rate from the Flux Density

Consider a beam of gamma photons incident on tissue.  Let us mark out at the surface an area of 1 cm² perpendicular to the beam and assume 100 photons of energy equal to 1 MeV are crossing the area per second.

These photons will impart to the medium a fraction of their energy per unit distance as they travel through, about 3 percent per centimeter in soft tissue.

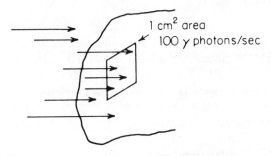

1 cm² area
100 γ photons/sec

8. The specific dose-rate constant, when dose units are expressed in rad to soft tissue, is only 3 percent less than the specific gamma ray constant ($\Gamma$), which gives the exposure in roentgens. The data in the literature are generally for the specific gamma ray constant, since this is defined for interactions in air, which can be more precisely defined than tissue. However, for purposes of numerical calculations in radiation protection, both constants may be used interchangeably. Elementary examples on the use of $\Gamma$ were given in part II, section 13.2.

Thus, the energy imparted in a region of cross section 1 cm² and 1 cm deep, that is to a volume of 1 cm³, is $100/\text{cm}^2\text{-sec} \times 1.0$ MeV $\times 0.03/\text{cm} = 3.0$ MeV/cm³-sec. Since the density is 1 g/cm³, the energy imparted per gram is $\dfrac{3 \text{ MeV/cm}^3\text{-sec}}{1 \text{ g/cm}^3} = 3$ MeV/g-sec. The absorbed dose rate is $\dfrac{3 \text{ MeV/g-sec} \times 3600 \text{ sec/hr}}{62{,}400 \text{ MeV/g-mrad}} = 0.172$ mrad/hr.

If the energy per photon had been twice as great, the dose rate from the 100 photons/cm²-sec would also have been twice as great, or 0.344 mrad/hr. The dose rate due to 100 photons/cm²-sec of energy E per photon is 0.172 E mrad/hr.

Let us designate the number of photons per square centimeter per second as $\phi$. The dose rate is equal to $\dfrac{0.172 \; \phi \; E}{100} = 0.00172 \; \phi \; E$ mrad/hr.

The quantity $\phi$ is the flux density (introduced in section 2.2). The fraction of the incident energy locally absorbed per centimeter is called the energy-absorption coefficient, $\mu_{en}$.[9] The mass energy-absorption coefficient, $\mu_{en}/\rho$, is obtained by dividing the energy-absorption coefficient by the density.[10] The product of $\mu_{en}/\rho$, $\phi$ and E gives the energy locally absorbed per unit mass per unit time. Detailed tables have been prepared giving the values of $\mu_{en}/\rho$ in various media (Evans, 1968; Jaeger, 1968).

*Example 11:* What is the energy absorbed per gram per second and the resultant dose rate in muscle from a flux density of 100 gamma photons/cm²-sec with photon energy equal to 2 MeV? ($\mu_{en}/\rho = 0.0257$ cm²/g).

The rate of energy absorption $= 0.0257 \times 100 \times 2$
$\qquad\qquad\qquad\qquad\qquad = 5.14$ MeV/g-sec.

The absorbed dose rate $= \dfrac{5.14 \times 3600}{62{,}400} = 0.296$ mrad/hr.

While the example here is for photons all traveling in the same direction, regions exposed to radiation are usually irradiated from many directions (as discussed in section 2.2). One way of determining the flux density in a region is to imagine a sphere is present with a cross-sectional area of 1 cm². Then the flux density is equal to the number of particles crossing the surface of the sphere per second. (If the sphere were applied to the figure in section

9. Compare to the attenuation coefficient, which gives the fraction (or probability) of photons interacting per unit distance (see part II, section 5.2).

10. The *mass energy-absorption* coefficient excludes energy carried by Compton-scattered, fluorescence, annihilation, and bremsstrahlung photons as locally absorbed. The *mass energy-transfer* coefficient excludes all of these except bremsstrahlung photons. The *mass absorption* coefficient excludes Compton-scattered photons only.

2.2, the unit areas of the beams shown would correspond to sections of the sphere through its center that were oriented perpendicular to the directions of the beams).

### 3.2.2 Calculation of Flux Density from the Activity and Distance

The flux density at a distance from a point source can be calculated very simply in the absence of attenuation, since the photons are emitted with equal intensity in all directions and travel in straight lines from the source. To evaluate the flux density at a distance $r$, we imagine a spherical surface of radius $r$ around the source (fig. 3.1). This surface has an area of $4\pi r^2$, which is irradiated uniformly by the photons emitted from the source. Thus, if the source strength $S$ is defined as the number of photons emitted per second, the photons penetrating through unit area per second is $S/4\pi r^2$. When the activity of the source (disintegrations per unit time) is given, the number of photons resulting from one disintegration must be determined before the strength can be calculated.

*Example 12:* What is the flux density at 1 and 5 cm from a millicurie source of $^{131}$I?

The photon emission from iodine-131 appears as

0.364 MeV gammas in 80 percent of the disintegrations,
0.638 MeV gammas in 8 percent of the disintegrations.

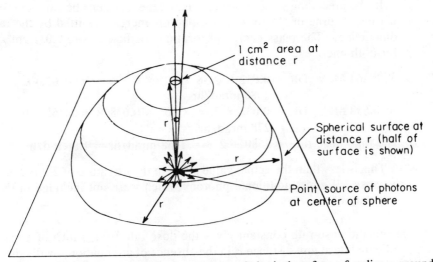

**Fig. 3.1** Illustration of inverse square law. Spherical surface of radius $r$ around source has area of $4\pi r^2$. Number of photons passing through 1 cm$^2$ of surface per second (flux density) equals number emitted per second divided by $4\pi r^2$ and thus varies as $1/r^2$.

The source strength is equal to

$3.7 \times 10^7/\text{sec-mCi} \times 0.8$
$$= 2.96 \times 10^7 \text{ photons/sec of } 0.364 \text{ MeV energy,}$$
$3.7 \times 10^7 \times 0.08 = 2.96 \times 10^6 \text{ photons/sec of } 0.638 \text{ MeV energy.}$

The flux density at 1 cm is equal to

$$\frac{2.96 \times 10^7}{4\pi(1)^2} = 2.36 \times 10^6 \frac{\text{photons}}{\text{cm}^2\text{-sec}} \text{ at } 0.364 \text{ MeV,}$$

$$\frac{2.96 \times 10^6}{4\pi(1)^2} = 2.36 \times 10^5 \frac{\text{photons}}{\text{cm}^2\text{-sec}} \text{ at } 0.638 \text{ MeV.}$$

The flux density at 5 cm is 1/25 the flux density at 1 cm and is equal to $9.4 \times 10^4/\text{cm}^2\text{-sec}$ at 0.364 MeV and $9.4 \times 10^3/\text{cm}^2\text{-sec}$ at 0.638 MeV.

### 3.2.3    Conversion from the Flux Density to the Specific Dose-Rate Constant

To calculate the specific dose-rate constant for tissue, $\Gamma_{tis}$, we need to determine the flux density at a distance of 1 cm from a 1 mCi source and then convert to dose rate by the method shown in section 3.2.1.

*Example 13:* Calculate $\Gamma_{tis}$ for $^{131}$I.

In the preceding section, we calculated the flux densities at 1 cm for a 1 mCi source of $^{131}$I for the two photon energies emitted by the radionuclide. The mass energy-absorption coefficients are 0.032 cm²/g for both energies.

At 0.364 MeV, DR $= 0.032 \times 2.36 \times 10^6 \times 0.364 \times 3600/62,400$
$$= 1580 \text{ mrad/hr.}$$
At 0.638 MeV, DR $= 0.032 \times 2.36 \times 10^5 \times 0.638 \times 3600/62,400$
$$= 278 \text{ mrad/hr.}$$
The total dose rate $= 1580 + 278 = 1858 \text{ mrad/hr} = 1.86 \text{ rad/hr.}$

This is less than the actual value given in the literature of 2.2 rad/hr, because $^{131}$I emits additional photons which were not included in the calculation.

The specific dose-rate constant gives the dose rate from 1 mCi of a specific radionuclide at any distance $r$, in the absence of attenuation, by dividing by $r^2$. In any specific instance, attenuation of the radiation in the medium is usually significant and can be evaluated by the methods presented in part II, section 5.3.

## 3.3   Dose from Distributed Gamma Sources by the Geometrical Factor Method

When we cannot consider the gamma source as a single point source, for example, when we must calculate the dose from a gamma emitter distributed throughout the body, we must divide the larger source into smaller sources, each of which can be considered as a point source.  Ideally, the source should be divided into infinitesimally small elements and the dose evaluated by means of the calculus.  For all but the simplest geometries, the resultant equations become too difficult to solve and subdivisions are established on a larger scale.  To minimize the computational effort required, the subdivisions increase.

Calculations of the dose imparted within a region, for a source distributed uniformly throughout the region, have been made for a variety of simple geometries.  The results are presented in terms of a quantity called the geometrical factor, $g$.  The geometrical factor takes into account the effects of both distance and energy absorption on the intensity of gamma photons as they penetrate the medium.  The absorbed dose rate is given by the product of the activity per unit volume, the specific dose-rate constant and the geometrical factor.  The value of the specific gamma ray constant, $\Gamma$, may be used in place of the specific dose rate constant, $\Gamma_{tis}$, since it is only about 3 percent greater.  Hence we shall drop the subscript of $\Gamma_{tis}$ in the notation.

In terms of units generally used:

Dose rate in rad/hr = 0.001 $C \rho \Gamma g$,

where $C$ is concentration in $\mu$Ci/g,

$\rho$ is density in g/cc,

$\Gamma$ is in $\dfrac{\text{rad-cm}^2}{\text{hr-mCi}} \left( \text{or } \dfrac{\text{R-cm}^2}{\text{hr-mCi}} \right)$,

$g$ is in cm.

The gamma dose rate will vary over different parts of the source.  It will be larger within the source than near the surface.  Values of $g$ are therefore calculated to give dose rates at various points of interest.  For example, for a spherical source, $g$ values may be given for the center and the surface.  From a radiation-protection point of view, the average dose rate to the region is also of interest, and this is calculated from an average $g$ value.[11]  The calculation of $g$ values is discussed in Hine and Brownell (1956).  Some values of

---

11. It is not difficult to show that, if attenuation of photons is neglected, $g$ for the center of a sphere of radius $r$ is $4\pi r$.  It is $2\pi r$ at the surface and the average value through the sphere is $3\pi r$.

**Table 3.1.** Average geometrical factor, $\bar{g}$ (cm) for γ-ray emitter uniformly distributed in total body tissues.

| Weight (kg) | Height (cm) | | | | | | |
|---|---|---|---|---|---|---|---|
| | 200 | 190 | 180 | 170 | 160 | 150 | 140 |
| 100 | 138 | 139 | 142 | 145 | 147 | 150 | 154 |
| 90 | 134 | 136 | 138 | 140 | 143 | 146 | 148 |
| 80 | 129 | 130 | 131 | 134 | 136 | 139 | 141 |
| 70 | 123 | 124 | 125 | 126 | 129 | 131 | 135 |
| 60 | 117 | 118 | 119 | 120 | 122 | 125 | 128 |
| 50 | 112 | 113 | 114 | 116 | 117 | 119 | 122 |
| 40 | 102 | 104 | 105 | 106 | 108 | 109 | 110 |

*Source:* Hine and Brownell, 1956, p. 858.

the average geometrical factor for the whole body and for cylinders are given in tables 3.1 and 3.2.

> *Example 14:* What is the average initial gamma dose rate to the body of a 70-kg man, 170 cm tall, administered 500 μCi of sodium-24 intravenously?
>
> Sodium-24 ($T^h$ = 15 hr) gives off one 1.37 MeV and one 2.75 MeV gamma photon per disintegration. $\Gamma$ = 18.1 rad/hr-mCi at 1 cm. $\bar{g}$ for the size of the subject is 126. Assuming the 500 μCi are distributed

**Table 3.2.** Average geometrical factor, $\bar{g}$ (cm) for cylinders containing a uniformly distributed γ-ray emitter.

| Length of cylinder (cm) | Radius of cylinder (cm) | | | | | | |
|---|---|---|---|---|---|---|---|
| | 1 | 2 | 3 | 5 | 10 | 20 | 30 |
| 2 | 6.5 | 11.7 | 15.7 | 21.6 | 25.2 | 30.5 | 35.4 |
| 5 | 10.6 | 18.8 | 25.6 | 36.0 | 48.5 | 62.6 | 73.0 |
| 10 | 12.7 | 23.6 | 33.0 | 47.1 | 70.2 | 94.0 | 109 |
| 20 | 14.2 | 26.7 | 38.0 | 56.3 | 89.6 | 127 | 147 |
| 30 | 14.5 | 27.6 | 39.7 | 59.9 | 98.8 | 144 | 172 |
| 40 | 14.8 | 28.2 | 40.7 | 62.4 | 103 | 156 | 187 |
| 60 | 14.8 | 28.7 | 41.7 | 65.6 | 109 | 171 | 206 |
| 80 | 14.8 | 28.8 | 42.1 | 65.8 | 112 | 176 | 214 |
| 100 | 14.8 | 29.2 | 42.5 | 66.2 | 114 | 179 | 218 |

*Source:* Focht, Quimby, and Gershowitz, 1965, p. 151. Absorption coefficient assumed equal to 0.028 cm⁻¹.

uniformly throughout the mass of the subject, we obtain:

$$\text{Initial dose rate} = 0.001 \times \overset{C}{\underset{70,000}{\frac{500}{}}} \times \overset{\rho}{1} \times \overset{\Gamma}{18.1} \times \overset{g}{126},$$

$$= 0.0163 \text{ rad/hr.}$$

The dose over a period of time can be obtained in the same manner as for beta particles by the methods given in section 1.5. We must multiply by the effective average life and the factor $(1 - \text{fraction remaining})$.

Dose in given time = Initial dose rate × Effective average life
× $(1 - \text{fraction remaining})$.

The following equation is readily derived for the dose in a given time. Note the effective average life has been replaced by the effective half-life in days.

$$D = 0.0346 \ g \cdot C \cdot \rho \cdot \Gamma \cdot T_e^h \cdot (1 - f)$$

$$\text{rads} \qquad \text{cm} \quad \frac{\mu\text{Ci}}{g} \quad \frac{g}{cc} \quad \frac{\text{rad-cm}^2}{\text{hr-mCi}} \quad \text{days.} \tag{3.2}$$

*Example 15:* What is the gamma dose imparted in 7 days from the $^{24}$Na given in the previous example?

Half-lives = 168/15 = 11.2.
Fraction remaining = 0.000425.
Effective average life = Physical average life = 1.44 × 15.0 = 21.6 hr.
Dose imparted = 0.0163 × 21.6 × (1 − 0.000425),
= 0.352 rad.

Using the alternate formula,

$$D = 0.0346 \times \overset{g}{126} \times \overset{C}{\underset{70,000}{\frac{500}{}}} \times \overset{\rho}{1} \times \overset{\Gamma}{18.1} \times \overset{T_e^h}{0.625} \times (1 - 0.000425),$$

$$= 0.352 \text{ rad.}$$

### 3.4  The Absorbed-Fraction Method—Dose within the Source Volume

Gamma-dose equations are more complex than beta-dose equations because most of the emitted gamma energy is absorbed at some distance from the source. However, if the dose points of interest are within the source volume, it is possible to adapt the methods and equations for beta dose to evaluate gamma dose by introducing a correction factor known as the absorbed fraction, $\phi$. This factor gives the fraction of the gamma energy emitted by the source that is absorbed within the source. It is specific for the source geometry, photon energy, and source material. A calculation of gamma dose

by the absorbed fraction method proceeds by first assuming that all the gamma energy emitted by the source is absorbed within the source.   The dose is calculated as for beta particles, and the results are multiplied by the absorbed fraction to correct for the gamma energy that is not absorbed within the source.   The concept of absorbed fraction was developed to provide medical investigators with a simple method for gamma-dose calculations. Values of absorbed fractions have been calculated for a large variety of radio-nuclides and organs (Snyder et al., 1969).

Referring to equation 1.2 for beta dose in section 1.5, we can convert it to an equation for gamma dose by replacing $E_\beta$ by $E_\gamma n_\gamma \phi$ where $n_\gamma$ is the mean number of photons of energy $E_\gamma$ emitted per disintegration, and $\phi$ is the absorbed fraction.   When photons of several energies are emitted, the con-tributions are summed (see example 17).   Thus,

$$\begin{matrix} \text{D} & = 73.8 \cdot & C & \cdot E_\gamma \cdot n_\gamma \cdot \phi \cdot T_e^h \cdot (1-f) \\ \text{rads} & & \dfrac{\mu\text{Ci}}{\text{g}} & \text{MeV} \qquad\quad \text{days} \end{matrix}$$

(3.3)

*Example 16:* Calculate the gamma dose imparted in 7 days from an intravenous injection of 500 $\mu$Ci $^{24}$Na in a 70-kg man.

The dose contributions must be calculated separately for the 1.37 and 2.75 MeV photons emitted for each disintegration.   By linear ex-trapolation of the data of Snyder et al. (1969) we determine absorbed fractions of 0.307 for 1.37 MeV photons and 0.268 for 2.75 MeV photons. The effective half-life is 0.625 days, and the term $(1-f)$ is close to 1 for a 7-day dose.

The dose in rads is:

$$\overset{C}{\overset{\displaystyle E_{\gamma 1}\quad \phi_1 \qquad E_{\gamma 2}\quad \phi_2 \qquad T_e^h}{}}$$

$$73.8 \times \frac{\overset{C}{500}}{70,000} \times [\overset{E_{\gamma 1}}{1.37} \times \overset{\phi_1}{0.307} + \overset{E_{\gamma 2}}{2.75} \times \overset{\phi_2}{0.268}] \times \overset{T_e^h}{0.625}$$

$$\times \overset{f}{(1 - 0.000425)} = 0.381 \text{ rad.}$$

This is within 10 percent of the value calculated previously by the geometrical factor method.

## 3.5   Dose to Targets outside the Source Volume by the Absorbed-Fraction Method

The absorbed-fraction concept may also be applied to evaluating the dose to organs external to the region where the source is localized.   In this case the absorbed fraction is defined as

$$\phi = \frac{\text{photon energy absorbed by target}}{\text{photon energy emitted by source}} \cdot$$

To calculate the dose in a target removed from the source, we multiply the photon energy emitted from the source by the absorbed fraction and divide by the mass of the target. The dose equation then becomes:

$$D = 73.8 \cdot \frac{\text{Source Activity}}{\text{Target Mass}} \cdot E_\gamma \cdot n_\gamma \cdot \phi \cdot T_e^h \cdot (1 - f)$$

$$\text{rads} \qquad \frac{\mu\text{Ci}}{\text{g}} \qquad \text{MeV} \qquad \text{days} \qquad\qquad (3.4)$$

The contributions at each photon energy must be summed.

*Example 17:* Calculate the dose to the vertebral marrow from 10 $\mu$Ci of $^{131}$I in the thyroid.

We use values of absorbed fractions calculated for a mathematical model of the spine (treated as an elliptical cylinder, length 56.5 cm, volume 887.5 cm$^3$, density 1.5 g/cm$^3$, mass 1331 g (Snyder et al., 1969).

The calculation for the various photon energies (Dillman, 1969) emitted from $^{131}$I atoms proceeds as follows:

| Photon energy | Mean number/ disintegration | Absorbed fraction[12] | $E_\gamma \cdot n_\gamma \cdot \phi \cdot 10^7$ |
|---|---|---|---|
| 0.03 | 0.047 | 0.00255 | 36 |
| .080 | .017 | .0099 | 135 |
| .284 | .047 | .0060 | 802 |
| .364 | .833 | .00578 | 17500 |
| .637 | .069 | .0052 | 2310 |
| .723 | .016 | .0052 | 603 |
| | | | 21386 |

The total absorbed energy is 0.00214 MeV.

The gamma dose to the spine $= 73.8 \times \dfrac{10}{1331} \times 0.00214 \times 7.2$,

$$= 0.00859 \text{ rad} = 8.59 \text{ mrad}.$$

### 3.6 Use of the Equilibrium Dose Constant—Computer-Generated Source Output Data

When sources emit primarily beta particles and high-energy gamma photons, it is usually possible to calculate doses directly from the data given in decay schemes. However, in the case of radionuclides that emit low-energy gamma rays or decay by electron capture, the radiations emitted in significant numbers from the source may result from several complex processes, including

12. Obtained by plotting and drawing curve through values of absorbed fractions given by Snyder et al., 1969.

internal conversion, x-ray emission, Auger electrons, and so on. The contributions from these sources can be evaluated only by extensive calculations. Fortunately, the required calculations have been made for most of the radionuclides of interest in nuclear medicine (Dillman, 1969). The output data obtained with digital computers include a listing of each particle emitted from the atom, the mean number per disintegration, the mean energy per particle, and an equilibrium dose constant, $\Delta$. The equilibrium dose constant gives the dose rate in rad/hr for a concentration of 1 $\mu$Ci/g on the assumption that all the emitted energy is locally absorbed. An example of the input and output data for Technetium-99m is given in table 3.3.

The particles listed in the output data are divided into nonpenetrating and penetrating radiations. The doses from the nonpenetrating radiations are evaluated as for beta particles while the doses from the penetrating radiations are determined by the absorbed-fraction or geometrical factor methods.

The dose equation for nonpenetrating radiation is

$$D_{NP} = 1.44 \cdot C \cdot \Delta \cdot T_e^h \cdot (1 - f)$$

$$\text{rads} \qquad \frac{\mu Ci}{g} \quad \frac{\text{g-rad}}{\mu Ci\text{-hr}} \quad \text{hr.} \tag{3.5}$$

The equation for doses within a source of penetrating radiation is

$$D = 1.44 \cdot C \cdot \Delta \cdot \phi \cdot T_e^h \cdot (1 - f)$$

$$\frac{\mu Ci}{g} \quad \frac{\text{g-rad}}{\mu Ci\text{-hr}} \quad \text{hr.} \tag{3.6}$$

The equation for doses external to a source of penetrating radiation is

$$D = 1.44 \cdot \frac{\text{Source activity}}{\text{Target mass}} \cdot \Delta \cdot \phi \cdot T_e^h \cdot (1 - f)$$

$$\frac{\mu Ci}{g} \quad \frac{\text{g-rad}}{\mu Ci\text{-hr}} \quad \text{hr.} \tag{3.7}$$

*Example 18:* Repeat the calculation in example 17 of the dose to the spine from 10 $\mu$Ci of $^{131}$I in the thyroid using the equilibrium dose constant.

The equilibrium dose constant (Dillman, 1969) is multiplied by the appropriate absorbed fraction (Snyder et al., 1969) for each photon energy and the products are summed to give $\Sigma \Delta_i \phi_i = 0.0046$. The dose to the spine is calculated from equation 3.7 (note the half-life is expressed in units of hours)

$$D = 1.44 \times \frac{10}{1331} \times 0.0046 \times 7.2 \times 24,$$

$$= 0.00859 \text{ rad.}$$

The result is identical to the value calculated in example 17.

**Table 3.3.** Equilibrium dose constants and energies of radiation emitted from technetium-99m (half-life = 6 hr).

| | Input Data | |
|---|---|---|
| Radiation | %/disintegration | Transition energy (MeV) |
| Gamma-1 | 98.6 | 0.0022 |
| Gamma-2 | 98.6 | 0.1405 |
| Gamma-3 | 1.4 | 0.1427 |

| | Output Data | | |
|---|---|---|---|
| Radiation (i) | Mean number/ disintegration ($n_i$) | Mean energy (MeV) ($\overline{E_i}$) | $\Delta_i$ ($\frac{\text{g-rad}}{\mu\text{Ci-hr}}$) |
| Gamma-1 | 0.000 | 0.0021 | 0.0000 |
| M int. con. electron, gamma-1 | .986 | .0017 | .0036 |
| Gamma-2 | .883 | .1405 | .2643 |
| K int. con. electron, gamma-2 | .0883 | .1195 | .0225 |
| L int. con. electron, gamma-2 | .0109 | .1377 | .0032 |
| M int. con. electron, gamma-2 | .0036 | .1401 | .0011 |
| Gamma-3 | .0003 | .1427 | .0001 |
| K int. con. electron, gamma-3 | .0096 | .1217 | .0025 |
| L int. con. electron, gamma-3 | .0030 | .1399 | .0009 |
| M int. con. electron, gamma-3 | .0010 | .1423 | .0003 |
| K $\alpha$-1 x rays | .0431 | .0184 | .0017 |
| K $\alpha$-2 x rays | .0216 | .183 | .0008 |
| K $\beta$-1 x rays | .0103 | .0206 | .0005 |
| K $\beta$-2 x rays | .0018 | .0210 | .0001 |
| L x rays | .0081 | .0024 | .0000 |
| KLL Auger electron | .0149 | .0155 | .0005 |
| KLX Auger electron | .0055 | .0178 | .0002 |
| KXY Auger electron | .0007 | .0202 | .0000 |
| LMM Auger electron | .106 | .0019 | .0004 |
| MXY Auger electron | 1.23 | .0004 | .0010 |

*Source:* Dillman, 1969, supplement no. 2.

### 3.6.1 Use of SI Units in Dose Calculations

The International Commission on Radiation Units and Measurements (ICRU) is encouraging the use of SI units (Bq, kg, Gy) in absorbed-dose calculations, claiming an improved consistency and simplicity as compared to the use of the traditional ($\mu$Ci, g, rad) units (ICRU, 1979). The use of the two

sets of units is compared here through a calculation of the dose to the liver from the intravenous administration of $^{99m}$Tc sulphur colloid, a procedure used for liver scans.  The typical activity administered to an adult is 3 mCi or 111 MBq (table 3.10).  Assume that 85 percent is localized quickly in the liver with an effective half-life (equal to the physical half-life) of 6 hr.  The SI quantity corresponding to the equilibrium dose constant (g-rad/$\mu$Ci-hr) used previously is the mean energy of radiation per nuclear transformation (kg-Gy/Bq-sec).  Both quantities have the same symbol, $\Delta$, which is written as $\Delta_i$ when applied to the $i$th particle type emitted.  The calculation proceeds with either system of units by listing the energies, determining the total number of disintegration over the dose period of interest and the energy imparted per unit mass.  The reference activity is 1 $\mu$Ci or 1 Bq.  The physical data for $^{99m}$Tc are given in table 3.3; they may be simplified by combining the data for the nonpenetrating radiation and omitting penetrating radiation that makes a negligible contribution.  The dose from sources outside the liver is not significant.

The calculation is set up as follows:

1. Physical properties of radiation

| Radiation type | Energy, $E_i$ (Joule) | Energy $E_i$ (MeV) | $\Delta_i$ (g-rad/$\mu$Ci-hr) | Fraction of disintegrations ($n_i$) | Absorbed fraction, liver, $\phi_i$ |
|---|---|---|---|---|---|
| $\gamma$ | $2.25 \times 10^{-14}$ | 0.140 | 0.263 | 0.879 | 0.162 |
| $K_\alpha$ x ray | $2.9 \times 10^{-15}$ | .018 | .0025 | .066 | .82 |
| $K_\beta$ x ray) | $3.3 \times 10^{-15}$ | .021 | .0005 | .011 | .78 |
| nonpenetrating | | | .037 | | |

2. Energy absorption rate per unit activity

| Radiation type | $E_i n_i \phi_i$ (J/Bq-sec) | $\Delta_i \phi_i$ (g-rad/$\mu$Ci-hr) |
|---|---|---|
| $\gamma$ | $3.2 \times 10^{-15}$ | 0.0426 |
| $K_\alpha$ x ray | $1.6 \times 10^{-16}$ | 0.002 |
| $K_\beta$ x ray | $2.9 \times 10^{-17}$ | 0.0004 |
| nonpenetrating | $2.77 \times 10^{-15}$ | 0.037 |
| $\Sigma$ | $6.16 \times 10^{-15}$ | 0.082 |

3. Absorbed dose
   (*a*) Time integral of activity, $\bar{A}$.
      SI:  $(1 \times 0.85)$ Bq $\times 1.44 \times 6$ hr $\times 3600$ sec/hr $= 2.64 \times 10^4$ Bq-sec.
      Rad: $(1 \times 0.85)$ $\mu$Ci $\times 1.44 \times 6$ hr $= 7.3$ $\mu$Ci-hr.
   (*b*) Dose per unit activity, $(\bar{A}/m)\Sigma\Delta_i\phi_i$.

SI: $\dfrac{6.16 \times 10^{-15}\ \text{J/Bq-sec}}{1.833\ \text{kg}} \times 2.64 \times 10^4\ \text{Bq-sec} = 8.87 \times 10^{-11}\ \text{Gy/Bq}.$

Rad: $\dfrac{0.082\ \text{g-rad}/\mu\text{Ci-hr}}{1833\ \text{g}} \times 7.3\ \mu\text{Ci-hr} = 0.327\ \text{mrad}/\mu\text{Ci}.$

(c) Dose to liver

SI:   $8.87 \times 10^{-11}\ \text{Gy/Bq} \times 111 \times 10^6\ \text{Bq} = 0.0098\ \text{Gy} = 9.8\ \text{mGy}.$

Rad: $0.327\ \text{mrad}/\mu\text{Ci} \times 3000\ \mu\text{Ci} = 980\ \text{mrad}.$

## 3.7   The S Factor—Doses from Cumulated Activity

The dose rate (rad/day) at a point results mainly from the local distribution of activity (microcuries). The total dose over a period of time is given by the cumulative effect of dose rate and time, and thus can be related to an exposure expressed in units of cumulated activity, $\tilde{A}$ (microcurie-days). The average absorbed dose per unit cumulated activity is known as the S factor. The introduction of the S factor spares the user of radionu-clides considerable numerical work in making dose calculations, and values of S have been tabulated for selected sources and target organs (Snyder et al., 1975). In applying this concept to dose calculations it is necessary to plot activity A versus time and then to obtain the area under the curve for the time period of interest ($\int A\ dt$). The result (in $\mu$Ci-days) is then mul-tiplied by the S factor (in rads per $\mu$Ci-day) to give the dose. When the ac-tivity falls off with a constant average life, the cumulated activity is merely the initial activity times the average life times (1 − fraction remaining).

S values for a target organ are tabulated in handbooks both for uniform distributions of activity within the organ and for activity in remote organs. Organ masses used are typical for a 70-kg adult. The results can be scaled approximately for other cases (Synder et al., 1975).

*Example 19:* Redo example 17 using S factors.

In the absence of a curve or equation for activity vs. time, assume as previously an effective half-life of 7.2 days, or an effective average life of $1.44 \times 7.2 = 10.37$ days (249 hr).

There is no S factor for Thyroid (source) → Spine (target) and we shall use instead the value given for the red bone marrow. Here $S = 2.4 \times 10^{-6}\ \text{rad}/\mu\text{Ci-hr}$ so the total dose (10 $\mu$Ci, $T^a = 249$ hr) = $5.98 \times 10^{-3}$ rad. This is comparable to the dose calculated to the spine.

The S factor for dose to the thyroid from radioactivity in the thyroid is $2.2 \times 10^{-2}\ \text{rad}/\mu\text{Ci-hr}$. Thus the thyroid dose from 10 $\mu$Ci = $2.2 \times 10^{-2} \times 10 \times 249 = 54.8$ rad. This may be compared to a dose of 53.3 rad calculated by the cruder method in section 5.2, part *b* (multiply 3 $\mu$Ci activity by 10/3 to compare results).

### 3.8    Committed Dose and Effective Dose Equivalent

An intake of radioactive material may be a brief incident—an injection of a radiopharmaceutical, an accidental inhalation of some airborne radioactivity released in a laboratory synthesis, or ingestion following contamination of the hands and subsequent contact of hand to mouth. Administered doses, however, are imparted over extended periods, depending on the effective half-life of the material in the body. Half-lives can vary from a few days or less to many decades. The dose expected to be imparted over the effective lifetime of the radioactivity in the body is called the *committed dose*. For radiation protection planning, the committed dose received by a worker is assigned to the year the radioactivity is taken into the body.[13] Example 32 (p. 165) describes the calculation of the committed dose from uranium in the body, a portion of which irradiates the body with an effective half-life of 5000 days (13.7 years). Regulatory limits for the control of occupational exposure to internal emitters are expressed in terms of the dose equivalent. The International Commission on Radiological Protection (ICRP) defines a working lifetime as 50 years and calls the dose equivalent received over the 50 year period the *committed dose equivalent* $(H_{50})$. For uranium, with an effective half-life of 13.7 years, the 50-year period encompasses 3.6 effective half-lives, and the committed dose equivalent is 92 percent $(1 - f = 1 - (1/2)^{3.6} = 0.92)$ of the value it would have if $f$ were set equal to zero.

While the basic occupational radiation standard is expressed as a uniform whole-body dose equivalent of 5 rem, radionuclides taken into the body are generally distributed unequally among the organs, and external radiation may also be limited to a portion of the body. The ICRP addresses the problem of expressing combined internal and external irradiation, selective uptake and distribution, and varying radiosensitivity by introducing the concept of the *effective dose equivalent*.

The effective dose equivalent is intended to replace the complex dose distribution pattern from internal and external irradiation by an equivalent, uniform, whole-body dose. The whole-body dose, expressed as an effective dose equivalent, is chosen to indicate an equivalent detriment to the health of the affected individuals as measured by excess fatal cancers and hereditary disease. This equivalent dose can then be compared with limits based on uniform irradiation of the whole body.

---

13. The ICRP previously specified limiting continuous intakes to rates which resulted, at equilibrium, in maximum dose equivalents of 3.75 rem in 13 weeks to any organ except the gonads, blood-forming organs or lenses of the eyes. These were not allowed to receive more than 1.25 rem (ICRP, 1959, Publication 2). The rate of intake could be varied provided that the total intake in any quarter was no greater than that resulting from continuous exposure at the allowable constant rate. The equilibrium activity in the body resulting in the limiting 13-week dose was referred to as the Maximum Permissible Body Burden (MPBB). For radionuclides with very long effective half-lives, which would not reach an equilibrium level in the body during a working lifetime, continuous uptake resulting from inhalation or ingestion was limited so the MPBB would be reached only at the end of a working lifetime of 50 years.

The value for the committed effective dose equivalent is obtained by calculating committed dose equivalents to the individual organs and converting them to equivalent whole-body doses by multiplying by *weighting factors*. These weighting factors express the relative risks of induction of fatal cancer in the organs of the body (except for the gonads, where hereditary disease is considered) when the body is uniformly exposed (see table 3.4). The contributions from the individual organs are then summed for comparison with the whole-body limit (see Example 1, p. 268). The calculation of the committed effective dose equivalent requires knowledge of the fate of the radioactivity after it enters the body. Metabolic models are given by the ICRP (ICRP, 1979a, 1987a). When exposure is from multiple sources, including external radiation, the sum of all the contributing doses, committed and external, must not exceed the basic whole-body limit. However, the annual dose to a single organ may not exceed 50 rem, even if higher values would be allowed according to the results of the formula. The concept of the effective dose equivalent is not only very useful for controlling exposure from irradiation by both external and internal sources, but is also used to explain to patients the significance of radiation exposures from the different procedures in medical radiology and nuclear medicine, procedures which produce very different distributions of radiation dose in the body.

### 3.8.1 The Annual Limit on Intake—A Secondary Standard of the ICRP

The approach of the International Commission on Radiological Protection to the control of internal hazards is to specify limits for the total intake of radionuclides in one year. Designated as the Annual Limit on Intake (ALI),

**Table 3.4.** Weighting factors for organ doses.

| Organ or tissue | Weighting factor |
| --- | --- |
| Gonads | 0.25 |
| Breast | .15 |
| Red bone marrow | .12 |
| Lung | .12 |
| Thyroid | .03 |
| Bone surfaces | .03 |
| Remainder | .30 |

*Note:* The weighting factor designated as "remainder" applies to organs not specifically listed. The five organs or tissues receiving the largest dose equivalents are each assigned a weighting factor of 0.06 while the exposure of all other tissues in this group is neglected (ICRP, 1977b, Publication 26). Because of their very low sensitivity to cancer induction, skin and lens of the eye are not considered as part of the remainder tissue. When the gastrointestinal tract is irradiated, the stomach, small intestine, upper large intestine and lower large intestine are considered as four separate organs.

this is the activity taken into the body in one year (by ingestion or inhalation) that will impart to the irradiated organs over the total duration of the radiation exposure (or 50 years, whichever is less) an effective dose equivalent of 5 rem. Values for ALI can then be used to set concentration limits for radionuclides in air and water that will not exceed the ALI, given particular volumes inhaled or ingested in a year.

While the ICRP does not set any restrictions on the rate at which the dose is imparted during the year, it does recommend that occupational exposures (ICRP, 1977) of women of childbearing capacity be controlled to avoid imparting the total allowed annual dose over a short time period, in consideration of the possible exposure to an embryo. Women known to be pregnant should not receive annual doses exceeding 0.3 of the dose equivalent limits.

### 3.8.2   The ICRP Bone Model for Calculation of ALI

The ICRP model for bone (ICRP, 1979a, Publication 30) identifies as the cells at risk of turning cancerous, the bone-forming cells on bone surfaces (osteogenic sarcomas); the blood-forming cells in the bone marrow (leukemia); and certain dividing epithelial cells close to bone surfaces (carcinomas of the paranasal sinuses and mastoids). The relationship of the cells to bone surfaces is shown in fig. 3.2. Bone dosimetry is concerned largely with the doses to these cells (Spiers, 1968). Doses to haematopoietic

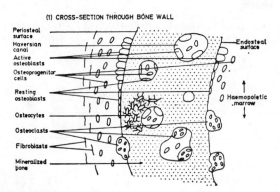

**Fig. 3.2** Structure and composition of bone. Bone is an extremely heterogeneous and specialized system consisting essentially of living soft tissue embedded in microcavities in mineralized matter (calcium, phosphate, carbonate, and citrate) with boundaries that vary in size and shape from spheres (fractions of a micron in diameter) to plane slabs and tubes (tens of microns thick). Bone surfaces have linings on both the external surface (periosteum) and internal surfaces (endosteum). Osteoblasts and osteoclasts are typically nondividing cells responsible for bone formation and removal respectively. They are formed from the division of stem cells (labelled as osteoprogenitor cells in the diagram). Osteocytes are a more mature form of osteoblast located as single cells in small spaces in mineralized bone. They receive nourishment via fine canaliculae, passageways 1 micron or less in diameter. *Source:* ICRP, 1968, Publication 11.

stem cells in adults are calculated as averages over marrow which entirely fills the cavities within trabecular bone.  Doses to cells associated with surfaces are calculated as an average over tissue up to a distance of 10 $\mu$m from the relevant bone surfaces.  Radionuclides are classified as either being distributed uniformly throughout bone or residing on bone surfaces.

Mineral bone is considered to consist of 4 kg of cortical bone and 1 kg of trabecular bone, each type with a surface area of 6 m$^2$ and an associated mass (10 $\mu$m thick) of 60 g (120 g total).  The active bone marrow is assigned a mass of 1500 g.  The energy deposition per gram by beta particles is greater in tissue than in mineral bone, and a very small marrow cavity in mineral bone irradiated with the same flux density of beta particles as the surrounding mineral bone will have a dose rate 1.07 times as great (that is, the mass stopping power of marrow is 1.07 times as much as the mass stopping power in bone).  Dose calculations are made by setting up source terms (in $\mu$Ci/g or Bq/g) and determining the energy absorbed in target organs through the use of absorbed fractions.

### 3.8.3   Calculation of the ALI for $^{90}$Sr Ingested in the Form of a Soluble Salt

Assume $^{90}$Sr distributes uniformly throughout trabecular and cortical bone and that $^{90}$Y is in equilibrium with it and has the same distribution.  The retention of the radioactivity in bone over time is described by the expression (ICRP, 1978, Report 30):

$$r(t) = 0.4\ e^{-0.25t} + 0.45\ (t + 0.2)^{-0.18}\ (0.45\ e^{-0.000265t} + 0.55\ e^{-0.000066t})$$

where $t$ is given in days.  This expression is much more complicated than the simple half-life relationships used previously.  It yields, for an initial activity of 1 disintegration per day, a total of 785 disintegrations in 50 years and for an initial activity of 1 Bq (1 dps), a total of $6.78 \times 10^7$ disintegrations in 50 years.  The same relation, of course, holds between the initial dose rate and the total dose.

Assume an initial activity in mineral bone of 1 Bq/g.  The initial dose rate is obtained from the equation:

$$D = C \times 1 \times \Sigma E_\beta \phi_\beta \times \frac{1}{62{,}400} \times 86{,}400$$

$$\frac{\text{rad}}{\text{day}} \quad \frac{\text{Bq}}{\text{g}} \quad \frac{1}{\text{sec-Bq}} \quad \text{MeV} \quad \frac{\text{g-mrad}}{\text{MeV}} \quad \frac{\text{sec}}{\text{day}} \tag{3.8}$$

$$= 1.38\ C$$

where $C$ is the quotient of source activity divided by target mass and $\phi_\beta$ is the absorbed fraction for a given beta particle spectrum with average energy $E_\beta$.  The contributions from $^{90}$Sr and $^{90}$Y are summed ($\Sigma E_\beta \phi_\beta$) for each source-target combination.  The data are given in table 3.5 and the results in table 3.6.

**Table 3.5.** Data for calculation of dose to bone from $^{90}$Sr.

| Source tissue | Mass (kg) | Target tissue | Mass (kg) | Absorbed Fraction | | $\Sigma\, E_\beta\, \phi_\beta$ | Weighting factor |
|---|---|---|---|---|---|---|---|
| | | | | $^{90}$Sr | $^{90}$Y | | |
| Trabecular bohe | 1 | Surface bone | 0.12 | 0.027 | 0.021 | 0.0244 | 0.03 |
| Trabecular bone | 1 | Bone marrow | 1.5 | .35 | .43 | .456 | .12 |
| Cortical bone | 4 | Surface bone | 0.12 | .015 | .014 | .0165 | .03 |
| Cortical bone | 4 | Bone marrow | 1.5 | .007 | .04 | .0202 | .12 |

**Table 3.6.**   Dose to bone from 1 Bq/g (mineral bone) $^{90}$Sr.

| Source tissue | Target tissue | Dose rate (mrad/day) | 50-yr dose (mrad) | Equivalent whole-body 50-yr dose (mrad) |
|---|---|---|---|---|
| Trabecular bone | Bone marrow | 0.421 | | |
| Cortical bone | Bone marrow | 0.073 | | |
| | Total marrow | 0.494 | 388 | 46.6 |
| Trabecular bone | Surface bone | 0.281 | | |
| Cortical bone | Surface bone | 0.719 | | |
| | Total surface | 1.0 | 785 | 23.6 |
| | | | Total equivalent | 70.2 |

Thus, an initial activity of 1 Bq/g in bone gives a total of 70.2 mrem.  The activity for 5000 mrem is then 71 Bq/g.  Assuming 0.3 of the intake reaches the bone, the ALI is 71 Bq/g $\times$ 5000 g $\div$ 0.3 = 1.18 $\times$ 10$^6$ Bq.  The ICRP value for the ALI is 1 $\times$ 10$^6$ Bq.

### 3.8.4   Maximum Permissible Concentration in Air—A Derived Limit

Maximum permissible concentrations of radionuclides in air are calculated by dividing the limit on intake by the volume of air breathed in over the working period.  Similar calculations can also be applied to ingestion of radioactively contaminated water, but this limit is of little practical use in the control of occupational exposure.  The ICRP recommends as a reference control value for airborne radioactivity the Derived Air Concentration (DAC), defined for any radionuclide as that concentration in air that, if breathed by Reference Man for a working year of 2000 hr (50 weeks at 40 hr/week) under conditions of "light activity" (that is, 0.02 m$^3$ air breathed/min), would result in the ALI by inhalation.  In equation form, DAC = ALI/volume of air breathed in one year.

The U.S. Nuclear Regulatory Commission uses as a basis for specifying maximum permissible concentrations in air and water, intakes of 10$^7$ cm$^3$ air per 8-hr work day (2 $\times$ 10$^7$ cm$^3$ air for continuous exposure), and 1100 cm$^3$ water per 8-hr day (2200 cm$^3$ for continuous exposure).  The concentration limits given in the Code of Federal Regulations, 10CFR20, can be converted to permissible intakes by multiplying by the volume of air or water used in the calculations.

*Example 20:* The ICRP value for the occupational annual limit on intake by inhalation for $^{125}$I is 2 $\times$ 10$^6$ Bq (0.027 mCi).  Calculate the concentration in air that should not be exceeded if the inhalation intake is controlled on a daily basis.

The daily limit on intake is $2 \times 10^6$ Bq/250 day = 8000 Bq (ICRP 1979a; this is based on the ICRP organ dose ceiling of 50 rem since the application of a 0.03 weighting factor gives a committed organ dose above this limit). The volume of air breathed in by the adult male doing light work during an 8-hr working day is 9600 liters (ICRP 1975, Publication 23). The maximum concentration is thus 8000 Bq/$9.6 \times 10^6$ cc = 0.00083 Bq/cc or 830 Bq/m$^3$. ICRP rounds this off to 1000 Bq/m$^3$ (0.027 pCi/cc). The current NRC value for the Derived Air Concentration is 0.011 pCi/cc, which is based on a maximum dose to the thyroid of 15 rem/year.

There is a safety factor in setting allowable concentrations by the method described here, since the controls are applied from the beginning of exposure, when levels in the body are likely to be insignificant, while the limits are derived on the assumption that the body contains the maximum permissible activity. The difference is not important for radionuclides with short effective half-lives, where equilibrium is achieved rapidly. For radionuclides with long effective half-lives, the procedure is very conservative. This is desirable since once these radionuclides are incorporated in the body, there is no way to reduce the dose rate and there is no margin for unexpected exposures that could be accidental or incurred deliberately in emergencies.

When radionuclides with very long half-lives are released to the environment it is customary to specify their significance in terms of the dose commitment to the population. This is the total per capita dose to be incurred over the lifetime of the radionuclide. Doses imparted to individuals throughout their lifetime are evaluated over a 50-year period following intake and referred to as a committed dose.

## 4. Summary of Formulas

### Radioactive Decay

$A = \lambda N$.

$T^a = 1/\lambda$.

$T^h = 0.693/\lambda$

$T^a = 1.44\ T^h$.

$N = AT^a$.

$N = 1.44\ AT^h$.

$f = e^{-\lambda t}$.

$A$ = activity.

$\lambda$ = decay constant.

$N$ = number of radioactive atoms, and also total number of disintegrations.

$T^a$ = average life.

$T^h$ = half-life.

$f$ = fraction remaining. $\lambda$ and $t$ (time) must be expressed in the same units of time; that is, if $t$ is in sec, $\lambda$ is in 1/sec.

$f$ by half-lives method: Determine the number of half-lives during the period of interest and read $f$ from curve or table.

## Radioactive Decay: Physical Decay + Biological Elimination

$$\lambda_e = \lambda_p + \lambda_b.$$
$$T_e^a = 1/(\lambda_p + \lambda_b).$$
$$T_e^h = 0.693/(\lambda_p + \lambda_b).$$
$$T_e^h = 0.693\ T_e^a.$$
$$T_e^h = T_p^h T_b^h/(T_p^h + T_b^h).$$
$$A = \lambda_p N.$$
$$N' = AT_e^a.$$
$$f = e^{-\lambda_e t}.$$

$\lambda_e$ = effective decay constant.

$\lambda_p$ = physical decay constant (fractional loss per unit time from radioactive decay).

$\lambda_b$ = fractional loss per unit time from biological elimination.

$T_e^a$ = effective average life.

$T_e^h$ = effective half-life.

$T_p^h$ = physical half-life.

$T_b^h$ = biological half-life.

$A$ = activity.

$N$ = number of atoms.

$N'$ = total number of disintegrations.

$f$ = fraction remaining (determined also from the number of elapsed effective half-lives).

## Dose from Nonpenetrating Radiation from Internal Emitters

$$DR_{NP} = 51\ C\ E.$$

$$D_{NP} = 73.8\ C\ E\ T_e^h\ (1 - f).$$

$DR_{NP}$ = dose rate in rad/day from nonpenetrating radiation.

$D_{NP}$ = dose in rad from nonpenetrating radiation.

$C$ = activity concentration of emitter in $\mu$Ci/g.

$E$ = average energy in MeV per disintegration carried by particles.

$T_e^h$ = effective half-life in days.

## Dose from Penetrating Radiation from Internal Emitters

$$D_P = 0.0346\ gC\rho\Gamma T_e^h\ (1 - f).$$

$$D_P = 73.8\ C\ E_\gamma n_\gamma \phi T_e^h\ (1 - f).$$

$D_P$ = dose in rad within source of penetrating radiation.

$C$ = activity concentration in $\mu$Ci/g.

$\rho$ = concentration of emitter in g/cc.

$\Gamma$ = specific gamma ray (or dose rate) constant in R (or rad) per mCi-hr at 1 cm.

$g$ = geometrical factor.

$\phi$ = absorbed fraction.

$T_e^h$ = effective half-life in days.

$E_\gamma$ = photon energy.

$n_\gamma$ = mean number of photons of energy $E_\gamma$ per disintegration.

$$D_P = 1.44 \; C \; \Delta \; \phi \; T_e^h \; (1 - f).$$

$\Delta$ = equilibrium dose constant in g-rad/$\mu$Ci-hr.

$T_e^h$ = effective half-life in hr.

$$D_{PX} = 1.44 \frac{A_s}{M_t} \Delta \phi T_e^h \; (1 - f).$$

$D_{PX}$ = dose in rad to organ external to source.

$A_s$ = activity of source in $\mu$Ci.

$M_t$ = mass of target organ in g.

Equations for penetrating radiation may be used for nonpenetrating radiation (beta particles and low-energy photons, say below 0.011 MeV) by setting $\phi = 1$.

## Inverse Square Law

$$\phi = S/4\pi r^2.$$

$\phi$ = flux density in particles/cm²-sec.

$$= 0.080 \; S/r^2.$$

$S$ = particles emitted from source per sec.

$r$ = distance from source in cm.

Approximate flux density to dose rate conversion factors:

100 $\beta$ particles/cm²-sec = 10 mrad/hr to skin.

100 $\gamma$ photons/cm²-sec, energy E per photon = 0.172 E mrad/hr to tissue.

## Dose Rates at a Distance from Gamma Sources

$$DR = 6 \; AE_\gamma n_\gamma/r^2.$$

$DR$ = approximate dose rate in mrad/hr or exposure rate in mR/hr.

$A$ = activity in mCi.

$E_\gamma n_\gamma$ = mean photon energy per disintegration in MeV.

$r$ = distance in ft.

$$DR = \frac{\Gamma A}{r^2}.$$

$DR$ = dose rate in rad (or $R$) per hr.

$\Gamma$ = specific dose rate (or gamma ray) constant in rad (or $R$) per mCi-hr at 1 cm.

$r$ = distance in cm.

$A$ = activity in mCi.

## Attenuation of Radiation

First, determine the dose rate or flux density by neglecting attenuation. Then, multiply by the Attenuation Factor (AF).

| | |
|---|---|
| $AF = e^{-\mu x}$ | AF = attenuation factor. |
| $\mu = 0.693/HVL.$ | $\mu$ = attenuation coefficient in $cm^{-1}$. |
| | $x$ = thickness of attenuating medium in cm. |
| $HVL = 0.693/\mu.$ | HVL = half-value layer. |

AF by half-value layers method.  Determine the number of half-value layers corresponding to the thickness of the medium between the source and dose point.

Obtain the attenuation factor AF from the HVL curve.

### Dose Equivalent

| | |
|---|---|
| $DE = QF\ D \ . \ . \ .$ | DE = dose equivalent in rem. |
| | QF = quality factor. |
| | $D$ = absorbed dose in rad. |
| . . . | multiply by other modifying factors that apply. |

## 5.  Dose Calculations for Specific Nuclides

We have seen that the calculation of dose is relatively simple in a region that is uniformly irradiated and in which the effective average life is constant over the period of interest.  In practice, the distribution of radionuclides is quite complex, and the effective average life changes as the material is acted on through physiological and biochemical processes.  It is the need to acquire accurate metabolic data rather than the performance of subsequent mathematical analyses that provides most of the difficulties in evaluating the dose from internal emitters.  Simplifying assumptions made in the absence or in place of accurate data can sometimes lead to significant errors.

Two of the major potential sources of error produced by simplifications in dose calculations are:

1. Failure to consider localization of the radionuclides in special parts of an organ, or even within special parts of a cell, and;

2. Failure to investigate the possibilities of long-term retention of a fraction of the ingested material, when most of the radioactivity appears to be eliminated with a short half-life.

In this section, we shall investigate these and other factors that influence the evaluation of radiation dose from internal emitters, with reference to some of the more important radionuclides that are now used in nuclear medicine or are otherwise involved in the exposure of human beings.

### 5.1  Hydrogen-3 (Tritium, Half-life 12.3 yr)

Beta particles.  Maximum energy and percent of
   disintegrations                                          0.018 MeV   100%

Average beta particle energy per disintegration      0.006 MeV

Tritium emits only very low energy beta particles and has a long half-life.

### 5.1.1   Tritiated Water

Tritiated water is administered to patients in tests for the determination of body water.  It appears in the atmosphere as a consequence of the release and oxidation of tritium from nuclear reactors.  It has also been produced by nuclear explosions in the atmosphere.

The general assumption is that tritiated water, whether ingested or inhaled, is completely absorbed and mixes freely with the body water.  It permeates all the tissues within a few hours and irradiates the body in a fairly uniform manner.  Thus body tissue is the critical tissue for intakes of tritiated water.  The percentage of body water varies in different tissues.  The average is about 60 percent.  It is about 80 percent in such important tissues as bone marrow and testes (Vennart, 1969).

We can obtain an estimate of the average time the tritiated water molecules remain in the body from the following reasoning.  Under normal conditions the body maintains its water content at a constant level.  This means that over a period of time, as much water is eliminated as is taken in.  If an adult male takes in 2500 ml of water per day (2200 by drinking, 300 as water of oxidation of foodstuffs), he also eliminates 2500 ml/day.  Assume a total water pool of 43,000 ml in the adult male.  Thus the fraction of the body water that is lost per day is 2500/43,000, or 0.058 per day.  This is the biological elimination rate.  The average life is 1/0.058, or 17.2 days, and the biological half-life is 0.693 × 17.2, or 12 days.

*Example 21:* Calculate the dose to tissues in the testes from the administration of 1 mCi of tritiated water.

| | |
|---|---|
| Physical half-life | 4480 days |
| $\lambda_p = 0.693/4480$ | 0.000155/day |
| $\lambda_b$ | 0.058/day |
| $\lambda_e$ | 0.058/day |
| Effective average life, $1/\lambda_e$ | 17.2 days |
| Effective half-life, $0.693 T_e^a$ | 12 days |
| Activity/g testes (0.8 of activity in body water): | |
| 0.80 × 1000 μCi/43,000 g | 0.0186 μCi/g |
| Average beta particle energy | 0.006 MeV |
| Dose = 73.8 × 0.0186 × 0.006 × 12 | 0.099 rad |

The injection or ingestion of 1 mCi of tritiated water in a test of body water in an adult male results in a dose of 99 mrad to the testes.

The assumption used in the dose calculation that the tritium atoms remain in the body water and are eliminated at a constant and relatively rapid rate is

only an approximation. Experiments with animals and studies of humans who accidentally ingested tritiated water have shown that a small fraction of the tritium is excreted at a much slower rate (Snyder et al., 1968). The concentration of tritium in the urine of a worker who had accidentally taken into his body 46 mCi of tritiated water was followed for over 400 days (Sanders and Reinig, 1968) and the concentration on the 415th day was still significantly above the concentration of tritium in urine from unexposed employees. The excretion curve could be interpreted as due to excretion of almost all of the tritium with a half-life of 6.14 days (the unusually rapid elimination was produced through administration of a diuretic) and excretion of the remainder in two fractions with half-lives of 23 days and 344 days. The complex excretion curve indicates that some of the tritium exchanges with organically bound hydrogen. The effect is to increase the dose calculated on the basis of a single short half-life, but by only a small percentage.

*Example 22:* What is the dose imparted to the testes as a result of breathing air containing tritiated water vapor at a concentration of 5pCi $(5 \times 10^{-6} \mu\mathrm{Ci})$ per cubic centimeter of air?

Assume an exposure of 40 hrs in a week. Also assume all inhaled water vapor is assimilated into body water. (Use physical data given in preceding problem.)

| | |
|---|---|
| Air intake during working day (8 hr) | $10^7$ cc. |
| Air intake during working week (40 hr) | $5 \times 10^7$ cc. |
| Microcuries inhaled during week: | |
| $5 \times 10^{-6} \times 5 \times 10^7$ | 250 $\mu$Ci. |
| Dose to the testes from 250 $\mu$Ci (from preceding problem, 1000 $\mu$Ci delivers 99 mrad) | 25 mrad. |

If exposure to the radioactive water vapor continues after the week at the same rate, the dose will accumulate, and the weekly dose rate will increase to a maximum value, which will be reached after several effective half-lives. This equilibrium weekly dose rate will be equal numerically to the total dose from a week's exposure,[14] and thus the maximum dose rate from inhalation will be 25 mrad/week.

The actual dose rate to the individual immersed in the tritiated water atmosphere will be considerably larger because a significant amount of HTO

---

14. Assume the total dose from a week's inhalation is essentially imparted in 4 weeks and the inhalation of the activity goes on for 40 weeks. Then the total dose imparted is $40 \times 25$ mrad and the maximum time over which this is imparted is 44 weeks. Under these conditions there is little error in assuming the dose from the inhaled activity is imparted over the 40-week inhalation period, and the average dose rate during this period is $40 \times 25/40$, or 25 mrad/week. The error in neglecting the delay in imparting the dose decreases as the inhalation time increases.

is absorbed through the skin, even when the individual is clothed. The actual buildup of tritium in the body is about 80 percent greater than that deduced on the basis of inhalation alone (Morgan and Turner, 1967, p. 336).

We thus estimate the total dose rate from $5 \times 10^{-6} \, \mu Ci/cc$ at 45 mrad per week. We may perhaps increase this by another 10 percent to account for the dose from long-term retention. An RBE of 1.7 was used by ICRP (1960) in deriving concentration limits for tritium. A quality factor of 1.0 is currently used in radiation protection (NCRP, 1971, Report 39). However, theoretical estimates for the RBE for tritium tend to be greater than one because of the higher LET ($5.5 \, keV/\mu m$) compared to more energetic beta-gamma emitters (less than $3.5 \, keV/\mu m$) (NCRP, 1979a, Report 62; NCRP, 1979, Report 63; Till et al., 1980).

### 5.1.2  Tritiated Thymidine

The calculation of the dose from tritiated water in the preceeding section was relatively simple because of the uncomplicated history of the water molecules in the body. The problem becomes much more difficult when the tritium is carried by a molecule with a specific metabolic pathway. As an example, let us consider the dose from thymidine labeled with tritium.

As a precursor of DNA, thymidine is used in studies of the synthesis of DNA molecules by cells. Such synthesis occurs in the nuclei of cells, and most of the thymidine is concentrated selectively in cell nuclei that are undergoing DNA synthesis at the time the thymidine is present.

How do we evaluate the dose in a situation like this? How do we assess the consequences? Since the tritiated precursors of DNA are extremely valuable in studies of cell function, can we establish permissible activities of tritiated DNA precursors for administration to human beings?

Animal experiments tell us that when tritium-labeled thymidine is administered intravenously, it is initially uniformly distributed throughout the body. It is then either promptly incorporated into DNA in cells that are actively proliferating or degraded to nonlabeling materials, primarily water. The result is a "flash" labeling.

The following data were obtained by Bond and Feinendegen (1966) following the administration of tritiated thymidine intravenously to rats. Radioautograph and counting techniques were used.

| | |
|---|---|
| Activity administered | $1 \, \mu Ci/g$ |
| Average activity per $10^6$ nucleated bone marrow cells, 1–2 hr after administration (by counting) | 6000 dis/min per $10^6$ cells |
| Fraction of nucleated bone marrow cells labeled (by radioautography) | 0.28 |
| Average activity per labeled bone marrow cell: $6000/(0.28 \times 10^6)$ | 0.022 dis/min |

Because of its very low energy, the tritium beta particle does not travel very far. The maximum range in water is 6 $\mu$m and the average range is 0.8–1 $\mu$m. The diameter of a nucleus may be of the order of 8 $\mu$m. Thus most of the energy of the beta particles emitted in the nucleus is deposited in the nucleus. For a nuclear diameter of 8 $\mu$m, 80 percent of the emitted energy remains in the nucleus.

The tritium in a given nucleus will irradiate the nucleus until the cell is destroyed and breaks up, if the dose is high enough, or until the cell divides. If the cell undergoes division, some of the tritium will be transferred through chromosome exchanges to the daughter cells. Thus, successive divisions of cells containing tritiated DNA will tend to lower the tritium activity in individual nuclei over successive generations, with a consequent lowering of exposure to successive generations of cells. Eventually the doses to individual cells will become very small.

An estimate of the time it takes a cell to divide after uptake of thymidine may require special experimentation, using autoradiography to determine the activity in individual nuclei. The generation time of most rat bone marrow cells is 10–15 hr.

*Example 23:* Using uptake data given in the paper by Bond and Feinendegen, calculate the dose from administration of 1 $\mu$Ci/g of tritiated thymidine.

Disintegrations during generation time of
of 15 hr: 0.022/min × 900 min          20
Mass of nucleus, diameter of 8 $\mu$          2.7 × 10$^{-10}$ g
Fraction of emitted energy absorbed in
nucleus          0.8
Average dose over 15 hr:

$$\frac{20 \text{ dis} \times 0.006 \text{ MeV/dis} \times 0.8}{2.7 \times 10^{-10} \text{ g} \times 62.4 \times 10^6 \text{ MeV/g-rad}} = 6 \text{ rad}.$$

Some cells receive as much as four times the average dose, or 24 rad.

The level of 1 $\mu$Ci/g was the minimum found to produce a definite physiological effect in experiments with rats, the effect involving diminution in the turnover rate of the cells. Occasional bi- and tetranucleated bone marrow cells were seen 3 days after injection.

The effects from tritiated thymidine were compared to the effects from various exposures to x rays. The authors reported that the dose levels to the nuclei producing effects such as mitotic delay, cell abnormalities, and some cell deaths in their experiments were comparable to x-ray dose levels to the whole cell to produce similar results.

The following conclusions were drawn by Bond and Feinendegen with regard to the administration of radioactive precursors of DNA. "The present studies indicate that early somatic effects can be predicted on the basis of the absorbed dose. The evidence is consistent with long-term somatic and genetic effects not exceeding those expected on the basis of absorbed dose, although further work is needed for adequate evaluation. Thus guides for 'allowable' levels of tritiated thymidine probably can be safely related to the amount of the compound that will deliver a dose to the cell nuclei of bone marrow, gonads, or other proliferating tissues that will not exceed the dose of external x or gamma radiation 'allowed' for these same tissues. Until further data become available, however, it remains prudent not to use $^3$H DNA-precursors in young individuals, particularly those in the childbearing age" (p. 1019).

## 5.2   Iodine-131 (Half-life 8.05 days) and Iodine-125 (Half-life 60 days)

|  | $^{131}$I | | $^{125}$I | |
|---|---|---|---|---|
|  | MeV | % | MeV | % |
| Beta particles.   Maximum energies and percent of disintegrations. | 0.61 | 87 |  |  |
|  | .34 | 9 |  |  |
|  | .26 | 3 |  |  |
| Gamma photons.   Energies and percent of disintegrations. | .72 | 3 | 0.027-x[15] | 112 |
|  | .64 | 9 | .031-x | 24 |
|  | .36 | 81 | .035 | 7 |
|  | .28 | 6 |  |  |
|  | .08 | 6 |  |  |
| Average beta particle or electron energy per disintegration. | .187 |  | .022 |  |
| Specific dose rate constant. | $2.1 \dfrac{\text{rad-cm}^2}{\text{mCi-hr}}$ | | $.6 \dfrac{\text{rad-cm}^2}{\text{mCi-hr}}$ | |

Iodine-131 emits approximately equal numbers of medium-energy beta particles and gamma rays. Iodine-125, because it decays by electron capture, gives off a mixture of low-energy gamma rays, conversion electrons, and x rays. Both isotopes have fairly short half-lives.

Radioiodines have been among the most important contributors to the environmental hazard of fission products from past nuclear weapons tests. They play a major role in the evaluation of the consequences of radioactivity releases resulting from reactor accidents. Their significance is due to their high yield in fission and selective uptake by the thyroid. In nuclear medicine, radioiodine is used primarily for medical examination and treatment of thy-

15. X ray following electron capture (see part II, fig. 2.8).

roid conditions. For this use it is administered as an inorganic salt, such as, NaI. Its use stems from its remarkable property of concentrating in the thyroid gland, and the radioactivity can be used either to trace the uptake of iodine in the gland and throughout the body or, in larger amounts, for destroying diseased tissue.

If NaI is injected intravenously, it will distribute in a short period throughout an "iodide space," comprising about 30 percent of the body weight (Spiers, 1968, pp. 55–57, 111–116). It will be eliminated from this space with a biological half-life of about 2 hr. It will reach a concentration in the red blood cells of about 0.56 that of plasma. As the bloodstream passes through the thyroid, perhaps 20 percent of the plasma iodide is removed per passage. In normal patients 0.5–6.8 percent in the circulating pool is extracted per hour. The gland may accumulate 30 percent of the injected or ingested activity in normal patients. In the gland, the iodine becomes bound rapidly to the protein hormone. It is released from the thyroid only very slowly, in accordance with control mechanisms that exist throughout the pituitary.

The biological half-life may be deduced from the following data. A typical value of the iodine content of the normal thyroid gland is approximately 8 mg, though it varies greatly in individuals. The body tissues have a concentration of about 1 $\mu$g/g. The thyroid releases about 0.08 mg/day, or 0.01 of its content per day ($\lambda_b$). The biological average life is thus $1/0.01$, or 100 days and the biological half-life is 69 days. Since the physical half-life of $^{131}$I is much shorter, that is, 8.05 days, the effective half-life is 7.2 days, only slightly less than the physical half-life. The biological half-life varies in individuals from 21 to 200 days.

In addition to concentrating in the thyroid, the iodine also concentrates in the salivary glands and gastric mucosa. Iodine released by the thyroid into the bloodstream circulates as protein-bound iodine (PBI), which is degraded in the peripheral regions, and, as a result, the iodine is set free as inorganic iodide. This again enters the body iodide pool and is available for use in the same manner as ingested iodine. Excretion of the iodines is almost entirely by way of urine.

*Example 24:* Evaluate the dose to the body from the intravenous administration of 10 $\mu$Ci of $^{131}$I.

a. Early period. Irradiation of iodide space.

| | |
|---|---|
| Mass of space for beta irradiation (value chosen is 30 percent of body weight of 70 kg) | 21,000 g |
| Effective half-life | 2 hr |
| Mass of space for gamma irradiation | 70,000 g |
| Geometrical factor, $\bar{g}$, mean value for body | 126 cm |
| Specific dose rate constant | $2.1 \dfrac{\text{rad-cm}^2}{\text{mCi-hr}}$ |

Beta dose =

$$73.8 \times \underset{C}{\frac{10\ \mu Ci}{21{,}000\ g}} \times \underset{E}{0.187\ MeV} \times \underset{T_e^h}{0.083\ days} = 0.00056\ rad.$$

Gamma dose =

$$0.0346 \times \underset{C}{\frac{10\ \mu Ci}{70{,}000\ g}} \times \underset{\rho}{1\ g/cm^3} \times \underset{\Gamma}{2.1\ rad\text{-}cm^2/mCi\text{-}hr}$$

$$\times \underset{\bar{g}}{126\ cm} \times \underset{T_e^h}{0.083\ days} = 0.00011\ rad.$$

b. Main period.  Thyroid dose.

| | |
|---|---|
| Activity (uptake of 30 percent) | 3 $\mu Ci$ |
| Mass of thyroid | 20 g |
| Equivalent radius of each lobe | 1.5 cm |
| Average geometrical factor ($3\pi r$) | 14.1 cm |

$$\text{Beta dose} = 73.8 \times \frac{3}{20} \times 0.187 \times 7.2 = 14.9\ rad.$$

$$\text{Gamma dose} = 0.0346 \times \frac{3}{20} \times 1 \times 2.1 \times 14.1 \times 7.2 = 1.1\ rad.$$

c. Total Dose to Blood and Bone Marrow.

The dose to the blood and bone marrow comes primarily from thyroxine and other [131]I-labeled organic molecules released slowly to the blood by the thyroid.  The retention history is complicated, and it cannot be described by an essentially instantaneous uptake and a constant half-life.  Experimental data on the activity in the blood as a function of time are shown in the following figure.

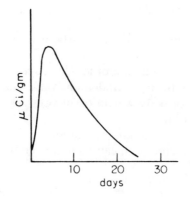

*Example 25:* Calculate the dose to the blood from the retention curve for iodine.

The total number of disintegrations is given by the area under the curve. For the conditions of the problem, the total number of disintegrations per gram of blood is $5.5 \times 10^6$. The beta dose then equals

$$\frac{5.5 \times 10^6 \text{ dis/g} \times 0.187 \text{ MeV/dis}}{62,400 \text{ MeV/g-mrad}} = 16.5 \text{ mrad.}$$

The gamma photons emitted by iodine in the thyroid also contribute to irradiation of the blood. The calculation is complicated. Basic data may be found in Spiers (1968) or in Medical Internal Radiation Dose Committee pamphlets. According to Spiers, the gamma dose to the blood from $^{131}I$ in the thyroid contributes another 24 percent to the dose from $^{131}I$ in the blood. The dose to the bone marrow is probably more critical than the dose to the blood. Compartmentation of the bone marrow by partitions known as trabeculae serves to reduce the dose through beta shielding by the trabeculae. The reader is referred to Spiers for details. The gamma contribution to the dose is less affected by the trabeculae, and the total dose to bone marrow is about 80 percent of the total dose to blood.

The iodine problem illustrates the many factors that can be involved in a thorough analysis of dose from administration of a radioisotope. The calculation considers selective dilution of the isotope in body tissues, selective shielding from body structures, and complex retention curves. The combination of high uptake in the thyroid and low mass available for irradiation produces a high dose to the thyroid for a small amount of ingested activity. It is because of this physiological peculiarity that radioiodine is considered a very hazardous isotope, particularly for infants, and maximum levels in air and water have been set very low. On the other hand, iodine is administered in large quantities to destroy the thyroid. In this case the dose to the bone marrow becomes significant and may have to be considered in treatment planning.

*Example 26:* What is the dose to the thyroid when 10 $\mu$Ci of $^{125}I$ is given instead of $^{131}I$ in a thyroid uptake test?

We shall calculate the dose from the penetrating radiation by the absorbed fraction method.

| | |
|---|---|
| Initial activity (uptake 30 percent) | 3 $\mu$Ci |
| Mass of thyroid | 20 g |
| $T_p^h$ | 60 days |
| $T_b^h$ | 69 days |
| $T_e^h \cdot \dfrac{60 \times 69}{60 + 69}$ | 32 days |

|       | MeV   | $\phi$ |
|-------|-------|--------|
| Absorbed fractions in thyroid (from linear | 0.027 | 0.184 |
| interpolation of "mird" data, Snyder et | 0.031 | 0.144 |
| al., 1969). | 0.035 | 0.124 |

Electron dose:

$$\underset{73.8}{\overset{C}{}} \times \underset{\frac{3}{20}}{} \times \underset{0.022}{\overset{E}{}} \times \underset{32}{\overset{T_e^h}{}} = 7.8 \text{ rad.}$$

Dose from penetrating radiation:

$$\underset{73.8}{\overset{C}{}} \times \frac{3}{20} \times \overset{(E_1 n_1 \phi_1 + E_2 n_2 \phi_2 + E_3 n_3 \phi_3)}{(0.00555 + 0.00107 + 0.00030)} \times \overset{T_e^h}{32} = 2.46 \text{ rad.}$$

The lower local dose rate as compared to $^{131}$I (because of the lower energy radiation) is largely offset by the longer half-life. However, $^{125}$I may be the radioisotope of choice in some thyroid tests because of the superiority of the imagery and localization data resulting from the lower photon energy.

### 5.2.1  Microdosimetry of Iodine-125

Iodine-125 decays by electron capture, and much of the radiation dose imparted to the thyroid is by charged particles of very low energy and hence very short range (Auger electrons). Under these circumstances, the evaluation of the dose is dependent upon the distribution of the iodine and the microstructure of the gland.

The thyroid gland is made up of a conglomeration of tiny units called follicles, more or less rounded in shape, and varying from 50 to 500 $\mu$m in diameter. The functional cells are closely packed together as a shell which encloses a viscous fluid called colloid. This fluid (which makes up about 50 percent of the total gland mass in a normal gland) contains 90 percent of the iodine in the thyroid. This is not particularly significant for $^{131}$I, because the energy imparted by the beta particles is more or less uniform over the whole gland, so it is valid to talk about a mean gland dose. However, because of the short range of the lower-energy electrons emitted by $^{125}$I (typically 35 keV, range 22 $\mu$m in tissue), there is a nonuniform energy distribution across the follicle. Much of the electron energy is absorbed within the lumen, and the interfollicular tissue in the gland neither contains activity nor gets the particulate radiation dose. Microdose calculations give a maximum at the center of the follicle, dropping off to 49 percent at the colloid cell interface, 25 percent over the nucleus, and 14 percent at the basal membrane. Calculations indicate follicular cell dose equal to 50 percent of the mean gland dose. Experiments on rat thyroid indicate that the mean cell dose for

50 percent cell survival is about twice as high for $^{125}$I as for $^{131}$I, which supports the hypothesis that, in this case, the follicular cell nucleus dose is the significant dose. The results may be applicable to treatment of hyperthyroidism with radioiodine, since it is postulated that the destruction of the reproductive integrity of the follicular cell is one of the causes of the consequent induction of hypothyroidism during the treatment of hyperthyroidism. Preliminary data indicate that there is relatively less hypothyroidism consequent to $^{125}$I therapy (Reddy et al., 1976).

### 5.3   Strontium-90 (Half-life 28 yr) → Yttrium-90 (Half-life 64 hr) → Zirconium-90 (stable)

|  | $^{90}$Sr | | $^{90}$Y | |
|---|---|---|---|---|
|  | MeV | % | MeV | % |
| Beta particles. Maximum energy and percent of disintegrations. | 0.544 | 100 | 2.27 | 100 |
| Average beta particle energy per disintegration. | 0.21 | | 0.89 | |

We have here an example of a radioactive decay series. Strontium-90 atoms with an average life of 1.44 × 28, or 40 years, decay into yttrium-90 atoms with an average life of 92 hours, which decay to stable zirconium-90. Every strontium decay is followed within a few days on the average by an yttrium decay with the emission of an yttrium beta particle. Most of the energy in this double decay comes from the yttrium. If we start out with fresh strontium, we will have no significant yttrium activity until the yttrium atoms have a chance to build up. In time, they will build up until they decay at the same rate at which they are produced. They will attain half their maximum level in one yttrium half-life (64 hr) and make up half the interval to the equilibrium activity in each succeeding half-life. In 4 half-lives they will be within 93 percent of their maximum level. By 7 half-lives, the yttrium is essentially in equilibrium with the strontium and has the same activity.[16]

16. The fraction of equilibrium reached by the $^{90}$Y at any time after starting from pure $^{90}$Sr can be calculated from the following reasoning. Assume first that we have a source with $^{90}$Sr and $^{90}$Y in equilibrium. They are both disintegrating at the same rate, with the long half-life of the $^{90}$Sr, so the $^{90}$Y remains constant. Now imagine that the $^{90}$Y is separated from the $^{90}$Sr. The separated $^{90}$Y decays with its half-life of 64 hr and new $^{90}$Y is formed from the decay of the $^{90}$Sr. The total $^{90}$Y still remains constant, and disintegrates at the equilibrium rate. Thus we can say for any time after separation:

Disintegration rate of all $^{90}$Y (equilibrium rate)
   = Disintegration rate of separated $^{90}$Y + Disintegration rate of new $^{90}$Y,
Disintegration rate of separated $^{90}$Y
   = Equilibrium rate × fraction remaining at time $t$,

We note the yttrium beta particles have a high maximum energy (2.27 MeV) for a radionuclide.

Strontium-90 is produced with a high yield in the fission of $^{235}$U (5.8 atoms/ 100 fissions). It is one of the most important constituents of fallout from nuclear weapons tests, producing population exposure primarily from ingestion of contaminated milk and milk products. It is the most important and most hazardous constituent of aged radioactive wastes from nuclear power plants.

Almost all the strontium (99 percent) retained by the body ends up in the skeleton. The chemistry and metabolism of strontium are very much like that of calcium, since these nuclides are in the same family in the periodic table. One group of experiments gave the following data following intravenous injections of $^{85}$SrCl$_2$ in humans: 73 percent was eliminated with a half-life of 3 days; 10 percent was eliminated with a half-life of 44 days. The remaining 17 percent became fixed in the body—at least over the time period studied. A nominal value for the biological half-life of $^{90}$Sr in bone is $1.8 \times 10^4$ days. The effective half-life is thus $6.4 \times 10^3$ days (ICRP, 1968, Publication 10).

A measure of the dose from $^{90}$Sr can be obtained by determining the total energy emitted in the skeleton over a period of time and dividing it by the mass of the skeleton. More refined calculations evaluate the dose only to the radiation sensitive parts of the skeleton, such as, the bone marrow and bone-forming cells. These are contained within a complex matrix in the skelton. The dose to the marrow may be one-third of the actual absorbed dose averaged over the skeleton. In addition, bone is a dynamic structure and is continuously being remodeled. Calcium, accompanied by strontium, is released from certain sections and incorporated into newly formed bone in other sections. The strontium that is ingested is not deposited uniformly over the skeleton but is incorporated into those regions where bone is being produced. This can result in high local dose rates, several times higher than those calculated by determining an average value over the skeleton. Certain models for dosimetry consider the strontium-calcium ratio rather than the $^{90}$Sr activity alone. The analysis takes into account the discrimination in favor of calcium over strontium retention in the body and makes use of an Observed Ratio, the Sr/Ca ratio in bone relative to Sr/Ca ratio in the diet (UNSCEAR, 1962). This is of the order of 0.25.

---

Disintegration rate of new $^{90}$Y
    = Equilibrium rate − disintegration rate of separated $^{90}$Y,
Disintegration rate of new $^{90}$Y
    = Equilibrium rate − Equilibrium rate × f = Equilibrium rate $(1 - f)$,

where $f$ (fraction remaining) is calculated from the $^{90}$Y half-lives elapsed after starting with pure $^{90}$Sr. Alternatively, we may write the exact mathematical expression for the fractional buildup to the equilibrium activity as $(1 - e^{-0.693t/T^h})$ where $T^h$ is the half-life of the $^{90}$Y.

*Example 27:* What is the expected dose to the skeleton in 13 weeks and in 1 year from ingesting 10 $\mu$Ci of $^{90}$Sr, assuming 9 percent becomes fixed in bone?

| | |
|---|---|
| Fraction reaching bone | 0.09 |
| Activity initially in bone | 0.9 $\mu$Ci |
| Mass of skeleton | 7000 g |
| Effective half-life | 17.5 yr (6400 days) |
| Effective average life | 25.2 yr (9200 days) |
| Effective decay constant | 0.0397/yr |

$$\text{Initial daily dose rate} = 51 \times \frac{0.9}{7000} \times 1.1 = 0.0072 \text{ rad/day}.$$

$$\text{Beta dose} = 73.8 \times \frac{0.9}{7000} \times 1.1 \times 6400 = 66.8 \text{ rad}.$$

The total dose of 66.8 rad would be delivered over several effective half-lives, with a duration longer than the lifetime of the exposed individual. Because of the long effective half-life, the dose rate may be considered essentially constant for periods of several months. Thus the total dose in the first 13 weeks (91 days) equals 7.2 mrad/day × 91 days = 655 mrad. By the end of the first year, the activity is 0.961 of the original activity. The average activity during any year is approximately 0.98 the activity at the beginning of the year. The dose during the first year is then 0.98 × 7.2 × 365 = 2575 mrad.

We have neglected the dose from pools with rapid turnover in this calculation. We have also not considered the possible variations in dose throughout the regions that take up strontium. The analysis is complicated and beyond the scope of this treatment. However, even when the dose pattern is determined, interpretation of the findings is still largely speculative on the basis of present radiobiological knowledge. An excellent discussion of the detailed dosimetry of bone seekers is given by Spiers (1968).

Maximum allowable concentrations of bone seekers are generally determined, not on the basis of dose calculations but by comparing energy emitted by the radionuclide in question with the energy emitted from 0.1 $\mu$Ci of radium-226 fixed in the body and the decay products of radium. This is the maximum permissible body burden for radium. Many individuals with radium body-burdens have been studied, and no cases of bone cancer or other fatal diseases have been found in individuals with several times the 0.1 $\mu$Ci level. In exposure situations as complex as that involving bone seekers, if hazard assignments are possible on the basis of epidemiologic findings, they take precedence over dose calculations.

The decay of radium atoms in the body is followed by the successive decay of a series of decay products with relatively short half-lives. The first decay product is the noble gas radon, with a half-life of 3.83 days. Because of

the average time for decay of the radon atoms (5.5 days), about 70 percent of them leave the body before decaying and giving rise to several more short-lived emitters of both alpha and beta particles. The effective energy deposited in bone by the radium series is 110 MeV. This result takes into account the loss of 70 percent of the radon and also includes a multiplication of the energies of the alpha particles by 10 to weight their increased hazard over that from beta particles. However, animal experiments on the toxicity of some of the beta-emitting bone seekers have indicated that the energy they release should also be increased by some modifying factor because of their deposition patterns. For $^{90}$Sr-Y, a modifying factor of 5 is used.

The maximum body-burden of a bone seeker is then determined as that activity which gives off the same amount of energy absorbed in the body, multiplied by appropriate modifying factors, as the energy absorbed from a body burden of 0.1 $\mu$Ci of radium.

*Example 28:* Estimate a maximum permissible body burden for $^{90}$Sr-Y, on the basis of energy release compared to 0.1 $\mu$Ci of $^{226}$Ra.

| | |
|---|---|
| Average beta energy of $^{90}$Sr-Y per disintegration | 1.1 MeV |
| Modifying factor | 5 |
| Effective energy per disintegration | 5.5 MeV |
| Energy imparted locally per radium disintegration (based on QF of 10 for alpha particles) | 110 MeV |

Maximum permissible body burden for $^{90}$Sr-Y = 0.1 × 110/5.5
= 2 $\mu$Ci.

Because the quality factor has been increased to 20 since the value of the body burden was set, this method for determining the maximum permissible body burden would now give a value of 4 $\mu$Ci.

## 5.4   Xenon-133 (Half-life 5.27 days) and Krypton-85 (Half-life 10.3 yr)

| | $^{133}$Xe | | $^{85}$Kr | |
|---|---|---|---|---|
| | MeV | % | MeV | % |
| Beta particles. Maximum energy and percent of disintegrations. | 0.34 | 100 | 0.15 | 0.4 |
| | | | 0.67 | 99.6 |
| Average beta particle energy per disintegration. | 0.13 | | 0.22 | |
| Gamma photons. Energy and percent of disintegrations. | 0.029-x[17] | 60 | | |
| | 0.081 | 40 | 0.51 | 0.4 |
| | 0.160 | 0.1 | | |
| Gamma constant (R/mCi-hr at 1 cm). | 0.44 | | 0.02 | |

17. X stands for x ray. Results from internal conversion in 60 percent of transitions as compared to 40 percent resulting in emission of 0.081 MeV gamma photons from nucleus.

Krypton-85 is one of the waste products from fission reactors.  Because it is a noble gas, it is difficult to remove, and it is discharged to the atmosphere when it is released from spent reactor fuel elements.  It has caused some concern as a potential environmental pollutant if a large fraction of the nation's power requirements come from nuclear power.

Both $^{85}$Kr and $^{133}$Xe are very useful in nuclear medicine in the diagnosis of lung function and cardiac shunts.  (Similar uses are also being found for cyclotron-produced radioactive gases such as $^{15}$O and $^{13}$N.)  Because it produces a much lower beta dose in the subject for an equivalent external gamma intensity, $^{133}$Xe is favored over $^{85}$Kr as a tracer.

### 5.4.1   Calculation of Beta and Gamma Dose to Surface of Body from Krypton in Air

Consider first exposure from a radioactive gas in the air.  The body is irra-diated externally by both beta particles and gamma rays and is irradiated in-ternally from gas that is brought into the lungs and dissolved in body tissues.

The maximum range of the beta particles in air is 180 cm.  Since an indi-vidual will always be surrounded by a volume of air greater than this max-imum range, he receives the same exposure as if he were immersed in an infinite source of beta radiation.  Because of the low attenuation of the gamma rays in air, the magnitude of the gamma exposure will depend on the extent of the source of radioactive gas.  It will begin to approach that from an infinite source if all the air within a distance of about 200 m is polluted with the gas.  The gamma dose will be much lower than that from an infinite source if the volume is limited, for example, to the size of a laboratory.  The geometry for the dose calculation is different from any we have encountered previously.  The irradiated object is immersed in the source.  Although the solution may appear complex, with a little reasoning we can find a simple way to solve this problem.

Consider first the dose at a point inside a large volume of air, much larger than the half-value layer of gamma rays.  We have then a situation where es-sentially all the energy produced in the volume is absorbed in the volume, except for boundary effects, which are minor in such a large volume.  The energy absorbed per gram of air is equal to the energy produced per gram of air, and the dose to the air is readily determined, as was done previously for beta sources distributed uniformly throughout a region.

Now if we introduce a small mass of tissue into the region, the energy ab-sorption per gram of tissue will be approximately equal to the energy absorp-tion per gram of air because of the similarity in tissue and air absorption for the energies under consideration.  Accordingly the gamma dose to a small mass of tissue within an infinite volume of air will be equal to the dose to the air itself.

If the tissue is of significant size, as in the case of a human being, then the dose will depend on the attenuation of the incident radiation to the dose point of interest.  In particular, the dose on a surface would be reduced by a

factor of 2, if the back side of the surface effectively shielded the radiation incident upon it, and the front of the surface saw essentially an entire half plane. Also, if tissue were next to the ground, only half the dose for an infinite medium would be imparted at the most, because the incident gamma radiation was again limited to the upper half space.

In the case of beta particles, the dose on the surface would be expected to be half the dose in an infinite medium, as betas cannot penetrate through the body. However, beta particles impart energy to tissue at about a 10 percent greater rate per centimeter than in air, and thus the surface dose to tissue from beta particles originating in air would have to be increased by the same amount, relative to the dose to air.

*Example 29:* Calculate the dose rate to the surface of the body from exposure to air containing $10^{-5}$ $\mu$Ci/cc of krypton-85.

Mass of 1 cc air at 20° C, 760 mm = 0.0012 g.
Beta energy emitted per gram air per hour

$$= 10^{-5} \ \mu\text{Ci/cc} \times \frac{1}{0.0012 \ \text{g/cc}} \times 1.32 \times 10^8 \ \text{dis}/\mu\text{Ci-hr}$$

$$\times \ 0.22 \ \text{MeV(av)/dis} = 2.42 \times 10^5 \ \text{MeV/g-hr}.$$

Beta dose rate to air $= \dfrac{2.42 \times 10^5}{62{,}400} = 3.87$ mrad/hr.

Mass stopping power tissue relative to air = 1.13.

Beta dose rate to tissue $= \dfrac{1.13 \times 3.87}{2} = 2.19$ mrad/hr.

Gamma energy emitted per disintegration = $0.51 \times 0.004$
$$= 2.04 \times 10^{-3} \ \text{MeV}.$$

Gamma dose rate to air $= 10^{-5} \times \dfrac{1}{0.0012} \times 1.32 \times 10^8$

$$\times \ 2.04 \times 10^{-3} \times \frac{1}{62{,}400} = 0.036 \ \text{mrad/hr}.$$

Gamma dose rate to tissue (assuming roughly that tissue receives half the air dose) = 0.018 mrad/hr.
Total dose rate from beta and gamma radiation = 2.21 mrad/hr.

This gives 88 mrad per 40-hr week. The concentration of $10^{-5}$ $\mu$Ci/cc is the Maximum Occupational Level for [85]Kr, obtained by rounding off from the level that gives 100 mrad/40 hr week.

### 5.4.2 Calculation of Dose from Krypton Inhaled into Lungs

Let us now evaluate the dose to the lungs when air containing [85]Kr is inhaled. We shall use the following model for the calculations.

The volume of inspired air in a single breath (called the tidal volume) is

600 cc, and 450 cc of this reaches the alveolar region of the lungs, where it mixes with 2500 cc of air available for exchange with the blood. This air is distributed through a lung mass of 1000 g. The remaining 150 cc is confined to the "dead space," consisting of the nasal passages, trachea, and larger bronchi preceding the alveolar region.

There are several ways to evaluate the dose to the lungs from breathing krypton, ranging from simple algebraic considerations to the use of calculus. As an example, consider the following simplified breathing pattern applied to a single breath of air containing krypton followed by breathing of nonradioactive air:

($a$) Instantaneous inhalation of tidal volume with concentration of krypton $= C$ and retention of gas in lung for time $\tau$.

($b$) Instantaneous exhalation after time $\tau$.

($c$) Immediate inhalation of nonradioactive air and retention for period $\tau$.

($d$) Continued washout of krypton by repeating the same breathing pattern.

We note that when air containing krypton is expired from the lungs, a portion is retained in the dead space and inspired in the next cycle along with an amount of nonradioactive air given by the tidal volume less the dead space volume.

Let $V_A$ = alveolar air volume (that is, excluding dead space) following exhalation.

$V_T$ = tidal volume.

$V_D$ = dead space volume.

In the first breath the alveolar region takes in an amount of krypton, $C (V_T - V_D)$ and receives an exposure proportional to $C (V_T - V_D) \tau$.

After exhalation and inspiration of nonradioactive air, the krypton activity is $C (V_T - V_D) \dfrac{V_A + V_D}{V_A + V_T}$, and the exposure is proportional to $C (V_T - V_D) \dfrac{V_A + V_D}{V_A + V_T} \tau$. The exposure accumulates in successive breaths according to the relationship

$$C (V_T - V_D) \tau \left[ 1 + \frac{V_A + V_D}{V_A + V_T} + \left(\frac{V_A + V_D}{V_A + V_T}\right)^2 + \left(\frac{V_A + V_D}{V_A + V_T}\right)^3 + \cdots \right]$$

$$= C (V_T - V_D) \tau \frac{1}{1 - \dfrac{V_A + V_D}{V_A + V_T}}$$

$$= C \tau (V_A + V_T).$$

Another approach is to consider the fractional loss per unit time as given by $\left(\dfrac{V_T - V_D}{V_A + V_T}\right) \dfrac{1}{\tau}$. This is equivalent to the decay constant, $\lambda$, so the average time in the lungs is given by $\dfrac{1}{\lambda}$ or $\tau \left(\dfrac{V_A + V_T}{V_T - V_D}\right)$.

Thus, the total exposure is proportional to the original activity in the lungs times the average life, or $C (V_T - V_D) \left(\dfrac{V_A + V_T}{V_T - V_D}\right) \tau = C \tau (V_A + V_T)$, the same as the result obtained by the previous methods.

This result may be generalized to any type of breathing pattern if $V_A + V_T$ is replaced by the average volume of air in the alveolar region during a breathing cycle and $\tau$ is the time interval between successive breaths. In this treatment, we have assumed that the physical average life is long compared to the biological average life. If the physical and biological average lives are comparable, the effective average life must be used.

*Example 30:* Calculate the dose to the alveolar region from a single breath of air containing a concentration of 1 $\mu$Ci/cc.

At end of first inspiration
| | |
|---|---|
| Activity in alveolar region | 450 $\mu$Ci. |
| Activity in dead space | 150 $\mu$Ci. |
| Volume of air in alveolar region | 2500 + 600 = 3100 cc. |
| Concentration of activity in alveolar region | 450/3100 = 0.145 $\mu$Ci/cc. |

At end of first expiration
| | |
|---|---|
| Fractional activity exhaled from alveolar region | 600/3100 = 0.19. |
| Fractional activity retained in alveolar region | 2500/3100 = 0.81. |
| Activity in alveolar region | 0.81 × 450 = 364. |
| Activity in dead space | 0.145 × 150 = 21.8. |

In succeeding breaths, we shall assume the inhaled air does not contain $^{85}$Kr. However a small amount of $^{85}$Kr is carried into the alveolar region by the air in the dead space of the lungs.

At the end of second inspiration (occurs at essentially same time as end of first expiration in our model)
| | |
|---|---|
| Activity in alveolar region | 364 + 21.8 = 386 or 0.855 of initial activity. |
| Activity in dead space | 0. |

At end of second expiration
| | |
|---|---|
| Activity in alveolar region | 386 × 2500/3100 = 311. |
| Activity in dead space | 386 × 150/3100 = 18.7. |

At end of third inspiration
| | |
|---|---|
| Activity in alveolar region | 330, or 0.855 of previous activity. |

We see the activity drops to 0.855 of its previous activity in each breath. If we assume the subject is taking 16 breaths per minute, the duration of a single breath is 1/16 min and the dose during the first breath is

$$\frac{450 \times 2.22 \times 10^6 \times 0.22 \times 1/16}{1000 \times 62400} = 0.22 \text{ mrad.}$$

The total dose $= 0.22 + 0.855 \times 0.22 + (0.855)^2 \times 0.22 + \cdots$

$$= 0.22 \left(\frac{1}{1 - 0.855}\right) = 1.52 \text{ mrad.}$$

The same result would be obtained with the aid of the formulas preceding the example.

The calculation of the dose from a single breath is of interest when krypton is administered to a patient in a medical test. The dose from taking several breaths is obtained by adding the contributions of the individual breaths.

When one is exposed to krypton in the environment, it is, of course, being breathed in continuously, and the levels in the lungs will rise until a maximum concentration will be reached which is equal to the concentration in the inspired air. The time to reach essential equilibrium with the concentration in the air is practically a few effective half-lives. For inhaling any inert gas, we see that this would take just a minute or so. Under these conditions, the calculation of the dose rate is very simple. The concentration in the lungs is equal to the concentration in the air, and for the conditions we have been using, it is thus 1 $\mu$Ci/cc. The dose rate to the lungs is

$$1 \ \mu\text{Ci/cc} \times \frac{3100 \text{ cc}}{1000 \text{ g}} \times 2.2 \times 10^6/\text{min-}\mu\text{Ci} \times 0.22 \text{ MeV}$$

$$\times \frac{1}{62,400 \text{ MeV/g-mrad}} = 24 \text{ mrad/min.}$$

In our calculations, we have neglected the gamma dose from krypton in the lungs. Because gamma photons are given off in only 0.4 percent of the disintegrations, the gamma dose is negligible compared to the beta dose.

### 5.4.3 Dose to Tissues from Inhalation of a Radioactive Gas

Radioactive gas is transferred from the lungs to the tissues by the blood. The blood leaving the lungs contains gas in equilibrium with the gas in the lungs, and, as the blood flows through the tissues, the dissolved gas transfers to the tissues. The concentration builds up to a value given by the relative solubility in the tissues versus the blood. The speed with which the equilibrium value is reached is given by the rate of flow through the tissues and the solubility. Intuition tells us that for insoluble radioactive gases, the doses to the

tissues will be much less than the dose to the lungs. The degree of difference can be determined by the following analysis.

We assume that as the blood leaves the lungs, the concentration of gas in the blood is in equilibrium with the gas concentration in the air in the alveolar region. Thus, we can write

$$\begin{pmatrix} \text{Concentration in} \\ \text{blood leaving lungs} \end{pmatrix} = \begin{pmatrix} \text{solubility coefficient} \\ \text{for blood} \end{pmatrix} \times \begin{pmatrix} \text{concentration in} \\ \text{gas in alveoli} \end{pmatrix}$$
$$C_b^l \qquad = \qquad \alpha_b \qquad \times \qquad C_g^A.$$

The gas diffuses from the blood into the body tissues permeated by the blood. If we know the concentration of gas in the blood as it enters the tissue and the reduced concentration upon leaving, then the difference represents the flow into the tissues. If we multiply the difference by the blood flow per unit volume of tissue, we obtain the rate of increase in gas concentration in tissue. Mathematically, we can write

$$\begin{matrix} \text{rate of change} \\ \text{of gas concen-} \\ \text{tration in} \\ \text{tissue} \end{matrix} = \begin{matrix} \text{blood flow} \\ \text{per unit} \\ \text{volume of} \\ \text{tissue} \end{matrix} \begin{pmatrix} \text{gas concen-} \\ \text{tration in} \\ \text{blood leaving} \\ \text{lungs} \end{pmatrix} \begin{matrix} \text{gas concentration} \\ \text{in blood leaving} \\ \text{tissue} \end{matrix}$$

$$\frac{dC_v}{dt} \qquad = \qquad f_b^v \qquad \times \qquad (C_b^l \qquad - \qquad C_b^v).$$

The concentration of gas in the blood leaving the tissue may be considered to be in equilibrium with the concentration of gas in the tissue. Thus

$$\begin{matrix} \text{concentration} \\ \text{in tissue} \end{matrix} = \begin{matrix} \text{partition coefficient} \\ \text{between tissue and} \\ \text{blood} \end{matrix} \times \begin{matrix} \text{concentration in} \\ \text{blood leaving} \\ \text{tissue} \end{matrix}$$

$$C_v \qquad = \qquad \frac{\alpha_v}{\alpha_b} \qquad \times \qquad C_b^v$$

Substituting for $C_b^v$ in the previous equation,

$$\frac{dC_v}{dt} = f_b^v \left( C_b^l - \frac{\alpha_b}{\alpha_v} C_v \right).$$

The concentration in the tissues will increase until there is no net flow between blood and tissue, that is, until

$$C_b^v = C_b^l \text{ and } \frac{dC_v}{dt} = 0.$$

Under these conditions,

$$C_v = \frac{\alpha_v}{\alpha_b} C_b^l.$$

Substituting for $C_b^L$

$$C_v = \alpha_v \, C_g^A .$$

*Example 31:* A patient breathes air containing 1 $\mu$Ci/cc $^{133}$Xe for 2 minutes in a lung-function test. Calculate the beta dose to the lungs and other tissues in the body resulting from the solubility of xenon in these tissues.

| | |
|---|---|
| Mass of lungs | 1000 g |
| Average beta energy | 0.13 MeV |
| Solubility coefficient ($\alpha_v$) | |
|     fatty tissue: air | 1.7 |
|     nonfat tissue: air | 0.13 |

Assume lung and tissue exposure results from equilibration with an air concentration of 1 $\mu$Ci/cc for 2 minutes. (This assumption may be shown to be valid by a mathematical treatment in which the gas equilibrates in an exponential manner (Lassen, 1964). The activity/cc of nonfat tissue is

$$\overset{C_g^A}{1} \times \overset{\alpha_v}{0.13} = 0.13 \ \mu\text{Ci/cc}.$$

Assuming a density of 1 g/cc, the nonfat tissue is exposed to an activity of 0.13 $\mu$Ci/g for 2 min. The dose is

$$0.13 \times 2.22 \times 10^6 \times 0.13 \times 2 \div 62{,}400 = 1.2 \text{ mrad.}$$

The dose to fatty tissue would be greater by the ratio of the solubility coefficients, or $(1.7/0.13) \times 1.2 = 15.7$ mrad.

The average dose to the lungs is

$$\frac{1 \ \mu\text{Ci/cc} \times 3100 \text{ cc} \times 2.22 \times 10^6 \text{ dis/min-}\mu\text{Ci} \times 0.13 \text{ MeV} \times 2 \text{ min}}{1000 \text{ g} \times 62{,}400 \text{ MeV/g-mrad}}$$

$$= 30.4 \text{ mrad.}$$

In diagnostic tests, instead of administering the gas through inhalation, it may be dissolved in physiological solution and injected intravenously over a brief period of time. For this procedure, we assume that all the gas is released to the alveolar region in the lungs, on passing through, and maintains equilibrium with the gas in the blood in the pulmonary capillaries. Its level in the blood then falls off in the same way as the concentration in the lungs as the lung-air exchanges with clean inspired air. Dosimetry for this and other conditions of administration is treated by Lassen (1964).

## 5.5  Uranium-238 ($\alpha$, 4.5 × 10$^9$ yr) → $^{234}$Th ($\beta$, 24 day) → $^{234m}$Pa ($\beta$, 1 min) → $^{234}$U ($\alpha$, 2.47 × 10$^5$ yr) → $^{230}$Th ($\alpha$, 8 × 10$^4$ yr) → $^{226}$Ra ($\alpha$, 1602 yr) → $^{222}$Rn ($\alpha$) →

Alpha particles: energies and percent of disintegration

| | $^{238}$U | | $^{234}$U | | $^{235}$U | | $^{230}$Th | | $^{226}$Ra | |
|---|---|---|---|---|---|---|---|---|---|---|
| | MeV | % | MeV | % | MeV | % | MeV | % | MeV | % |
| | 4.20 | 75 | 4.77 | 72 | 4.4 | 100 | 4.68 | 76 | 4.78 | 95 |
| | 4.15 | 25 | 4.72 | 28 | (av.) | | 4.62 | 24 | 4.60 | 5 |

| Specific activity ($\mu$Ci/mg) | $^{238}$U | $^{234}$U | $^{235}$U | $^{230}$Th | $^{226}$Ra |
|---|---|---|---|---|---|
| | 3.34 × 10$^{-4}$ | 6.19 | 2.14 × 10$^{-3}$ | 19.4 | 1000 |

Uranium is a naturally occurring primordial radionuclide; that is, it was one of the elements created after the big bang (part I) and is the last naturally occurring element in the periodic table.  Natural uranium consists of $^{238}$U (99.27%), $^{235}$U (0.72%), and $^{234}$U (0.0054%) (based on equilibrium with $^{238}$U). The ICRP definition of a special curie of natural uranium is 3.7 × 10$^{10}$ dis/sec of $^{238}$U, 3.7 × 10$^{10}$ dis/sec of $^{234}$U, and 1.7 × 10$^9$ dis/sec of $^{235}$U.  The decay of the $^{238}$U nucleus by alpha emission is followed after two beta decays by the decay of uranium, thorium, and radium nuclei in succession, all by alpha emission.  Radium decays to radon, an alpha-emitting noble gas with a half-life of 3.82 days.  The radon may decay in the ground or it may diffuse out to the air before it undergoes an additional series of decays (discussed in the next section), including three by alpha emission.  Thus, the uranium series is responsible for significant contamination of the environment with alpha radioactivity.

The normal daily intake of uranium by an adult male is 1.9 $\mu$g, with a resultant equilibrium body content of 90 $\mu$g.  The distribution is 66 percent in the skeleton and 34 percent in soft tissue (7.8 percent in the kidneys) (ICRP, 1975, Report 23).  The uptake to blood following ingestion is 0.05 for water soluble inorganic compounds (hexavalent uranium) and 0.002 for insoluble compounds ($UF_4$, $UO_2$, $U_3O_8$, usually tetravalent uranium) (ICRP, 1976; ICRP, 1979a; ICRP, 1988).

The long-term retention in bone and kidney following unit uptake to blood is given by the following equations (ICRP, 1979a). (The first one says that 20 percent is retained with an effective half-life of 20 days and 2.3 percent with an effective half-life of 5000 days.)

$$R_{bone}(t) = 0.20 \, e^{-0.693t/20} + 0.023 \, e^{-0.693t/5000}$$
$$R_{kidney} = 0.12 \, e^{-0.693t/6} + 0.00052 \, e^{-0.693t/1500}; \ t \text{ in days.}$$

The thorium-232 series is the other major source of alpha radioactivity in humans. The normal daily intake is 3 $\mu$g, and the content of mineral bone is 30 $\mu$g. The uptake to blood following ingestion is 0.001. Retention in bone following unit uptake to blood is given by the equation

$$R_{bone} = 0.70 \, e^{-0.693t/8000} \, ; \, t \text{ in days.}$$

*Example 32:* The intake of natural uranium in soluble form is limited by its chemical toxicity to the kidney rather than by the radiation dose. The Nuclear Regulatory Commission in its proposed revision to 10CFR20 lists the occupational limit of intake of soluble uranium as 10 milligrams in a week in consideration of its chemical toxicity. Calculate the annual alpha dose to bone (7000 g) from ingestion at this limit. Assume 5 percent of the ingested soluble uranium reaches the blood.

The activity of a daily intake of 2 mg is:

$^{238}$U, 2 mg $\times$ 0.9927 $\times$ 3.34 $\times$ $10^{-4}$ $\mu$Ci/mg = 0.00067 $\mu$Ci, 4.19 MeV $\alpha$.
$^{234}$U, 2 mg $\times$ 5.4 $\times$ $10^{-5}$ $\times$ 6.19 $\mu$Ci/mg = 0.00067 $\mu$Ci, 4.76 MeV $\alpha$.
$^{235}$U, 2 mg $\times$ 0.0072 $\times$ 2.14 $\times$ $10^{-3}$ $\mu$Ci/mg = 3.07 $\times$ $10^{-5}$ $\mu$Ci, 4.4 MeV $\alpha$.

The total activity is 0.00136 $\mu$Ci and the average alpha particle energy is 4.47 MeV.

The contribution of the short-lived component to the annual dose from daily ingestion for 50 weeks, 5 days per week, will be 73.8 $\times$ (0.00136 $\times$ 0.05 $\times$ 0.20)/7000 $\mu$Ci/g $\times$ 4.47 MeV $\times$ 20 day $\times$ 250 day = 0.0032 rad or 0.064 rem (QF = 20). If a distribution factor (DF) of 5 is assumed, the calculated dose equivalent is 0.32 rem. The total committed dose from the long-lived component following intake for one year is 0.00037 $\times$ 250 = 0.093 rad and the actual amount imparted in the first following year would be approximately 0.093 (1 $-$ $0.5^{365/5000}$) = 0.0045 rad (0.45 rem) or a dose about 50 percent greater than the dose from the short-lived component. If the uranium is in insoluble form (that is, $UO_2$, $U_3O_8$), the uptake from the GI tract is only 4 percent of the soluble form and the dose will be correspondingly less.

### 5.5.1 Radium-226 ($\alpha$, 1602 yr) $\rightarrow$

The normal daily intake of radium by an adult male is 2.3 pCi with a resultant equilibrium body content of 31 pCi (31 pg). The distribution is 87 percent in the skeleton and 15 percent in soft tissue (4.5 percent in muscle). The uptake to blood following ingestion is 0.2. The long-term retention in bone following unit uptake to blood is given by the equation

$$R_s(t) = 0.54e^{-0.693t/0.4} + 0.29e^{-0.693t/5} + 0.11e^{-0.693t/60}$$
$$+ \, 0.04e^{-0.693t/700} + 0.02e^{-0.693t/5000};$$

$t$ in days (ICRP, 1988, Publication 54).

From the decay series presented under uranium, we see that radium is a decay product of uranium and is in radioactive equilibrium with it on a global basis. However it is much more water soluble, and thus is leached out of the soil by groundwater and makes its way to drinking water and food. The actual concentrations vary greatly in different locations and different foods. Radium in the body becomes incorporated in bone where it remains virtually indefinitely.

The maximum permissible level for radium in the body is based on epidemiologic data. From studies of hundreds of persons who had accumulated radium in their bones occupationally or medically, it was determined that an acceptable radium level was 0.1 $\mu$g fixed in the body. This limit has served as a basis for setting limits for other bone seekers. One approach is to determine levels of other bone seekers that give the same effects in animals as does radium. The other is on the basis of dose. The International Commission on Radiological Protection has recommended that (ICRP, 1960) "the effective RBE dose delivered to the bone from internal or external radiation during any 13-week period averaged over the entire skeleton shall not exceed the average RBE dose to the skeleton due to a body burden of 0.1 $\mu$Ci of $^{226}$Ra" (p. 3). The associated dose rate is 0.06 rad/week.

The dose rate is obtained by assuming that 99 percent of the radium in the body is in the bone, the mass irradiated is 7000 g, and 30 percent of the radon and decay products are retained in bone (ICRP, 1959).

**5.6**   → **Radon-222 ($\alpha$, 3.825 day)** → $^{218}$**Po ($\alpha$, 3.05 Min)** → $^{214}$**Pb ($\beta$, 26.8 min)** → $^{214}$**Bi ($\beta$, 19.7 min)** → $^{214}$**Po ($\alpha$, 1.64 $\times$ 10$^{-4}$ sec)** → $^{210}$**Pb ($\beta$, 22 yr)** → $^{210}$**Bi ($\beta$, 5 day)** → $^{210}$**Po ($\alpha$, 138 day)** → $^{206}$**Pb (stable)**

The radioactive noble gas radon-222 is produced continuously from the decay of radium in the ground. It dissolves in groundwater which often carries it in high concentrations and releases it to areas inhabited by humans. It diffuses readily through soil and into the atmosphere. Thus it is always present in the air at levels which are determined by local geology and meteorology. It imparts the highest organ dose (to the lungs) of any radioactive environmental contaminant.

Large quantities of radon are emitted to the environment from radium-containing wastes produced at uranium mills. The radium is left behind in the wastes, known as mill tailings, after the uranium is extracted from the ore. These wastes are often piled up in huge mounds, tens of meters high. Mill tailings have also been used as fill and in the construction of foundations for residential and commercial buildings, producing dramatic increases in radiation and radon levels.

The hazards of radon were first suspected in the 1930s when a high incidence of lung cancer was discovered among miners working in the radium mines of Schneeberg, Germany, and Joachimstal, Czechoslovakia. Over half the deaths of the miners were from lung cancers and most occurred before the miners had reached 50 years of age.

Because high levels of radon gas occurred in these mines, attention was turned to the alpha dose to the lungs from inhaled radon and its short-lived decay products as the possible causes. The radiations emitted are shown in table 3.7.

Early dose calculations (Evans and Goodman, 1940) were based on energy imparted to the lung by the alpha particles from radon itself and from the decay products of the radon molecules decaying in the lung. The doses did not seem to have been high enough to produce the lung cancers. In 1951 Bale pointed out that the "radiation dosage due to the disintegration products of radon present in the air under most conditions where radon itself is present conceivably and likely will far exceed the radiation dosage due to radon itself and to disintegration products formed while the radon is in the bronchi. This additional dosage is associated with the fact that disintegration products of radon remain suspended in the air for a long time; tend to collect on any suspended dust particles in the air; and that the human respiratory apparatus probably clears dust from air, and the attached radon disintegration products, with reasonable efficiency" (Bale, 1951). Bale calculated an average dose to the lungs by dividing the alpha energy released by the decay products deposited by the mass of the lung. This was followed up by a detailed theoretical and experimental study of the mean dose imparted to the lungs and the dose imparted locally to various portions of the respiratory tract for a variety of atmospheres containing radon. Simplified sampling procedures were developed for radon and its decay products (Shapiro, 1954; Bale and Shapiro, 1955; Shapiro, 1956a,b; Burgess and Shapiro, 1968). The MPC for radon and its decay products was based quite considerably on these data and on the work of Chamberlain and Dyson, 1956 (ICRP, 1966).

**Table 3.7.** Radiations from radon and its decay products.

| Radionuclide | Half-life | Major radiation energies (MeV) and percent of disintegrations | | |
| | | $\alpha$ | $\beta$ | $\gamma$ |
| --- | --- | --- | --- | --- |
| Radon-222 ($^{222}$Rn) | 3.823 day | 5.49 (100%) | | |
| Polonium-218 ($^{218}$Po) | 3.05 min | 6.00 (100%) | | |
| Lead-214 ($^{214}$Pb) | 26.8 min | | 0.65–0.98 | 0.295 (19%) |
| | | | | .352 (36%) |
| Bismuth-214 ($^{214}$Bi) | 19.7 min | | 1.0–3.26 | .609 (17%) |
| | | | | 1.120 (17%) |
| | | | | 1.764 (17%) |
| Polonium-214 ($^{214}$Po) | 164 $\mu$sec | 7.6 (100%) | | |
| Lead-210 ($^{210}$Pb) | 21 yr | | 0.016–0.061 | .047 (4%) |
| Bismuth-210 ($^{210}$Bi) | 5 day | | 1.161 (100%) | |
| Polonium-210 ($^{210}$Po) | 138 day | 5.31 (100%) | | |
| Lead-206 ($^{206}$Pb) | Stable | | | |

*Source:* BRH, 1970.

Consider an enclosed volume containing radon at a typical atmospheric concentration of 100 pCi/m$^3$. All of the short-lived decay products will be in equilibrium with the radon and thus will have the same activity as the radon in the volume.[18] A fraction of them will be attached to the surface of the enclosure so the airborne activity concentrations will be somewhat less than 100 pCi/m$^3$, depending on the dust loading, air motions, and so on. (Clean air vigorously stirred would favor deposition on the surface rather than suspension in air.)

It is a good first approximation to assume that any atom of the short-lived decay products that is deposited in the lung will decay in the lung. The energies of the $^{218}$Po and $^{214}$Po alpha particles are 6.00 MeV and 7.69 MeV respectively. Every $^{218}$Po atom deposited will lead to the release of 6 + 7.69 = 13.69 MeV of alpha energy. Every $^{214}$Pb, $^{214}$Bi, and $^{214}$Po atom deposited will lead to the release of 7.69 MeV of alpha energy. The total alpha energy emitted in the lungs by the decay product per cubic meter of air inhaled is equal to the number of atoms of each of the decay radionuclides of concern per cubic meter times the fraction of those atoms deposited in the lungs times the alpha energy associated with the decay of each of the radionuclides.

*Example 33:* Calculate the energy released in the lungs from deposition of the short-lived decay products in equilibrium with 100 pCi of $^{222}$Rn.

The number of $^{218}$Po atoms ($T^h$ = 3.05 m) = 100 pCi × 2.22 min$^{-1}$ pCi$^{-1}$ × 1.44 × 3.05 min = 975. Similar calculations for $^{214}$Pb, $^{214}$Bi, and $^{214}$Po give 8567, 6298, and 0.0009 atoms respectively. Therefore, the total alpha energy associated with the decay of 100 pCi of the short-lived radionuclides = 975 × 13.69 + (8567 + 6298) × 7.69 = 1.3 × 10$^5$ MeV.

*Example 34:* Calculate the average dose to the lungs from one year's exposure to the short-lived decay products in equilibrium with 100 pCi/m$^3$ of $^{222}$Rn.

Assume a total daily inhalation volume (adult male) of 23 m$^3$ (ICRP, 1975, Publication 23, p. 346), a lung mass of 1000 g, and an average deposition (and retention) of 25 percent (Shapiro, 1956a). The total alpha energy absorbed in the lungs per year is $\dfrac{365 \text{ days}}{\text{yr}} \times \dfrac{23 \text{ m}^3}{\text{day}} \times 0.25 \times \dfrac{1.3 \times 10^5 \text{ MeV}}{\text{m}^3}$ = 2.73 × 10$^8$ MeV. The average annual absorbed dose to the lungs = $\dfrac{2.73 \times 10^8 \text{ MeV}}{1000 \text{ g} \times 62{,}400 \text{ MeV/g-mrad}}$ = 4.36 mrad.

18. See section 5.3 on $^{90}$Sr-$^{90}$Y and note 16 for discussion of equilibrium.

The Working Level is defined as any combination of short-lived radon decay products (through $^{214}$Po) per liter of air that will result in the emission of $1.3 \times 10^5$ MeV of alpha energy. From the preceding example, this is the alpha energy released when all the short-lived decay products in equilibrium with 100 pCi of $^{222}$Rn undergo decay. The Working Level is characteristic of radon levels in uranium mines (100 pCi/l) and is 1000 times as high as the value used in the previous example as characteristic of naturally occuring radon levels. A person exposed to 1 WL for 170 hr is said to have acquired an exposure of one Working Level Month (WLM). The Working Level (WL) and Working Level Month (WLM) are the units used for expressing occupational exposure to radon, and most risk assessments are based on the direct relationship between lung cancer incidence among miners and exposure as experienced in WLM. Original exposure standards allowed for an annual exposure of 12 WLM. Current standards call for 4 WLM per year.

*Example 35:* Calculate the mean dose to the lungs from exposure to 1 WLM of radon decay products.

The same approach is used as in example 31. Assume 9600 l/air are breathed during an 8-hour working day and 25 percent of the decay products are retained.

$$\frac{1.3 \times 10^5 \text{ MeV}}{\text{WL-l}} \times 0.25 \times \frac{1}{1000 \text{ g}} \times \frac{\text{g-mrad}}{62,400 \text{ MeV}}$$

$$= 5.2 \times 10^{-4} \text{ mrad/WL-l}.$$

$$\frac{5.2 \times 10^{-4} \text{ mrad}}{\text{WL-l}} \times \frac{9600 \text{ l}}{8 \text{ hr}} \times \frac{170 \text{ hr}}{\text{month}} = 106 \text{ mrad/WLM}.$$

Doses to individual regions of the lung vary greatly from the mean dose because of the anatomy of the respiratory tract (fig. 3.3). The lung passageways make up a complex labyrinth of tubes that branch out from the trachea (windpipe) to hundreds of thousands of successively smaller tubes (bronchioles) to millions of tiny ducts at the end that terminate in tiny sacs or alveoli with walls one cell thick. These serve as partitions between air and blood through which oxygen, carbon dioxide, and other gases pass in and out of the body. The largest particles in the inspired air do not get very far; many are filtered by the hairs lining the nasal passageways. In fact, particles with dimensions larger than 5 microns are considered as nonrespirable. The smaller particles are deposited in varying degrees as they proceed down the tract, some by settling under the influence of gravity, some by impacting against the sides as the air makes sharp turns from one branch to another, and the smallest by diffusing to the walls and sticking. A fraction of those of appropriate size will actually reach the alveolar region. Replicas of the respiratory passages have been cast from lung specimens and detailed measurements made of passageway dimensions. The data have been used

**Fig. 3.3** Front view of the trachea and bronchi. *Source:* Gray, 1977.

to develop idealized models of the respiratory tract that have been used to calculate deposition and dose distributions for various types of radioactive aerosols and breathing patterns. (Findeisen, 1935; Landahl, 1950; Weibel, 1963).

Published dose calculations have been performed with increasing degrees of sophistication. Early approaches assumed that the deposited particles remained at the point of deposition and that all the emitted alpha energy was absorbed by the tissue at risk (Shapiro, 1954). Subsequently, account was taken of absorption of some of the alpha energy by the mucous lining the passageways, and the clearance of particles through transport by the mucous back up the respiratory tree to the mouth where they were swallowed and largely excreted. (Jacobi and Eisfeld, 1981; Altshuler et al., 1964; Jacobi, 1964; James et al., 1980; Harley and Pasternack, 1972; Burgess and Shapiro, 1968.)

There are no cilia in the alveoli; other means are used to remove particles deposited there. Some particles will dissolve in regional fluids and be transferred to the blood from which they may be taken up by cells or excreted. Others may be absorbed by mobile cells known as macrophages and carried away, generally to lymph nodes. Others may resist all methods that can be mobilized for clearance and remain in place for very long periods of time. While alveolar clearance is very important in determining the dose from radioactivity of long half-life, the significance is minor when considering the radon decay products with half-lives which are of the order of tens of minutes.

The different calculation methods result in different values for doses to the various portions of the respiratory tract. Since lung cancer among uranium miners appears primarily in the area of the large bronchi and presumably

originates in the basal cells of the upper bronchial epithelium, there is particular interest in the dose to this region. Calculations by various investigators of the dose varies from 0.2–10 rad/WLM. A nominal value for the dose from a typical mining atmosphere is one rad per WLM. Some of the results of individual calculations are given in table 3.8.

## 5.7 Plutonium-239 (Half-life 24,390 yr) and Plutonium-240 (Half-life 6,600 yr)

|  | $^{239}$Pu | | $^{240}$Pu | |
|---|---|---|---|---|
|  | MeV | % | MeV | % |
| Alpha particles. Energies and percent of dis- | 5.16 | 88 | 5.17 | 76 |
| integrations. | 5.11 | 11 | 5.12 | 24 |
| Gamma photons. | (see Radiological Health Handbook) | | | |

Plutonium-239 is used as fuel in nuclear power reactors and as the explosive for nuclear weapons. Reactor-grade plutonium is roughly 70 percent $^{239}$Pu and 30 percent $^{240}$Pu. Weapons-grade plutonium is roughly 93 percent $^{239}$Pu and 7 percent $^{240}$Pu. A liquid-metal fueled fast-breed reactor could contain 3,000 kg of plutonium. One scenario for meeting the nation's power requirements projects an annual production rate of $^{239}$Pu from about 20,000 kg in the 1970 to 1980 period to 60,000 kg in the 1980 to 1990 decade and to 80,000 kg in the 1990 to 2000 period.

Only 0.003 percent of ingested plutonium is considered to be transferred from the GI tract to the blood. The resultant fractional retention in organs is (ICRP, 1979a): $0.45\ e^{-0.69t/37,000}$ in bone; $0.45\ e^{-0.693t/37,000}$ in liver; $0.1\ e^{-0.693t/0.3}$ excreted; and 0.00035 in testes ($t$ in days).

### 5.7.1 Dose to Lungs

The main hazard to humans from plutonium in the environment is from inhalation. Dose calculations following inhalation can be made through application of the lung model developed by the International Commission on Radiological Protection (ICRP, 1966). The model is shown schematically in fig. 3.4.

The lung model gives values for purposes of radiation-protection calculations of the fraction of inhaled dusts that are deposited in various regions of the respiratory tract, the biological half-lives, and the fractions that become translocated through the bloodstream to other organs in the body. The values shown in the figure apply to plutonium dioxide, a highly insoluble form to which humans are likely to be exposed in releases from nuclear power plants. Following inhalation, 10 percent is deposited in the nasopharynx region, 8 percent in the tracheobronchial region, and 32 percent in the pulmonary region.

**Table 3.8.** Calculated dose rates to lungs from air contaminated with radon and radon decay products (assumed radon concentration of $10^{-10}$ Ci/1.).

| Calculation no. | Irradiated region | Mrad/hr from inhaled daughter products | | Mrad/hr from inhaled radon | | Ratio of daughter dose to Rn dose | |
|---|---|---|---|---|---|---|---|
| | | All alpha particles | RaC' alpha only | All alpha particles | RaC' alpha only | All alpha particles | RaC' alpha only |
| 1 | Whole lung-average dose rate | 0.53 | | 0.026 | | 20 | |
| 2 | Bronchi, clearance by mucous transport considered | | | | | | |
| | a. Main bronchus | 10.3 | 7.05 | .114 | 0.0038 | 90.5 | 1850 |
| | b. Lobar bonchus | 13.3 | 9.05 | .054 | .0052 | 246 | 1740 |
| | c. Segmental bronchus | 14.5 | 10.2 | .034 | .0067 | 427 | 1520 |
| 3 | Bronchi, clearance not considered | | | | | | |
| | a. Main bronchus | 1.10 | | .204 | | 5.4 | |
| | b. Lobar bronchus | 2.03 | | .0835 | | 24 | |
| | c. Segmental bronchus | 2.95 | | .041 | | 73 | |

*Source:* Burgess and Shapiro, 1968. . For results of other calculations, see NCRP, 1984; ICRP, 1981; UNSCEAR, 1988. Assumptions in calculations:

*Calculation 1.* Whole lung: RaA in equilibrium with Rn; RaB and RaC' at 50% equilibrium; 25% retentation of inhaled daughter products, lung weight 455 g; $2 \times 10^7$ ml/day inhaled (Control of Radon and Daughters in Uranium Mines and Calculations on Biologic Effects. D. A. Holaday *et al.*, U.S. Department of Health, Education and Welfare, Public Health Service, Publication No. 492).

*Calculation 2.* Bronchi: RaA, RaB, RaC at 94%, 62%, and 44% equilibria respectively with radon, with assigned distribution on ions, nuclei and particles >0.1$\mu$ (hypothetical mine atmosphere). Minute volume of 15 l./min and tidal volume of 1000 ml. B. Altshuler, N. Nelson and M. Kuschner, *Health Phys.* 10: 1137 (1964). The dose rates from inhaled radon were not given by Altshuler but were calculated using Altshuler's calculations on regional disintegrations relative to regional deposition based on a consideration of translocation by mucous transport.

*Calculation 3.* Bronchi: Radon daughters in equilibrium with radon; distributed on nuclei with diffusion coefficient of $16 \times 10^{-6}$ cm²/sec. Minute volume 6.75 l./min; tidal volume 450 cc. (An Evaluation of the Pulmonary Radiation Dosage from Radon and its Daughter Products, J. Shapiro, University of Rochester, Atomic Energy Project Report UR-298, Sept. 1954.) (Reproduced from *Health Physics*, vol. 15, p. 120 (1968) by permission of the Health Physics Society.)

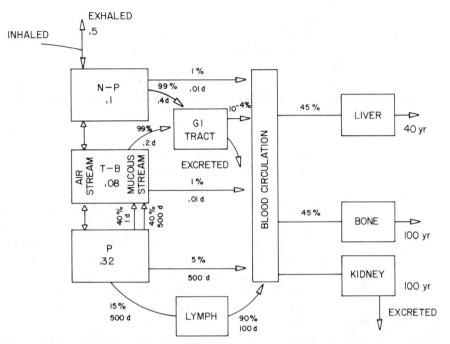

**Fig. 3.4** Lung model applicable to data for dose calculations for plutonium. N-P, T-B, and P stand for nasopharynx, tracheobronchial, and pulmonary regions respectively. Parameters apply to PuO$_2$ particles, size 0.4 $\mu$m. Fraction in box gives deposition in compartment. Flow lines show percentages removed from compartment and clearance rate (expressed roughly as a biological half-life). *Source:* Bennett, 1974.

This model is a sequel to a simpler model (ICRP, 1960) that in fact forms the basis of many of the standards for radionuclides in air. This model makes the following assumptions: The amount of air inhaled is 10 m$^3$ in an 8-hr work day and 20 m$^3$ in 24 hr; 25 percent of the inhaled particles are exhaled; 50 percent are deposited in the upper respiratory passages and subsequently swallowed; and 25 percent are deposited in the lower respiratory passages of the lungs. Of particles categorized as insoluble, half the particles (12.5 percent of inhaled) are eliminated from the lower passages in the first 24 hr. The remaining 12.5 percent are retained with a half-life of 120 days, and it is assumed that this portion is taken up into body fluids. If the particles are classified as soluble, it is assumed that all of the particles deposited in the lower passages are taken up into the body. Separate values of 1 yr and 4 yr, instead of 120 days, are used for the biological half-lives of plutonium and thorium respectively.

The activity in the pulmonary region is eliminated with a half-life of 500 days — 15 percent goes to the lymph nodes (10 percent of which is retained permanently), 5 percent goes to the blood, and 80 percent is carried back along the respiratory tract to the mouth to be swallowed. The plutonium in the blood is divided equally between liver and bone. The fractional transfer from the GI tract to the blood is extremely low, about 10$^{-6}$.

*Example 36:* Calculate the equilibrium annual average dose to the pulmonary region of the lungs from continuous exposure to the environmental limit of 1 pCi/m³ of plutonium-239 in insoluble form (10CFR20, Table II, col. 1).

The daily intake (23 m³ of air inhaled) is 23 pCi. Pulmonary deposition is 32 percent with half-lives of 1 day (1.44 average) and 500 days (720 average) (fig. 3.4).

1 pCi/m³ × 23 m³/day × 365 day/yr × 0.32 × 3,197/day-pCi
        × 5.1 MeV × (0.4 × 1.44 day + 0.6 × 720 day)
                ÷ 1,000 g ÷ 62,400 MeV/g-mrad = 304 mrad/yr.
304 mrad/yr × 20 = 6,060 mrem/yr.

A calculation based on the earlier model (ICRP, 1960, also described in fig. 3.4) gives 126 mrad/yr.

Multiplying by the former value of the quality factor for alpha radiation of 10 gives a dose equivalent of 1,260 mrem/yr, which is approximately 10 percent of the organ limit of 15 rem then in effect.

The calculation of the dose from highly radioactive plutonium particles by averaging over the whole lung is defended as radiologically sound by Bair, Richmond, and Wachholz (1974).

### 5.7.2  Determination of the Plutonium Standard for Bone

The current standard for plutonium in bone was developed from data reviewed in 1950 (Healy, 1975). The basis was the allowable limit of 0.1 μg for radium fixed in the body (that is, bone). Comparison of bone tumors in rats, mice, and rabbits caused by plutonium and radium indicated that plutonium was 15 times more toxic as measured by activity injected. When corrected for retention (75 percent of plutonium and 25 percent of radium retained in rodent), and twice the ratio of radium to plutonium energy deposition in man as compared to the rat (due to 80–85 percent escape of radon from rats as compared to 50 percent in man), plutonium was deduced to be 2.5 times as effective as radium and thus allowable limits for plutonium in the body were set at 0.1/2.5 or 0.04 μCi.

The average dose to bone from 0.04 μCi in the body (bone fraction = 0.9) is

$$\frac{0.04 \ \mu\text{Ci} \times 0.9 \times 1.17 \times 10^{12} \ \text{yr}^{-1} \ \mu\text{Ci}^{-1} \times 5.1 \ \text{MeV}}{7000 \ \text{g} \times 62{,}400 \ \text{MeV/g-mrad}} = 0.49 \ \text{rad/yr};$$

0.49 × 5 × 20 = 49 rem/yr. This is comparable to the dose from 0.1 μCi radium (60 rem/yr).

Considering the judgment that must be applied in the application of available data, it is not surprising that experts disagree on permissible levels of exposure and that proposed values can disagree by orders of magnitude.

Morgan (1975) suggested that the maximum permissible body burden based on bone be reduced by at least a factor of 200.

## 5.8   Dose Rates from Small, Highly Radioactive Particles

Contamination produced as a result of operations with radioactive materials of high specific activity, that is, of high radioactivity per unit mass, consists of particles that are individually significant radioactive sources, down to very small particle sizes.   Examples of sources of highly radioactive particulate contamination include the man-made alpha emitters polonium-210, plutonium-238, plutonium-239, and americium-241; high specific activity compounds prepared by radiochemical companies for research purposes; and fission products produced in the fuel of nuclear power reactors or as a result of nuclear explosions.   The hazards of the radiochemical and fission-product sources are primarily due to beta particles.   Of particular significance from a public health point of view are the radioactive particles released to the environment as a result of the testing of nuclear weapons in the atmosphere.   The particles produced in these nuclear explosions are carried to high altitudes and circulate around the earth to be deposited on the ground, mainly by rain and snow.   Some of the particles in the air at ground level are inhaled by human beings and are deposited in the lungs.

Most of the particles that make their way into the lungs are eliminated by normal lung clearance processes, but a few remain for months or longer. Many of the retained particles are carried to the lymph nodes by scavenger cells, where they accumulate and produce unusually high local doses.

The doses from fallout particles are evaluated by considering them as point sources of radioactivity.   The activities of the particles depend on the particle size, time after the detonation, and the nature of the explosion.   A characteristic activity found for 1-micron diameter particles in fallout 100 days old was 6 disintegrations per minute (Sisefsky, 1960).   For other times in days, $(T)$, and diameters in microns, $(D)$, the activity of particles of similar composition would be given, in disintegrations per minute, by $6 \, D^3 \left( \frac{100^{1.15}}{T^{1.15}} \right)$.   Note that the activity does not follow a single half-life mode of decay characteristic of single radionuclides, since fallout contains a mixture of radioactive fission products of different half-lives.

The beta dose rates at various distances from these particles are calculated from formulas which give the dose rate in tissue for point sources of beta particles (Hine and Brownell, 1956).   Dose rates for nanocurie activities of various alpha- and beta-emitting radionuclides are given in table 3.9. The average energy of beta particles from fission products would be somewhat lower than from corresponding activities of $^{32}P$.

The interpretation of these high localized dose rates is largely speculative, and it has not been possible to establish standards of radiation protection

**Table 3.9.**  Dose rate in tissue near 1 nanocurie particle (2220 dis/min).

| Distances from particles (microns) | Dose rate (mrad/hr) | | |
|---|---|---|---|
| | $^{14}C$ | $^{32}P$ | $\alpha$ emitter 5.5 MeV |
| 10 | 2,000,000 | 380,000 | $1.7 \times 10^8$ |
| 20 | | | $5.2 \times 10^7$ |
| 41 | | | 0 |
| 100 | 1,500 | 3,700 | |
| 200 | 40 | 930 | |
| 400 | 0.03 | 230 | |
| 600 | | 100 | |
| 1,000 | | 30 | |
| 2,000 | | 7. | |
| 4,000 | | 0.7 | |
| 6,000 | | .1 | |
| 8,000 | | .01 | |

*Source:* NAS-NRC, 1961a.

which apply specifically to highly radioactive particles.  With respect to exposure of the lung, current practice is to average the energy imparted by the radiation to the lungs over the whole mass of the lungs without regard to any specific source geometries of the contamination.  A great deal of epidemiologic and animal work will have to be done before it can be established whether hot particles require special standards.

### 5.9  Radiation Doses in Nuclear Medicine

A summary of doses imparted in some of the more commonly used diagnostic procedures is given in table 3.10.  Both the whole-body dose and dose to the organ receiving the highest dose are listed.  The data are given for an adult.  Doses to children are several times higher.  The doses are only rough estimates of the doses actually imparted to a particular patient.  Metabolic data are limited and must be inferred from whatever data are available. Adjustments are required for age, sex, or condition of patient.  Sometimes the metabolic data must be inferred from animal experimentation or from compounds or radionuclides that differ from the substance administered. There are just too many compounds being used in nuclear medicine to permit the detailed studies that have been done, for example, on the most significant nuclides in radioactive fallout.  The dose problems are much simpler in the nuclear medicine field, however, because of the short half-lives of the compounds generally used.

As a first approximation it may be assumed that percentage uptake and time dependence of activity in an organ are independent of age.  The extrap-

**Table 3.10.** Doses imparted by radiopharmaceuticals in routine nuclear medicine procedures.

| Function or organ examined | Tc-99m labeled radiopharmaceuticals | Activity given (mCi) | Organ dose (rad) | Effective dose equivalent (rem) |
|---|---|---|---|---|
| Bone | Pyrophosphate | 19–27 | 4.4–6.3 | 0.56–0.80 |
| Brain | Gluconate | 20–27 | 4.2–5.6 (bladder) | 0.68–0.90 |
| Liver | Sulfur colloid | 2.7–5.0 | 0.75–1.40 | 0.14–0.26 |
| Lung | Microaggregated albumin | 2.7–5.4 | 0.67–1.34 | 0.12–0.24 |
| Heart (cardiac output) | Erythrocytes | 20–24.3 | 1.7–2.07 | 0.63–0.77 |
| Renal | Gluconate | 10–16.2 | 2.07–3.36 (bladder) | 0.33–0.54 |
| Thyroid (scan) | Pertechnetate | 2.7–10 | 0.23–0.85 0.62–2.30 (intestine) | 0.13–0.48 |

| Function or organ examined | Other radionuclides | Activity given (mCi) | Organ dose (rad) | Effective dose equivalent (rem) |
|---|---|---|---|---|
| Thyroid (uptake, 35 percent) | I-131 Sodium iodide | 0.0051–.054 | 6.8–72 | 0.21–2.2 |
| Thyroid (scan, 35 percent uptake) | I-123 Sodium iodide | 0.203 | 3.4 | 0.11 |
| Inflammation | Ga-67 Gallium citrate | 2.7–6.75 | 5.9–14.8 (bone surface) | 1.2–3.0 |
| Heart | Th-201 Thallous chloride | 2.0–2.16 | 4.1–4.5 (testes) | 1.7–1.84 |

*Notes:* 1 millicurie = 37 megabecquerels. 1 rem = 10 millisieverts. Activities administered taken from Huda and Gordon (1989), who give the upper values generally used in administrations to adults. Data on doses are taken from ICRP (1987, 1987a), Publications 52 and 53, and refer to adults. Doses to a 5-year-old child relative to adults are 3–5 times as high. Organ doses are to organ examined unless otherwise indicated.

olation of doses from nonpenetrating radiation depends then only on knowledge of the organ mass. This can be taken proportional to body mass as a first approximation, but more representative values are available (ICRP, 1975). The extrapolation of doses from penetrating radiation to age groups that differ from those listed is affected by anatomical factors in addition to masses. As a first approximation body dimensions can be taken as proportional to the one-third power of the mass (Webster et al., 1974).

The actual amount of activity administered to patients is essentially independent of age in studies of organ uptake, organ function, and organ blood flow by external counting methods. The activity is proportional to body mass in blood volume studies and to the 2/3 power of the mass in imaging (Webster et al., 1974).

The ICRP recommends that the activity administered to patients should be the minimum consistent with adequate information for the diagnosis or investigation concerned (ICRP, 1971, Publication 17). When pregnant patients are being treated, consideration must be given to the quantity of activity transmitted across the placenta and to the resulting fetal uptake. Examinations of women of reproductive capacity should be restricted to the first 14 days following onset of menses. Activities administered to children should be reduced on a weight or other reasonable basis. When repeat and serial tests are being considered, the overall dose received during each series of tests should be considered rather than the dose in any one investigation. Certainly, unnecessary repeat investigations should be avoided. Blocking agents, when they are available, should always be considered before administering a radioactive nuclide. An estimate must be made of the dose to the organ that then is likely to receive the maximum dose. A review of the factors influencing the choice and use of radionuclides in medical diagnosis and therapy has been issued by NCRP (1980). The report includes examples of dose calculations in nuclear medicine.

## 6.  Evaluation of Doses within the Body from X Rays

The radiation incident on a patient in an x-ray examination is absorbed strongly as it enters the body. As a result, the dose falls off rapidly with depth. Figure 3.5 shows the depth dose in water. The fall-off in soft tissue is very similar and the data may be applied to determine the dose imparted to points inside the body if the only shielding material encountered by the incident beam is soft tissue.

The attenuation curves of fig. 3.5 include the effect of distance as well as attenuation by the medium. Thus they apply strictly only to the 30-inch source-surface distance under which the data were obtained. However, they may be used for a limited range of other distances between the source and surface and, in particular, to surface doses imparted to patients x rayed at the typical target-film distance of 40 inches.

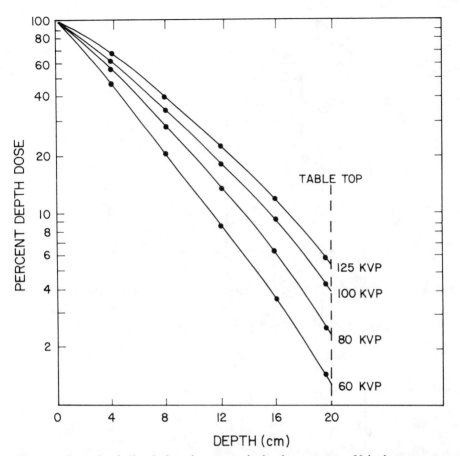

**Fig. 3.5**  Central axis depth dose in water: single-phase system, 30-inch source-to-skin distance, 40-inch source-to-film distance, 14 × 17-in. field at 40 in., 3 in. aluminum filtration.  *Source:* Kelley and Trout, 1971.

There is also some scattered radiation dose outside the direct (collimated) beam, and while it is only a small fraction of the direct radiation, it is often of interest.  For a given energy, the scattered dose at different depths depends primarily on the distance from the edge of the field as defined by the collimator.  Measurements in a water phantom with 100 kVp x rays give a scattered dose of 10 percent of the central beam dose at 1.3 cm from the edge and 1 percent at 8.8 cm (Trout and Kelley, 1965).

Figure 3.6 gives a model of the adult human torso developed for calculating the dose to organs within the body.  An anterior view of the principal organs is given in fig. 3.7 and their dimensions are shown on an isometric drawing in fig. 3.8.  The organs are represented mathematically primarily as

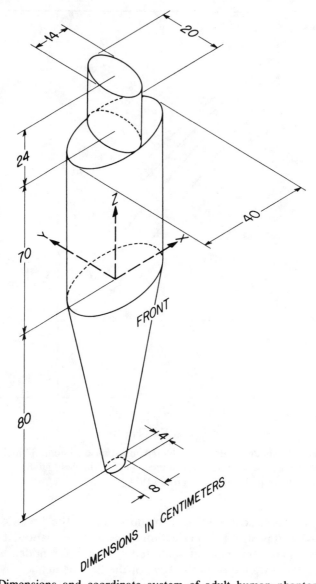

**Fig. 3.6** Dimensions and coordinate system of adult human phantom. *Source:* Snyder, et al., 1979.

The trunk is an elliptical cylinder given by

$$\left(\frac{x}{20}\right)^2 + \left(\frac{y}{10}\right)^2 \leq 1,$$

$$0 \leq z \leq 70.$$

The head is also an elliptical cylinder,

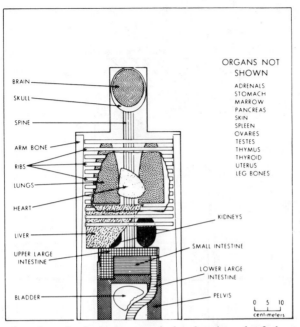

**Fig. 3.7** Anterior view of principal organs in head and trunk of phantom. *Source:* Snyder, et al., 1969.

ellipsoids, and the figure shows the principal axes. Because the dose through an organ is not uniform, the value at the midline may be used as an average value for radiation-protection purposes and thus may be calculated with the use of the depth dose data for water given in fig. 3.5. In radiotherapy, a detailed dose plot is necessary, and the location and geometry of the organs of patients undergoing treatment must be accurately determined, either by taking a series of x rays or by computerized axial tomography.

Dose distributions may also be determined from basic data. One calculation (Rosenstein, 1976b) considers monoenergetic parallel collimated beams normally incident on grid elements, 4 cm × 4 cm, that cover the vertical

$$\left(\frac{x}{7}\right)^2 + \left(\frac{y}{10}\right)^2 \leq 1,$$

$$70 < z \leq 94.$$

The legs are considered together to be a truncated elliptical cone,

$$\left(\frac{x}{20}\right)^2 + \left(\frac{y}{10}\right)^2 \leq \left(\frac{100 + z}{100}\right)^2,$$

$$-80 \leq z < 0.$$

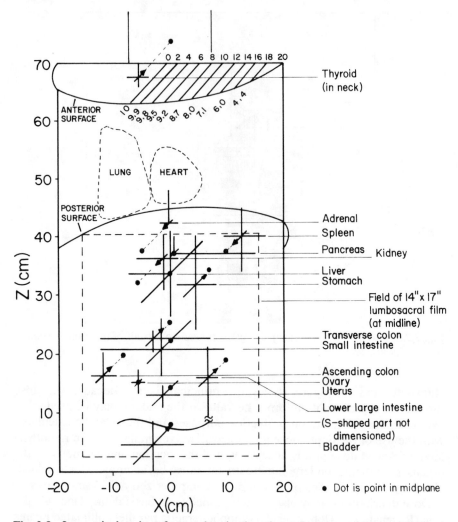

**Fig. 3.8** Isometric drawing of torso showing locations of organs, which are idealized mathematically as ellipsoids. The dimensions are taken from Snyder et al., 1969. The solid lines are the principle axes of the ellipsoid. The y axis is drawn at 45° to x and z and serves to locate the organ with respect to the midline (that is, the plane that divides the body in half, front to back). To obtain organ location and dimensions: (1) follow the dashed line leading from the y axis to its terminal point in the x-z plane, shown as a dot. This dot gives the z and x coordinates of the centroid of the organ. (2) Determine the distance from the dot to the center of the organ (as given by the intersection of the three axes). (3) Determine the distance from the surface of the body through the y principle axis in the midline by following from the dot up along the z axis to z = 70 and then measuring out along the y axis to the anterior surface. (4) Calculate the depth of the organ, which is the difference between the surface y coordinate and the organ centroid y coordinate.

midplane of the phantom.  The photons are followed through successive interactions in the body (by a mathematical technique known as the Monte Carlo method) until they are absorbed or leave the body.  The results are determined for several photon energies that adequately represent the energy range of diagnostic x rays.  Any diagnostic x-ray spectrum is simulated by a weighted combination of these energies.  The calculations are very lengthy and tedious and must be made with the use of high-speed computers.  Doses to organs in a reference adult patient have been obtained by this method for a variety of common x-ray projections using the mathematical models of figs. 3.6 and 3.7 (Rosenstein, 1976b).  Corresponding data are also available for children (Beck and Rosenstein, 1979; Rosenstein, Beck, and Warner, 1979).  The basic data are presented in terms of the *tissue-air ratio*, which is the average absorbed dose (rads) in the organ per unit exposure (R) at the organ reference plane in the absence of the attenuating medium (that is, *free-in-air*).  The organs selected for the calculations included the testes,

**Table 3.11.**  Example of organ dose data for diagnostic x rays: lumbar spine organ dose (mrad) for 1,000 mR entrance skin exposure (free-in-air).

| Organ | View | Beam HVL (mm AL) | | | | | |
|---|---|---|---|---|---|---|---|
| | | 1.5 | 2.0 | 2.5 | 3.0 | 3.5 | 4.0 |
| | | Dose (mrad) | | | | | |
| Testes | AP | 1.1 | 2.2 | 3.7 | 5.6 | 7.8 | 10.0 |
| | LAT | 0.2 | 0.4 | 0.7 | 1.1 | 1.6 | 2.3 |
| Ovaries | AP | 91 | 139 | 188 | 238 | 288 | 336 |
| | LAT | 15 | 27 | 41 | 58 | 76 | 96 |
| Thyroid | AP | .05 | .2 | .3 | .5 | .8 | 1.1 |
| | LAT | a | a | a | a | a | a |
| Active bone | AP | 13 | 21 | 32 | 46 | 62 | 81 |
| marrow | LAT | 8.2 | 13 | 19 | 27 | 37 | 48 |
| Uterus (Embryo) | AP | 128 | 189 | 250 | 309 | 366 | 419 |
| | LAT | 9.4 | 17 | 27 | 39 | 53 | 68 |

*Source:* Rosenstein, 1976a.
Conditions: SID-102 cm (40 in.).  Film size = Field size, 35.6 cm × 43.2 cm (14 in. × 17 in.).  Entrance exposure (free-in-air), 1,000 mR.
Projection: Lumbar spine.
a. <0.01 mrad.

Example: Calculate the depth of the kidney below the surface in an AP exposure. The kidney centroid (right side of the body) is 6 cm behind the dot, which is at $z = 32$ cm and $x = 5$ cm as read in the $x$-$z$ plane. The distance from the midline to the surface at $x = 5$ cm is 9.5 cm as read at $z = 70$. Therefore the depth of the kidney from the anterior surface is $9.5 + 5 = 14.5$ cm.

ovaries, thyroid, active bone marrow, and the uterus (embryo). To facilitate use of the data by practitioners, organ doses in terms of the entrance skin exposure have also been compiled in handbook form (free-in-air) (Rosenstein, 1976a). An example of the data for a lumbar spine x ray, expressed in millirads per 1000 mR entrance skin exposure is given in table 3.11.

The beam quality (HVL, mm Al) is either measured directly or estimated from the kVp, total filtration, and machine wave form. Some data are given in table 3.12. A characteristic value for total filtration on diagnostic x-ray machines is 3 mm Al. Table 3.13 gives a compilation of data from the handbook of organ doses for a 3 mm Al HVL beam as determined from the handbook. Note that the skin exposures are considerably higher for a lateral than an AP projection, and much less for a thoracic examination than an abdominal examination.

### 6.1   Organ Doses in Prescribed X-Ray Examinations

The most common x-ray examination is the single posterior-anterior (PA) chest x ray. This x ray is prescribed so routinely that it approaches the status of an initiation ritual for hospital patients, school teachers, new employees, first-visit patients, and so on, even in the absence of symptoms to indicate the need for examination of the chest. Its only saving grace is that the doses imparted to organs in the body are very low if the x ray is taken properly.

When symptoms indicate the need for x rays, the number of films taken increases because each x-ray film shows only a projection of the internal struc-

**Table 3.12.**   Half-value layers as a function of filtration and the tube potential for diagnostic units[a]

| Total filtration (mm Al) | Peak potential (kVp) | | | | | |
|---|---|---|---|---|---|---|
| | 70 | 80 | 90 | 100 | 110 | 120 |
| | Typical half-value layers in millimeters of aluminum | | | | | |
| 0.5 | 0.76 | 0.84 | 0.92 | 1.00 | 1.08 | 1.16 |
| 1.0 | 1.21 | 1.33 | 1.46 | 1.58 | 1.70 | 1.82 |
| 1.5 | 1.59[b] | 1.75 | 1.90 | 2.08 | 2.25 | 2.42 |
| 2.0 | 1.90 | 2.10 | 2.28 | 2.48 | 2.70 | 2.90 |
| 2.5 | 2.16 | 2.37[b, c] | 2.58[b, c] | 2.82[b, c] | 3.06[b, c] | 3.30[b, c] |
| 3.0 | 2.40 | 2.62 | 2.86 | 3.12 | 3.38 | 3.65 |
| 3.5 | 2.60 | 2.86 | 3.12 | 3.40 | 3.68 | 3.95 |

*Source:* NCRP, 1968, Hdb. 33
a. For full-wave rectified potential.
b. Recommended minimum HVL for radiographic units.
c. Recommended minimum HVL for fluoroscopes.

**Table 3.13.**  Selected organ doses for projections common in diagnostic radiology.

| Projection | View | Exposure at skin (mR)[c] | Organ dose (mrad)[a] | | | | |
|---|---|---|---|---|---|---|---|
| | | | Active bone marrow | Uterus (embryo) | Ovaries | Testes | Thyroid |
| Retrograde pyelogram, KUB, barium enema, lumbosacral spine, IVP | AP | 470 | 23 | 155 | 121 | 10 | X[b] |
| | PA | 250 | 33 | 44 | 50 | 3 | X |
| | LAT | 1000 | 31 | 53 | 70 | 4 | X |
| Lumbar spine | AP | 736 | 34 | 227 | 175 | 4 | X |
| | LAT | 2670 | 72 | 104 | 155 | 3 | X |
| Pelvis, lumbopelvic | AP | 1100 | 52 | 388 | 288 | 103 | X |
| | LAT | 3500 | 116 | 196 | 256 | 105 | X |
| Upper GI | AP | 256 | 8 | 9 | 11 | X | 0.6 |
| Chest (72 in. SID) | PA | 14 | 1.4 | 0.03 | 0.02 | X | 0.6 |
| | LAT | 45 | 1.9 | 0.04 | 0.04 | X | 5.2 |

*Source:* BRH, 1976.

a. For source to image (SID) distance of 102 cm; 14 in. × 17 in. film size; 3.0 mm Al HVL, unless otherwise indicated.

b. X = insignificant.

c. Measured in air in absence of patient.  Doses for other exposures may be determined by ratio provided beam quality (HVL) is the same.  (See Table 2.16, on page 94, for recent exposure data.)

**Table 3.14.**   Organ doses in x-ray examination.   Film: Chronex IV (medium speed); Screen: High speed; Developer: H. R. Simon; Total filter: 3 mm Al; Tube Target-film distance: 40″; Skin distance: 30″; Output 76 cm, 100 mAs: 624 mR at 80 kV, 987 mR at 100 kV.   Includes backscatter.   Prescription: Lumbar spine.

(a) Conditions of examination

| Film no. | 1 | 2 | 3 | 4, 5 |
|---|---|---|---|---|
| Class. | Standard | Standard | Standard | Extra views[a] |
| View | AP | Lateral, right side toward x-ray tube | Lateral spot (L5-S1) | AP, oblique |
| Grid | 16:1 | 16:1 | 16:1 | 16:1 |
| Film size | 14″ × 17″ | 14″ × 10″ | 8″ × 10″ | 14″ × 17″ |
| kVp | 70 | 80 | 80 | 90 |
| mA × sec | 100 × 2 | 300 × 2 | 300 × 2 | 100 × 2 |
| Center point of field | Crest of illium | Crest of illium | 2″ below crest | Crest of illium |
| HVL, mm Al | 1.5 | 2.2 | 2.2 | 2.6 |

(b) Doses (mrad)

| Organ | Doses for single film | | | | Total organ dose | $w_T$ | Equivalent whole-body dose |
|---|---|---|---|---|---|---|---|
|  | 1 | 2 | 3 | 4, 5 | | | |
| Skin | 1030 | 3744 | 3744 | 1580 | | | |
| Bone marrow | 10 | 46 | 15 | 16 | 103 | 0.15[b] | 15 |
| Testes | 0.85 | 1.6 | 0.55 | 1.3 | 6 | 0.25 | |
| Ovaries | 72 | 98 | 98 | 111 | 490 | 0.25 | 123 |
| Uterus | 102 | 64 | 64 | 155 | 540 | | |
| Pancreas | 206 | 29 | 29 | 435 | 1134 | 0.06 | 68 |
| Spleen | 144 | 15 | 15 | 308 | 790 | 0.06 | 47 |
| Stomach | 422 | 52 | 52 | 822 | 2170 | 0.06 | 130 |
| Liver | 170 | 165 | 165 | 379 | 1258 | 0.06 | 75 |
| Kidney | 56 | 288/41[c] | 288/41[c] | 142 | 670 | .06 | 40 |
| Small intestine | 200 | 112 | 112 | 585 | 1693 | .06 | 102 |
| Colon | 453 | 767/15[c] | 767/15[c] | 885 | 2995 | .06 | 180 |
| Bladder | 412 | 112 | 112 | 758 | 2152 | .06 | 129 |
| | | | | | | Total[d] | 754 |

a. Decision to take these views depends on films 1–3, unless they are prescribed in original requisition.

b. Includes 0.12 for red bone marrow and 0.03 for bone surfaces.   Not considered separately.

**Table 3.14** (*continued*)

c. Doses to right and left sections.

d. Weighting factor of 0.06 is assigned to organs classified as *remainder* in ICRP, 1977b, Publication 26. ICRP recommends that for these organs, the summation should apply to the five organs or tissues receiving the highest dose equivalents, and the exposure of all other remaining tissues can be neglected. It recommends that when the gastrointestinal tract is irradiated, the stomach, small intestine, upper large intestine, and lower large intestine are treated as four separate organs.

*Note:* Current (1989) exposures are one-third those given in this example.

ture in the path of the beam and several views are often necessary to provide the information needed for the diagnosis. Standard x-ray examinations have been designed for exploring specific conditions. A check for pneumonia requires 2 films, posterior-anterior (PA), and lateral. The lateral requires much higher exposures because the x rays have to make their way through much more material when they enter the body from the side. Stomach symptoms can lead to an upper GI series, which require up to 20 films. Many of these can be eliminated if the physician stays on top of the examination and prescribes successive films only when indicated by earlier ones.

It might contribute to the reduction of population dose from medical x rays if prescribing physicians were aware of the number of views and films (and associated doses) accompanying each prescription and could exercise some judgment on the number of films actually needed. Organ doses imparted in a lumbar spine x-ray examination at one institution are given in table 3.14. The examinations were performed on adults with a manually controlled x-ray machine. Data on positioning of the film and the machine settings were obtained from the x-ray technologist. Exposures at the skin were then measured in a mock-up of the examination. The measurements were made with a condenser ionization chamber which rested on a polyethylene phantom. Doses for organs covered in the BRH Organ Dose Handbook (Rosenstein, 1976a) were obtained directly from the handbook.[19] The handbook results are based on the exposure rate free-in-air, while the measurements were made at the surface of the phantom, so about 30 percent of the measured value was subtracted to correct for backscattered radiation. Doses to organs not covered in the handbook were obtained by attenuating the measured surface dose, using the depth-dose curve of fig. 3.5. The organ depth was taken as the midline of the organ. Doses to organs outside the direct beam were not considered. The doses to organs not completely in the beam were reduced by the estimated fraction not directly irradiated.

19. Values of beam quality (HVL mm Al) needed to compute organ dose using the BRH handbook may be estimated from machine settings from data in NCRP, 1968, Report 33, or measured directly. A procedure for determining the HVL is given in NEXT, 1976.

**Table 3.15.**   Relative skin doses produced under an automatic exposure control system.

| Age of patient | Thickness (cm) | Weight (kg) | Relative skin dose[a] |
|:---:|:---:|:---:|:---:|
| 1 | 10 | 12 | 6 |
| 5 | 12 | 20 | 11 |
| 10 | 15 | 33 | 26 |
| 15 | 17 | 55 | 44 |
| adult | 20 | 70 | 100 |

*Source:* Webster et al., 1974.

a. Exposed for x ray of unit density, 70 kVp, 8:1 grid, 2.5 mm Al filtration.

The values presented should be taken as rough estimates only.  It is particularly difficult to make estimates of the more complicated views such as the oblique projections.  Additional data on doses from medical x rays are given in part II, sections 14.6 and 14.7, and part VI, section 4.3.1.

Many x-ray machines have automatic exposure control systems.  A sensor at the imaging device automatically sets the high voltage, current, and operating time to produce a satisfactory image.  Surface doses for this type of machine will depend on the thickness of the region x rayed and must be measured with the use of a phantom designed to simulate the thickness of the patient.  Nominal values of body thickness for typical patient ages and heights are given in table 3.15.

# Part IV

# Radiation Measurements

The most widely used radiation detectors are devices that respond to ionizing particles by producing electrical pulses. The pulses are initiated by the imparting of energy by the ionizing particles to electrons in the sensitive volume of the counter.

Two major modes of signal production are utilized in radiation counter designs. In one mode, the deposited energy serves merely as a trigger to produce an output electrical pulse of constant form every time an interaction occurs in the detector. The output pulse is constant regardless of the amount of energy deposited in the detector, or the nature of the particle. This type of behavior is exhibited by the Geiger-Mueller counter. In the other mode, the magnitude of the output pulse is proportional to the amount of energy deposited in the detector; that is, the greater the energy deposited, the larger the output pulse. This type of behavior is exhibited by scintillation counters, gas proportional counters, and semiconductor detectors.

We shall now examine various kinds of radiation detectors, the types of signals they produce and means of analyzing these signals, with particular attention to Geiger-Mueller counters and scintillation detectors as examples of the constant output and proportional output detectors respectively.

## 1. Radiation Counting with a Geiger-Mueller Counter

The Geiger Mueller (G-M) counter is the best-known radiation detector. It is popular because it is simple in principle, inexpensive to construct, easy to operate, sensitive, reliable, and very versatile as a detector of ionizing particles. It is particularly suitable for radiation-protection surveys. It is used

with a scaler if counts are to be tallied or with a ratemeter if the counting rate (generally specified as counts per minute) is desired.

## 1.1   A G-M Counter Described

Put a gas whose molecules have a very low affinity for electrons (for example, helium, neon, or argon) into a conducting shell, mount at the center a fine wire that is insulated from the shell, connect a positive high voltage source between the wire and the shell, and you will have a Geiger counter.

Any incident particle that ionizes at least one molecule of the gas will institute a succession of ionizations and discharges in the counter that causes the center wire to collect a multitude of additional electrons. This tremendous multiplication of charge, consisting of perhaps $10^9$ electrons, will produce, in a typical G-M circuit, a signal of about 1 volt, which is then used to activate a counting circuit.

Details and specifications for a commonly used G-M tube are given in figure 4.1. The tube is called an end-window detector because the end of the cylindrical shell is provided with a very thin covering to allow low-energy beta particles to penetrate into the counter. A window thickness equivalent to 30 microns of unit density material is thin enough to allow about 65 percent of the beta particles emitted by carbon-14 to pass through. Windows in tubes used to detect alpha particles, which are less penetrating, should be thinner, that is, less than 15 microns at unit density. Gamma rays do not require a special window and can penetrate the counter from any direction.

Practically every beta particle that reaches the counter gas will cause a discharge and register a count on the counting equipment. On the other hand, when gamma photons are incident upon the counter, only a small frac-

**Fig. 4.1**   End-window Geiger-Mueller tube. Specifications (Anton Electronic Laboratories, Model 220): Fill, organic admixture with helium; Life, $10^9$ counts; Mica window thickness, 1.4–2.0 mg/cm²; Operating voltage, 1200–1250 V; Operating plateau slope, approx. 1%/100 V; Operating plateau length, approx. 300 V; Starting voltage, 1090–1160 V.

tion will interact with the walls, and a much smaller fraction with the gas, to liberate electrons that will penetrate into the gas and produce a discharge. The other photons will pass through without any interaction and thus will not be recorded. Clearly, G-M counters are much more efficient in detecting the directly ionizing beta particles than the indirectly ionizing photons. Of course, the window must be thin enough to let the directly ionizing particles through.

The signals from a G-M counter that is working properly are all of constant size, independent of the kinds of particles detected or their energies. The G-M tube is thus purely a particle counter, and its output signal cannot be used to provide information on the particles that triggered it off.

### 1.2 Adjusting the High Voltage on a G-M Counter and Obtaining a Plateau

The operation of a G-M counter requires an applied high voltage, and this must be adjusted properly if the counter is to give reliable results. If the voltage is too low, the counter will not function. If the voltage is too high, the gas in the counter will break down, and the counter will go into continuous discharge, which will damage it.

The high voltage is adjusted by exposing the counter to a source of radioactivity and recording the counts accumulated in a given time period as the voltage is increased. At low voltages, the signals from the counter will be very small and of varying sizes and will not activate the counting circuit or scaler. As the voltage is raised, a level will be reached at which some pulses from the detector are just large enough to activate the scaler and produce a low counting rate. This is called the starting voltage. As the voltage is increased further, the pulses will increase in height, and when the Geiger region is reached, all the pulses will become uniform, regardless of the type of particle or energy deposited in the detector. The voltage at which the pulses become uniform is known as the threshold voltage, and it can be recognized from the counting rate, because once the threshold voltage is reached, the counting rate increases only slowly as the voltage is increased. The region over which the counting rate varies slowly with increased voltage is known as the plateau. The plateau slope is usually expressed as percent change in counting rate per 100-V change in high voltage. An example of a plateau is shown in fig. 4.2. The slope is approximately 10 percent/100 V at 900 V. This is adequate for most counting purposes, but much flatter plateaus can be obtained.

### 1.3 How a G-M Counter Can Lose Counts and Even Become Paralyzed

A G-M tube requires a certain recovery time after each pulse. If a succeeding event is initiated by an incident particle before the tube recovers, the discharge will not occur and the event will not be recorded. The recovery time generally varies between $10^{-4}$ and $10^{-3}$ seconds. For low counting

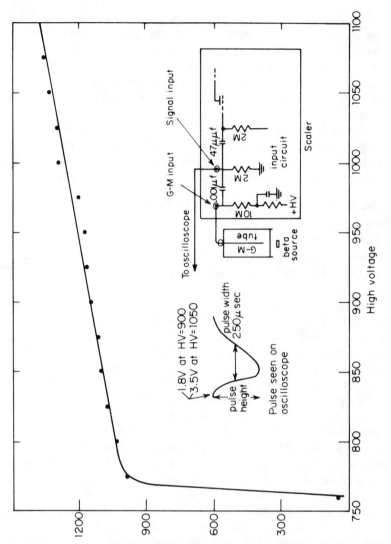

**Fig. 4.2**  Results of measurement of plateau of G-M counting tube. The tube was connected to a scaler that provided the high voltage and counted the events initiated in the detector. The shape of the pulse was observed by connecting an oscilloscope to the "signal" input to the scaler. The input circuit for the scaler used is shown in the graph. Note that the signal input is isolated from the high voltage and is used when the high voltage is not required. G-M tube: Nuclear Chicago Model T108, 900 V halogen-quenched, end window. Caution! When determining a plateau, do not cover the full plateau range because of the risk of applying excessive voltage which will drive the tube into continuous discharge and damage it.

rates, essentially all the intervals between pulses are larger than this recovery time, and all the events are recorded. With higher counting rates, the intervals between successive events in the counter decrease, and more events occur at intervals shorter than the recovery time and fail to produce counts. Corrections for lost counts must be made to the observed counting rate.

A useful formula for increasing the observed counting rate to correct for counting losses is:

$$\text{Correction added to count rate} = \frac{R^2\tau}{1 - R\tau}.$$

$R$ is the observed counting rate and $\tau$ is the recovery time. (Alternate terms, with slightly different meanings, are the dead time and the resolving time.) $R$ and $\tau$ must of course be expressed in the same time units (see Evans, 1955, pp. 785–789 for detailed treatment).

> *Example 1:* The recovery time of a G-M counter is given as $3.5 \times 10^{-4}$ seconds. What is the counting rate corrected for dead-time losses, if the measured counting rate of a sample is 26,000 c/min?
> The recovery time is $5.83 \times 10^{-6}$ minutes.
>
> $$\text{Correction} = \frac{(2.6 \times 10^4)^2 \times 5.83 \times 10^{-6}}{1 - 2.6 \times 10^4 \times 5.83 \times 10^{-6}}$$
> $$= 4650 \text{ c/min.}$$
>
> Corrected rate $= 26{,}000 + 4650 = 30{,}650$ c/min.

In most G-M survey meters, if the rate of triggering by incident particles becomes too high, the counter becomes paralyzed and records no counts. This is a serious deficiency for G-M counters. Some G-M meters have special circuitry to produce a full-scale reading in very high fields. Since a G-M counter always gives some response to the radiation background, a condition of absolutely no counts can be recognized as due to either a defective counter or a seriously high radiation level. G-M counters that can become paralyzed must not be relied upon as the sole monitor for levels potentially high enough to paralyze the counter, and must be replaced or supplemented with other instruments as described in later sections.

### 1.4 How to Distinguish between Beta and Gamma Radiation with a G-M Counter

We have noted previously that once a G-M counter is triggered, it is impossible to tell from the resulting signal the type of radiation responsible or the amount of energy deposited in the counter. However, beta particles and gamma photons can be readily distinguished by the use of absorbers. If a thin absorber is placed in front of the window, it will stop the beta particles but will have relatively little effect on the gamma photons. Thus the

counting rate with and without the absorber can be used to distinguish beta particles from gamma photons. A suitable absorber thickness for most applications is the equivalent of 5 mm of unit-density material. Thus, 5 mm of lucite, which has a density fairly close to 1 g/cc, or 1.85 mm of aluminum (density 2.7), would be equally effective in stopping beta particles.

*Example 2:* Using an end-window G-M tube to survey his laboratory bench after an experiment, an investigator found a counting rate of 15,000 c/min. When he covered the window with a beta shield, the counting rate was reduced to 300 c/min. The radiation background away from the contaminated area was 35 c/min. The contamination was reported as follows:

Beta counting rate: 15,000 − 300 = 14,700 c/min
Gamma counting rate: 300 − 35 = 265 c/min.

If one is dealing with very low energy gamma photons, a correction may have to be made for attenuation of the gamma photons in the beta absorber, but generally this is not necessary.

### 1.5    How to Determine Source Strength of a Beta Emitter with a G-M Counter

Suppose one needs to determine the strength of a source of beta radioactivity, that is, the number of particles it emits per unit time. The source may be material contained in a planchet or contamination on a surface. The counter is positioned over the source, and a reading taken in counts per minute. How is this converted to the rate of emission of radiation from the source?

The simplest approach is to compare the counting rate for the unknown source with that of a reference source of known emission rate. If the unknown and reference sources are identical except for activity, they are detected with the same efficiency. In this case, all we have to do is compare the measured counts per minute, since the ratio of the two counting rates is the ratio of the source strengths. By multiplying the known emission rate of the reference source by the ratio of the counting rates of the sample and reference source, we obtain the emission rate of the sample.

*Example 3:* A surface is surveyed with a G-M counter for contamination and a small spot of contamination is found which reads 15,000 c/min. The background reading is 45 c/min. The counting rate becomes negligible when a 5 mm plastic absorber is placed between the source and the counter, showing the counts are due to beta particles. The counting rate of a bismuth-210 beta reference source counted in the same manner as the contaminated surface is

9400 c/min.   The reference source emits 32,600 beta particles/min. What is the rate of emission of beta particles from the surface?

The beta particles from $^{210}$Bi have a maximum energy of 1.17 MeV, which is fairly energetic for a beta-particle source.   Their attenuation in a thin end-window G-M counter is low and can be neglected for purposes of this example.   If the beta particles emitted from the contaminated spot are also energetic and attenuation in the counter window can be neglected, the strength of the source of contamination is

$$14{,}955 \times \frac{32{,}600}{9355} = 52{,}000 \text{ beta particles/min.}$$

In converting the measured counting rate to disintegrations per minute, it was assumed that the counter detected the same fraction of beta particles emitted from the reference source and the contaminated surface.   However, there are many factors that affect the actual counting rate for a sample of a given emission rate, and if the sample and reference source differ in any way, corrections may have to be made.

### 1.6   Factors Affecting Efficiency of Detection of Beta Particles

A detector intercepts and registers only a fraction of the particles emitted by a radioactive source.   The ratio of the detector counts per minute to the number of particles emitted per minute by the source is called the detector efficiency.   If the efficiency is known, the source strength can be determined from the counting rate of the detector.

$$\frac{\text{Counts/min}}{\text{Efficiency}} = \text{Particles emitted/min from source.}$$

The major factors determining the fraction of particles emitted by a source that actuate a detector are depicted in fig. 4.3 (Price, 1964, pp. 127–137). They include:

1. The fraction of particles emitted by the source which travel in the direction of the detector window: $f_w$.

For a point source located on the axis of an end window G-M tube, a distance $d$ from the circular detector window of radius $r$,

$$f_w = \frac{1}{2}\left(1 - \frac{d}{\sqrt{(d^2 + r^2)}}\right). \tag{1.1}$$

2. The fraction emitted in the direction of the detector window which actually reach the window: $f_i$.

The beta particles may be prevented from reaching the window by absorption in the source itself, in any material covering the source, or in the air or other media between the source and the detector; or by deflection away from

**Fig. 4.3** Factors affecting the efficiency of detection of beta particles by a G-M counter.

the source window in the intervening media.   An approximate formula for the attenuation of beta particles is given by eq. 3.1, part II.

3. The fraction of particles incident on the window which actually pass through the window, into the sensitive volume of the counter and produce an ionization: $f_c$.

The sensitive volume of the counter is the volume in the gas within which a particle must penetrate if any ionization it produces is to result in a discharge.   There is a narrow region behind the window and also at the extreme corners of the tube where G-M discharges will not be initiated, even if an ionization is produced.

4. The fraction which leaves the source in a direction other than toward the detector but is scattered into the detector window: $f_s$.

This factor increases the detector response, in contrast to factors 2 and 3, which attenuate the particles.   The additional particles may be backscattered into the detector from backing material for the source, or from the source material itself, or they may be scattered into the detector by the medium between the source and the detector.

The backscattering from the support of the source depends strongly on the energy of the beta particles and the material of the scatterer, increasing with the energy and the atomic number of the scatterer.   Materials with low atomic numbers, such as plastics, give minimal backscattering.   Scattering from aluminum is low, while backscattering from lead is high.   Curves giving the backscattering factor as a function of atomic number of the sample planchet are given in fig. 4.4 for several beta sources.

The four factors contributing to the efficiency of detection are multiplied to give an overall efficiency factor relating source emission rate and detector

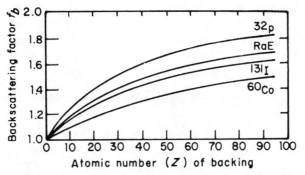

**Fig. 4.4**   Saturation backscattering factors versus atomic number (Zumwalt, 1950).

counting rate.   Thus, letting $R$ and $S$ equal counting rate and emission rate respectively:[1]

$$R = Sf_w f_s f_i f_c.$$

*Example 4:* Calculate the efficiency of detection of an end-window G-M counter for beta particles from "point" sources of $^{14}$C and $^{32}$P deposited on a copper planchet ($Z = 29$), for the following specifications:

| | $^{14}$C | $^{32}$P |
|---|---|---|
| Distance from source to detector window | 1 cm | |
| Diameter of detector window | 2.54 cm | |
| Window thickness, expressed for unit density material | 30 $\mu$m | |
| $f_w = \dfrac{1}{2}\left(1 - \dfrac{1}{\sqrt{(1 + 1.27^2)}}\right)$ | 0.19 | 0.19 |
| Thickness of attenuating media at unit density (0.0012 cm for air; 0.003 cm for window) | 0.0042 cm | 0.0042 cm |
| Half-value layer (from eq. 3.1, part II) | 0.0049 cm | 0.076 cm |
| Number of half-value layers in air + window | 0.86 | 0.055 |
| Attenuation factor in air and window ($f_i f_c$) | 0.55 | 0.96 |
| Backscatter factor | 1.2 | 1.5 |
| Overall efficiency ($f_w f_i f_c f_s$) | 0.13 | 0.27 |

1. For a detailed treatment, see Price, 1964, pp. 127–137.

We note that low-energy beta particles from $^{14}$C are attenuated significantly, even by the air. Combined with the attenuation in the window, the efficiency of detection is about half that calculated for the high-energy beta particles emitted by $^{32}$P. These undergo very little attenuation, either in the air or in the window of the detector.

## 1.7   Correcting for Attenuation of Beta Particles by Determining Absorption Curves

A correction for the absorption of beta particles in the medium between the source and detector can be made experimentally by obtaining an absorption curve. Absorbers of known thickness are added between the detector and the source, and the counting rate is plotted as a function of total absorber thickness.

The total absorber thickness includes not only the added absorbers but also the intrinsic thickness associated with the counting geometry, such as the air and counter window, all expressed in terms of unit density equivalent. The measured count rate is plotted against total thickness and extrapolated to zero thickness for the case of no attenuation. Results obtained with this method are shown in the insert in fig. 4.5.

If the sample emits gamma photons also, the contribution from the photons must be subtracted to obtain the beta counting rate. This is done by adding absorbers until the counting rate falls off in a slow manner, indicating that only gamma radiation remains. The gamma tail to the absorption curve is then extrapolated to zero absorber thickness, and its value is subtracted from the total count rate to give the beta contribution. An example of the gamma correction when counting $^{131}$I is shown in fig. 4.5.

## 1.8   Counting Gamma Photons with a G-M Counter

Gamma photons, because they are more penetrating than beta particles, undergo very little interaction in the gas of the G-M counter. Most of the gamma photons that make a collision in a detector interact in the detector wall. As a result of the collisions, electrons are liberated. Some of these electrons enter the sensitive volume of the detector and initiate a discharge. Generally, only a small fraction of the gamma photons incident on a G-M detector are counted.

The actual efficiency of detection of a G-M counter may be determined experimentally by using a source of known gamma emission. The efficiency depends strongly on the energy of the gamma photons; thus efficiencies measured with one type of nuclide cannot be used for other nuclides emitting gamma photons with different energies, unless corrections are made.

Measurements of the energies of gamma photons may be made in principle with G-M counters by making attenuation measurements with calibrated absorbers and estimating the energy from the half-value layer. However, the accuracy is poor, and attenuation methods are not used for any but the gross-

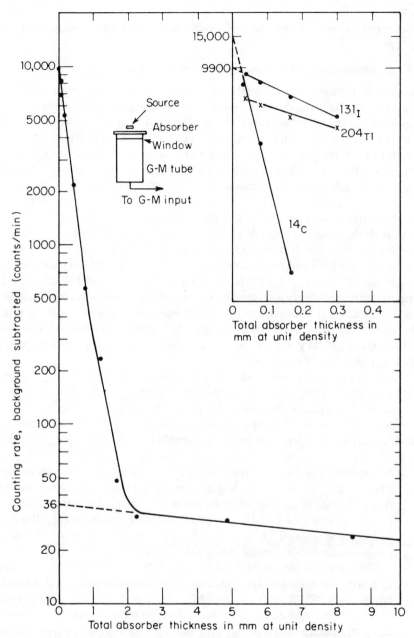

**Fig. 4.5** Absorption curve for correcting for window absorption and gamma counts in counting beta particles from [131]I. The total absorber thickness includes the counting tube window (0.017 mm). The insert includes, for comparison, results for [14]C and [204]Tl. The [14]C beta curve extrapolates to 15,000 c/min for zero window thickness. The [131]I curve extrapolates to 9900 c/min. The gamma contribution to this counting rate is only 36 c/min. Note that the absorber is placed as close to the window as possible when an extrapolation to give window thickness is made.

est determinations.   An example of a half-value layer measurement is given in fig. 2.9.

## 1.9   Standardization of Radionuclides with G-M Counters

The standardization of a radionuclide requires an accurate determination of its activity.   The procedures to be followed are essentially the same as those required for the determination of the source strength.   Whereas source strength refers to the particle emission per unit time, activity is defined as the number of nuclear transformations per unit time.   It is the nuclear transformations that result in the emission of particles—sometimes in a one-to-one correspondence, sometimes in more complex relationships.   Thus, the activity may be determined from a measurement of the source strength, provided the decay scheme of the nuclide is known.

As with the determination of source strengths for beta sources discussed previously, the simplest method of standardization is to compare the counting rate of the unknown with a standard of identical composition and geometry.   When sample and standard are identical except for activity, the ratio of counting rates is also the ratio of activities.   Any detector, including a G-M detector, is satisfactory for determining the ratio of counting rates. The only precaution to be taken is that, if the counting rates for the sample and the standard vary widely and are excessively high, appropriate corrections be made for "dead time" losses.

Generally, there are differences of size and construction between sample and standard, and the effort to be made in correcting for the differences will depend on the degree of accuracy required.   Experience shows that as the accuracy requirements become stringent, say, below 15 percent, detailed corrections for all differences between sample and standard must be made.

*Example 5:* It is desired to standardize an aliquot of $^{131}$I on a planchet. The sample is counted on September 30 at 11 A.M., and its counting rate is 2580 c/min.   The background is 15 c/min.   The sample activity is to be determined with the use of a standardized solution of $^{131}$I whose activity is given as 0.25 $\mu$Ci/ml as of September 26 at 9 A.M.   Describe the procedures for standardizing the sample.

The period between the time for which the activity of the standardized solution is known and the time of the measurement is 4 days and 2 hours, or 4.083 days.   The half-life of $^{131}$I is 8.1 days.   The elapsed time is 0.503 half-lives, and the corresponding fraction remaining, using the decay curve in fig. 2.11 is 0.705.   Thus, the activity of the standardized solution is 0.176 $\mu$Ci/ml at the time of the measurement, or 390,000 dis/min-ml.

A standard prepared from the solution should not give more than about 10,000 c/min to minimize dead-time losses.   If it is assumed

(from experience) that the counting rate is approximately 20 percent of the sample activity, a reference source should be prepared with an activity of about 50,000 dis/min.  A suitable reference source may be obtained with 0.1 ml of the solution.  This has an activity of 39,000 dis/min at the time of measurement.

The standard solution is counted on the same kind of planchet as used for the sample.  If we assume the reference source gives a counting rate of 7280 c/min, the net counting rate is 7280 − 15, or 7265 c/min.

The activity of the sample is thus $\frac{2565}{7265} \times 39,000$, or 13,800 dis/min.

## 2.  Energy Measurements with a Scintillation Detector

We have seen how a G-M counter can be used to count ionizing particles that trigger it and noted that, once the counter is triggered, the signal is independent of the characteristics of the particle that initiated the discharge. We now turn to detectors that produce signals whose magnitudes are proportional to the energy deposited in the detectors.  Such detectors are generally much more useful than G-M counters in tracer experiments or in analytical measurements.  We shall consider the scintillation counter as an example of energy-sensitive devices.

### 2.1  Description of Scintillation Detectors and Photomultipliers

When an energetic charged particle, such as a beta particle, slows down in a scintillator, a fraction of the energy it imparts to the atoms is converted into light photons.  The greater the amount of energy imparted by a beta particle to the scintillator, the greater is the number of light photons produced and the more intense is the light signal produced in the scintillator.  When gamma photons pass through a scintillator, they impart energy to electrons, which also cause the atoms in the crystal to emit light photons as they slow down.  The more energetic the gamma photons, the more energetic (on the average) are the electrons they liberate, and the more intense are the pulses of light produced.  The amount of light in each pulse is determined with a photomultiplier tube and represents a measure of the energy deposited in the scintillator.  The ability to evaluate these energies provides a means of sorting radiations from different sources and of identifying and determining the magnitudes of the radiation sources.  The operation of a scintillator-photomultiplier combination is shown in fig. 4.6.

Scintillators of all kinds of materials—gaseous, liquid, and solid—and in all shapes and sizes are available.  Some are of plastic; others are of dense inorganic material such as sodium iodide.  The larger and heavier scintillators are used to detect gamma photons, since their greater mass gives them a higher detection efficiency.

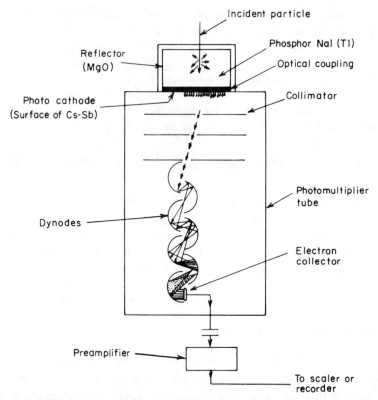

**Fig. 4.6** Scintillation crystal-photomultiplier tube radiation detector (Experimental Manual, Nuclear Chicago Corporation, 1959). The light emitted from the scintillator as a result of absorption of energy from the ionizing particle is converted to an electrical signal in a photomultiplier tube, which consists of a photosensitive cathode and a sequence of electrodes called dynodes. The cathode emits electrons when irradiated by the light released in the scintillator. The number of electrons emitted by the photocathode is proportional to the amount of light incident on it. The electrons are accelerated within the tube and strike the first dynode, which emits several additional electrons for each electron that strikes it. The multiplied electrons from the first dynode are accelerated in turn to collide with successive dynodes. In this way, a large multiplication is obtained. Photomultiplier tubes of 10 dynodes, with accelerating voltages of about 100 V between dynodes (that is, high voltage of about 1000 V) have multiplication factors of the order of $10^6$. The electrons are collected at the anode and deposited on a capacitor, where they produce a voltage signal for subsequent processing and analysis by electronic circuits.

## 2.2   Pulse Counting with a Scintillation Counter and Scaler

Figure 4.6 shows how an electrical charge proportional in size to the energy imparted by the radiation in the scintillator is produced in a photomultiplier tube.

Increasing the voltage applied to the tube accelerates the electrons to higher energies between dynodes and increases the number of secondary electrons produced per stage. Hence, the gain of the tube and the output signal are increased.

When a source of beta particles or gamma rays is counted with a scintillator, a variety of magnitudes of energy transfer occurs in the scintillator and a wide distribution of pulse heights is produced by the photomultiplier tube. The pulses also include spurious pulses not produced by radiation interactions in the scintillator. Some are very small and are associated with so-called noise in the amplifier or in the thermionic emission of electrons from the cathode of the photomultiplier. Some are large, usually the result of electrical interference.

In the simplest application of a scintillation detector, one merely counts the pulses produced by means of a scaler. The scaler counts all pulses above a certain voltage level determined by its sensitivity. Many scalers for general use respond only to signals of 0.25 V or larger.

As mentioned earlier, the sizes of the pulses from the photomultiplier can be increased by increasing the high voltage. There is usually an optimum setting or range of settings depending on the objectives of the investigator. If the voltage is too low, many of the pulses supplied by the detector to the scaler will be too small to produce counts. As the voltage on the photomultiplier tube is increased, more pulses have heights above the sensitivity threshold of the scaler and are counted. Obviously, the detection efficiency of the system is increased at the higher voltage setting.

If the voltage gets too high, low-energy electrons emitted by thermionic emission from the cathode of the photomultiplier tube will acquire enough energy to produce pulses large enough to be counted. The counting rate increases greatly, and the system is useless for counting particles.

The best setting of the high voltage is determined by counting a source over a range of high-voltage settings. Care must be taken not to exceed the maximum voltage that can be applied to the tube as specified by the manufacturer. A convenient source gives about 3000 counts for a 10-second counting time. A background count without the source is also taken at each high-voltage setting for a time sufficient to accumulate at least a few hundred counts. The net counts/minute and the background counts/minute are plotted on a graph as a function of the high voltage. Statistical considerations show that the best value for the high-voltage setting is given by the highest ratio of the square of the net counting rate to the background. A graph of count rates as a function of high voltage is given in fig. 4.7.

## 2.3  Pulse-Height Distributions from Scintillation Detectors

In the previous section we noted that the detection of beta particles or gamma rays by scintillators produced a wide range of pulse heights in the output, in contrast to the uniformly large pulses from a G-M tube. The scin-

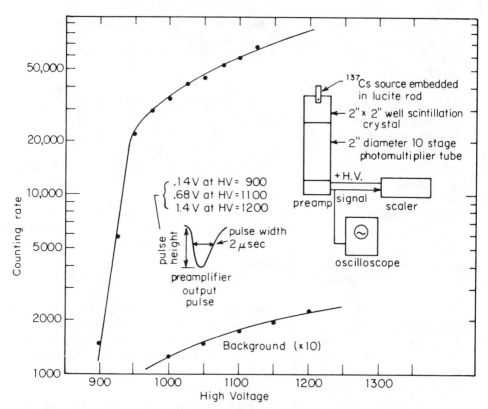

**Fig. 4.7** Net count rate of a simple scintillation counting system as a function of high voltage. At each voltage setting, the sample was counted for 10 sec, and the background for 1 min. The values given for the pulse heights are the maximum observed for $^{137}$Cs and are due to complete absorption of the energy of the 0.667 MeV photon.

tillation detector becomes a much more powerful tool for radiation measurements if we can perform detailed analyses on the pulses it produces. In the next section we shall describe electronic methods of analyzing the pulses, but first let us examine the general form of pulse distributions that are produced. We shall consider the two most frequent methods of using scintillation detectors—beta counting with a liquid scintillation system and gamma counting with a sodium-iodide solid crystal.

### 2.3.1   Pulse-Height Distributions from Beta Emitters in a Liquid Scintillator

The two radionuclides most widely used in research in the life sciences are the beta emitters, carbon-14 and hydrogen-3. The beta rays from $^{3}$H are emitted with energies up to 0.018 MeV, and those from $^{14}$C with energies up

to 0.154 MeV. Because of the low energies and short ranges in matter, the most feasible way to detect these radionuclides is to dissolve them in a liquid scintillator. The beta particles are released directly into the scintillating medium, producing light pulses of intensity proportional to their energies. This technique eliminates problems posed by the existence of attenuating matter between the source and the detecting medium in external counting. It is because of the development of liquid scintillation counting that $^{14}$C and $^{3}$H play the wide role they do in medical experimentation.

Theoretically, the distribution of pulse heights produced in a liquid scintillation detector should have the same shape as the distribution of energies of the beta particles emitted by the radioactive source, since the amount of light emitted is proportional to the energy imparted to the scintillator by the particle. However, an actual measurement of the distribution of pulse heights produced by a source will differ from the true energy spectrum. The main reason for the difference is that the liquid scintillation detector has a relatively poor energy resolution. By this, we mean that the absorption of charged particles of a single energy within the scintillator will not produce a unique light or voltage signal but instead a distribution of pulse heights about a mean value characteristic of the energy of the particle. The spread of the pulse about the mean value determines the energy resolution of the detector.

Another cause of a discrepancy between the observed pulse-height distribution and the distribution of energy absorption events in the detector is that the mean amount of light produced by the absorbed energy may not be strictly proportional to the energy imparted. This lack of proportionality is most marked for low-energy electrons in organic scintillators.

Even with these limitations, useful estimates of the energies of the particles can be obtained from the measured pulse heights. However, the main use made of the pulse-height distributions produced in liquid scintillators is to separate the individual contributions from coexisting beta emitters. Use of the method for distinguishing between the signals from different nuclides is discussed in section 2.4.2 and illustrated in fig. 4.12.

### 2.3.2 Pulse-Height Distributions from a Sodium-Iodide Solid Scintillation Detector Exposed to Gamma Emitters

One of the best scintillators for detecting gamma photons is a single crystal of sodium iodide to which has been added a small amount of thallium. The advantages of this detector are: (1) It is dense (specific gravity 3.67); therefore the probability of interaction per centimeter is higher. (2) It has a high light yield from deposited energy. (3) It has a high atomic number (due to iodine). The gamma interactions are more likely to result in photon absorption (with all the photon energies imparted to the scintillator), rather than photon scattering (with only part of the energy imparted). In contrast, in organic scintillators, which consist primarily of carbon and hydrogen, both

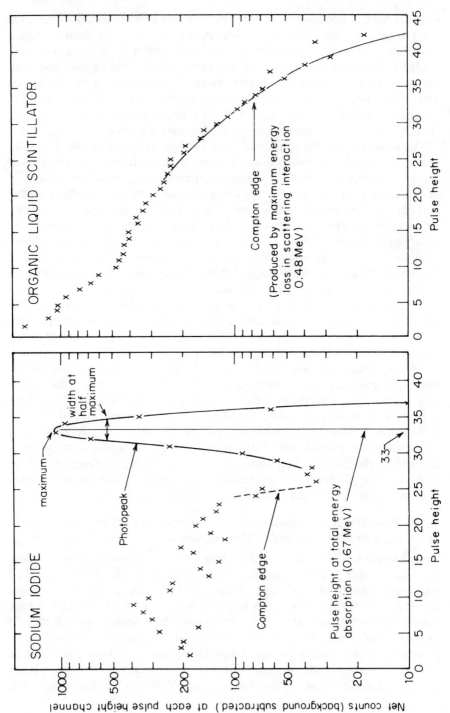

of low atomic number, most of the interactions are scatterings with relatively small energy transfers; that is, the photons escape from the detector, carrying most of the initial energy with them.

An example of the distribution of pulse heights corresponding to the interactions of the 0.66 MeV gamma photons from cesium-137 in a 3″ by 3″ sodium-iodide crystal is given in fig. 4.8. (Pulse-height distributions obtained with a germanium detector, which gives much better discrimination between energies, are shown in fig. 4.14c, section 3.2.) For a comparison, a pulse-height spectrum obtained with a liquid scintillator (volume 10 ml) is also presented. As noted earlier, because of the low atomic number of the plastic crystal, only an insignificant fraction of the gamma photons are totally absorbed.

The distribution of pulse heights produced by the gamma scintillation detector and its photomultiplier will not reproduce exactly the events produced in the scintillator because of the finite energy resolution of the system. The effect of finite resolution may be observed in fig. 4.8 by examining the part of the spectrum labeled photopeak. The pulse heights near the photopeak are all due to the absorption of the same amount of energy, 0.66 MeV from

---

**Fig. 4.8** Comparison of pulse-height distributions from interactions of the monoenergetic gamma photons from cesium-137 (0.667 MeV) in sodium iodide and organic liquid scintillators. The interactions of the 0.667 MeV gamma photons from $^{137}$Cs in the sodium-iodide crystal include a large number of interactions with the relatively high atomic number iodine atoms that result in complete absorption of the gamma photons and produce the peak located at pulse height 33. This peak is generally referred to as the *photopeak* or *full energy peak*. Note that although all the pulses in the photopeak are produced by absorption of the same amount of energy, the pulse heights vary somewhat. The spread of pulse heights about the most probable value is given by the resolution of the system, which is defined as the ratio of (1) the difference in heights at which the counting rate is half the peak, to (2) the pulse height at the peak. The resolution of the measuring system is $(3/33) \times 100 = 9.1$ percent. The pulse-height distribution for the organic scintillator does not show a photopeak. Because of the low atomic numbers of the atoms constituting the scintillator, the number of photon interactions resulting in complete absorption of the photon is negligible, and most of the interactions are photon scatterings which involve small photon energy losses. The electrons liberated as a result are relatively low in energy and are responsible for the steep rise of the curve at the lower pulse heights. The interaction accounting for this distribution is known as Compton scattering. The maximum energy imparted in Compton scattering is less than the photopeak and is known as the Compton edge. Although, theoretically, the Compton edge should show a vertical drop at the upper limit, the finite resolution of the detection system produces a more gradual slope. The pulse-height distributions were obtained with a 100 channel analyzer (section 2.4.4). The relative pulse-height values for the NaI and liquid scintillators are not significant and were obtained by adjusting the amplifiers in each case to distribute the pulses over a convenient number of channels.

[137]Cs. A quantitive measure of the resolution is given by the ratio of the energy pulse-height span over which the pulse count-rate drops by a factor of 2 to the value of the pulse height at the peak count-rate. The resolution for the crystal shown is 9 percent at 0.66 MeV, which is characteristic of a high performance NaI detector.

### 2.4   Electronic Processing of Pulses Produced by Scintillation Detectors

The output electrical charge from a photomultiplier tube (fig. 4.6) is processed by a variety of electronic cirucits whose functions include amplification, discrimination, and counting. A block diagram of the instrumentation is given in fig. 4.9, that also shows pulse shapes as determined with an oscilloscope at various points. The output of the radiation detector is connected first to a preamplifier, which is located physically as close as possible to the detector. The function of the preamplifier is to couple the detector to the other electronic circuits, which may be located at any convenient location.

The most common type of preamplifier currently used is the *charge-sensitive type*, shown schematically in fig. 4.9. The charge-sensitive preamplifier provides a signal proportional to the charge produced in the detector. This is accomplished through a circuit design which transfers essentially all the charge $Q_D$ from the detector to the feedback capacitor, $C_f$. The capacitative feedback loop creates a very large effective input capacitance; the capacitance is stable and serves to minimize the effect of small variations in capacitance elsewhere in the system, such as the interconnecting leads and preamplifier input capacitance. The output of the preamplifier (volts) is $Q_D$ (coulombs)/$C_f$ (farads). $C_f$ generally is of the order of 1 pf in scintillation counting. Since the charge on the electron is $1.6 \times 10^{-19}$ C, the introduction of one electron on the capacitor will produce a voltage of $1.6 \times 10^{-19}/10^{-12} = 1.6 \times 10^{-7}$ V.

The preamplifier pulse typically has a very sharp leading edge and a relatively slow exponential decay of a duration given by the time constant $(R_f C_f)$ of the feedback circuit in fig. 4.9. $R_f$ must be made large to minimize the noise and is of the order of $5 \times 10^9$ $\Omega$. Thus $R_f C_f$ is typically $5 \times 10^9 \times 10^{-12} = 5$ msec. The preamplifier includes a second amplification stage which reduces the time constant of the pulse to about 50 $\mu$sec.

*Voltage-sensitive preamplifiers* were used before charge-sensitive preamplifiers were perfected and they are also satisfactory for scintillation counting. The circuit is shown in fig. 4.9. The signal is produced by deposition of the charge from the photomultiplier on the total input capacitance $(C_{in})$ of the preamplifier. This input capacitance is the sum of the capacitance contributed by the detector, connecting leads, and input circuit capacitance. The voltage signal produced is $Q_D/C_{in}$. The capacitance should be as small as possible (that is, very short connecting leads between detector and preamplifier) to obtain the maximum voltage signal. Typically, it is of

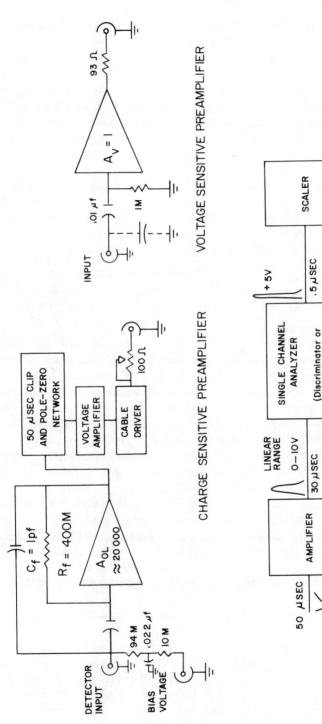

VOLTAGE SENSITIVE PREAMPLIFIER

CHARGE SENSITIVE PREAMPLIFIER

**Fig. 4.9** Block diagram of radiation measuring system.

the order of $10^{-11}$ f. Voltage-sensitive preamplifiers inherently provide higher signal pulses relative to noise pulses (signal-noise ratio) than charge-sensitive preamplifiers. Charge-sensitive preamplifiers also can be built with very favorable signal-noise ratios, but only with the use of much more complicated circuitry and special input transistors (that is, the field effects transistor or FET). However, the disadvantage of the strong dependence of the signal on the capacitance of the input elements in voltage-sensitive preamplifiers usually outweighs the simpler circuitry, particularly because of the ease with which complicated electronic circuits can now be fabricated.

Let us estimate the magnitude of the voltage signal produced by the interaction of radiation with a scintillator. About 500 eV absorbed in a high-quality scintillation detector will result in the release of one photoelectron at the cathode of the photomultiplier. Multiplication factors of $10^6$ are readily achieved in the photomultiplier tube. If the capacitance is $10^{-11}$ f, the signal developed from a 0.018 MeV tritium beta particle is $\frac{18,000}{500} \times \frac{1.6 \times 10^{-19} \times 10^6}{10^{11}} = 0.56$ V. The signal from a 0.154 MeV carbon-14 beta particle would be 4.8 V.

However, not all inputs would be of exactly the same voltage. Ionization is a statistical process and the exact number of ion pairs produced will vary from one particle to the next of exactly the same energy. The spread is of the order of the square root of the number of ion pairs (see section 6.5). For example, the absorption of a 0.05 MeV beta particle (average energy for $^{14}$C) will release 100 photoelectrons on the average with a spread of $\pm\sqrt{100}$ or 10 electrons. This is 10 percent of the average. The absorption of .006 MeV, average energy for tritium, gives only 12 photoelectrons with a spread of $\pm\sqrt{12}$ or 29 percent. The spread of pulse heights is further increased a small amount by the noise of the signal processing electronics.

The pulses pass from the preamplifier through the amplifier which clips them to about 2 $\mu$sec and shapes them to produce maximum signal to noise ratio and minimum spectrum distortion at high counting rates. The amplifier changes the size of each input pulse by a constant factor (as set by the operator) to bring the pulse heights into the working range of the analyzer (usually 0–10 V). The amplifier can also change the polarity of the pulse as shown in fig. 4.9.

A hypothetical sequence of pulse heights appearing at the output of an amplifier is shown in fig. 4.10. The pulses are labeled according to origin—radiation background, radiation source, and noise. Noise pulses arise from erratic and random behavior of various electrical and electronic elements and from outside electrical interference. Almost all the larger noise pulses can be eliminated by proper design, including effective shielding and grounding of the system. Low-level noise is inherent to the

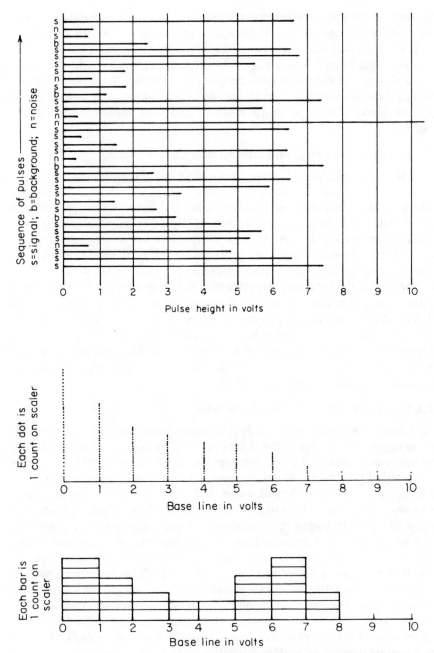

**Fig. 4.10** Examples of discriminate counting of sequence of pulses from single-channel analyzer. The dots represent counts from pulses greater than the baseline setting. The histogram at the bottom gives registered counts from pulses that pass through a window between the baseline setting and 1 V above the baseline.

system, and although by selection of specially designed high-quality components its magnitude can be minimized, it cannot be eliminated completely.

The pulses that pass through the analyzer are counted by a scaler. The analyzer determines which pulses will get through for counting. It may allow through all pulses above a certain level, or only those pulses that fall within a certain voltage interval, known as a window. Let us examine the various kinds of pulse selection methods and their application to counting problems.

### 2.4.1   Integral Counting and Integral Bias Curves

The simplest selection of pulses is through integral counting. All pulses above a certain value are counted. Those below that value are not counted. The level at which pulses are counted is set by a control known as a discriminator, which acts as an electrical gate. It is used mainly to reject low level pulses from spurious sources such as electrical noise. It will, of course, also reject pulses from the lower-energy radiation interactions. The effect of a discriminator on the transmission of pulses is shown in fig. 4.10.

For any particular counting problem, a determination of the optimum discriminator setting may be made by obtaining an integral bias curve. Counts in a fixed time interval are determined as the discriminator is varied systematically from a minimum value to a maximum value. The measurements are repeated with the source removed to determine the effect of the background. An example of an integral bias curve and its use in obtaining the best discriminator setting is given in fig. 4.11.

### 2.4.2   Counting with the Use of a Window

Additional discrimination in analyzing pulses is obtained by the imposition of an upper limit to size of the pulses that will be counted. This is done by an upper-level discriminator. An upper-level and lower-level discriminator can be used together to selectively pass pulses in a specified energy range to a counter. A combination of upper and lower discriminators is called a window. The effect of a window on the transmission of pulses is shown in fig. 4.10. Usually two or three windows are used in liquid scintillation counters to separate contributions from several radionuclides counted simultaneously, such as $^{14}C$ and $^3H$. A block diagram of the major components of a liquid scintillation counter is given in fig. 4.12. The figure also presents measurements on the efficiencies of detection of disintegrations from $^3H$ and $^{14}C$ samples in two separate channels, each adjusted for optimum detection of one of the radionuclides. Data such as that presented in the figure allow adjustment of the analyzer to distinguish between the activities of $^3H$ and $^{14}C$ in a sample containing both radionuclides.

*Example 6:* The liquid scintillation counter used to derive the curves in fig. 4.12 is used to count a sample containing both $^{14}C$ and $^3H$. The

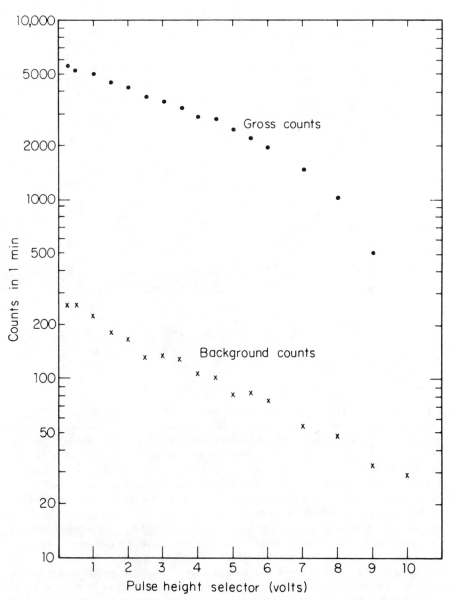

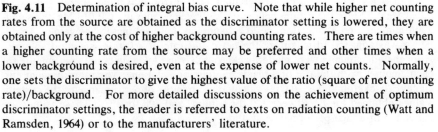

**Fig. 4.11** Determination of integral bias curve. Note that while higher net counting rates from the source are obtained as the discriminator setting is lowered, they are obtained only at the cost of higher background counting rates. There are times when a higher counting rate from the source may be preferred and other times when a lower background is desired, even at the expense of lower net counts. Normally, one sets the discriminator to give the highest value of the ratio (square of net counting rate)/background. For more detailed discussions on the achievement of optimum discriminator settings, the reader is referred to texts on radiation counting (Watt and Ramsden, 1964) or to the manufacturers' literature.

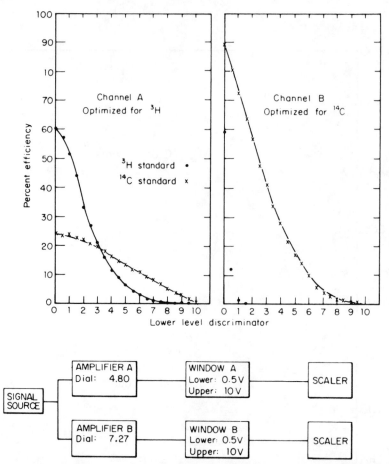

**Fig. 4.12** Use of windows to distinguish between $^3$H ($E_{max} = 0.0186$ MeV) and $^{14}$C ($E_{max} = 0.156$ MeV) counts in a double-labeled isotope experiment. The plotted points give the efficiencies of detection for $^3$H and $^{14}$C liquid scintillation standards as a function of the lower-level settings of the windows in a two-channel system. The upper-level setting remained constant at 10 V. In setting up the liquid scintillation system, the upper levels of the windows were set at their maximum value of 10 V and the lower-level settings were set at 0.5 V. The gain of Amplifier B was increased until the counting rate of a $^{14}$C standard solution approached a maximum level. At this point, the window was passing almost all the $^{14}$C signals. The largest pulses, produced from absorption of the $^{14}$C beta particles of maximum energy (0.156 MeV), were at a voltage approximately equal to the upper-level setting of 10 V. The lower level of 0.5 V passed pulses greater than 1/20 of the maximum energy pulses, or 0.008 MeV. Since the tritium beta particles have energies up to 0.018 MeV, a significant number were counted in the $^{14}$C channel at these settings. The gain of Amplifier A was adjusted to maximize the net count rate of a tritium standard solution. After the adjustments were made, backgrounds were taken in counts per minute for each channel, with the use of a blank scintillation solution. The ratio (percent efficiency)$^2$/background, ($E^2/B$), is evaluated as an index of performance of the system. Values obtained for $E^2/B$ were 150 for tritium, and 308 for $^{14}$C. These values are indicative of a high-performance system.

lower-level discriminators are set at 0.5 for channel A and 1 for channel B. The sample is counted for 20 min and gives 7920 c in channel A and 8340 c in channel B. The background counting rate for both channels is 20 c/min. Calculate the $^{14}$C and $^{3}$H activities in the sample.

Let $e$ represent the detection efficiency for a channel; use a superscript to indicate the nuclide and a subscript to denote the channel. Thus $e_A^C$ is the efficiency of detection of $^{14}$C in channel A. From fig. 4.12, $e_A^H = 0.57$; $e_A^C = 0.24$; $e_B^H = 0.013$; $e_B^C = 0.72$. The net counting rates in channels A and B are 376/min and 397/min respectively. If we denote the activities of $^{3}$H and $^{14}$C by $X$ and $Y$ respectively, the equations to be solved are

$376 = 0.57 X + 0.24 Y.$
$397 = 0.013X + 0.72Y.$
The solutions are $X = 430$ $^{3}$H dis/min.
$$Y = 545 \ ^{14}C \ dis/min.$$

If we had assumed the tritium contribution to channel B was negligible, we would have calculated

$Y = 551$ $^{14}$C dis/min.
$$X = \frac{376 - 0.24 \times 551}{0.57} = 426 \ ^{3}H \ dis/min.$$

### 2.4.3  Differential Pulse-Height Analysis with a Single Channel Analyzer

If, instead of counting only the pulses in a specific energy range, we wish to determine the distribution of pulses over the whole energy spectrum, we have to use a differential analyzer. In a single channel analyzer, a window is provided that allows through only those pulses above a continuously variable lower-level setting, known as the baseline, and below an upper level which is always a fixed voltage above the lower level. The difference between the upper and lower levels is determined by the "window setting."

If the window setting is at 0.1 V, it will pass only those pulses between the lower-level setting and a level 0.1 V above that setting. A curve can be plotted of counts obtained in a fixed counting time as we increase the level of the baseline stepwise. Such a curve is known as a differential spectrum. An example of a spectrum obtained with a single channel analyzer for $^{137}$Cs is shown in fig. 4.13. The amplifier was adjusted to give an output pulse of 3.3 V when all the energy of the 0.667 MeV photon from $^{137}$Cs was absorbed in the crystal (that is, photopeak is at pulse height of 3.3 V).

The integral bias curve, obtained with the same analyzer, is shown along with the differential spectrum for comparison. Note that the value for the integral count above any baseline may be obtained in principle from the differential count by adding up the counts obtained at each setting above the

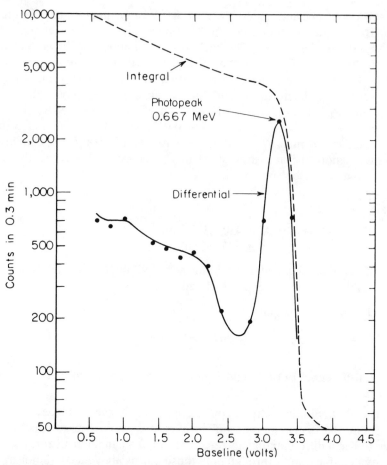

**Fig. 4.13** Differential and integral spectra obtained with a single-channel pulse-height analyzer. Source: ¹³⁷Cs; Detector: 3″ × 3″ solid sodium-iodide crystal; Window: 0.2 V; Interval between successive settings on baseline: 0.2 V. The ¹³⁷Cs photon energy of 0.667 MeV is identified with the "photopeak" on the differential curve, and with the maximum rate of change of counts on the integral curve. In reading the differential curve, the baseline value should be increased by half the window width since it represents the lower level of the window.

baseline. On the other hand, the differential spectrum can be obtained from the integral curve by determining the difference in integral counts at the settings which bracket each differential reading. However, an accurate sorting of pulses into consecutive voltage increments can be obtained only through the use of a multichannel analyzer.

### 2.4.4 Use of Multichannel Analyzers in Pulse-Height Analysis

A multichannel analyzer sorts pulses into a large number of intervals, known as channels. Transistorized analyzers have a working range of about 10 V.

A 1000 channel analyzer would thus separate the incoming pulses into 0.01 V intervals.

Data obtained from analysis of $^{137}$Cs and $^{60}$Co sources with a multichannel analyzer are presented in fig. 4.14. The amplifier of the analyzer was adjusted so that the 0.667 MeV $^{137}$Cs photopeak fell in channel 33. This caused the $^{60}$Co 1.17 and 1.33 MeV photopeaks to fall in channels 58 and 66 respectively. The number of pulses with heights that fall between the limits set for the photopeak (referred to as counts under the photopeak) are generally used in evaluating the data obtained with the scintillator. The simplest approach is to add the counts in a fixed number of channels on each side of the channel containing the greatest number of counts. It is preferable to sum up the counts in a number of channels rather than to use only the counts in a single channel. This procedure minimizes the effect of drift, that is, the shifting of the channel containing the peak associated with a particular energy as a result of slight changes in amplification. Also, the larger number of counts obtained with several channels provides improved counting statistics for the same measuring time.

When we discussed pulse-height distributions in section 2.3, we noted that the interaction of gamma photons with a NaI detector resulted in a large range of energy absorption, giving a distribution of pulse heights with a maximum pulse-height value corresponding to absorption of all the energy of the photon. Thus, when photons of several energies are counted, any peak below that corresponding to the maximum photon energy contains, in addition to contributions from complete absorption of the photon of energy associated with the peak, contributions from higher-energy photons that are only partially absorbed. An approximate way to subtract out the counts that are not attributable to photons at the photopeak energy is to draw a line between the left and right sides of the peak and subtract the counts under the line that fall in the channels under consideration. An example of the calculation of the photopeak area and the photopeak center is given in fig. 4.15. The procedure for correcting for contributions from higher energy photons is known as "spectrum stripping." For complex spectra, accurate identification and evaluation of peaks by spectrum stripping can be a laborious process if done by hand computations, and the data are best processed by computer techniques (Heath, 1964; DeBeeck, 1975; Quittner, 1972; DeVoe, 1969). The processing can include background subtraction, correction for interference effects between channels, and even calculations of source strengths from calibration data stored in the computer. The computer circuitry may be built into the multichannel analyzer, or the data may be fed to an external computer facility.

Multichannel analyzers cannot process incoming pulses instantaneously so the live counting time (that is, the time during which the analyzer is actually counting photons) is less than the clock counting time. Normally the analyzer timer is designed to operate on "live" time. Its accuracy can be checked by counting the source along with a pulser of constant known rate.

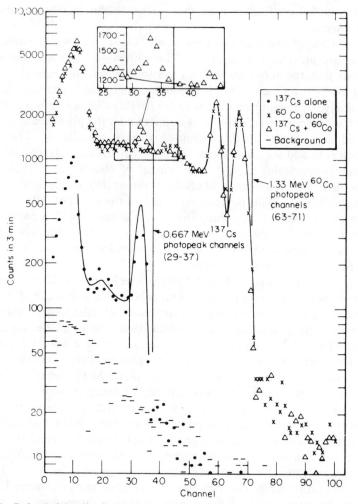

**Fig. 4.14** Pulse-height distributions obtained with a 100-channel analyzer. The distributions are given for counts of a $^{137}$Cs source, a $^{60}$Co source, and the $^{137}$Cs and $^{60}$Co sources counted together. The channel counts include the background, and the results of a separate background count are plotted as horizontal bars. The contribution from $^{137}$Cs to the counts in the channels assigned to its photopeak (29–37) is determined approximately by extending the curve from the right to the left side of the photopeak in a smooth manner and subtracting it from the photopeak as shown in the insert. The extended curve represents the contributions from scattering interactions of the higher-energy photons, in this case $^{60}$Co. Note how the $^{137}$Cs peak, which is very prominent when the source is counted alone, appears suppressed when plotted on semilog paper on top of the $^{60}$Co distribution.

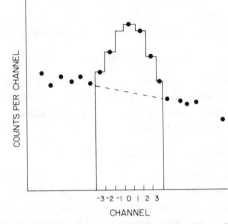

**Fig. 4.15** Determination of peak area.   Call peak channel $i = 0$ and select $n$ channels on each side ($n = 3$ in the figure).   Draw a straight line between the channel counts outside the left and right hand boundaries of the peak.   Let $a_i$ refer to the counts in the channels inside the peak and $b_R$, $b_L$ equal the backgrounds at the left and right boundaries.   Then the peak area is given by $A = \Sigma_{i=-n}^{+n} a_i - (n + \frac{1}{2})(b_L + b_R)$.   To determine the peak center, weight each channel in the symmetrical portion of the peak (for example, above the half-maximum height) by the net counts, add, and divide the sum by the total counts in the channels weighted: $\bar{X} = \Sigma N_X X / \Sigma N_X$ where $X$ is the channel number and $N_X$ is the net counts in channel $X$ (Baedecker, 1971).

The following counts were obtained for the sources and channels indicated:

| Source | Channels 63–71 ($^{60}$Co photopeak) | | Channels 29–37 ($^{137}$Cs photopeak) | |
|---|---|---|---|---|
| | Gross | Net | Gross | Net |
| $^{137}$Cs | 49 | 0 | 1,925 | 1,735 |
| $^{60}$Co | 9504 | 9437 | 10,411 | 10,221 |
| Background | 67 | | 190 | |

The counts in channels 29–37 contributed by $^{60}$Co equal 1.08 times the counts in channels 63–71.   To determine the $^{137}$Cs contribution in any other combination of $^{137}$Cs and $^{60}$Co, one would multiply the net counts in channels 63–71 by 1.08 and subtract from the net counts in channels 29–37.   The same approach is used for other pairs of energies.   For more than two energies, the procedure is to start with the two highest energies and work down in succession.   Of course, it is necessary to have standard pulse-height distributions for each of the photon energies contributing to the composite spectrum.   References for more sophisticated analytical methods with the use of computers are given in the text.

The pulser signal is adjusted to appear in a channel that is approximately 10 percent above the gamma-ray peak. The live time can be computed from the number of pulses accumulated during the counting period.

## 3.   Detectors for Special Counting Problems

We have examined two of the most frequently used detectors for radiation counting—the G-M tube and the scintillator. Other detectors are preferred for special applications. Two of the most important are gas-filled proportional counters and semiconductors.

### 3.1   Gas-Filled Proportional Counters

Gas-filled counters can be used to measure the energy of particles but their use is confined to particles with very short range because of the low density of the gas (for example, alpha particles, very low energy beta particles, very low energy x rays). The signal is produced by the electrical charge or current resulting from ionization of the gas by the radiation. Only part of the imparted energy goes into ionization, the rest produces excitation, which does not contribute any charge. On the average, one ion pair is produced for every 34 eV of energy absorbed in air; similar values apply to other gases commonly used in counters, such as helium, argon, and nitrogen. The total number of ion pairs produced is a measure of the total energy absorbed in the gas.

The production of ion pairs is a statistical process, and the exact number of charges produced from absorption of a given amount of energy varies. The variation is measured by the square root of the average number of charges produced (see section 6.5). This variation is one of the factors affecting detector resolution, discussed previously in connection with the photopeak produced by scintillation detectors (section 2.3.2, 2.4).

The negative electrons and positive ions produced by ionization are collected by the imposition of an electrical voltage between the central wire and the outer shell of the counting tube (see section 1.1 on G-M counters). The central wire is made positive to attract the electrons. As they drift toward it, they make many collisions with the gas molecules in the detector. In between collisions, they are accelerated and given energy that may be sufficient to ionize the molecules with which they collide. These in turn produce additional ionization that constitutes an amplification process. There is a range of operating voltages where the amplified charge remains directly proportional to the energy absorbed in the detector. A counter operating on this range is called a proportional counter. Proportional counter amplification of the initial charge is generally a thousand times or more.

Gas-filled proportional detectors can easily distinguish between alpha and beta particles through pulse-height discrimination. A 5.49 MeV alpha particle from Americium-241 has a range at standard temperature and pressure of 4 cm. Since alpha particles ionize at an average energy expenditure of

35 eV per ion pair, a $^{241}$Am alpha particle produces $5.49 \times 10^6/35 = 1.56 \times 10^5$ i.p. A beta particle would lose 0.01 MeV in the same 4 cm, producing (at 34 eV/i.p. for $\beta$ particles) 294 ion pairs. Thus in a gas counter with dimensions of 4 cm, the ratio of the heights of $\alpha$ to $\beta$ pulses would be $1.56 \times 10^5/294 = 534$, and they would be easily separable by pulse-height discrimination. Proportional counters do not work well with air; the oxygen has a strong affinity for electrons and prevents multiplication. A 90 percent argon, 10 percent methane mixture is popular.[2] The counters are often operated as flow counters, that is, the gas flows through at a slow rate at atmospheric pressure. This avoids the buildup of impurities in the gas that can occur through outgassing in a sealed counter and that degrades the counter performance.

Gas-filled proportional counters are particularly suited for low-level alpha measurements because they can be built with a large detection area and very low background. A typical proportional counting system and operating characteristics are shown in fig. 4.16.

### 3.2   Semiconductor Detectors

Semiconductor detectors are the detectors of choice for very high resolution energy measurements. The basic detection medium is silicon (specific gravity = 2.42) or germanium (specific gravity = 5.36). The reason for the superior performance of semiconductors is that much less energy is required to produce an ion pair than is required in gases or scintillators. The average energy needed to produce an ion pair in silicon is 3.62 eV (300° K) and in germanium is 2.95 eV (80° K), compared to 34 eV in air and 500 eV in a scintillator. Thus, many more ion pairs are produced per unit energy absorbed. This produces a smaller spread in the distribution of pulses and improved resolution.

Silicon detectors are generally used for alpha and beta particles. The sensitive volume is made thicker than the maximum range of the particle in the medium. A standard thickness (depletion depth) for the sensitive volume of a silicon detector is 100 $\mu$m. This is equal to the range of 12 MeV alpha particles and 0.14 MeV beta particles. Detectors with active areas up to 900 mm$^2$ are standard catalog items. Silicon detectors with smaller areas are offered to 500 $\mu$m thickness (range of 2.5 MeV $\beta$ particles).

Germanium detectors operated at liquid nitrogen temperature (80° K) are generally used for gamma radiation. They must be thick enough to give adequate sensitivity for photons in the energy range of interest. The needed

---

2. The range of an alpha particle in a medium other than air is given approximately by the Bragg-Kleeman rule (Evans, 1955, p. 652), $R = (\rho_a/R_a)\sqrt{A/A_a}$ where $R_a$, $\rho_a$, and $A_a$ are the range, density, and effective atomic number (= 14.6) for air respectively. The range in argon is about 20 percent greater than the range in air and the average energy expended in producing an ion pair is 26 eV (Attix and Roesch, 1968, p. 320).

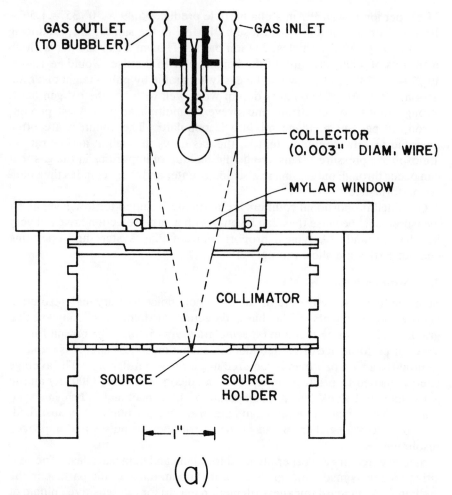

GAS OUTLET
(TO BUBBLER)

GAS INLET

COLLECTOR
(0.003" DIAM. WIRE)

MYLAR WINDOW

COLLIMATOR

SOURCE

SOURCE
HOLDER

├─ 1" ─┤

(a)

**Fig. 4.16**  Operation of gas counters.  (*a*) Typical setup for flow-type counter.  (*b*) Variation of pulse size with voltage.  (*c*) Counting rate versus counter voltage for a flow-type proportional counter.

thickness can be evaluated from the half-value layer (1.9 cm for the 0.67 MeV $^{137}$Cs photons).  The improvement in resolution of a gamma spectrum obtained with a semiconductor compared to NaI is shown in fig. 4.17. Notice the additional energies that can be distinguished with a germanium crystal—these overlap and cannot be distinguished in a scintillation detector.  It costs much more to make semiconductor than NaI detectors of comparable detection efficiency for gamma rays, so NaI detectors are the detector of choice when cost is a factor or high efficiency detection of photons of known energy is required.

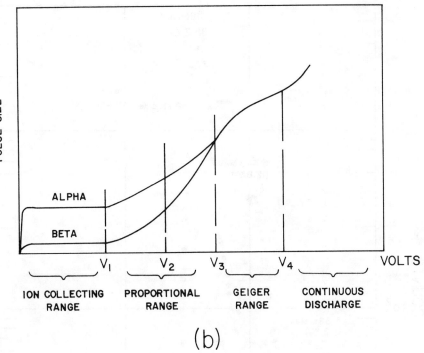

(b)

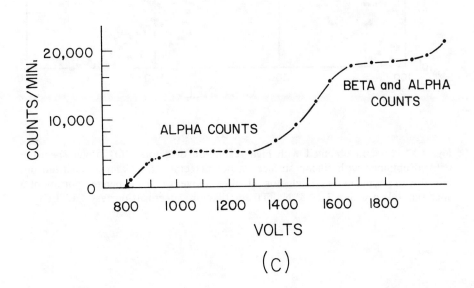

(c)

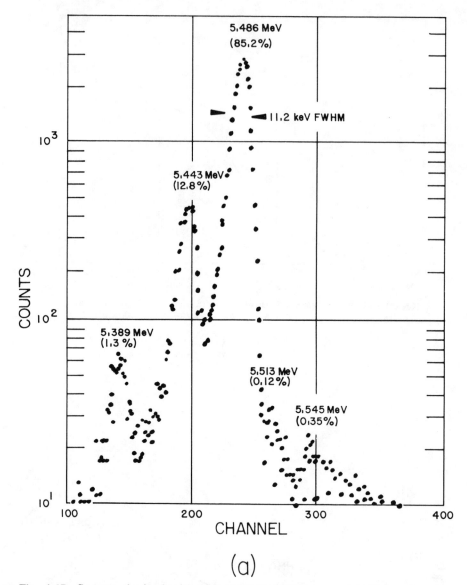

5,486 MeV
(85,2%)

11,2 keV FWHM

5,443 MeV
(12,8%)

5,389 MeV
(1,3%)

5,513 MeV
(0,12%)

5,545 MeV
(0,35%)

COUNTS

CHANNEL

(a)

**Fig. 4.17** Spectra obtained with high resolution detectors. (*a*) Alpha spectrum (²⁴¹Am) obtained with silicon surface barrier detector. (*b*) Gamma spectrum obtained with germanium (Li) detector. Plotted above it is the expanded portion of a spectrum taken with a 3″ × 3″ NaI(Tl) scintillation detector (Courtesy ORTEC).

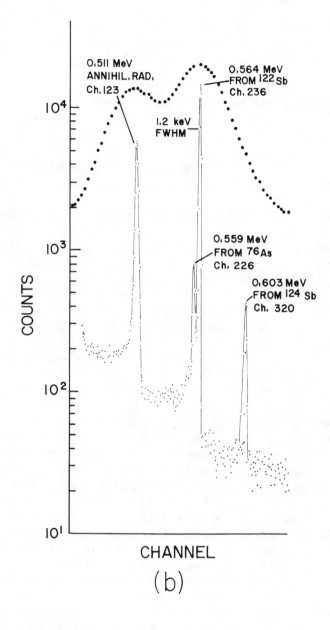

CHANNEL

(b)

## 4.  Measuring Radiation Dose Rates

The pulse detectors and associated instrumentation discussed in the previous sections are used primarily for counting particles and determining their energies.  We shall now consider radiation measuring devices which give readings closely representative of the absorbed dose rate.  The discussion

here is confined mainly to x and gamma radiation. A report of the NCRP (1978, Report 57) covers dose-rate measurements for other types of radiation, including neutrons, beta radiation and high-energy electrons.

## 4.1   Measuring X and Gamma Dose Rates with Ionization-Type Survey Meters

The simplest type of detector that responds to the absorbed energy in the detector medium is the ionization chamber. This consists of a container filled with gas. The ion pairs produced by the absorbed energy are collected by maintaining a suitable voltage difference between the wall of the chamber and an inner electrode. However, the operating voltage is much lower than in proportional and G-M counters because there is no multiplication. Continuous exposure to radiation produces an ionization current that is measured with a sensitive electrometer. Thus the electrometer current is a measure of the dose rate to the gas. If the gas is air, and the radiation consists of x and gamma rays, the ionization is expressed in terms of a quantity known as the exposure. The exposure is defined as the total negative or positive charge liberated by photons as a result of interactions in unit mass of air.

The charge is that produced in the process of the complete slowing down in air of all the electrons liberated by the photons. However, the dimensions of actual chambers are generally much smaller than the range in air of the electrons. As a result, the chamber gas gets only a fraction of the ionization (and resultant current) from the slowing down of the electrons liberated by photon interactions in air. Most of the ionization is produced by electrons released from photon interactions in the chamber walls. If the walls of the chamber are made of air-equivalent material the thickness of which approximates the maximum range of the electrons released by the x or gamma radiation, electron equilibrium exists. This means that the ionization produced in the chamber gas by electrons liberated from the walls compensates exactly for the ionization that would have been produced in the air by the electrons liberated in the gas. In other words, the ionization produced in the chamber air is the same as if it were caused by the complete absorption in the air of all the electrons liberated in the air. The special unit of exposure is called the roentgen, R (defined in part II, section 10). Since 1 R produces a dose of 0.93–0.97 rad to muscle, depending on the photon energy, we may equate an air exposure of 1 R to a soft-tissue dose of 1 rad, for all practical purposes.

Air-filled ionization chamber-type survey instruments for measuring exposure rates of the order of 1 milliroentgen per hour (mR/hr) can be built simply and are very useful for monitoring work spaces. The ionization chamber is usually in the form of a cylinder, with typical dimensions 8 cm in diameter by 10 cm in length. An ion-chamber survey meter is shown in fig. 4.18. Ionization chambers used to measure radiation at low levels comparable to the natural background must be larger than those used in work areas to

**Fig. 4.18** Dose rate and count rate monitoring instruments. (*a*) G-M counter and rate meter (Eberline Instrument Corp. Model E-120), for general monitoring of x and gamma radiation. Small speaker (Model SK-1) is shown attached to "phone" output for aural monitoring. (*b*) Ion chamber (Victoreen Instrument Co. Model 470A "Panoramic"), for measuring exposure rates around x-ray machines and gamma sources. (*c*) Rugged, logarithmic ion chamber type gamma survey meter (Victoreen Instrument Co. Radector III). (*d*) Low-energy gamma scintillation detector (Ludlum Measurements Inc. Model 2 count rate meter with Model 44-3 probe), particularly useful for monitoring for $^{125}$I and other low energy gamma emitters. (*e*) Gas-flow proportional counter (Eberline Model PAC-4G), shown with alpha probe. Behind alpha probe are "windowless" detector for tritium and cylinder of counting gas (75 percent propane).

achieve the required sensitivity. A spherical chamber with a volume of 16 l has been used extensively for background measurements.

> *Example 7:* Calculate the current produced in a cylindrical air ionization chamber 8 cm in diameter by 10 cm in length, exposed in a field of 1 mR/hr. The temperature and pressure are 25° C and 770 mm Hg respectively. Assume that radiation equilibrium exists.
>
> The chamber volume is 503 cc. The mass of air in the chamber equals:
>
> $$503 \text{ cc} \times \frac{0.001293 \text{ g}}{\text{cc}} \times \frac{273° \text{ K}}{298° \text{ K}} \times \frac{770 \text{ mm Hg}}{760 \text{ mm Hg}} = 0.604 \text{ g}.$$

The current is then:

$$\frac{1 \text{ mR}}{\text{hr}} \times \frac{2.58 \times 10^{-10} \text{ C}}{\text{mR-g}} \times 0.60 \text{ g} \times \frac{1 \text{ hr}}{3600 \text{ sec}}$$

$$= 4.3 \times \frac{10^{-14} \text{ C}}{\text{sec}} = 4.3 \times 10^{-14} \text{ amperes.}$$

This is a very small current and is about 10 times the limit detectable by portable survey instruments.

### 4.2  Use of Scintillation Detectors to Measure Dose Rates

Scintillators may be used to indicate the rate of energy absorption if current from the photomultiplier is measured. Used in this way, the scintillation detector is a dose-rate measuring device. If an organic scintillator is used, the energy absorption, and consequently the dose, are very similar to that produced in tissue.

The output current from scintillation dose-rate instruments is hundreds of times greater than that from ionization chambers of the same volume, but scintillation detectors are not used as widely for radiation monitoring. Some of the reasons are: a strong dependence of the gain of the photomultiplier tube on temperature and applied voltage, a high inherent background current from thermionic emission from the dynodes of the photomultiplier, fragility, and high cost.

### 4.3  Use of G-M Counters to Monitor Dose Rates

The type of radiation survey instrument used most often for monitoring of beta and gamma radiation is a G-M counter connected to a count rate meter with a scale reading in terms of mR/hr (fig. 4.18). These instruments are used because of their low cost, simplicity, reliability, and high sensitivity. From our previous discussion, it is apparent, however, that the G-M counter does not actually measure exposure rate or dose rate. All it does is register counts for whatever incident radiation happens to produce an ionization in the sensitive volume. However, it does turn out that, in fact, the G-M survey meter can be made into a fairly accurate indicator of actual exposure rate over a wide range of x and gamma ray energies. This is done through the use of appropriate filters around the detector. The energy response of a specially filtered detector is shown in fig. 4.19. When the dose rate is very high, G-M counters cannot be used. Ionization-type survey instruments should be used instead.

### 4.4  Routine Performance Checks of Survey Meters

Survey meters should be checked for signs of malfunction whenever they are taken off the shelf for use. The following procedures apply specifically to instruments with needle indicators, but the general approach is also applicable to digital readouts.

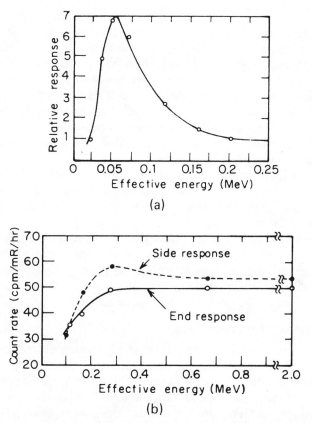

**Fig. 4.19**  Energy response of G-M tube.  (*a*) unmodified; (*b*) filtered, 0.053 in. tin + 0.010 in. lead on sides; 0.022 in. tin + 0.004 in. lead on end (Wagner and Hurst, 1961; see also Jones, 1962).

1. Look over instrument carefully.  Are there indications that it may have been dropped or otherwise mistreated?  Is anything damaged on it?  If the detector is used as a probe, does the cable show signs of breakage?  Was the instrument used to monitor loose radioactive contamination?  If so, check that it is free of significant radioactive contamination.  Is the needle at its zero position or at the point specified by the manufacturer?  Does it bounce around excessively when the meter is moved, indicating poor damping?

2. Turn on the instrument and allow it to warm up.  You may find that the instrument was already on, that the person who used it before you forgot to turn it off.  This means that the batteries are probably weak.  If there is no battery check, replace the batteries.

3. Turn to the battery check position and see that the batteries are good. Record the battery check reading.

4. Turn the knob gently to the first scale and let the needle stabilize. Continue turning to more sensitive scales until you get a response.  (Give

the needle time to settle down at each new position. It generally takes longer on the more sensitive scales.) The needle will fluctuate, more so at the lower readings, because of the random nature of the detected events. Record the background, noting the highest and lowest reading at which the needle remains for a second or so, that is, do not record momentary swings. Always record the scale along with the meter reading.

5. Check the response of the meter on each operational scale with a radiation check source that gives a reading close to midscale. Repeat three times to test reproducibility. The readings obtained should not deviate from the mean value by more than 10 percent.

6. Note the meter readings with the check source held in place while the instrument is oriented in three mutually perpendicular planes. If there are significant differences, be careful to use the instrument in the same orientation as during calibration.

7. Compare the check source reading with the reading obtained when the meter was given a complete calibration. If the two readings differ by more than 20 percent, the instrument should be recalibrated. Use the check source on the instrument prior to each use during intermittent use conditions, and several times a day during continuous use.

### 4.5   Calibration of Survey Meters

Meters are calibrated by exposing them to a radiation source with a known output. The calibration should be performed preferably under conditions of minimum scatter, by placing the source and detector far from walls, floor, and so on. If the calibration is done in a small room, scatter corrections should be made. A technique for making a calibration, using a G-M counter as an example, is illustrated in fig. 4.20. At least two points should be calibrated on each scale to determine the degree of linearity of response of the instrument. Readings also should be taken on each operational scale at the time of the calibration with a check source and repeated routinely prior to use. Calibrations should be performed on a regular schedule and after maintenance, after change of batteries, and when check source readings indicate departure from calibration greater than 20 percent. It is important to keep records of all calibration, maintenance, repair, and modification data for each instrument. A label should be affixed to the instrument giving the date of calibration, check-source reading, any calibration curves or correction factors, special energy or specific use correction factors, and the identity of the calibrator. Extensive treatments of calibration may be found in ANSI, 1975; ICRU, 1971, Report 20; IAEA, 1971, Technical Reports Series No. 133.

### 4.5.1   Calibration Sources

Ideally, a meter should be calibrated in a radiation field identical to the field to be monitored; for example, a meter that will be used to measure the exposure rate around a cesium irradiator should be calibrated with a cesium

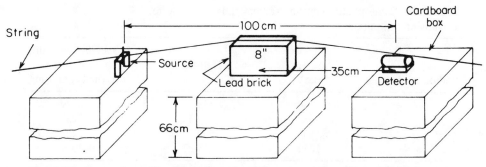

**Fig. 4.20** Setup for calibration of gamma survey meters with a standard source. The dose rate due to the primary photons at a given distance from the source is evaluated by the inverse square law (air attenuation can usually be neglected). The contribution from the additional photons scattered into the detector by the floor, walls, and other structures is evaluated experimentally by shielding out the direct photons with a 2″ × 4″ × 8″ lead brick. The shield cross section should be as small as practical and the shield should be positioned very precisely or part of the detector will see the source and the reading for the scattered radiation will be erroneously high. In the figure, the equipment is shown lined up with the use of a taut string. The source shield, and detector are positioned on top of cardboard cartons, which scatter a minimum amount of radiation because of their small mass.

The following calibration data were taken at 1 and 2 m. The purpose of taking the readings at two points was to check that the inverse square law applied and that the correction for scattered radiation was being made properly.

Source: $^{137}$Cs, 5 mCi. Dose rate: 1.6 mrad/hr at 1 m.

| Source-detector distance (m) | Unshielded | | Shielded | | Counts/min from direct beam |
|---|---|---|---|---|---|
| | Counting time (min) | Counts/min | Counting time (min) | Counts/min | |
| 1 | 1 | 4778[a] | 5 | 373[a] | 4405 |
| 2 | 1 | 1215 | 10 | 187 | 1028 |

a. Corrected for coincidence loss (G-M resolving time $3.5 \times 10^{-4}$ sec) and background rate of 42 c/min.

The measured ratio of 4405/1028 = 4.3 follows the inverse square law approximately. The use of longer counting times to reduce the statistical variation in the counts and a shadow shield contoured to shield the direct radiation with a minimum effect on the scattered component would improve the agreement.

Using the measurements at 1 m, the calibration constant for the G-M tube becomes 4405 c/min = 1.6 mrad/hr, or 1000 c/min = 0.36 mrad/hr. In calibrating a survey meter, measurements should be made at enough distances to cover all ranges of the instrument. The problems connected with reporting G-M readings in mrad/hr or mR/hr should be understood and the possibilities of making large errors at low energies recognized.

**Table 4.1.**  Some photon-emitting radionuclides suitable for instrument calibration.

| Radionuclide | Effective energy (keV) | Half-life (yr) | Specific exposure rate constant R/(hr-Ci) at 1 m[a] |
|---|---|---|---|
| $^{241}$Am | 60 | 433 | 0.0129 |
| $^{137}$Cs | 662 | 30.1 | .323 |
| $^{226}$Ra | 836[b] | 1600 | .825[c] |
| $^{60}$Co | 1250 | 5.27 | 1.30 |

*Source:* ANSI, 1975.
a. Assume negligible self absorption, scattering, and bremsstrahlung.
b. $^{226}$Ra emits gamma rays of many energies from 19 to 2448 keV.
c. In equilibrium with its decay products and with 0.5 mm Pt filtration.

source attenuated to give an energy spectrum similar to that from the irradiator, and an x-ray survey meter should be calibrated with an x-ray machine, and so on.  Calibrated in this way, any radiation detector could be used to monitor exposure rates.  In practice, one must rely on the *energy independence* of the meter; that is, one calibrated to read accurately in roentgens with a source of a specific energy such as $^{137}$Cs will be satisfactory for monitoring fields at other energies.  Most instruments, however, are accurate only over a limited energy range.  It is important to know the energy response and the corrections that should be made for sources that differ from the calibration source.  The information should be supplied by the manufacturer, or obtained by the use of calibration sources with different energies, if necessary.

Calibration sources should have reasonably long half-lives so they do not have to be corrected for decay or replaced frequently.  Some of the more popular sources are listed in table 4.1.

Commercial calibration sources should be checked independently.  They may be calibrated by the National Bureau of Standards, or checked against other sources that were standardized by NBS.

### 4.5.2  Determination of Exposure Rates for Calibration

Since there is some attenuation of the source materials by the encapsulating materials, calibration sources generally are specified not by the activity contained, but by the equivalent activity of an uncapsulated source.  When this is the case, the exposure rate produced by the direct radiation from the source can be determined readily with the specific exposure rate constant.

*Example 8:*  A Cs-137 source is obtained, certified to have an equivalent activity of 5.0 mCi on September 1, 1977.  What is the exposure rate at a point 50 cm from the source on March 15, 1980?

From table 4.1, the specific exposure rate constant is 0.323 (R-m²)/

(hr-Ci) or 0.323 mR/hr from 1 mCi at 1 m. The elapsed number of half-lives equals 0.084 and the decay factor equals 0.94. Therefore, the exposure rate at 50 cm on March 15, 1980 equals $5.0 \times 0.323 \times (100/50)^2 \times 0.94 = 6.07$ mR/hr.

The value of the specific exposure rate constant may be due to photons of a single energy or of a range of energies. It usually does not include very low energy photons emitted by the source that ordinarily do not penetrate through encapsulating materials, or if they did, would probably not get through the detector walls. On the other hand, if a source had only a very thin covering and was monitored with a thin-walled detector (one designed for low-energy x rays), the meter might respond to the low-energy photons and these would have to be included (with appropriate corrections for attenuation) in the specific exposure rate constant. Generally, this is not a problem, but the possibility of complicating source emissions under special conditions should be kept in mind. For example, the specific exposure rate constant for $^{137}$Cs is calculated for the 0.662 MeV photons. Barium x rays in the 30 keV range are also emitted, but their contribution to the dose rate if unattenuated is only about 1 percent. Their actual contribution is even less because of attenuation in the source encapsulating material. Beta particles emitted from the source are generally absorbed by the encapsulating material and detector walls. However, high-energy beta particles may emerge and contribute to the detector reading. This can lead to significant calibration errors, particularly in the case of $^{226}$Ra sources, which emit 3.26 MeV (max) beta particles from the decay product $^{214}$Bi. The contribution of beta particles can be checked by taking an absorption curve. The results will also indicate how thick an absorber is necessary to eliminate their effect on a given detector. Of course, the use of added absorber requires a correction in the stated output of the calibration source. No one ever said that careful calibration was easy.

### 4.5.3  Effects of Calibration Geometry

The basic calibration exercise involves determining the distance from the source to give a desired exposure rate by use of the inverse square law; setting up the detector at this distance; and adjusting the detector to read properly. This procedure is quite adequate for radiation-protection purposes most of the time, but there are pitfalls. The calculated exposure rate refers to a point that is located at a precise distance, while the detector has a finite size and the distance is somewhat indefinite. Radiation scattered from the structures nearby the source and the detector—ground, walls, or other surfaces in the calibration area—adds to the direct emission from the source. Absorption in air can be significant if the distance between source and detector is large enough or the energy is low enough. Source containers may also introduce some attenuation. Fortunately, these factors often tend to cancel out each other or be insignificant in the first place.

The calibration procedure can be designed to minimize some of these effects. The uncertainty in the effective distance due to the detector or source dimensions is minimized by making the separation distance large enough, preferably greater than seven times the maximum dimension of the source or detector, whichever is larger. On the other hand, the relative effect of scattering from external surfaces is reduced by decreasing the distance between source and detector, since the direct radiation increases inversely as the square of the distance while the scattered radiation changes more slowly. The distance to scattering objects from the source and from the detector should be greater than the distance between the source and the detector. The structure holding the source and detector should be as light as possible.

It is well worthwhile to check the radiation levels at the calibration points with a standard instrument that is highly accurate and reliable, such as a cavity ion chamber (R meter). Preferably, the instrument should have been calibrated at the National Bureau of Standards or, alternatively, with sources traceable to NBS. Close agreement between the measurements with the standard instrument and the calculations should give confidence in the accuracy of the calibration values.

### 4.5.4 Corrections for Scattered Radiation

If there is any question about the significance of scattered radiation, it can be evaluated by the shadow-shield technique (fig. 4.20). Another way is to compare the readings in the calibration facility with readings in as scatter-free a situation as possible, say 2 m above the roof of the building. The differences in readings will indicate whether scattering is important. A third check is made by testing whether measurements at different source-detector distances follow the inverse square law. Significant scatter will result in a drop-off considerably slower than the inverse square.

### 4.5.5 Directionality Checks

A survey meter should give a reading that does not depend on the angle of incidence or directionality of the radiation. This should be checked by reading the meter at various orientations to the source. If there is a directional dependence, this must be taken into account in the radiation survey.

### 4.5.6 Linearity Checks

The linearity of an instrument's response can be checked over its entire operating range by a "two-source" procedure. Each of the two sources should have sufficient output to produce maximum dose rates desired for calibration when the sources are placed close to the detector. Choose a scale, position source A to give 40 percent of the upper limit, and mark the position. This is the reference position. Remove source A and place source B in a different location that also gives 40 percent of the upper limit. Record the reading, return source A to its original location and record the reading for the two sources together. The ratio of the sum of the two separate

readings to the combined reading is the correction factor for the combined reading. Repeat at positions where the two sources together produce a reading that is 40 percent of full scale. The ratio of the combined reading to the sum of the two readings for the sources used separately is the correction factor for the single source reading. Repeat for each range and plot correction factors as a separate curve for each range. Then obtain between-range corrections by positioning each source to give 80 percent of full scale. The sum should be 16 percent of full scale on the next higher range if the ranges differ by a factor of 10. The overall correction factor is the product of all within-scale and between-scale correction factors determined in reaching a particular value.

In this method, the sources may be placed very close to the detector; thus readings on the high ranges with sources of relatively low activity may be obtained. Errors may be introduced, however, when the source-detector distance is very short compared to the detector dimensions, because of the nonuniform production rate of ions. At high exposure rates, this could result in excessive recombination of ions and erroneously low meter readings.

### 4.5.7 Determination of Source-to-Detector Distance—Center of Detection

Ideally a dose-rate measuring instrument should give a measurement of the dose-rate at a point. However, this can be done only by a point detector, and all radiation detectors have finite dimensions. There is no problem if the field is essentially uniform in space, such as at large distances from a point source (compared to detector dimensions). If the radiation field in which the meter is placed varies over the sensitive volume of the meter, the reading will be an average response to the radiation field over the whole volume rather than a measure of the dose rate at a point.

In practice, instruments are calibrated at relatively short distances from a "point" source. If the distance is about a meter and the dimensions of the detector are only a centimeter or two, the variation of the radiation field over the detector can usually be neglected; that is, the inverse square law dose rate varies by a few percent over the detector, but as the distance decreases the variation can be quite appreciable. At 50 cm, the variation over a 10-cm ion chamber is about 50 percent. The usual way of handling this problem is to measure the distance from the source to the geometric center of the detector and to calibrate to the dose rate calculated for this distance by means of the inverse square law (with corrections for scattered radiation if necessary). This is quite satisfactory for most calibration distances. However, the geometric center becomes an invalid reference point as distances approach detector dimensions. At these distances, it is still usually possible to identify a reference point known as the center of detection, a point that can be used for determining source-detector distances for purposes of calibration by the inverse square law. It can be determined by plotting on log-log graph paper the dose rate as a function of distance between the source and

an arbitrary point on the detector, and repeating for other detector points until a straight line with a slope of 2 is obtained.   Only 3 or 4 distances are needed for each detector reference point.   Appropriate corrections should be made for scattered radiation if significant.   The center-of-detection concept breaks down eventually as the separation distance decreases.

The existence of a center of detection is obvious if the detector signal is due to interactions in a small defined area.   For example, most of the response of ionization chambers comes from interactions in the walls.   If only the forward wall contributes most of the signal, the center of detection of a chamber of even substantial dimensions is at the front wall.   In practice, one would expect to find the center of detection somewhere between its front wall and the geometric center.

### 4.6  Beta Dose-Rate Measurements

Monitoring for beta radiation is usually done with the same types of instruments used for gamma radiation (ionization chambers and G-M counters) except that the instruments have a thin window for admitting the beta particles. In principle a gamma calibration of an ionization chamber-type instrument should also hold for beta measurements, since the ionization is done by electrons in each case.   However, a survey meter is usually calibrated with a radiation field that is uniform through the sensitive volume of the detector, while the field is not likely to be uniform in monitoring beta radiation.   The reason is that the beta measurements are usually made very close to the source of beta particles and there is strong inverse-square-law attentuation over the dimensions of the detector.   One should determine a correction factor for converting the instrument reading to actual beta dose rate.   Because of the strong attenuation of the lower-energy beta particles in the dead layer of the skin, it may be desirable to use the detector with an absorber to include this effect.   A good nominal value for absorber thickness is 7 mg/cm$^2$ (0.007 cm at unit density).

When G-M survey meters are used to monitor for beta contamination, the results are usually reported in terms of the meter reading, which is in milliroentgens per hour (based on a gamma calibration).   There is no reason why the gamma calibration should apply, since the instrument is actually giving the number of beta particles crossing the window of the detector per unit time.   It turns out fortuitously that there is a rough correspondence between the actual beta dose rate and the dose-rate readings made with a 1″ diameter by 3″ long G-M tube, the most common size used.   The accurate way to make beta dose-rate measurements is to determine the energy distribution and flux density of the beta particles, or to measure the energy absorption in a thin tissue-equivalent detector, such as a plastic scintillator.

Because of the strong dependence of the instrument response on beta energy and direction, it is necessary for accurate measurements to calibrate with a source of the same energy spectrum and geometry as the one under

measurement.   For general monitoring a uranium slab is often used as the calibration source (233 mrad/hr with 7 mg/cm² absorber), but the calibration applies only to monitoring higher-energy beta emitters.

### 4.7   Neutron Measurements

The conversion factor for neutron absorbed dose to dose equivalent is strongly dependent on neutron energy (table 2.7), which makes neutron dosimetry more complicated than gamma dosimetry.   Therefore a neutron dose measuring device should be able to discriminate neutrons from gamma rays, determine the energies of the neutrons, and weight them appropriately. Alternatively, an instrument could weight signals produced in a tissue-equivalent medium from their linear energy transfer without consideration of the types of radiation or their energies; this approach is the basis of a dose-equivalent meter which uses a tissue-equivalent gas proportional counter as the detector (Baum et al., 1970; Kuehner et al., 1973).   Perhaps the simplest and most rugged neutron dose measuring instruments are those based on a thermal neutron detector surrounded by a moderator.   The thermal neutron detector responds only to neutrons, and the moderator is shaped to produce a count from thermal neutrons proportional to the neutron dose equivalent.   One of the most successful designs utilizes a small $BF_3$ tube enclosed in a polyethylene cylinder.   The desired response is obtained by sizing the moderator, drilling holes in it, and incorporating a thin cadmium absorber (Andersson and Braun, 1963).   This instrument is very sensitive, giving about 7000 c/mrem, with a background of only a few counts per hour.   There are also designs of moderated thermal neutron detectors based on spherical geometry (Hankins, 1968; Nachtigall and Burger, 1972).   An Am-Be neutron source is often used for calibration (Nachtigall, 1967; ICRU, 1969, Report 13).

### 5.   Measuring Accumulated Doses over Extended Periods— Personnel and Environmental Monitoring

In long-term monitoring of low levels of radiation, the dose rate is not particularly interesting.   We are more interested in knowing the dose accumulated over an extended period, say a month.

There are several different types of detectors which are suitable for personnel and environmental monitoring.   These are illustrated in fig. 4.21.

*The nuclear emulsion monitor.*   This is the most widely used personnel monitor for x and gamma radiation and charged particles.   For such use, it is inserted in a special holder which can be clipped to the clothes, and is therefore called a "film badge."   The effect of radiation exposure appears as a darkening of the developed film.   The amount of darkening is read with a densitometer and is proportional to the absorbed dose to the film.   Because the nuclear emulsion is composed largely of grains of silver bromide (in contrast to tissue, which is largely carbon, hydrogen, and oxygen), the response to radiations of different energy is different from that of tissue, and the dose

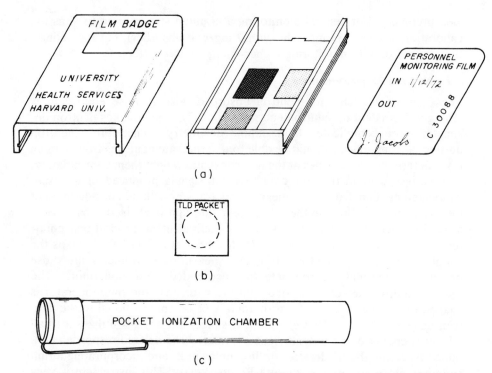

**Fig. 4.21** Personnel monitoring devices. (*a*) Film badge, shown disassembled into front and back portions and film packet. The plastic case has an open-window area to admit beta particles and three filters (aluminum, cadmium, and lead, each 0.04 in. thick) mounted on both the front and back sections. The differences in densities of the negative under the various filtered areas enables evaluation of the photon energy. Each film packet carries an identification number that appears on the negative subsequent to development. A clip is attached to the rear of the badge. (*b*) TLD dosimeter, shown as a Teflon disc impregnated with lithium fluoride, sealed in a polyethylene envelope. Because TLD detectors are small, they are very useful for monitoring dose to the fingers. (*c*) Pocket ionization chamber. The direct-reading type is shown. It is particularly useful for keeping a running account of radiation exposure during work in high dose-rate areas.

to the film as indicated by its darkening may not be representative of the dose to a human being. However, with the use of selective radiation filters over the film, such as copper, lead, and plastic, the resultant density distribution produced by the radiation can be used to identify the general energy range of the radiation and allows conversion of the film dose to tissue dose.

*Thermoluminescent dosimeters.* These "TLD" detectors are well-suited to general personnel and environmental monitoring of x and gamma radiation. The principle of operation is that energy absorbed from the radiation raises the molecules of the detector material to metastable states. They remain in these excited states until they are heated to a temperature high

enough to cause the material to return to its normal state with the emission of light. The amount of light emitted is proportional to the energy absorbed, hence is proportional also to the dose to the detector. The emitted light is measured with a photomultiplier tube.

The most commonly used thermoluminescent material is lithium fluoride activated with magnesium and titanium. Calcium fluoride is much more sensitive but it is not tissue equivalent (as (LiF is) and has poor low-energy response. This, however, can be largely corrected with the use of appropriate filters (that is, 2 mm steel; Shambon, 1974). Both materials performed well in international field-monitoring tests that were conducted for six weeks in a hot and humid climate (Gesell et al., 1976). The detector readings for an actual exposure of 16.3 mR were (standard deviation given in parentheses): LiF, 15.6 mR (18.6%), $CaF_2$: Dy, 16.7 mR (32.2%); and $CaF_2$: Mn, 14.7 mR (20.1%). The dosimeters were packaged in heat-sealable polyethylene bags (0.05 mm thick) in addition to the packaging used by the participants. Results such as these, however, can be obtained only with great care. Good reproducibility depends on proper annealing, use of pure nitrogen in the heating atmosphere, carefully adjusted heater and reading cycle, minimal handling of dosimeter, avoidance of light and so on (Becker, 1973). Best results are obtained with automatic readers and encapsulated detectors that can be placed in the reader without handling the detector or exposing it to light. Under these conditions the entire measurement procedure can be done in the dark with no handling of the detector material itself. Properties of various TLD materials commercially available are given in table 4.2.

In the evaluation of any long-term dose registration device, the possible loss of information before read-out is important. The retention of the information can be affected by such environmental variables as temperature and humidity. In general, TLD materials are less affected by environmental changes and hold the information longer than photographic emulsions do. Emulsions (before development) are particularly affected by humidity, and much of the information can be lost after a few days if the humidity is high. However, the emulsion equipped with filters contains more information than the TLD detector and the developed emulsion provides a permanent record for future reference. We could continue to propound the relative advantages of TLD and nuclear emulsion for personnel dosimetry, and the choice of one system over another may not be clearly indicated in many applications. It appears that for some time to come, both types of systems will share the market for personnel dosimeters approximately equally.

*Pocket ion chamber dosimeters.* The direct-reading pocket ionization chamber consists of a small capacitor, charged prior to use and connected to a glass fiber electroscope. The unit is mounted in a pen-type housing which can be clipped into the pocket of a shirt or laboratory coat. Exposure of the chamber to ionizing radiation results in loss of charge proportional to the amount of exposure and a corresponding deflection of the fiber. The deflection can be viewed directly by means of a lens and a scale built into the in-

**Table 4.2.** Properties of some TLD materials.

| Property | LiF | $Li_2B_4O_7(Mn)$ | $CaF_2(Mn)$ | $CaF_2(Dy)$ |
|---|---|---|---|---|
| Density (g/cc) | ~2.6 (solid) ~1.3 (powder) | ~2.4 (solid) ~1.2 (powder) | 3.18 | 3.18 |
| Temperature of main TL glow peak | 195° C | 200° C | 260° C | 180° C |
| Efficiency at $^{60}$Co relative to LiF | 1.0 | 0.15 | 10 | 30 |
| Energy response (30 keV/$^{60}$Co) | 1.25 | .9 | ~13 | 12.5 |
| Useful range | mR to $3 \times 10^5$ R | 50 mR to $10^6$ + R | mR to $3 \times 10^5$ R | 10 $\mu$R to $10^6$ R |
| Fading | Negligible (5%/yr at 20° C) | <5%/in 3 mo. | 10% first 16 hr; 15% in 2 wk | 10% first 24 hr; 16% in 2 wk |

*Source:* Harshaw Chemical Co.
*Note:* LiF is available from Harshaw as TLD 100 and $CaF_2(Dy)$ as TLD 200.

strument.   Simpler versions of the pocket ionization chamber may also be used which are read not directly but by means of auxiliary electrometers.

Although pocket ionization chambers are convenient to use, they must be handled carefully.   If they are exposed to excessive moisture, leakage across the insulator will result and cause deflection of the fiber and erroneous readings.   Rough handling can also produce spurious results.   The direct-reading chambers, however, are the best available monitors for following significant exposure levels directly.

*Miscellaneous dosimeters.*   There are a variety of other devices useful for special applications.   Silver-activated phosphate glass on exposure to radiation undergoes two effects that can be used for dosimetry: (1) an increase in optical density, and (2) the formation of stable fluorescing centers that continuously emit orange light under ultraviolet excitation.   The detector generally consists of a small glass rod (for example, 1 mm diameter by 6 mm long).   Commercially available systems offer a reliable, economical, and fast method for gamma-radiation dosimetry that is insensitive to neutrons and approaches TLD or emulsion in sensitivity.

Certain plastics when exposed to highly ionizing particles such as fission products, alpha particles, or protons will show pitting or tracks at the site of deposition of energy from the ionizing particle after being etched with suitable caustic solutions.   The etched track method is useful for monitoring neutrons present near high-energy accelerators.   Good reviews of the types of detectors available for dosimetry may be found in Attix and Roesch, 1966, vol. II; ICRU, 1971, Report 20; Barkas, 1963; Becker, 1966, 1973; Fleischer et al., 1975.

## 6.   Specifying Statistical Variations in Counting Results

If you are given a dozen apples to count, the chances are your answer will be 12 apples.   If you repeat the count, your answer probably will be the same, and you will always come up with the same result unless you become fatigued or bored.   On the other hand, when you repeat a measurement with a radiation counter, you will very likely come up with a different result.   A count of 12 may be followed by 11, or 13, or 14, and by an occasional 6 or 18 or even larger discrepancies.   These variations are due not to any inherent malfunction of the counter or its readout system but to the radiation and radiation-absorption process.   Since the probability of penetration of the radiation and interaction in the detector is strictly the result of random processes, the variability of repeat counts with a properly functioning detector can be described with mathematical rigor, and a good estimate of its magnitude can be made, based solely on the magnitude of the count.

### 6.1   Nature of Counting Distributions

To appreciate the variability among many successive counts on the same sample, let us examine some actual data.   The results of a hundred 10-second counts and of a hundred 100-second counts on the same sample are

given in table 4.3.  If we should make an additional count on the sample, we would probably obtain one of the values presented in the table.  There would be a possibility of obtaining a value outside the limits of the data obtained, but the probability of this would be very small.

Which values would we be most likely to find in repeat counts?  We can find out by presenting the data in a manner that shows the frequency with which different values of the count were obtained.  A histogram of the distributions for the data in table 4.3 is presented in fig. 4.22.  We see that the distribution may be characterized by a most probable value, and that the greater the deviation of any particular value from the most probable value, the less is the chance that it will be obtained.

## 6.2   Sample Average and Confidence Limits

If we make a number of repeat measurements and the results differ, we ordinarily average the results to obtain a "best" value.  The averages of the values of the counts presented in table 4.1 are recorded in the histogram in fig. 4.22.  As the number of repeat counts increases, the average of the values approaches a limit that we shall call the true mean.  Ideally, it is this limit that we should like to determine when we make a radiation measurement.  However, radiation counts generally consist of a single measurement over a

**Table 4.3.**   Results of repeat counts on a radioactive sample.

| 10 second counts | | | | | 100 second counts | | | | |
|---|---|---|---|---|---|---|---|---|---|
| 7 | 9 | 11 | 13 | 9 | 120 | 92 | 108 | 107 | 117 |
| 13 | 13 | 9 | 11 | 11 | 98 | 146 | 117 | 112 | 92 |
| 11 | 6 | 11 | 15 | 15 | 131 | 86 | 90 | 109 | 112 |
| 8 | 9 | 13 | 12 | 19 | 119 | 123 | 88 | 101 | 112 |
| 18 | 11 | 9 | 12 | 9 | 127 | 104 | 85 | 111 | 99 |
| 12 | 10 | 10 | 12 | 10 | 114 | 118 | 133 | 127 | 107 |
| 11 | 17 | 8 | 15 | 11 | 96 | 115 | 118 | 113 | 120 |
| 15 | 24 | 7 | 8 | 14 | 119 | 109 | 97 | 110 | 94 |
| 12 | 11 | 15 | 10 | 8 | 114 | 123 | 114 | 123 | 97 |
| 14 | 11 | 10 | 4 | 11 | 121 | 80 | 98 | 108 | 126 |
| 8 | 8 | 9 | 13 | 8 | 97 | 131 | 97 | 105 | 125 |
| 15 | 11 | 6 | 11 | 17 | 93 | 120 | 112 | 115 | 118 |
| 14 | 14 | 14 | 8 | 12 | 130 | 121 | 111 | 110 | 114 |
| 8 | 10 | 10 | 9 | 15 | 114 | 101 | 117 | 109 | 122 |
| 12 | 12 | 9 | 14 | 19 | 113 | 108 | 106 | 128 | 122 |
| 9 | 14 | 6 | 6 | 13 | 100 | 90 | 126 | 111 | 94 |
| 11 | 11 | 8 | 14 | 10 | 115 | 104 | 119 | 105 | 102 |
| 10 | 10 | 10 | 14 | 7 | 103 | 98 | 105 | 120 | 108 |
| 7 | 9 | 11 | 13 | 11 | 116 | 123 | 130 | 109 | 110 |
| 14 | 10 | 15 | 12 | 10 | 107 | 112 | 122 | 109 | 131 |

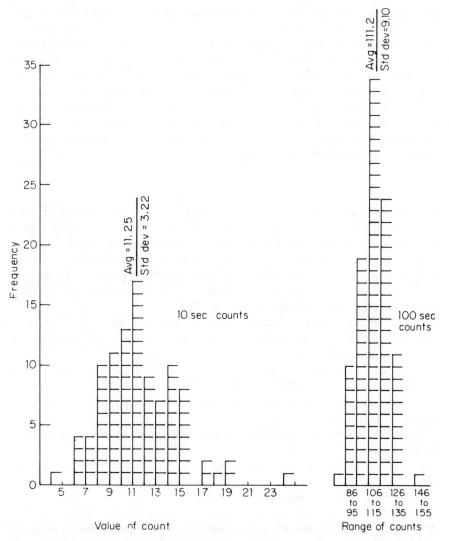

**Fig. 4.22**   Histogram of frequency distribution of 100 repeat counts for two counting periods.

limited time interval and provide only an estimate of the true mean for the sample. Accordingly, the result of a measurement should specify the degree of confidence in the estimate.

One way of expressing the degree of confidence is in terms of confidence limits. These are upper and lower values between which it is highly probable that the true mean lies. The greater the confidence interval, the greater the probability that the true mean lies within the limits. Referring again to

the measurements in table 4.1, let us determine within what ranges 95 percent of the counts lie. For the 10-second measurements, 95 percent of the values (that is, 95 determinations in this example) lie between 6 and 17 counts, or within 51 percent of the average of 11.25. For the 100-second measurements, 95 percent lie within 25 counts, or within 23 percent of the average of 111.2. We refer to the intervals containing 95 percent of the values as "95-percent confidence limits." Other confidence intervals for expressing the result of an investigation may be preferred. The limits the investigator chooses, however, are usually expressed as a multiple of a quantity known as the standard deviation.

## 6.3   Standard Deviation

The standard deviation is the most useful measure of the spread of a distribution of values about the average. It is defined as the square root of the arithmetic average of the squares of the deviations from the mean. The calculation of an unbiased estimate of the standard deviation of a frequency distribution from a sampling of observations proceeds as follows.

Call the number of measurements made $n$, call an individual measurement $X$, and call the sum of the measurements $\Sigma X$.

a. Calculate the average value, $\bar{x}$, of the $n$ measurements: $\bar{x} = \Sigma X/n$.

b. Subtract each measurement from the mean, square the resulting difference, and sum the squares: $\Sigma(\bar{x} - X)^2$.

c. Divide this result by one less than the number of measurements, to obtain the variance $s^2$: $s^2 = \Sigma(\bar{x} - X)^2/(n - 1)$.

d. Take the square root of the variance to obtain the standard deviation, $s$: $s = \sqrt{[\Sigma(\bar{x} - X)^2/(n - 1)]}$.

The following method for calculation of the standard deviation is often used:

a. Sum the measurements and the squares of the measurements, $\Sigma X$ and $\Sigma X^2$.

b. Determine the average value, $\Sigma X/n$.

c. Subtract from $\Sigma X^2$ the square of the sum divided by $n$. $\Sigma X^2 - (\Sigma X)^2/n$. This is the sum of the squares of the deviations from the mean, or sum of squares for short.

d. Divide by one less than the number of measurements to obtain the variance, $s^2$.

e. Take the square root of the variance to obtain the standard deviation, $s$.

*Example 9:* Calculate the standard deviation from the following sample of five readings: 8, 13, 7, 4, 9.

$n = 5$.
$\Sigma X = 41$.
$\Sigma X^2 = 379$.

$(\Sigma X)^2/n = 336.$

sum of squares $= 379 - 336 = 43.$

$s^2 = 43/4 = 10.75.$

$s = 3.28.$

The calculation of confidence limits from the value of the standard deviation is based on the close resemblance between the shape of the distribution curve for successive radiation counts and the normal curve of error.

### 6.4   The Normal Error Curve—A Good Fit for Count Distributions

A set of measurements that are the result of numerous random contributing factors—and this includes most counting determinations—corresponds approximately to the normal error curve.[3]  This curve may be drawn from knowledge of just two parameters—the average and the standard deviation. The distribution and its properties are illustrated in fig. 4.23.  It is characteristic of the normal distribution that 68 percent of the values fall within one standard deviation, 95 percent within 1.96 standard deviations, and 99 percent within 2.58 standard deviations.

The histogram in fig. 4.22 for the repeated counts with an arithmetic mean of 111.2 can be fit nicely with a normal error curve.  The histogram for the distribution with a mean of only 11.25 counts shows a distinct asymmetry, and some error is introduced in replacing it with the symmetrical normal curve.  The asymmetry becomes more pronounced as the mean value decreases, because the accumulation of counts from a radioactive source results from random processes whose probability of occurrence is very small and constant.  As a result, the variability in repeat counts follows the Poisson rather than the normal distribution.[4]  While the Poisson distribution is asymmetrical for small numbers of observed events (that is, less than 16), it rapidly approaches the shape of the normal distribution as the number of events increases.  It is a property of the Poisson distribution that the mean value is equal to the square of the standard deviation.  Thus the normal curve fitted to the data can be drawn if only one parameter, the arithmetic mean, is given.  The standard deviation is obtained simply by taking the square root of the mean.  Referring to the measurements presented in fig. 4.22, the standard deviation for the 10-second measurements as calculated for a normal distribution with a mean of 11.25 is 3.35, and the standard deviation for the 100-second measurements as calculated for a normal distribution with a mean of 111.2 is 10.5.  These values are in good agreement with the values of 3.22 and 9.10 as calculated for the series of 100 measurements.

---

3. Theoretically, repeat counts follow a Poisson distribution (see table 4.5), but when more than just a few counts are accumulated, that is, more than 16, the normal distribution is a good approximation.

4. The Poisson distribution gives the probability of obtaining a count $x$, when the mean is $m$, as $e^{-m} m^x/x!$ (Evans, 1955, chap. 26).

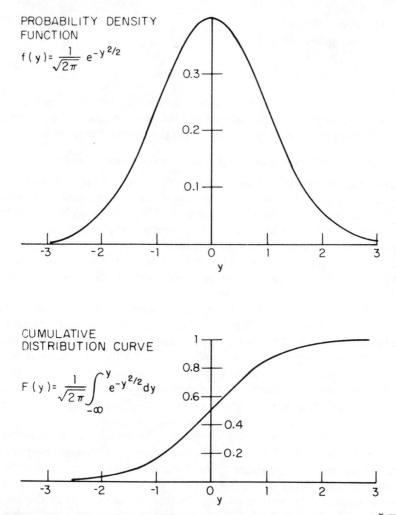

PROBABILITY DENSITY FUNCTION

$$f(y) = \frac{1}{\sqrt{2\pi}} \, e^{-y^2/2}$$

CUMULATIVE DISTRIBUTION CURVE

$$F(y) = \frac{1}{\sqrt{2\pi}} \int_{-\infty}^{y} e^{-y^2/2} dy$$

**Fig. 4.23**   Properties of the normal distribution.   The abscissa $y$ is equal to $\dfrac{x-\mu}{\sigma}$, where $x$ is the value of a specific measurement, $\mu$ is the limit approached by the average value as the number of measurements increases, and $\sigma$ is the limit approached by the standard deviation as the number of measurements increases.   The area under the probability-density function between any two points, $y_1$ and $y_2$, gives the probability that a measured value will fall between $y_1$ and $y_2$.   The area under the tails of the curve, bounded by $y = \pm 1.96$, and the area under the curve to the right of $y = 1.645$ are both 5 percent of the total area under the curve.   The value of the ordinate at any point $y_1$ on the cumulative distribution curve gives the probability that the value of a measurement will be less than $y_1$.   The difference between values of the ordinates at $y_1$ and $y_2$ on the cumulative distribution curve gives the probability that a measured value will fall between $y_1$ and $y_2$, and therefore, the area under the probability-density function between $y_1$ and $y_2$.

From the theory of the normal distribution, we expect 32 percent of the values to differ from the mean by more than one standard deviation. This expectation may be compared to the actual numbers found, which were 23 and 37 out of 100 determinations for the 10- and 100-second measurements respectively.

## 6.5 Precision of a Single Radiation Measurement

In previous sections, we were concerned primarily with the properties of repeat determinations of radiation counts. Now we come to the problem of presenting and interpreting actual results. First let us consider the meaning of a single measurement. The number of counts determined in the measurement may be many thousands, if the sample is fairly active, or it may be only a few counts, such as that obtained in low-level counting. What is the significance of the number?

First, it is obviously the best estimate of the mean value we would obtain if we were to make many repeat determinations. It is best because we have no other measurements. Second, we know that the true mean is probably different from our measurement, and we can specify limits within which the true mean probably lies. The probability that the true mean lies within specified limits around the measured value is determined from the normal error curve, drawn with a mean value equal to the measured counts and standard deviation ($s$) equal to the square root of the measured counts: $s = \sqrt{N}$.[5]

There is a 68-percent probability that the true mean lies within 1 standard deviation, or the square root of the count.

There is a 95-percent probability that the true mean lies within 1.96 times the square root of the count.

There is a 99-percent probability that the true mean lies within 2.58 times the square root of the count.

Using statistical language, we may say:

the 68-percent confidence interval is equal to measured value $\pm 1s$;

the 95-percent confidence interval is equal to measured value $\pm 1.96s$;

the 99-percent confidence interval is equal to measured value $\pm 2.58s$.

The spread of the limits we choose for the measurements will depend on the consequences of the error if the true sample mean should in fact fall outside the limits applied to the measurement, and the judgment of the investigator must determine what type of confidence limits should be chosen.

In practice, the 95-percent confidence level is usually chosen; that is, most investigators will set these limits so there is a 95-percent chance that the average is within the limits applied to the estimate. In very critical situations, 99-percent limits may be chosen; in others they may be set as low as 50 percent.

5. Common practice is to use the symbol $\sigma$ to represent the true value of the standard deviation of a distribution, and $s$ to represent the estimate of the standard deviation as determined from the sample data.

**Table 4.4.**   Limits of confidence intervals.

| Accumulated counts, $N$ | Limits of confidence intervals expressed as counts and fraction of measured value | | | |
|---|---|---|---|---|
| | 68% C.I. | | 95% C.I. | |
| | $\sqrt{N}$ | $\sqrt{N}/N$ | $1.96\sqrt{N}$ | $1.96\sqrt{N}/N$ |
| 20 | 4.47 | 0.22 | 8.75 | 0.432 |
| 60 | 7.74 | .13 | 15.2 | .255 |
| 100 | 10.0 | .10 | 19.6 | .196 |
| 600 | 24.5 | .041 | 47.9 | .080 |
| 1000 | 31.6 | .032 | 61.9 | .062 |
| 6000 | 77.4 | .013 | 152.0 | .026 |
| 10,000 | 100.0 | .010 | 196.0 | .020 |

In table 4.4, we show the 68- and 95-percent confidence intervals for various accumulated numbers of counts. We present the limits, not only as absolute numbers of counts but as fractions of the measured values. Note how the fractional limits decrease as the number of accumulated counts increases.

When the number of counts accumulated falls to a very small number, say, less than 16, the distributions no longer follow the normal curve accurately and the analysis is based on the Poisson distribution. Some results are presented in table 4.5.

It is important to reemphasize that the inferences of confidence intervals and standard deviations depend on the random nature of the counts. The counts do not have to come from a single nuclide or a single source. They may come from any number of radiation sources, including background, but they must not include nonrandom events. Such nonrandom events might come, for example, from electrical interference, such as operation of a welding machine in the vicinity of the counter; interference from a radar transmitter; and high voltage discharges through the insulation of the detector.

## 6.6   The Effect of Background on the Precision of Radiation Measurements

In the preceding section we discussed the estimate of the true mean from a single measurement. When the measurement also includes a significant contribution from the radiation background, the background value must be subtracted. Values of repeated background determinations are also random and follow a normal distribution. As a result, the difference between sample and background values follows a normal distribution with true mean equal to the difference of true sample and background means, but with variability greater than the variability of sample or background counts

**Table 4.5.** Probable limits (95% confidence level) of true mean based on observed count for low numbers of counts (Poisson distribution).

| Observed count | Lower limit | Upper limit |
|:---:|:---:|:---:|
| 0 | 0.000 | 3.69 |
| 1 | .0253 | 5.57 |
| 2 | .242 | 7.22 |
| 3 | .619 | 8.77 |
| 4 | 1.09 | 10.24 |
| 5 | 1.62 | 11.67 |
| 6 | 2.20 | 13.06 |
| 7 | 2.81 | 14.42 |
| 8 | 3.45 | 15.76 |
| 9 | 4.12 | 17.08 |
| 10 | 4.80 | 18.39 |
| 11 | 5.49 | 19.68 |
| 12 | 6.20 | 20.96 |
| 13 | 6.92 | 22.23 |
| 14 | 7.65 | 23.49 |
| 15 | 8.40 | 24.74 |
| 16 | 9.15 | 25.98 |

*Source:* Pearson and Hartley, 1966.

alone. If the counting times of sample and background are equal, then the best estimate of the standard deviation of the difference is given by the square root of the sum of the two measurements, except when they consist of only a few counts. The statistics for differences of small numbers of counts depart somewhat from the normal distribution and have been analyzed in detail (Sterlinski, 1969).

*Example 10:* A sample is counted for 10 min and gives 650 c. The background, also counted for a 10-min period, is 380 c. Give the net sample count rate and a measure of its precision.

The net count is 650 − 380, or 270 in 10 min. The standard deviation of the difference is $\sqrt{(650 + 380)}$ or 32.1, and $1.96s = 62.9$.

The difference may be expressed as $270 \pm 63$, at the 95 percent confidence level.

The count rate may be expressed as $27 \pm 6.3$ c/min, at the 95 percent confidence level.

When the counting times for the sample and background are different, the net count rate would be

$$R = \frac{S}{t_S} - \frac{B}{t_B}.$$

$S$ and $B$ are total and background counts accumulated in times $t_S$ and $t_B$ respectively. The standard deviation of the net count rate is estimated by

$$s = \sqrt{\left(\frac{S}{t_S^2} + \frac{B}{t_B^2}\right)}.$$

> *Example 11:* A sample counted for 10 min yields 3300 c. A 1-min background count gives 45 c. Find the net counting rate of the sample, and a measure of its precision.
>
> The net counting rate is $330 - 45$, or 285 c/min. The standard deviation is
>
> $$\sqrt{\left(\frac{3300}{10^2} + \frac{45}{1^2}\right)} = \sqrt{(33 + 45)} = 8.83. \qquad 1.96s = 17.3.$$
>
> As in example 10, the count rate may be expressed as $285 \pm 18.4$ c/min at the 95 percent confidence level.

When a finite time is available for counting both sample and background, statistical analysis provides a means of determining the most efficient way of partitioning that time. If $R_S$ is the counting rate of the sample and $R_B$ is that of the background, then

$$\frac{t_S}{t_B} = \sqrt{\frac{R_S}{R_B}}.$$

> *Example 12:* A 1-hr period is available for counting a sample which is approximately twice as active as the background. How can the counting time be best divided between sample and background?
>
> $$\frac{t_S}{t_B} = \sqrt{\left(\frac{2\,R_B}{R_B}\right)} = \sqrt{2}.$$
>
> $$t_S = 1.4\, t_B.$$
>
> The sample counting time should be 1.4 times the background counting time. Thus, $1.4\, t_B + t_B = 60$, $t_B = 25$ min.
>
> The background is counted for 25 min and the sample for 35 min.

## 6.7   The Precision of the Ratio of Two Measurements

Instead of calculating the difference between two measurements, it may be necessary to determine the ratio of one measurement to another, where each measurement is given with a degree of precision. For example, in medical uptake studies, a ratio is obtained of the activity retained in the patient to the activity administered to him. The standard deviation of the ratio is obtained by the following equation:

Standard deviation of ratio of two measurements $= \dfrac{M_1}{M_2} \sqrt{\left(\dfrac{s_1^2}{M_1^2} + \dfrac{s_2^2}{M_2^2}\right)}$

where $M_1$ is the value of the measurement of the patient, with estimated standard deviation $s_1$, and $M_2$ is the value of the measurement of the reference activity with standard deviation $s_2$.

*Example 13:* The following data were obtained in a thyroid uptake study.
Background measurement: 3200 c in 10 min.

|  | Patient | Reference |
| --- | --- | --- |
| Gross counts | 4200 | 7200 |
| Counting time (min) | 5 | 5 |
| Gross c/min | 840 | 1440 |
| Net c/min | 520 | 1120 |

Calculate the percent uptake and the 95 percent confidence interval.

$$\text{Std. dev. of net c/min (patient)} = \sqrt{\left(\dfrac{4200}{(5)^2} + \dfrac{3200}{(10)^2}\right)} = 14.1.$$

$$\text{Std. dev. of net c/min (reference)} = \sqrt{\left(\dfrac{7200}{(5)^2} + \dfrac{3200}{(10)^2}\right)} = 17.9.$$

$$\text{Std. dev. of ratio} = \dfrac{520}{1120} \sqrt{\left(\dfrac{200}{(520)^2} + \dfrac{320}{(1120)^2}\right)}$$
$$= 1.46 \times 10^{-2}$$

Percent uptake with 95-percent confidence limits
$$= 46.4 \pm 1.96 \times 1.46 = 46.4 \pm 2.86.$$

## 6.8 Testing the Distribution of a Series of Counts

The operation of a counting system can be tested by comparing the distribution of a series of repeat measurements with the expected distribution. One measure of performance is the Poisson index of dispersion, defined as

$$\chi^2 = \sum_{i=1}^{n} \dfrac{(x_i - \bar{x})^2}{\bar{x}}$$

(Evans, 1955, p. 777; Evans, 1963). $\chi^2$ is a commonly used variable in statistical tests and is plotted in fig. 4.24 as a function of the *degrees of freedom*, $F$. In this case, $F = n - 1$, where $n$ is the number of measurements. The number of measurements are reduced by 1 because they are used to determine one parameter, the sample mean, in the summation given. A series of measurements is considered to be suspect if the probability of $\chi^2$ is too high or too low relative to designated values. For example we may say that if $P$

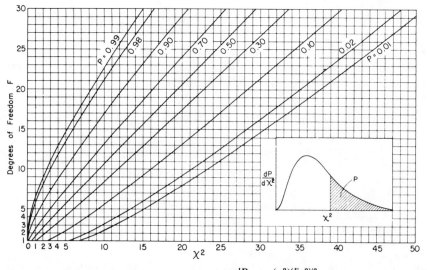

**Fig. 4.24** Integrals of the $\chi^2$ distribution, $\dfrac{dP}{d(\chi^2)} = \dfrac{(\chi^2)^{(F-2)/2}}{2^{F/2}\,(F/2)}\,e^{-\chi^2/2}$ (Evans, 1955, 1963).

lies between 0.1 and 0.9, the system would be accepted as working normally, while if $P$ is less than 0.02 or more than 0.98, the system performance is suspect (Evans, 1955, p. 775).

> *Example 14:* Test the first 5 readings in the third column of table 4.1 for conformance with the Poisson distribution.  The numbers are 11, 9, 11, 13, 9.
>
> $\bar{x} = 10.6$        $\Sigma(x_i - \bar{x})^2 = 11.2$        $\chi^2 = 11.2/10.6 = 1.06$
>
> $P = 0.9$.  The data look somewhat more uniform than expected, but meet the criteria for acceptance.  The next 5 numbers are 10, 8, 7, 15, 10.
>
> $\bar{x} = 10$        $\Sigma(x_i - \bar{x})^2 = 38$        $\chi^2 = 3.8$
>
> $P$ is between 0.3 and 0.5.  This indicates that the system is performing satisfactorily.

## 6.9  Measurements at the Limits of Sensitivity of Detectors[6]

There are times when it is necessary to make measurements at the lowest levels possible with a given detector.  In theory, one could get the degree of precision desired by accumulating as many counts as necessary, but at low counting rates the length of time needed would be impractical.  Also, the

---

6. This section is primarily for reference.  It may be helpful if the detection of counting rates very close to background is required in a radiation protection problem.

longer the counting time, the greater the possibility of extraneous and nonrandom effects on the detector counts, both of which could nullify the advantages of longer counting times.

How do we determine the lowest practical limits of sensitivity of a detector and how do we express and interpret results obtained near these lowest limits? Obviously, the limits are determined by the magnitude of the background counts and their variability, and the precision with which it is possible to accumulate data with the detector. To define the problem in concrete terms, consider a hypothetical measurement of a very low level of activity. Let us assume that in a 10-hr period, we accumulate 13 counts from the sample. A background count for the same counting period yields 10 counts (see Donn and Wolke, 1977, for treatment of different sample and background counting periods).

We are interested in evaluating the significance of the two measurements: (a) sample reading of 13, and (b) background reading of 10. Because of the variability in repeat determinations, we may not conclude that the sample radioactivity has a net value of 3 counts in 10 hr. How can we present and interpret the results?

1. We can assign upper and lower limits to the true values of sample and background measurements, and hence estimate upper and lower limits for the net sample count. Thus, the upper estimate of the true sample count (background included), using 95 percent confidence limits, is $13 + 1.96\sqrt{13}$. A lower limit to the true background count is $10 - 1.96\sqrt{10}$. We may be tempted to conclude that the maximum value of the net counts could be as high as $20.1 - 3.8$ or 16.3 counts. However, it is a gross overestimate, from a statistical point of view, to report that the sample activity may be as high as 16 counts, based on a measured difference of 3 counts.

2. We can present the difference with confidence limits. If we assume the normal distribution still holds, even at these low levels, we can say the standard deviation of the difference is $\sqrt{(10 + 13)} = \sqrt{23}$ counts, and, at the 95 percent confidence level, the difference is $3 \pm 1.96\sqrt{23}$. This means that we are estimating the difference between sample and background as being between $-6.4$ and 12.4, and expect that 5 percent of the time the true difference will fall outside these limits. On the basis of this analysis, the precision of the difference is too poor to accept.

To this point, we have not used the information that, if the instrumentation is working properly, the difference between true sample and background means cannot be less than zero. With this restriction, only the upper limit of the difference is tested (one-tailed test) rather than both upper and lower limits (two-tailed test). If we select the probability of exceeding the upper limit as being no greater than 5 percent, the upper limit is $3 + 1.645\sqrt{23}$, or 10.9 counts. The value of 1.645 is chosen from the curve in fig. 4.23 so that the area under the curve to the right of $y' = 1.645$ is 0.05. Limits for other probability values are readily obtained from fig. 4.23.

3. We can use the results to test certain hypotheses, such as (a) the true

mean count of the sample is no different from the background, and (b) the true mean count of the sample is no greater than the background. Because this uses more information than the first, it provides a more sensitive test. However, it is based on the assumption that the mean value of the background does not change.

4. We can compare the measurement with a minimum count specified (in advance) as significant. After the minimum significant count is specified, we can also determine the minimum true count that would give a positive reading with significant probability, say at the 95 percent confidence level.

Let us examine how we apply these statistical concepts to our counting results.

### 6.9.1   Test of the Hypothesis that the Sample Activity Is No Different from the Background[7]

The measured net count is $13 - 10 = 3$.

If the net difference of the true sample and background mean values were in fact 0, repeat net counts would be distributed about 0 with an estimated standard deviation of $\sqrt{(13 + 10)} = 4.8$.

The chance of obtaining net counts different from 0 as a function of the estimated number of standard deviations has already been discussed in section 6.5. At the 95-percent confidence level, a difference of 1.96 standard deviations, or 9.4 counts, will be needed to establish a significant difference. Since this is greater than the measured difference of 3 counts, the measured difference is not significant.

### 6.9.2   Test of the Hypothesis that the Sample Activity Is Not Greater than the Background, That Is that the Sample Is Not Radioactive

If we feel that the mean background rate did not change during the measurements, and therefore, that the mean sample count must be at least equal to or greater than the mean background count, we may use the more sensitive one-tailed test of significance. Values of multiples of standard deviations for different confidence levels, as derived from the curves in fig. 4.23 are given in table 4.6. The significant difference at the 95-percent confidence level is 1.645 standard deviations, or 7.9 counts. The smaller difference calculated on the basis of this hypothesis is still greater than the measured difference, which is therefore not considered significant.

### 6.9.3   Calculation of the Minimum Significant Difference between Sample and Background Counts

Rather than test the validity of individual measurements, we can calculate the minimum count above a given background count that could be considered significant. The net sample count that is significant must be equal to or

---

7. The theory for this discussion on lower limits of detection is taken from a paper by Altshuler and Pasternack (1963).

**Table 4.6.** Limits at various confidence levels in one-tailed tests of significance.

| Confidence level (%) | $\alpha$ or $\beta$ | Limit in terms of standard deviations $k_\alpha$ or $k_\beta$ |
|---|---|---|
| 99 | 0.01 | 2.326 |
| 95 | .05 | 1.645 |
| 90 | .10 | 1.282 |
| 84 | .16 | 1.000 |
| 75 | .25 | 0.674 |

greater than a specified multiple, $k_\alpha$, of the estimated standard deviation of the difference between sample and background.

$$S - B \geq k_\alpha \sqrt{(S + B)}. \tag{6.1}$$

$S$ = counts with a sample (including background).
$k_\alpha$ = factor associated with the assigned confidence level.
$B$ = background counts.

We rewrite equation 6.1 to allow solution in terms of $S - B$.

$$S - B \geq k_\alpha \sqrt{(S - B + 2B)}. \tag{6.2}$$

For the lowest value of $S - B$, we solve equation 6.2 as an equality and obtain

$$(S - B)_{min} = \tfrac{1}{2} [k_\alpha^2 + \sqrt{(k_\alpha^4 + 8k_\alpha^2 B)}]. \tag{6.3}$$

For a 95-percent confidence level

$$(S - B)_{min} = \tfrac{1}{2} \{(1.645)^2 + \sqrt{[(1.645)^4 + 8(1.645)^2(10)]}\},$$
$$= 8.8.$$

Thus, for a measured background count of 10, it would take a net difference of 9 counts to be considered significant. The difference of 9 counts is significant at the 95 percent confidence level. A smaller difference would be significant if we used a smaller confidence level, that is, if we were willing to accept a higher probability of making the error of assuming that the counts were different when in fact they were the same. Thus, we could consider a difference of 1 standard deviation as significant—this would constitute a test at the 84-percent confidence level. On the average, in 16 cases out of 100 we would be saying a difference existed when in fact if did not. We tend to accept higher probabilities of making the wrong conclusion when it is important to accept a difference, if there is a chance that it exists.

### 6.9.4 Calculation of the Minimum Net True Source Count That Will Provide a Positive Result with a Given Probability

A good way to describe the sensitivity of detection systems is to specify the minimum true source count which would yield a significant sample count in a specified percentage of the measurements. Here we designate the true

source count as the true mean count attributable to the source alone during a fixed counting interval.  As before, we refer to the value of the measurement of the sample (which includes the background) as the sample count.  The minimum value depends on the confidence level used in accepting a count as significant and the acceptable chance of not finding a true difference.  Let us calculate the true source count that would give a result accepted as not different from the background in 10 percent of the measurements if the background count were 10 in the same counting period.  We shall also accept an error frequency of 5 percent in concluding the existence of a source in addition to the background when none exists.

We designate the true source count as $\bar{S}'$.  The distributions of counts around $\bar{S}'$ and for zero activity are shown in fig. 4.25.  Consider two measurements made in identical counting times that yield $S$ for the gross count and $B$ for the background.  Let the difference $S - B = S'$.

The condition for not assuming $S$ and $B$ are different (even when the true mean net count, $\bar{S}'$ is significant) is always given by

$$\frac{S - B}{\sqrt{(\bar{S} + \bar{B})}} \leq k_\alpha \tag{6.4}$$

where $\alpha$ is the probability of making the error of assuming the count means are different when they are, in fact, the same.  For purposes of making calculations, we replace $\bar{S} + \bar{B}$ by its estimate, $S + B$.

Values of $\bar{S}'$ that will produce an insignificant value $S - B$ as determined by equation 6.4 in a fraction of the measurements less than $\beta$ are given by the inequality:

$$\frac{(S - B)_{\min} - \bar{S}'}{\sqrt{(\bar{S} + \bar{B})}} \leq - k_\beta \tag{6.5}$$

where $(S - B)_{min}$ is the minimum significant count difference between sample and background.

Values of $k_\alpha$ and $k_\beta$ are given in table 4.6.

Equation 6.5 may be solved for $(S - B)_{\min}$ by writing it as an equality, replacing $\bar{S} + \bar{B}$ by its best estimate, $S + B$, and rewriting $S + B$ as $S - B + 2B$.  Using $S'_{\min}$ for $(S - B)_{\min}$, we obtain

$$S'_{\min} = \tfrac{1}{2} [2\, \bar{S}'_{\min} + k_\beta^2 + \sqrt{(4\, \bar{S}_{\min} k_\beta^2 + k_\beta^4 + 8\, k_\beta^2\, B)}]. \tag{6.6}$$

We obtain another expression for $S'_{\min}$ from equation 6.4

$$S'_{\min} = \tfrac{1}{2} [k_\alpha^2 + \sqrt{(k_\alpha^4 + 8\, k_\alpha^2\, B)}].$$

And equating both expressions for $S'_{\min}$ we obtain finally

$$\bar{S}'_{\min} = \tfrac{1}{2} \{k_\alpha^2 + \sqrt{(k_\alpha^4 + 8\, k_\alpha^2\, B)} + \sqrt{[8\, k_\beta^2\, B + 2\, k_\beta^2\, k_\alpha^2 + 2\, k_\beta^2\, \sqrt{(k_\alpha^4 + 8\, k_\alpha^2\, B)}]}\}. \tag{6.7}$$

Using $B = 10$, $k_\alpha = 1.645$, $k_\beta = 1.282$, we calculate $\bar{S}'_{\min} = 18$ and call it

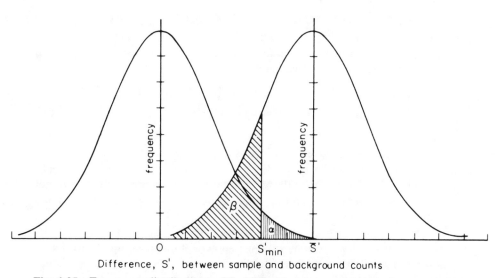

**Fig. 4.25** Frequency distributions of the difference between successive sample and background counts for the same counting periods (drawn after Altshuler and Pasternack, 1963).

The curve on the left gives the distribution when there is no activity in the sample. The average value of the differences approaches 0 as the number of measurements increases and the standard deviation approaches the limit $\sqrt{2\bar{B}}$ where $\bar{B}$ is the limit approached by the average of repeated background measurements. The curve on the right gives the distribution when the sample is active. The average value of the difference approaches the limit $\bar{S'}$, and the standard deviation of the difference, the limit $\sqrt{\bar{S'} + \bar{B}}$). The point $S'_{min}$ is the minimum difference between sample and background counts that is accepted as indicative of activity in the sample. When the sample is nonradioactive, the fraction of times the sample-background difference will be great enough to produce the conclusion that the sample contains activity is given by the shaded area to the right of $S'_{min}$ and denoted as $\alpha$. If the sample is radioactive, the fraction of times the sample-background difference will be less than $S'_{min}$ and produce the conclusion that the sample is not active is given by the shaded area to the left of $S'_{min}$ and denoted as $\beta$. The choice of permissible levels for $\alpha$ and $\beta$ determines the sample-background differences that are accepted as significant and the minimum true sample count that will be detected with the desired frequency.

the minimum detectable true source count for the specified $\alpha$ and $\beta$ confidence levels.

Thus, if over a given period, the background is 10 counts, it is concluded that a minimum true source count of 18 in the same period is necessary to be detected under the specified conditions, that is, in order that in only 10 percent of the time will the counts be low enough to be considered insignificant in a one-tailed test of significance at the 95-percent confidence level.

A considerable increase in precision is obtained if the mean background count is known with good accuracy from separate independent measure-

ments (that is, long-term counts over periods when samples are not counted), and if its value is considered to be stable. Under these conditions, the test for significance is $(S - \bar{B})/\sqrt{\bar{B}} \geq k_\alpha$ and the expression for minimum detectable true source count is

$$\bar{S}'_{min} = \sqrt{\bar{B}}\,[k_\alpha + k_\beta\sqrt{(1 + k_\alpha/\sqrt{\bar{B}} + k_\beta^2/4\bar{B})} + k_\beta^2/2\sqrt{\bar{B}}]. \qquad (6.8)$$

$$\bar{S}'_{min} \cong (k_\alpha + k_\beta)\sqrt{\bar{B}} \text{ when } (k_\alpha + k_\beta)/\sqrt{\bar{B}} \ll 1. \qquad (6.9)$$

For $\bar{B} = 10$, $k_\alpha = 1.645$, $k_\beta = 1.28$, $\bar{S}'_{min} \simeq 2.9\sqrt{10} = 9$ counts.

The largest acceptable error in considering nonradioactive samples as radioactive is probably 25 percent, $k_\alpha$ at this level is 0.674, and the confidence limit is 0.674 $\sigma$. Under these conditions, the minimum significant net count is $0.674 \sqrt{10} = 2.13$, and we might choose to consider a net count of 3 as significant.

The analyses to this point were based on the assumption that the counts followed a normal distribution, which is an acceptable assumption for background counts as low as 4. The situation for counts below 4 has been studied by Sterlinski (1969). He concluded that the significant difference in counts of the sample and background taken in the same time interval (at the 0.01 level of significance) was 6 for average values of the background count between 2.96 and 4. Other values of significant differences for corresponding ranges of the mean background count (in parentheses) were: 5(2.0–2.96); 4(1.18–2.0); 3(0.56–1.18); 2(0.18–0.56) and 1(0–0.18).

## 7. Comments on Making Accurate Measurements[8]

The successful acquisition of experimental data does not follow automatically from good technical training and sophisticated measuring equipment. There are less tangible requirements revolving about the attitudes and habits of the experimenter or operator—the exercise of great care, preoccupation with accuracy, concern for details, use of controls and so on. These habits, of course, all should have been developed during the technical education of the worker, and there should be no need to mention them here except that their breach is so often the cause of invalid results. Accordingly, we conclude this part with a list of practices for meaningful radiation measurements.

1. Test the detection instruments frequently with a test source to determine whether they are responding accurately and reproducibly.

2. Repeat measurements wherever possible to verify reproducibility of technique.

3. Make measurements of lengths of distances as accurately as possible. The ruler is used frequently in radiation measurements, and in spite of its

---

8. Appreciation is due Dr. Godofredo Gomez-Crespo for suggesting the inclusion of a section on precautions in making measurements and also for contributing some very useful recommendations.

simplicity, it is often used incorrectly.   Only a small error in reading a ruler or positioning a detector often will give a large error in the results obtained.

4. When using instruments in the field, check to see that the reading is not dependent on the orientation in space.   If the reading depends on how the instrument is positioned, and this fault cannot be corrected, make sure that the instrument is always positioned the same way.

5. Ascertain the effect on the instrumentation of environmental factors, such as temperature, humidity, and atmospheric electricity.

6. Be sure the right instrument is used for the quantity being measured. (Do not use a thick-walled detector to measure alpha particles.)

7. Always examine instruments and equipment for modifications in the original construction that may have been introduced by previous users. This is particularly important if several users are sharing the same equipment.

In summary, always execute measurements with great care and never take the performance of the instrumentation for granted.   Continually check operation of the measuring equipment with test equipment or test runs and scrutinize the results critically for consistency and reasonableness.

# Part V

# Practical Aspects of the Use of Radionuclides

Users of sources of radiation find their lives complicated by governmental and institutional regulations, legal requirements, inspections, committee reviews, record keeping, public relations, and so on. All result from the efforts of society to protect the worker, the public, and the environment, to prevent radiation accidents, and to institute proper corrective action if they occur. The extent of the regulations to which a radiation user is committed is generally but not always commensurate with the degree of hazard involved. The technical and administrative measures, relatively innocuous for users of radionuclides in tracer amounts, become complex and costly for operators of nuclear power plants or nuclear fuel processing facilities. Obviously the control of strong radiation sources must be in the hands of highly trained professionals. Here we shall limit ourselves to discussing primarily the responsibilities and working procedures of individuals who work with radionuclides in amounts that are not high enough to require the direct supervision of a specialist in radiation protection. Our approach will be to consider, in turn, the various items that are likely to be of concern to an individual from the time he decides to use radionuclides to the time he terminates such work. Our presentation will be consistent with current and proposed revisions of the standards for protection against radiation of the Nuclear Regulatory Commission as promulgated in the Code of Federal Regulations, Title 10, Part 20. References to the present regulations will be cited as 10CFR20; revisions to the code, which should go into effect in 1991

or 1992, will be cited as 10CFR20REV. This chapter is by no means meant to be a comprehensive treatment of NRC regulations, however. The reader will have to make the considerable effort required to become familiar with whatever regulations apply to his use of radioactive materials.

### 1.  Obtaining Authorization to Use Radionuclides

The chances are that an individual initiating a program of work with radionuclides will have to obtain authorization from a government agency on the federal or state level, either the U.S. Nuclear Regulatory Commission (NRC) or a state health department. If he is working at an institution, he will need to obtain this authorization through the institution. It is instructive to consider some features of the licensing of the use of radionuclides by the U.S. Nuclear Regulatory Commission.[1]

The commission is authorized by Congress to regulate the distribution of all radionuclides produced in nuclear reactors.[2] Under this authorization, it has decreed that reactor-produced radionuclides (referred to as by-product material) can be obtained and transferred only under specific or general licenses,[3] except for certain exempt items, concentrations, and quantities. Some exempt quantities and concentrations are listed in table 5.1, column (*b*). These exempt quantities are still covered under a general license (10CFR31.9) and the commission has the authority to regulate their use. The exemption applies only to the need to make actual application for a license. Users are exempt from the regulations in parts 30–34 and 39 (10CFR30.18a) but not from the regulations in part 20. Material obtained under this exemption may not be used for commercial distribution.

A specific license is issued to a named individual, corporation, institution,

1. Federal regulations pertaining to radiation control are issued in the Code of Federal Regulations. The regulations of the Nuclear Regulatory Commission are issued as Title 10 of the Code (Energy). The most important sections for users of radionuclides are: *Standards for Protection against Radiation,* Part 20 (IOCFR 20); *Rules of General Applicability to Licensing of Byproduct Material,* Part 30 (IOCFR 30); *Human Uses of Byproduct Material,* Part 35 (IOCFR 35); and Notices, Instructions, and Reports to Workers; Inspections (10CFR 19).

The NRC also issues Regulatory Guides that describe methods acceptable to its regulatory staff for implementing specific parts of the commission's regulations. Regulatory Guides are useful in preparing the applications and complying with regulations. Some of the available guides are listed in the Selected Bibliography. They may be obtained upon request from the Nuclear Regulatory Commission, Washington D.C. 20555. Attention: Director, Division of Document Control.

2. Radionuclides not produced in a reactor (such as radium) or cyclotron-produced nuclides, are not under the control of the NRC. However, if a user is working with both reactor-produced nuclides and other sources of radiation, the NRC assumes the authority to review all his radiation work under the reasoning that it has the responsibility to determine that the user has complied with exposure standards for the use of reactor-produced isotopes *when added to* exposure from all other radiation sources.

3. Title 10, Parts 30, 31, and 35 of the Code of Federal Regulations relate to licensing of users of radioactivity. The basic standards of radiation control for licensed users are given in Part 20.

**Table 5.1.** Quantities and concentrations exempt from
a specific byproduct material license.

| Radionuclide | (a) Quantity ($\mu$Ci) | (b) Concentration in liquids and solids ($\mu$Ci/l) |
|---|---|---|
| Calcium-45 | 10 | 0.09 |
| Carbon-14 | 100 | 8 |
| Cesium-137 | 10 | — |
| Chlorine-36 | 10 | — |
| Chromium-51 | 1000 | 20 |
| Cobalt-60 | 1 | 0.5 |
| Copper-64 | 100 | 3 |
| Gold-198 | 100 | 0.5 |
| Hydrogen-3 | 1000 | 30 |
| Iodine-125 | 1 | — |
| Iodine-131 | 1 | 0.02 |
| Iron-55 | 100 | 8 |
| Iron-59 | 10 | 0.6 |
| Molybdenum-99 | 100 | 2 |
| Phosphorous-32 | 10 | 0.2 |
| Potassium-42 | 10 | 3 |
| Sodium-24 | 10 | 2 |
| Strontium-90 | 0.1 | — |
| Sulfur-35 | 100 | 0.6 |
| Zinc-65 | 10 | 1 |

*Sources:* 10CFR30.14, 30.70 Schedule A; 10CFR30.18, 30.71 Schedule B (November 1988).

or government agency. Applicants must fill out a special material license form, NRC Form 313, which requests information on the radionuclides to be obtained, the intended use, maximum quantities to be possessed at any one time, training and experience of the person responsible for the radiation safety program and the individual users, radiation detection instruments available, personnel monitoring procedures to be used (including bioassay), laboratory facilities, handling equipment, and waste management procedures. In addition, a description of the radiation safety program is required. The license authorizes possession and use only at the locations specified in the application, and radioactive material may not be transferred except as authorized by the regulations and the license.

Compliance with the terms of the NRC regulations and the conditions of the license is the responsibility of the management of the institution. The radiation safety program must include, to the extent practicable, procedures and engineering controls to ensure that doses to workers and members of the

public are kept as low as reasonably achievable (ALARA). The management must review the content and implementation of the radiation protection program at least annually (10CFR20REV.101).

The radiation safety program is implemented by the Radiation Protection Officer (RPO), also called the Radiation Safety Officer (RSO). The duties of the RPO include preparing regulations, providing advice and training on matters of radiation protection, maintaining a system of accountability for all radioactive material from procurement to disposal, inspecting work spaces and handling procedures, determining personnel radiation exposures, monitoring environmental radiation levels, and instituting corrective action in the event of accidents or emergencies. The main points that should be covered in radiation surveys of research laboratories are given in fig. 5.1 in the form of a survey checklist.

Institutions engaging in research and meeting requirements on staffing, experience, facilities, and controls may obtain a license of broad scope (10CFR33,35). This license does not require the naming of the individual users and does not limit radionuclides to specific uses. It allows the institution to review applications from individual staff members and to authorize use of radionuclides to qualified individuals without special application to the regulatory agency for each individual user. Authority resides in a Radiation Safety Committee (RSC), composed of the Radiation Protection Officer, a representative of management, and persons trained and experienced in the safe use of radioactive materials. The RSC also establishes policies, provides overall guidance and supervision of the radiation protection program, and enforces compliance with the program. The ultimate responsibility for compliance rests with the institution's management.[4] Figure 5.2 gives an example of a permit or authorization to use radionuclides issued by the Radiation Safety Committee at one institution which holds a broad license from the NRC.

### 1.1  Administration of Radioactive Material to Humans

The NRC issues specific licenses to medical institutions for the use of radioactive material within the institution in the practice of medicine. Only the institution's management may apply and the use is limited to physicians named in the license. These physicians must satisfy the commission's requirements regarding training, experience, access to hospital facilities, and

---

4. Handbooks on the organization of radiation-protection programs have been published by the National Council on Radiation Protection and Measurements (NCRP, 1978, Report No. 59), the International Commission on Radiological Protection (particularly for hospitals and medical research establishments, ICRP, 1977, Publication 25) and the International Atomic Energy Agency (IAEA, 1973, Safety Series No. 38). Procedures acceptable to the Nuclear Regulatory Commission are given in regulatory guides, which are issued periodically. These and other sources on practices and procedures are given in the Selective Bibliography.

HARVARD UNIVERSITY
ENVIRONMENTAL HEALTH AND SAFETY

RADIATION PROTECTION OFFICE

SURVEY CHECK LIST

DATE _____ LOCATION _____

LICENSEE _____ SURVEYED BY _____

MEASUREMENT

... Meter check for external dose rates and contamination of surfaces (hot sinks, hoods, storage areas, refrigerators).
... Wipe tests of all suspected areas of contamination (sink ledge, hood ledge, bench top) plus check of "clean areas."
... Air sampling (where required).

INSPECTION

... NRC Form 3 posted.
... Institutional regulations posted.
... Proper signs (radiation area, radioactive material) posted.
... Storage and laboratory areas containing radionuclides controlled, posted, and secured.
... Waste disposal area controlled and posted.
... Hood flow satisfactory.
... Sources, waste solutions, etc., properly labeled and secured.
... Sink disposal records posted and up to date.

MONITORING INSTRUMENTATION

... Available.
... Performance check, calibrated.

REVIEW OF WORKING PROCEDURES

... No evidence of eating, drinking, smoking in laboratory.
... Personnel monitoring devices worn (whole body and hands).
... Records of monitoring saved.
... No pipetting by mouth.
... Protective clothing utilized, including gloves, coats.

**Fig. 5.1** Radiation survey check list.

HARVARD UNIVERSITY
RADIATION SAFETY COMMITTEE

AUTHORIZATION TO USE RADIONUCLIDES

Valid through _____

Authorized user _____     Office phone _____

Department _____     Building and room number _____

Alternate _____     Contact person _____

RADIONUCLIDES, CHEMICAL FORM, AND MAXIMUM ACTIVITIES THAT CAN BE POSSESSED, INCLUDING ACTIVITIES IN STORAGE, IN USE, AND WASTE

NATURE OF WORK WITH RADIONUCLIDES

ROOM NUMBERS WHERE MATERIALS WILL BE USED AND STORED

MONITORING INSTRUMENTATION

PERSONNEL PERMITTED TO WORK UNDER SUPERVISION OF AUTHORIZED USER

Special conditions for source, exposure, and contamination control, including work with biohazards and carcinogens. (These supplement regulations in Radiation Safety Manual, supplementary notices, and statements made in application.)

Date _____     By _____
                                       Chairman, Radiation Safety Committee

**Fig. 5.2** Example of certificate issued to investigators authorized to obtain and use radionuclides.

monitoring equipment. They may use only the specific radionuclides and perform only the clinical procedures specifically mentioned in the license. Physicians may apply directly for a license only if the application is for medical use and will be administered outside a medical institution. A single by-product material license is issued to cover an entire radioisotope program except teletherapy, nuclear-powered pacemakers, and irradiators. Requirements and procedures for obtaining a license are given in the Code of Federal Regulations, Title 10, Part 35 (1988 revision), and in NRC Regulatory Guide 10.8 (NRC, 1987).

The institution must have a Radiation Safety Committee to evaluate all proposals for clinical research, diagnostic, and therapeutic uses of radionuclides within the institution and to ensure that licensed material is used safely and in compliance with NRC regulations and the institutional license. The physicians named on the institution's license cannot conduct their programs without the approval of the Radiation Safety Committee. Institutional licenses provide a means whereby nonapproved physicians under the supervision of physicians named on the license may obtain basic and clinical training and experience that may enable them to qualify as individual users.

The NRC also issues specific licenses of broad scope for medical use, which do not name individual users nor limit the use of radionuclides to specific procedures. Instead, individual users and proposed methods of use are authorized by the institution's Radiation Safety Committee. To qualify for this type of license, an institution must be engaged in medical research using radionuclides under a specific license and must satisfy NRC requirements on personnel, equipment, and facilities (see NRC Regulatory Guide 10.8 and 10CFR33).

The NRC also issues a general license to any physician, clinical laboratory, or hospital for use of small quantities of specific radionuclides in prepackaged units for *in vitro* clinical or laboratory tests (10CFR31.11). These include[125]I and [131]I (maximum 10 $\mu$Ci); [14]C (10 $\mu$Ci); [3]H (50 $\mu$Ci); [59]Fe (20 $\mu$Ci); [75]Se (10 $\mu$Ci); and mock-[125]I reference or calibration sources in units not exceeding 0.05 $\mu$Ci [129]I and 0.0005 $\mu$Ci [241]Am. The use of these materials is also exempt from the requirements of Part 20, except for mock-[125]I, which is still subject to waste disposal restrictions (10CFR20.301).

## 1.2 Requirements for Obtaining Approval to Use New Radioactive Drugs

A new radiopharmaceutical drug (RDP) must be approved by the Food and Drug Administration (FDA) as safe and effective before it can be administered clinically to humans.[5] This authority of the FDA is limited to the

---

5. Regulations of the FDA are given in Title 21, Part 361 of the Code of Federal Regulations (21CFR361).

approval of new drugs. The NRC retains jurisdiction in the areas of licensing for possession, laboratory safety, and routine administration of drugs to patients by physicians.[6]

The developer of a new drug must submit a Notice of Claimed Investigational Exemption for a New Drug (IND) to the FDA. The IND presents the protocol for the investigation to determine its safety and effectiveness. It describes the drug, including radiochemical and radionuclidic purity, and presents the results of all preclinical investigations, a protocol of the planned investigation, and the qualifications of the investigators. The preclinical investigations generally include studies of the drug's pharmacology, toxicity, and biodistribution, as well as the acquisition of sufficient animal data to establish reasonable safety. The IND also provides for notification of adverse effects and annual progress reports.

Certain studies may be done without the filing of an IND if they are conducted under the auspices and approval of an FDA-approved Radioactive Drug Research Committee (RDRC, 21CFR361.1). These studies are limited to the use of radioactive drugs in human research subjects during the course of a research project intended to obtain basic information regarding the metabolism (including kinetics, distribution, and localization) of a radioactively labeled drug in humans or regarding its effects on human physiology, pathophysiology, or biochemistry. They are not intended to serve immediate therapeutic, diagnostic, or similar purposes, or to determine the safety and effectiveness of the drug in humans for such purposes, that is, to be used as a clinical trial. Certain basic research studies, such as studies to determine whether a drug accumulates in a particular organ or fluid space and to describe the kinetics, may have eventual therapeutic or diagnostic implications, but the actual studies are considered basic research prior to established use.

### 1.3 Protection of the Patient in Nuclear Medicine

Radiation protection in the administration of radiopharmaceuticals to patients in clinical medicine is normally concerned with minimizing the dose to the patient while achieving the desired effect. Although the ICRP recommends that "no practice shall be adopted unless its introduction produces a positive net benefit" (referred to as justification), the professional judgment of the nuclear medicine physician and of the referring physician that a proposed use of radiation will be of net benefit to a patient is all that is normally required as justification of the patient's exposure. Therefore, referring physicians should be aware of the biological effects of ionizing radiation and of the doses and associated risks for the prescribed tests.

---

6. *Guide for the Preparation of Applications for Medical Use Programs,* NRC Regulatory Guide 10.8, Rev. 2 (NRC, 1987).

Nuclear medicine studies on volunteer patients, which do not benefit the individual on whom they are performed, play an important role in the advancement of medicine through research.  Most carry negligible risk, but they can be implemented only with the approval of the Radiation Safety Committee after a review has been made of the doses and considerations of age and state of health of the individuals.  Prospective subjects must be fully informed of the estimated risks of the irradiation and of the significance of the exposures with respect to regulatory limits and normal background limits so that they are competent to give their "free and informed consent."

The FDA sets limits on radiation doses to adults from a single study or cumulatively from a number of studies conducted within 1 year (21CFR361.1).  They are: 3 rem for a single dose and 5 rem for an annual and total dose commitment to the whole body, active blood-forming organs, lens of the eye, and gonads; 5 rem for a single dose and 15 rem for an annual and total dose commitment to other organs.  These limits are ten times the limits allowed for research subjects under 18 years of age.

*Example 1.* A proposal is presented before a Radioactive Drug Research Committee to determine under an IND whether a tumor-targeting protein tagged with indium-111 will locate and stick to cancer tissue in the body.  Utilizing data from biopsy samples and gamma camera images, the manufacturer of the radiopharmaceutical has supplied values for organ doses for an administered activity of 5 mCi.  Evaluation of the effective dose equivalent proceeds as follows:

| Part of body | Organ dose, $D$ (rad) | Weighting factor, $W_T$ | $W_T \times D$ (rem) |
|---|---|---|---|
| *Basic organs* | | | |
| Gonads (male or female) | 2 | 0.25 | 0.50 |
| Breast | 2 | 0.15 | 0.3 |
| Red marrow | 3 | 0.12 | 0.36 |
| Lung | 2 | 0.12 | 0.24 |
| Thyroid | 2 | 0.03 | 0.06 |
| Bone surfaces | 2 | 0.03 | 0.06 |
| | | | |
| *Remaining organs (maximum of 5)* | | | |
| Liver | 16 | 0.06 | 0.96 |
| Spleen | 12 | 0.06 | 0.72 |
| Kidney | 10 | 0.06 | 0.6 |
| Additional organ (a) | 2 | 0.06 | 0.12 |
| Additional organ (b) | 2 | 0.06 | 0.12 |
| | | Effective dose equivalent | 4 rem |

Because the study is being done under an IND to determine safety and effectiveness for administration clinically to humans, it is not subject to dose restrictions for investigations processed through the RDRC. If the proposal were submitted to the RDRC as a study to obtain basic information, it would not be approved because the effective whole-body dose and three single-organ doses are above acceptable limits for a single administration. All radioactive materials included in a drug, either as essential material or as a significant contaminant or impurity, are considered in determining the total radiation doses and dose commitments. Radiation doses from x-ray procedures that are part of the research study (that is, would not have occurred but for the study) are also included. The possibility of follow-up studies must be considered when doses are calculated.

The radiation exposure must be justified by the quality of the study being undertaken and the importance of the information it can be expected to provide. Requirements are also specified regarding qualifications of the investigator, proper licensure for handling radioactive materials, selection and consent of research subjects, quality of radioactive drugs used, research protocol design, reporting of adverse reactions, and approval by an appropriate Institutional Review Committee. The RDRC must also submit an annual report to the FDA on the research use of radioactive drugs.

The radioactive drug chosen for the study must have the combination of half-life, types of radiations, radiation energy, metabolism, chemical properties, and so on that results in the lowest dose to the whole body or specific organs from which it is possible to obtain the necessary information.

The RDRC must determine that radioactive materials for parenteral use are prepared in sterile and pyrogen-free form. Each female research subject of childbearing potential must state in writing that she is not pregnant or, on the basis of a pregnancy test, be confirmed as not pregnant before she may participate in any study.

## 2.   Training Required for Working with Radionuclides

NRC training requirements vary depending on the magnitude of the radiation hazards to users and whether the purposeful irradiation of human beings for medical purposes is involved. The basic training program must cover four major areas (which also form the basis for the organization of this book): (a) principles and practices of radiological health and safety; (b) radioactivity measurements, standardization and monitoring techniques, and instruments; (c) radiation calculations; and (d) biological effects. Training in radiation protection for normal laboratory use of radionuclides should require about 20 hours of instruction. The NRC has issued regulatory guides for the training of personnel in different kinds of facilities (NRC, 1984, 1981).

Training and experience requirements set by the NRC for physicians desiring licenses authorizing the use of radionuclides in humans are much more stringent. The details are given in NRC rules and regulations pertaining to medical use of by-product material (10CFR35, Subpart J, 1988). The training required depends on the types of studies the applicant wishes to pursue. Training for uptake, dilution, and excretion studies requires 40 hours of classroom and laboratory training in basic radionuclide handling techniques applicable to the use of prepared radiopharmaceuticals and 20 hours of clinical experience under the supervision of an authorized user. Training for imaging and localization studies requires 200 hours of classroom and laboratory training and 500 hours of supervised clinical experience. Certification in nuclear medicine or diagnostic radiology or successful completion of a six-month training program in nuclear medicine also satisfies the training requirements.

## 3.  Responsibilities of Radionuclide Users

A user who receives authorization to work with radionuclides becomes directly responsible for (1) compliance with all regulations governing the use of radionuclides in his possession and (2) the safe use of his radionuclides by other investigators or technicians who work with the material under his supervision. He must limit the possession and use of radionuclides to the quantities and for the purposes specified in the authorization. He has the obligation to:

(a) Ensure that individuals working with radionuclides under his control are properly supervised and have obtained the training and indoctrination required to ensure safe working habits, compliance with the regulations, and prevention of exposure to others or contamination of the surroundings. In addition, workers should be instructed in the health-protection problems associated with exposure to pertinent radioactive materials or radiation, and female workers should be given specific instruction about prenatal exposure risks to the developing embryo and fetus.[7]  (Inadequate supervision and lack of training have been cited in radiation lawsuits as indicative of negligence.)

(b) Avoid any unnecessary exposure, either to himself or to others working under him.

(c) Limit the use of radionuclides under his charge to specified locations and to individuals authorized to use them by the Radiation Protection Office and over whom he has supervision.

(d) Keep current working records of the receipt and disposition of radionuclides in his possession, including details of use in research, waste disposal, transfer, storage, and so on.

7. See 10CFR19 for details on notices, instructions, and reports to workers and their rights regarding inspections.  NRC Regulatory Guide 8.13 describes the instructions the NRC wants provided to female workers concerning biological risks to embryos or fetuses resulting from prenatal exposure.

(e) Notify the appropriate administrative departments of any personnel changes and changes in rooms or areas in which radioactive materials may be used or stored.

(f) Keep an inventory of the amount of radioactive material on hand and be prepared to submit this inventory to inspectors upon request.

(g) Ensure that functional calibrated survey instrumentation is available to enable personnel to monitor for radiation exposure and surface contamination.

(h) Inform the radiation protection office at his institution when he cannot fulfill his responsibilities because of absence and designate another qualified individual to supervise the work.

(i) Inform the radiation protection office when a woman who is or will be working with a source of radiation under his supervision is known to be pregnant.

The importance of proper record keeping by the individual users as well as by the institution under whose auspices the work is being performed cannot be overemphasized. Records of personnel exposure, radiation surveys, instrument calibration, waste disposal, radiation incidents, and all the other activities discussed in this part represent the main proof of compliance with protection regulations. They are important for legal purposes as well as for effective administration of the radiation protection program.

## 4.   Standards for Protection against Radiation

The basic radiation-protection standards formulated by the NRC for radionuclide users are published in the Code of Federal Regulations, Title 10, Part 20.[8] Every user of radionuclides should obtain and study these standards, which cover many topics including permissible doses, permissible levels, permissible concentrations, precautionary procedures, waste disposal, records, reports, and notification of the NRC in the event of radiation accidents. Some of the radiation exposure limits defined in the regulations are given in tables 2.8 and 2.10.

*It should be emphasized again that regardless of limits that are set for allowable radiation exposures, the general policy is to avoid all unnecessary exposure to ionizing radiation.*[9]

---

8. The standards are prepared from the recommendations of such advisory bodies as the National Council on Radiation Protection and Measurements (see NCRP, 1987, Report 91).

9. This policy is referred to as the "as low as reasonably achievable" (ALARA) principle by the Nuclear Regulatory Commission (10CFR20.1C). The commission expects that its licensees will make every reasonable effort to maintain exposures to radiation as far below the limits as is reasonably achievable. Specific recommendations for implementing this policy are contained in NRC Regulatory Guides 8.8 (primarily for nuclear power stations), 8.1 (and an associated detailed report, NUREG-0267, for medical institutions), and 8.10. Some of the measures listed as indicators of a commitment by management to an ALARA policy include promulgation of the policy in statements and instructions to personnel; review of exposures and operating proce-

## 5.  Personnel Monitoring for External Radiation Exposure

Personnel monitoring devices are required by law, and records must be kept if workers receive or are liable to receive from sources external to the body a dose in any calendar quarter in excess of 25 percent of the occupational dose limits.  Thus, they are required if the external dose from whole-body radiation is in excess of 0.3 rem/quarter.  Exposure records are reviewed periodically by government inspectors.  Exposure histories of workers are also often requested when employees leave one job and report to a new employer.  (In 10CFR20REV, monitoring is required if the worker is likely to receive in one year a dose in excess of 10 percent of the applicable limits. The employment of minors is accepted, but the limits for minors are 10 percent those for adults.)

Monitoring devices are worn on the trunk, between waist and shoulder level.  They should be located at the site of the highest exposure rates to which the body is subjected.  If the hands are exposed to levels significantly higher than the rest of the body because of close work with localized sources, a separate monitoring device should be worn on the wrist or finger.

The personnel monitoring devices generally used for long-term monitoring are the film badge and thermoluminescent dosimeter (see part IV, section 5).  Film badges should not be worn for longer than a month between changes because of fading of the latent image.  Thermoluminescent dosimeters may be worn for longer periods between changes if the risk of excessive exposure is low.  Direct-reading pocket ionization chambers are worn in high-risk areas where it is desirable to have immediate knowledge of integrated exposure.  Pocket ionization chambers which cannot be read without a special readout system are also used for monitoring brief exposures.

Personnel monitoring devices are very useful in radiation control even when the possibility of significant exposure is small.  Their use ensures that unexpected exposures will not go undetected and may help point out situations where controls are inadequate.  They serve as a constant reminder to maintain safe working habits.  They provide the best legal evidence of the actual exposure or lack of exposure of the worker.

Personnel monitoring devices, to be effective, must always be worn by the worker when he is exposed to radiation and must not be exposed to radiation when they are not being worn.  It may seem unnecessary to make these obvious statements, but a significant percentage of high readings on personnel monitoring devices, upon investigation, are found to be due to the storage of the monitoring device in a high-radiation field to which the wearer was never exposed.  The other extreme is that some researchers neglect to wear film badges or other monitoring devices and express surprise at repeated

dures to examine compliance with ALARA; and training programs including periodic reviews or testing of the understanding of workers on how radiation protection relates to their jobs.

negative readings when they know they are being exposed to high levels of radiation.

## 6. Monitoring Personnel Subject to Intakes of Radioactive Material

Radioactive substances enter the body through inhalation, ingestion, or penetration through the skin. The inhalation route is best monitored for an individual worker at the breathing zone. This is done with a personal air sampler, consisting of a filter and a small, battery-driven pump that draws air through it. The filter can be fastened to the lapel of the lab coat. Personal air samplers are widely used to monitor labeling operations with radioiodine that are accompanied by the release of free iodine. A glass filter impregnated with charcoal is used to collect the iodine. An example of a personal air monitoring system is shown in fig. 5.3.

Although personal samplers have the advantage of monitoring the actual breathing zone of the worker, limitations of portability result in samplers with much lower sampling rates, and therefore much lower sensitivities, than environmental monitors. Personal samplers should be investigated thoroughly to see if they have adequate sensitivity for a particular operation.

The worker himself is usually the best monitor for radioiodine. Over 20 percent of the inhaled iodine finds its way to the thyroid, which provides a source close to the surface of the neck. The iodine can be detected efficiently with a NaI scintillator placed against the neck over the thyroid. A crystal 2 mm thick has good efficiency for the low-energy gamma photons emitted by iodine-125, and reduced response to the higher-energy photons in the background.

Gamma-emitting radionuclides in the lungs or more generally throughout the body can be monitored with whole-body counters. The greatest sensitivity is obtained with the low-background room type, but sufficient sensitivity can often be obtained with a shadow-shield type at a much lower cost (Palmer and Roesch, 1965; Orvis, 1970; Masse and Bolton, 1970).

Whole-body counters are ineffective for beta emitters (the most sensitive ones may detect bremsstrahlung from the higher-energy beta particles). Urine analysis is done instead, though the evaluation of body burden from measurements on urine can be quite complicated and uncertain (ICRP, 1988). An exception is the bioassay for tritiated water since the concentration is the same for water in the body as it is for water in urine.

Bioassays for radioiodine and tritium are within the capabilities of research workers who use them. Analyses for most other radionuclides are more difficult (Harley, 1972) and it may be advisable to utilize commercial services to arrange for them.

NRC requirements for bioassays are not specifically stated in 10CFR20 but are incorporated into the NRC licenses. They generally follow the recommendations of the regulatory guides. The revised standards

**Fig. 5.3** Air monitoring equipment. (*a*) Continuous heavy-duty air sampler, rotary vane oil-less vacuum pump (Gast Manufacturing Co. model 0522). Weighs 27 lb., pulls 4 cfm at atmospheric pressure, 3.25 cfm under 5″ Hg, 0.95 cfm under 20″ Hg. Pump shown with holder for charcoal filter and rotameter for indicating air flow. (*b*) Light-duty diaphragm oil-less sampling pump (Cole-Palmer Instrument Co. Air Cadet). Pulls 0.52 cfm at atmospheric pressure, 0.4 cfm under 5″ Hg. (*c*) Hi-Volume Air Sampler, turbine type blower uses 4″ diameter filters. Samples at 18 cfm with Whatman #41 filters (good efficiency for diameters down to 0.01 $\mu$m). Rotameter shows flow rates from 0–70 cfm. Similar units produced by Atomic Products Corp. (illustrated) and Staplex Co. (*d*) Personal air sampler (Mine Safety Appliances Co. Monitaire sampler). Rechargeable battery-operated diaphragm pump. Adjustable flowmeter shows flow rates from 0–2 or 0–10 scfh. (*e*) Charcoal filter cartridge, TEDA-impregnated for adsorption of radioactive iodine (Scott model 605018-03). (*f*) Filter holder for 50-mm diameter filters. (*g*) Gas drying tube. When filled with charcoal, as shown, can be used for sampling or removing radioiodine. (*h*) Flowmeter for field use. Available with or without metering valve. Standard ranges from 0.1–200 scfh (Dwyer Manufacturing Co. Series 500). (*i*) Laboratory flowmeters (for calibration). Ranges from 0.0013-68.2 1/min (Manostat, 36-541 series, manufactured by Fisher and Porter).

(10CFR20REV) require monitoring of the occupational intake of radioactive material and assessment of the committed effective dose equivalent to adults likely to receive, in one year, an intake in excess of 10 percent of the applicable Annual Limits on Intake. Minors and declared pregnant women require monitoring of the occupational intake if they are likely to receive, in one year, a committed effective dose equivalent in excess of 0.05 rem.

## 7. Airborne Radioactivity Concentration Limits

Occupational airborne radioactivity concentration limits, known as derived air concentrations (DAC), are given in table 5.2 for selected radionuclides. The table also includes the revised limits expected to go into effect in 1991 or 1992. A worker exposed 40 hours each week for several effective half-lives at the limits in effect at least through 1990 will receive (according to the calculation scheme used) a weekly dose of 100 mrem to the total body, gonads, or hemopoietic system, or 300 mrem to one of the other organs, depending on which dose was limiting in establishing the maximum concentrations. A worker exposed at the revised limits will receive an effective dose equivalent (committed plus external) of 5 rem (or a 50-rem organ dose in the few instances it is limiting).

The NRC regulates internal exposure by setting a maximum activity which may be inhaled by a worker in a 13-week period. This is equal to $6.3 \times 10^8$ cc/quarter $\times$ the DAC for an individual working a 40-hr week 50 workweeks per year ($6.3 \times 10^8$ is the product of $10^7$ cm$^3$ air inhaled during an 8-hr workday $\times$ 5 days/week $\times$ 13 weeks/quarter $\times$ 50 workweeks per year $\div$ 52 weeks per year). If radioactivity is also absorbed through the skin, the total intake (inhalation plus skin absorption) cannot exceed that allowable on the basis of inhalation alone. The quarterly control period is dropped and an annual time period used in 10CFR20REV.

> *Example 2:* A worker who performed syntheses with $^{125}$I was given a thyroid scan which showed an uptake of 80 nCi in his thyroid. His previous scan had been given 30 days earlier. Determine if his exposure was in compliance with the limits, assuming that the uptake was by inhalation.
>
> In the absence of other data, it may be assumed that his uptake occurred immediately following the previous scan. For an effective half-life of 32 days, the elapsed time was $30/32 = 0.94$ half-lives (fractional decay $= 0.52$), so the maximum uptake could have been $80/0.52 = 154$ nCi. Assume the uptake in the thyroid is 30 percent of the activity getting into the body and, in the absence of other data, that all the radioactivity in the inspired air is deposited in the body. This gives an intake of 513 nCi. The derived air concentration is $5 \times 10^{-9}$ $\mu$Ci/cc ($3 \times 10^{-8}$ in 10 CFR20REV); multiplying this figure by $6.3 \times 10^8$ gives a maximum quarterly intake of 3,150 nCi. The exposure is well within occupational limits, but the investigator should still examine his methods to determine if the exposure could have been lowered with additional reasonable precautions.

The evaluation of airborne levels is conducted on a weekly basis. The maximum time individuals are in the area in any week is determined, and the

concentration averaged over the week. Methods must be used to the extent practicable to avoid the need to classify an area as an airborne radioactivity area (see section 8, paragraph *d*, below). Otherwise surveillance is required to ensure that the material inhaled does not exceed that which would result from inhalation of such material for 40 hours in any 7 consecutive days at the uniform concentrations specified in the "occupational" column in table 5.2 (taken from 10CFR20, appendix B). If the intake exceeds the 40-hr control measure, evaluations must be made and actions taken as necessary to ensure against recurrence. Records of such occurrences, evaluations, and actions taken must be maintained in a clear and readily identifiable form suitable for summary review and evaluation. The exposures need not be reported to the NRC unless the quarterly limit is exceeded. (Once 10CFR20REV takes effect, reports must be made if the annual limit is exceeded.)

*Example 3:* A nuclear medicine laboratory plans to use 10 mCi of $^{133}$Xe per patient and will perform a maximum of 10 studies per week. What ventilation rate is required to ensure compliance with the regulations?

The maximum activity used per week is 100 mCi. Assume 25 percent of the activity used leaks to the room during the week and let the leakage rate of activity per hour equal *L*. Assume the concentration is not to exceed the value *C*, the room has a volume *V*, and the fraction of the air turned over per hour is *r*, that is, the number of air changes per hour is *r*. The leakage of radioactivity into the room must be compen-

**Table 5.2.** Concentration guides for radionuclides (in pCi/cc).

| Radionuclide | In air, occupational | | In air, environmental | | In water, environmental | |
|---|---|---|---|---|---|---|
| | Current | Revised | Current | Revised | Current | Revised |
| HTO water | 5 | 20 | 0.2 | 0.1 | 3000 | 1000 |
| $^{14}CO_2$ gas | 50 | 90 | 1 | 0.3 | | |
| $^{14}C$ compounds | 1 | 1 | .1 | .003 | 800 | 30 |
| $^{22}$Na | .009 | .3 | .0003 | .0009 | 30 | 6 |
| $^{24}$Na | .1 | 2 | .005 | .007 | 30 | 50 |
| $^{32}$P | .07 | .2 | .002 | .0005 | 20 | 9 |
| $^{35}$S | .3 | .9 | .009 | .003 | 60 | 100 |
| $^{36}$Cl | .02 | .1 | .008 | .0003 | 60 | 20 |
| $^{42}$K | .1 | 2 | .004 | .007 | 20 | 60 |
| $^{45}$Ca | .03 | .4 | .001 | .001 | 9 | 20 |
| $^{51}$Cr | 2 | 8 | .08 | .03 | 2000 | 500 |
| $^{57}$Co | .2 | .3 | .006 | .0009 | 400 | 60 |
| $^{59}$Fe | .05 | .1 | .002 | .0005 | 50 | 10 |
| $^{60}$Co | .009 | .01 | .0003 | .00005 | 30 | 3 |
| $^{67}$Ga | | 4 | | .01 | | 100 |

**Table 5.2.** (*continued*)

| Radionuclide | In air, occupational | | In air, environmental | | In water, environmental | |
|---|---|---|---|---|---|---|
| | Current | Revised | Current | Revised | Current | Revised |
| $^{75}$Se | .1 | .3 | .004 | .0008 | 300 | 7 |
| $^{82}$Br | .2 | 2 | .006 | .005 | 40 | 40 |
| $^{85}$Kr | 10 | 20 | .3 | .1 | | |
| $^{86}$Rb | .07 | .3 | .002 | .001 | 20 | 7 |
| $^{90}$Sr | .001 | .002 | .00003 | .000006 | .3 | .5 |
| $^{109}$Cd | .05 | .01 | .002 | .0002 | 200 | 6 |
| $^{111}$In | | 3 | | .009 | | 60 |
| $^{125}$I | .005 | .03 | .00008 | .0003 | .2 | 2 |
| $^{131}$I | .009 | .02 | .0001 | .0002 | .3 | 1 |
| $^{133}$Xe | 10 | 100 | .3 | .5 | | |
| $^{201}$Tl | .9 | 9 | .03 | .03 | 200 | 200 |
| *Microspheres* | | | | | | |
| $^{46}$Sc | .02 | .1 | .0008 | .0003 | 40 | 10 |
| $^{85}$Sr | .1 | .6 | .004 | .002 | 100 | 40 |
| $^{95}$Nb | .1 | .5 | .003 | .002 | 100 | 30 |
| $^{103}$Ru | .08 | .3 | .003 | .0009 | 80 | 30 |
| $^{113}$Sn | .05 | .2 | .002 | .0008 | 80 | 30 |
| $^{114}$In | .02 | .03 | .0007 | .00009 | 20 | 5 |
| $^{141}$Ce | .2 | .2 | .005 | .0008 | 90 | 30 |
| $^{153}$Gd | .09 | .06 | .003 | .0003 | 200 | 60 |
| *Alpha emitters* | | | | | | |
| $^{222}$Rn | .03 | .03 | .003 | .0001 | | |
| $^{226}$Ra | $3 \times 10^{-5}$ | $3 \times 10^{-4}$ | $2 \times 10^{-6}$ | $9 \times 10^{-7}$ | .03 | .06 |
| $^{228}$Th | $6 \times 10^{-6}$ | $4 \times 10^{-6}$ | $2 \times 10^{-7}$ | $2 \times 10^{-8}$ | 7 | .2 |
| $^{232}$Th | $3 \times 10^{-5}$ | $5 \times 10^{-7}$ | $1 \times 10^{-6}$ | $4 \times 10^{-9}$ | 2 | .03 |
| $^{238}$U | $7 \times 10^{-5}$ | $2 \times 10^{-5}$ | $3 \times 10^{-6}$ | $6 \times 10^{-8}$ | 40 | .3 |
| $^{239}$Pu | $2 \times 10^{-6}$ | $3 \times 10^{-6}$ | $6 \times 10^{-8}$ | $2 \times 10^{-8}$ | 5 | .02 |

*Sources:* Current: CFR, 1987; Revised, NRC, 1988. The limits are those promulgated by the U.S. Nuclear Regulatory Commission and include those currently in effect and a proposed revision set to be implemented in 1991 or 1992. The revised limits are based on the use of the committed effective dose equivalent (see part VI, section 1). The revised environmental limits are based on an effective dose equivalent limit of 0.1 rem. These limits are less than current limits, which are based on limits of 0.5 rem for the whole body or 1.5 rem for critical organs in individual members of the public. The derived concentrations were reduced by another factor of 2 to take into account age differences in sensitivity in the general population.

*Notes:* Lowest values listed in the tables are given here and may be for soluble or insoluble forms. Sources should be consulted for details.

Permissible releases to sewers (10CFR20REV) are 10 times the limits for environmental releases and may be averaged over a month.

sated by ventilation to keep the concentration at the acceptable level, that is,

$$L = C \times V \times r.$$

Leakage into room per hour
$$= DAC \times volume \times fraction\ of\ volume\ exchanged/hr.$$

$$\frac{25,000\ \mu Ci}{40\ hr} = \frac{10^{-5}\ \mu Ci}{ml} \times V \times r.$$

The volume of air replaced per hour $(rV) = \dfrac{25,000}{40 \times 10^{-5}}$ ml/hr.

Ventilation rate $= 6.25 \times 10^7$ ml/hr $= 36.8$ cfm.

It is desirable to keep the average concentration at 25 percent of DAC (12 DAC-hours or 30 percent in 10CFR20REV) to avoid the airborne-radioactivity classification. This requires a ventilation rate of $4 \times 36.8$ or 147 cfm. If the room has a volume of 1,000 ft$^3$, $r = 147$ ft$^3$/min $\div$ 1,000 ft$^3$ $= 0.147$/min, and the required number of air changes is $60 \times 0.147$ or 8.8/hr.

Table 5.2 also gives limits for airborne radioactivity in unrestricted areas. They are based on an assumption of continuous occupancy (168 hours per week, including sleeping hours) and an allowable dose of 10 percent of the occupational dose. It is also assumed that the quantity of air inhaled in 168 hours (and the resultant radiation dose) is three times as much as during a 40-hour workweek. The result is that the limits listed in the regulations for non-occupational exposure are approximately 1/30 the limits for occupational exposure. Concentrations may be averaged over a period not greater than one year.

Values for airborne radioactivity limits in unrestricted areas given in 10CFR20REV are also shown in table 5.2. These values are based on an annual effective dose equivalent of 100 mrem for members of the public as the primary dose limit, reduced by an additional factor of 2 to reflect the potential exposure of children in releases to the environment. This reduction from 500 mrem to 50 mrem results in a lowering of the DAC's for most of the radionuclides (iodine-125 is a notable exception). If the limits had remained unchanged, the effective dose equivalent approach would have generally resulted in higher air concentrations than the concentration limits based on a maximum organ dose of 15 rem.

*Example 4:* An environmental monitor located at the boundary of a facility handling large amounts of $^{125}$I indicated an average concentration over 3 months of $2 \times 10^{-10}$ $\mu$Ci/cc. Estimate the dose to the thyroid of a member of the public resulting from exposure to this level for 1 quarter.

The occupational DAC given in example 2 is a rounded-off level for a dose of 15/4 rem/quarter to the thyroid from continuous occupational exposure (40 hr/wk, 12.5 wk/quarter, 3.15 $\mu$Ci occupational limit on intake). The quarterly intake by a member of the public would be $2 \times 10^7$ cc/day $\times$ 91 days/quarter $\times 2 \times 10^{-10}$ $\mu$Ci/cc $= 0.364$ $\mu$Ci. The thyroid dose would be $0.364/3.15 \times 15/4 = 0.43$ rem. This is greater than the allowable quarterly thyroid dose to a member of the public (0.375 rem). The measured level is also about twice the environmental limit for $^{125}$I in 10CFR20 ($8 \times 10^{-11}$ $\mu$Ci/cc).

The International Commission on Radiological Protection uses an annual limit for internal exposures. It is given as the allowable activity that can be taken into the body and is expressed as an Annual Limit on Intake (ALI). ICRP set the ALI at one time so that the activity accumulated in body organs after a working lifetime (50 years) of exposure to the ALI never reached the activity limit which could be maintained continuously without exceeding the dose limits. These original limits were derived by specifying maximum allowable annual doses to single organs (15 rem occupational except 5 rem to gonads, blood-forming organs, and total body) and were based on ICRP recommendations in 1959, 1962, and 1966. Current NRC standards for concentrations of radionuclides in air and water are consistent with these limits.

The current ICRP limits (in ICRP, 1979a, Publication 30) are based on the considerably more complex concept of effective dose equivalent. This concept employs a methodology in which doses to individual organs from intake of radioactivity are converted to whole-body doses that are considered to produce an equivalent risk to the individual. The equivalent whole-body doses are summed, and at the ALI are equal to the dose-equivalent limit for uniform irradiation of the whole body of 5 rem/yr (see part III, section 3.8.1 and note 13 for calculation methods). The NRC limits in 10CFR20REV are based on this scheme. Values for the ALI based on both approaches are given in table 5.3.

## 7.1  Air Monitoring for Environmental Radioactivity

The air must be monitored if significant levels of airborne contaminants can occur in working areas. Air samplers are designed to remove contaminants quantitatively from the air by collection on a filter, absorbant, or solvent, and the sampling medium is then assayed for radioactivity (NCRP, 1978; IAEA, 1971a). The air can be monitored continuously by making the radiation detector an integral part of the sampler. The sampler should be placed in the work area at breathing zone level.

In addition to the sampling medium, an air monitoring system requires a pump to draw the air, a meter for determining rate of flow or quantity of flow, and whatever controls are desired for adjusting flow. Flow-limiting devices can be used to fix the rate of air flow through the sample. Alterna-

**Table 5.3.** Annual limits on intake (in mCi).

| Radionuclide | Occupational (10CFR20 Revised) | | Occupational (ICRP, 1979a) | |
|---|---|---|---|---|
| | Ingestion | Inhalation | Ingestion | Inhalation |
| HTO water | 80 | 80 | 81.1 | 81.1 |
| $^{14}CO_2$ gas | | 200 | | 216 |
| $^{14}CO_2$ | 2 | 2 | 2.4 | 2.4 |
| $^{22}Na$ | 0.4 | 0.6 | 0.54 | 0.54 |
| $^{24}Na$ | 4 | 5 | 2.7 | 5.4 |
| $^{32}P$ | 0.6 | 0.9 | 0.54 | 0.27 |
| $^{35}S$ | 6 | 2 | 5.4 | 2.16 |
| $^{36}Cl$ | 2 | 0.2 | 1.62 | 0.24 |
| $^{42}K$ | 5 | 5 | 5.4 | 5.4 |
| $^{45}Ca$ | 2 | 0.8 | 1.62 | 0.81 |
| $^{51}Cr$ | 40 | 20 | 27 | 18.9 |
| $^{57}Co$ | 4 | 0.7 | 5.4 | 0.54 |
| $^{59}Fe$ | 0.8 | 0.3 | 0.81 | 0.27 |
| $^{60}Co$ | 0.2 | 0.03 | 0.19 | 0.027 |
| $^{67}Ga$ | 7 | 10 | 8.1 | 10.8 |
| $^{75}Se$ | 0.5 | 0.6 | 0.54 | 0.54 |
| $^{82}Br$ | 3 | 4 | 2.7 | 2.7 |
| $^{86}Rb$ | 0.5 | 0.8 | 0.54 | 0.81 |
| $^{90}Sr$ | 0.03 | 0.004 | 0.027 | 0.0027 |
| $^{109}Cd$ | 0.3 | 0.04 | 0.27 | 0.027 |
| $^{111}In$ | 4 | 6 | 5.4 | 5.4 |
| $^{125}I$ | 0.04 | 0.06 | 0.027 | 0.054 |
| $^{131}I$ | 0.03 | 0.05 | 0.027 | 0.054 |
| $^{201}Tl$ | 20 | 20 | 16.2 | 21.6 |
| *Microspheres* | | | | |
| $^{46}Sc$ | 0.9 | 0.2 | 0.81 | 0.24 |
| $^{85}Sr$ | 3 | 2 | 2.4 | 1.62 |
| $^{95}Nb$ | 2 | 1 | 2.16 | 1.08 |
| $^{103}Ru$ | 2 | 0.6 | 1.9 | 0.54 |
| $^{113}Sn$ | 2 | 0.5 | 1.62 | 0.54 |
| $^{114}In$ | 0.3 | 0.06 | 0.27 | 0.05 |
| $^{141}Ce$ | 2 | 0.6 | 1.62 | 0.54 |
| $^{153}Gd$ | 5 | 0.1 | 5.4 | 0.14 |
| *Alpha emitters* | | | | |
| $^{226}Ra$ | 0.002 | 0.0006 | 0.0019 | 0.00054 |
| $^{228}Th$ | 0.006 | 0.00001 | 0.0054 | 0.00011 |
| $^{232}Th$ | 0.0007 | 0.000001 | 0.00081 | 0.0000011 |
| $^{238}U$ | 0.001 | 0.00004 | 0.0135 | 0.000054 |
| $^{239}Pu$ | 0.0008 | 0.000006 | 0.0054 | 0.0000054 |

*Note:* Values from ICRP 30 are not rounded off as they were converted from becquerels to millicuries, whereas values from 10CFR20 were originally expressed in terms of the curie, and rounded off in the NRC tables. All values shown here are the most restrictive ALI for each radionuclide given in the references.

tively, gas meters in the line will give the total air volume sampled independent of flow rate (ACGIH, 1983). Air monitoring instrumentation is shown in fig. 5.3.

Oilless pumps are less messy than ones that must be oiled. Because of their portability, smaller pumps are useful if they must be used at several locations, but the resultant loss in sensitivity because of lower sampling rates must be checked. Flow rates can be monitored by inserting a rotameter between the sampler and the pump. Some types of rotameters can also be used to regulate the flow rate.

The flow rate will decrease if the sampling medium becomes clogged; eventually it may be reduced to such a low level that the pump will overheat and become damaged or ruined. This can be prevented by placing a relief valve in the line between the sampling medium and pump that opens to let in additional air if the resistance of the sampler gets too high.

There are times in sampling air containing particles above a particular size that the air velocity through the sampler must be adjusted to equal the velocity in the air stream. This condition is known as isokinetic sampling. If it is not met, there can be reduced intake of particulates and errors in determining particle concentration or size distribution (Mercer, 1973; Silverman et al., 1971).

### 8. Posting of Areas

The following types of signs are required in areas where significant levels of radiation or radioactivity are present:

(a) "CAUTION RADIATION AREA"—This sign is used in areas accessible to personnel in which a major portion of the body could receive in any 1 hr a dose of 5 mrem or in any 5 consecutive days a dose in excess of 100 mrem. (10CFR20REV specifies that the limit applies at 30 cm from the object containing the source.)

(b) "CAUTION RADIOACTIVE MATERIAL"—This sign is required in areas or rooms in which radioactive material is used or stored in an amount exceeding quantities listed in table 5.4.

(c) "CAUTION RADIOACTIVE MATERIAL" (label)—A durable, clearly visible label is required on any container in which is transported, stored, or used a quantity of any material greater than the quantity specified in table 5.4. When containers are used for storage, the labels must state also the quantities and kinds of radioactive materials in the containers and the date of measurement of the quantities.

(d) "AIRBORNE RADIOACTIVITY AREA"—This sign is required if airborne radioactivity exists at any time in concentrations in excess of the derived air concentrations for 40 hours' occupational exposure (table 5.2), or if the average over the number of hours in any week during which individuals are in the area exceeds 25 percent of the maximum permissible. (10CFR20REV requires that this sign be posted if an individual could receive

**Table 5.4.**    Minimum quantities of some radioactive materials requiring warning signs (in $\mu$Ci).

| Radionuclide | (a) Sign in room[a] | | (b) Label[b] | |
|---|---|---|---|---|
| | Current | Revised | Current | Revised |
| $^3$H | 10,000 | 10,000 | 1,000 | 1,000 |
| $^{14}$C | 1,000 | 1,000 | 100 | 100 |
| $^{22}$Na | | 100 | | 10 |
| $^{24}$Na | 100 | 1,000 | 10 | 100 |
| $^{32}$P | 100 | 100 | 10 | 10 |
| $^{35}$S | 1,000 | 1,000 | 100 | 100 |
| $^{36}$Cl | 100 | 100 | 10 | 10 |
| $^{42}$K | 100 | 10,000 | 10 | 1,000 |
| $^{45}$Ca | 100 | 1,000 | 10 | 100 |
| $^{51}$Cr | 10,000 | 10,000 | 1,000 | 1,000 |
| $^{57}$Co | | 1,000 | | 100 |
| $^{55}$Fe | 1,000 | 1,000 | 100 | 100 |
| $^{59}$Fe | 100 | 100 | 10 | 10 |
| $^{60}$Co | 10 | 10 | 1 | 1 |
| $^{64}$Cu | 1,000 | 10,000 | 100 | 1,000 |
| $^{65}$Zn | 100 | 100 | 10 | 10 |
| $^{75}$Se | 100 | 1,000 | 10 | 100 |
| $^{82}$Br | 100 | 1,000 | 10 | 100 |
| $^{85}$Kr | 1,000 | 10,000 | 100 | 1,000 |
| $^{86}$Rb | 100 | 1,000 | 10 | 100 |
| $^{90}$Sr | 1 | 1 | 0.1 | 0.1 |
| $^{109}$Cd | 100 | 10 | 10 | 1 |
| $^{111}$In | | 1,000 | | 100 |
| $^{125}$I | 10 | 10 | 1 | 1 |
| $^{131}$I | 10 | 10 | 1 | 1 |
| $^{133}$Xe | 1,000 | 10,000 | 100 | 1,000 |
| $^{198}$Au | 1,000 | 1,000 | 100 | 100 |
| $^{201}$Tl | 1,000 | 10,000 | 100 | 1,000 |
| *Microspheres* | | | | |
| $^{46}$Sc | 100 | 100 | 10 | 10 |
| $^{85}$Sr | 100 | 1,000 | 10 | 100 |
| $^{95}$Nb | 100 | 1,000 | 10 | 100 |
| $^{103}$Ru | 100 | 1,000 | 10 | 100 |
| $^{113}$Sn | 100 | 1,000 | 10 | 100 |
| $^{114}$In | 100 | 100 | 10 | 10 |
| $^{141}$Ce | 1,000 | 1,000 | 100 | 100 |
| $^{153}$Gd | 100 | 100 | 10 | 10 |
| Unidentified, but not an $\alpha$ emitter | 1 | 0.1 | 0.1 | 0.01 |
| Unidentified $\alpha$ emitter | 0.1 | 0.01 | 0.01 | 0.001 |

**Table 5.4.**  *(continued)*

| Radionuclide | (*a*) Sign in room[a] | | (*b*) Label[b] | |
| --- | --- | --- | --- | --- |
| | Current | Revised | Current | Revised |
| *Alpha emitters* | | | | |
| [222]Rn | | 10 | | 1 |
| [226]Ra | 0.1 | 1 | 0.01 | 0.1 |
| Th (natural) | 10,000 | 1,000 | 100 | 100 |
| U (natural) | 10,000 | 1,000 | 100 | 100 |
| [239]Pu | 0.1 | 0.01 | 0.01 | 0.001 |

a.  These quantities are 10 times the values in column (*b*), except for natural uranium and thorium.  Caution signs are not required to be posted at areas or rooms containing radioactive materials for periods of less than 8 hr provided (1) the materials are constantly attended during such periods by an individual who shall take the precautions necessary to prevent the exposure of any individual to radiation or radioactive materials in excess of the limits established by the regulations; (2) such area or room is subject to the authorized user's control.

b.  These are also minimum quantities requiring specific licenses from the NRC when an institution does not have a broad license (see 10CFR30).  These values in 10CFR20REV were obtained by taking 1/10 of the most restrictive occupational ALI, rounding to the nearest factor of 10, and arbitrarily constraining the values listed between 0.001 and 1,000 $\mu$Ci.  Values of 100 $\mu$Ci have been assigned for radionuclides having a half-life in excess of $10^9$ years (except rhenium, 1,000 $\mu$Ci) to take into account their low specific activity.

in the number of hours spent in the area in the course of a week an intake of 0.6 percent of ALI or 12 DAC hours; that is, if the actual concentration $\times$ the hours spent is greater than DAC $\times$ 12 hours.)

(*e*)  "HIGH RADIATION AREA"—This sign is required if the radiation dose to a major portion of the body of a person in the area could be in excess of 100 mrem in any one hour.  (10CFR20REV specifies that the limits apply at 30 cm from the object containing the source.)  These areas also require audible or visible alarm signals.

The signs must bear the three-bladed radioactive caution symbol (magenta or purple on yellow background).

Warning signs are essential, since individuals might otherwise be unaware of the presence of the radiation field. On the other hand, signs should not be used when they are not needed.

Nuclear Regulatory Commission licensees are also required to inform workers by posted notices of the availability of copies of 10CFR19 and 10CFR20 and of the regulations, the license and amendments, the operating procedures applicable to licensed activities, and notices of violations involving radiological working conditions (10CFR19.11). The NRC also requires posting of a special form (NRC-3) notifying employees of the regulations and inspections.

## 9.  Laboratory Facilities

Laboratory facilities for handling unsealed radioactive materials must provide adequate containment and allow for ease of cleanup in the event of contamination incidents. All surfaces, especially the floors and walls around sinks, should be smooth and nonporous. Generally, a well-designed and well-maintained chemistry laboratory suffices. Glassware, tongs, and other equipment used to handle unsealed radioactive material should be segregated and given a distinct marking to prevent their use with nonradioactive materials. For handling exceptionally high levels of highly toxic radionuclides or strong gamma emitters, special glove boxes and radiation shields may have to be installed. If special facilities are required, the reader should consult available handbooks and guides for high-level operations (NCRP, 1964; Report 30; ICRP, 1977a, Publication 25; IAEA, 1973, Safety Series no. 38).

Hoods are necessary for controlling possible airborne contamination arising from work with radioactive materials. The airflow into the hood must be adequate, and the hood must be designed so the flowlines are all directed into the hood. Airflow into the hood should be between 100 and 125 linear feet per minute when the hood sash is at its normal open position during use (a recommended opening is 14 inches, to give eye protection as well as effective ventilation). Flows above 125 feet per minute may lead to turbulence and some release of hood air to the laboratory. If appreciable levels of activity are used, the hood should have its own exhaust system and not be connected into other hoods, as this could be a mechanism for the transmission of airborne contamination to other laboratories through improper baffling. The exhaust system should have provision for installing filters, if needed. The working surface should be able to support lead shielding. Controls for air, water, and so on should be located outside the hood. Even when hoods are used it is often worthwhile to collect and filter radioactive airborne particulates and vapors from the operation with local suction devices located near the source, since this can help minimize contamination of the hood and diminish the work required later for decontamination.

Even the best hoods do not completely isolate the area inside the hood

from the laboratory, so there is a limit to the maximum amount of activity that can be handled. If the worker is very careful, he should be able to process solutions containing up to 100 mCi of the less hazardous beta emitters in the hood without serious contamination to himself or the surroundings. However, if he must perform complex wet operations with risk of serious spills, or dry and dusty operations, he may need to use a completely isolating system such as a glove box or a hot cell (if massive shielding is needed).

An arrangement that gives protection somewhere between that provided by a glove box and a hood is a small enclosure with ports for inserting the hands and a local exhaust. The exhaust from the enclosure is cleaned before it is discharged, preferably inside a hood. This method allows the use of smaller filters and charcoal adsorption beds for cleanup at much lower cost. Additional protection is obtained if the unit in turn is placed in a hood.

Another control method is to recirculate the air from the filter back into the box, at a flow rate chosen so the air turns over every 2–3 minutes. This serves to clean the air in the box, thus reducing the discharge to the environment. It is a particularly useful method when close to 100 percent filtration is needed but not readily achievable with a once-through filtering system.

Some examples of facilities used in working with radionuclides are shown in figure 5.4.

### 10.  Protective Clothing

Suitable gloves must be worn whenever hand contamination is likely. Extra care should be exercised to prevent contamination of skin areas where there is a break in the skin. In addition to gloves, other protective clothing, such as coveralls, laboratory coats, and shoe covers, should be worn wherever contamination of clothing with radioactive materials is possible. Protective clothing must not be taken out of the local areas in which their use is required unless they are monitored and determined to be free of contamination. Under no conditions should protective clothing be worn in eating places.

There are many kinds of disposable gloves for users who do not care to bother with decontamination. Plastic gloves are the most inexpensive but are clumsy to use and are suitable only for the very simplest operations. Disposable surgeon's gloves are recommended when good dexterity is needed. Sometimes two pairs of gloves are worn when handling extrahazardous materials to prevent skin contamination in the event of a break in one of the gloves.

The potential of contamination is very high when vials of high-specific-activity radionuclides are handled. A tiny droplet from these solutions carries a lot of activity and is easily carried through the air. Gloves should always be worn when opening vials, since the covers and vials may become contaminated, even with cautious handling.

(a)

(b)

(c)

(d)

(*e*)

**Fig. 5.4** Some arrangements for working with radioactive material. Operations with hazardous quantities of unsealed sources, even if they do not entail the release of airborne activity, should be performed in a hood as a safety precaution. (*a*) Simple bench-top shield for low-energy gamma emitters, formed by bending lead sheet. (*b*) Protective lead barrier, including viewing window of leaded glass. Lead sheet was wrapped around the commercial unit, as shown, for additional protection. The investigator is wearing lead-lined gloves. (*c*) Shielded radionuclide generators stored in hood. (*d*) Source storage area, showing shielded compartments and pit in floor. (*e*) Storage area for radioactive wastes, including freezer for putrefiable materials.

## 11.  Trays and Handling Tools

Work that can result in contamination of table tops and work surfaces should be done in trays with a protective liner.

Tweezers, tongs, or other suitable devices should be used as needed to handle sources with significant surface dose rates. Maintaining a distance of even a few inches with tweezers or tongs can cut down the exposure rate by orders of magnitude relative to handling small sources directly with the fingers, because of the inverse square law. Syringe shields are available that provide effective protection when personnel inject large quantities of beta or low-energy gamma emitters.

## 12.  Special Handling Precautions for Radioiodine

The control of radioiodine is a problem because of its volatility and very low permissible concentrations. The following handling procedures are recommended when volatile species of radioiodine are processed.

1. Always work in a well-ventilated fume hood.  The hood should be equipped with an activated charcoal stack filter if releases approach allowable limits.

2. Two pairs of gloves should be used because radioiodine can diffuse through rubber and plastic.  The inner pair must be free of contamination.

3. Do not handle contaminated vials or items directly.  To ensure a secure grip on containers, use forceps fitted with rubber sleeves, such as one-inch lengths of ⅛-inch O.D. latex surgical tubing.  The sleeves are replaced easily when contaminated.

4. Do not leave vials containing radioiodine open any longer than necessary and cap tightly when not in use.

5. Always open vials in a hood because the pressure of the radioactive vapor builds up in the vial while it is in storage.

6. Double-bag all contaminated materials.

7. Decontaminate spills using a solution consisting of 0.1 M NaI, 0.1 M NaOH, and 0.1 M $Na_2S_2O_3$.  This helps to stabilize the material and minimize evolution of volatile species.  Complete the cleanup with a detergent.

8. Do not add acids to radioiodine solutions.  The volatility of $^{125}I$ is enhanced significantly at low pH.

9. If the quantities handled require better control than that provided by a hood, place in the hood a transparent enclosure (for example, Lucite) fitted with a blower unit that recycles the air through an activated charcoal filter. The enclosure is equipped with sliding doors that provide convenient access and can be adjusted to the minimum opening required for performing operations in the enclosure.  For work with smaller quantities of radioiodine, a once-through filter cycle may be adequate, in which air flows from the room into the enclosure and is exhausted through the charcoal filter into the hood and up the stack.

10. Venting of vials through a charcoal trap is recommended before opening if there are likely to be volatile species in the vial airspace.  A simple vent is constructed by placing charcoal in the barrel of a hypodermic syringe between glass-wool plugs.  The syringe is fitted with an 18-gauge hypodermic needle for penetrating septa and closures.  The needle should be protected with a plastic shield when it is not in use.

11. Iodine-125 should be monitored with a thin sodium-iodide detector. This has an efficiency of over 20 percent at contact compared with less than 0.5 percent from a G-M counter.  Scintillation monitors for $^{125}I$ are available from commercial companies (see fig. 4.18).

A useful pamphlet on the safe handling of $^{125}I$ is available from New England Nuclear Corporation, Boston, Massachusetts.

Large quantities of $^{131}I$ are handled as NaI in hospitals for diagnosis and treatment of diseases of the thyroid.  The iodine is not very volatile in this form, provided the solution is not acidic.  Studies have found some releases to the air, however, both in handling the radioiodine and through exhalation by the patient (Krzesniak et al., 1979).  The airborne iodine exists as ele-

mental iodine, organic iodine, and iodine adsorbed on aerosols. Patients administered about 20 mCi exhaled between 0.003 and 0.07 percent, and concentrations measured in the air were several times greater than concentration guides on two occasions, but they were less than 20 percent of concentration guides when averaged over the year.

### 13. Hygiene

Eating, smoking, storing food, and pipetting by mouth cannot be allowed in areas where work with radioactive materials is being conducted, or in rooms containing appreciable loose contamination, because of the potential for ingestion of radioactivity. Personnel working in areas containing unsealed sources of radioactivity must "wash up" before eating, smoking, or leaving work and must use an appropriate detection instrument to monitor hands, clothing, and so on, for possible contamination. Unnecessary exposure or transfer of activity from undetected contamination can be avoided by making a habit of "washing up" and "surveying."

### 14. Trial Runs

For nonroutine or high-level operations, the user should conduct a trial run with inactive or low-activity material to test the adequacy of procedures and equipment.

### 15. Delivery of Radionuclides

All packages of radionuclides must be carefully checked upon receipt for evidence of damage or leakage. A record of receipts of material must be maintained. An outline of recommended procedures to be followed when receiving radioactive shipments, which was prepared in a form suitable for posting, is given in fig. 5.5 (see NRC licensing guide, NRC, 1987).

Packages labeled according to Department of Transportation regulations as containing radioactive material or showing evidence of potential contamination must be monitored for contamination and radiation levels. The monitoring must be done no later than 3 hr after the package is received at the licensee's facility if it is received during the licensee's normal working hours, or 3 hr from the beginning of the next working day if it is received after hours. (These requirements are promulgated in 10CFR20REV and are slightly different from the previous version.) If removable beta-gamma radioactive contamination in excess of 22,000 dis/min per 100 $cm^2$ of package surface is found on the external surfaces of the package, or if the radiation levels exceed 200 mrem/hr at the surface of the package or 10 mrem/hr at 1 meter from the surface, the licensee must immediately notify the final delivering carrier and by telephone and telegraph, mailgram, or fascimile the appropriate NRC Inspection and Enforcement office.

Rules regarding the handling of shipments will vary depending on the local circumstances. Measures must be taken to ensure that the packages are

# HOW TO HANDLE RADIOISOTOPE SHIPMENTS

### AN OUTLINE OF RECOMMENDED PROCEDURES TO BE FOLLOWED WHEN RECEIVING RADIOACTIVE SHIPMENTS.

**Open and inspect packages immediately upon receipt.**
Radioactive solutions inadvertently stored upside down may gradually leak and cause contamination problems; furthermore, vendors often will not accept claims for shipments not inspected within 15 days after delivery.

**Monitor package for radiation field.**
It is suggested that plastic gloves be worn while processing the received package.

### To process soft beta, hard beta and gamma emitters:

1. Wipe test package for removable contamination.
2. Note radiation units stated on package, verify and record in receipt log. (Hard beta and gamma only)
3. Place package in vented hood.
4. Open outer package and remove packing slip. Open inner package and verify that the contents agree in name and quantity with the packing slip.
5. Measure radiation field of unshielded container—if necessary place container behind shielding to reduce field to allowable limits and proceed with remote handling devices. (Hard beta and gamma only)
6. Check for possible breakage of seals or containers, loss of liquid or change in color

of absorbing material.
7. Wipe test inner contents and document any pertinent findings on packing slip. Note: The liner, shield and isotope container may have surface contamination; they should be discarded in hot waste disposal containers.
8. Record type of activity, quantity present and location of delivery in receiving log.
9. Deliver processed package to proper laboratory. If delivery is delayed notify recipient of its arrival and clearance.
10. If material has been packaged in dry ice, refrigerate or deliver immediately to ultimate user.
11. If contamination, leakage or shortages are observed, notify the Radiation Safety Officer.

**Fig. 5.5** Poster displaying instructions for handling shipments of radioactive material. (Source: New England Nuclear Corporation. See also 10CFR20.205).

always placed in designated, secure locations until they are opened and processed. Institutions have reported to the Nuclear Regulatory Commission that unsecured radioactive-materials packages delivered to research laboratories have been accidentally thrown out by housekeeping personnel as ordinary trash or have disappeared for unknown reasons. Packages ideally should be received at a central radiation facility, where the contents of the package are inspected, monitored, and logged by trained personnel and the material secured until picked up by the authorized user. If delivery is made to a general receiving area of the institution, the package should be logged in and then transferred with dispatch to the user, the radiation facility, or another secured, controlled, and protected area established for storage of radioactive materials. Highly visible signs should be posted in the

receiving area giving the specific instructions for handling packages. The receiving area must have a record of the name of the person receiving the package and the person to whom it was transferred or who placed it in a locked area. This procedure allows tracking down of any packages that might be misplaced after being received.

*Packages must not be left on the floor or unsecured and unattended on a bench top when they are delivered to a laboratory. They must be placed in a designated secure location and the responsible person must be promptly notified if he is not present to receive it.*

### 16.  Storage and Control of Radionuclides

The NRC requires that stored licensed materials must be secure from unauthorized removal or access. This means that storage areas must be locked and placed under the control of responsible individuals only. The radionuclides must be stored in suitable containers that are adequately shielded. It is usually practicable and desirable to shield stored materials so the radiation level at one foot from the surface of the shield is less than 5 mrem/hr. In any event, the level should be less than 100 mrem in 1 hr. Otherwise the area is a high-radiation area and must be equipped with visible or audible alarm signals. Sources must be properly labeled and area signs posted. The radiation protection office must be kept informed of any transfer of a source to new storage or use areas.

Some radioactive materials must be stored under refrigeration, and those that also contain flammable solvents constitute an explosion hazard. Explosions have occurred in refrigerators, ignited by a spark in the controls or switches, and have resulted in extensive physical damage, starting of fires, and bodily injury. Flammable materials must be stored in explosion-proof refrigerators, that is, refrigerators with controls and other potential spark-producing components mounted on the outside.

Material not secured must be under the control and constant surveillance of the licensee.

### 17.  Storage of Wastes

Radioactive wastes may be stored only in restricted areas. Liquid waste should be stored in shatterproof containers, such as in polyethylene bottles. If circumstances make this impracticable, an outer container of shatterproof materials must be used.

Flammable wastes should be kept to a minimum in the laboratory. Waste containers must be metallic. A fire extinguisher must be located in the vicinity and a sign posted giving its location.

During storage there must be no possibility of a chemical reaction that might cause an explosion or the release of chemically toxic or radioactive gases. This is usually accomplished by the following precautions: (*a*) liquids must be neutralized (pH 6 to 8) prior to placement into the waste container;

(*b*) containers of volatile compounds must be sealed to prevent the release of airborne activity; and (*c*) highly reactive materials (such as metallic sodium or potassium) must be reacted to completion before storage.

## 18.   Waste Disposal

A limited quantity of wastes may be disposed of by release to the atmosphere, inland or tidal waters, sewerage, or by burial. The limits are established by federal and state agencies. Short-lived radionuclides are often stored and allowed to decay until they can be disposed of as nonradioactive wastes. The NRC requires a minimum decay time of 10 half-lives before release as ordinary waste for waste designated for decay storage. This period reduces the activity to less than 0.1 percent of the original value. Longer decay periods are necessary if significant levels of radioactivity are detected after this time. When special waste disposal problems occur, disposal through a commercial company licensed to handle radioactive material often constitutes the most satisfactory approach. Records must be kept of the disposal of all radioactive wastes as evidence that the regulations have been observed.

### 18.1   Disposal of Gases to the Atmosphere

The Nuclear Regulatory Commission requires that the radioactivity concentrations in gases released through a stack to an unrestricted area must not exceed limits specific to each radionuclide. The simplest way to ensure compliance with the regulations is to limit the concentration at the stack discharge point to the maximum allowed if the effluent were breathed continuously by a person standing at the point of discharge. The concentrations may be averaged over a period not exceeding one year. If the discharge is within a restricted area, the limit may be applied at the boundary by using appropriate factors for dilution, dispersion, or decay between the point of discharge and the boundary. The user may petition the NRC to allow higher concentrations at the discharge point by demonstrating that it is not likely that any member of the public will be exposed to concentrations greater than those allowed by the regulations.

Some values (including values in 10CFR20REV) for maximum permissible concentrations in air for unrestricted areas are given in table 5.2. If the discharged gas contains combinations of radionuclides in known amounts, a limit may be derived for the combination by determining the ratio between the quantity present in the combination and the limit allowable when it is the sole constituent. The sum of the ratios determined in this manner for each of the constituents may not exceed unity.

> *Example 5:*  A department of nuclear medicine in a metropolitan hospital is conducting studies with xenon-133 and releasing the recovered xenon through a hood to a discharge point on the roof of the building.

The velocity of flow of gas through the hood, when the area of the opening is 3.5 ft$^2$, is 125 linear ft/min, as measured with a velometer. Assuming releases are controlled on a weekly basis, what is the maximum permissible weekly discharge rate? What are the restrictions when $^{14}$C and $^{131}$I are also discharged through the hood?

The flow rate of air through the hood is 125 × 3.5, or 437.5 ft$^3$/min. This gives $1.24 \times 10^7 \times 1440 = 1.78 \times 10^{10}$ cm$^3$/day. From table 5.2, the maximum permissible concentration of $^{133}$Xe in air in unrestricted areas is 0.3 pCi/cc or $3 \times 10^{-7}$ μCi/cc. The permissible discharge is thus $1.78 \times 10^{10} \times 3 \times 10^{-7} = 5.34 \times 10^3$ μCi/day or 5.34 mCi/day. The maximum weekly discharge for control purposes is 37.4 mCi.

Similarly, one could dispose of 12.3 mCi $^{14}$C or 12.3 μCi of $^{131}$I per week, if either one were the only radionuclide discharged. If in a particular week it were necessary to discharge 2 mCi of $^{14}$C and 3 μCi of $^{131}$I, 2/12.3 + 3/12.3, or 0.407 of the permissible discharge would be used up. Thus, 0.593 of the permissible discharge would still remain, allowing release of 0.593 × 37.4 = 22.2 mCi of $^{33}$Xe, if this were the only other radionuclide to be released.

*Example 6:* A radiochemist accidentally released 1 curie of tritiated water through a hood while performing a synthesis. The air flow rate was 100 ft/min with a 1-ft opening. The width of the opening was 4.5 ft. Were the radioactivity release limits exceeded? Assume no other radionuclides were released through the hood during the year.

The flow rate is $1.84 \times 10^{10}$ cc/day. The maximum permissible concentration at the point of release to the atmosphere is $2 \times 10^{-7}$ μCi/cc. The maximum permissible daily release is 3.67 mCi, and the annual limit is 1.34 Ci. Since it is permissble to average releases over the year, the accident resulted in the release of 75 percent of the annual limit, and the radioactivity release limits were not exceeded. Of course, release of activity through the hood is restricted for the remainder of the year as a result of the accident.

If the release of any radionuclide exceeds 10 times any applicable limit set by the NRC, it is necessary to submit a report to the Administrator of the appropriate NRC regional office within 30 days (details for preparing the report are given in 10CFR20). A release of 1.84 Ci of HTO (500 times the average daily limit) would have required notification within 24 hr by telephone and telegraph. A release of 18.4 Ci (5,000 times the average daily limit) would have required immediate notification by telephone and telegraph. (Different reporting criteria are given in 10CFR20REV.)

## 18.2   Disposal of Liquids to Unrestricted Areas

The concentration in liquid effluents discharged to inland or tidal waters is limited to the maximum permitted in drinking water consumed by the

public. The maximum concentration may be evaluated for the boundary of the restricted area and averaged over a year. As with discharges to the atmosphere, the NRC may accept higher limits if it is not likely that individuals would be exposed to levels in excess of applicable radiation protection guides, but any action taken by the NRC is based on the condition that the user first take every reasonable measure to keep releases of radioactivity in effluents as low as practicable. Concentration limits in water in unrestricted areas are given in table 5.2.

## 18.3   Disposal of Liquid Wastes to Sewerage Systems

The maximum concentrations allowed in the sewerage are based on occupational exposure standards and amount to about 30 times those set for drinking water for public consumption. Some values are given in table 5.5. If several radionuclides are being discharged, the determination of compliance with the limits is made as described in section 18.1.

Both daily and monthly concentration limits must be satisfied. In each case, the quantities released in any one day or in any given month divided by the average daily or monthly sewage released must not exceed the drinking water limits for restricted areas. In any event, the user is allowed to release daily 10 times the minimum quantity requiring a license (table 5.4, column b), provided the concentration limits over a month are not exceeded, but may not release more than one curie of licensed and other radioactive material into the sewerage system per year. The liquid waste must be readily soluble or dispersible in water.

Concentration values in 10CFR20REV are more restrictive (see table 5.5). On the other hand, maximum annual limits will be increased to 5 Ci for $^3$H, 1 Ci for $^{14}$C, and 1 Ci for all other radioactive material combined. Excreta from individuals undergoing medical diagnosis or therapy with radioactive material are exempt from these limitations.

Although the sewerage system is convenient and recommended for the disposal of the low-level soluble wastes remaining after counting experiments, it should never by used for disposal of high-level concentrated solutions, such as master solutions used in radionuclide synthesis. These should be disposed of in their original containers through a commercial company as bulk waste. Of course, if they are short-lived, they can be stored for decay.

Complications arise when the material to be disposed of is also a chemical hazard. For example, flammable solvents that are not miscible with water should not be flushed down the drain. They should be poured into a solvent can (properly labeled) in a hood and disposed of ultimately by evaporation, incineration, or through a commercial disposal company.

It is sometimes desirable to reduce the volume of significant quantities of liquid wastes or to partially clean up the liquid prior to disposal. The ultimate disposal arrangement is dependent on individual circumstances, and consultation with a specialist in radiation protection is advisable.

**Table 5.5.** Concentrations for release to sewerage (monthly average, in pCi/cc).

| Radionuclide | 10CFR20 Current | | 10CFR20 Revised |
|---|---|---|---|
| | Soluble | Insoluble | |
| HTO water | 100,000 | 100,000 | 10,000 |
| $^{14}$C | 20,000 | | 300 |
| $^{22}$Na | 1,000 | 900 | 60 |
| $^{24}$Na | 6,000 | 800 | 500 |
| $^{32}$P | 500 | 700 | 90 |
| $^{35}$S | 2,000 | 8,000 | 1,000 |
| $^{36}$Cl | 2,000 | 2,000 | 200 |
| $^{42}$K | 9,000 | 600 | 600 |
| $^{45}$Ca | 300 | 5,000 | 200 |
| $^{51}$Cr | 50,000 | 50,000 | 5,000 |
| $^{57}$Co | 20,000 | 10,000 | 600 |
| $^{59}$Fe | 2,000 | 2,000 | 100 |
| $^{60}$Co | 1,000 | 1,000 | 30 |
| $^{67}$Ga | | | 1,000 |
| $^{75}$Se | 9,000 | 8,000 | 70 |
| $^{82}$Br | 8,000 | 1,000 | 400 |
| $^{86}$Rb | 2,000 | 700 | 70 |
| $^{90}$Sr | 10 | 1,000 | 5 |
| $^{109}$Cd | 5,000 | 5,000 | 60 |
| $^{111}$In | | | 600 |
| $^{125}$I | 40 | 6,000 | 20 |
| $^{131}$I | 60 | 2,000 | 10 |
| $^{201}$Tl | 9,000 | 5,000 | 2,000 |
| *Microspheres* | | | |
| $^{46}$Sc | 1,000 | 1,000 | 100 |
| $^{85}$Sr | 3,000 | 3,000 | 400 |
| $^{95}$Nb | 3,000 | 3,000 | 300 |
| $^{103}$Ru | 2,000 | 2,000 | 300 |
| $^{113}$Sn | 2,000 | 2,000 | 300 |
| $^{114m}$In | 500 | 500 | 50 |
| $^{141}$Ce | 3,000 | 3,000 | 300 |
| $^{153}$Gd | 6,000 | 6,000 | 600 |
| *Alpha emitters* | | | |
| $^{226}$Ra | 0.4 | 900 | 0.6 |
| $^{228}$Th | 200 | 400 | 2 |
| $^{232}$Th | 50 | 1,000 | 0.3 |
| $^{238}$U | 1,000 | 1,000 | 3 |
| $^{239}$Pu | 100 | 800 | 0.2 |

*Sources:* Current, CFR, 1987; Revised, NRC, 1988. The limits are those promulgated by the U.S. Nuclear Regulatory Commission and include those currently in effect and a proposed revision (expected implementation 1991 or 1992). The current limits are occupational limits for drinking water. The revised limits were derived by taking the most restrictive occupational stochastic ingestion ALI and dividing by the annual water intake by "Reference Man" ($7.3 \times 10^6$ ml) and a factor of 10, such that the concentrations, if the sewage released by the licensee were the only source of water ingested by a reference man during a year, would result in a committed effective dose equivalent of 0.5 rem.

*Example 7:* Determine how much $^{125}$I and $^{32}$P can be dumped into the sewer if the water flow to the sewerage (based on the water bill) is 1.2 × 10$^7$ ft$^3$/yr.

The maximum concentrations for $^{125}$I and $^{32}$P are 40 pCi/cc and 500 pCi/cc respectively. (They are considerably lower in 10CFR20REV.) The average daily water flow is 9.32 × 10$^8$ cc. The daily limits are 37.3 mCi for $^{125}$I and 466 mCi for $^{32}$P, if the particular nuclide is the sole constituent of the waste. Otherwise, the analysis must be made in terms of the fraction of the maximum discharge limits, as discussed in section 18.1. It must be borne in mind that notwithstanding the high limits calculated, the maximum gross activity that can be released into the sewer for the year is 1 curie.

## 18.4 Solid Wastes

Covered metal cans (the type equipped with foot-operated lids is convenient for small volumes) should be used to contain nonflammable solid wastes in low-level laboratories. The cans should be easily distinguishable from cans for ordinary trash to prevent accidental disposal of radioactive materials into the regular trash, and they should display a "radioactive materials" label. A plastic bag should be used as a liner. Hypodermic needles and other sharp objects should be wrapped so they do not pierce through the liner; even a mere scratch to a person handling the bag can result in serious infection or disease. When the contents of the can are to be disposed of, the plastic bag is sealed and a tag stating the upper limits to the contents is attached for the information of the disposer. Materials contaminated with radioiodine should be enclosed in two bags before discarding. Animal carcasses are best stored in a freezer prior to final disposal. If sufficient storage or freezer space is available, the shorter-lived nuclides may be allowed to decay to insignificant levels. Otherwise, the wastes must be disposed of by burial, by incineration, or through a commercial company. When the wastes collected from a laboratory are to be shipped out in drums, and the volume generated is large enough, it is sometimes convenient to keep the shipping drum in the laboratory for use also as a waste receptacle. For all practical purposes current regulations do not allow disposal of radioactive solid waste through public sanitation departments.

Incineration is a good bulk-reducing method but requires approval from regulatory agencies. The simplest method of satisfying NRC regulations is to ensure that the concentrations released to unrestricted areas do not exceed the limits specified for continuous exposure of the public. Concentrations may be averaged over a period not greater than a year. Incineration is the method of choice for putrefiable materials, especially animal carcasses. Carcasses containing $^{14}$C and $^3$H leave very little radioactive ash. If incineration leaves a radioactive ash, the ash must also be disposed of as radioactive waste. The NRC does allow the disposal of $^3$H and $^{14}$C in media

used for liquid scintillation counting or in animal carcasses, without regard to their radioactivity, provided that the concentrations are less than 0.05 microcuries per gram.

*Example 8:* A small, gas-fired incinerator is used to dispose of radioactive carcasses. The manufacturer reports that the incinerator consumes 200–300 ft$^3$/min of air during combustion. What are the maximum quantities of $^3$H and $^{14}$C in animal carcasses that could be burned in a week?

The flow of air through the incinerator in 1 week (200 ft$^3$/min) is 5.7 $\times$ 10$^{10}$ cc. The maximum permissible concentrations are 1 $\times$ 10$^{-7}$ $\mu$Ci/cc for $^{14}$C and 2 $\times$ 10$^{-7}$ $\mu$Ci/cc for $^3$H. The weekly limits, when only one radionuclide is burned, are 5.7 mCi for $^{14}$C and 11.4 mCi for $^3$H.

Incineration is particularly attractive when the waste material is a fuel itself. For example, the scintillation fluids prepared for liquid scintillation counting consist mainly of toluene or xylene, solvents with high heat content. The incineration of toluene consumes about 15 l of air per ml. (The reaction $2CH_2 + 3O_2 \rightarrow 2CO_2 + 2H_2O$ requires 3.4 g $O_2$ to oxidize 1 g of $CH_2$, or the oxygen in about 12 l of air.) The combustion of 20 ml of scintillation fluid (volume in a typical vial) containing 20,000 dis/min of $^3$H would result in a gaseous effluent with a concentration of 1.3 dis/m-l. This is only three times the limit for continuous exposure of a member of the public. Levels orders of magnitude below the limits for environmental releases are attained readily by mixing the scintillation fluid with fuel used for incineration, heating, or power production. Alternatively, even if the toluene is burned directly, concentrations can be reduced to trivial levels by diluting the effluent with large amounts of air prior to discharge from the stack.

Burial is sometimes preferred. Until February 1981, NRC regulations provided that licensees could bury on their property up to 1,000 times the minimum activity requiring a license in a single burial without prior approval. They allowed up to a maximum of 12 burials per year, separated by distances of at least 6 feet and at a minimum depth of 4 feet. In February 1981, the NRC discontinued the generic authorization of burials. They now require licensees to apply for authorization to bury radioactive materials on their property. Applicants have to demonstrate that local land burial is preferable to other disposal alternatives. They have to submit information and justification (where applicable) on the type and quantity of material to be buried, the packaging, burial location, nature of the burial site, control of the site, recordkeeping and radiation safety procedures. They also have to assure that all requirements of local governing authorities are met. The buried wastes should not require long-term site control for the protection of public health, and the applicant has to demonstrate by analysis that transport of radioactive material away from the site is highly unlikely to occur.

The burial depth has to be at least 4 feet below the surface and the high point for the water table has to be a minimum of 10 feet below the burial depth.

## 18.5 Government Regulation of the Disposal of Hazardous Wastes

The technologically advanced societies produce enormous quantities of hazardous waste materials as by-products of manufacturing activities. According to the Environmental Protection Agency (EPA, 1978; Crawford, 1987), about 247 million metric tons of hazardous waste subject to regulation by the Environmental Protection Agency under the Resource Conservation and Recovery Act are generated annually. These wastes must be properly handled, transported, treated, stored and disposed of to safeguard public health and the environment. In addition, there are billions of tons of mining, agricultural, and other wastes and about 246 million tons of municipal waste (Abelson, 1987). Thoughtless and irresponsible waste disposal practices have led to the contamination of groundwater supplies, the condemnation of wells and other sources of drinking water, and tragic illness for many persons living near waste disposal sites.

The Resource Conservation and Recovery Act (RCRA) passed by Congress in 1976 seeks to bring about development of comprehensive state and local solid-waste programs that include regulation of hazardous wastes from the point of generation through disposal. It includes institution of a manifest system to track these wastes from point of generation to point of disposal and organization of a permit system for waste treatment, storage, and disposal facilities. Standards have been prepared that cover record keeping, labeling of containers, the use of appropriate containers, the furnishing of information on waste composition, and the submission of reports to the EPA or authorized state agencies. Public participation is being encouraged and provided for in the development of all programs, guidelines, and regulations under the act.

Research and development activities also produce hazardous wastes that, although in quantities nowhere near those produced in manufacturing, nevertheless constitute part of the total inventory and therefore are subject to the same controls. When the waste is both radioactive and hazardous, it is classified as "mixed" waste, and oftentimes there is no clear approach to disposing of this type of waste. Facilities designed to handle hazardous waste may not be licensed to receive radioactive wastes, and radioactive waste sites may not be allowed to accept or interested in accepting hazardous wastes. Thus, users of radioactive materials that are also classified as hazardous have to devote considerable time, energy, and money to finding ways to dispose of these wastes. They cannot throw materials of any kind into the radioactive waste disposal barrels without compunction, seal the drum, and feel relieved of them, just by paying the waste disposal company a fee. The waste disposal company is merely a transporter; it usually does not

have the authority to look into the barrels given to it and is not responsible for the safe packaging of the contents. The mark of the originator of the waste remains with it unto perpetuity. Furthermore, the shipper must look into the credentials of the waste disposal company to determine that the wastes will be handled properly. Waste disposal companies have gone bankrupt, causing the wastes to revert back to the shipper; others have disposed of wastes in ways that hardly conformed with the regulations (Raloff, 1979). For example, the nation's largest handler of solid and chemical wastes was accused of mixing toxic wastes with used motor oil that was then handed over without charge to contractors as surfacing material for roads. Other companies have engaged in "midnight dumping," dumping the wastes covertly by the side of the road when no one was looking. In these instances, the original shipper could well be responsible for paying the costs of correcting the situation. Until the political process works out practical means of disposing of mixed wastes, on-site storage may be the only option in some instances.

## 18.6   Disposal of Liquid Scintillator Wastes

A significant fraction of the waste from research institutions consists of vials of slightly radioactive solvents prepared for liquid scintillation counting, which are stigmatized by the triple mark of radioactivity, flammability, and chemical toxicity, all of a low grade of hazard but each compounding the problem from both a regulatory and a public relations point of view. The simplest approach is to ship the vials in metal drums without further processing. This is very costly. The vials must be placed in the drums with sufficient absorbent material to absorb at least twice the solvent contained in the drums. As a result, only about 1,500 standard-size (20-ml) vials can be shipped in a single 30-gallon drum. Larger volumes of solvent must be solidified in their container; that is, absorbent must be introduced into the liquids in the containers in sufficient quantity to absorb them completely.

An exercise to evaluate the significance of the radioactivity of liquid scintillation counting solutions is most instructive. A typical vial may contain tritium with an activity of perhaps 20,000 dis/min. Each disintegration releases on the average 0.006 MeV of beta-particle energy. Compare this with the activity of the radium which exists naturally in the human body. Each decay of a radium atom is followed within a few days by 5 additional decays, representing a sum total of 3 alpha particles, 2 beta particles, and 2.3 gamma photons. The total alpha energy adds up to 19.2 MeV, the beta energy to 0.9 MeV and the gamma energy to 1.8 MeV. The alpha energy is multiplied by 20 to account for the high hazard relative to beta and gamma radiation, so the energy is equivalent to 384 MeV, dwarfing the beta and gamma energy. A total of 266 radium atoms decay per minute in the body. If we assume only 30 percent of the first decay product, radon (a noble gas), is retained in the body, the equivalent alpha energy released per minute (including the radium

alpha particles, 4.77 MeV) is 266 × (4.77 + 0.3 × 19.2) × 20 = 56,000 MeV, and another 500 MeV is contributed by beta and gamma radiation. To the 56,500 MeV/min from radium decay in the body may be added 157,000 from the decay of $^{40}$K, 10,300 from $^{14}$C, 53,300 from $^{210}$Po, and 2,800 from $^{90}$Sr, to make a total of 280,000 MeV/min. Consider a 30-gallon drum which contains vials of scintillation fluid with a typical activity of about 20,000 dis/min of tritium per vial. The drum will contain only about 1,500 vials, holding 15,000 ml (4 gal) of liquid. The remaining volume is taken up by the absorbent material required by the regulations and the empty space in the vials. The total decay energy in a drum amounts to 0.006 MeV × 20,000 × 1,500 = 180,000 MeV/min. The result is that the radioactivity in a single person, by this reasoning, is greater than the radioactivity in a drum.

Because of the limited number of commercial burial grounds for radioactive materials, radioactive wastes must often be shipped long distances. For many years, users on the East Coast had to ship liquid scintillation vials, at very high cost, to states across the country for burial. They were given considerable relief, however, when in March 1981 the NRC amended its regulations to permit licensees to dispose of $^{3}$H and $^{14}$C in media used for liquid scintillation counting or in animal carcasses, without regard to their radioactivity, provided that the concentrations were less than 0.05 microcuries per gram. The concentration in animal tissue could be averaged over the weight of the entire animal. The NRC ruling made it possible to dispose of these wastes through incineration or commercial services to the extent permitted by applicable local government regulations. Users of radioactive materials could realize extensive savings through this deregulation, but perhaps of greater import was the resultant reduction in the shipment of the more innocuous radioactive wastes to radioactive waste disposal sites and the prolongation in site use for wastes that required the high degree of containment provided. The deregulated radioactive wastes were still subject to other federal, state and local regulations governing any other toxic properties of the materials, and to recordkeeping on receipt, transfer and disposal as specified in NRC licensing regulations in 10CFR30.

### 18.7  Volume Reduction in Waste Disposal

With facilities for disposal continually diminishing, and disposal costs continually rising, it is important that users actively work to reduce the volume of radioactive waste generated. Storage for decay is a practical management method for short-lived wastes. The NRC requires a minimum storage period of 10 half-lives, which is usually manageable for short-lived radionuclides like iodine-131 and phosphorus-32 but is more difficult for iodine-125 (requiring a minimum of 600 days in storage). It usually pays for institutions to set up central storage facilities if significant volumes of wastes contaminated by iodine-125 are produced. Such facilities require careful management to store the wastes efficiently and retrieve them after the required

decay period. The wastes may be stored in fiber drums and then incinerated as nonradioactive trash if they do not contain hazardous chemicals. Drums must be monitored before they are released to ensure that the residual radiation is insignificant. Complete and accurate records must be kept.

Compaction on site leads to large reductions in volumes of solid waste that is disposed of by shipment to a commercial burial site. Some commercial companies utilize supercompactors to minimize the volume to be buried.

Users can reduce waste designated for disposal as radioactive by carefully monitoring all waste generated and designating as radioactive only those wastes that give positive readings. Glassware containing trace amounts of radioactivity can be rinsed and disposed of with nonradioactive laboratory waste after being monitored. An effective volume reduction program will require special processing by the institution for each of the different types of radionuclides, so wastes disposed through the institution should be segregated by the user and labeled according to the radionuclide and other information required. Solid waste should be packed in clear plastic bags to allow for inspection of the contents. Sharp objects should be packed in puncture-proof containers.

Institutions have realized very large savings in disposal of scintillation vials by acquiring vial crushers, separating the contents from the crushed vials, rinsing the fragments and disposing of them as nonradioactive while the contents of the vials are disposed as bulk liquids. (S&G Enterprises of Milwaukee makes a vial crusher, called the Vyleater, that processes 7,000 plastic or 10,000 glass vials per hour.) The use of mini-vials produces substantial savings in both volumes of scintillation cocktail used and in the volume of vials for disposal.

These and other methods can reduce volumes to a small fraction of that disposed of without treatment. The effort to reduce volume is labor-intensive and therefore not popular in a busy research laboratory. Both the regulatory process and the economics of waste disposal, however, will force the allocation of time and resources needed to effect large volume reductions in radioactive waste.

### 18.8   The Designation of *De Minimus* Concentrations of Radioactivity

The discussion in section 18.6 on the high cost of disposal of used liquid scintillation solvents points out the waste of resources when controls designed for relatively small volumes of truly hazardous wastes are applied to the much larger volumes of materials with minimal radioactivity resulting from physical, biological, and medical research with radioactive tracers. Such practices can, in fact, result in a net harm to the environment if one considers the environmental costs of the control measures. Users who must dispose of materials with trace amounts of radioactivity desperately need standards to define levels that pose no significant radiation hazard to the public or the environment, standards which allow for disposal in accordance

with the regulations for comparable nonradioactive substances. Such levels are known as *de minimus* levels (*de minimus* comes from the Latin maxim *de minimus non curat lex,* "the law does not concern itself with trifles").

So far, government regulations have not attempted to define *de minimus* levels, although the following numerical guides to meet the criterion "as low as is reasonably achievable" (ALARA) for radioactive material in light-water nuclear power reactor effluents may be used to suggest appropriate values (10CFR50, Appendix I).

1. The calculated annual total quantity of all radioactive material above background to be released from each light-water-cooled nuclear power reactor to unrestricted areas will not result in an estimated annual dose or dose commitment from liquid effluents . . . in excess of 3 millirems to the total body or 10 millirems to any organ.

2. The calculated annual total quantity of all radioactive material above background to be released from each light-water-cooled nuclear power reactor to unrestricted areas will not result in an estimated annual air dose from gaseous effluents at any location near ground level which could be occupied by individuals in unrestricted areas in excess of 20 millirads for gamma radiation or 20 millirads for beta radiation.

3. The calculated annual total quantity of all radioactive iodine and radioactive material in particulate form above the background to be released from each light-water-cooled nuclear power reactor in effluents to the atmosphere will not result in an estimated annual dose or dose commitment from such radioactive iodine and radioactive material in particulate form for any individual in an unrestricted area from all pathways of exposure in excess of 15 millirems to any organ.

Another approach is to set *de minimus* levels at some level comparable to variations in the natural environment. Recommended values have been in the range of 1 mrem per year to the total body or 3 mrem per year to individual organs (Rodger et al., 1978). Guidance on *de minimus* values may also be obtained from values of concentrations exempt from a license (10CFR20.14), quantities exempt from a license (10CFR20.18), and the regulations of the Department of Transportation (49CFR173.389, par. 5e). Here it is stated that "Materials in which the estimated specific activity is not greater than 0.002 microcuries (74 dis/sec) per gram of material, and in which the radioactivity is essentially uniformly distributed, are not considered to be radioactive materials."

## 18.9 Natural Radioactivity as a Reference in the Control of Environmental Releases

While the use of radioactive materials must be strictly controlled to prevent excessive releases to the environment that can affect the public health, it should be borne in mind that the environment is naturally very radioactive. One of the ways to assess the significance of the disposal of radioactive

waste materials is by comparison with naturally occurring radioactivity. It includes radioactivity in the air (as radioactive gases or particles), in the ground, in rainwater, in groundwater, in building materials, in food, and in the human body. The levels vary appreciably in different locations. The naturally occurring radionuclides also differ greatly in their toxicities, and include some radionuclides that rank among the most hazardous as well as others that rank among the least hazardous.

Natural radioactivity in the environment originates from a variety of sources. The most significant are the radionuclides potassium-40, uranium-238, and thorium-232, which were produced when the universe was created some ten billion years ago and remain in significant quantities today because of their long half-lives (greater than a billion years). When they decay they are followed by many additional radioactive products with shorter half-lives, such as radium-226 (1,960 years), radon-222 (3.8 days), polonium-214 ($10^{-5}$ sec), and polonium-210 (120 days). Except for potassium-40, the preceding radionuclides emit alpha radiation and are considered to be highly toxic.

All of the radionuclides listed except one are solids and are distributed throughout the ground, from which they are taken up by vegetation or dissolved in groundwater. One radioactive decay product, radon-222, is a noble gas. It originates from the decay of the radium in the ground, but it diffuses out of the ground and reaches significant concentrations in the atmosphere, particularly when the air is still. It also leaks into buildings, where the levels reached depend on the concentration in the ground, on cracks and other openings in the building, on the building's ventilation, and on pressure differentials between the building and the soil. Heat conservation measures in buildings in cold climates result in minimizing air exchange with the environment and serve to increase radon levels. Many studies have been and are being conducted of radon levels in buildings throughout the world, and unacceptably high levels of radon in many homes, schools and commercial buildings have been found. Indoor radon pollution is now recognized as a major public health problem requiring remedial action. Most of the dose from radon is not caused by the decay of radon but of the subsequent decay products. The decay of each radon atom is followed by six successive decays, producing radionuclides which emit alpha, beta, and gamma radiation. The decay products form radioactive aerosols in the air, which are breathed in and retained in the lungs and which are also responsible for contamination of the ground, food, and water.

Radionuclides are also generated continuously from the action of cosmic radiation on elements in the atmosphere. The most significant are carbon-14 and hydrogen-3 (tritium). Both emit very low energy beta radiation and are among the least hazardous of radioactive materials.

The cosmic radiation and the gamma radiation emitted by radioactive materials in the ground are responsible for large differences in external

radiation doses in different places (NCRP, 1987a, Report 94). For example, at 1.6 km (1 mile) altitude, the cosmic ray annual dose of 45 mrem is 17 mrem/yr greater than the dose at sea level. Neutrons contribute an additional 30 mrem at 1.6 km and 6 mrem at sea level. Values of annual doses in the United States (including both terrestrial and cosmic radiation but not neutrons) range in various locations from 32 mrem to 197 mrem, a total difference of 165 mrem. Residents of the city of Denver receive a whole-body dose of 125 mrem/yr, compared to 65 mrem/yr to inhabitants of the Atlantic and Gulf coastal states and 80 mrem/yr to the majority of the U.S. population. There are also large differences in radioactivity in the air, primarily due to the naturally occurring radioactive gas radon-222. Concentrations of $^{222}$Rn in outdoor air range from 20 to 1,000 pCi/m$^3$. The corresponding average dose rates to the lungs (from the radon decay products) range from 20 to 1,000 mrem/yr. Much higher levels are found indoors and lung doses of many rem per year can be imparted from continuous exposure to radon in some homes. Variations in radium-226 content in the diet produce variations in the dose to bone of about 10 mrem/yr around an average annual dose of about 100 mrem/yr.

Despite the large differences in radiation levels, very few people give any thought to natural radioactivity in selecting a place to work or live. There is no evidence that these variations are significant in affecting the incidence of cancer or other diseases. In fact, one can select areas throughout the country where the cancer incidence goes down as the natural radiation level increases (Frigerio and Stowe, 1976). Yet, the maximum whole-body doses resulting from the Three Mile Island nuclear power plant accident (which caused so much concern) were not much different from variations in levels in various parts of the country, and these maximum doses were imparted to only a few individuals.

Because of the natural abundance of radioactive materials, the disposal of sufficiently small quantities of radioactive materials via the ground and the air would not produce any significant change in the existing levels. Typical levels of radioactivity in the ground and in the air are given in table 5.6. These are quite significant, and it must be noted that the radionuclides are not contained but are accessible to groundwater, to food crops, and to the atmosphere. Discharges that contribute only a small fraction to the activity already present in the environment should have no noticeable effect on the public health. Of course, the existence of natural levels of radioactivity does not give a license to pollute indiscriminately. The release of low levels of pollutants should be weighed against the benefit to society of the activities that produced the pollutants. In any event, the releases should be reviewed for compliance with the ALARA principle, which requires that the discharge of pollutants to the environment be kept as low as reasonably achievable and not merely in compliance with air-pollution regulations.

**Table 5.6.** Activity in the environment and in people of naturally occurring long-lived radionuclides.

| Radionuclide | Half-life (years) | Global inventory (millions of curies) | Activity in soil to depth of 2 meters | | Concentration in | | Activity in body (pCi) |
|---|---|---|---|---|---|---|---|
| | | | 1 acre (mCi) | 1 km² (mCi) | Air (pCi/m³) | Water (pCi/m³) | |
| Alpha-particle emitters | | | | | | | |
| Uranium-238 | 4.5 billion | | 10 | 2,520 | 0.00012 | | 26 |
| Thorium-232 | 14 billion | | 10 | 2,520 | .00003 | | |
| Radium-226 | 1600 | | 10 | 2,520 | .00012 | 1,000–10,000 (well water) | 120 |
| Radon-222 | 3.82 days | 25 (atmosphere) | | | 70 | | |
| Polonium-210 | 138 days | 20 | 13 | 3,240 | .0033 | 100 | 200 |
| Beta-particle emitters | | | | | | | |
| Potassium-40 | 1.3 billion | | 175 | 43,200 | | | 130,000 |
| Carbon-14 | 5,730 | 300 | | | | | 87,000 |
| Hydrogen-3 (tritium) | 12.3 | 34 (natural) 1700 (fallout) | | | .038 | 6,000–24,000 | |
| Lead-210 | 21 | 20 | 13 | 3,240 | .014 | 100 | |

*Sources:* UNSCEAR, 1977; NCRP, 1975.

*Notes:* 1 acre = 4047 m²; 1 km² = 247 acres.  Assume soil density of 1800 kg/m³.  Mean value of radon emanation rate from soil is 0.42 pCi/m²-s, range $6 \times 10^{-3}$ to 1.4 pCi/m²-s.

### 19.   Use of Radioactive Materials in Animals

Injection of radioactive materials into animals should be performed in trays lined with absorbent material. Cages housing animals injected with radio-isotopes should be labeled as to radionuclide, quantity of material injected per animal, date of injection, and user. Metabolic-type or filter cages should be used if contamination is a problem. These cages should be segregated from those housing other animals. Animal excreta may be disposed of via the sewer if the concentration is in accordance with limits applicable to liquid waste and the excreta are not mixed with sawdust or wood shavings; otherwise, the excreta may be placed in plastic bags and disposed of as solid wastes.

Adequate ventilation must be provided in instances where animals are kept after an injection with radioactive materials that may become volatil-ized and dispersed into the room at significant levels. Animal handlers must be indoctrinated by the responsible investigator as to the dose levels, time limitations in the area, and the handling requirements of the animals and excreta.

### 20.   Transportation of Radionuclides

#### 20.1   Transportation within the Institution

Within institutional grounds, all radionuclides must be transported in non-shatterable containers or carrying cases with the cover fastened securely so it will not fall off if the case is dropped. Shielding of containers should follow federal transportation regulations, which limit dose rates to less than 200 mrem/hr in contact with the container and 10 mrem/hr at 3 ft from the surface of the container (dose rates should be reduced as much below these limits as practicable in accordance with the ALARA principle). There should not be any removable radioactive contamination on the surface of the container, but in the event there *is* contamination it should be below 1,000 dis/min per 100 cm$^2$ for beta or gamma contamination (except for $^{125}$I, for which the limit is 200 dis/min) and below 20 dis/min per 100 cm$^2$ for alpha contamination (limits for most radionuclides in NRC Regulatory Guides and a Health Physics Society standard for release of materials for uncontrolled use; Department of Transportation limits are higher). A route should be chosen to encounter minimal pedestrian traffic.

#### 20.2   Mailing through the U.S. Postal Service

Government regulations pertaining to the packaging and shipment of radio-active materials are quite complicated. If the specific activity of material to be shipped is greater than 0.002 $\mu$Ci/g, the shipper has the problem of inquir-ing into the existence and content of applicable regulations.

The U.S. Postal Service does not allow the mailing of any radioactive-materials package that bears any of the Department of Transportation's

"Radioactive" labels (white-I, yellow-II, or yellow-III), but it does allow the mailing of "small quantities" of radioactive materials and certain radioactive manufactured articles that are exempt from specific packaging, marking, and labeling regulations prescribed for higher levels of radioactivity by the Department of Transportation. The regulations are given in Postal Service Publication 6, *Radioactive Matter* (USPS, 1983). The package limits are one-tenth the limits for packages designated as "limited quantity" by the DOT and are given for selected radionuclides in table 5.7. Note that two categories are identified, "special form" for sources that are encapsulated and meet stringent test requirements (49CFR173.469) and "normal form" for all other items. These exemptions allow the mailing of up to a millicurie[10] of the less hazardous beta-gamma emitters in common use, provided the following conditions are met:

1. Strong, tight packages are used that will not leak or release material under typical conditions of transportation. If the contents of the package are liquid, enough absorbent material must be included in the package to hold twice the volume of liquid in case of spillage.

2. Maximum dose rate on surface is less than 0.5 mrem/hr.

3. There is no significant removable surface contamination (that is, less than 2,200 dis/min/100 cm$^2$ beta-gamma; 220 dis/min/100 cm$^2$ alpha).

4. The outside of the inner container bears the marking "Radioactive Material—No Label Required." The identity or nature of the contents must be stated plainly on the outside of the parcel. The full name and address of both the sender and addressee must be included on the package.

### 20.3   Shipment of "Limited Quantities"

The packaging and transportation in interstate or foreign commerce of radioactive materials not shipped through the postal service are governed by regulations issued by the U.S. Department of Transportation (DOT).[11] The NRC has identified in its regulations (10CFR71.5) those sections in the DOT regulations of most interest to users of radionuclides. They include packaging, marking and labeling, placarding, accident reporting, and shipping papers, and the most recent regulations should be checked before making any shipments. If shipments can be limited to what DOT defines as limited quantities, regulations are much simpler, as these quantities are exempt

---

10. Some exceptions are 0.04 mCi for $^{90}$Sr; 2 Ci of tritium per article as a gas, luminous paint, or absorbed on solid material; or 7 mCi of $^{125}$I. The regulations should be checked for the limits set for a specific radionuclide. For a brief summary of mailing regulations, request the U.S. Postal Service pamphlet *Radioactive Matter,* Publication 6, September 1983.

11. The regulations of the Department of Transportation incorporate recommendations of various government agencies, including the Nuclear Regulatory Commission, Federal Aviation Agency, Coastguard, and Post Office. See DOT, 1983; and the Code of Federal Regulations, Title 49 (Transportation).

from specific packaging, marking, and labeling requirements. The containers must be strong, tight packages that will not leak under conditions normally encountered in transportation. The radiation level may not exceed 0.5 mrem/hr at any point on the surface and the removable contamination on the external surface may not exceed 2,200 dpm/100 cm$^2$ beta-gamma and 220 dpm/100 cm$^2$ alpha averaged over the surface wiped. The outside of the inner packaging must bear the marking "Radioactive" and a notice must be included in the package that includes the name of the consignor or consignee and the following statement: "This package conforms to the conditions and limitations specified in 49CFR173.421 for excepted radioactive material, limited quantity, n.o.s., UN2910" ("n.o.s." stands for "not otherwise specified"). There are other exceptions for instruments and articles. Maximum quantities which can be shipped as limited quantities depend on the radionuclide shipped and whether the material is in "special" or "normal" form (see section 20.2, above). Limits for solids are ten times those for liquids, and the limit for most of the beta-gamma radionuclides used in tracer research is greater than 10 mCi as solids and 1 mCi as liquids. Specific limits for shipment as liquids include 2 mCi for H-3 in organic form, 6 mCi for C-14, 7 mCi for I-125 and 1 mCi for I-131. Limits for selected other radionuclides are 10 times the values give in table 5.7. It is not possible to present the detailed regulations here; a copy of the regulations should be obtained if a shipment must be made (see 49CFR173.421–443).

## 20.4 Shipment of "Low-Specific-Activity" Materials

If the amount of activity to be shipped is greater than a limited quantity, some requirements of the regulations are still exempted if the material can be classified as "low-specific-activity" (LSA).[12] The simplest requirements apply if the shipment is sent "exclusive use" or "sole use." This means that the shipment comes from a single source and all initial, intermediate, and final loading and unloading are carried out in accordance with the direction of the shipper or the receiver. Any loading or unloading must be performed by personnel having radiological training and resources appropriate for safe handling of the shipment. Specific instructions for maintenance of exclusive-use shipment controls must be issued in writing and included with the information that accompanies the shipment (49CFR173.403).

LSA materials shipped as exclusive use are excepted from specific packaging, marking, and labeling requirements. The materials must be packaged in strong, tight packages so that there will be no leakage of radioactive material under conditions normally incident to transportation. The exterior of each package must be stenciled or otherwise marked "Radioactive—

---

12. Specific activity less than 0.3 mCi/g for the less hazardous beta-gamma emitters. Details are given in 49 CFR 173.392.

**Table 5.7.** Maximum mailable quantities of some radionuclides in solid form. These values are one-tenth the upper limits for the designation of "limited quantities" assigned to radionuclides by the Department of Transportation. Values for liquids are one-tenth those listed here.

| Radionuclide | Radiochemicals —normal form (mCi) | Sealed sources —special form (mCi) |
|---|---|---|
| $^3$H (gas, luminous paint, adsorbed on solid) | 100 | 100 |
| $^2$H (water) | 100 | 100 |
| $^3$H (other forms) | 2 | 2 |
| $^{14}$C | 6 | 100 |
| $^{24}$Na | 0.5 | 0.5 |
| $^{32}$P | 3 | 3 |
| $^{35}$S | 6 | 100 |
| $^{36}$Cl | 1 | 30 |
| $^{42}$K | 1 | 1 |
| $^{45}$Ca | 2.5 | 100 |
| $^{51}$Cr | 60 | 60 |
| $^{55}$Fe | 100 | 100 |
| $^{59}$Fe | 1 | 1 |
| $^{60}$Co | 0.7 | 0.7 |
| $^{64}$Cu | 2.5 | 8 |
| $^{65}$Zn | 3 | 3 |
| $^{67}$Ga | 10 | 10 |
| $^{75}$Se | 4 | 4 |
| $^{82}$Br | 0.6 | 0.6 |
| $^{85}$Kr (uncompressed) | 100 | 100 |
| $^{86}$Rb | 3 | 3 |
| $^{90}$Sr | 0.04 | 1 |
| $^{109}$Cd | 7 | 100 |
| $^{111}$In | 2.5 | 3 |
| $^{125}$I | 7 | 100 |
| $^{131}$I | 1 | 4 |
| $^{133}$Xe (uncompressed) | 100 | 100 |
| $^{198}$Au | 2 | 4 |
| $^{201}$Tl | 20 | 20 |
| *Microspheres* | | |
| $^{46}$Sc | 0.8 | 0.8 |
| $^{85}$Sr | 3 | 3 |
| $^{95}$Nb | 2 | 2 |
| $^{103}$Ru | 2.5 | 3 |
| $^{113}$Sn | 6 | 6 |
| $^{114}$In | 2 | 3 |
| $^{141}$Ce | 2.5 | 30 |
| $^{153}$Gd | 10 | 20 |

**Table 5.7.** (*continued*)

| Radionuclide | Radiochemicals —normal form (mCi) | Sealed sources —special form (mCi) |
|---|---|---|
| *Alpha emitters* | | |
| $^{222}$Rn | 0.2 | 1 |
| $^{226}$Ra | 0.005 | 1 |
| $^{228}$Th | 0.0008 | 0.6 |
| $^{232}$Th | Unlimited | Unlimited |
| $^{238}$U | Unlimited | Unlimited |
| $^{239}$Pu | 0.0002 | 0.2 |

*Note: Normal form* is defined as material which could be dispersed from the package, contaminate the environment, and present an inhalation and ingestion problem. Typically this class includes liquids, powders, and solids in glass, metal, wood, or cardboard containers. *Special form* is defined as material which is encapsulated and is not likely to be dispersed, contaminate the environment, and present an inhalation and ingestion problem. The hazard is only from direct radiation from the source.

Up to 10,000 times the quantities listed here can be shipped by common or contract carriers as type-A packages.

LSA''. There must not be any significant removable surface contamination and external radiation must meet limits applicable to radioactive packages.

When LSA materials are part of another shipment, they must be contained in packaging that meets the DOT specifications for type-A packages, with just a few exemptions (49CFR173.425).

Objects of nonradioactive material that have surface radioactive contamination below 1 $\mu$Ci/cm$^2$ (averaged over 1 square meter) for almost all radionuclides can be shipped unpackaged, provided the shipment is exclusive use and the objects are suitably wrapped or enclosed (49CFR173.425).

### 20.5 Shipment of Type-A Packages

Most shipments in quantities or concentrations above the "exempt" level will fall into the type-A category. Typical packaging includes fiberboard boxes, wooden boxes, and steel drums strong enough to prevent loss or dispersal of the radioactive contents and to maintain the incorporated radiation shielding properties if the package is subjected to defined normal conditions of transport. The maximum quantities which can be shipped as type-A packages are 10,000 times the values in Table 5.7. Containers certified to meet type-A requirements are available from commercial suppliers. Type-B packaging is for high-level sources and is designed to withstand certain serious accident damage test conditions.

If radioactive material is transported in a cargo-carrying vehicle that is not

exclusively for the use of the radionuclides, the dose rate cannot exceed 200 mrem/hr at the surface of the package and 10 mrem/hr at 1 meter. If the vehicle is for the radionuclides only and the shipment is loaded and unloaded by personnel properly trained in radiation protection, the dose rate can be 1,000 mrem/hr at 1 meter from the surface of the package, 200 mrem/hr at any point on the external surface of the vehicle, 10 mrem/hr at 2 m from the external surface of the vehicle, and 2 mrem/hr in any normally occupied position in the vehicle. Special written instructions must be provided to the driver.

The following labels must be placed on packages containing radioactive materials unless the contents are exempt as "limited quantities." Packages carrying these labels are not mailable: (a) a radioactive white-I label, if the dose rate at any point on the external surface of the package is less than 0.5 mrem/hr and the contents are above a "limited quantity"; (b) a radioactive yellow-II label if the dose rate is greater than 0.5 mrem/hr but less than 50 mrem/hr on the surface and less than 1 mrem/hr at 1 meter; and (c) a radioactive yellow-III label if the dose rate on the surface is greater than 50 mrem/hr or greater than 1 mrem/hr at 1 m. Each package in an exclusive-use LSA shipment must be marked "Radioactive—LSA." There are labeling exemptions for instruments and manufactured articles containing activity below prescribed limits (49CFR173.422) and for articles containing natural uranium or thorium (49CFR173.424).

The yellow labels have an entry for the "transport index." This is the maximum radiation level in millirem per hour (rounded up to the first decimal place) at one meter from the external surface of the package. The number of packages bearing radioactive yellow-II or radioactive yellow-III labels stored in any one storage area must be limited so that the sum of the transport indexes in any individual group of packages does not exceed 50. Groups of these packages must be stored so as to maintain a spacing of at least 6 meters from other groups of packages containing radioactive materials.

Packages shipped by passenger-carrying aircraft cannot have a transport index greater than 3.0.

A vehicle has to be provided with *radioactive*[13] signs if it is carrying packages with yellow-III labels or is carrying LSA packages as an exclusive-use shipment. Users sending radioactive material by taxi should ensure that the taxi will not carry passengers and the package is stored only in the trunk (49CFR177.870). The user should also determine his responsibilities as shipper, including provision of shipping papers and shipper's certification. Users who have a license to transport radioactive materials in their own cars

---

13. For current regulations as to the exact wording and dimensions of the sign, see Code of Federal Regulations, Title 49.

should be aware that their insurance policy may contain an exclusion clause with regard to accidents involving radioactive materials.

In the event of a spill, DOT regulations state (173.443) that vehicles may not be placed in service until the radition dose rate at any accessible surface is less than 0.5 mrem/hr and removable contamination levels are less than 2,200 dis/min per 100 cm$^2$ beta-gamma and 220 dis/min per 100 cm$^2$ alpha.

## 20.6 Shipping Papers and Shipper's Certification

All radioactive-materials shipments must be accompanied by shipping papers which describe the radioactive material in a format specified by the Department of Transportation. For "limited quantities," the information must include the name of the consignor or consignee and the statement, "This package conforms to the conditions and limitations specified in 49CFR173.421 for excepted radioactive material, limited quantity, n.o.s., UN2910." Similar wording applies to several other types of excepted articles. Incidents of decontamination (such as of vehicles or packages) associated with the shipment must be reported.

Shipping papers for activities greater than "limited quantities" must include the proper shipping name and identification number in sequence; the name of each radionuclide; physical and chemical form; activity in terms of curies, millicuries, or microcuries; the category of the label, for example, radioactive yellow-II; and the transport index. Abbreviations are not allowed unless specifically authorized or required. The following certification must also be printed on the shipping paper: "This is to certify that the above-named materials are properly classified, described, packaged, marked and labeled, and are in proper condition for transportation according to the applicable regulations of the Department of Transportation."

## 21. Contamination Control

Loose contamination should not be tolerated on exposed surfaces such as bench tops and floors and should be removed as soon as possible. Work areas should be monitored for contamination before and after work with radioactive materials. Library books, periodicals, or reports must not be used in areas where there is a reasonable possibility of their becoming contaminated with radioactive materials. Contaminated equipment must be labeled, wrapped, and stored in a manner that constitutes no hazard to personnel, and there must be no possibility of spread of contamination.

All spills of radioactive material must be cleaned up promptly (IAEA, 1979). A survey must be made after cleanup to verify that the radioactive material has been removed. Cleaning tools must not be removed or used elsewhere without thorough decontamination. (Instructions for handling spills and other accidents are given in Appendix I to this part.)

The hazard from a contaminated surface is difficult to evaluate. One mechanism of intake of the contamination by humans is through dispersion

of the contamination into the air and subsequent inhalation. Some of the contamination may be transferred from the surface to the hands and then from the hands to the mouth to be swallowed.

How contaminated can we allow a surface to be without worrying about hazard to individuals? In most cases the question becomes academic, as other considerations force removing the contamination to as great a degree as possible. At least in research laboratories, where contamination on surfaces can spread to counting equipment and complicate low-level measurements, there is strong motivation to keep contamination levels as low as possible, well below levels that could cause harm to individuals. Where low-level counting is not a factor, it is still accepted practice to keep surfaces as clean as practicable.[14] Where work is done with "hot particles," that is, with particles of such high specific activity that single particles small enough to be inhaled could produce appreciable local doses, contamination control has to be very stringent.

### 21.1   Monitoring for Contamination

The most widely used monitor for beta-gamma contamination is the end-window G-M tube. The time-honored G-M probe is a cylindrical detector with a 1-inch window having a thickness equivalent to 0.03 mm unit-density material. The 2-inch-diameter "pancake" type is also very popular because its higher sensitivity shortens the time required to monitor objects for contamination. Unshielded 1-inch-diameter end-window tubes give count rates from the natural background of the order of 40 c/min. The 2-inch-diameter pancake tubes give about 70 c/min background. A doubling of the background counting rate might be considered a positive indication of contamination. Monitor performance checks are discussed in Section 4.4.

The best monitor for alpha contamination is one employing a proportional flow counter with a very thin window for the detector. The bias is adjusted so only the pulses due to alpha particles are counted. Scintillation detectors are easier to use, but care must be taken to prevent light leaks in the detector covering as they produce spurious counts.

Monitoring for contamination is done by slowly moving the detector over the suspected surfaces (Clayton, 1970). It is very useful to have an aural signal, such as from earphones or a loudspeaker, since small increases of radiation above the background are detected most easily by listening to the clicks. It is also easier to pay attention to the surface being monitored if the meter does not have to be watched. Measurements of beta-gamma contamination with a G-M counter are taken with and without interposing a shield

---

14. Control levels recommended for transferable surface contamination in unrestricted areas cover a wide range from 200 dis/min per 100 cm² for beta-gamma emitters and 20 dis/min per 100 cm² for alpha emitters to levels 100 times as high. (see Fitzgerald, 1969, vol. 1, p. 50; IAEA, 1962, pp. 115–119; NRC, 1976, Appendix C; IAEA, 1979).

that stops beta particles. The difference between the readings gives the contribution from beta radiation.

For monitoring loose contamination, an operation known as a wipe test is performed. A piece of filter paper is wiped over an area of approximately 100 cm² and then counted with a shielded end-window G-M detector. It has also been found convenient to use liquid scintillation counting by inserting the filter paper into a liquid scintillation vial. This method is attractive because liquid scintillation counting systems are equipped with automatic sample changers and printouts and are very efficient for processing a large number of samples.

## 21.2  Decontamination of Equipment and Buildings—Limits for Uncontrolled Release

The removal of radioactive contamination from surfaces is a battle against chemical and physical binding forces; the weapons include chemical and physical methods of decontamination. The literature on decontamination and cleaning is voluminous (Ayres, 1970; Lanza, Gautsch, and Weisgerber, 1979; Nelson, 1981; Osterhout, 1980). The Radiological Health Handbook lists methods applicable to most routine problems.

The effort required for decontamination depends very strongly on how low the contamination level must be reduced. Considerable thought has been given to acceptable limits (Fish, 1967; Healy, 1971; Clayton, 1970). In the final analysis, limits for release to the public are determined by the ALARA principle rather than by hazard considerations, subject, of course, to the condition that ALARA must be below acceptable levels from the hazards point of view. Examples of limits in use are given in NRC Regulatory Guides 1.86 and 8.23 (see the Selective Bibliography at end of book) and in a standard of the Health Physics Society (Shapiro, 1980; HPS, 1988). Some values of limits for uncontrolled use are given in table 5.8.

## 22.  Personnel Contamination and Decontamination

When hands, body surfaces, clothing, or shoes become contaminated, steps should be taken as soon as possible to remove loose contamination. Care must be exercised to prevent contamination on the body from spreading or from getting into wounds. Washing with a mild soap or a good detergent and water is generally the best initial approach. This is followed by more harsh methods when necessary, such as (a) mild abrasive soap, (b) complexing solution, and (c) mild organic acid (citric acid). Specific instructions for personnel decontamination in an emergency are given in Appendix I to this part.

When monitoring of hands indicates that the tips of the fingers are contaminated, clipping the fingernails may remove most of the residual activity after washing. When other measures still leave residual contamination on the hands, it may be worthwhile to wear a rubber glove for a day or so. The induced sweating has been reported as very effective in certain instances.

**Table 5.8.** Surface radioactivity guides (in dpm/100 cm$^2$).

| Radioactive material | Health Physics Society standard[a] | | Nuclear Regulatory Commission Guide 8.23 | |
|---|---|---|---|---|
| | Removable | Total | Removable | Total |
| All alpha emitters except natural or depleted uranium and natural thorium; Pb-210; Ra-228[b] | 20 | 300 | 20[f] | 100 |
| Sr-90; I-125,126,129,131[c] | 200 | 5,000 | 200[g] | 1,000 |
| All beta and gamma emitters not otherwise specified except pure beta emitters with $E_{max} \leq$ 150 keV[d] | 1,000 | 5,000 | 1,000 | 5,000 |
| Natural or depleted uranium, natural thorium, and their associated decay products[e] | 200 | 1,000 | 1,000[h] | 5,000 |

a. For purposes of this standard, the disintegration rate refers to those disintegrations which result in the emission of alpha particles, beta particles, or electrons with $E_{max} \geq$ 150 keV or photons of energy $\leq$ 20 keV, provided these particles are responsible for more than 80 percent of the dose.

Where both alpha and beta-gamma emitting radionuclides exist, the limits established for alpha and beta-gamma emitted nuclides shall apply independently.

The levels may be averaged over one square meter provided the maximum surface activity in any area of 100 cm$^2$ is less than three times the guide values. For purposes of averaging, any square meter of surface shall be considered to be above the activity guide $G$ if (1) from measurements of a representative number $n$ of sections it is determined that $(1/n) \Sigma s_i \geq G$, where $s_i$ is the dpm/100 cm$^2$ determined from measurement of section $i$; or (2) it is determined that the sum of the activity of all isolated spots or particles in any 100 cm$^2$ exceeds $3G$.

b. Pb-210 is included because of the presence of an alpha emitter, Po-210, in its decay chain, and Ra-228 is included because of the presence of another alpha emitter, Th-228, in its decay chain (HPS standard).

c. Of the radionuclides undergoing beta or electron capture decay, these present the greatest hazards as surface radioactivity (HPS standard).

d. The pure beta emitters with maximum energy less than 150 keV are excluded because detection by direct methods is not practical and they must be treated on a case-by-case basis. However, radionuclides that are detectable by direct measurement with appropriate instrumentation through emission of low-energy x rays and gamma rays (as in electron capture) or through the presence of short-lived decay products are included in this category.

e. $U_{nat}$ and $Th_{nat}$ include gross alpha disintegration rates of natural uranium, depleted uranium, uranium enriched to less than 10 percent U-235, Th-232, and their decay products.

f. NRC Guide 8.23 includes in this category Ac-227, I-125, and I-129.

g. NRC Guide 8.23 places I-125 and I-129 in the more restrictive alpha emitters category. It includes here, in addition to those listed, Th-nat, Th-232, Ra-223, Ra-224, U-232.

h. NRC Guide 8.23 places Th-nat into the more restrictive Sr-90 category, which results in limits equal to those used by the HPS standard in this category for Th-nat and U-nat.

## 23.  Leak Tests of Sealed Sources

Sealed radioactive sources must be checked for leakage when received and on a regular schedule thereafter.  The source is wiped or "smeared" with a filter paper or other absorbent material, which is then counted for radioactivity.  If the surface dose rate from radiation with significant ranges in air is excessive, for example, greater than 1 rem/min, the wiping of the source must be done with long-handled tools or other adequate means of protection.  For the smaller sources, a medical swab may be satisfactory.  Often the swab is moistened with ethanol to improve the transfer of any contaminant.[15]  A common limit used by regulatory agencies for removable contamination is 0.005 $\mu$Ci.

Leak tests must be performed at intervals generally not exceeding 6 months.  Alpha and beta sources are particularly vulnerable to developing leaks in the covering, which must be thin enough to allow penetration of the particles.

## 24.  Notification of Authorities in the Event of Radiation Incidents

Notification of radiation protection authorities is required in the event of accidents involving possible body contamination or ingestion of radioactivity by personnel, overexposure to radiation, losses of sources, or significant contamination incidents.  Conditions requiring notification of the NRC by its licensees are presented in 10CFR20.  Users must report an accident to the radiation protection office at their institution, which in turn will notify the appropriate government agencies.

## 25.  Termination of Work with Radionuclides

The radiation-protection office must be notified when work with radionuclides is to be terminated at a laboratory.  The laboratory must be surveyed thoroughly and decontaminated, if necessary, before it may revert to unrestricted use.  The radioactive material in storage must be disposed of or transferred to another authorized location.

One occasionally comes across areas in laboratories or even homes that were contaminated years earlier and were left contaminated without notification to proper authorities.  One of the more notorious episodes involved a residence in Pennsylvania that had been severely contaminated with radium by a radiologist before being turned over to an unsuspecting family.  Employees of the Pennsylvania Department of Health learned of the possibly contaminated house through hearsay.  When they came to survey the house, they found that their meters were reading off scale even before they entered the driveway.  With the controls that exist today, episodes of this type are very improbable.

15. A special leak test is used for radium.  It is based on the detection of the noble gas radon, the decay product of radium (see Wood, 1968).

## APPENDIX I TO PART V

### Emergency Instructions in the Event of Release of Radioactivity and Contamination of Personnel

The following instructions cover only the radiation aspects of accidents.  If injuries occur, the procedures must be coordinated with appropriate first aid measures, and priorities assigned to provide necessary medical care.

### Objectives of Remedial Action

In the event of an accident involving the release of significant quantities of radioactive material, the objectives of all remedial action are to:

(*a*) Minimize the amount of radioactive material entering the body by ingestion, inhalation, or through any wounds.

(*b*) Prevent the spread of contamination from the area of the accident.

(*c*) Remove the radioactive contamination on personnel.

(*d*) Start area decontamination procedures under qualified supervision. Inexperienced personnel should not attempt unsupervised decontamination.

### Procedures for Dealing with Minor Spills and Contamination

Most accidents will involve only minor quantities of radioactivity (that is, at the microcurie level).

(*a*) Put on gloves to prevent contamination of hands.  (Wash hands first if they are contaminated as result of accident.)

(*b*) Drop absorbent paper or cloth on spill to limit spread of contamination.

(*c*) Mark off contaminated area.  Do not allow anyone to leave contaminated area without being monitored.

(*d*) Notify the radiation-protection office of the accident.

(*e*) Start decontamination procedures as soon as possible.  Normal cleaning agents should be adequate.  Keep cleaning supplies to the minimum needed to do the job and place into sealed bags after use.  (Recommendations for difficult jobs may be found in the *Radiological Health Handbook*, listed in the Selected Bibliography.)  Proceed from the outermost edges of the contaminated area inward, reducing systematically the area that is decontaminated.  (This principle may not apply in decontamination of highly radioactive areas, which would require supervision by a radiation-protection specialist.)

(*f*) Put all contaminated objects into containers to prevent spread of contamination.

(*g*) Assign a person equipped with a survey meter to follow the work and to watch for the accidental spread of contamination.

### Personnel Decontamination

If personnel contamination is suspected, first identify contaminated areas with survey meter.  Do not use decontamination methods that will spread

localized material or increase penetration of the contaminant into the body (such as by abrasion of the skin). Decontamination of wounds should be accomplished under the supervision of a physician.

Irrigate any wounds profusely with tepid water, and clean with a swab. Follow with soap or detergent and water (and gentle scrubbing with a soft brush, if needed). Avoid the use of highly alkaline soaps (may result in fixation of contaminant) or organic solvents (may increase skin penetration by contaminant).

Use the following procedures on intact skin:

(*a*) Wet hands and apply detergent.

(*b*) Work up good lather, keep lather wet.

(*c*) Work lather into contaminated area by rubbing gently for at least 3 minutes. Apply water frequently.

(*d*) Rinse thoroughly with lukewarm water (limiting water to contaminated areas).

(*e*) Repeat above procedures several times, gently scrubbing residual contaminated areas with a soft brush, if necessary.

(*f*) If radiation level is still excessive, initiate more-powerful decontamination procedures after consultation with the radiation protection office.

Contamination measured on the fingertips is often sharply reduced by clipping the nails. For additional details, see Saenger, 1963.

## Major Releases of Airborne Radioactivity as a Result of Explosions, Leakage of High-Level Sealed Gaseous and Powdered Sources

(It is not possible to present recommendations that apply to all types of accidents. Details are given in specialized texts (Lanzl, Pingel, and Rust, 1965). Personnel working with high-level sources must receive training from radiation protection specialists and proceed in accordance with previously formulated accident plans and emergency measures based on hazards analysis of possible types of accidents, potential airborne radioactivity levels, and dose rates.)

(*a*) If possible, cut off the release of radioactive materials from the source to the environment but avoid breathing in high concentrations of radioactive material. Close windows.

(*b*) Evacuate room and close doors. Remove contaminated shoes and laboratory coats at laboratory door to avoid tracking radioactive material around.

(*c*) Report incident to radiation-protection office.

(*d*) Shut off all ventilation, heating, and air-conditioning equipment that can transport contaminated air from the laboratory to other parts of the building.

(*e*) Shut off hoods if they are connected to other hoods in building or if they are not equipped with exhaust filters.

(*f*) Seal doors with tape if airborne material is involved and if there is no net flow of air into room (that is, as a result of exhaust through hoods).

(*g*) Lock or guard the doors and post appropriate signs warning against entry.

(*h*) Assemble in nearby room with other personnel suspected of being contaminated. Wash off possibly exposed areas of the skin, if there is a delay in performing a survey. Do not leave the control area until you have been thoroughly surveyed for contamination. (Personnel decontamination measures should be instituted promptly if significant contamination is found.)

(*i*) Major decontamination jobs should be attempted only by personnel experienced in radiation protection.

# APPENDIX II TO PART V

**The Regulatory Process**

The control of radiation is exercised at national, state, and local levels. The regulatory process starts with legislation that provides for a designated authority to develop and enforce regulations (Marks, 1959). The passage of this legislation can be a long, drawn-out process because many interests are involved—the worker, the citizen (as consumer and as guardian of the environment), the industrialist, the politician, and so on. The records of legislative hearings often make fascinating reading and provide valuable reference material in the field of radiation protection.

## 1.   Radiation Control at the Federal Level

The main federal agencies now concerned with radiation control are the Nuclear Regulatory Commission (NRC); Department of Health, Education, and Welfare, through the Food and Drug Administration (FDA) and its National Center for Devices and Radiological Health (NCDRH); Environmental Protection Agency (EPA), through the Office of Radiation Programs; Department of Transportation (DOT); Department of Labor through the Occupational Safety and Health Administration (OSHA); and Department of Interior, through the Mining Enforcement and Safety Administration (MESA). Areas of jurisdiction sometimes overlap, and conflicts are generally resolved by agreements between the parties involved on division or delegation of authority. At times, judicial resolution of conflicting interests has been required.

The rule-making procedure by the regulatory agencies is designed to allow input from concerned parties to identify problem areas. Provisions are made for receipt of comments and for public hearings. The NRC also has a mechanism for the initiation of rule-making procedures by members of the public through "Petitions for Rule Making" and "Requests for a Hearing." The rules are accompanied by a rationale that describes the public hearings, analyses, and inputs by interested persons prior to adoption. The details of the regulations are much too extensive and undergo changes too frequently

for inclusion here. Concerned persons should request the latest regulations from local, state, and federal agencies. Following are the most important acts of the Congress setting up federal control agencies, selected material in the acts giving purposes and methods of administration, and references to the regulations in the Federal Register.

## A.   Atomic Energy Act of 1946, as Amended (Including Energy Reorganization Act of 1974)

The U.S. Congress determined that the processing and utilization of *source, material* (natural uranium and thorium), *special nuclear material* (pluto-nium, uranium-233, or uranium enriched in the isotopes 233 or 235), and *by-product material* (radioisotopes produced in the operation of a nuclear reac-tor) must be regulated in the national interest, in order to provide for the common defense and security, and to protect the health and safety of the public. It therefore provided in this act for a program for government con-trol of the possession, use, and production of atomic energy. The control is exercised by the Nuclear Regulatory Commission, appointed by the Presi-dent. The act specifies that no person may manufacture, produce, transfer, acquire, own, process, import, or export the radioactive material identified above except to the extent authorized by the Commission.

The act does not give the Commission authority to regulate such naturally occurring radioactive materials as radium and radon, accelerator produced radioisotopes (such as cobalt-57), or machine-produced radiation (for exam-ple, radiation resulting from the operation of an accelerator or an x-ray ma-chine). Thus the NRC does not control exposure to uranium ore while it is in the ground but assumes responsibility as soon as it leaves the mine. Oc-cupational radiation exposure of uranium miners (and other miners such as phosphate and coal miners) exposed to naturally occurring radioactive sub-stances is regulated by the Mine Safety and Health Administration of the De-partment of Labor. The MSHA also regulates occupational radiation expo-sure of workers in the uranium milling industry.

The NRC licenses users, writes standards in the form of regulations, in-spects licensees to determine if they are complying with the conditions of their license, and enforces the regulations. The regulations are issued as Title 10 (Atomic Energy) of the Code of Federal Regulations. The most im-portant sections for users of radionuclides are: Standards for Protection Against Radiation (Part 20); rules of General Applicability to Licensing of Byproduct Material (Part 30); General Domestic Licenses for Byproduct Material (Part 31); and Human Uses of Byproduct Material (Part 35).

The NRC is also empowered to enter into agreements with state govern-ments whereby the state assumes licensing and regulatory functions over the use of radioisotopes and certain other nuclear materials within the state. A condition of the agreement is that both the NRC and the state put forth their best efforts to maintain continuing regulatory compatibility. By January 1980, the NRC had entered into agreements with 26 states.

## B. Radiation Control for Health and Safety Act of 1968 (Public Law 90-602 Amendment to the Public Health Service Act)

The purpose of the act is to protect the public health and safety from the dangers of electronic-product radiation. The Secretary of the Department of Health, Eduction, and Welfare was directed to establish an electronic-product radiation control program that included the development and administration of radiation safety performance standards to control the emission of radiation from electronic products, and the undertaking by public and private organizations of research and investigations into effects and control of such radiation emissions. "Electronic product radiation," as defined by the act, includes both ionizing and nonionizing electromagnetic and particulate radiation, as well as sonic, infrasonic, and ultrasonic waves.

The Bureau of Radiological Health, an agency of the Food and Drug Administration, has the responsibility for conducting the regulatory program. Its authority is limited to regulating the manufacture and repair of equipment and is exercised through its promulgation of performance standards. Standards pertaining to ionizing radiation have been issued for diagnostic x-ray systems and their major components, television receivers, gas discharge tubes, and cabinet x-ray systems, including x-ray baggage systems. It performs surveys on the exposure of the population to medical radiation. It conducts an active educational program on the proper use of x rays for medical purposes and has completed teaching aids for x ray technicians, medical students, and residents in radiology. It has published recommendations for quality assurance programs at medical radiological facilities to minimize patient exposure. It has also issued standards pertaining to nonionizing radiation, such as microwaves and laser beams.

## C. Pure Food, Drug and Cosmetic Act of 1938 and Amendments (1962, 1976)

It took five years of often intense controversy to pass this act. The original legislation limited the Food and Drug Administration to regulating the safety of drugs offered for interstate commerce through the control of product labeling. Later legislative amendments in 1962 extended its authority to include control over the manufacture and efficacy of drugs, including radioactive drugs and (in 1976) to the manufacture and distribution of medical devices. The latter include cobalt-60 irradiators for radiation therapy and gamma scanners for use in nuclear medicine. The FDA does not have the authority to control the use of radioactive (or other) drugs on patients by physicians once they are approved for routine use. The FDA requires the manufacturer to carry out investigational programs, including clinical trials, to establish the safety and efficacy of new drugs. The FDA does regulate the investigational use of radioactive drugs on human subjects before they are approved for routine use.

## D.  Occupational Safety and Health Act of 1970 (Public Law 91-596)

The purpose of this act was "to assure so far as possible every working man and woman in the Nation safe and healthful working conditions and to preserve our human resources."  Under the jurisdiction of the Secretary of Labor, it provided for the establishment of the Occupational Safety and Health Administration with power to set and enforce mandatory occupational safety and health standards.  However, the act specifically excludes the OSHA from jurisdiction in areas covered by other legislation, including the Atomic Energy Act.  This limits the OSHA, as far as occupational radiation exposure is concerned, to radiation from x-ray machines, accelerators, and other electronic products; natural radioactive material (such as radium); and accelerator-produced radioactive material.  A National Institute for Occupational Safety and Health (NIOSH) was established in the Department of Health, Education, and Welfare to conduct research needed for the promulgation of safety and health standards and to carry on training and employee education to carry out the policies presented in the act.  An Occupational Safety and Health Review Commission was also established to carry out adjudicatory functions under the act.  Regulations of the Occupational Safety and Health Administration pertaining to the control of radiation sources are given in the Federal Register under Title 29, specifically Part 1910.96.

## E.  The Environmental Protection Agency (EPA)—Product of a Presidential Reorganization Plan (1970)

Unlike the previous agencies, which were established by acts of Congress, the EPA was the result of a presidential reorganization plan that transferred to one agency responsibilities in the area of environmental protection that had been divided previously among several other agencies.  The EPA assumed the functions of the Federal Radiation Council, which had been authorized to provide guidance to other federal agencies in the formation of radiation standards, both occupational and environmental (the FRC was abolished); assumed the responsibility from the Atomic Energy Commission for setting both levels of radioactivity and exposure in the general environment, an authority created under the Atomic Energy Act and applying only to material covered under that act; and took from the Public Health Service the responsibility to collate, analyze, and interpret data on environmental radiation levels.  The EPA also has authority under various statutes to regulate the discharge in navigable waters of radioactive materials, like radium, not covered by the Atomic Energy Act; to establish national drinking-water standards and to protect supplies when states fail to do so; to regulate the recovery and disposal of radioactive wastes not covered by the Atomic Energy Act; and to control airborne emissions of all radioactive materials.  It has instituted a limited program of monitoring general environmental radiation levels with the help of the states through a monitoring network called the Environmental Radiation Ambient Monitoring system, and conducts special field studies where an environmental problem has been identified.  It

maintains a special interest in population exposure from natural radioactivity, an area that is outside the jurisdiction of other agencies. It publishes an annual report, "Radiation Protection Activities," which summarizes the work and findings of the federal agencies.

## F.  National Environment Policy Act of 1969 (Public Law 91-190)

This act served as a declaration of national policy "to create and maintain conditions under which man and nature can exist in productive harmony, and to fulfill the social, economic, and other requirements of present and future generations of Americans." It required that a detailed statement of environmental impact be included in every recommendation or report on proposals for legislation and other major federal actions significantly affecting the quality of the human environment. The statement was also required to include any adverse environmental effects that cannot be avoided should the proposal be implemented; alternatives to the proposed action; the relationship between local short-term uses of man's environment and the maintenance and enhancement of long-term productivity; and any irreversible and irretrievable commitments of resources that would be involved in the proposed action should it be implemented. The act also created in the executive office of the President a three-member Council on Environmental Quality (CEQ), whose functions were to assist the President in the preparation of an annual Environmental Quality Report and to perform a variety of other duties such as information gathering, program review, and policy, research, and documentation studies.

Thousands of "environmental impact statements," some thousands of pages long and costing millions of dollars have been produced under the law. Hundreds of lawsuits have been brought, alleging violations of the act by the federal agencies responsible for building, financing, or permitting various kinds of projects, including nuclear power plants, oil pipelines, dams, and highways. A report issued in 1976 by the CEQ on the first six years' experience with NEPA concluded that it was working well. It has been observed that judges have had to become the true enforcers of NEPA "because of the lack of commitment on the part of those in power, and that perhaps only if controls on economic growth are instituted to curb consumption and resource depletion, will NEPA become truly effective" (Carter, 1976).

## 2.  Radiation Control at the State Level

The basic responsibility for the protection of workers and the public against occupational and environmental hazards lies with the individual states, although the federal government has intervened through the various acts of Congress previously described and may preempt control authority previously exercised by the states. Thus, there is a provision in its Radiation Control for Health and Safety Act that no state or political subdivision of a state can establish or continue in effect any standard that is applicable to the

same aspect of performance of an electronic product for which there is a federal standard, unless the state regulation is identical to the federal standard. It also appears that states are preempted from saying anything about radiation hazards from materials covered under the Atomic Energy Act (*Northern States Power Co.* v *Minnesota*). Situations where state and federal authorities both maintain strong interests can result in considerable confusion. In the end, the limits of the powers of the various levels of government in regulation must be resolved by the judicial branch of government.

Communication between states in matters of radiation control is maintained through the Conference of Radiation Control Program Directors, which is supported by NRC, EPA, and FDA. This group holds annual conferences to discuss current problems. The proceedings of these conferences, which cover policy, technical, and regulatory matters, are published by the Bureau of Radiological Health.

### 3. Inspection and Enforcement

Inspections are an essential part of the regulatory process. The frequency of inspections of a facility depends on the significance of the radiation hazard. The U.S. Nuclear Regulatory Commission's inspection program for materials licensees (which does not include nuclear reactors) gives first priority to radiopharmaceutical companies and manufacturers of radiographic sources, scheduling inspections at least once a year. Radiographers, large teaching hospitals, and universities using large amounts of activity also receive high priority and are inspected on approximately an annual basis. Inspections of industrial radiation sources by state enforcement agencies appear to be less frequent. Industrial facilities containing x-ray machines have been inspected every 7 years on the average, and those containing radium sources every 4 years (Cohen, Kinsman and Maccabee, 1976).

The nature of enforcement varies depending on the powers granted in the enabling legislation and the severity of violations. The OSHA has powers to impose severe financial penalties; the NRC can revoke licenses as well as impose fines. Minor violations may draw only a citation from the inspection agency, pointing out the infraction and requesting that the regulatory agency be informed when the condition is corrected. One of the most effective enforcement methods is the publication of inspection results and disciplinary actions as part of the public record, thereby creating the possibility of considerable embarassment to its licensee.

The conduct of inspections varies for different agencies and even for different inspectors from the same agency. Therefore it is not possible to describe a standard inspection in detail, but it generally proceeds along the following lines:

The inspector reviews the organization of the radiation-safety office to get an overall impression of the scope of the program. He notes the attitude prevailing toward compliance with regulations and safety measures. This

guides him in the actual conduct of the inspection, which has, as major components, review of records, questioning of all levels of personnel, observations of work areas, and independent measurements.  He determines whether citations and unresolved items remaining from previous inspections were corrected.  He then considers other items such as training of workers, safety procedures that are being followed, adequacy of personnel monitoring and bioassays, waste disposal, records and reports, and environmental monitoring.  He examines the license to insure that special license conditions are being fulfilled.  Many inspectors talk directly with workers to determine their habits and the degree of compliance with the regulations.  The involvement of management through its awareness of the program and the extent of quality assurance measures are also reviewed.  Following the inspection there is a closing session with management at a high level to explain the findings and to obtain commitments from management to correct faults.  These findings, and the commitments from management, are also documented in a letter sent to the licensee.

Noncompliance items are grouped into the categories of violations, infractions, and deficiencies.  A violation is very serious.  The criterion for a violation is a large exposure or potential for a large exposure.  An infraction is a condition that could lead to exposure if allowed to continue, and includes failures to make surveys, conduct training sessions, and so on.  A deficiency is a violation of regulations that could not lead to overexposure, such as record keeping.  The letter requests a response in 30 days in which the licensee tells what he has done to correct the conditions, what he will do to prevent recurrences in the future, and when he will be in full compliance with the regulations.

If the inspection indicates serious control problems, NRC management will phone or meet with licensees.  If the outcome is unsatisfactory, there may be a letter from headquarters in Washington; this can be followed by a civil penalty.  Civil penalties are used if (1) doses have occurred or could occur that are large enough to cause injury (that is, no training to workers) and (2) the licensee shows complete recalcitrance—there is no communication with the commission or effort made to correct conditions.  Fines have been extremely effective in these situations, not only because of the financial loss, but also because of the accompanying publicity.  All correspondence and actions of the Nuclear Regulatory Commission are a matter of public record.  In extreme cases, the license is modified or revoked completely.

There are typical and recurring citations of violations or poor practices: lack of personal involvement by the management; excessive reliance on outside consultants; inadequate surveys; inadequate records; lack of security of sources; inadequate leak testing; improper procedures for handling packages.  Problems also arise in institutions where control is exercised through departments rather than a central authority, while the license is issued to the institution.  Special license conditions may be forgotten, particularly when a

license is transferred from one person to another who does not check special conditions. There is also greater risk of use of radionuclides by unauthorized personnel. Central to satisfactory compliance with the regulations and good practice is an adequate quality assurance program and periodic audit by management of radiation-protection operations.

## APPENDIX III TO PART V

### Control of Airborne Releases to the Environment

Airborne contamination from laboratory operations with radioactive materials is in the form of vapors, gases, or particles. The operations must be performed in a hood if significant exposure of workers is possible. The contaminated air can be disposed of by dilution and discharge through a stack; it is further diluted by spreading out as it flows away from the stack. Alternatively, the air can be cleaned prior to discharge with the use of filters (for particles) and absorbers (for vapors and gases). These must then be disposed of as radioactive waste.

### 1. Dilution in the Atmosphere

The transport of radioactive emissions through the atmosphere subsequent to discharge from a stack is governed primarily by the properties of the prevailing air currents. Many pathways can be taken by the discharged material. One need only look at the plumes from smoke stacks over a period of time and under various weather conditions to see how many possibilities there are. The smoke leaving a stack can proceed straight up or travel horizontally; it can meander at constant height above the ground, fan out, loop down—the possibilities seem endless.

The objective of the analysis of stack discharges is to determine the concentration of the radioactivity as a function of time and distance from the stack and the resulting doses to exposed personnel. The equations, while based on diffusional processes, are largely empirical and describe the concentrations vertically and laterally to the effluent flow in terms of the normal error curve.

Consider the discharge into a stable atmosphere in fig. 5.6. A quantity $Q$ $\mu$Ci is released over a period of $\tau$ seconds and mixes with the air stream, which is flowing by at an average velocity of $u$ m/sec. In $\tau$ seconds, a column of air $u\tau$ meters long will have flowed by and therefore acquire a contamination loading of $Q/u\tau$ $\mu$Ci/m. The activity along a differential element $dx$ is $Q/u\tau \, dx$. The activity will spread out laterally and horizontally as it is carried along by the air stream. The degree of spread is determined in the horizontal direction primarily by shifting wind directions, and in the vertical direction by the temperature gradient. We wish to fit the spreading to a form given by the normal curve of error. This is $\phi(y) = (1/\sqrt{2\pi}\,\sigma)e^{-y^2/2\sigma^2}$,

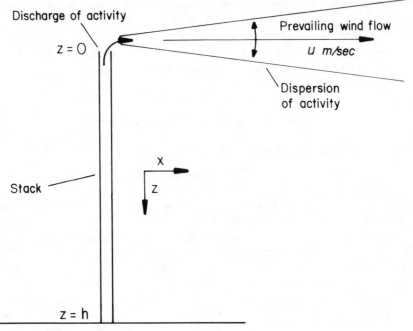

**Fig. 5.6**   Transport of activity discharged from stack.

where $\sigma$ is the standard deviation.   The area under this curve,

$$\int_{-\infty}^{\infty} \phi(y)\; dy = 1.$$

Thus we can let $y$ represent a horizontal coordinate and spread the activity out laterally to give:

$$\frac{Q}{u\tau\sqrt{2\pi}\;\sigma_y}\; e^{-y^2/2\sigma_y^2}\; dy\; dx;$$

or we can spread it out both vertically ($z$ direction) and laterally:

$$\frac{Q}{u\tau\sqrt{2\pi}\;\sigma_y\sqrt{2\pi}\;\sigma_z}\cdot e^{-y^2/2\sigma_y^2}\cdot e^{-z^2/2\sigma_z^2}\; dx\; dy\; dz.$$

Since the area under the curve is still unity we have not changed the total activity to be expected at any distance $x$ downwind from the stack.   If this has the concentration $\psi$,

$$\psi_{x,y,z} = \frac{Q}{2\pi u\tau\sigma_y\sigma_z}\; e^{-y^2/2\sigma_y^2}\; e^{-z^2/2\sigma_z^2}.$$

The concentration is doubled when the plume reaches the ground ($z = h$) because of reflection from the surface.

The wind fluctuates constantly about its mean direction. An empirical expression has been derived for $\sigma_y$ as a function of the extent of the variation of wind direction. If the angle of fluctuation from the mean direction is given by $\theta$, and $\sigma_\theta$ is its standard deviation (in radians), then,

$$\sigma_y^2 = \frac{Ax}{u} - \frac{A^2}{2(\sigma_\theta u)^2}(1 - e^{-2(\sigma_\theta u)^2 x/Au}).$$

$A$ is related to scale of turbulence. An empirical expression for $A$ is $A = 13.0 + 232\,\sigma_\theta u$. For $u = 5$ m/sec, $\sigma_\theta u = 0.05$ for instantaneous release and 0.2 for intermediate (1 hr) release. In the vertical direction:

$$\sigma_z^2 = a\,(1 - e^{-k^2 x^2/u^2}) + bx/u$$

where $a$, $k^2$, $b$ are functions of degree of stability; $a = 97$ m², $k^2 = 2.5 \times 10^{-4}$ sec⁻², $b = 0.33$ m²/sec for moderately stable conditions. For additional data applicable to a wide range of meteorological conditions, see Slade, 1968.

Much of the analysis presented here is for dispersion over long distances and over smooth terrain. Local dispersion, say in a congested area surrounded by buildings of various sizes is much more complex and not amenable to a simplified treatment. While there is a tendency to apply the equations presented here to such conditions, the results are suspect. Some attention has been given to this problem but no simple calculational methodology has been found (Smith, 1975, 1978). Accordingly, releases in congested areas should be monitored carefully and kept as low as possible.

## 2.  Filtration of Particles

When air laden with particles is incident on a fiber, the air will flow around it but the particles, because of their inertia, will tend to continue in a straight line and impact on the fiber. Filters are made by packing the fibers in a mat, and the filtering action (for small particles) is the result of the action of the individual fibers rather than a sieving action. After impact, the particles are held to the fibers by physical short-range forces (Van der Waals forces). As particles get smaller, their inertia decreases, and they are more prone to follow the stream lines. At still smaller sizes, they again stray from the stream lines as the result of collisions with the individual air molecules (Brownian motion). This increases the probability of contact with the fibers and removal from the stream. Thus, a graph of the efficiency of a fiber filter versus decreasing particle size shows a decrease at first as the inertia decreases, but a gradual turnaround and increase as diffusion due to Brownian motion becomes important. The particle size for minimum filtration efficiency depends on the type of filter material and air velocity and is in the range of 0.1 to 0.3 $\mu$m (Dennis, 1976, p. 62). Equations for the collection efficiency of isolated fibers, which must take into account diffusion, inertia, and gravity effects, are extremely complicated (Iinoya and Orr, 1977).

Paper filters used for laboratory analysis have a fiber diameter of about 20 $\mu$m and a void fraction of 0.70. The thickness is usually between 0.2 and 0.3 mm. Their collection efficiency is less than 90 percent for 0.3-$\mu$m particles. High efficiency particulate air (HEPA) filters are used for very toxic radioactive dusts and bacterial particulates. They are composed of fine glass fibers (0.3 to 0.5 $\mu$m in diameter) mixed with coarser fibers for support. They show at least 99.97 weight percent collection efficiency for particles having diameters of 0.3 $\mu$m.

Filters resist the flow of air and the pressure drop across a filter under anticipated air velocities is critical in evaluating its suitability for a particular application. Even if a filter is superbly effective in preventing the passage of particles, it is of no use if it also presents such a high resistance that only a trickle flow of air is possible. The pressure drop will increase as the filter becomes clogged with dust. Eventually the flow rate will be affected and will decrease to a point where the filter is not usable. Thus the pressure drop must be followed to determine when the filter must be replaced or cleaned.

The particles that initially contact a fiber do not necessarily adhere to it and are not necessarily permanently bound to it if they do adhere initially. They can be knocked off by other particles and turbulent air currents. An interesting reentrainment mechanism occurs in the filtration of particles that carry alpha radioactivity. When an alpha particle is emitted, the resulting recoil can be sufficient to knock a small particle off a fiber (Ryan et al., 1975; Mercer, 1976). Reentrainment is generally not very important, but the possibility must be considered for very hazardous substances such as plutonium, where extremely high filter efficiency is required (McDowell et al., 1977).

There are times in sampling air containing particles above a particular size that the air speed through the sampler should be adjusted to be equal to the speed in the airstream. This condition is known as isokinetic sampling and its need should be determined in specific cases (ACGIH, 1978).

### 3.   Adsorption of Gases and Vapors on Charcoal

Pollutant gases and vapors can be removed by adsorbents. The adsorbent usually used is activated charcoal (Smisek and Cerny, 1970). Beds containing ten tons of charcoal or more are not uncommon as part of the air-cleaning systems for radioactive noble gases and iodine in nuclear power plants. Smaller adsorption systems, containing charcoal in panels, are used in hood exhausts, or on a larger scale, in the building exhausts of research institutions and hospitals. Canisters containing 10 to 100 g of charcoal are used in sampling in contaminated atmospheres, and cartridges of charcoal are often used in respirators.

The contaminating molecules reach the interior surfaces of the charcoal grains by diffusion from the airstream. This surface is extremely irregular, consisting of innumerable tiny cavities and tortuous channels, and presents

an enormous area to the diffusing pollutant. For example, a high-quality activated charcoal made from coconut shell can have a surface area as high as 1500 m²/g. Chemically inert molecules, such as krypton and xenon, that reach the surface are held briefly by physical forces (Van der Waals forces), escape, struggle from point to point, become lost in the passageways in the charcoal, but eventually make their way down the bed. The charcoal bed serves to hold up the flow of these contaminants, a delaying action that is effective in the control of radioactive noble gases with half-lives short compared to the holdup time of the bed. This method works well in the nuclear power industry in the control, through radioactive decay of discharges of short-lived nuclides such as $^{85m}$Kr ($T^h = 4.4$ hr), $^{133}$Xe (5.3 d) and $^{131m}$Xe (12 d).

The mean holdup volume of a charcoal bed for noble gases can be determined by a simple test. A pulse of the radioactive gas (for example, $^{85}$Kr) is injected into a stream of air flowing at a constant rate into the bed. The effluent is passed through a gas flow ionization chamber or other detector that gives a reading proportional to the concentration of the radioactivity in the gas, $C_v$, and the reading is monitored continuously until the radiation level reaches background. A gas meter is also connected in the line and the total volume flow $V$ recorded periodically. Since the flow rate is constant, the volume is known as a continuous function of time (and radiation reading). The mean holdup volume is given by the equation $\bar{V} = \int_0^\infty V\,C_v\,dV / \int_0^\infty C_v\,dV$.

The mean holdup volume is proportional to the mass of charcoal, and the ratio can be considered to be an adsorption coefficient, $k$. If a radioactive gas with half-life $T^h$ passes through a charcoal bed of mass $m$ in a carrier gas with volume flow rate $v$, the mean residence time of the charcoal is $k/v$ and the ratio of the effluent and input concentrations is given by the expression $C/C_o = e^{-0.693km/T^h v}$. Adsorption coefficients are affected by temperature, pressure, relative humidity, and other adsorbed materials. Thus it is important to determine them under actual operating conditions and to test the bed periodically after it is in use. Rough estimates of required bed size may be made by using the relationships: 1 gram charcoal per 40 cc throughput of air containing krypton and per 520 cc air containing xenon (at room temperature).

Additional insight into bed performance can be obtained from breakthrough curves. These are measurements of effluent concentration versus time (or volume flow) on a sample of the adsorber during continuous passage of the contaminated gas. The curve is S-shaped and is closely fit by the cumulative distribution curve of the normal distribution (Grubner and Burgess, 1979). The form of the curve follows from the random nature of the penetration of individual contaminant molecules through the bed, which causes some to get through more quickly and others less quickly than the average velocity for the flow. The volume flow at which the effluent concentration is 50 percent of the influent concentration has particular significance. The product of this volume and the input concentration, less the amount of con-

taminant in the pores of the adsorber, gives the amount of contaminant that is actually held by the bed. This result follows from the symmetry of the breakthrough curve. The data can be used to design a bed to give a desired degree of performance, or to estimate how long a bed can be used before breakthrough occurs, provided the bed is used under the same conditions as during the test. The presence of certain contaminants such as organic vapors, or the occurences of unusual temperature or humidity conditions in the field can serve to reduce significantly the actual performance and service time.

Breakthrough curves are useful when the forces of adsorption are primarily physical. When the adsorption mechanisms are largely chemical in nature (for example, adsorption of iodine on charcoal) the action of the bed is quite different. The contaminants are adsorbed at sites on the surface by a mechanism that is essentially irreversible. At the low mass concentrations characteristic of radioactive contaminants, the concentration of the contaminant decreases exponentially with distance down the bed. The basic determining factor for removal is the time $t$ in contact with the bed. If $V$ = bulk volume of the sorption material and $v$ = volumetric flow rate of the gas, then $t = V/v$ at constant flow velocity.

The ratio between the influent and effluent concentrations, $c_o/c$, known as the decontamination factor, is given by the expression $c_o/c = e^{Kt}$, where $K$ is referred to as the $K$-factor or performance index, and depends on many factors that cannot be accounted for in a given bed. It must be determined experimentally for each batch of material used. However, fresh impregnated activated carbon should have a $K$-factor of at least 5 in a test with radioactive methyl iodide at 90–100 percent relative humidity, 30°C and anticipated face velocity (usually 20–50 cm/sec).

The sites at which chemical adsorption occurs become unavailable for further adsorption. As already stated, radioactive contaminants are not likely to affect a significant fraction of the sites, but if appreciable quantities of the nonradioactive form are in the air, they will gradually immobilize all the sites. As the available sites become exhausted, the contaminant will finally break through and be transported through the bed at essentially the speed of the transporting air.

Certain trace impurities in the air which can neither be anticipated or adequately accounted for can have significant effects on the performance of a bed. Rapid decreases of removal efficiencies can result from adsorption of solvents and oil vapors (as from newly painted surfaces or recently cured plastic materials). Beds subjected to unknown and possibly deleterious atmospheres should be tested periodically. One possible test procedure is to place a sample of the charcoal in a test bed that is followed by one or more backup beds to trap the effluents being removed. Air is passed through at a typical face velocity (about 20 cm/sec). The labeled contaminant is then injected into the input air. Several injections are preferable at 15-minute in-

tervals. Following the injections air is passed through the bed for an additional hour. The activity of the contaminant in the test bed and in the backup beds is then measured and the retention computed. The test should be carried out at relative humidities of 70 and 95 percent.

Radioactive contaminants are carried in the airstream in different forms (particulate, vapor) and compounds. It is often useful to determine the various forms and their penetration through the bed. This can be done by constructing the backup bed of several components, each having a selective absorption for one of the contaminants.

## 4. Adsorbers for Radioiodine

Radioactive iodine is released in laboratory operations either as elemental iodine ($I_2$) or as part of some organic molecule. Elemental iodine is removed very effectively from an airstream by activated coconut charcoal (8/16 mesh) even in humid air. It is held quite adequately to the charcoal by physical (Van der Waals) attractive forces. Organic iodine is not bound as well on charcoal, which loses effectiveness at high humidity. The charcoal must be impregnated with a chemical with which the organic iodine will combine. Two compounds have been widely used as impregnants, each providing a different mechanism of binding—potassium iodide (KI) and triethylenediamine (TEDA). The KI works through an isotopic exchange mechanism; the organically bound iodine exchanges with the iodine on the KI. If the compound is methyl iodide, the reaction is $CH_3{}^{131}I$ (air) + $K^{127}I$ (charcoal) $\rightarrow CH_3{}^{127}I$ (air) + $K^{131}I$ (charcoal). The methyl-iodide molecule itself is not trapped by the exchange mechanism. On the other hand, when TEDA is used, the amine group reacts with the methyl iodide converting the radioiodine molecule to an ionic form ($R_3N + CH_3{}^{131}I \rightarrow R_3N^+CH_3{}^{131}I^-$). The quaternary iodide produced is a stable nonvolatile compound that is adsorbed strongly on the charcoal. TEDA-impregnated charcoals are effective even with airstreams of high moisture content. The highly polar water molecules are strongly attracted to each other in competition with the nonpolar carbon surface which adsorbs selectively the larger, less polar organic iodides. Impregnated activated carbon is tested at 95-percent relative humidity, 80° C, a face velocity of the gas of 20 cm/sec in a 50-mm deep bed (Burchsted et al., 1976). The bed is challenged with a concentration of approximately 2 mg $CH_3I/m^3$ for 2 hr. Beds should be designed to provide a minimum contact time of 0.25 sec. A good quality impregnated charcoal should give greater than 99-percent methyl-iodide retention at 80° C, 95-percent relative humidity, and 1-atmosphere pressure. Even higher performance is obtained in removing elemental iodine. (Suppliers of treated charcoal include Charcoal Engineering Corporation, Bellingham, Mass., and Sutcliff-Speakman Inc., Baltimore, Md.)

# Part VI

# Ionizing Radiation and Public Health

### 1. Formulation of Standards for Radiation Protection

Up to this point, we have been concerned with the technical aspects of radiation protection, involving studies of the properties of radiation; methods of defining, calculating, and measuring radiation exposure; and practical measures for radiation control. Our objective has been to prepare the reader to prevent excessive exposure to himself and others when working with radionuclides and radiation machines, and, as guides for excessive exposure, we have used maximum levels specified in government regulations. Exposure of healthy individuals below these levels is legally permissible; the levels represent the current basis for the protection of the public. It is important that every user of radiation understand the evolution of present radiation control standards and the degree of protection they offer. It is also important to appreciate the type of information that must be continuously developed in order to appraise and revise standards of control when necessary. There is a need not only to provide adequate control but also to deal with the complementary problem of avoiding excessive controls or restrictions that will prevent the development of technology or medical care for the maximum benefit of the public.

In order to better understand the present radiation standards, let us chronicle some of the important findings and studies that led up to them. X rays were discovered in 1895. By 1920, many of the early radiologists and technicians had developed skin cancer and others had died of anemia and probably leukemia. The concept of a "tolerance dose" was developed to protect radiation workers. One approach to establishing a tolerance dose was to consider the exposure that produced reddening (erythema) of the skin. This

reddening followed the exposure within a period of about a week. It was suggested that exposure in any monthly period be limited to a small fraction of the "threshold erythema" exposure, less than 1 percent. In terms of present values of erythema doses expressed in roentgens, this provided a monthly limit of 5 R, or a daily limit of 0.2 R. The reasoning behind the establishment of these limits was the belief that the body could repair any damage that might occur at these levels. The production of genetic effects and permanent residual injury from radiation exposure was not known at that time.

In 1934 the International X-ray and Radium Protection Commission, (established by the Second International Congress of Radiology in 1928), also recommended a "tolerance dose" of 0.2 R/day. This recommendation was based on observations of the health of fluoroscopists, x-ray therapy technicians, x-ray therapy patients, and radium therapists and technicians, and it was concluded that deleterious effects had not been shown in individuals exposed at these levels. The same value was recommended in the United States by the Advisory Committee on X-ray and Radium Protection. In 1936 the advisory committee reduced the "tolerance dose" to 0.1 R/day at the suggestion of Dr. G. Failla.

There were no definite data to indicate that the previous level should be reduced by a factor of 2, but the genetic hazards of radiation were becoming apparent and there was a general feeling the limit should be reduced. Dr. Failla suggested the 0.1 R/day level because he had found no effect on blood cell counts taken over periods of three and four and a half years from two technicians who had been working with a radium source. He estimated their exposure had averaged around 0.1 R/day, and noted, "This could hardly be considered satisfactory evidence (for a safe level) but it was better than anything available at the time." (Failla, 1960, p. 203).

In 1949 the U.S. National Committee on Radiation Protection (NCRP) recommended that the permissible dose be reduced to 0.3 rem per week. The International Commission on Radiological Protection (ICRP) adopted the same recommendation a year later. (Both these committees had evolved from the X-ray and Radium Protection committees referred to earlier.[1])

Again, this reduction was supported not by concrete evidence that the original levels had been harmful, but by a desire to be on the safe side.

1. The NCRP was granted a Congressional charter in 1964 and has since operated as an independent organization financed by contributions from government, scientific societies, and manufacturing associations. The ICRP operates under rules approved by the International Congress of Radiology. The members are selected by the ICRP from nominations submitted to it by the National Delegations to the International Congress of Radiology and by the ICRP itself. The selections are subject to approval by the International Executive Committee of the Congress. The ICRP receives financial support from the World Health Organization, the International Atomic Energy Agency, The United Nations Environment Program, the International Society of Radiology, and other international and national sources.

Higher energy sources were coming into use, and the radiations penetrated the body more readily and irradiated it more uniformly than the radiations from the lower-energy x-ray machines for which the earlier limits had been devised. The increased internal body dose relative to surface dose imparted by the higher-energy radiations could be compensated for in part by lowering the limits.

By 1956 the prospects for the large-scale use of nuclear power had grown significantly, and the potential for irradiation of a large number of workers was growing. The committees on radiation protection were uneasy about allowing the irradiation of large numbers of individuals without further reduction of dose levels, and accordingly they reduced the limits for whole-body irradiation by approximately a factor of three. However, the older limits still applied in cases where only single organs, other than the gonads and the eyes, were exposed.

Limits also had to be set for the possible incorporation of radioactive materials in the body. The concept of "critical organ" was used; that is, the organ was identified which received the greatest exposure as a result of ingestion of a particular radionuclide. It was decided that irradiation of the critical organ from radionuclides in the body should not be allowed to exceed the dose that had been set for exposure of single organs from external radiation, 0.3 rem per week.[2]

As yet there were no official recommendations concerning the exposure of individuals nonoccupationally exposed to radiation and therefore not receiving special monitoring or other protection. In 1956 the National Council on Radiation Protection and Measurements (the new name for the NCRP, with the same initials) and the ICRP both recommended that, for individuals nonoccupationally exposed, the levels be set at one-tenth the occupational limits, that is, at 500 mrem/yr for whole-body exposure.

The need to establish limits of exposure for the childbearing segment of the population in order to restrict genetic damage was also recognized, and by 1959 specific recommendations were formulated by the ICRP. For an entire population, a limit equal to that which had been recommended by the Genetic Committee of the National Academy of Sciences of 10 R to the reproduction cells was adopted. The 10 R limit applied from conception to age 30 and was in addition to the dose from the natural background radiation. The value had been chosen by the NAS committee as an acceptably small fraction of the dose (30–80 R) that was believed to double the number of harmful mutations that occurred spontaneously in the population over the same period.[3]

2. In the special case of bone, the limit of 0.1 $\mu$Ci for occupational exposure to radium-226, established in 1941, has stood as a separate standard. This limit, which is supported by extensive detailed data on humans with radium body-burdens, serves as a reference point for evaluating the hazards of other radionuclides that localize in bone.

3. NAS-NRC, 1956. For additional discussion on "doubling dose," see part II, section 11. UNSCEAR (1977) cites a value of 100 R as the doubling dose.

For practical reasons, the "10 R in 30 yr" recommendation developed into an allocation of 5 R for medical practice and 5 R for radiation exposure associated with all other man-made sources. This amounted to specifying separate limits of 170 mR/yr average to the population from medical radiation and from all other man-made sources.

At about the same time, the Federal Radiation Council, which had been formed in the United States to provide a federal policy on exposure of human beings to ionizing radiation, reviewed existing standards. It reaffirmed the standard for the exposure of individual members of the public, which it expressed as an annual Radiation Protection Guide (RPG) of 0.5 rem. It also introduced an operational technique which specified that the RPG would be considered met if the average per capita dose of a suitable sample of the population did not exceed one-third the individual guide of 0.5 rem, or 0.17 rem. Thus, through two different avenues, the figure of 170 mrem/yr was associated in 1960 with a maximum level of exposure for large numbers of individuals to nonmedical man-made sources.

Accompanying the specifications of upper limits was the special recommendation that radiation exposure should be kept as far below the limits as practicable, and in particular, that medical exposure be kept as low as consistent with the necessary requirements of modern medical practice.

The NCRP issued a new report on basic radiation protection criteria in 1971 (NCRP, 1971). The report essentially reaffirmed the limits recommended a decade earlier, except for minor modifications and additions. The limits in the new report applied primarily to the dose incurred in any one year. Both occupational exposure and exposure of the public were covered. The report also provided guidance for regulatory agencies concerned with the preparation of regulations for the control of exposure. In presenting dose limits for workers, the public, emergency cases, and the families of patients receiving radioactivity, the NCRP cautioned that the application of the limits was conditioned substantially by the qualifications and comments provided in its report.

The ICRP revised its basic recommendations in 1977 as a result of new information that had emerged in the previous decade.[4] The basic limit of 5 rem (50 mSv) in one year for occupational exposure to uniform whole-body radiation was retained. The total dose could be accumulated in a single occupational exposure (except that women diagnosed as pregnant should work only under conditions in which it was unlikely that the annual exposure could exceed three-tenths of the dose equivalent limit, that is 1.5 rem). The Commission did not make a separate definitive recommendation for women of reproductive age, but expressed its belief that appropriate protection during the essential period of organogenesis would be provided by limitation of the accumulation of the dose equivalent (as determined by the maximum

---

4. ICRP, 1977, Publication 26. The previous basic recommendations were published in 1966 (ICRP, Publication 9) followed by amendments in 1969 and 1971.

**Table 6.1.**   Dose-limiting recommendations of NCRP (1987).

| | |
|---|---|
| *Occupational exposure (annual)* | |
| Effective dose equivalent (whole body, external and internal) | 50 mSv (5 rem) |
| Lens of eye | 150 mSv (15 rem) |
| All other organs (consistent with limits on whole-body effective dose equivalent) | 500 mSv (50 rem) |
| Guidance: Cumulative exposure not to exceed 10 mSv × age in yrs | |
| | |
| *Exposure to public (annual)* | |
| Effective dose equivalent, primary limit | 1 mSv (0.1 rem) |
| Effective dose equivalent, infrequent | 5 mSv (0.5 rem) |
| Lens of eye, skin, extremities | 50 mSv (5 rem) |
| Embryo-fetus | 5 mSv total |
| | 0.5 mSv in a month |
| | |
| *Planned special occupational exposure* | |
| Single event and working lifetime | 100 mSv (10 rem) |

*Source:* NCRP, 1987, Table 22.1

value in a 30-cm sphere) to an approximately regular rate of 5 rem/yr). This would make it "unlikely that any embryo could receive more than 500 mrem (5 mSv) during the first 2 months of pregnancy." The Commission dropped all previous recommendations on exposures of parts of the body or single organs, including the concept of critical organ. Instead, it recommended that an accounting be made of the doses in all the irradiated tissues and the associated risk (of inducing fatal cancer) be determined. Partial body exposures were to be considered within allowable limits if the associated risk was less than that incurred from exposure of the whole body to the allowable limit.

Individual organ doses were assigned weighting factors, multiplying factors that converted the dose to an equivalent whole-body dose with regard to risk of excess fatal cancer and hereditary disease. The contributions of the weighted doses from all irradiated parts of the body to the "effective dose equivalent" were added, and the sum could not exceed the 5 rem whole-body limit. The weighting factors were based on the best estimates of the risk of production of cancer from single-organ exposure, compared to the risk of malignancy from whole-body exposure. The values assigned were: gonads, 0.25; breast, 0.15; red bone marrow and lung, 0.12 each; thyroid and bone surfaces, 0.03 each; and remainder, 0.30 (assignable as 0.06 to each of five remaining organs or tissues receiving the highest doses).

If only a single organ were exposed, this procedure could lead to levels of

exposure that, while not producing a risk of cancer greater than that produced by the acceptable level for whole-body exposure, could result in unacceptable damage to the organ (such as, cataract of the lens of the eye; nonmalignant damage to the skin, blood vessels, or other tissue; abnormal blood counts; or impairment of fertility).  To prevent this, the commission set an upper limit of dose for any individual organ of 50 rem (500 mSv), except the thyroid where the limit was set at 30 rem (300 mSv).

An important application of the single dose limit is in determining limits for internal emitters.  These are expressed in terms of Annual Limits on Intake (ALI), levels that will not produce organ doses that, when multiplied by the appropriate weighting factors and summed, will exceed the whole-body limit.  The formula considers external and internal exposures together in evaluating conformance with the limits and was designed to remove the ambiguity in applying the previous separate limits for internal and external exposure when both external and internal exposure occurred.

The commission allowed additional exposures (from external radiation and intakes) in exceptional cases, provided the total dose did not exceed twice the relevant annual limit in a single event and five times the limit in a lifetime (equivalent to the 25-rem emergency exposure in previous recommendations).  Such exposures could be permitted only infrequently and for a few workers.

Recognizing the difficulty in specifying an equivalent dose when external radiation produced nonuniform internal dose distributions, the commission specified that its limits would be met for external exposure if the maximum value of the dose equivalent in a 30-cm sphere (called the Dose Equivalent Index) were less than 5 rem (50 mSv).

The commission emphasized that its limits were intended to ensure adequate protection even for the most highly exposed individuals, and that these typically constituted only a small fraction of the working force.  It advised that the planning of exposures close to the annual limits for extended periods of a considerable proportion of workers in any particular occupation would be acceptable only if a careful cost-benefit analysis had shown that the higher resultant risk would be justified.

Individual members of the public were not to receive whole-body doses more than 500 mrem (5 mSv) in any year, but average doses over many years should not average more than 100 mrem/yr. (In 1985, the ICRP affirmed 100 mrem/yr as its principal dose limit for members of the public; ICRP, 1985.) Higher limits were allowed for partial-body irradiation in accordance with the weighting factors discussed previously.  In any case, an overriding annual dose equivalent limit of 5 rem (50 mSv) for single organs applied.

Dose limits were not set for populations; here each man-made contribution had to be justified by its benefits.  The commission felt that its system of dose limitation and other factors were likely to insure that the average dose equivalent to the population would be much less than the limits for individuals, that is, less than 10 percent (50 mrem/yr).

When the NCRP issued new recommendations in 1987, it adopted, in principle, the risk-based, effective dose equivalent system used by the ICRP but modified and updated this approach in several respects. It recognized that recent information indicated that risk estimates utilized in setting the standards might be low "by an undetermined amount, perhaps a factor of two or more" (NCRP, 1987), but, because of the incomplete nature of the new data and analyses, and the loose coupling between risks and limits, it was not ready to make any changes in the ICRP limits. Highlights of the NCRP recommendations are given in table 6.1. While the new concepts of dose limitation provide a more logical approach to dose limits, they do serve to legitimize considerably higher single-organ exposures than allowable under the current NRC limits, and therefore run counter to the trend toward lower limits. Limits set by regulatory agencies in the United States for the exposures of the public from the radiation produced by nuclear power plants are much lower than those given in the standards. They are set in accordance with the principle of keeping radiation exposures *as low as reasonably achievable* (ALARA). The Nuclear Regulatory Commission specifies as design objectives for planned releases from a single commercial nuclear power plant annual whole-body doses of 5 mrem from airborne effluents and 3 mrem from liquid effluents. Annual organ doses caused by a single reactor are limited to 15 mrem from airborne effluents and 10 mrem from liquid effluents. The Environmental Protection Agency has a whole-body dose limit for planned releases from all nuclear power operations of 25 mrem for both the whole body and individual organs except the thyroid which has a limit of 75 mrem (Moeller et al., 1978).

## 2.   Medical Findings on Humans Exposed to Radiation

The nature of the interaction of radiation with human tissue is such that, at any level of exposure, there may be a risk of initiating a serious disease such as leukemia or another cancer, or of producing detrimental genetic effects that show up in future generations. On the other hand, some radiation exposure of human beings is an unavoidable consequence of the benefits of radiation used in medicine and technology. Thus, in establishing standards of radiation exposure, it is necessary to weigh both benefits and risks of specific radiation uses. The benefit-risk decision may be made for exposure of a specific individual, as in connection with medical treatment or occupational exposure; or for society as a whole, as in connection with the development of nuclear power.

Benefit-risk decisions, by their nature, must be based on judgment. A very important element in any decision is the knowledge of the actual extent of the risk and harm to individuals or society resulting from particular radiation uses. Thus it is extremely important that individuals in a position to be exposed—or in position to expose others—understand clearly what is known and what is not known about the effects of low-level exposure.

### 2.1   Sources of Human Exposure Data

Data on the effects of low-level radiation on humans come from the following sources:

1. Survivors of the atomic bombing of Hiroshima and Nagasaki. This source provides the largest sample of individuals exposed to date. There have been difficulties in determining the actual doses to individuals and in defining control populations for comparisons. However, the data have contributed toward determining the values for the risk of leukemia and other cancers from exposure to a single significant dose of radiation.

2. Children exposed prenatally as a result of abdominal x-ray examination of the mother during pregnancy. These irradiations occurred at the most radiation-sensitive time during the lifespan of the individual. Thus the results yield an upper limit to the risk.

3. Children treated for enlarged thymus glands by irradiation of the thymus. The treatments resulted in high-level irradiation of a relatively small region of the body.

4. Adults who underwent x-ray treatment to the spine for ankylosing spondylitis. These exposures resulted in substantial irradiation of much of the bone marrow. Smaller but significant doses were also given to other organs.

5. Adults who received radioactive iodine for treatment of thyroid conditions. When compared with data on the irradiation of the thyroid gland in children, the results provide valuable data on the sensitivity of the thyroid to radiation as a function of age.

6. Individuals with body burdens of radium. Epidemiologic studies of this group provided the basis for setting the limits of exposure to the bone by radium and by other bone-seeking radionuclides.

7. Uranium miners exposed to high levels of radioactive gases and radioactive particles. These occupational exposures are providing data on the development of lung cancer from irradiation of regions of the lung.

The findings from these and other significant studies are given in table 6.2, which should be studied carefully. The data in the table do not include studies of detrimental effects in offspring or irradiated parents (genetic effects). Such studies are extremely difficult to conduct and interpret, and those that have been made have been inconclusive. The genetic risk associated with radiation exposure in humans is discussed separately in section 2.3.

Most of the medical findings in table 6.2 consist of comparisons of the "observed" incidences of malignancies in the irradiated groups and "expected" incidences in comparable unirradiated groups. Values for the expected incidences precise enough to allow comparison with the incidences observed at low exposure levels can be obtained only by studying the medical histories of very large groups of individuals. The control groups should be identical in composition to the exposed group in all respects except that they did not receive the type of exposure being evaluated. The difficulties in defining and obtaining incidence data for suitable control groups are enor-

Table 6.2.   Findings of epidemiologic studies of cancer in irradiated populations.

| Subject of study | Follow-up time (yr) | Dose (R or rad) | No. of persons[a] | Form of cancer | No. of cases Observed in exposed group[b] | No. of cases Expected if not exposed[c] |
|---|---|---|---|---|---|---|
| 1. Hiroshima and Nagasaki A-bomb survivors (bomb exploded 1945). Ichimaru and Ishimaru, 1975. | 26 | 0–1<br>1–99<br>>100 | 61,263<br>39,093<br>6,046 | Leukemia<br>Leukemia<br>Leukemia | 36<br>43<br>61 | 36 (controls)<br>23<br>3.6 |
| 2. Hiroshima and Nagasaki A-bomb survivors (women), in age groups shown at time of bombing. All exposed to more than 100 rad and observed 1950–1969. McGregor et al., 1977. | 5–24 | Age: 0–9 yr<br>10–19 yr<br>20–34 yr<br>35–49 yr<br>50 + yr<br>Total | 429<br>1,048<br>887<br>685<br>309<br>3,358 | Breast<br>Breast<br>Breast<br>Breast<br>Breast<br>Breast | 0<br>10<br>13<br>7<br>4<br>34 | 0.1<br>1.4<br>3.8<br>3.5<br>0.9<br>9.7 |
| 3. Hiroshima and Nagasaki A-bomb survivors exposed prenatally. Jablon and Kato, 1970. | 10 | >64,500 person-rad[d] | 1,292 | All cancers | 1 | 0.75 |
| 4. Japanese A-bomb survivors exposed within 1400 m of detonation (died 1950–1962). Angevine and Jablon, 1964. | 17 | | 1,215 autopsies | All cancers except leukemia | 61 | 56.8 |

| | Age | Dose | Population | Cancer type | Number | Ratio |
|---|---|---|---|---|---|---|
| 5. Children exposed prenatally due to abdominal x ray to mother (exposed 1945–1956 and died before end of 1958). Court Brown et al., 1960. | 2–12 | — | 39,166 | Leukemia | 9 | 10.5 |
| 6. Children exposed prenatally (born in 1947–1954 and died before end of 1960). MacMahon, 1962. | 4–13 | 1–2 | 77,000[e] | All cancers | 85 | 60 |
| 7. Infants who received irradiation of chest before age 6 mo. in treatment for enlarged thymus (treated 1926–1957; follow-up to 1971). Hemplemann et al., 1975. | 13–45 | 119 av. to thyroid; air dose 225 | 2,872 (69,402 person-yr at risk)[f] | Thyroid | 24 | 0.29 |
| | | | | Thyroid (benign) | 52 | 3.42 |
| | | | | Leukemia or lymphoma | 8 | 3.97 |
| | | | | Other | 14 | 8.1 |
| | | | | Other (benign) | 69 | 34 |
| Subgroup: high doses, large ports, apparently more susceptible, genetically. | | 399 av. to thyroid; air dose 461 | 261 (8,088 person-yr at risk) | Thyroid | 13 | 0.04 |
| | | | | Thyroid (benign) | 20 | .4 |
| | | | | Leukemia | 2 | .49 |
| | | | | Other | 5 | 1.84 |
| | | | | Other (benign) | 16 | 2.24 |

**Table 6.2.** (continued)

| Subject of study | Follow-up time (yr) | Dose (R or rad) | No. of persons[a] | Form of cancer | No. of cases | |
|---|---|---|---|---|---|---|
| | | | | | Observed in exposed group[b] | Expected if not exposed[c] |
| 8. Infants irradiated routinely with x rays to anterior mediastinum through small (4 × 4 cm) port, 7 days after birth, as "apparently harmless and perhaps beneficial procedure" (x ray 1938–46, follow-up 1956–58). Conti et al., 1960. | 10–20 | 75–450 mostly 150 | 1,401, including 244 with enlarged thymus | Thyroid carcinoma Leukemia | 0 0 | 0.03 0.95 |
| 9. Children treated with x rays to head, neck, or chest for various benign conditions, mainly "enlarged" thymus and adenitis, treated before age 16 and followed till age 23. Saenger et al., 1960. | >11 (83%) | <50 (4%) 50–200 (36%) 200–600 (33%) | 1,644 | Thyroid Thyroid (benign) | 11 7 | 0 0 |

| Description | Age | Dose | Number | Effect | Observed | Expected |
|---|---|---|---|---|---|---|
| 10. Children treated before age 16 with x rays for enlarged thymus, pertussis, and head and neck diseases; and died before age 23 (treated 1930–1956; follow-up 1940–1956). Murray et al., 1959. | Up to 23 | Not given | 3,872 | Leukemia | 7 | 1.4 |
| 11. Children irradiated for ringworm of the scalp. Up to 3 treatments if relapses occurred. Follow-up to 1973. Modan et al., 1974. | 12–23 | 350–400 (140 to brain; 6.5 to thyroid) | 10,902 | Brain | 8 | 1 |
| | | | | Brain (benign) | 8 | 1 |
| | | | | Thyroid | 12 | 2 |
| | | | | Scalp | 1 | 0 |
| | | | | Leukemia | 7 | 5 |
| | | | | Lymphoma | 8 | 5 |
| | | | | Breast | 2 | 0 |
| 12. Patients (most between ages 10–40) treated with x rays for benign lesions in neck, mainly for tuberculous adenitis (treated between 1920–50). Hanford et al., 1962. | 10–40 | 100–2,000 | 295 | Thyroid | 8 | 0.1 |
| 13. Patients ages 20–70, treated with x rays to thyroid for benign disorders. DeLawter and Winship, 1963. | 10–35 | 1,500–2,000 | 222 | Thyroid | 0 | |
| 14. Hyperthyroid patients, ages 20–60, treated with x rays (treated 1946–53; follow-up 1959–61). Sheline et al., 1962. | 5–15 | Not given | 182 | Thyroid (probable) | 1 | |
| | | | | Multiple benign thyroid nodules | 7 | |

**Table 6.2.** (continued)

| Subject of study | Follow-up time (yr) | Dose (R or rad) | No. of persons[a] | Form of cancer | No. of cases Observed in exposed group[b] | No. of cases Expected if not exposed[c] |
|---|---|---|---|---|---|---|
| 15. Patients treated with x rays to spine for ankylosing spondylitis (treated 1935–54; follow-up to Jan. 1963). Court, Brown, and Doll, 1965. | 5–28 | 250–2500 to spinal marrow; approx. 7% of spinal dose to other sensitive areas | 14,302 (165,631 person-yr at risk) | Leukemia<br>Aplastic anemia<br>Cancer of heavily irradiated sites (after 6 yr) | 60<br>16<br>200 | 6.8<br>.61<br>107 |
| 16. Female tuberculosis patients who received many fluoroscopic examinations. Boice and Monson, 1977. | 21–45 | 400+<br>300–399<br>200–299<br>100–199<br>1–99<br>0 | 62<br>65<br>177<br>251<br>469<br>717 | Breast<br>Breast<br>Breast<br>Breast<br>Breast<br>Breast | 4<br>3<br>12<br>12<br>10<br>15 | 1.1<br>1.5<br>4.8<br>5.7<br>9.6<br>14.1 |
| Classified by age at first exposure. | | Age: <15 yr<br>15–19 yr<br>20–24 yr<br>25–29 yr<br>30–34 yr<br>35+ | 99<br>242<br>263<br>200<br>105<br>138 | Breast<br>Breast<br>Breast<br>Breast<br>Breast<br>Breast | 2<br>13<br>9<br>9<br>4<br>4 | 0.9<br>3.4<br>5.4<br>5.5<br>3.3<br>4.8 |
| 17. Women treated with x rays for acute postpartum mastitis. Shore et al., 1977. | 19–34 | 50–1065 (air); 377 average to irradiated breast | 571 | Breast<br>Breast<br>(benign) | 37<br>29 | 11.3<br>15 |
| 18. Patients treated with x rays for cancer of the cervix. Hutchison, 1968. | 4–8 (31%)<br><4 (69%) | 300–1,500 av. to bone marrow | 27,793 (57,121 person-yr) | Leukemia<br>Lymphatic malignancy | 4<br>6 | 5.1<br>6.3 |

| Study | Period | Dose | Population | Cause | Observed | Expected |
|---|---|---|---|---|---|---|
| 19. American radiologists (died 1948–1964). Lewis, 1970. | Through 1964 | | 530 deaths | Leukemia | 13 | 3.91 |
| | | | | Multiple myeloma | 5 | 1.01 |
| | | | | Aplastic anemia | 5 | .23 |
| 20. American radiologists. Warren and Lombard, 1966. | Through 1960 | | 5,982 | Leukemia | | |
| | | | | 1940–44 | 4 | 0.5 |
| | | | | 1945–49 | 7 | .86 |
| | | | | 1950–54 | 6 | 1.26 |
| | | | | 1955–60 | 7 | 2.05 |
| 21. American radiologists. Seltser and Sartwell, 1965. | 1935–58 | | 3,521 (48,895 person-yr) | Ages 35–49 | | |
| | | | | Leukemia | 2 | 1.9 |
| | | | | Other cancer | 9 | 7.3 |
| | | | | Total deaths | 79 | 61.5 |
| | | | | Ages 50–64 | | |
| | | | | Leukemia | 8 | 1.1 |
| | | | | Other cancer | 54 | 32 |
| | | | | Total deaths | 339 | 271.5 |
| | | | | Ages 65–79 | | |
| | | | | Leukemia | 9 | 4.7 |
| | | | | Other cancer | 72 | 48 |
| | | | | Total deaths | 438 | 295 |
| 22. Hyperthyroid patients treated with [131]I (treated 1946–64; followup through June 1967). Saenger et al., 1968. | 3–21 | 7–15 rads to bone marrow (9 mCi [131]I av.) | 18,370 (119,000 person yr at risk) | Leukemia | 17 | 11.9 |
| Comparison group treated by surgery and not given [131]I. Saenger et al., 1968. | | | 10,731 (114,000 person yr at risk) | Leukemia | 16 | 11.4 |

**Table 6.2.**   (continued)

| Subject of study | Follow-up time (yr) | Dose (R or rad) | No. of persons[a] | Form of cancer | No. of cases | |
|---|---|---|---|---|---|---|
| | | | | | Observed in exposed group[b] | Expected if not exposed[c] |
| 23. Population of Marshall Islands accidentally exposed to radioactive fallout from test of 17-megaton thermonuclear device, 1945. Conard, 1976. | 22 | 200(av) | 243 | Thyroid | 7 | 0 |
| 24. Children in Utah and Nevada exposed to fallout in the 1950s. Rallison et al., 1974. | 12–15 | 46 av.; >100, max. | 1,378 | Thyroid | 0 | 1.05 (0.64)[g] |
| | | | | Thyroid (benign) | 6 | 4.2 (3.9) |
| | | | | Adolescent goiter | 22 | 12.6 (21.2) |
| | | | | Hyperthyroidism and misc. | | |
| 25. Radium dial painters and others who ingested radium. Evans, 1974; Evans et al., 1972. | 40–50 | 1–100 | 381 | Bone | 5 | 3.1 (2.6) |
| | | 100–1,000 | 122 | Head | 0 | |
| | | 1,000–5,000 | 42 | Bone | 0 | |
| | | | | Head | 9 | |
| | | 5,000–50,000 | 25 | Bone | 2 | |
| | | | | Head | 3 | |
| | | | | | 5 | |

| | | ²²⁶Ra equivalent entering blood (μCi) | | | |
|---|---|---|---|---|---|
| 26. Radium dial painters (began dial painting before 1930). Evans, 1967; Rowland et al., 1978. | 50 | 100 to >2,500 | 115 | Bone | 38 |
| | | 0.5–99 | 439 | Bone | 0 |
| | | <0.5 | 205 | Bone | 0 |
| | | 25 to >1,000 | 134 | Head | 17 |
| | | 0.5–24.9 | 388 | Head | 0 |
| | | <0.5 | 227 | Head | 0 |
| | | | 3,366 P-YR^f | | |
| | | WLM^h | P-YR^f | (a) smokers | |
| 27. Uranium miners (white) exposed to radon gas and decay products; started mining before 1964. Mortality follow-up to September, 1974. Archer et al., 1976. | >10 | >1,800 | 5,907 | Respiratory | 60 |
| | | 360–1,799 | 16,331 | Respiratory | 55 |
| | | 1–359 | 14,031 | Respiratory | 25 |
| | | | | (b) Nonsmokers | |
| | | >1800 | 1,437 | Respiratory | 2 |
| | | 360–1,799 | 3,488 | Respiratory | 3 |
| | | 1–359 | 4,918 | Respiratory | 1 |

a. This refers to the number of individuals at risk unless otherwise specified.

b. The information needed to determine the number of cases is obtained by either following a designated study population or by working back from a review of all death certificates in a defined geographical area.

c. The numbers in this column are based on available statistical data for unexposed populations.

d. The term person-rads pertains to the dose imparted to a population and is equal to the sum of the doses incurred by the individuals in the population.

e. This figure is based on a systematic sampling of the population rather than a review of all the records.

f. The term person-years at risk is the sum of the number of years in which the disease could develop in each member of the group. The number in parentheses is

g. The first number is based on 1313 children who moved into the area after ¹³¹I fallout decayed. The second number is based on 2140 children in southeastern Arizona, an area remote from the fallout.

h. Working Level Months (see part III, section 5.6).

mous, and the conclusions must often be viewed with less than total confidence.[5]

Studies in which a population is identified in advance for determination of the incidence of a specific disease are called prospective studies. When it is not practical to establish and follow such a population, a retrospective study may be undertaken. In such a study, the individuals with the disease in question are designated as a group and their histories are obtained. Histories are also obtained for a control group as comparable as possible to the former group in all respects except that they do not have the disease under study. A comparison is made of the frequencies with which the factor suspected of affecting the incidence of the disease occurred in both groups, and if the frequency is significantly higher in the group with the disease, it is assumed to have a causative role. In making a test for a specific factor, it is necessary to correct for the effect of other characteristics that differ in the two groups. As an example, in studies made on the association of prenatal x rays to the fetus and the subsequent appearance in childhood of leukemia or other cancer, some differences that had to be considered (between the x-rayed and non-x-rayed groups) included birth order, sex ratio, and maternal age.

Retrospective studies are more difficult to interpret than prospective studies and the results usually do not merit the same degree of confidence. However, they require fewer resources and smaller populations and sometimes represent the only feasible approach. The results of two retrospective studies concerned with testing the association between excess risks of childhood cancer and prenatal x-ray exposure are presented in the next section.

In examining the human exposure data presented in table 6.2, note the numbers of subjects involved, the actual number of cases of disease, and the follow-up times.[6] These data form the main resource for evaluating the effects of subjecting major segments of the population to radiation.

## 2.2   Risk of Induction of Leukemia or Other Cancer

In 1930 the betting odds were 180 chances in 100,000 that a designated white newborn male (U.S.) would eventually die of leukemia. By 1955, this probability had risen to 600 chances in 100,000, but the rate of increase had leveled off. Leukemia mortality rates began to show a slight downturn in the period 1961–1965. While it was natural to investigate the possibility that medical and other radiation exposures were responsible for the changes in mortality, all the available evidence indicated that the effect of radiation was small and that other factors had to be implicated (see Fraumeni and Miller, 1967).

The general consensus from reviewing human exposure data (table 6.2,

5. For discussion of the methodology and problems of obtaining population statistics, see Grove and Hetzel, 1968.

6. Leukemia incidence should be followed for about 15 years after exposure; cancer incidence should be followed for at least 30 years.

items 1, 15) is that the risk of induction of leukemia in a period of 13 years following an x- or γ-ray dose of 100 rads to a substantial part of the blood-forming organs averages out to 1 or 2 in 10,000 in each year following the exposure (ICRP, 1966, p. 4).  The experience of the Japanese atomic bomb survivors indicates that the risk peaks 6–7 years after the exposure and diminishes substantially after a period of perhaps 15 years (Fig. 6.1), but it does not become negligible even 30 years later (Okada et al., 1975).

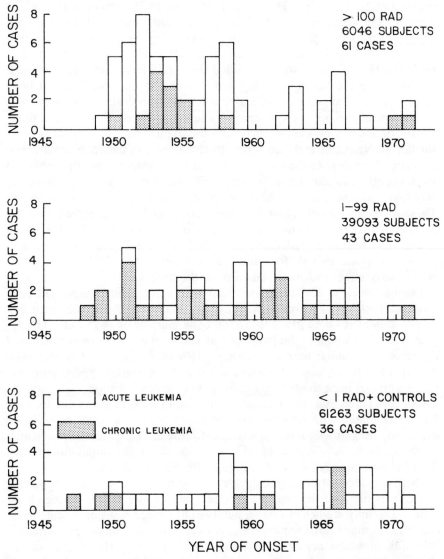

**Fig. 6.1**  Incidence of leukemia in atomic bomb survivors and controls (Okada et al., 1975).

The incidence of leukemia was much greater at Hiroshima than at Nagasaki in the lower dose range of 10–99 rad. It was originally believed that the nature of the radiation exposures in the two cities was quite different, that at Hiroshima, 20 percent of the dose (kerma) was contributed by neutrons, whereas at Nagasaki less than 0.3 percent was contributed by neutrons. This was interpreted to mean that the leukemias at low doses were induced primarily by the neutrons and the data appeared to be a valuable resource for evaluating the relative biological effectiveness of neutrons (Rossi and Mays, 1978). However, in the mid-1970s, researchers working on computer simulations realized the neutron component had been substantially overestimated and this stimulated a U.S.-Japanese joint reassessment of the atomic bomb radiation dosimetry. The findings were published in 1987 (RERF, 1987). It was concluded that the attenuation effects of high humidity and the bomb shielding material on the neutrons had not been taken into account adequately, and that the neutron dose at Hiroshima was 10 percent of the previous estimate. The gamma dose was 2 to 3.5 times higher, depending on the distance from the hypocenter. The changes were smaller at Nagasaki and had little effect on the evaluation of dose. The estimate of the dose to the survivors was further reduced when the enhanced shielding effect of clusters of houses, which had been neglected previously, was taken into account. Refinements were also made in organ dosimetry. These revisions served to eliminate the Hiroshima data as a reference for the RBE of neutrons and pointed to significant increases in the estimates of risk of exposure to gamma radiation, a two-fold increase for leukemia, and a 50 percent increase in risk for other cancers (Roberts, 1987). They could significantly affect radiation standards in the future.

The incidence of leukemia was studied in adult patients who had been given radioiodine as a treatment for hyperthyroidism (table 6.2, item 22). The treatment resulted in a dose to the bone marrow of 7–15 rad. The appearance of leukemia in the patients was about 50 percent greater than that expected in a similar untreated group. However, the leukemia incidence was also greater by about the same amount in a group of hyperthyroid patients who had been treated surgically and not given radiation. The investigators concluded that the increased incidence of leukemia was due to some factor associated with hyperthyroidism rather than as a result of radiation exposure. Regardless of the true reason for the increase the study indicated dramatically the possibilities of error when incidence in a population treated for an abnormal condition is compared with healthy controls.

There is evidence that diagnostic x-ray examinations resulting in exposure of the fetus increase the chances of leukemia or other cancer during childhood. The only studies providing numbers of cancer cases on a scale large enough to demonstrate the possible existence of a risk from doses characteristic of diagnostic x rays were retrospective in nature. The records of the children who died of cancer were reviewed to see if they received x-ray ex-

posures in excess of those expected for a similar sample that was free of cancer. The results of two major retrospective studies by Stewart and Kneale (1970) and by MacMahon (1962) are given in table 6.3.

MacMahon concluded that mortality from leukemia and other cancers was about 40 percent higher among children exposed to diagnostic x-ray study in utero than among children not so exposed. It was estimated that prenatal x rays produced an excess of 3.03 cancer deaths (including leukemia) before the age of 14 for every 10,000 live births (the expected mortality derived from the unexposed control group was 3.97 from leukemia and 3.31 from other cancers).

Stewart and Kneale, after reviewing over 7600 cancer deaths and an equal number of cancer-free controls, concluded that the risk of childhood cancer depended on the number of x-ray films (and on the fetal dose). The risk was expressed as 300–800 extra deaths before the age of 10 among one million children who received a dose of one rad shortly before birth.

A large prospective study (table 6.2, item 5) failed to demonstrate the appearance of leukemia or cancer in children after prenatal diagnostic x rays. However, although over 39,000 cases of fetal x rays were followed, the sample size was not large enough to rule out with a high degree of confidence as much as a 50 percent increase in leukemia.

It has been reported that postnatal exposure also increases the risk of leukemia (Graham et al., 1966). The relative risk from postnatal x rays was said to vary from an increase of 50 percent to 400 percent, with the greatest risk in children exposed to both medical and dental x rays. The number of

**Table 6.3.** Occurrence of prenatal x rays in children dying of cancer.

| Reference | No. of cancer deaths | | No. x-rayed in uterus | No. expected as determined from cancer-free controls |
|---|---|---|---|---|
| Stewart and Kneale, 1970 | 7649 | | 1141 | 774 |
| | | | By number of films: | |
| | | 1 | 274 | 218 |
| | | 2 | 201 | 151 |
| | | 3 | 103 | 58 |
| | | 4 | 60 | 28 |
| | | >4 | 65 | 29 |
| | | No record | 438 | 290 |
| MacMahon, 1962[a] | 556 | | 85 | 63 |

a. This study is also entered in table 6.2 (item 6), as the information provided enabled an estimate of the population at risk.

cases involved in the study, however, was small.  Only 19 leukemia cases were in the combined dental plus medical x-ray group receiving the highest exposures, compared to 31 cases in a large control group.  The conclusions were based on a retrospective study.  The parents of children who had died of cancer were questioned concerning the exposure of their children during infancy, and their replies were compared with those of the parents of healthy controls.  The two groups of children were matched as closely as possible. One major weakness of the study was reliance on the memory of the parents to determine the frequency of x rays.  The results of several independent studies suggest the need for continuing investigations into the effects of mass medical and dental x rays on the population, particularly in children.

In children, acute exposure of the thyroid to x rays was found to produce leukemia and increased thyroid cancer (table 6.2, item 7).  The observed numbers of thyroid cancers in the irradiated group were almost 100 times greater than expected and over 300 times greater than expected in a selected high-risk subgroup.  A minimum latent period of 5 years was observed in the appearance of thyroid cancer, and 10 years for benign lesions.  It appears that even after 30 years, an excess number of cases was still appearing.  The investigators concluded that if there were a threshold dose for the induction of thyroid nodules, it was below 20 rad (Hempelmann, 1968).  The risk of tumor induction remained elevated beyond the age at which the leukemia risk appeared to disappear.  The risk for the induction of thyroid cancer was 2.5 cases per million per year per roentgen.  At this level, the probability of producing cancer of the thyroid 30 yr after a dose of 300 rad would be $2.5 \times 10^{-6} \times 300 \times 30$, or about 1 in 40.  The prevalence of all spontaneous thyroid nodules per 100 persons at a given age is about 0.08 times the age; about 12 percent are malignant (Maxon et al., 1977, p. 972).

An association was found between irradiation of the scalp with x rays to treat the fungus condition tinea capita and cancer of the brain (table 6.2, item 11).  Increased incidence of cancer of the thyroid was also found at doses as low as 6.5 rad.  The possibility was not ruled out that the doses may have been higher than evaluated because of carelessness during treatment.  It was also possible that thyroid cancer could have been induced through a hypophyseal/thyroid axis after the absorption of a high radiation dose by the hypophysis.

The testing of nuclear weapons in the atmosphere resulted in the release of enormous quantities of $^{131}$I (see section 4.5.1).  Studies were made of possible effects on the thyroid of children living in the region of the heaviest fallout around the test site during the testing period in the 1950s (table 6.2, item 24).  Estimates of thyroid doses were 46 rad for all children in Utah between 1952 and 1955 and over 100 rad for children residing in southwestern Utah. No significant differences were found between the children in Utah and Nevada exposed to the highest fallout level and control groups living in Utah and Arizona at the time of the study.  However, the follow-up time was only

about ten years and data for longer follow-up time is needed.  One interesting outcome of the study was that only 6 of the 201 children with thyroid disease knew of their disease prior to the examination.  According to the authors this indicated the need for more attention to the thyroid in routine medical checkups of children.

The best estimate of the cancer risk to the thyroid from external photon radiation applicable to all ages appears to be four carcinomas per rad per million persons per year at risk (expressed as 4 cases per $10^6$ PY per rad (BEIR III, 1980).  Benign adenomas are also induced by radiation, with an absolute risk of 12 adenomas per $10^6$ PY per rad.  While the thyroid is one of the organs more susceptible to radiation-induced cancer, there may be some comfort in the knowledge that radiation does not appear to produce the highly malignant anaplastic carcinoma that is responsible for most deaths from thyroid cancer, but rather carcinomas of the papillary and follicular types which are fatal in only a small percentage of the cases.  The risks associated with the use of radioactive iodine for treatment of thyroid conditions appear to be much lower than those attributed to external irradiation on an organ-dose basis, perhaps by a factor of 70 for induction of thyroid cancer (Maxon et al., 1977).

The relative importance of cancer of the breast in women as a consequence of exposure to radiation is increasing as data become available for longer follow-up times.  The total number of breast cancers among the Japanese survivors attributed to radiation has already exceeded the number of leukemias (table 6.2, item 2, McGregor, 1977).  Women exposed to 100 or more rads had 3.3 times the breast cancer incidence during the period 1950–69 compared to those exposed to less than 10 rad.  The most sensitive age group with regard to radiation-induced breast cancer was 10–19 years.  It was the only age group that showed strong evidence of increased risk of breast cancer in the intermediate dose range (10–99 rad).  These figures are for a population that shows a very low natural incidence compared to other countries; the rate is about one-fifth that of U.S. white women.  Thus it is quite possible that the radiation risk to American women could be significantly greater than that found among the Japanese, if it is enhanced by environmental factors or life style.

Data on the sensitivity of the breast to radiation-induced cancer are also provided from surveys of women with tuberculosis who received frequent fluoroscopic examinations for artificial pneumothorax (table 6.2, item 16) and postpartum mastitis patients treated with radiotherapy (table 6.2, item 17).

The study of tuberculosis patients, who were fluoroscopically examined an average of 102 times with average doses to the breast of 150 rad, indicated that the greatest absolute excess breast cancer risk occurred among exposed women who were first treated between the ages of 15 and 19 years.  Among those women 30 years of age and older at the time of first exposure,

no elevated breast cancer risk was detected; however, the failure to observe an excess did not exclude a risk increased by as much as 50 percent. In the mastitis patients, who received an average dose of 377 rad to the irradiated breast, it was concluded that the overall relative risk of breast cancer was 2.2 for years 10–34 postirradiation and 3.6 for years 20–34. Women over age 30 years at radiation treatment had as great an excess risk of breast cancer as did younger women, an apparent contradiction to the findings for the tuberculosis patients. If this were a real difference, the authors suggested that the reason may have been that the breasts of the mastitis patients were actively lactating at the time of radiation, whereas they were quiescent in the other studies.

The late incidence of cancer has been followed in patients administered high doses of x-rays to the spine as a treatment for ankylosing spondylitis (table 6.2, item 15). In the first decade following irradiation of the patients, interest focused on the incidence of leukemia, which was about double that of all other cancers combined. After a decade, the incidence of excess cancers attributed to the irradiation rose significantly at some sites, while the leukemia incidence dropped. The increase in cancer incidence with time is given in table 6.4. When the lower doses to the sites away from the spine are taken into account (they were about 7 percent of the spinal doses), the data suggest that, for a uniform whole-body dose, the number of fatal malignancies (other than leukemia) to appear eventually may reach 10 times the number of leukemias occurring in the first 15 years (Tamplin and Gofman, 1970).

**Table 6.4.** Change in rate of induced malignant disease with duration of time since exposure in irradiated ankylosing spondylitics (from data in table VI of Court, Brown, and Doll, 1965).

| Years after irradiation | Cases per 10,000 person-years at risk | |
|---|---|---|
| | Leukemia + aplastic anaemia | Cancers at heavily irradiated sites |
| 0–2 | 2.5 | 3.0 |
| 3–5 | 6.0 | 0.7 |
| 6–8 | 5.2 | 3.6 |
| 9–11 | 3.6 | 13 |
| 12–14 | 4.0 | 17 |
| 15–27 | 0.4 | 20 |
| Total of expected cases in 10,000 persons in 27 yr calculated from rates given | 67 | 369 |

*Source:* ICRP, 1969.

Data on exposure to alpha radiation are given in table 6.2, items 25–27. The organs considered are the lung and bone. The lung data (item 27) come from studies of exposure to radon gas in uranium mines. Radon levels in mines in the United States ranged generally between 10 and 100 Working Levels (WL, part III, section 5.6) before 1960. These were well above most levels reported for other countries, as was the average cumulative exposure of the miners, 1180 Working Level Months (WLM). The risk per unit exposure was reported to be much less for the American miners as compared to findings outside the United States, and while the difference can be associated with a much higher dose rate in the American mines, the reason is not clear. The overall risk of mortality from cancer appears to vary with age. Expressed at exposure rates of about 1 WL and with characteristic smoking experience, risk estimates in cases per $10^6$ person-years per WLM for different age groups are: 10 (35–49 yr), 20 (50–65 yr), and 50 for those over 65 years. This may also be expressed as an incidence of 22–45 deaths per $10^6$ PY per rad of alpha radiation exposure to the bronchial epithelium, based on a dose of 0.4–0.8 rad for 1 WLM (Harley and Pasternack, 1972; Jacobi, 1972). This gives an RBE between 8 and 15 for alpha radiation dose to the bronchial epithelium, and an order of magnitude higher for average alpha lung dose. These figures, as already stated, are based on studies outside the United States. Risk levels obtained for U.S. miners are much lower.

Radon emanation from the ground and building materials is a source of significant exposure of the public, the levels varying greatly, depending on the type of materials. Public health authorities are considering the need for action in controlling exposures from these sources and the occupational data are extremely important in evaluating risks and the need for corrective action.

The bone data (table 6.2, items 25 and 26) show apparent evidence of a threshold, that is, there were no excess cases of bone cancer found below an average skeletal dose of 1000 rad of alpha radiation. Minimum doses resulting in findings of head carcinomas were a factor of two lower.

It is extremely difficult to determine the risk of cancer throughout the lifetime of the individual as a function of dose. The analysis must consider a minimal latent period, the rate of appearance of cancer with time following the latent period, and the period of time over which the cancers will appear. There may be differences in susceptibility as a function of age at exposure and of sex. Dose-response relationships must be developed to infer effect at doses not encountered in the experimental studies. The projections of lifetime risk to cancer can vary considerably depending on whether an *absolute* or *relative* risk model is used. The "absolute risk" projection assumes that the exposure produces an excess risk of cancer incidence per year which remains constant following a latent period. The risk may end at a specified age or continue throughout the lifetime of the person. The relative risk con-

**Table 6.5.**  Estimated excess cancer incidence (excluding leukemia and bone cancer) per million persons per year per rad, 11–30 yr after exposure, by site, sex, and age at exposure.

| Site | Age at Exposure (yr) | | | | |
|---|---|---|---|---|---|
| | 0–9 | 10–19 | 20–34 | 35–49 | 50+ |
| **Males** | | | | | |
| Thyroid | 2.20 | 2.20 | 2.20 | 2.20 | 2.20 |
| Lung | 0.00 | 0.54 | 2.45 | 5.10 | 6.79 |
| Esophagus | .07 | .07 | 0.13 | 0.21 | 0.56 |
| Stomach | .40 | .40 | .77 | 1.27 | 3.35 |
| Intestine | .26 | .26 | .52 | .84 | 2.23 |
| Liver | .70 | .70 | .70 | .70 | .70 |
| Pancreas | .24 | .24 | .45 | .75 | 1.97 |
| Urinary | .04 | .23 | .50 | .92 | 1.62 |
| Lymphoma | .27 | .27 | .27 | .27 | .27 |
| Other | .62 | .38 | 1.12 | 1.40 | 2.90 |
| All sites | 4.80 | 5.29 | 9.11 | 13.66 | 22.59 |
| **Females** | | | | | |
| Thyroid | 5.80 | 5.80 | 5.80 | 5.80 | 5.80 |
| Breast | 0.00 | 7.30 | 6.60 | 6.60 | 6.60 |
| Lung | .00 | 0.54 | 2.45 | 5.10 | 6.79 |
| Esophagus | .07 | .07 | 0.13 | 0.21 | 0.56 |
| Stomach | .40 | .40 | .77 | 1.27 | 3.35 |
| Intestine | .26 | .26 | .52 | .84 | 2.23 |
| Liver | .70 | .70 | .70 | .70 | .70 |
| Pancreas | .24 | .24 | .45 | .75 | 1.97 |
| Urinary | .04 | .23 | .50 | .92 | 1.62 |
| Lymphoma | .27 | .27 | .27 | .27 | .27 |
| Other | .62 | .38 | 1.12 | 1.40 | 2.90 |
| All sites | 8.40 | 16.19 | 19.31 | 23.86 | 32.79 |

Fetus

Cancer in children (mortality) from irradiation of fetus is $400/10^6$/rad.

*Source:* NAS-NRC, 1980.

siders an excess risk which may increase gradually throughout the life of the individual and is proportional to the spontaneous risk, which increases with age for nearly all cancers. Thus, the relative risk model gives a greater projected total cancer occurrence.

Most of the data on effects of radiation on people come from studies of populations who received high radiation doses. The risk estimates, on the other hand, are of most interest at quite low dose levels.

Assumptions as to the relationship between dose and effect greatly influence the risk estimates for low doses. The linear dose-effect model is be-

lieved to be conservative and quite suitable for purposes of radiation protection, but the linear-quadratic model (for low-LET radiation) is generally felt to be more consistent with both knowledge and theory. It takes the form $I(D) = (\alpha_0 + \alpha_1 D + \alpha_2 D^2) \exp(-\beta_1 D - \beta_2 D^2)$, where $I$ is the cancer incidence in the irradiated population at radiation dose $D$. The modifying exponential function represents the competing effect of cell killing at high doses. Values derived from this model for the risk at low doses are less than those derived from the linear model and may be used to define the lower limits of risk from low dose, low-LET radiation (Fabricant, 1980; NAS-NRC, 1980).

The Advisory Committee on the Biological Effects of Ionizing Radiations of the National Academy of Sciences (BEIR Committee, NAS-NRC, 1980) used different assumptions in deriving risks from prenatal and postnatal radiation. The assumption for fetal radiation exposure was that childhood cancers induced by radiation do not have any latent period after birth, the leukemia risk is 25 cases in $10^6$ children exposed per year per rad for a period of 12 years, and the risk of other cancers is 28 cases per $10^6$ children per year per rad for a period of 10 years.

The computations of risks from radiation received after birth were based on observations between 11 and 30 years following exposure and the assumption that the risk so inferred continued until the end of life. Exposure of children less than 10 years of age was treated somewhat differently.

The Committee concluded that the lifetime risk of cancer mortality (all sites) induced by low-LET radiation from a single whole-body absorbed dose of 10 rad to a U.S. population based on the linear-quadratic dose-response model is in the range of 0.5 to 1.4 percent of the naturally occurring cancer mortality. For continuous lifetime exposure to 1 rad/yr, the estimates ranged from 3 to 8 percent. The linear model gave risks up to four times higher, and the quadratic model 4 times lower than the combined model.

Estimates by the BEIR Committee of cancer induction to specific organs as a function of age at exposure are given in table 6.5. The data apply to the risk of incidence per year from 11 to 30 years following exposure. Risks estimated for longer periods should continue at least at the level given in the table and may well be higher.

Projections of lifetime risks of fatal cancer from exposure to 1 rad of low LET radiation based on epidemiology at high doses are given in table 6.6.[7] Estimates are based on revised calculations of the radiation doses received by the Japanese survivors and on the assumption that the relative risk is proportional to the spontaneous over the life span (relative risk model). Some estimates are based on only a few cases and the precision is poor, but

---

7. Some investigators have conducted studies which they claim indicate that the risks of low-level radiation are considerably greater than normally assumed (Bross, Ball and Falen, 1979; Bross and Natarajan, 1972, 1977; Mancuso, 1978; Mancuso, Stewart, and Kneale, 1977, 1978; Najarian and Colton, 1978). However, the validity of their results has been questioned (Anderson, 1978; Boice and Land, 1979; Reissland, 1978; Sanders, 1978) and more work is needed before results in this most important area can be reported with confidence.

**Table 6.6.** Risks of various consequences of exposure to 1 rad of low LET radiation.

(a) Excess cancer death rates observed in Japanese survivors by age at death by linear extrapolation from high doses and dose rates. Numbers in parentheses give cancer mortality in corresponding age brackets in U.S. population (1979), except for the >70 column, where data are for ages 70–79. These numbers, when multiplied by excess relative risk values in (b), give another estimate of excess deaths.

| | Excess deaths per $10^6$ persons per year per rad, by age at death[a] | | | |
|---|---|---|---|---|
| Cause of death | 40–49 | 50–59 | 60–69 | >70 |
| Leukemia | 1.88 | 1.54 | 1.09 | 4.24 |
| | (35) | (72) | (174) | (338) |
| Breast cancer (female) | 0.76 | 2.88 | 0.61 | 0.02 |
| | (328) | (695) | (966) | (1,191) |
| Lung cancer | 0.56 | 1.11 | 2.62 | 5.50 |
| | (239) | (771) | (1,660) | (2,170) |
| Stomach cancer | 2.10 | 3.41 | 1.19 | 8.20 |
| | (33) | (96) | (247) | (516) |
| All cancers (including leukemia) | 7.23 | 11.16 | 7.94 | 34.77 |
| | (984) | (2,840) | (6,196) | (10,557) |
| U.S. death rate by all causes, 1979 | (4,135) | (9,945) | (22,320) | (52,460) |

(b) Excess cancer deaths per $10^6$ persons from 1 rad of low LET radiation to entire population.

| | | Projected lifetime risks of fatal cancer per $10^6$ persons per rad in working population (25–64 years) | |
|---|---|---|---|
| Cause of death | Excess relative risk per rad[b] | ICRP (1977)[c] | UNSCEAR (1988)[d] |
| Leukemia | 0.052 | 20 | 97 |
| Breast cancer (female) | 0.0119 | 25 | 60 |
| Lung cancer | 0.0063 | 20 | 150 |
| Stomach cancer | 0.0027 | | 130 |
| Uniform whole-body radiation | | 100 | 800[e] |
| Risk of serious hereditary ill health within the first two generations following exposure of either parent | | 100 | 30 |

*Notes:* These risk values should be taken only as crude estimates which are useful for assessment of radiation control measures. Large ranges for these estimates are quoted in the literature. Note the scatter in the data on the change in excess cancer death rate with age at death in table (a). While the data generally give support to the relative risk model, the support is not strong.

a. Radiation cancer data from UNSCEAR (1988), Table 52, p. 520; cancer death rates in general population from National Cancer Institute Monograph No. 57; mortality rates for general population from U.S. National Center for National Health Statistics, as presented in *Statistical Abstracts* (1982–83).

b. UNSCEAR (1988), Table 54, p. 522.

c. Additive model. Postulates that the annual excess risk of cancer arises after a period of latency and then remains constant over time. These risk data apply to both sexes and all ages

they help to place radiation risks in perspective with other risks accepted by society. For example, consider the fate of individuals born in the United States in a given year, say 1960 (4,257,850 live births). At present projections, 25 percent, or 1,064,000 individuals, will eventually develop cancer and 15 percent or 650,000 will die of cancer. About one-sixth of these deaths, or 107,000, are due to lung cancer and are primarily caused by cigarette smoking. If the same population is exposed from birth to the maximum whole-body radiation dose currently allowed (100 mrad per year), the total dose accumulated over the average life span of 65 years is 6.5 rad. Assuming a risk of fatal cancer induction of 1/2,500 per rad, the total number of cancers would equal (1/2,500) × 6.5 × 4,257,850 = 11,070. Because society is willing to pay the economic cost of greatly reducing radiation exposure, regulations are written to ensure that the average radiation dose to the public from man-made nonmedical sources does not exceed a few percent of these limits. It appears that the health of only a very small number of individuals may be affected by the controlled radiation emissions of a nuclear power industry, in sharp contrast to the effects of noncontrolled (but preventable) exposure to cigarettes.

## 2.3  Genetic Risks

It is much more difficult to develop risk data for genetic effects than for somatic effects. Only when the mutation occurs to a dominant gene is the abnormality readily apparent in the affected individual. If a recessive gene is affected the result is generally much more subtle and the harm produced more difficult to identify. The largest population of exposed individuals is the group of Japanese survivors of Hiroshima and Nagasaki, and the only effect which has been reported with any degree of confidence is a slight change in the sex ratio in the offspring of irradiated mothers. In a comparison of groups exposed to 8 rad and 200 rad respectively, the percentage of male births dropped from 52.0 percent (in 19,610 live births) to 51.2 percent (in 2,268 live births). The percentage of male births in 43,544 live births of unirradiated parents was 52.1 percent. Because of the lack of pertinent human data, the assessment of risk is based on indirect evidence, most of which comes from experimental studies of mice. Thus, the estimates are tenuous: they should be regarded only as indicators of radiation effects rather than as reliable predictors of the genetic consequences of exposure.

The population currently carries a heavy burden of inherited disorders and traits that seriously handicap the afflicted persons at some time during their

---

and were used in the assignment of weighting factors in the ICRP (1977) system of dose limitation, incorporated into 10CFR20 Revised.

d. UNSCEAR (1988), Table 9, p. 39. Multiplicative (relative risk) model. Postulates that the annual excess of risk observed in irradiated populations follows the same pattern as the distribution of naturally occurring cancers in time. Applies to ages 25–64 years. Based on linear extrapolation from high dose–high dose rate data.

e. A more reasonable risk factor for uniform whole-body radiation for radiation protection purposes, which assumes that low dose rate risks are a factor of 2 or 3 below high dose rate risks, is probably 400 excess deaths per million persons per rad (Nelson, 1988; Clarke, 1988).

lives. In one study, it was reported that in each million live-born offspring, 107,000 entered the world with some significant inherited handicap. If the parents had received doses of 1 rem, it is estimated that this would have resulted in an additional 5 to 65 live-born offspring so affected (NAS-NRC, 1980). If the population were subjected to this additional exposure during the childbearing years for many generations (that is, typically 1 rem to age 30 or an average of 33 mrem per year), it is estimated that eventually, the incidence of genetic defects would reach an equilibrium level of 60 to 1100 per million live-born offspring. These conclusions may also be expressed in terms of a relative increase of disorders of 0.02 to 0.004 at equilibrium per rem of parental exposure received in each generation before conception. Estimates of the dose required to double the naturally occuring rate of genetic disorders (doubling dose) range between 50 and 250 rem. These numbers also indicate that the natural radiation background (considered as 3 rem/generation) may account for 1 to 6 percent of the mutations responsible for disorders in the human population. Table 6.6 includes other estimates of genetic damage presented by ICRP. The risk of serious hereditary ill-health within the first two generations following exposure of either parent is given as 1 in 10,000 per rad. The risk of additional damage to later generations is an additional 1 in 10,000 per rad.

Animal experiments indicate that the risk of transmitting mutations to offspring for a given dose to the parent prior to conception is considerably reduced in females irradiated at low dose rates or who do not conceive until several months after exposure at high dose rates (Russell, 1967). A delay in conception of about two months following irradiation of the male is also likely to reduce the risk of abnormalities in the offspring.

### 2.4   Production of Chromosome Aberrations

The most sensitive way to detect signs of radiation exposure in a person is to look for chromosome aberrations in the nuclei of lymphocytes (one of the types of white blood cells). Researchers have found chromosome damage in individuals many years after exposure to radiation. Although the clinical significance of an increased number of aberrations is not understood, they do demonstrate the long-term persistence of the effects of radiation. Chromosome damage has been reported five years or more after x-ray therapy for ankylosing spondylitis (Buckton et al., 1962) and 17–18 years after the exposure of the Japanese to the atom bomb (Dolda et al., 1965). Aberrations may be seen after only a few roentgens of exposure.[8]

### 3.   Results of Animal Experiments

It is difficult to set radiation protection standards for humans on the basis of animal experiments, but such studies do provide guidance in the interpretation and extension of data on human exposure. Animal experiments pro-

---

8. A detailed review is given in UNSCEAR, 1977.

vide valuable answers to such questions as: Is there a threshold dose below which no effects appear?  Is susceptibility to cancer induction dependent on age, sex, and hereditary factors?  What are the general effects of dose rate on the risk of cancer and other radiation-induced diseases?  Are there chemical agents that can reduce injury from radiation or that enhance or promote injury subsequent to radiation exposure (such as cigarette smoke)?  What is the relative effectiveness of the different types of radiation, such as gamma rays, neutrons, and alpha particles, on tumor induction and other life-shortening effects?  What is the effectiveness of partial-body irradiation versus whole-body irradiation?  What is the toxicity from ingestion or inhalation of a particular radionuclide?  At what period in the life span are genetic effects most pronounced?

In an authoritative review of animal exposure data prepared by the National Committee on Radiation Protection (NAS-NRC, 1961), the following conclusions were presented:

(a) A rather high degree of correlation exists between results from animal experiments and those from man.

(b) An unusually high susceptibility seems to exist in some experimental animal species or strains for certain diseases, for example, ovarian tumors and lymphatic leukemia in mice and mammary tumors in rats.

(c) Most animal experiments, usually performed on relatively homogeneous populations, have demonstrated that there are dose levels below which no detectable increase in incidence of certain neoplasms can be found; the dose-effect relationship is not linear.  On the other hand, a few experiments with relatively homogeneous populations of animals have shown that for some tumors in certain species or strains of animals the incidence is increased at such low dose levels that there may not be a practical threshold for the production of an increased incidence of tumors.

In a study using 576 mice per exposure group at five levels of single whole-body exposures between 50 and 475 R, it was concluded that, in plots of life span versus dose, "the fit to a straight line was very good, and the intersection with the vertical axis showed that there was no apparent threshold for life shortening within the experimental error . . . The mice lost 5.66 ± 0.2 weeks (5%) of their lifespan/100 R." (Lindop and Rotblat, 1961).  It was also concluded that life shortening by irradiation was due, not to the induction of a specific disease, but to the advancement in time of all causes of death.

In another study of effects at low doses (Bond et al., 1960), it was found that at short exposures as low as 25 R, 5 out of 47 female rats developed breast cancers within 11 months.  This was an incidence of 12 percent compared to an incidence of 1 percent in the controls.  The dose-effect relationship appeared linear over a range of 25–400 R.  However, the data did not allow conclusions concerning the presence or absence of a threshold below 25 R.  The authors cautioned that results of rat experiments could not be extrapolated to humans inasmuch as other experiments showed that there

were hormonal influences on the induction of tumors that differed in the two species. The animals used in these experiments had a high natural susceptibility to breast cancer. In one series of studies of virgin female Sprague–Dawley rats allowed to live out their lives,[9] between 51 and 80 percent developed breast tumors, of which 12 percent were malignant (that is, a natural cancer incidence between 5 and 10 percent) (Davis et al., 1956). Accordingly, the results cannot be applied to species, or individuals in species, with a higher resistance to cancer induction. On the other hand, they point to the possibility of a much higher susceptibility to cancer production by radiation in individuals who have a genetic tendency to develop cancer.

Another organ having high radiosensitivity is the mouse ovary. In the RF mouse, a significant increase in the incidence of ovarian tumors was produced by a dose as low as 32 R (Upton et al., 1954). At the lowest exposure rate thus far systematically investigated (0.11 R/day), mice exposed daily throughout their lives to radium gamma rays exhibited a slightly increased incidence of certain types of cancer (Lorenz et al., 1955). Because of statistical limitations, however, the data do not enable confident extrapolation to lower dose levels.

One of the most critical questions that must be considered in decisions on the large-scale development of nuclear power is the toxicity of plutonium. While it is universally agreed that plutonium is extremely toxic, there are large differences of opinion on how great a risk to the health of the public and the safety of the environment it in fact represents (Edsall, 1976). There are very little published data on the hazards of plutonium to humans, yet health and safety standards are necessary and must be soundly based if a reasonable judgment on the acceptability of nuclear power from a health and safety point of view can be made. In the absence of adequate human data, considerable reliance must be placed on animal data for guidance in setting standards. Studies have been conducted with many different species of animals (ICRP, 1980), particularly the beagle. All dogs exposed to 3–20 nCi/g lung developed malignant tumors after periods of 6–13 years. It was concluded that a dose of more than 1 nCi $^{239}$Pu/g could cause premature death from a lung tumor in a beagle. Nine of thirteen beagles each injected with 48 nCi of $^{239}$Pu developed bone sarcomas over a period that averaged 8.5 years. The experiments indicate that the 40 nCi limit for plutonium may be several-fold less safe than the 100 nCi limit for radium (Bair and Thompson, 1974). It has been estimated that a maintained skeletal burden of 0.04 $\mu$Ci would lead to possibly 2 cases of leukemia and 13 cases of bone sarcoma per 1000 persons over 50 years (Spiers and Vaughan, 1976, p. 534), and based on rat data, 1 in 8 persons might develop lung cancer from a lung burden of

9. The average lifespan of Sprague Dawley rats given in one series of studies is 739–792 days, with a range between 205 and 1105 days.

16 nCi (Bair and Thomas, 1975). Thus there have been suggestions to reduce the current standard for plutonium (0.04 $\mu$Ci), ranging from a factor of 240 (Morgan, 1975) to 9 (Mays, 1975).

## 4. Sources Producing Population Exposure

The standards of radiation protection allow for the imparting of low radiation doses to the public as a result of the use of radiation in technology, although a slight increase in the incidence of cancer, leukemia, or birth defects may result.  The justification is that the benefit from the use of radiation outweighs the risk of injury.  The decision as to the level of exposure at which benefit outweighs risk is a matter of judgment, and by its nature will always be controversial.  Certainly if experts disagree on this question it must be extremely difficult for the layman to make an objective judgment.  In fact, the permissible levels for population exposure will be set by the most persuasive elements of our society.

In the absence of conclusive data on the effects of very low-level radiation exposure of large numbers of people, the basic yardstick for measuring the significance of population exposure from man-made sources is the exposure already being incurred by the population from natural sources.  As a result, considerable effort has been expended by scientists on the evaluation of this exposure.

## 4.1  Natural Sources of External Radiation

It is convenient to divide the exposure of the population into exposures from external and internal sources, although the effects of the radiation on the body depend only on the dose imparted, regardless of origin.  The external background radiation comes from the interactions in the atmosphere of cosmic rays from outer space and from gamma photons emitted by radioactive minerals in the ground (fig. 6.2).

### 4.1.1  Radiation from Cosmic-Ray Interactions in the Atmosphere

About $2 \times 10^{18}$ primary cosmic-ray particles (mainly protons) of energy greater than one billion electron volts are incident on the atmosphere every second.  They interact with atoms in the atmosphere and produce a large variety of secondary particles.  At sea level, essentially all the original particles have disappeared.  The cosmic-ray dose is produced by the secondary particles.  Figure 6.2 shows the progeny particles produced by a single energetic cosmic-ray particle.  The penetration of a single proton of relatively low energy into the atmosphere may result in the ultimate appearance of only a single particle (a muon, usually) at ground level.  A very energetic proton may produce a shower containing hundreds of millions of particles, including muons, electrons, photons, and some neutrons.

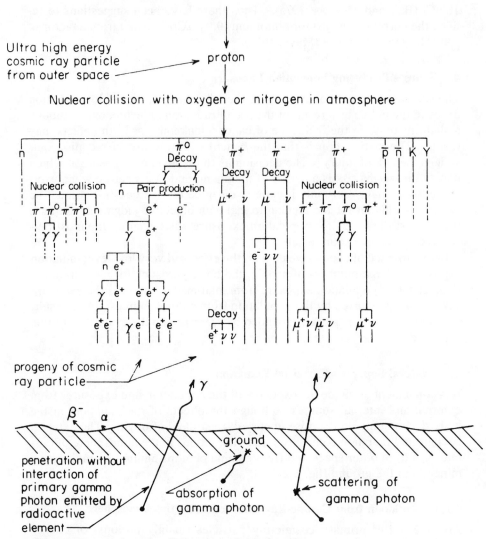

**Fig. 6.2**  Penetration of radiation to surface of earth.

### 4.1.2   Radiation Emitted by Radioactive Matter in the Ground

Radionuclides that were part of the original composition of the earth, and additional radionuclides formed as a result of their decay, emit gamma radiation which contributes a large share of the environmental radiation dose. The extent of the exposure at any particular location depends on the amount and distribution of radioactive material.  The distribution of radioactive elements in the ground has been studied extensively.  The major sources are

provided by potassium, of which the typical concentration is a few grams per hundred grams of ground material, and thorium and uranium, the typical concentration of which is a few grams per million grams. Data on concentration, expressed as fractional weight and activity per gram for selected locations, are presented in table 6.7.

While the values in table 6.7 are typical, there are areas with unusually high levels. For example, uranium concentrations in phosphate rock in the United States reach levels of 400 g per million grams (267 pCi/g; EPA, 1977). The commercial phosphate fertilizers derived from these rocks also contain a high uranium content, and runoff from fertilized areas has resulted in the increase of the uranium content of North American rivers.

Most of the gamma photons emitted by radioactivity in the ground are absorbed in the ground. The environmental exposure is produced primarily by photons originating near the surface. Estimates of the doses from the major contributors, for uniform concentrations in the ground, expressed in picocuries per gram, are given by the following formulas:

|  | mrad/yr at 1 m above ground |
|---|---|
| For $^{238}$U + decay products | $17.8 \times$ pCi/g |
| For $^{232}$Th + decay products | $25.5 \times$ pCi/g |
| For $^{40}$K | $1.6 \times$ pCi/g |

The gamma photons emitted in the decay of the natural atmospheric radioactivity also contribute to the external dose. The external dose from radon and its decay products is given approximately by the expression: yearly dose (in mrad) = $14 \times$ concentration (in pCi/l). At a concentration of 0.1 pCi/l, this adds 1.4 mrad/yr to the dose. The contribution from thoron and its decay products is generally much less.

**Table 6.7.**    Concentration of radioactive materials in the ground.

| Type of rock | Concentration (fraction by weight) | | | Activity (pCi/g) | | |
|---|---|---|---|---|---|---|
|  | Potassium $\times 10^2$ | Uranium $\times 10^6$ | Thorium $\times 10^6$ | Potassium | Uranium | Thorium |
| Igneous | 2.6 | 4 | 12 | 21.6 | 1.33 | 1.31 |
| Sandstone | 1.1 | 1.2 | 6 | 9.1 | 0.40 | 0.65 |
| Shale | 2.7 | 1.2 | 10 | 22.5 | 0.40 | 1.09 |
| Limestone | 0.27 | 1.3 | 1.3 | 2.25 | 0.43 | 0.14 |
| Granite | 3.5–5 | 9–12 | 36–44 | >29 | >3.0 | >3.9 |

*Sources:* For igneous, sandstone, shale, and limestone, UNSCEAR, 1958, p. 52; for granite, Adams and Lowder, 1964.

### 4.1.3   Doses from External Sources

Representative doses from external natural sources are:

(*a*) From cosmic radiation with low linear energy transfer
(photons, muons, electrons)                                                              28    mrad/yr.
(*b*) From cosmic ray neutrons (high linear energy transfer)    0.35 mrad/yr.
(*c*) From gamma photons originating in the ground                  50    mrad/yr.

The low-LET cosmic ray dose rises to 53 mrad/yr in Denver (1600 m) and
to 2,630 mrad/yr at 12,000 m (40,000 ft). The neutron dose rises to 3.1
mrad/yr (31 mrem/yr) in Denver and 193 mrad/yr at 12,000 m. Measurements of radiation levels of natural origin in several cities in the United
States are given in table 6.8.

### 4.2   Natural Sources of Radioactivity within the Body

Section 12 of part II presents information on radioactivity in the body. The
radioactivity results primarily from ingestion of radioactive nuclides that
occur naturally in food and drinking water, with some contribution from inhalation of radioactivity in the air. The most important radionuclides that
are ingested are potassium-40, radium-226, and the decay products of radium-226. Carbon-14 and tritium are also of interest, although they make
only minor contributions to the absorbed dose. The major contributors to
dose from inhalation are the radioactive noble gases, radon (radon-222) and
thoron (radon-220), and their decay products.

Potassium is relatively abundant in nature, and some data on the potassium content in the ground has already been presented in table 6.7. The element contains 0.0119 percent by weight of the radioactive isotope potassium-40. The body content of potassium is maintained at a fairly constant

**Table 6.8.**   Radiation exposure levels in different cities.

| Location | Exposure rate ($\mu$R/hr) | | | |
|---|---|---|---|---|
| | Terrestrial sources (potassium, uranium, thorium) | Cosmic rays | Total ($\mu$R/hr) | Total (mrad/yr) |
| Denver | 7.1–15.2 | 5.9–6.3 | 13–21.5 | 114–188 |
| New York City | 6.3 | 3.6 | 9.9 | 87 |
| Conway, N.H. | 10.9 | 3.6 | 14.5 | 127 |
| Burlington, Vt. | 5.2 | 3.6 | 8.8 | 77 |

*Sources:* For Denver and New York, Beck et al., 1966; for Conway and Burlington,
Lowder and Condon, 1965.

*Note:* Natural gamma dose rates at Pelham, N.Y., fluctuated between 7 and 8.2
$\mu$R/hr between 5/3/63 and 7/29/65 (Beck et al., 1966). The variability is attributed
primarily to variations in the moisture content in the ground. In the past, fallout
added several $\mu$R/hr to the external exposure levels.

level, about 140 g in a person weighing 70 kg.   This amount of potassium has a potassium-40 content of approximately 0.1 $\mu$Ci.

Some results of measurements of the concentrations of other radionuclides in food and water are presented in table 6.9.   Note the high variability in the levels in different sources.

Carbon and hydrogen in the biosphere contain radioactive [14]C and tritium ([3]H) that result from the interaction of cosmic-ray neutrons with the nitrogen in the atmosphere.   Because production of these radionuclides has been proceeding at a constant rate throughout a period much longer than their half-lives, the world inventory is essentially constant, and the atoms are decaying at rates equal to the rates at which they are being produced.   Libby (1955) calculated that $1.3 \times 10^{19}$ atoms of [14]C are produced each second, yielding a world inventory at equilibrium of 365 million Ci.   The rate of tritium production is about 10 percent that of [14]C, and the world inventory of tritium is about 30 million Ci.

The [14]C produced in the atmosphere is rapidly oxidized to radioactive carbon dioxide and ultimately appears in the carbon compounds in the sea and in all living matter.   The measured value of specific radioactivity is constant at 16 dis/min per gram of carbon and agrees well with calculations based on dispersion of the [14]C in a carbon reservoir of $42 \times 10^{18}$ g.   The tritium is maintained at an equilibrium concentration of 1 tritium atom for $2 \times 10^{17}$ hydrogen atoms, or about 0.036 dis/min per milliliter of water.

From a radiation-protection point of view, of more interest than the concentration of the activity in water and various foods is the daily intake.   The intake varies widely with locality.   For example, values for daily intake of radium-226 in Great Britain vary by a factor of 500, with an upper limit of 5.9 picocuries.   The actual significance of daily intake depends on the absorption of the materials by the gastrointestinal tract; [40]K, [137]Cs, and [131]I are almost completely absorbed.   Significant absorption also occurs for [210]Pb and [210]Po.   The absorption of [14]C and tritium depends on the metabolism of the molecules in which they are incorporated.   The rest of the radionuclides ingested by man are only poorly absorbed.

**Table 6.9.**   Concentrations of radionuclides in food and water.

| Substance | Concentration (pCi/kg) | | | |
| --- | --- | --- | --- | --- |
| | [226]Ra | [210]Po | [90]Sr | [137]Cs |
| Cereal grains (N. Amer.) | 1.5–4 | 1–4 | 15–60 | 50 |
| Nuts | 0.5–2000 | | 3–120 | |
| Beef | 0.3–0.9 | 3–300 | 1 | 100–5000 |
| Cow's milk | 0.15–0.25 | 1 | 3–15 | 20–200 |
| Water (Great Britain, some locations) | 3.3 | | | |

*Source:* Mayneord and Hill, 1969, Table VII.

**Table 6.10.**   Activity in the environment and in people of naturally occurring long-lived radionuclides.

| Radionuclide | Alpha Emitters (except $^{210}$Pb) | | | | | | Beta Emitters | | | |
|---|---|---|---|---|---|---|---|---|---|---|
| | $^{238}$U | $^{232}$Th | $^{226}$Ra | $^{228}$Ra | $^{210}$Pb | $^{210}$Po | $^{40}$K | $^{14}$C | $^{3}$H | $^{87}$Rb |
| Half-life (yr) | $4.5 \times 10^9$ | $1.4 \times 10^{10}$ | 1,600 | 5.8 | 21 | 0.38 | $1.26 \times 10^9$ | 5,730 | 12.3 | $4.8 \times 10^{10}$ |
| Activity in soil (pCi/kg) | 700 | 700 | 700 | 700$^p$ | 900$^a$ | 900$^a$ | 12,000 | 6,100/kg Carbon | 146/kg Hydrogen | |
| Activity in air ($10^{-5}$ pCi/m$^3$) | 7$^b$ | 7$^b$ | 7$^b$ | 7$^b$ | 1,400$^c$ | 330$^c$ | | | | |
| Activity in water (pCi/l) | <0.03 | | | | 3$^d$ | 0.5$^d$ | | | 16 (natural) 84 (fallout) | |
| Daily intake | | | | | | | | | | |
| Inhalation (pCi) | 0.0014 | 0.001 | 0.001 | | 0.3$^e$ | 0.07$^e$ | | | | |
| Ingestion (pCi) | 0.4$^f$ | 0.1$^g$ | 1$^h$ | 1 | 3 | 3 | | | | |
| Activity in tissues | | | | | | | | | | |
| Soft tissue (pCi/kg) | 0.2 | 0.05 | 0.13 | 0.1 | 6 | 6 | 1,600 | | | 220 |
| Bone (pCi/kg$^l$) | 4 | 0.5 | 8$^j$ | 2.4$^k$ | 80$^k$ | 64$^k$ | 400$^k$ | | | 640 |
| Whole body (pCi) | 26 | 120 | 50 | | 600 | 200 | 130,000 | 87,000 | 700 (natural) 27,000 (fallout) | 29,000 |

| Annual absorbed dose | | | | | | | | | |
|---|---|---|---|---|---|---|---|---|---|
| Soft tissue (mrad) | 0.02 | 0.004[l] | 0.03 | 0.06 | 0.6 | 17 | 0.6 | 0.001 (natural) 0.06 (fallout) | 0.4 |
| Red marrow (mrad) | 0.02 | 0.05 | 0.09 | 0.18 | 0.7 | 27 | 2.2 | 0.001 | 0.4 |
| Bone lining cells (mrad) | 0.12[m] | 0.8 | 0.7[n] | 1.08[n] | 3 | 15 | 2.0 | 0.001 | 0.9 |

*Sources:* UNSCEAR, 1977; NCRP, 1975; Spiers, 1968; Holtzman, 1977.

a. Average activity in top layer, 20 cm thick. $^{210}$Pb is a beta emitter, a sixth generation decay product of $^{226}$Ra and the precursor of $^{210}$Po. Contributions in pCi/kg are 200 from dry deposition, 100 from wet deposition, and 600 from radium in ground under the assumption that 90 percent of radon is retained in soil. The corresponding area concentration is 68 mCi/km² from dry deposition, 37 mCi/km² from wet deposition. The total radium activity in a layer of rock 1 m thick in continental U.S. (excluding Alaska), assuming specific gravity of 2.7 = $700 \times 10^{-12}$ Ci/kg $\times$ 2700 kg/m³ $\times$ 1 m $\times$ 8 $\times$ 10¹² m² = $1.5 \times 10^7$ Ci.

b. Based on resuspension of dust particles as main natural source in atmosphere, dust loading of 100 µg/m³ in surface air of populated areas, and dust specific activity of 700 pCi/kg.

c. Results primarily from decay of $^{222}$Rn in air.

d. In rain water; less than 0.1 pCi/l $^{210}$Po in drinking water.

e. Cigarettes contain 0.6 pCi $^{210}$Pb, 0.4 pCi $^{210}$Po. Estimated intakes (10% $^{210}$Pb and 20% $^{210}$Po in cigarettes) for 20 cigarettes/day are 1.2 pCi $^{210}$Pb and 1.6 pCi $^{210}$Po.

f. Intake primarily from food in diet; activity in tap water usually less than 0.03 pCi/l, which can be neglected, but concentrations as high as 5000 pCi/l have been measured in wells.

g. Makes negligible contribution to body content because of very low absorption of thorium through gastrointestinal tract.

h. Populated areas with high concentrations of thorium and uranium in their soil show higher daily intakes: 3 pCi $^{226}$Ra and 160 pCi $^{228}$Ra along coast of Kerala in India; 10–40 pCi $^{226}$Ra, 60–240 pCi $^{228}$Ra in 196 individuals in the Araxa-Tapira region in Bazil.

**Table 6.10.**   (continued)

i.   UNSCEAR (1977) expresses activity concentrations in bone as per unit mass of *dry* bone, given as 5 kg, which comprises 4 kg of compact bone and 1 kg of cancellous bone; the total bone surface in an adult man is 10 m² with 5 m² in compact bone and 5 m² in cancellous bone.

j.   ICRP model on the metabolism of alkaline earths in adult man gives 126.3 pCi/day time integral of bone activity and 143.7 pCi/day whole-body activity from a blood uptake of 1 pCi of $^{226}$Ra corresponding to an intake of about 6 pCi and a bone-to-diet quotient of 4.2 pCi/kg per pCi/day intake.   Average value found for ratio is about 6 pCi/kg per pCi/day.

k.   There is 5 pCi/kg $^{210}$Pb, 4 pCi/kg $^{210}$Po, 3600 pCi/kg $^{40}$K in red bone marrow.   Lower value of $^{228}$Ra compared to $^{226}$Ra results from shorter half-life combined with biological half-life of 10 yr.

l.   Activity concentrations of $^{230}$Th (in $^{238}$U decay series) and $^{232}$Th are about equal, and thus levels of $^{230}$Th are similar in man and make similar contributions to dose.

m.   $^{234}$U in equilibrium with $^{238}$U adds approximately equal dose.

n.   Based on average retention factor in skeleton and soft tissues of 0.33 for $^{222}$Rn and of 1.0 for $^{220}$Rn and a uniform concentration of radium and its short-lived decay products over the total mass of mineral bone.

p.   $^{228}$Th is a beta emitter; alpha particles are emitted by its decay products.

Data on environmental levels of the long-lived naturally occurring radio-nuclides are given in table 6.10.   All the alpha emitters are part of the radio-active decay series that originates from primordial uranium and thorium and that includes many members (see sections 5.5 and 5.6 in part III).   Most of these radionuclides are taken up in bone and retained for long periods of time, producing alpha radiation doses to the bone marrow, bone-forming cells, and cells lining the bone surfaces.   Daily intakes and absorbed doses to these tissues are given in the table.   The absorbed doses of the alpha emit-ters must be mulitplied by 20 to obtain the dose equivalent.   The radionu-clide lead-210 listed in the table is a low-energy beta emitter in the radium decay series rather than an alpha emitter, but its dosimetric significance re-sults primarily because it decays into the alpha emitter polonium-210.   Since $^{210}$Pb and $^{210}$Po follow the decay of the noble gas radon-222 in the $^{238}$U–$^{226}$Ra decay series, the initial distribution in the environment is determined by the distribution of radon gas in the ground and in the atmosphere following its production from the decay of $^{226}$Ra (UNSCEAR, 1977; Jaworowski, 1969).   The airborne radioactive gases are discussed in the following section.   The environmental contamination levels of the naturally occurring long-lived ra-dionuclides and their decay products are a useful reference for assessing the significance of disposal of manmade radioactive wastes.   Note that the inter-nal whole-body dose from naturally occurring radionuclides adds about 20 mrem/yr or 25 percent to the external dose, and that localized regions in bone receive even higher doses.

The data in table 6.10 can be used to provide estimates of the total quanti-ties of natural radioactive material at different depths in soil.   For example, consider the continental U.S. (excluding Alaska) with an area of $8 \times 10^{12}$ m$^2$, an average rock density of $2.7 \times 10^6$ g/m$^3$, and a concentration of uranium-238 (specific activity $3.33 \times 10^{-7}$ Ci/g) of $2.7 \times 10^{-6}$ g per gram of rock.   A layer of rock 1 m thick in the continental U.S. contains $58.3 \times 10^{12}$ g uranium with a total activity of $19.4 \times 10^6$ Ci.   A layer of rock 600 m thick (the projected depth for burial of high-level radioactive wastes) contains $1.2 \times 10^{10}$ Ci.   Equal quantities of radioactivity are contributed by the 13 radioactive decay products of $^{238}$U including $^{234}$U, $^{234}$Th, $^{226}$Ra, and $^{210}$Po.   Similar contributions are made by the thorium series.   While we have focused attention on the long-lived alpha emitters as the constituents in high-level waste of most concern, their activity is matched by the beta-emitting $^{40}$K in the ground.   Its activity is about 20 times that of uranium, and therefore is comparable to the whole uranium series.   Of course, the alpha energy imparted by the radiation from the uranium and thorium series is much greater than the beta energy from potassium.

### 4.2.1   Atmospheric Aerosols

There is constant leakage from the ground of two alpha-emitting noble gases, radon-222 (radon) and radon-220 (thoron).   These gases are produced in the uranium and thorium decay series.   The amount that emanates from the

ground at any given place and time depends not only on the local concentrations of the parent radionuclides, but also on the porosity of the ground, moisture content, ground cover, snow cover, temperature, pressure, and other meteorological conditions.

It is estimated that the total radon emanation rate from land areas of the earth is 50 Ci/sec and produces an equilibrium activity in the atmosphere of 25 million Ci. Measured emanation rates from soil are as high as 1.4 pCi/m²-sec with a mean value of 0.42 pCi/m²-sec (Wilkening et al., 1972). The concentration of radon at ground level depends strongly on meteorological conditions but is about 0.1 pCi/l in continental air, 0.01 pCi/l in coastal areas and 0.001 PCi/l over oceans and arctic areas. The thoron activity concentrations in surface air are somewhat lower than radon, but the total thoron inventory in the atmosphere is much less because of its much shorter half-life (55 sec as compared to 38 days for radon).

The decay products of both radon and thoron are also radioactive and undergo a series of additional decays by alpha and beta-gamma emission. The decay products, which are atoms of polonium, lead, and bismuth are breathed in and deposited in the lungs, either as free atoms, part of a cluster of atoms, or attached to particles in the air. They are responsible for most of the dose to the lungs resulting from breathing in an atmosphere containing radon and thoron (see part III, section 5.6 for a detailed treatment of the dosimetry).

Radon concentrations will build up to appreciable levels indoors, depending on the rate of radon emanation from the materials of construction and the ventilation rate (Moeller and Underhill, 1976). Measurements reported for indoor levels vary over several orders of magnitude. A ten-state survey by the Environmental Protection Agency reported in *Science News* of August 15, 1987, found that 21 percent of the 11,600 homes sampled during the winter—or more than one home in every five—had levels exceeding EPA's action level of 4 picocuries per liter of air. One percent of the homes had levels exceeding 20 pCi/l and a few had levels exceeding 150 pCi/l. A representative value for the average $^{222}$Rn concentration indoors is about 1 pCi/l, giving an annual dose (assuming a decay product equilibrium factor of 0.5) averaged over the whole lung of about 30 mrad (600 mrem) and 160 mrad (3200 mrem) in the basal cells of the bronchial epithelium (UNSCEAR, 1977, p. 79). These dose rates produce the highest organ doses (in mrem) from natural sources.

Small concentrations of other radionuclides are also found in air. These originate primarily from airborne soil. Some reported levels (NCRP, 1975, p. 77) in pCi/m³ air are: $^{238}$U, 12 × 10$^{-5}$; $^{230}$Th, 4.5 × 10$^{-5}$; $^{232}$Th, 3.0 × 10$^{-5}$ and $^{228}$Th, 3.0 × 10$^{-5}$. Radium levels are comparable to the uranium levels. A significant portion is probably contributed by coal-burning power plants (Moore and Poet, 1976). Lead-210 and $^{210}$Po, the long-lived decay products of $^{222}$Rn, also contribute to airborne radioactivity, reaching levels of 0.01 pCi/m³ and 0.001 pCi/m³ respectively. The $^{210}$Po levels result

from releases from soil of about $5 \times 10^{-6}$ pCi/m$^2$ on calm, clear days to $70 \times 10^{-6}$ pCi/m$^2$ when the air is dusty (Moore et al., 1976).

## 4.3   Population Exposure from External Man-Made Sources

The most important contributions to exposure of the population from man-made sources of radiation are from the medical and dental professions. Of much lesser importance are contributions to date by the nulcear power industry and the military. We shall discuss the magnitude of exposure from external sources in this section and, in section 4.4, examine internal exposure resulting from contamination of the environment or from administration of radioactive materials in medical diagnosis.

### 4.3.1   Population Exposure from Medical and Dental X Rays

The extent of the exposure of the population to radiation in the United States can be appreciated from examination of statistics on x-ray visits published by the U.S. Public Health Service as a result of studies made in 1970.[10] They apply to visits made by the civilian noninstitutional population, a group containing about 200 million individuals. Approximately 130 million, or 65 percent of this group, had one or more x-ray visits during the year.

The total number of x-ray examinations or therapeutic procedures are given in the following table (data for 1980 based on less extensive studies; NCRP, 1989). The rate of radiographic examinations increased from 67 to 79 per 100 population from 1970 to 1980 and the dental rate rose from 32 to 45 per 100 (Mettler, 1987).

|               | 1970         | 1980        |
|---------------|--------------|-------------|
| radiographic  | 129   million | 180 million |
| dental        | 68    million | 101 million |
| fluoroscopic  | 12.6 million  |             |
| therapy       | 2.6 million   |             |
| Total         | 212   million |             |

The Public Health Service also evaluated the exposures imparted in common medical and dental procedures in 1970. Some of their findings are presented in table 6.11. Medical x-ray exposures ranged from 100 mR per film to the extremities to 910 mR per film to the abdomen. The mean exposure from dental x-rays was 910 mR per film. The examinations produced gonad doses that ranged from less than 1 mrad (for example, from dental x rays) to over 2 rads. The genetically significant dose to the U.S. population was found to be 20 mrads per person per year (BRH, 1976).

We noted in the discussion on x-ray protection (section 14, part II) that

10. BRH, 1973. For results of previous study, see Gitlin and Lawrence, 1964.

**Table 6.11.**   Estimated mean exposure per film by type of examination.

| Body area examined | Mean exposure at skin entrance (mR) | |
|---|---|---|
| | 1973 | 1983 |
| Head and neck | 310 | |
| Chest, radiographic | 47 | 20 |
| Chest, photofluorographic | 504 | |
| Abdomen | 910 | 500 |
| Extremities | 100 | |
| Teeth | 900 | 300 |

*Sources:* BRH 1973, tables 35 and 36; Johnson and Goetz, 1986.

exposures vary considerably depending on the techniques and equipment used. Fluoroscopy, that, under the best conditions without the use of an image intensifier, gives about 5 R/min exposure to the skin, gives one-third as much with image intensifiers. Chest x rays made with fast, full-size x-ray film in direct contact with an intensifying screen produce no more than 10 mR at the skin, as compared with exposures up to 100 times as high with other commonly-used techniques.

The significance of exposure to x rays is more readily evaluated from doses to individual organs in the body rather than an exposure at the surface of the skin. However, the organs exposed and their relative exposures differ greatly in different examinations. A measure of the overall impact of the exposure is desirable. This can be expressed as a somatic detriment, determined from the organ doses and the cumulative lifetime risk of cancer incidence for each organ (considered proportional to the dose to the organ). The somatic detriment has been expressed in various ways (Pochin, 1968; Jacobi, 1975). A simplified approach is through the use of a somatic dose index, based on doses and risks to the most important exposed organs (active bone marrow, thyroid, female breast, and lung). Malignancies in other organs and tissue are considered as a group. The somatic dose index is defined as the uniform dose to the organs that would have the same somatic detriment as the non-uniform doses absorbed by the individual organs in the actual examination. (Laws and Rosenstein, 1978). Some values for organ doses and the somatic dose index are given in table 6.12. The Bureau of Radiological Health of the U.S. Public Health Service is considering the establishment of entrance exposure guidelines to minimize organ doses in radiological examinations. The somatic dose index is one measure of dose reduction potential that could be considered in evaluating the proposed guidelines (Laws and Rosenstein, 1980).

Studies have also been made of the x-ray dose in the head and neck region from dental x-ray examinations (UNSCEAR, 1977; Alcox, 1974). Maximum values reported at the lens of the eye were 84 mR for the two-film tech-

**Table 6.12.**  Dose index and absorbed doses for common radiographic examinations of females.

| Examination | View | Somatic dose index for 1000 mR at skin | Typical exposure at skin (mR) | Millions of exams/yr | Average no. of films per exam | Somatic dose index[a] (mrad) | Organ doses (mrad) | | | |
|---|---|---|---|---|---|---|---|---|---|---|
| | | | | | | | Active bone marrow | Breast | Lung | Uterus/embryo |
| Chest | P/A | 98 | 26 | 21.8 | 1.5 | 11 | 3.0 | 14 | 20 | 0.06 |
| | LAT | 146 | 82 | | | | | | | |
| Upper GI | A/P | 47 | 641 | | | | | | | |
| | P/A | 44 | 548 | 2.9 | 4.3 | 138 | 114 | 53 | 476 | 48 |
| | LAT | 24 | 1149 | | | | | | | |
| | OBL | 35 | 774 | | | | | | | |
| Barium enema | A/P | 25 | 760 | | | | | | | |
| | P/A | 33 | 773 | 1.9 | 4.0 | 132 | 298 | <0.01 | 48 | 822 |
| | LAT | 12 | 4011 | | | | | | | |
| | OBL | 21 | 1348 | | | | | | | |
| Lumbosacral spine | A/P | 25 | 911 | | | | | | | |
| | P/A | 33 | 1952 | 0.8 | 3.4 | 119 | 224 | <0.01 | 35 | 639 |
| | LAT | 12 | 3480 | | | | | | | |
| | OBL | 21 | 1606 | | | | | | | |

*Sources:* Laws and Rosenstein, 1978, 1980.  See also UNSCEAR, 1977, table 15, p. 319.
*Note:* Doses calculated for a beam quality of 2.5 mm Al HVL (approx).  Doses to uterus/embryo do not contribute to somatic dose index and are included for information only.

a. Somatic population dose index is product of number of examinations and somatic dose index.

nique and up to 1.66 R for whole-mouth (18 film) examinations.  The exposure to the thyroid was between 2.4 and 9 mR for the two-film and between 35 and 70 mR for the whole-mouth examination.  Maximum doses were to the midline of the upper lip (philtrum) and varied between 0.8 and 2 R depending on the technique.  Orthopantomography gives somewhat lower skin doses than full-mouth (18 film) x rays.  A Norwegian study gave skin exposures around the rotational axes up to 700 mR, but it was much lower elsewhere.  Bone marrow dose was 2 mrad (compared to 7 mrad for whole-mouth series).  The dose to the gonads from a single dental x ray has been estimated as 5 microrads for adults and 25 microrads for children (equivalent to about 2 hr exposure to the natural radiation background).

Detailed measurements on a skeleton encased in plastic gave doses of over 6,000 mR in the teeth region during a full-face examination with a periapical unit.  The exposures received from periapical equipment were several times those obtained from panoramic devices, but the image provided by the panoramic units lacked the fine detail often needed for complete diagnosis (McKlveen, 1980).

Some interesting data on the possibilities of dose reduction in the administration of dental x-rays are presented in table 6.13.  Dose values are given for two different techniques; in one, high-speed film was used; in the second, special measures were taken to limit the x-ray beam to the region of study.  There was minimum overlap of irradiated areas per exposure, and minimum irradition of sensitive regions such as the thyroid and cornea of the eye.  It may be seen that with special shielding, the doses to the cornea and thyroid were greatly reduced.

The typical exposures reported in tables 6.11 and 6.12 are only a small fraction of the typical exposures received by a patient in the first decades

**Table 6.13.**  Accumulated dose (mrad) from full mouth (22 films) x ray with high speed dental x ray film (using special dose reduction techniques).

| Technique[a] | Dose (mrad) | | |
|---|---|---|---|
| | Mandibular bone (area 3rd molar) | Cornea | Thyroid |
| Lead-lined rectangular collimator and 16" source—end of collimator distance to give 2-¾" diameter beam | 2101 | 342 | 92 |
| Special rectangular collimating device and lead backing on film to shield rest of mouth | 776 | 19 | 10 |

*Source:* Winkler, 1968.

a. Film: ASA speed group D[17].  Exposure conditions: 90 kVp, 15 ma, 2.5 mm aluminum HVL.

**Table 6.14.**   Relative speeds for Kodak dental x-ray films.

| Year introduced | Type | Relative time/exposure |
|---|---|---|
| 1923 | Regular | 1 |
| 1939 | Radiatized | 1/2 |
| 1941 | Ultra speed | 1/4 |
| 1955 | Radiatized | 1/4 |
| 1955 | Ultra speed | 1/24 |
| 1982 | Ekta speed | 1/48 |

*Sources:* Richards, 1969; Eastman Kodak.

following the introduction of x rays. Some rather startling facts are given in a paper by Braestrup (1969). "Within the first few years of Roentgen's discovery, the application of x-rays in diagnosis required doses of the order of 1000 times that required today. Radiographs of heavy parts of the body took exposures 30–60 minutes long. Maximum allowable exposures were set by the production of skin erythemas (300–400 rad). Thus the skin served as a personal monitor. The Wappler fluoroscope, manufactured around 1930–1935, produced 125–150 R/min at the panel. Skin reactions were produced and in some cases, permanent injury. To minimize hazard, a 100 R per examination limit was set in the New York City hospitals."

Data on the relative increases in film speed achieved over the years are presented in table 6.14. Increases in the speeds of film and fluorescent viewing screens, along with extensive improvements in equipment and measurement techniques designed to limit the x-ray beam to the region under study, cut exposure drastically.

### 4.3.2   Environmental Radiation Levels From Fallout From Past Weapons Tests

Next to medical x rays, the only other significant source of external radiation to the population from man-made sources has been fallout from nuclear bombs exploded in the atmosphere. The fallout emits gamma photons of various energies, with an average of about 0.9 MeV. The radiation levels produced by fallout on the ground depend on a variety of factors, including terrain, pattern of the fallout, and the particular radioactive nuclides that dominate the fallout at that particular time. The main mechanism for the deposition of fallout is through rainfall and snowfall, and thus the radiation levels from fallout in any region are strongly dependent on the precipitation. Other factors, such as latitude, wind direction, and distance from the original detonation, are also important (Glasstone, 1962).

In 1963, at Argonne, Illinois, fallout increased natural background levels by as much as 30 percent (UNSCEAR, 1966, p. 6). In subsequent years, the dose rate decreased due to the decay of the shorter-lived contributors, $^{95}$Zr,

$^{144}$Ce, and $^{106}$Ru, and thereafter, the main contributor was $^{137}$Cs.  Examples of the seasonal variation of gamma fallout levels in Japan and the United Kingdom following the peak testing period in 1962 are shown in fig. 6.3.

The total external dose imparted by gamma radiation resulting from complete decay of fallout will amount to about 247 mrad, of which 133 mrad will be due to $^{137}$Cs and will be delivered over many decades.  The other 114 mrad is from the shorter-lived nuclides and has already been delivered essentially in full.  The actual dose to the gonads and blood-forming organs is estimated at 20 percent of the environmental level because of shielding by buildings and screening by body tissue.

While the average population dose from external gamma radiation as a result of bomb testing has been quite low, there have been fallout patterns considerably above the average in some local areas.  For example, a very unusual deposit was observed in Troy, New York, in April 1954 following a violent electrical storm that occurred after a 43 kiloton[11] bomb test (Simon) in Nevada, 36 hr earlier and 2300 miles to the west (Clark, 1954).  Representative gamma levels were of the order of 0.4 mR/hr, 1.1 days after onset, with levels as high as 6 mR/hr found on a pavement near a drain.  It was estimated that the accumulated gamma exposure in 10 weeks was 55 mR.

Close to the Nevada test site, in towns in Nevada and Utah, fairly high dose rates occurred as a result of atmospheric tests of nuclear fission bombs in the 1 to 61 kiloton range in 1952 and 1953 (Tamplin and Fisher, 1966).  Dose rates 24 hr after the detonation were: 30 mrem/hr in Hurricane, Utah; 26 mrem/hr in St. George, Utah, and 40 mrem/hr at Bunkerville, Nevada.  Other measurements off the test site ranged as high as 115 mrem/hr (24 miles west of Mesquite, Nevada).  It should be noted that the half-life of fission products varies approximately as the time since the detonation, so the measurements given are for radioactive nuclides of fairly short half-lives, that is, 24 hr one day after the explosion, and rising to 7 days after 1 week.  A 40 mrem/hr dose rate at 20 hr implies a dose of about 1580 mrem in the next 7 days, increasing to a maximum of 4800 mrem when essentially all the atoms have decayed.

The fallout levels discussed above were not high enough to produce demonstrable injury to the small populations exposed.  However, in at least one test, at Bikini Atoll on March 1, 1954, fallout produced severe radiation injuries (Eisenbud, 1963).  The high radiation exposures resulted from fallout from a megaton bomb.[12]  The highest exposures were incurred by 64 natives of Rongelap Atoll, 105 miles east of Bikini, and 23 fishermen on the Japanese fishing vessel Fukuru Maru about 80 miles east of Bikini.  The exposed individuals had no knowledge of the hazards of the fallout and there-

11. A 1-kiloton nuclear test is equivalent in energy released to the detonation of 1000 tons of TNT.

12. A yield of 1 megaton is equivalent in explosive power to the detonation of 1 million tons of TNT.

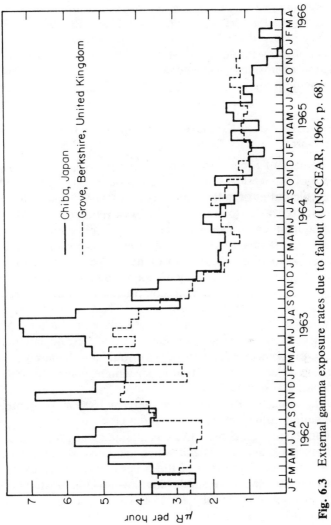

**Fig. 6.3**   External gamma exposure rates due to fallout (UNSCEAR, 1966, p. 68).

fore took no protective measures. They incurred external whole-body doses between 200–500 rem plus much higher local beta exposures. Skin lesions and epilation resulted.

The fallout was originally detected on the Island of Rongerik, 160 miles east of Bikini, where 28 American servicemen were operating a weather station. Evacuation procedures for the Americans on Rongerik were put into effect some 30 hr after the detonation, and 23 hr after the fallout was detected. They received whole-body doses estimated at 78 rem.

The experience at Bikini demonstrated the potential severity of fallout from megaton explosions produced with thermonuclear weapons. It provided a dramatic portent of the holocaust that would result if the major nuclear powers were to unleash their nuclear arsenals in the madness of war.

### 4.3.3 Potential External Exposure to the Population from Large-Scale Use of Nuclear Power

The development of a nuclear power industry to supply a fraction of the power needs of the world will result in the production of enormous and unprecedented quantities of radioactive wastes. It will be necessary to control and confine these wastes to prevent excessive exposure of the world's population. Although there are strong differences of opinion as to man's capacity to confine the radioactivity resulting from such power production, it is not within the scope of this book to examine the practicability of controlling those wastes that might accidentally escape to the environment. However, there are gaseous wastes (from the fission process) that may be released deliberately and routinely to the environment. The most significant is the radioactive rare gas, krypton-85, which is not metabolized when inhaled from the air and accordingly is treated for purposes of dose calculations as an external source of radioactivity, distributed throughout the atmosphere. The calculation of the dose at a location in an infinite volume of $^{85}$Kr was described in part III, section 5.4.

Data on the projected $^{85}$Kr release in the year 2000 are presented in table 6.15. The equilibrium inventory of krypton-85 when this radionuclide is introduced into the air at a constant rate is attained when the rate of decay of krypton atoms is equal to the rate at which additional atoms are introduced. The time to reach equilibrium is of the order of several times the krypton half-life of 10.8 yr. Thus, the equilibrium inventory indicated in table 6.15 based on production rates in the year 2000 would be close to attainment by about the year 2030.

Assuming that krypton discharged to the atmosphere mixes uniformly with the air in the troposphere on a mass basis, one may calculate that a steady annual discharge rate of 520 megacuries after the year 2000 will result in a concentration in the air at sea level of $1.9 \times 10^{-9} \ \mu Ci/cc$. If the released material should remain confined to specific latitudes, the concentration here may be several times higher. The United States Code of Federal

**Table 6.15.** Some statistics on $^{85}$Kr projected for year 2000.

| | |
|---|---|
| Estimated world inventory of $^{85}$Kr[a] | 3150 Megacuries |
| Nuclear power capacity (thermal) for generation of electricity (50% of total) | $3.32 \times 10^6$ Megawatts |
| Production of $^{85}$Kr in year 2000 | 520 Megacuries |
| Equilibrium world inventory if production rate continues as in year 2000 | 8100 Megacuries |
| Volume of atmosphere available for dilution[b] | $4.2 \times 10^{24}$ cc |
| Equilibrium concentration of $^{85}$Kr at sea level if production rate continues as in year 2000 and all $^{85}$Kr released to atmosphere | $1.9 \times 10^{-9}$ $\mu$Ci/cc |
| Maximum level specified in regulations for continuous exposure to any individual | $3 \times 10^{-7}$ $\mu$Ci/cc |

a. Cowser et al., 1966.

b. This is the volume if the whole atmosphere, with a mass of $5.1 \times 10^{21}$ g had a uniform density, equal to 0.0012 g/cc (density of air at 760 mm pressure and 20°C).

Regulations (Title 10, Part 20) specifies a maximum concentration of $3 \times 10^{-7}$ $\mu$Ci/cc in the environment for unrestricted exposure. Thus, the potential atmospheric concentration due to uncontrolled discharge of $^{85}$Kr within the next 60 yr will be a small percentage of the present limit for continuous exposure.

The limit of $3 \times 10^{-7}$ $\mu$Ci/cc is consistent with a maximum dose of 500 mrem/yr produced from continuous exposure to radiation from $^{85}$Kr. The dose is imparted almost entirely by beta particles incident upon the surface of the body, since only 1 percent of the emitted energy is carried by gamma photons. Thus only the outermost regions of the body are exposed. For this reason there is much less concern about producing low levels of environmental contamination from $^{85}$Kr than for some other radionuclide with a greater yield of penetrating gamma photons that would irradiate the gonads and blood-forming organs. The gamma dose from $^{85}$Kr is 7 mrem/yr at the concentration limit.

There is also a beta-particle contribution to the dose inside the body from gas that is dissolved in the body fluids. Since the concentration (in the body) of krypton at equilibrium with body tissues other than fat is approximately 1/20 the concentration in the surrounding air (JCAE, 1969, p. 255), the internal dose from this source is negligible.

The worldwide distribution of $^{85}$Kr will be maintained well below the levels allowed by regulatory agencies, because the releases from any particular power plant must satisfy restrictions established on behalf of the local populations. Estimates of $^{85}$Kr releases reported for various facilities are given in table 6.16. Thanks to use of appropriate meteorological controls, releases of $^{85}$Kr and other radionuclides to the atmosphere have to date produced exposures well below statutory limits.

**Table 6.16.**   Krypton-85 release from various nuclear power facilities and processes.

| Facility/process | Amount released |
|---|---|
| Production in fission reactors per Mw(e) or 3 Mw(t)[a] | 480 Ci/yr |
| Release from a water-cooled nuclear power plant—1000 Mw(e)[b] | 200 Ci/hr |
| Release from a single fuel reprocessing plant[c] | 6300 Ci/day |
| Production in nuclear explosions using fusion, 10 Kt fission/Mt fusion[a] | 240 Ci/Mt |

a. See note to table 6.18 for data used in calculations.

b. Upper limit estimated from discharge rates (Goldman, 1968, p. 778; Kahn et al., 1970, table 4.1).

c. Davies, 1968.

## 4.4   Population Exposure (Internal) from Radiopharmaceuticals

With the growth of nuclear medicine, radioactive drugs have become the largest manmade source of internal exposure of the population. New applications occur continually for diagnosing abnormal conditions, evaluating organ function, and imaging organs in the body. The number of diagnostic examinations appears to be doubling every 3 years. The frequency of radio-pharmaceutical application increased from .32/1000 population in 1955 to 32/1000 in 1975 in West Berlin, and from 1.5/1000 in 1965 to 9.9/1000 in 1974 in the German Democratic Republic (UNSCEAR, 1977, p. 331).

Most examinations using radiopharmaceuticals give organ doses the same or less than those of complementary x-ray examinations, with the exception of the use of $^{131}$I for examination of the thyroid. However, progressive medical institutions are largely abandoning the use of $^{131}$I as a diagnostic tool, replacing it with shorter-lived $^{99m}$Tc for scanning and in vitro T-3 and T-4 tests for uptake.

The major reason for the phenomenal success of nuclear medicine techniques in diagnosis was the introduction in the mid 1960s of technetium-99m, a short-lived (6 hr) radionuclide that can be tagged on to many diagnostic agents. Because of its short half-life, $^{99m}$Tc produces much lower doses than the much longer-lived agents that it has replaced. Examples of the doses imparted in nuclear medicine are given in part III, section 5.9.

## 4.5   Population Exposure (Internal) from Environmental Pollutants

The atmosphere provides a convenient receptacle for the discharge of waste materials. It carries offensive wastes away from the polluter's environment and, if the wastes are particulate, spreads them thinly before dumping them back on the ground. In the case of gaseous wastes, the enormous capacity of the reservoir provided by the atmosphere dilutes the discharges to such low levels that the effects of individual discharges are seldom significant. Usually, it takes a continual accumulation of wastes, with the absence of any

accompanying removal process, to lead to the establishment of levels that cause concern.

The initial dilution of waste introduced into the atmosphere near the surface of the earth takes place in the lower part of the atmosphere (the troposphere—an unstable turbulent region 10–15 kilometers in depth). It is capped by a stagnant region known as the tropopause. Measurements on radioactive fallout indicate it takes about 20 to 40 days for half the particulate matter in the troposphere to settle out.

The region above the tropopause is called the stratosphere. Under normal discharge conditions, it does not receive wastes. It takes something like a megaton hydrogen bomb explosion to propel the contaminants into the stratosphere. Because of the relative isolation between stratosphere and troposphere, the activity deposited in the stratosphere is returned to the lower levels at a low rate. The time for half the fallout from air-burst bombs to leave the stratosphere is about eight months. Data on volumes available for diluting wastes injected into the earth's atmosphere are presented in table 6.17.

### 4.5.1   Fallout from Bomb Tests

A considerable amount of radioactivity has been injected into the atmosphere as a result of nuclear bomb tests. The radionuclides in the resultant fallout that present the greatest ingestion hazard are $^{131}I$, $^{90}Sr$, $^{89}Sr$, and $^{137}Cs$. Other radionuclides of interest are $^{14}C$, $^{3}H$, $^{239}Pu$, and $^{238}Pu$. Data on the quantities of these radionuclides produced in various nuclear operations are given in table 6.18. Power reactor data are included for later reference.

A summary of the bomb tests conducted in the atmosphere is given in table 6.19. The explosive power from fission alone was over 200 megatons and actually amounted to a small percentage of the megatonnage which has been postulated for a hypothetical full-scale nuclear engagement between the major nuclear powers.

The behavior of fallout has been studied closely, and extensive data are available on its deposition, incorporation into the food chain, and subsequent ingestion and metabolism by man. The radionuclide that has been in-

**Table 6.17.**   The earth as a global dump.

| | |
|---|---|
| Radius of earth | $6.37 \times 10^{8}$ cm |
| Surface area of earth | $5.11 \times 10^{18}$ cm$^2$ |
| Area of earth between 80° N and 50° S | $4.48 \times 10^{18}$ cm$^2$ |
| 0–80°N | $2.51 \times 10^{18}$ cm$^2$ |
| 0–50°S | $1.96 \times 10^{18}$ cm$^2$ |
| Height of troposphere | $1.28 \times 10^{6}$ cm$^3$ |
| Volume of troposphere | $6.5 \times 10^{24}$ cm$^3$ |
| Volume of gas in troposphere at 76 cm, 20°C | $2.9 \times 10^{24}$ cm$^3$ |

**Table 6.18.**  Magnitudes of sources (megacuries) associated with various nuclear operations.

| Radionuclide (half-life) | $^{131}I$ (8 days) | $^{137}Cs$ (30 yr) | $^{89}Sr$ (51 days) | $^{90}Sr$ (28 yr) | $^{14}C$ (5700 yr) | $^{3}H$ (12.3 yr) | $^{85}Kr$ (10.8 yr) |
|---|---|---|---|---|---|---|---|
| 1 megaton fission explosion in atmosphere | 113 | 0.169 | 29.6 | 0.181 | 0.020[a] | 0.0007[b] | 0.024 |
| 1 megaton fusion explosion in atmosphere | | | | | 0.020[a] | 10–50[b] | |
| 1000 megawatt (thermal) reactor | | | | | | | |
| After 1 mo operation | 22.5 | .095 | 13.6 | .129 | | .00039 | .014 |
| After 1 yr operation | 25.1 | 1.13 | 40.2 | 1.24 | | .0046 | .169 |
| After 5 yr operation | 25.1 | 5.90 | 40.2 | 5.60 | | .021 | .720 |
| Equilibrium level | 25.1 | 49.5 | 40.2 | 49.5 | | .084 | 2.51 |

*Note*: Calculations for the yield of fission products are based on $1.45 \times 10^{26}$ fissions/megaton fission energy (Glasstone, 1962), where 1 megaton is the energy equivalent of the explosion of one million tons of TNT or the complete fissioning of 56,000 g of $^{235}U$. Other megaton equivalents are $10^{15}$ calories, $1.15 \times 10^{9}$ kilowatt-hours, and $1.8 \times 10^{12}$ BTU.  The fission yields for the radionuclides presented in the table in atoms per hundred fissions are $^{90}Sr$, 5.9; $^{89}Sr$, 4.8; $^{137}Cs$, 5.9; $^{85}Kr$, 0.3; $^{3}H$, 0.01; $^{131}I$, 1.9 (Etherington, 1958).  The large thermonuclear explosions produced during weapons testing provided the energy approximately equally from fission and fusion.  Calculations for the 1000 megawatt reactor are based on the conversion factor, 1 watt (thermal) = $3.1 \times 10^{10}$ fissions/sec.

a. *USAEC*, 1959.

b. Jacobs, 1968.

**Table 6.19.**    Summary of nuclear weapons tests conducted in the atmosphere.

| Inclusive years | Country | No. of tests | Megaton range | Fission yield (megatons) | Total yield (megatons) |
|---|---|---|---|---|---|
| 1945–1951 | U.S. | 24 | 0 | 0.8 | 0.8 |
| | U.S.S.R. | 3 | 0 | | |
| 1952–1954 | U.S. | 27 | 3 | | |
| | U.K. | 3 | 0 | 38 | 60 |
| | U.S.S.R. | 3 | 0 | | |
| 1955–1956 | U.S. | 22 | 1 | | |
| | U.K. | 6 | 3 | 13 | 28 |
| | U.S.S.R. | 11 | 3 | | |
| 1957–1958 | U.S. | 78 | 2 | | |
| | U.K. | 12 | 7 | 40 | 85 |
| | U.S.S.R. | 38 | 14 | | |
| 1959–1960 | Moratorium on Air Burst Bomb Tests by U.S.A. and U.S.S.R. | | | | |
| 1961 | U.S.S.R. | 31 | ? | 25 | 120 |
| 1962 | U.S. | 36 | ? | 16 | 217 |
| | U.S.S.R. | 37 | ? | 60 | |
| 1964–1965 | China | 2 | 0 | .06 | .06 |
| 1966–1968 | China | 6 | 2 | 4.1 | 6.6 |
| | France | 13 | 2 | 3 | 4.7 |
| 1969 | China | 1 | 1 | 1.5 | 3 |
| 1970–1971 | China | 2 | 1 | 1.5 | 3 |
| | France | 8 | 3 | 1 | 2.5 |
| 1972–1973 | China | 3 | 1 | 1.5 | 2.5 |
| | France | 7 | | | |
| 1974 | China | 1 | 1 | .6 | .6 |
| | France | 8 | 1 | | 1.5 |
| 1976 | China | 3 | 1 | 2.2 | 4.2 |
| 1977 | China | 1 | | .02 | .02 |

*Sources:* Telegadas, 1959; Hardy, 1970; FRC, 1963; Telegadas, 1977; Carter and Moghissi, 1977.

*Note:* The largest nuclear test had a total yield (fission plus fusion) of 58 megatons, and was conducted by the USSR in 1961. In 1962 the USSR again conducted two high-yield tests, about 30 MT each. The largest test conducted by the U.S. was 15 MT in 1954.

vestigated in greatest detail is $^{90}$Sr because of its abundance, long half-life, and long-term incorporation in bone (see fig. 6.3). A total of 15 megacuries fell to the earth prior to January 1970. This represents almost all the fallout that will occur unless major testing is resumed. Estimates of the fallout deposited per unit area on the surface of the earth are made by averaging over the area between 80 °N and the equator for deposition in the Northern Hemisphere, and between 50 °S and the equator for deposition in the Southern Hemisphere, since this includes over 97 percent of the deposition

(UNSCEAR, 1966, p. 6). The fraction of the fallout that deposits in each hemisphere depends on the site of the tests, the nature of the explosion, and the time; so far, about 76 percent of the fallout has been deposited in the Northern Hemisphere; the Northern and Southern hemispheres received 12.1 and 3.9 megacuries respectively through 1975.

The amount of fallout in different areas within a hemisphere varied considerably. For example, fig. 6.4 shows the annual deposition of $^{90}$Sr in the Northern Hemisphere as a whole and in New York City. Taking the year in which the greatest deposition occurred, 1963, we note that the deposition in the Northern Hemisphere was 2.6 megacuries, and the deposition in New

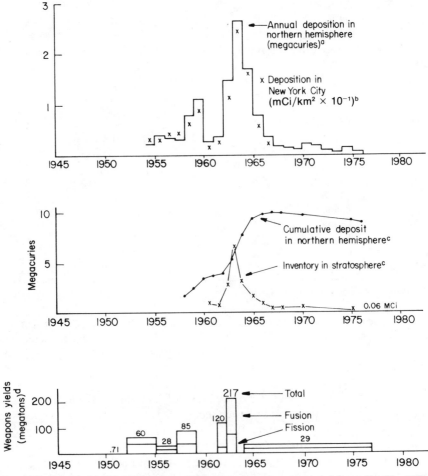

**Fig. 6.4** Worldwide dissemination of $^{90}$Sr from weapons tests, (a) from HASL, 1970, report 223; (b) from Volchok, 1967; (c) from UNSCEAR, 1969; UNSCEAR 1977 and (d) FRC, 1963, report 4; Carter and Moghissi, 1977.

York City, 24 mCi/km². Averaged over 0–80 °N, where almost all the fallout occurred (an area of $2.51 \times 10^8$ km²) the average deposition in the Northern Hemisphere was 10.3 mCi/km², or less than half the deposition per square kilometer in New York City.

Values of the doses received by the world population as a result of exploding nuclear bombs in the atmosphere are presented in table 6.20. Both external and internal sources are included for comparison. The doses are expressed in terms of dose commitments, defined here as the dose delivered during complete decay of the radioactivity (except for [14]C, which is calculated to year 2000).

From table 6.20 it can be seen that the dose commitment from fallout is low. However, large local deviations from the average deposition levels have been found. For example, in the Minot-Mandan region of North Dakota, [90]Sr levels in milk increased steadily from 33 pCi/g calcium in August 1957 to 105 in the spring of 1963 (Pfeiffer, 1965). This is four times the levels shown in fig. 6.5. The higher levels, however, are still less than those believed to be cause for concern by regulatory agencies in the United States (that is, the Federal Council on Radiation Protection specified 200 pCi/g calcium as the point at which intake should be monitored, the lower limit of their so-called Range III).

More serious deposition incidents occurred in the 1950s in the United States from fallout injected into the lower atmosphere following tests of kiloton weapons in Nevada. The fallout was high in many cities far removed from the tests. For example, data from the gummed film network operated

**Table 6.20.** Dose commitments to population in north temperate zone from bomb tests.

| | External | Internal | | |
|---|---|---|---|---|
| Source | | Gonads | Cells lining bone surface | Bone marrow |
| [137]Cs | 62 | 27 | 27 | 27 |
| [90]Sr[a] | | | 120 | 84 |
| [89]Sr | | | | 0.4 |
| [14]C[b] | | 7 | 29 | 32 |
| Short-lived fission products | 48 | | | |

The column group "Internal" spans Gonads, Cells lining bone surface, and Bone marrow. The overall heading is "Dose commitment (mrad)".

*Source:* UNSCEAR, 1977, p. 153.

a. The evaluation of the dose to bone from an intake of [90]Sr is a complex procedure (see Spiers, 1968). For long-term ingestion, a concentration of 1 picocurie of [90]Sr per gram calcium in the skeleton will give a dose of 1.4 mrad/yr to bone lining cells and 0.7 mrad/yr to bone marrow.

b. Dose commitment calculated to year 2000.

by the USAEC gave fallout levels as high as 80 $\mu$Ci/m² in Albany, New York, 75 in Salt Lake City, 65 in Roswell, New Mexico, and 25 in Boston (Tamplin and Fisher, 1966).

One of the highest fallout incidents occurred in Troy, New York, in 1954, as discussed earlier in connection with external radiation exposure. Levels as high as $13 \times 10^6$ dis/min per square foot of ground area were observed, and it was estimated that about 50 Ci of fission products were introduced into the Tomhannock Reservoir alone the first day. Activity of tap water (not from the Tomhannock supply) was 2.62 pCi/ml at 1 day after arrival. However, the activity was short-lived, as is characteristic of fresh fallout, and was down to 0.034 pCi/ml 16 days later.

Fallout that arrives within days of a nuclear detonation has a high content of radioactive iodine, which becomes concentrated in the thyroid after ingestion and produces a high local dose. It has been estimated that a contamination of forage by $^{131}$I of 1 $\mu$Ci/m² will lead to a dose of 30 rad to the thyroid of an infant fed milk of cows that grazed in the contaminated pasture. Particularly high levels of iodine were deposited in Nevada and adjacent states after many of the bomb tests conducted at the Nevada test site. According to Tamplin and Fisher (1966) thyroid doses above 100 rads were probably received by children who drank milk from cows which grazed in the areas exposed to these levels of fallout.

Serious contamination occurred as an aftermath to the 1954 Bikini Atoll thermonuclear bomb test discussed previously in section 4.3.2. The individuals living in the Rongelap Island were in close contact with the fallout for many days before they were removed from the contaminated environment. As a result, they accumulated body burdens of radionuclides: 6 $\mu$Ci of $^{131}$I, 3 $\mu$Ci of $^{140}$Ba, and 2 $\mu$Ci of $^{89}$Sr. The iodine produced substantial thyroid doses: about 10–15 rad, which was small, however, compared to the dose from the external radiation. It may be noted that the $^{131}$I activity was approximately that normally administered in thyroid function tests, which are very common in medical practice. The accumulated body burdens were considered to be surprisingly low in view of the extremely heavy contamination that existed, and the amounts of radionuclides deposited in tissues did not contribute appreciably to the overall effects observed. After three and a half years, the Rongelap inhabitants were allowed to return to their island. Because of the residual comtamination, they continued to accumulate $^{90}$Sr, although the levels are well below current recommended limits.

### 4.5.1.1 Strontium-90

The uptake of $^{90}$Sr in living matter has been studied intensively. In foods and in the body $^{90}$Sr levels are almost always given in terms of strontium activity per unit mass of calcium (picocuries of strontium per gram calcium), since the strontium and calcium follow similar pathways. However, the body discriminates against strontium, and the concentration of strontium relative to calcium in the body is about 25 percent of that in food.

Levels in the bones of children in the 1–4 yr age group as high as 11.8 pCi $^{90}Sr/g$ Ca were reported from Norway in 1965. Measurements made in New York City in 1965 showed a peak of 7 pCi/g in the bones of children between 1 and 2 years of age. The levels decreased to 4 pCi/g in 1967 and 1.6 in 1975 in children 4 years old. Levels in the 5–19 year age group were about 3 pCi/g in the 1956–1968 period and down to 1.4 in 1975 (UNSCEAR, 1969, 1977). Levels for the $^{90}Sr$–Ca ratio in milk measured in New York City peaked at 26 pCi/g in 1963, were down to 9 pCi/g by 1968, and 4 pCi/g in 1977 (Hardy and Rivera, 1965; Bennett and Klusek, 1978). In Norway and Ireland levels several times higher were found.

From consideration of the uptake data, it has been possible to make some general correlations between amount of $^{90}Sr$ deposited and subsequent appearance of this nuclide in milk. One relationship (UNSCEAR, 1966) is

Yearly average $^{90}Sr/Ca$ ratio in milk supplies, pCi/g
$\qquad$ = 0.3 (total accumulated $^{90}Sr$ deposit in soil, mCi/km$^2$)
$\qquad\qquad$ + 0.8 (yearly fallout rate of $^{90}Sr$ in given year, mCi/km$^2$.)

The daily intake of $^{90}Sr$ by residents of New York City and San Francisco for the period 1960–1978 is shown in fig. 6.5. The intake was calculated from data on the $^{90}Sr$ content of the foods in a representative diet which provided a yearly intake of 350 g Ca out of a total mass of 637,000 g. Dairy products (200 kg/yr) provided 58 percent of the calcium; vegetables, 9 percent; fruit, 3 percent; grains, 20 percent; and meat, fish and eggs, 10 percent (Bennett and Klusek, 1978). The maximum intake was 35 pCi/g Ca in 1963.

### 4.5.1.2 Carbon-14

The distribution of carbon-14 has been followed in some detail. The radiocarbon is produced in significant quantities in atmospheric thermonuclear explosions as a result of absorption of neutrons by the nitrogen in the air. Since it occurs mainly as carbon dioxide (a gas), it does not settle to the ground as do the particles that comprise fallout; eventually it is incor-

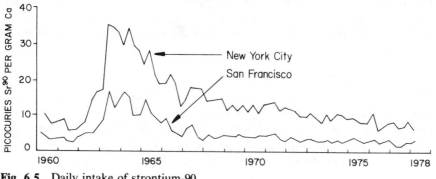

**Fig. 6.5** Daily intake of strontium-90.

**Table 6.21.** Global carbon inventories.

| Region | | Natural content prior to bomb tests | |
|---|---|---|---|
| | | Elemental carbon $(10^{18}/g)$ | $^{14}C$ $(10^{27}$ atoms) |
| Atmosphere | | 0.61 | 40 |
| Biosphere | | 0.31 | 19 |
| Humus | | 1.0 | 55 |
| Surface water of ocean (above thermocline) | | 0.92 | 55 |
| Remainder of ocean | | 38 | 2000 |
| | Total | 41.4 | 2170 |

| | Excess $^{14}C$ as a result of bomb tests (percent above normal) | |
|---|---|---|
| | 1965 | 1980 (est.) |
| Troposphere | 69 | 28 |
| Ocean (surface) | 13 | 17 |

*Source:* UNSCEAR, 1977, p. 119.

a. Natural production rate of $^{14}C$ is $3.7 \times 10^{26}$ atoms/yr; 2.3 atoms cm$^2$-sec; 0.038 MCi/yr.

porated into living tissue through the pathways involved in the carbon cycle. Dilution of $^{14}C$ is limited initially to the atmosphere, surface waters of the ocean, and living matter. Eventually, after many years, the $^{14}C$ becomes further diluted by transfer to the much larger mass of carbon in the deeper part of the ocean. The magnitudes of the carbon reservoirs and of $^{14}C$ inventories produced by both natural processes and bomb tests are given in table 6.21.

The transfer to different compartments is reflected in measurements of atmospheric $^{14}C$ generated from bomb tests. The peak introduction of $^{14}C$ approximately doubled the natural atmospheric activity, but the level is gradually decreasing due to absorption in the oceans. By the year 2040 the activity of $^{14}C$ will be only 3 percent above the normal atmospheric level—if there are no further air-burst bomb tests.

### 4.5.1.3 Iodine-131

Iodine-131 is a fission product which becomes concentrated in the thyroid after ingestion and produces a high local dose. The fission products also contain other radioisotopes of iodine, but these are much less important. The highest levels of radioiodine in people occurred during the early years of weapons testing in the United States in the 1950s in parts of Utah and Ne-

vada in the path of fallout from the Nevada test site. However, there was no serious program to measure environmental levels and doses. The short-lived [131]I disappeared during the three-year moratorium beginning in 1958, but when testing resumed with a vengeance in the fall of 1961 detailed studies of the transport and uptake of [131]I were made (Bustad, 1963). These included the monitoring of radioiodine in milk nationwide through the Pasteurized Milk Network (PMN) of the U.S. Public Health Service. The highest levels were reported for Palmer, Alaska, with a peak monthly average (in September 1962) of 852 pCi/l and Salt Lake City with a peak monthly average (in July 1962) of 524 pCi/l. The maximum concentration found in the milk in Palmer was 2530 pCi/l (Dahl et al., 1963).

Other milk samples showed, in pCi/l, 2000 (Salt Lake City, Utah), 1240 (Spokane, Washington), 700 (Dallas, Texas), and 660 (Wichita, Kansas). These were associated with levels of gross beta activity in precipitation that ranged from 100,000 to 200,000 pCi/m² and concentrations in the air that ranged from 10–800 pCi/m³. The air concentrations were averaged over a 24-hr period (Machta, 1963).

About 23 billion curies of [131]I were injected into the atmosphere from the 200 megatons of fission explosive power produced in weapons tests. Most of the dose to humans from the resultant fallout occurred from the contamination of forage and ingestion through the cow-milk chain. It has been estimated that a contamination of forage by [131]I of 1 $\mu$Ci/m² will lead to a dose of 30 rad to the thyroid of an infant fed milk of cows that grazed on this contaminated pasture.

In 1962, the concentration of radioiodine in milk in the United States averaged over the year was 32 picocuries (pCi) per liter, resulting in an annual dose of 200 mrad to the thyroid glands of infants 6–18 months old (consumption 1 l/day, uptake 30 percent, thyroid mass 2 g, effective half-life 7.6 d Eisenbud, 1968; FRC, 1961). This annual dose was probably typical over a decade of weapons testing. While most of the dose resulted from ingestion of milk, there was also a contribution from inhalation. Levels in air were 3.8 pCi/m³ in October 1961. Since a 1-year-old inhales 1 m³ air per day, this gives an annual dose of 24 mrad. The average daily concentration of 32 pCi/l results in an integrated annual milk concentration of 32 × 365 or 11.7 nCi-d/l. Integrated annual milk concentrations resulting from later periods of weapons testing were, in nCi-days/l: 3.7 (Houston, 1967); 0.9 (Nashville, 1972); and 27 (Buenos Aires, 1966). When other data were not available, the integrated concentration was taken as 10 times the highest observed concentration in nCi/l. To convert these figures to dose to infants, UNSCEAR (1977) assumed a daily milk consumption of 0.7 l and the conversion factor, nCi-days/l × 11.5 = mrad to thyroid. Thus the associated infant doses were 42.6, 10.4, and 311 mrad respectively for the year.

Little is known about doses to the fetus from [131]I, and the data available show a wide variation in the relative dose to the fetus compared to children

and adults.  Thus, the concentration in pCi/g was measured to be 9 times greater in a 12-week fetus than in the thyroids of children, the ratio dropping sharply with fetal age for other measurements (Eisenbud, 1968).  On the other hand, measurements made on a pregnant woman who died suddenly gave a fetal concentration which was 30 percent greater than in the mother (Beierwaltes et al., 1963).

Because of the failure to monitor for radioiodine in the early 1950s, the dose to the thyroids of infants during that period must be inferred from available data on gross beta activity in air (Pendleton et al., 1963).  The 1962 data indicated that a beta activity of 3400 pCi/m$^3$ in air was associated with an intake in infants of 58,000 pCi $^{131}$I with a resultant dose of 1 rad to the thyroid.  The beta activity was determined from the maximum concentration averaged over 24 hr and corrected to 1 day after the detonation, assuming a (time)$^{-1.2}$ variation in activity.  On this basis, a 24-hr average air concentration of 287,000 pCi/m$^3$ measured in St. George, Utah in 1953 was assumed to have resulted in an average infant thyroid dose of 84 rad.  The highest dose evaluated for 1962 was 14 rad (800,000 pCi intake).

### 4.5.2  Release of Plutonium to the Environment

Over five thousand kilograms (320 kCi) of plutonium have been injected into the stratosphere and subsequently deposited worldwide as a result of testing programs related to the development of nuclear weapons.  In addition, one kilogram (17 kCi) of plutonium-238, which was used as fuel for a power pack, vaporized into the atmosphere as the result of the burn-up of a United States Snap 17A satellite.  The environmental consequences of these releases may be summarized as follows (Wrenn, 1974):

Total explosive power in weapons tests, 1945–1973
  Equivalent to more than 200 million tons of TNT (200 MT).
Plutonium released (as insoluble particles of oxide):
  5480 kg, 440 kCi (58% $^{239}$Pu, 39% $^{240}$Pu, 3% $^{238}$Pu)
Plutonium deposited near the testing sites:

| | | | | |
|---|---|---|---|---|
| $^{239}$Pu | 1039 | kg | 64 | kCi |
| $^{240}$Pu | 180 | kg | 43 | kCi |
| $^{238}$Pu | 0.19 | kg | 3.3 | kCi |

Plutonium deposited worldwide from stratosphere (residence half-time about 1 yr):

| | | | | |
|---|---|---|---|---|
| $^{239}$Pu | 3117 | kg | 191 | kCi |
| $^{240}$Pu | 567 | kg | 129 | kCi |
| $^{238}$Pu | 0.57 | kg | 9.9 | kCi |

Deposited in the soils of conterminous United States:
                    10–15 kCi
Still suspended in atmosphere (1975):
                    less than 1 kCi

Additional contribution from burnout of SNAP power supply:
$^{238}$Pu            0.98 kg            17 kCi
Additional alpha activity from americium-241 (25 percent of plutonium activity):
$^{241}$Am                                110 kCi

The plutonium alpha activity deposited from fallout may be compared to the activity from the actinides occurring naturally in U.S. soil. Since soils contain typically 1 pCi/g of both uranium and thorium, it is estimated that the top 2 cm contain 1.6 million curies of uranium and thorium and 4.4 million curies of all alpha emitters (including the decay products). The concentration and amount of activity from Pu-238, -239, -240 in surface soil (top 2 cm) is about 1 percent of the natural background activity (Wrenn, 1974).

The worldwide release of plutonium resulted in the following local levels (New York) about a decade after the peak activity (UNSCEAR, 1977). These levels were subsequently changing at only a slow rate.

| | | |
|---|---|---|
| Cumulative deposition density, 1974 | 2.68 | mCi/km² |
| Average deposition density rate, 1972–1974 | 0.017 | mCi/km²-yr |
| Air activity 1972 | 0.031 | fCi/m³ |
| 1963 (peak) | 1.7 | fCi/m³ |
| Cumulative intake by inhalation, 1954–1975 | 43 | pCi |
| Average annual dietary intake, 1972–1974 | 1.6 | pCi |
| Maximum activity in body 1974 | 2.4 | pCi |
| 1964 | 4 | pCi |
| Average plutonium contents of body organs, 1972–1973 | | |
| Lung, 1 kg | 0.27 | pCi |
| Liver, 1.7 kg | 1.16 | pCi |
| Lymph nodes 0.015 kg | .17 | pCi |
| Bone, 5 kg | 1.55 | pCi |
| Cumulative organ doses to year 2000 from inhalation | | |
| Lungs | 1.6 | mrad |
| Liver | 1.7 | mrad |
| Bone-lining cells | 1.5 | mrad |

Bone dose from ingestion
The dose rate from plutonium fixed in bone is 0.098 mrad/yr-pCi. Assume 1.6 pCi/yr ingested in diet (steady state, resulting from cumulative deposit of 2.65 mCi/km²), $3 \times 10^{-5}$ absorbed through GI tract and 45 percent transported to bone. Assume ingestion for 70 years, or an average residence time of 35 years. Total dose in 70 yr is $35 \times 1.6 \times 3 \times 10^{-5} \times 0.45 \times 0.098 = 7.4 \times 10^{-5}$ mrad.

The $^{239}$Pu accumulation is uneven; the areas with greater rainfall generally have higher fallout. Typical cumulative deposits (by 1971), in mCi/km² are

2.3 for the eastern half of the country and 0.8 for the coastal part of California. The vertical distribution of plutonium in soil has been measured at several sites. About 80 percent was found to be deposited in the top 5 cm in a sandy loam sample from New England, and measurable quantities were found down to 20 cm ($^{137}$Cs exhibits a similar behavior; $^{90}$Sr is retained somewhat less in the top soil and can be found down to 30 cm).

### 4.5.3  Atmospheric Pollutants from a Nuclear Power Industry

With the discontinuance of large-scale atmospheric testing of nuclear weapons, the major man-made contaminants introduced into the environment in the absence of nuclear warfare will result from the use of nuclear power reactors to produce electricity or from the possible employment of nuclear explosives for excavation or other industrial activities. Contamination of the atmosphere on a large scale occurs from these sources primarily as a result of the release of radioactive gases such as $^{85}$Kr, $^{14}$C, and tritium. Data on the production of these atmospheric contaminants are presented in table 6.18. Exposure from $^{85}$Kr was discussed in section 4.3.3, since it is primarily a source of external exposure.

Interest in atmospheric sources of internal exposure has been centered on tritium and $^{14}$C. The tritium is produced as a waste by-product in both nuclear power reactors and thermonuclear explosions. In nuclear fission reactors, the tritium nucleus is produced as one of the products of fission, with a yield of 1 atom in 10,000 fissions. It is also produced in large amounts in reactions of the thermal neutrons in the reactor with lithium-6 and boron, which may occur either as impurities or as neutron absorbers for reactor control. Data on levels of tritium and resultant doses which might occur by the year 2000 in a nuclear power economy are given in table 6.22. In ther-

**Table 6.22.**  Tritium production and dose rates from fission power production.

| | |
|---|---|
| Background production rate | 4–8 MCi/yr |
| Production rate from nuclear power in year 2000[a] | 15 MCi/yr |
| Accumulated activity by year 2000 from nuclear power | 96 MCi |
| Steady state inventory, based on continued production rate at level predicted for year 2000 | 260 MCi |
| Volume for dilution (circulating water) | $2.74 \times 10^{16}$ m$^3$ |
| Concentration in H$_2$O | $3.5 \times 10^{-9}$ $\mu$Ci/ml |
| Concentration in atmosphere[b] | $8.6 \times 10^{-14}$ $\mu$Ci/cm$^3$ |
| Annual dose from drinking water | $5.6 \times 10^{-4}$ mrem |
| Annual dose from inhalation and absorption of water through skin | $2.6 \times 10^{-4}$ mrem |

*Source:* Jacobs, 1968, Table 6.1.

a. Based on $3320 \times 10^3$ Mw (th); load factor of 0.7 at year 2000.

b. Atmospheric concentrations based on 0.47% of water present in atmospheric water vapor in first 10 km of earth's surface (volume $5.1 \times 10^{18}$ cm$^3$).

monuclear detonations, tritium is released primarily as a residual component of a deuterium explosive. Tritium release to the atmosphere is not likely to be a limiting factor in considerations involving large-scale peacetime use of thermonuclear explosives.

Tritium released to the air is diluted within a few years in the earth's circulating water, which has a volume of $2.74 \times 10^{22}$ cm$^3$. However, because meteorological processes tend to favor initial retention of the wastes in the latitudes in which they are released, most of the initial dispersion has been limited to the Northern Hemisphere, with perhaps half the tritium depositing on 10 percent of the earth's surface.

About 1700 megacuries of tritium were released to the atmosphere as a result of the testing of nuclear bombs, adding to the 60–125 megacuries already present (mainly in the waters of the earth) from natural sources. An interesting comparison of the world tritium inventories projected for a nuclear power economy, and inventories of tritium produced naturally and as a result of past bomb tests, is given in fig. 6.6. Although in a nuclear-power economy based on fission reactors tritium may pose some local contamination problems, its effect on worldwide population dose will be negligible.

Carbon-14 production is of significance only as a result of the detonation of thermonuclear explosives in the atmosphere, and results from reactions of the large numbers of neutrons produced in these explosions with the nitrogen in the air. Since nonmilitary explosives are of interest only for use underground, $^{14}$C production will not be significant in industrial applications of thermonuclear explosives.

## 5. Population Exposure from Radiation Accidents

In spite of the great attention to safety in the design, construction, and operation of nuclear devices and facilities, accidents have occurred. We shall review several that have resulted in significant environmental releases, including chemical explosions involving nuclear weapons, fires at a plutonium processing plant, and the overheating of the core of a nuclear power reactor. The details of these accidents and the responses to them are invaluable to all concerned with the large-scale use of nuclear energy and radiation, whether from the viewpoint of accident prevention, emergency planning, or political and social responsibility.

### 5.1  Palomares, Spain—Atomic Bombs Drop from the Sky in an Accident, Igniting and Contaminating a Countryside

A portentous incident occurred over Palomares, Spain, in January 1966, when a U.S. Air Force bomber carrying four atomic bombs collided with a refueling plane. The bombs fell to the ground. No nuclear explosion occurred, but the high explosive components of two weapons detonated upon impact, one in low mountains and the other on land used for agriculture, setting the weapons on fire. Clouds of plutonium were released into the air and

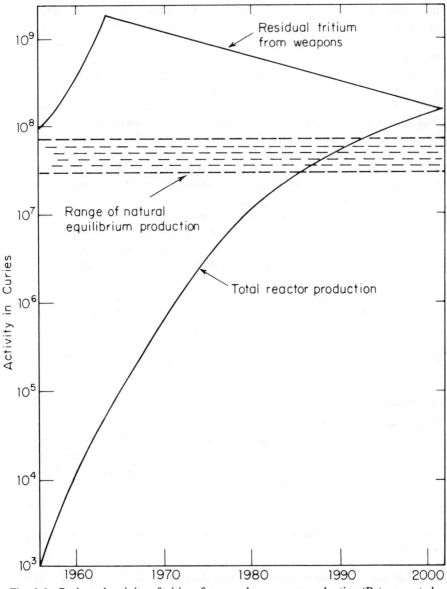

**Fig. 6.6**    Projected activity of tritium from nuclear power production (Peterson et al., 1969).

dispersed by a 35-mph wind, contaminating the countryside with highly radioactive plutonium particles.    An area one-half mile long and one-sixteenth of a mile wide was contaminated with 50 to 500 $\mu g/m^2$.    Low levels of plutonium were detectable to a distance of approximately two miles.

The United States and the Spanish governments agreed that soil contami-

nated with more than 32 $\mu$Ci/m² (521 $\mu$g/m²) would have the top 10 cm removed for disposal in the United States; removed soil would be replaced where needed with soil free of plutonium from the incident; and crops in fields with contamination levels above 5 $\mu$g/m² would be removed and destroyed.

The incident caused a tremendous stir. To quote from Flora Lewis's book, *One of Our H-Bombs Is Missing* (1967, chapter 7): "By two weeks after the accident there was a solidly based community of 64 tents, 747 people, a motor pool, a kitchen with 22 cooks who baked 100 loaves of bread a day, a PX, and a nightly open-air movie (p. 95). . . . In the end, 604 acres (nearly a square mile) were treated either by soil removal or by plowing, with topsoil carried away wherever the reading showed anything above 60,000 counts per square meter. . . . The decontamination job took eight weeks . . . 4879 blue metal 55 gallon drums were filled with contaminated soil, loaded on barges that came up on the beach, and transferred at sea to the USNS Boyce" for transfer to the United States and burial.

About 90 percent of the activity appeared to have been in the top 15 cm of soil. Surface activities following decontamination were as high as 5000 dis/min/g, with 120 dis/min/g reported as an average. Levels in plants (tomatoes, maize, beans, alfalfa) ranged between 0.02 and 6 dis/min/g(wet), and in fruit were about 0.003 dis/min/g. Measurements on control plants in Spain ranged from 0.02–0.2, and on fruit between 0.003 and 0.0009. In the U.S., values were reported between 0.0007 and 0.02. Urine samples were taken from the 100 villagers most likely affected and "insignificant levels" of the order of 0.1–0.2 dis/min per 24-hr sample were obtained from 30 samples. Chest counts were also taken to determine the presence of activity in the lungs (at the level of detection) and no positive counts were found.

Six years after the accident, there appeared to be little change in the community, according to the U.S. Atomic Energy Commission. Farming habits had changed, but mostly due to other factors such as drought, flash flooding, and economics. Follow-up studies showed little change in exposed persons and none was expected.

## 5.2  Thule, Greenland—A Bomber Crashes and Its Nuclear Weapons Ignite

In January 1968, a U.S. Air Force plane carrying four nuclear weapons crashed on ice in the artic near Thule, Greenland, while attempting an emergency landing necessitated by an on-board fire (EPA, 1974). The weapons were unarmed and no nuclear explosion occurred, but the high-explosive components of all four weapons detonated on impact, igniting the fuel and producing an intense fire. All this occurred while the debris produced by the crash was propelled at a high forward velocity. The fire continued to burn for at least 220 min, producing a cloud that reached a height of approximately 2400 ft and a length of about 2200 ft. The burning plutonium was converted largely to extremely insoluble oxides and dispersed as fine insolu-

ble particles, from fractions of a micron to several microns in diameter. Particles of plutonium-oxide were impinged into all bomb and plane surfaces struck by the high-explosive shock wave, entrained and carried forward in the splashing fuel, blown into the crushed ice at the impact point, and carried aloft in the smoke plume along with the combustion products of the burning fuel.

The impact and momentum of debris produced a long patch of black discolored ice extending away from the aircraft's impact point, 100 m wide by 700 m long. About 99 percent of the plutonium, (between 2500 and 3700 g) was on the surface in the blackened area. The contamination level was about 0.9 mg/m² at the edge, extending up to 380 mg/m² averaged over the most contaminated portion. The average calculated mass median diameter of the particles bearing the plutonium was about 4 microns, and appeared to be 4 to 5 times larger than the plutonium particles themselves. Road graders windrowed the black material and mechanized loaders placed it in large wooden boxes for removal from the contaminated area. Eventually sixty-seven 25,000-gallon fuel containers were filled with this material and four additional such containers were required to store contaminated equipment and gear. This material was shipped to the United States for final disposal. Low-level surface contamination was measured on land masses in the near vicinity of the crash site, but the risk to inhabitants or to their ecology was believed to be insignificant. Investigators concluded that only a small percentage of the total plutonium involved in the accident escaped as an airborne aerosol for distribution away from the local area of the accident.

### 5.3   Rocky Flats, Colorado—A Case History in Environmental Plutonium Contamination from an Industrial Plant

The Rocky Flats Nuclear Weapons Plant, which processes large quantities of plutonium, is located 15 miles northwest of Denver, Colorado, on federally owned land two miles square. Two creeks on the boundaries drain into public water supplies. Plans exist for commercial and residential development close by. The terrain is typically prairie—arid and sparsely vegetated except where it is irrigated. Windstorms occur frequently during the fall and winter months with gusts over 45 m/sec (100 mph) recorded. Current control efforts at the plant are directed toward producing near-zero releases, which the plant hopes to achieve in the 1980s through additional filtration of effluents and more exhaustive treatment of liquid wastes. While controlled releases have been reported to be low in the past, accidental releases occurred from four separate accidents since the plant began operation in 1953: two major fires in 1957 and 1969, an accidental release of plutonium to the air in 1974, and leakage (about 500 gallons) of cutting oil contaminated with plutonium from corroded barrels that had been stored outdoors since 1958. Leakage of the barrels was first detected in 1964, and it was decided to transfer the material to new drums. A small building was constructed for the op-

eration and the last drum was removed four years later in 1968. Subsequently the storage area was monitored and alpha activity levels were found from $2 \times 10^5$ to $3 \times 10^7$ dis/min/g with penetration of the activity from 1 to 8 in. Fill was applied the following year to help contain the activity, and the actual area on which barrels had been stored, a 395 by 370 ft rectangle, was covered with an asphalt pad completed in November 1969. Additional fill was added around the pad in 1970 when soil samples containing from tens to hundreds of dis/min/g were obtained. Soil stabilization studies were started for the entire area, and a revegetation program was begun (Hammond, 1971).

The 1969 fire started with the spontaneous ignition of plutonium metal in a glove box and resulted in the burning of several kilograms of plutonium. Large amounts of smoke were seen to leave the stack and spread to surrounding areas. The community was greatly concerned about the possibilities of environmental contamination. A Rocky Flats subcommittee of the Colorado Committee for Environmental Information expressed disbelief in the contentions of plant management that no significant amount of plutonium had been released during the fire. Subsequently the plant collected some 50 soil samples in August 1969, but postponed analyzing them or even developing an analytical method for them until they had completed other environmental samples. In the meantime Ed Martell and Stewart Poet of the National Center for Atmospheric Research in Boulder collected soil and water samples in the area and analyzed them in their laboratory. Soil samples from 15 locations mostly east of the plant ranged from 0.04 dis/min/g (background) to 13.5 dis/min/g of plutonium based on the top centimeter, and seven water samples ranged from 0.003 to 0.4 dis/min/l.

The following description and commentary is taken from an article in *Ramparts* magazine (May 1970): "The contamination of Denver ranged from 10 to 200 times higher than the plutonium fallout deposited by all atomic bomb testing. And it was nearly 1000 times higher than the amount plant spokesmen said was being emitted . . ." The article quoted Dr. Arthur Tamplin as follows:

A study by Dr. Edward Martell, a nuclear chemist with the National Center for Atmospheric Research in Boulder showed about one trillion pure plutonium oxide particles have escaped from Rocky Flats. These are very hot particles. You may only have to inhale 300 of them to double your risk of lung cancer. Inhaled plutonium oxide produces very intense alpha radiation dose to lung tissues, thousands of times higher than the intensity for radioactive fallout particles and millions of times more intense than the dose from natural alpha radioactivity. An inhaled plutonium oxide particle stays in your lungs for an average of two years, emitting radiation that can destroy lung tissue. If the plutonium from the May 11 fire is being redistributed as Martell suggests, then it could increase the lung cancer rate for Denver by as much as 10 percent.

The article does not mention that although the radiation is intense, the mass of tissue affected is very small, and the risk of cancer is much less than that implied by the commentator. However, the hazard of contamination by intensely radioactive particles presents a condition very different from other sources of radioactivity discussed previously, and because the implications are not well understood, remains a highly controversial subject.

The Health and Safety Laboratory of the Atomic Energy Commission (now the Environmental Measurements Laboratory of the Department of Energy) conducted an independent study of plutonium contamination in the area in February 1970 (Krey and Hardy, 1970). The air concentrations decreased with half-times of approximately 1–2 years, reflecting (according to the authors) the decreasing availability of plutonium, probably as the result of penetration into the soil and/or changes in the particle size. The data were obtained from soil samples collected to a depth of 20 cm, which was considered sufficiently deep to account for total deposition of plutonium. Levels as high as 2000 mCi/km$^2$ were found offsite near the plant boundary. Later it was found (Krey et al., 1977) that over 90 percent of the activity was in the first 10 cm.

Other samples were taken from shallower depths, on the basis that the plutonium contamination was more available for resuspension and inhalation. Samples were studied from the top 10 cm (Krey, 1976), top 5 cm (Krey et al., 1976), and the top centimeter (Poet and Martell, 1972). Surface soil particles were collected by vacuuming (Krey et al., 1974), by brushing the superficial soil from within the top 0.5 cm (Johnson et al., 1976), and by using sticky paper to collect the very top layer (Krey et al., 1977). Attempts were also made to identify the respirable fraction in the sampler. Sampling directly for the respirable fraction in soil was also attempted. Selective sampling for only a fraction of the activity may be more representative of the potential airborne hazard, but also gives results that are more variable and more difficult to interpret and generalize.

Sampling results were given in terms of activity per unit mass of soil (dis/min/g) averaged over various soil depths and as deposition per unit area (mCi/km$^2$). The value in dis/min/g depends on the mass over which the activity is averaged. Obviously, averaging over a 20-cm depth will give a lower value than over a 10-cm depth and will not be as valid if most of the activity is in the first 10 cm. It is useful to obtain the activity per gram of soil that is resuspended into the air because this provides better data for determining the amount that is actually inhaled. The Colorado State Health Department proposed in 1973 an interim standard for land for residential development of 2 dis/min/g in soil taken at a depth of 0–0.5 cm, which favored the part that tended to become airborne. Because the hazard of soil contamination is such a complex problem, intensive and continuous air monitoring may turn out to be the best public health measure for control and evalua-

tion (Volchok et al., 1977). In any event, the studies conducted at Rocky Flats represent a most valuable resource for evaluating the hazards of soil contamination.

### 5.4   Gabon, Africa—Site of Nature's Own Nuclear Reactor

The half-life of uranium-235 is $7.1 \times 10^8$ yr. The half-life of uranium-238 is $4.51 \times 10^9$ yr. Natural uranium is 0.72 percent $^{235}U$. Two billion years ago natural uranium was 3.7 percent $^{235}U$. This is similar to the enrichment of $^{235}U$ in the fuel of a light water nuclear power reactor.

One might expect then, that under the right circumstances a natural uranium ore-body at some time in the past could actually undergo sustained nuclear fission reactions with the release of energy and the production of fission products. Evidence is strong that just such a phenomenon occurred two billion years ago at a place now called Oklo in the southeastern part of the Gabon republic, near the Equator, on the coast of West Africa (Cowan, 1976). The power produced was similar to that from a six-reactor complex. Studies on the abundance of plutonium in the ground indicate the generation of some fifteen thousand megawatt years of fission energy, producing 6 tons of fission products and 2.5 tons of plutonium. Apparently there was very little migration of the plutonium. Mother Nature was not only a good power engineer, but also a good environmental engineer. Those who are saddled with the problem of the safe disposal of nuclear wastes surely cannot escape the feeling that if Mother Nature can do it, they should be able to do it as well.

### 5.5   Three Mile Island, Pennsylvania—A Nation Confronts the Awesome Presence of the Atom.

Three Mile Island is the site of two nuclear power plants. The plants are nearly identical and each has the capacity to generate about 900 megawatts of electricity. The island is situated in the Susquehanna River 12 miles southeast of Harrisburg, Pennsylvania, which has a population of 68,000 (1970). The site is surrounded by farmland within a radius of ten miles.

The fuel in the nuclear reactors is uranium. It generates heat by nuclear fission, which releases about 200 MeV per atom fissioned.[13] The heat is

13. The energy is divided among the kinetic energy of the two fission fragments, 166 MeV; 2.5 neutrons (average) released per fission, 5 MeV; prompt gamma rays, 7 MeV; beta and gamma energy released at a later time in the decay of the radioactive fission products, 12 MeV; and energy carried out of the reactor by the neutrinos accompanying beta decay, 10 MeV. The loss of the energy carried by the neutrinos is largely made up by the instantaneous and decay energy resulting from the capture of neutrons in the structure of the reactor. Thus it is commonly assumed that at equilibrium 200 MeV of heat are produced per fission. This converts to $3.1 \times 10^{10}$ fissions/sec per watt of energy. The fission of one pound of uranium or plutonium provides as much energy as 8000 tons of TNT, 1000 tons of high quality coal, or 6000 barrels of oil.

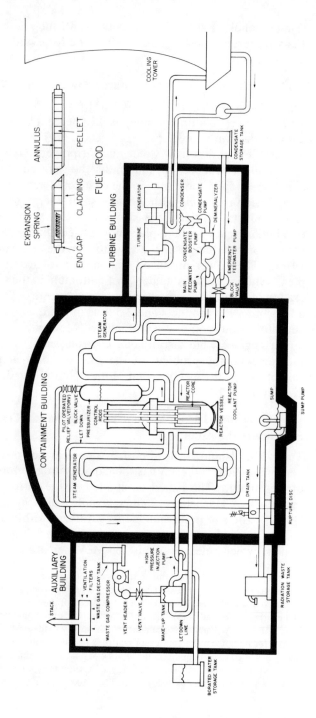

**Fig. 6.7**  Elements of the pressurized water nuclear power plant at TMI.  The heat is produced by fission in the fuel rods, which are loaded with uranium oxide pellets.  The fuel rods are assembled into square arrays, which are combined to form the core of the reactor.  The water is heated as it flows through the core and transfers its heat to the secondary system in the steam generator where steam is produced to drive the turbine.  The reactor has two outlet nozzles, each leading to a steam generator.  The outlet of each generator on the primary side is connected with two coolant pumps, each of which is connected to an inlet nozzle at the reactor vessel.  (Other designs have four loops, each with its own steam generator and coolant pump).  The function of the pressurizer, which is connected to the "hot leg" of the primary coolant circuit, is to maintain the pressure of the primary coolant near the design value.  Too high a pressure could result in rupture of the piping; too low a pressure, to boiling and the formation of steam in the reactor.  The pressurizer volume is occupied partly by water and partly by steam; it has heaters for boiling water and sprayers for condensing steam, as needed to regulate the pressure.  Emergency cooling systems, including a passive accumulator system and a high pressure injector system, are incorporated for supplying coolant to the core through the "cold leg" in the event that the primary system fails.

To operate a plant of this capacity (1000 Mw$_e$) requires an initial loading of fuel derived from 452 tons of $U_3O_8$.  Annual refueling at 75 percent capacity requires 200 tons of uranium ore without recycling (125 tons with recycling) and 6400 tons during the 30-year lifetime of the plant (4080 tons with recycling of plutonium).  Fresh fuel has 3.2% $^{235}U$, spent (design) has 0.9% $^{235}U$, 0.6% $^{239,241}Pu$ (produced from $^{238}U$ at the ratio of 0.6 atoms of Pu per fission of either $^{235}U$ or $^{239}Pu$).

Typical Dimensions and Specifications:

(a) Fuel pellet.  $UO_2$, enriched to 3.2 percent in $^{235}U$; cylindrical, 0.37″ diameter × 0.75″ long.  Total of about 9 million in reactor.

(b) Fuel rod.  Tube of zirconium-aluminum alloy, 0.0265″ thick × 0.43″ OD, filled with pellets; active length 144″. Fuel assembly consists of 208 fuel rods.

(c) Core.  12′ high by 11.4′ in diameter; contains 177 fuel assemblies.  Total fuel mass is 98 metric tons (average enrichment 2.6 percent).  Maximum design fuel central temperature is 4400 °F and the cladding surface temperature at design power is 654 °F.

(d) Pressure vessel.  Typically 14′ OD, 40′ high, carbon steel walls, 8″ or more thick.

(e) Primary coolant system.  Water enters core at 2200 psia, 554 °F, leaves at 603 °F.  The total flow is 131.3 × 10⁶ pounds per hour (124.2 × 10⁶ pounds per hour effective for heat transfer).

used to produce steam, which in turn drives a turbine to produce electricity. The Three Mile Island plants are known as pressurized water reactors (fig. 6.7). The uranium atom splits up in more than 40 different ways, yielding over 80 primary fission products. These are highly radioactive, and on the average go through three subsequent decay stages before a stable species is formed. Thus there are over 200 radioactive species present among the fission products after a short time. While the reactor is operating, the decay of the fission products produces a significant fraction of the operating power, about 8 percent. This decay heat decreases after shutdown, rapidly at first, and more slowly as time passes. At 10 seconds, the decay power is about 5 percent of the reactor operating power, and decreases to 1 percent after 1 hr. By one day, it is down to approximately 0.5 percent, the actual amount depending on the time the reactor was operating.[14]

The fission products represent an enormous amount of radioactivity. The activity of an individual radionuclide at a given time depends on its fission yield, half-life, and the operating history of the reactor. The inventories of fission products likely to produce most of the exposure of the local population in the event of an accident are given in table 6.23 for the thermal power level of 3000 Mw required to produce 900 Mw of electricity. The fuel must be encased in special cladding material to prevent the escape of the fission products to the coolant and ultimately to the environment. A large fraction of the radioactivity is contributed by radionuclides that are noble gases and build up to high pressures in the fuel during operation. Even small pinholes in the cladding will result in the escape of large amounts of these gases since they diffuse so easily. Because it is volatile, radioactive iodine is another fission product that tends to escape from the fuel when the cladding is breached. Fission products that are normally nonvolatile solids leak out much less readily.

Because of the decay heat generated by the fission products, a nuclear reactor must be cooled even after it is shut down to prevent overheating and damage to the cladding and fuel. The cooling must continue until the radioactivity has died down to a point where it cannot produce temperatures high enough to damage the core. A catastrophic accident is possible if a reactor operating at full power loses the coolant; even if it is shut down, enough decay heat is generated to damage the cladding or even produce a meltdown, resulting in the release of the fission products.

Should a major accident occur, the final barrier to the escape of the radioactivity from the plant is the containment structure. This houses the reac-

---

14. The rate of emission of beta and gamma energy following fission is approximately equal to $2.8 \times 10^{-6} t^{-1.2}$ MeV/sec-fission. The decay heat power $P$ at a time $t$ days after startup of a reactor that was operating at a power level $P_o$ for $T_o$ days is readily derived from this expression to give $P = P_o \times 6.1 \times 10^{-3} [(t - T_o)^{-0.2} - t^{-0.2}]$. Here $t - T_o$ is the time in days after shutdown, that is, the cooling period.

**Table 6.23.**  Inventories of fission products important to accident considerations after one year of reactor operation at 3000 megawatts (th).

| Fission product | Half-life | Inventory (MCi) At shutdown | 1 day after shutdown | Comments |
|---|---|---|---|---|
| Xenon | | 316 | 186 | Rare gases, large quan- |
| -131 m | 12 days | 0.9 | 0.9 | tities released, mainly |
| -133 m | 2.3 days | 3 | 2.1 | external gamma |
| -133 | 5.27 days | 162 | 141 | hazard |
| -135 m | 15.6 min | 48 | 0 | |
| -135 | 9.2 hr | 102 | 42 | |
| Krypton | | 147 | 1 | |
| -83 m | 114 min | 9 | | |
| -85 | 10.27 yr | .3 | .3 | |
| -85 m | 4.4 hr | 24 | .6 | |
| -87 | 78 min | 45 | 0 | |
| -88 | 2.8 hr | 69 | .3 | |
| Bromine-83 | 2.3 hr | 9 | 0 | High volatility, external gamma hazard |
| Iodine | | 708 | 160 | High volatility, inges- |
| -129 | $17 \times 10^6$ yr | $3 \times 10^{-6}$ | $3 \times 10^{-6}$ | tion hazard (thyroid) |
| -131 | 8.1 days | 75 | 69 | |
| -132 | 2.3 hr | 114 | 0 | |
| -133 | 21 hr | 165 | 78 | |
| -134 | 52 min | 189 | 0 | |
| -135 | 6.7 hr | 165 | 13 | |
| Cesium-137 | 26.6 yr | 3.8 | 3.8 | Moderately volatile, ingestion (whole body) |
| Tellurium | 25 min–105 days | 551 | 107 | Moderately volatile, |
| -132 | 77 hr | 112 | 90 | decays to $^{123}$I |
| Ruthenium | | 82 | 82 | High volatility under |
| -103 | 41 days | 77 | 77 | strongly oxidizing |
| -106 | 1 yr | 4.6 | 4.6 | conditions |
| Strontium | | 274 | 150 | Relatively low volatility, |
| -89 | 54 days | 117 | 117 | hazard to bone and |
| -90 | 28 yr | 3.6 | 3.6 | lung |
| -91 | 9.7 hr | 153 | 29 | |
| Barium-140 | 12.8 days | 159 | 144 | |

*Note:* Radionuclides with half-lives shorter than 25 min not included. Activity at shutdown calculated from equation $A = 0.0084\, Y M (1 - e^{-0.693t/T^h})$ where $A$ is the activity in megacuries, $Y$ is the percent fission yield (atoms/fission $\times$ 100), $M$ is the continuous power level in megawatts, $T^h$ is the half-life, and $t$ is the length of time the reactor was operating.

*Source:* Parker and Barton, 1973.

tor, steam generators, reactor coolant pumps, and pressurizer. The containment shell at Three Mile Island was designed to limit leakage of the radioactivity from the building to 0.2 percent per day at a maximum design pressure of 60 psi gauge. This leakage rate was used by the Nuclear Regulatory Commission for evaluating the suitability of the site in relation to the consequences of a major accident. The evaluation considered the factors of population density and land use in the region around the site.

It is routine in such evaluations to consider three particular geographical units: the exclusion area, which is the immediate area around the plant within the complete control of the reactor licensee; the low population zone, which contains a population small enough so that it can be evacuated quickly in the event of a serious accident; and the nearest population center. The exclusion area must be large enough so a person standing at the boundary would not receive more than 25 rem whole body or 300 rem to the thyroid from iodine exposure during the two-hour period immediately following the release of the fission products. The outer boundary of the low population zone must be at a sufficient distance so an individual located at any point on its outer boundary who is exposed to the radioactive cloud resulting from a postulated fission-product release (during the entire period of its passage) would not receive a total radiation dose to the whole body in excess of 25 rem or a total radiation dose to the thyroid in excess of 300 rem from inhalation of radioactive iodine.[15] The nearest boundary of a population center must be at least one and one-third times the distance from the reactor to the outer boundary of the low population zone.

Thus the examination of site suitability includes an exercise in dose calculations. A fission-product release must be assumed that is the largest that would result from any credible accident. Typically it is assumed that 100 percent of the noble gases, 50 percent of the halogens, and 1 percent of the solids in the fission-product inventory are released inside the containment building. Such a release represents approximately 15 percent of the gross fission-product activity. Assumptions are then made for the airborne activity in the containment vessel, the leakage to the environment, and the atmospheric dispersion from the reactor building to occupied areas, based on the meteorological characteristics of the area (DiNunno et al., 1962). The Three Mile Island exclusion distance was 2000 feet and the low population zone (pop. 2380) extended 2 miles from the plant (ONRR, 1976). The popu-

---

15. While NRC regulations (10CRF100) specify a maximum of 300 rem to the thyroid, the Commission policy is to require designing to a maximum of 150 rem. The NRC emphasizes that these dose limits are not intended to constitute acceptable limits for emergency doses to the public, but only to serve as reference values for the evaluation of sites with respect to potential reactor accidents of exceedingly low probability of occurrence and low risk of public exposure to radiation. The regulations are currently undergoing intensive review and will be revised significantly as a result of the Three Mile Island accident.

lation center, Harrisburg, Pennsylvania, was at a distance well beyond the minimum required.

On March 29, 1979, at 4 a.m., Unit 2 on Three Mile Island underwent an accident involving a major loss of coolant (Kemeny, 1979; Rogovin, 1980). The feed pumps that sent condensed steam back to the steam generators were automatically shut down (tripped) for reasons not yet clearly understood. This caused the turbine to trip. With the loss of water flow, the steam generators ceased to remove heat from the reactor coolant. As a result, the coolant heated up, the pressure rose quickly, and the reactor shut down. At the same time, auxiliary pumps were supposed to turn on automatically to send water into the steam generators so they could continue cooling the water flowing through the reactor, but nothing happened; the water was blocked by two valves that had been left closed after a recent maintenance check, in violation of operating procedures. As the pressure rose in the primary system above 2255 psi, the pilot-operated relief valve (PORV) opened and discharged water from the primary coolant loop into a quench tank to relieve the pressure. The valve was supposed to close automatically when the pressure dropped to 2205 psi and, indeed, electric power to the solenoid which activated the valve did shut off at this point. However, the valve stuck open and water continued to pour out of the system, unknown to the operators. They were assuming that the valve was shut because the only signal at the control panel monitoring its condition, a pilot light which indicated whether electric power was being supplied to the solenoid, was indicating that the power was off. The true condition of the valve was not recognized for almost two and one-half hours during which water continued to pour out of the primary system, ultimately overflowing the quench tank and flowing onto the floor of the containment vessel. When the pressure dropped to 1600 psi, the high-pressure injection system (HPI) automatically pumped water into the system to make up for the water being lost; however, in response to a variety of control-panel indicators, the operators wrongly decided to override this automatic emergency action and sharply reduced the HPI flow, flow that was not resumed until three hours later. About one hour into the incident, the primary coolant pumps were vibrating badly, and they were turned off manually (the vibrations were due to a lack of water in the primary system, a condition not recognized by the plant operators). At this point, water should have continued to flow by natural convection but did not, because of air in the system. Without passage of coolant water through the core, it overheated. A large portion of the upper part of the core was apparently uncovered at this point for an unknown period of time. After the circulation pumps were restarted, a gas bubble 1000 cubic feet in volume was detected. It was suspected to contain hydrogen and this produced a new worry about a possible hydrogen explosion. There was also concern that the presence of the bubble could force water from the core and expose it again. However, the bubble was eventually eliminated. The

reactor was cooled with the primary pumps and one steam generator until April 27, and after that the core was left to cool by convection.

The coolant on the floor of the containment vessel contained large amounts of radioactive noble gases and some radioactive iodine. A valve should have shut, isolating all this water within the containment. Instead, the water was erroneously pumped for a short time to an auxiliary building. This building was shielded and equipped with air filters but radioactive gases were released to the environment exposing persons in the area. This release plus others in the following month added up to a total activity calculated to be 2.5 million curies, almost all of which consisted of noble gases (Rogovin, 1980, vol. II, part 2). Fortunately, the maximum dose to any person offsite from these releases was estimated to be less than 100 mrem. The only radionuclide released in significant quantities was xenon-133. Also released were some xenon-135 and about 15 Ci of iodine-131.

The events of Three Mile Island constituted a drama of epic proportions played before the people of the world through television and newspaper accounts. For perhaps the first time, the public became acutely aware of the almost supernatural power locked up in a nuclear reactor and the possibility of loss of control of that power. Every hint of trouble, every concern for danger, every feeling of anxiety by those operating the plant or responsible for the safety of the public was relayed almost instantaneously to the world. The President of the United States and his wife visited the plant, donned protective clothing, and entered the control room to demonstrate that the plant was under control. The Governor of Pennsylvania kept his constituents abreast of emergency plans and finally suggested evacuation of pregnant women and children near the plant. The Director of the Office of Nuclear Reactor Regulation of the Nuclear Regulatory Commission reported to the public continually from the site on the problems and progress in coping with the accident. Some reporters sensationalized the dangers of radiation exposure even though actual exposures were minimal; a scientist was shown on television making measurements with a Geiger counter in streets near the plant and interpreting very low environmental readings as if there had been a serious fallout incident. Actually, the one bit of good news was that the radioactivity was contained and the risk of cancer from radiation exposure to any member of the public was minimal. While the press had continuously played upon the chances that the reactor might melt or explode, the fact that no uranium was found in the coolant solution indicated that the fuel never melted or began to melt. But core damage was extensive. The zirconium tubing holding the fuel together was severely damaged as a result of reactions with water at temperatures of 2700 °F or higher. Perhaps 30 percent of the fuel pellets may have fallen out of place as a result.

The operators faced an enormous cleanup job. The damage to the core and possibly to the piping as a result of countermeasures to the accident were great and there was some question as to whether the billion dollar plant would operate again.

### 5.5.1   Nuclear Power from the Perspective of the Three Mile Island and the Chernobyl Accidents

The energy locked up in the uranium nucleus is enormous.   A kilogram (2.2 lb) of uranium has a heat content of 23 million kilowatt hours (assuming all the uranium is eventually fissioned, as in a breeder reactor).   This is equivalent to 2.674 million kilograms (2674 tons) of coal or 13,529 barrels (U.S., 42 gal) of oil.   A 1000 megawatt (electrical) power station consumes 3 kilograms per day of uranium by fission as compared to 10,000 tons of coal per day (delivered in 140 railcars) and 40,000 barrels of oil per day (delivered by 1 supertanker per week, Wilson and Jones, 1974).   The refueling schedule calls for the annual delivery of 35 tons of uranium enriched to 3.3% in uranium-235 (Nero, 1979, p. 266).   The daily emissions from a coal plant to the atmosphere include between 33 and 330 tons of sulfur dioxide, 55 tons of nitrous oxide, over 16,000 tons of carbon dioxide, and large quantities of nitrogen oxides, hydrocarbons, heavy metals, and fly ash, all of which produce deleterious health effects.   The sulfur dioxide, although a pollutant in its own right, is converted in the atmosphere to sulfate, which is an even greater problem.   A large coal plant increases the sulfate level over a wide area encompassing several states by perhaps 1 $\mu g/m^3$.   When superimposed on existing pollution levels typically of the order of 12 $\mu g/m^3$ in industrialized areas (associated with ambient $SO_2$ levels of 80 $\mu g/m^3$), this produces significant increases in asthmatic attacks, aggravates heart and lung diseases, lower respiratory disease in children and chronic respiratory disease symptoms, and causes a significant increase in premature deaths.   The sulfates in the atmosphere also produce an acid rain that is very destructive to fish and in some cases has caused their complete disappearance from lakes.   The large quantities of $CO_2$ introduced into the atmosphere from increasing use of fossil fuels could change the global climate and seriously affect living conditions.   Radioactivity is also released to the atmosphere from coal-burning plants in quantities that have a greater radiological significance than the radioactivity released by a normally operating nuclear plant of equal capacity (McBride et al., 1978).   The hydrocarbons released to the atmosphere are known to be carcinogenic but the extent of their impact is unclear.   Also generated daily at a coal power plant are 100 truckloads of ash (about 200,000 tons of ash per year) containing such toxic substances as selenium, mercury, vanadium, and benzopyrene.   The wastes are dumped close to the surface of the ground, a practice that leads to pollution of the groundwater. The extremely large quantities of radioactive wastes produced in a nuclear power plant are also a worry, and they must be carefully controlled and disposed of in sites selected for their isolation from the pathways that could lead them to public consumption.

The main concern in the utilization of nuclear power is really over the possibility of a catastrophic accident at a nuclear power plant, a possibility that was pointed out so dramatically at Three Mile Island.   Little happened in the way of radiological consequences to the public or to the environment.

But how bad could it have been? What if every barrier had failed? What if the fuel had vaporized, fuel containing an inventory of 15 billion curies of fission products, an inventory equivalent to the fallout of thousands of Hiroshima-type weapons, almost 4 billion curies of which was in the form of volatile gases? Suppose all this had gotten through the containment and been carried as a radioactive cloud over the surrounding region? Even then, if the weather conditions were right, damage would not be catastrophic. But if the weather brought down this cloud as fallout over nearby populated areas, the consequences could have included thousands of fatalities from acute radiation sickness, tens of thousands of later cancer deaths, and damage amounting to billions of dollars. The probability of an accident of this type was felt to be about one in a billion per plant per year before Three Mile Island (NRC, 1975). Did Three Mile Island show that, in fact, the chances are much greater?

A disaster of sobering proportions did occur at Chernobyl in the USSR on April 26, 1986. It was a runaway of a 3200-megawatt (thermal) boiling-water, graphite-moderated reactor. It began at 1:23 A.M. The fission rate in the reactor core suddenly shot up to hundreds of times the normal operating level. In a little over a second, the fuel temperature went from 330°C to well beyond the uranium dioxide melting point of 2760°C (DOE, 1987). The accompanying explosion lifted a 1000-ton cover plate off the reactor (Wilson, 1987), took off the roof, and blew fuel out. The mixture of hot fuel fragments and graphite led to some 30 fires in and around the reactor. Fission products began escaping in large amounts to the atmosphere from the huge inventory that had accumulated as the result of $5.6 \times 10^{27}$ fissions over 2 years and 5 months of operations; an inventory that included 140 megacuries of molybdenum-99, 168 megacuries of xenon-133, 111 megacuries of tellurium-132, 82 megacuries of iodine-131, 6.2 megacuries of cesium-137, and 4.6 megacuries of strontium-90. A massive effort was undertaken to control the fires. The firefighters had to work in an incredibly hazardous environment of intense radiation, high temperature, toxic fumes, and escaping steam. Helicopters dropped 5000 tons of various materials on the inferno as scientists tried out different approaches to extinguish it—40 tons of boron carbide (to prevent the reactor from going critical again), 800 tons of dolomite (to generate carbon dioxide gas), 1800 tons of a clay-sand mixture (to smother the fire and filter the escaping radioactivity), and 1400 tons of lead (to absorb heat by melting and provide a liquid layer that would in time solidify to seal and shield the top of the core vault). They worked frantically for 10 days and succeeded in extinguishing the fires (after 250 tons of graphite had burned up) and curtailing the release of radioactivity to the environment. The radioactivity was contained only after liquid nitrogen had been injected into the passages below the reactor core to cool the reactor sufficiently to prevent evaporation of the fission products. Two hundred thirty-seven workers suffered acute radiation sickness and 31 of them died. When it was all over, 100 million curies of fission products had escaped, and

30 million curies of activity were contaminating the environment within 30 km of the reactor (Anspaugh et al., 1987). The released activity included all the noble gases, half the inventory of iodine-131 (54 megacuries) and cesium-137 (2.7 megacuries) and as much as 5 percent of the more refractory material, such as strontium, cerium, and plutonium. The 2.7 million curies of Cs-137 ejected was about 10 percent of that released to the atmosphere in all the nuclear weapons tests. The radioactive fallout was worldwide. Most of the population dose was and would be from cesium-137, of which 1 million curies fell on the European portion of the USSR, 12,000 curies on the United Kingdom, 51,000 curies on Italy, 7,600 curies on the USA, and 143 curies over Israel. Estimates of individual external doses that would be imparted over 50 years were 13 mrad in the UK, 47 mrad in Italy, 0.2 mrad in the USA, and 20 mrad in Israel. The dose from ingestion would produce a comparable dose over the next 50 years. One hundred fifteen thousand persons were evacuated from a 30-km zone around the reactor. Of these, 50,000 received 50 rad or more (Anspaugh et al., 1988), including 4,000 persons subjected to an average dose of 200 rad. It was expected that the incidence of spontaneous fatal acute myeloid leukemia (about 1 in 10,000 per year) would increase by about 150 percent in the heavily exposed group. The direct costs of the accident (loss of the reactor, decontamination, relocation, and medical care) amounted to about 7 billion dollars. While the Chernobyl disaster is considered by some to prove the folly of using nuclear power, the power plant design was not at all like those used elsewhere in the world. The reactor had a positive void coefficient at low power, meaning that with loss of water, the multiplication of neutrons and power level actually increased. This was a foolhardy design and not found anywhere outside the Soviet Union. Prior to the accident, the operators had deliberately disconnected some of the safety systems designed to prevent a reactor runaway. The building containing the Soviet reactor did not provide the degree of protection against leakage of radioactivity to the environment at overpressures provided by the concrete or steel structures in the United States (Ahearne, 1987).

The Three Mile Island accident led to intensive investigations of the causes and responses and to recommendations for achieving an acceptable level of safety (Kemeny, 1979; Rogovin, 1980). Since then, many measures have been taken to prevent accidents, including greater attention to additional safety controls and to training. Chernobyl greatly diminished public confidence in nuclear power throughout the world, despite the much greater susceptibility of the Chernobyl reactor to an accident. The nuclear industry has its work cut out to demonstrate that with proper designs, training, and operational controls, nuclear power is a viable and desirable technology.

Perhaps, in the final analysis, the question to be answered is, "How badly do we need nuclear power?" The answer is not clear. What are the alternatives, their harmful effects, and their economics? Most experts in the field do not believe they know enough to say with confidence whether nu-

clear power should be abandoned on the basis of economics or risk to the worker or public safety. More experience is needed. To date injury to life and property has not been out of line with other industrial operations and the savings in fossil fuels have been very beneficial. Fortunately the great risks of nuclear power are appreciated, and society realizes that the operations of nuclear facilities must be policed with great care, and a continuing surveillance must be maintained of the effects of radiation on working populations, the public, and the environment. Beyond that, only time and experience can provide the answers for the optimists and the pessimists.

We conclude this section with some data on the contributions that can be made to our energy supply from alternative energy sources as given in table 6.24. Any decisions on energy policy and justifiable risks must begin with these data.

**Table 6.24.**    U.S. energy resources (1977).

| Energy Source | Production Annual | Reserves | Energy Consumption Annual, quads[a] | |
|---|---|---|---|---|
| | | | Domestic supplies | Imported fuel |
| Crude oil, millions of barrels | 2,860 | 29,500 | 20 | 17.4 |
| Natural gas liquids, millions of barrels | 700 | 5,990 | | |
| Natural gas, trillions of cubic feet | 19.4 | 209 | 19.1 | 1.0 |
| Coal, millions of tons | 700 | 250,000 | 13.0 | |
| Uranium, thousands of tons $U_3O_8$ | | 1,090 | 2.7 | |
| Biomass | | | 1.8 | |
| Hydro | | | 2.7 | |
| | | | 59.3 | 18.4 |
| | | | Total: 77.7 quads | |

*Source:* Hayes, 1979.

*Note:* Available resources depend heavily on cost of extraction. Potential developable crude oil resources 100,000 million barrels. U.S. nuclear electrical generating capacity (1978) is 48 GW. Ultimate capacity without breeder reactor is about 200 GW. Breeder reactor would increase uranium fuel reserves by seventy times; thorium breeder would increase energy supply by even greater factor.

a. 1 quad = $10^{15}$ BTU = $1.055 \times 10^{18}$ joules = 12,200 gigawatt days = 33.4 gigawatt years = 170 million barrels of oil; 40 million tons of bituminous coal; $10^{12}$ ft$^3$ of natural gas; 12,760 kg (12.76 tons) of uranium fissioned.

## 5.6   Nuclear Weapons—Ready for Armageddon

On June 18, 1979, President of the United States of America, Jimmy Carter, and General Secretary of the C.P.S.U. Central Committee and President of the U.S.S.R. Supreme Soviet, Leonid I. Brezhnev, signed a treaty on the limitation of strategic offensive arms (SALT II). The treaty expressed the "deep conviction that special importance should be attached to the problems of the prevention of nuclear war and to curbing the competition in strategic arms." Implementation of the treaty required ratification by the United States Senate. The treaty was never ratified because of widespread concern that it in fact compromised the national security, but both signatories have been complying with its provisions.

The treaty placed a ceiling of 2400 on the number of land-based intercontinental ballistic missle (ICBM) launchers, submarine ballistic missile (SLBM) launchers, heavy bombers, and air to surface ballistic missiles (ASBM) allowed each side until the end of 1981. Thereafter, the ceiling would drop to 2250 offensive weapons systems until January 1, 1985. Under the overall ceiling the number of ICBMs with multiple warheads (MIRVs) would be limited to 820; the number of ICBMs and SLBMs with MIRVs would be limited to 1200; and the number of multiple-warhead ICBM's and SLBMs and bombers with cruise missles would be limited to 1320. The treaty did not regulate the maximum number of nuclear warheads, but limited the number of multiple warheads on a single missile to the number already tested, a maximum of 10 on land-based weapons and 14 on those based on submarines. Heavy bombers were restricted to a total of 28 cruise missiles (although no existing plane is able to carry more than 20). Each party undertook not to flight-test or deploy new types of heavy ICBMs.

Both signatories already possessed large numbers of strategic weapons systems (ISS, 1978). The Soviet Union had 1400 land-based ICBMs. The largest were the SS-9 and SS-18 (300 deployed) with a throw-weight of 6–10 tons. They could carry one 18–25 megaton (MT) or several smaller megaton warheads. The United States had 1054 land based ICBMs. The largest was the Titan II (54 deployed) with a throw weight of 3.75 tons. It could carry one 5–10-MT warhead. The Soviet Union had 1015 SLBMs on 90 submarines. The missiles carried mainly single 1–2 MT warheads. The United States had 496 Poseiden SLBMs, each carrying ten 50-kiloton (kT) warheads on 31 submarines, and 160 Polaris SLBMs, each carrying three 200-kT warheads on 10 submarines. It was constructing four 24-tube Trident boats designed to carry the Trident missle with eight 100-kT warheads. In addition, NATO had 128 SLBMs in the 200-kT to 1-MT range. The various arsenals also contained a great many short-range missiles in the low-kT range. The United States strategic forces had 2142 vehicles with the capability of delivering over 11,000 warheads against the Soviet Union. The Soviet Union forces had 2550 vehicles capable of delivering roughly 4500 warheads against the United States. With replacements with new MIRV-equipped missiles, this total could rise to over 7500 in the early 1980s.

Yields of strategic nuclear weapons fall roughly into classes of 10 MT, 1 MT, 200 kT and 50 kT.   (The Hiroshima and Nagasaki bombs were in the 20 kT class; the biggest bombs ever made from conventional explosives contained the equivalent of 10 tons of TNT.)   Most of the land-based missiles are in the megaton range.   The United States submarine launched missiles each carry several independently targeted warheads in the 50-kT range. Most Soviet submarine launched missiles carry single warheads of 1–2 megatons.   The United States has more warheads.   The Soviet Union has on the average more firepower per warhead and probably more megatonnage.

What would be the effects of detonating a 1-MT bomb at an altitude of 1000 m or so above the ground (giving the greatest blast and thermal effect)?   The energy released, equivalent to that from one million tons of TNT, is $4.6 \times 10^{15}$ joules.   But while the power of a nuclear explosion is expressed in terms of the blast effect of an equivalent tonnage of TNT, the uniqueness of this weapon is in the incredible heat of the fireball—a manmade sun that destroys by heat radiation (35 percent of the total energy released) all that has not already succumbed to the blast and nuclear radiation.   Perhaps 50 percent of the deaths at Hiroshima and Nagasaki were caused by burns from the fireball as compared to 10 percent from radiation sickness.   Intense heat produced charring and blackening of trees, wood posts, and fabrics up to 10,000 ft from ground zero.   Combustible materials were set afire up to 3500 feet away.   At Hiroshima the burning developed into a fire storm.   The storm began about 20 minutes after the bomb burst. Winds blew toward the burning area of the city from all directions, gradually increasing in intensity and reaching a maximum velocity of 30–40 mph some two to three hours after the explosion.   The winds were accompanied by intermittent rain.   The strong inward draft did limit the spread of the fire beyond the initial ignited area, but virtually everything combustible within the boundary of the storm was destroyed.

The fireball is the result of the production of a tremendous amount of energy in a small volume.   It is preceded by shock waves that demolish and crush with far greater effectiveness and range than conventional explosives.   The enormous concentration of energy then creates very high temperatures, which at the time of the detonation are thousands of times greater than the 5000° C maximum produced by a conventional explosive weapon (Glasstone, 1962).   At these high temperatures, reaching 100 million degrees, about one-third of the energy is converted to low-energy x-rays.[16]

16. The energy radiated from a black body as a function of temperature is given by Planck's equation: $J_\lambda = (c/4)(8\pi hc/\lambda^5)(e^{E/kT} - 1)^{-1}$.   $J_\lambda$ is the energy radiated per cm² per sec per A°; E is the energy of the photon of wavelength $\lambda(A°)$; and the other constants are given in Appendix IV.   The temperature produced when the bomb is triggered is between $10^7$ and $10^{8°}$ K.   At this temperature most of the thermal radiation is in the 120 to 0.12 keV energy region.   It is absorbed in the air with a half-value layer of $E^3/7$ cm, E in keV.   The resulting fireball has a surface temperature of about 8,000° K.   This radiates mainly in the ultraviolet, visible, and infrared regions of the spectrum, very much like sunlight at the surface of the earth.

This energy is absorbed in the air (by the photoelectric effect) within a distance of a few feet, and heats it to thousands of degrees, producing the fireball. The fireball immediately grows in size and rises rapidly, initially at 250 to 350 feet per second (over 200 mph). The fireball from a 1-megaton weapon extends about 440 feet across within 0.7 milliseconds and increases to a maximum diameter of about 7200 feet in 10 seconds. After a minute, it is 4.5 miles high and has cooled to such an extent that it no longer emits visible radiation; from here on, vapor condenses to form a cloud. If sufficient energy remains in the cloud it will penetrate the tropopause into the stratosphere. The cloud attains its maximum height after about 10 minutes and is then said to be stabilized. It continues to grow laterally, however, to produce the mushroom shape that is characteristic of nuclear explosions. The cloud may continue to be visible for about an hour or more before being dispersed by the winds into the surrounding atmosphere where it merges with natural clouds in the sky. In contrast to a megaton burst, the typical cloud from a 10 kiloton air burst reaches a height of 30,000 feet with the base at about 15,000 feet. The horizontal extent is also roughly 15,000 feet.

The potential effects of the blast and nuclear radiation have been given intensive study (York, 1976). Wooden homes and most of their inhabitants are destroyed by blast and fire as far as 9 km from detonation. Nuclear fallout sufficient to kill most persons in the open extends to 100 km, and to 25–50 km for persons sheltered in basements of buildings. The way it fans out is shown in fig. 6.8 for 1-, 5-, and 25-MT bombs (DCPA, 1973). What would this do to an industrial city large enough to warrant the use of very large weapons? The consequences have been worked out for the city of Detroit (OTA, 1979). First, consider a 1-MT detonation on the surface. This produces the greatest fallout. The detonation point is the civic center. The explosion leaves a crater about 1000 ft in diameter and 200 ft deep, surrounded by a rim of highly radioactive soil about twice this diameter thrown out of the crater. There is not a significant structure standing less than 1.7 miles from the civic center (overpressure 12 psi). During working hours, the entire downtown population of 200,000 is killed. (After working hours there are 70,000 people around to get killed.) Between 1.7 and 2.7 miles (overpressure 5 psi), the walls are completely blown out of multistory buildings; total destruction is the fate of individual residences; some heavy industrial plants remain functional at the outer distance. Fifty percent of the people are killed, the rest injured. Between 2.7 and 4.7 miles from ground zero there are 50 percent casualties (mostly injuries), and between 4.7 and 7.4 miles, 25 percent casualties (few deaths) with only light damage to commercial structures and moderate damage to residences. The attack causes a quarter million deaths, plus half a million injuries, destruction of 70 square miles of property (subject to overpressures more than 2 psi), and additional damage from widespread fires. The radioactive fallout pattern depends on the wind velocity and the distance from the explosion.

The fallout is most dangerous during the first few days.  Possible dose distributions are shown in fig. 6.9.  People in the inner contour not in adequate fallout shelters receive fatal radiation doses in the first week.  People in the second contour receive a fatal dose if they spend much time outdoors and incur severe radiation sickness even if they remain indoors but not in the shelter.

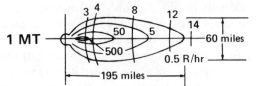

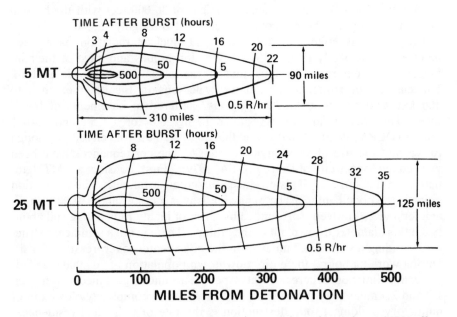

**Fig. 6.8**  Fallout patterns: peak dose rates (R/hr) and time of peak for 15 MPH effective wind.  The 1-MT, 5-MT and 25-MT cases cover the yield range of current Soviet missile warheads.  The values are calculations of maximum dose rates that would be observed by measurements taken at three feet above a smooth, infinite plane.  The actual dose rates would be less than shown here by a factor of 2 or perhaps more because of the roughness of the surfaces on which fallout had deposited, as well as the limited extent of these surfaces.  Also shown, by curved vertical lines, is the time after detonation, in hours, at which the dose rate would attain its maximum.  Note that the point 30 miles downwind is always in the heaviest fallout area.  *Source:* DCPA, 1973.

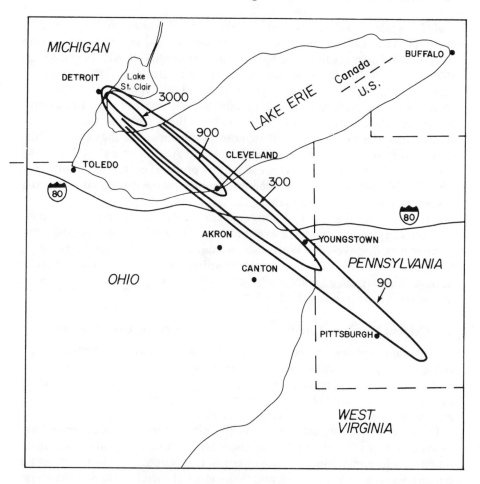

**Fig. 6.9** Main fallout pattern (1-MT surface burst in Detroit). Uniform 15 mph northwest wind. Contours for 7-day accumulated dose (without shielding) of 3000, 900, 300, and 90 rem. Detonation point assumed at Detroit Civic Center. *Source:* OTA, 1979.

If Detroit is subjected to an air burst at 6000 feet rather than at the surface, the area affected by blast and fire increases. There is no significant fallout and no crater, and the strongest structures may survive in part even directly under the blast. In the event of a 25-MT air burst at 17,500 feet, the whole metropolitan area is heavily damaged. There are few survivors (1.1 million available to assist 3.2 million casualties). There is virtually no habitable housing in the area and essentially all heavy industry is totally destroyed. As a result, rescue operations would have to be totally supported from outside the area, with evacuation of the survivors the only feasible course.

A full-scale attack could subject the United States to fire-power of 6000 MT, two-thirds dropped on military targets and one-third on civilian targets, that could result in one hundred million deaths (JCAE, 1959a; Mark, 1976; CFR, 1975).   If the attack were limited to strategic targets, perhaps involving 2000 MT, the deaths might be reduced to seven million.   Some analysts study the consequences of a major nuclear war and prescribe appropriate civil defense measures (Kahn, 1959); others feel that the survivors would envy the dead, that civil defense is meaningless, that every effort should go into the prevention of nuclear war.   A warning by the Secretary General of the United Nations presents this precarious state of affairs very well (UNSG, 1968): "There is one inescapable and basic fact.   It is that the nuclear armories which are in being already contain large megaton weapons every one of which has a destructive power greater than that of all the conventional explosives that have ever been used in warfare since the day gunpowder was discovered.   Were such weapons ever to be used in number, hundreds of millions of people might be killed, and civilization as we know it, as well as organized community life, would inevitably come to an end in the countries involved in the conflict."

### 6.   Current Issues in Radiation Protection — Where the Experts Stand

This section contains discussions of major issues in radiation protection unchanged from the presentation in previous editions.   While the issues of nuclear explosives and atmospheric testing of nuclear weapons are currently dormant, they are still included because the arguments presented have general relevance and interest and were just too precious to take out.

Presented below are statements on these major issues by recognized authorities taken from the technical literature, periodicals, books, and testimony before congressional committees.   The purpose is not to present a comprehensive coverage of all points of view but merely to define the major issues as delineated by some knowledgeable and concerned people and possibly to inspire the reader to think about the problem areas in radiation protection and to contribute informed opinion and responsible action.

*On Reducing Population Radiation Exposure from Medical and Dental X-Rays*

The director of the Health Physics Division, Oak Ridge National Laboratory, and first president of the International Radiation Protection Association, appeals for greater controls in the use of medical and dental x rays.

Although I have been very proud of some of the actions taken by ICRP, NCRP and FRC which have led to the reduction of population exposure, I feel very strongly that more specific recommendations should be made to prevent the exposure of a patient by a physician untrained in the use of ionizing radiation, radiation physics and in radiation protection.   I believe values of maximum permissible dose should be given for

certain types of diagnostic exposure that would be expected to remove some of the disparity that at present results in a difference of more than an order of magnitude in dose delivered to the skin of a patient by various dentists for the same dental information or some x-ray technicians for the same chest x-ray examination. I feel the Federation Radiation Council has been particularly conspicuous by its lack of action in regard to patient exposure.

I have no doubt that measures discussed later in this paper, if properly applied, would reduce the average diagnostic per capita dose to 10% of its present value. (K. Z. Morgan, 1967)

The president of the National Council on Radiation Protection and Measurements comments in an interview on the significance of exposure of the public to x rays.

*Question by interviewer:* Does x-radiation to the public add up to a dangerous level?

*Answer:* No, but it adds up to some potential harm. I am deeply concerned over the possible deleterious effects of radiation which is received by people without any positive return of benefit—that is, unnecessary radiation.

Now, I'm not hysterical about it, but I am concerned, because this is a source of damage that you simply don't have to put up with. (L. S. Taylor, 1961)

The director, Office of Radiation Control, New York City Department of Health, discusses the problem of the prescription of excess x rays.

The problem of excessive use of unnecessarily repeated examinations are abuses that could not easily be regulated under any circumstances. Popular feeling and professional education has and will probably continue to be the only effective controls.

And I don't think we should overlook popular feeling. Those of you who have been in the field a long time know that it was once the practice of pediatricians to fluoroscope babies and young children every month and when they had the annual checkup. When we questioned this practice, pediatricians would say, "Well, the parents expect it. They think if I don't fluoroscope the patients, they are not getting a complete examination."

Well, times changed. We had fallout, then we had the National Academy of Sciences Report pointing out the dangers of x-rays, and now today pediatricians say that when they want to fluoroscope or x-ray a child, they often encounter parent's resistance. As a result, there is very little routine fluoroscopy being practiced today on young patients. I think this sort of result of the population's education is most important in any improvements we want to make.

I think this feeling, this reaction of the public is going to be helpful to us. But I think we have to do something to stimulate it properly without frightening patients. (H. W. Blatz, 1970)

A report of the International Commission on Radiological Protection gives recommendations for minimizing the hazards of irradiation of the fetus during pregnancy.

The Commission wishes to call attention to reports of embryonic and fetal sensitivity to ionizing radiation and to emphasize that the possibility of pregnancy must be taken into account by the attending physician when deciding on radiological examinations that involve the lower abdomen and pelvis of women of reproductive capacity. The Commission also wishes to point out that the 10-day interval following the onset of menstruation is the only time when it is most improbable that such women could be pregnant. Therefore, it is recommended that all radiological examinations of the lower abdomen and pelvis of women of reproductive capacity that are not of importance in connection with the immediate illness of the patient be limited in time to this period when pregnancy is improbable. (International Commission on Radiological Protection, ICRP, 1966a, Publication 9)

A radiologist urges the discontinuance of routine abdominal diagnostic x rays during pregnancy.

The percentage of x-ray pelvimetries performed on pregnant patients in the Sloane Hospital for Women between the years 1950 and 1963 (my own compilation) has decreased from 15 to 5 percent. One might be concerned about an adverse effect upon the neonatal mortality here. Denying pregnant mothers the benefits of roentgen pelvimetry may conceivably damage the baby more than irradiation. It is well known that this has happened in individual cases. Therefore, I prepared another statistical analysis that compares the employment of x-ray pelvimetry with the neonatal mortality at the same institution . . . the neonatal mortality has remained constant over the years despite the decrease in the number of x-ray procedures. The only exception is the year 1959, when neonatal mortality was slightly higher than in other years. This is attributed to an outbreak of influenza.

In conclusion, abdominal diagnostic x-ray procedures should not be performed during pregnancy unless absolutely necessary. (G. S. Schwarz, 1968)

A professor of radiology deplores the unnecessary administration of x rays.

Even more serious . . . is the growing tendency of medicine to use radiological methods unwisely and for purposes other than to answer clinical questions for which these methods are uniquely suited. I speak here of the increasing extent to which our services are used without careful consideration of clinical benefit and cost, without adequate evaluation of the patient, and often as a means merely to provide medicolegal protection. We radiologists have generally assumed that all radiological procedures are of clinical benefit, favorably influencing the clinical course of the individuals on whom they have been performed, and that all examinations are valuable regardless of cost. Recent studies have shown that these assumptions are all too often unfounded and that there is urgent need for research critically evaluating the clinical benefits of radiological procedures and the conditions under which they may be optimally applied.

The system of medical care in the United States has tended to avoid investigations of this sort, investigations which measure quality of performance and which suggest alternative methods which potentially yield greater information at lower cost. How-

ever, society demands that such research be undertaken and, if I dare a prediction, I forecast that in the next decade investigations which fall into the general category of "quality control" will receive major emphasis.  (R. H. Morgan, 1972)

A radiologist comments on overuse of medical x rays.

My problem is to stop OVERUSE.  X-rays are being used too much for diagnosis in our country, and at a rate of increase that is scandalous.  The last time I looked into the matter we were exposing annually 11,000 acres of x-ray film every year and were clamoring for more.  Now we are trying to slow down and it isn't easy—old habits, ripe prejudices, and the love of money being what they are.  In passing, it has always seemed interesting to me, that after all the years of pleas and lamentations of geneticists and the indispensible alarms of Ralph Nader, our present clear call for restraint comes not from the laboratory, it comes from the Treasury.  There has been prodigious waste, and we can no more afford prodigality in radiology than we can in any other branch of science or government.  (J. L. McClenahan, 1976)

The United Nations points out the high contribution of medical radiation to population dose.

Medical exposures contribute the highest man-made per capita doses in the population, are given with high instantaneous dose rates and cause the highest individual organ doses short of accidental exposures.  From the radiation protection point of view, they also offer the largest scope for implementing methods of dose reduction without loss of the information required.  (UNSCEAR, 1977, p. 301)

*Effect on the Environment of Large-Scale Use of Nuclear Power*

A specialist in environmental and radiological health writes on pollution from power sources.

In any case, present experience indicates that continuous release of gaseous wastes from either the pressurized water reactors or the boiling water reactors presents a lower order of hazard than that of coal-fired plants.

Nuclear energy has a critically important role in combating the growing assault on our atmosphere.  Still, even with nuclear energy completely supplanting fossil fuels for new plants built late in this century, much more must be done.  What then can the nuclear energy industry do to aid our fight for clean air?  The answer is implicit in the very advantages claimed by nuclear power.  Unquestionably, the potential for massive pollution exists in the fission products produced by a nuclear reactor; in the absence of effective control to restrict the emission of radioactivity, the nuclear program could have become a leading contributor to atmospheric pollution.  The key word is control.  Essentially every phase of design, site selection, construction, and operation of a nuclear power plant is under the strict surveillance and control of responsible and technically competent review boards.  The same tight control is overdue for other actual and potential polluters and must surely come into being, hopefully soon.  (B. R. Fish, 1969)

*Two journalists warn dramatically against nuclear power.*

Thus, when atomic power advocates are asked about the dangers of contaminating the environment they imply that the relatively small amounts of radioactive materials released under "planned" conditions are harmless.

This view is a myth. . . .

Efforts are of course being made toward effective handling of the waste problems, but many technical barriers must still be overcome. It is unlikely they will all be overcome by the end of the century, when waste tanks will boil with 6 billion curies of strontium-90, 5.3 billion curies of cesium-137, 6.07 billion curies of prometheum-147, 10.1 billion curies of cerium-144, and millions of curies of other isotopes . . .

The burden that radioactive wastes place on future generations is cruel and may prove intolerable . . .

What must be done to avert the period of the peaceful atom? . . . The only course may be to turn boldly away from atomic energy as a major source of electricity production, abandoning it as this nation has abandoned other costly but unsuccessful technological enterprises. (R. Curtis and E. Hogan, 1969)

*An eloquent friend of nuclear power belittles the waste disposal problem.*

People just don't like the idea of radioactive wastes being put out of the way for thousands of years . . . They fear this danger not because it is great, but because it is new . . . Radioactive poisons underground, threatening somehow to get into your food—no matter how absurdly small the probability, it's new, it's a danger that wasn't there before.

The hell it wasn't. There are some 30 trillion cancer doses under the surface of the United States—the deposits of uranium and its daughters. They are not sealed into glass, they are not in salt formations, they are not deliberately put where it is safest, they occur in random places where Mother Nature decided to put them. And they do occasionally get into water and food, and they do occasionally kill people . . . The mean number of Americans killed by ingesting uranium or its daughters from natural sources is 12 per year.

"There is nothing we can do about those 30 trillion cancer doses," some people say when they first learn about them, "but at least we need not add any more to them."

But we add nothing. We take uranium ore out of the unsafe places where Nature put them, and after we extract some of its energy, we put the wastes back in a safer place than before, though we put them back in fewer places in more concentrated form . . . Plutonium, with its half-life of almost 25,000 years slows the decay process, but it remains there only as an impurity that failed to be recovered for further use as a valuable fuel. And what if the Luddites have their way and dispose of the plutonium unused? Like the proverbial man who killed his parent and then demanded the Court's mercy on the grounds that he was an orphan, they want to waste plutonium and then scare people with the long half-life of nuclear wastes. (P. Beckmann, 1976)

*A distinguished Russian physicist argues for the development of nuclear power.*

The development of nuclear technology has proceeded with much greater attention on the problems of safety techniques and preservation of the environment than the development of such branches of technology as metallurgy, coke chemistry, mining, chemical industry, coal power stations, modern transportation, chemicalization of agriculture, etc. Therefore, the present situation in nuclear power is relatively good from the point of view of safety and possible effects on the environment. The ways to improve it further are also quite clear. The basic peculiarity that distinguishes nuclear technology from that using chemical fuels is the high concentration and small volume of the dangerous byproducts and the small size of the process as a whole. This makes it easier to solve the safety and environmental problems for a nuclear power station than it is for a power station using coal, oil, etc.

Therefore I assert that the development of nuclear technology is one of the necessary conditions for the preservation of the economic and political independence of every country—of those that have already reached a high development stage as well as of those that are just developing. For the countries of Western Europe and Japan, the importance of nuclear technology is particularly great. If the economy of these countries continues to be in any important way dependent on the supply of chemical fuels from the USSR or from countries which are under her influence, the West will find itself under constant threat of the cutting off of these channels. This will result in a humiliating political dependence. In politics, one concession always leads to another and where it will finally lead is hard to foresee. (A. D. Sakharov, 1978)

The need for extraordinary safety and control measures for the nuclear power industry is voiced by a well-known radiation scientist in a "Journal of Politics."

No more important engineering challenge exists today than making sure that the reactors coming into use conform to a rigid set of codes so that the public safety is assured for the coming decades of nuclear power.

I do not make the charge that the AEC is imposing an unsafe system of nuclear power on the nation; I submit that the public record is not visible to substantiate public confidence in the AEC's assurance.

The nation needs power, clean power, and I believe it is not beyond our technological capabilities to design, site and operate nuclear power plants *and* insure the public safety. But as we, meaning all of us, enter into the nuclear decades, it is essential that the record is clear—that we, not just a few experts in a closed community, audit the nuclear books and lay the basis for public confidence in our nuclear future. (R. E. Lapp, 1971)

*Safety of the Use of Nuclear Explosives Underground for Large-Scale Excavation or Development of Natural Resources*

The Chairman of the U.S.S.R. State Committee for the Utilization of Atomic Energy affirms the safety of nuclear explosions for peaceful purposes, in an interview for Pravda.

*Question:* When nuclear explosions are being discussed, the question of radiation inevitably arises. Of course, each of us understands that people's security is insured, but is there no danger from the side effects of irradiation?

*Answer:* In our country there is an effective radiation security service. It has the right to veto any work if the slightest doubt arises. This concerns not only nuclear explosions for peaceful purposes, but also the use of atomic power stations and work with radioactive isotopes. In whatever form you may come into contact with atomic science and technology, you inevitably feel the presence of the radiation security service.

So far as nuclear explosions for peaceful purposes are concerned, since they are carried out deep under the ground there is, naturally, no escape of radioactive products to the surface. (A. M. Petrosyants, 1969)

**The Chief Judge, United States District Court for the District of Colorado, in a ruling rejects a suit to block a project for the release of natural gas by an underground nuclear explosion (Project Rulison) for reasons of public safety.**

Now, as to the . . . nuisance claim, I think the law is clear, as the government attorney pointed out, that action which is the direct result or an incident which is the direct result of an authorized activity, that is, authorized by the Congress of the United States, cannot be a nuisance in the legal sense. It certainly can be a nuisance, all right, but I mean, in a strictly legal sense, and that's the one we are concerned with here, of course, is the legal sense.

There is evidence that the government has expended something in the neighborhood of a half a million dollars on this project up to this point, and that if the continuation of the project, that is the detonation schedule, isn't permitted, there is something in the evidence that suggests that the daily expense to the Commission would be something in the neighborhood of $31,000 per day.

Now, I have gone over much of the material that has been submitted, I have gone over all of the affidavits, the letters, copies of letters, the Exhibit F series, and it would take me some days, probably up beyond the target date, to understand what is all involved, but I am impressed with the fact that the government has up to this point exercised extreme caution and care to protect the persons, the animal life, the plant life, the water supply and any other things that may be adversely affected by the detonation of this device.

I think it is fair to say that certainly an experiment such as this necessarily carries some risk with it. Any experiment in a new area where you are dealing with materials such as this is bound to carry some risk. An airplane flying over this building may be a risk; if it should fall it might do considerable damage both to the property and to the people. In congested areas such as New York City, with LaGuardia and Kennedy and New York all close by there, and literally hundreds of airplanes coming and going a day, right over the densely populated areas of the city, there are risks there, and they are not experiments. This is a day to day happening. (H. A. Arraj, 1969)

*Hazards to the Public from Fallout from Testing of Nuclear Bombs*

A Nobel laureate in chemistry, and a leader of the opposition to bombs testing, writes a letter to the *New York Times* on the genetic damage from $^{14}C$ in fallout.

A straightforward calculation based on the above assumptions leads directly to the conclusion that 1 year of testing at the standard rate of 30 megatons a year (two 15-megaton bombs, similar to the one detonated by the United States on March 1, 1954) will ultimately be responsible for the birth of 230,000 seriously defective children and also for 420,000 embryonic and neonatal deaths . . .

As other people have pointed out, these numbers will represent a minute fraction of the total number of seriously defective children and of embryonic and neonatal deaths during coming centuries.  But I feel that each human being is important, and that it is well worthwhile to calculate the numbers of individual human beings who will be caused to suffer or to die because of the bomb tests, rather than to talk about "negligible effects," "undetectable increase," "extremely small fraction."  (L. W. Pauling, 1958)

A university professor comments on the policy-making process regarding nuclear bomb testing.

In sum, here are the tasks which the fallout problem imposes upon us.  Research into the hazards of fallout radiation needs to be more fully and widely published so that the scientific community will be constantly aware of the changes which world-wide radiation is making in the life of the planet and its inhabitants.  This knowledge must be at the ready command of every scientist, so that we can all participate in the broad educational campaign that must be put into effect to bring this knowledge to the public.  If we succeed in this we will have met our major duty, for a public informed on this issue is the only true source of the moral wisdom that must determine our Nation's policy on the testing and the belligerent use of nuclear weapons.

There is a full circle of relationships which connects science and society.  The advance of science has thrust grave social issues upon us.  And, in turn, social morality will determine whether the enormous natural forces that we now control will be used for destruction—or reserved for the creative purposes that alone give meaning to the pursuit of knowledge.  (B. Commoner, 1958)

*Consequences to Civilization of an All-Out Thermonuclear War*

An authority in the field of national defense claims that effective defense measures can be taken against thermonuclear war.

The general belief persists today that an all-out thermonuclear war would inevitably result in mutual annihilation, and that nothing can be done to make it otherwise. Even those who do not believe in total annihilation often do believe that the shock effect of the casualties, the immediate destruction of wealth, and the longterm deleterious effects of fallout would inevitably jeopardize the survival of civilization.

A study recently carried out by the author and a number of colleagues at Rand, and privately financed by the Rand Corporation, has reached conclusions that seriously question these beliefs.  While a thermonuclear war would be a catastrophe, in some ways an unprecedented catastrophe, it would still be limited catastrophe.  Even more important, the limits on the magnitude of the catastrophe might be sharply dependent on what prewar measures had been taken.  The study suggests that for the next 10 or 15 years, and perhaps for much longer, feasible combinations of military and nonmilitary defense measures can come pretty close to preserving a reasonable semblance of prewar society.  (H. Kahn, 1959)

A distinguished scientist and member of the General Advisory Committee of the Atomic Energy Commission speaks in favor of preparedness for nuclear war.

There are relatively simple things we can do in preparation for the time of disaster which will make a tremendous difference in our response as individuals and as a nation.

The most effective way to reduce war casualties is to not have the war; and the national policy is to work continually toward conditions which lead to a lasting, just peace for all men.

We are led, when we review the history of man, ancient and modern, to the conclusion that it is wise to take out some insurance for our protection in the event that something goes wrong and peaceful international relations come to an end.

The nature of the effects of modern nuclear weapons and the range over which these effects can produce casualties may provoke the question: "Is there really anything we can do?" My answer to this question is, 'Yes.' " (W. F. Libby, 1959)

The following statement was made by Albert Einstein in February 1950, shortly after the announcement by President Truman that the United States would engage in an all-out effort to develop a hydrogen bomb.

The arms race between the United States and the Soviet Union, initiated originally as a preventive measure, assumes hysterical proportions. On both sides, means of mass destruction are being perfected with feverish haste and behind walls of secrecy. And now the public has been advised that the production of the hydrogen bomb is the new goal which will probably be accomplished. An accelerated development toward this end has been solemnly proclaimed by the President. If these efforts should prove successful, radioactive poisoning of the atmosphere, and hence, annihilation of all life on earth will have been brought within the range of what is technically possible. The weird aspect of this development lies in its apparently inexorable character. Each step appears as the inevitable consequence of the one that went before. And at the end, looming ever clearer, lies general annihilation. (O. Nathan and H. Norden, 1960)

A former director of the Livermore Radiation Laboratory, responsible for the development of nuclear weapons, writes about "the ultimate absurdity" in the arms race between the United States and the Soviet Union.

As we have seen, deployment of MIRV (multiple independently targetable reentry vehicles) by both sides, coupled with advances in accuracy and reliability, will put a very high premium on the use of the frightful launch-on-warning tactic and may place an even higher premium on a preemptive strike strategy. Under such circumstances, any fixed land-based-missile system must be able to launch its missiles so soon after receipt of warning that high-level human authorities cannot be included in a decision-making process without seriously degrading the system, unless perhaps such authorities have been properly preprogrammed to produce the "right" decision in the short time that might be available to them . . . Thus we seem to be heading for a state of

affairs in which the determination of whether or not doomsday has arrived will be made either by an automatic device designed for the purpose or by a preprogrammed President who, whether he knows it or not, will be carrying out orders written years before by some operations analyst.

Such a situation must be called the ultimate absurdity.   (H. F. York, 1970)

## A Personal Statement

We are in danger, programmed to destroy ourselves by the very nuclear arsenals established in pursuit of self-preservation.   To prevent nuclear war, we will need all the wisdom with which the human intellect is endowed.   But will the dimensions of the problem respond to the intellect alone?   I believe we also need those values that emanate from the human soul—values that speak of conduct constrained by a sense of accountability to our Creator, of the sanctity of life, of the search for eternal truths, and of the pursuit of justice; values that call for people to transcend political and religious boundaries and to form bonds of friendship and respect throughout the world. Here is the way to security that is the antithesis to the deployment of weapons of mass destruction.   Here lies the hope for effecting their neutralization and ultimate obsolescence.

# Appendix I

# Problems

Formulas used in solving the problems are listed in part III, section 4. References to the sections of the text which cover the subject matter of the problems or present similar illustrative examples are given after each problem. Data needed to solve these problems are given in Appendix II. If you need a refresher exercise in working with powers of ten, see Appendix V.

1. Converting mass into energy.
Calculate with the use of Einstein's mass-energy equation, $E = mc^2$, the energy in MeV produced from complete conversion of the mass of an electron. ($m = 9.11 \times 10^{-31}$ kg, $c = 2.998 \times 10^8$ m/s, 1 MeV $= 1.6 \times 10^{-13}$ joules) (Ref.: part I.)

2. Shielding beta particles.
Determine the thickness of aluminum (density = 2.7 g/cm³) needed to stop all the beta particles from a $^{90}$Sr source. Why should aluminum be used over a "heavier" metal, like lead? (Ref.: part II, table 2.1 and example 1, section 3.1.3)

3. Shielding gamma photons.
Determine the thickness of concrete required to reduce the intensity of the 1.33 MeV gamma radiation from $^{60}$Co to 1/100 of its value when unshielded. (Ref.: part II, figs. 2.11, 2.12)

4. Determining equivalent thicknesses of different materials for shielding.
Calculate the thickness of lead that is equivalent in shielding effectiveness to a concrete block 20 cm thick for 0.66 MeV gamma photons from $^{137}$Cs.

The densities of lead and concrete are 11.3 and 2.3 g/cc respectively. (Ref.: part II, figs. 2.11, 2.12)

5.  Calculating the thickness of shielding required for reducing the dose rate to a given level.

Determine the thickness of lead shielding required to reduce the dose rate from a 30 mCi $^{137}$Cs source to 5 mrem/hr at 30 cm from the source. (Ref.: part II, fig. 2.12)

6.  Determining exposure rate by "rule of thumb" and by use of the specific gamma rate constant.

(a) Calculate the exposure rate in mR/hr at 15 cm from a vial containing 5 mCi of $^{131}$I. (Ref.: part II, section 13.2).  Use methods of examples 12 and 13.

(b) Calculate the exposure rate at 15 cm if the vial in (a) is shielded by 2 mm lead (half-value layer of lead for $^{131}$I gamma photons is 3 mm). (Ref.: part II, section 13.3)

7.  Illustrating that even though a radionuclide may be stored in a lead container, the dose rate at the surface of the container can be quite high, especially if the container is small.

Assume that 10 mCi of $^{24}$Na in 100 $\mu$l of solution are contained in a small bottle.  The bottle is kept in a lead container with an inner diameter of 1.5 cm and walls 1.2 cm thick.

(a) Calculate the dose rate at the surface of the container and the dose to the hands if the lead container is held in the hands for 30 sec.  Assume the photons are incident perpendicular to the surface.

(b) Calculate the dose equivalent rate in mrem/hr at 30 cm from the axis of the container. (Ref.: part II, section 13.3)

8.  Illustrating how permissible working time may be controlled to comply with standards of exposure.

A technician in a pharmaceutical company handles routinely 500 mCi of $^{131}$I, 100 mCi of $^{198}$Au, and 25 mCi of $^{42}$K, all stored together in a hood. When he works in front of the hood, his mean body position is 60 cm from the active material.

How long can the technician work per week in front of the hood without additional shielding? (Ref.: part II, table 2.8, and accompanying discussion; Section 13.2)

9.  Calculating the increased working distance needed to allow a specified working time.

At what distance from the sources described in Problem 8 must the technician stand to allow a working time of 5 hr per week? (Ref.: part II, table 2.8, and accompanying discussion; section 13.2.  For additional discussion on inverse square law, see part III, section 3.2.2)

10.   Determining the size of a potion of a radioactive pharmaceutical to administer to a patient.

A patient is to be given 10 $\mu$Ci of $^{131}$I on Friday morning at 10 A.M. for a thyroid function test.   The assay of the master solution was 2 $\mu$Ci/ml on the preceding Monday at 2 P.M.   How many milliliters from the master solution must be given to the patient?   (Ref.: part II, section 13.4)

11.   Evaluating the dose from inhalation of a radioactive aerosol in a radiation accident.

The liquid contents of a plastic bottle containing 10 mCi of $^{131}$I are vaporized in a fire in a closed room 3 m $\times$ 4 m $\times$ 3 m high.   A person attempting to put out the fire breathes the vapor for 10 min.   Calculate the exposure to the thyroid: (a) in microcuries deposited, (b) in rads.   Assume a breathing rate of 1200 l/hr; an average uptake by the thyroid gland of 27 percent of the inhaled activity; a 20-g mass for the thyroid, effective half-life of 7.6 days, and a gamma dose equal to 10 percent of the beta dose.

How would you evaluate the seriousness of this exposure?   What would you recommend regarding subsequent handling of this person?   (Ref.: part II, section 13.1; part III, section 1.5)

12.   Calculating whole-body beta dose.

An investigator proposes the use of $^{14}$C-labeled alanine to study its turnover in obese patients.   He plans to inject 50 $\mu$Ci into each subject.   The alanine is rapidly eliminated with a biological half-life of 120 min.

(a) What value may we use for the effective half-life?

(b) Calculate the total dose received by the patient for an irradiated mass of 70,000 g.

(c) What restrictions, if any, would you place on the choice of patients? (Ref.: part III, section 1.5)

13.   Calculating the beta dose to a tissue.

One mCi of $^{32}$P is injected into the body.   Thirty percent concentrates rapidly in the bones.   The patient weighs 70 kg, and the bones constitute 10 percent of the body weight.

(a) Calculate the initial average dose rate to the bones in mrad/hr.

(b) Calculate the total dose to the bones as a result of this injection. (Ref.: part III, section 1.5)

14.   Another exercise in a beta-dose calculation for a tissue.

A certain compound is tagged with $^{35}$S, a pure beta emitter.   After administration it is found that 1/5 is promptly excreted, 1/5 is concentrated in the skin (mass 2 kg), and the remainder uniformly distributed through the soft tissues (60 kg).   The effective half-life in the body is 18 days.   Assuming maximum permissible doses of 100 mrem in a week for the whole body and 300 mrem in a week for the skin, what is the maximum permissible tracer dose?   (Ref.: part III, section 1.5)

15.   Checking for dose to reproductive organs in administration of a beta emitter.

It is proposed to use $^{35}$S-labeled sulfate in measurements of extracellular fluid. The protocol calls for the injection of 100 $\mu$Ci.

Calculate the dose to the testes as a result of this test if 0.2 percent of the administered activity localizes in the testes with a biological half-life of 627 days. Assume a mass of 80 g for the testes.   (Ref.: part III, section 1.5)

16.   Obtaining metabolic data for a human use study.

An investigator must determine the biological half-life of a radioactive compound he is proposing to administer to patients in an experimental study.   The radionuclide is $^{35}$S.   He administers 2 $\mu$Ci of the compound to a volunteer.   He collects all the urine and feces for 30 days for radioassay and finds that the total activity in the excreta at the end of the thirtieth day is 0.8 $\mu$Ci.

(*a*) What would the activity in the patient be after 30 days if none were excreted?

(*b*) What is the actual activity remaining in the patient?

(*c*) What is the biological half-life, assuming it was constant during the period of collection of the excreta?   (Ref.: part III, section 1.4)

17.   Calculating gamma flux densities and approximate dose rates.

An isotope user obtains a molybdenum-99 "cow" for generating technetium-99m.   The activity of the $^{99}$Mo is 100 mCi at the time of receipt.   Assume the $^{99m}$Tc is in equilibrium with the $^{99}$Mo parent, and therefore has the same activity.

(*a*) What are the source strengths in photons per second, for each of the gamma energies emitted by both the $^{99}$Mo and the $^{99m}$Tc at the time of receipt?   (Ref.: part II, sections 12.1, 12.2)

(*b*) What is the gamma flux density at 30 cm from the generator, assuming no absorption inside the generator?   (Ref.: part III, section 3.2.2, example 12)

(*c*) What is the gamma tissue-dose rate 30 cm from the source, as determined from the approximate rate of energy loss of 3 percent per cm?   (Ref.: part III, section 3.2.1)

18.   Calculating beta and gamma dose to an organ in the human use of radioisotopes.

Calculate the beta and gamma dose to the heart from 10 $\mu$Ci of $^{59}$Fe administered intravenously.   Use the geometrical factor method for the gamma dose.   Assume blood volume of 5 l and a spherical mass of blood 12 cm in diameter in the heart space.   The effective half-life of $^{59}$Fe in the blood is 27 days.   (Ref.: part III, section 3.3, note 11)

19.   Dose calculations associated with human use of a gamma emitter.

A patient is given 2 mCi of microaggregated albumin tagged with $^{99m}$Tc for a liver scan.

(*a*) What is the gamma dose rate at 1 m from the patient at the time the isotope is administered?   Neglect attenuation in the patient and assume a point source.

(*b*) What is the gamma dose to the liver of the patient if 80 percent of the administered activity is taken up by the liver?   Neglect the contribution from activity external to the liver.

Biological half-life of microaggregated albumin = 4 hr; weight of liver = 1700 g; absorbed fraction = 0.15.   (Ref.: part III, sections 3.3, 3.4)

20.   Assaying a sample with a G-M counter.

A G-M counter was used to measure the calcium-45 content of a labelled sample by comparison with an aliquot from a $^{45}$Ca standard solution.

The standard solution was obtained from the National Bureau of Standards and had an activity of 7380 dis/sec/ml at the time it was shipped, 23 days prior to the day of the measurement.   An aliquot of 0.2 ml of this solution was diluted to 10 ml, and 1 ml of the solution was evaporated to dryness and counted on the second shelf.   A 1 ml aliquot of the sample was evaporated to dryness and also counted on the same shelf.   The following counts were obtained in two minutes: Sample, 5400; Standard, 8100; Background, 45.   Find the activity of the sample in dis/min per ml.   (Ref.: part IV, section 1.9)

21.   Preparing a gamma calibration curve for a survey meter.

A cobalt-60 source was used to calibrate a survey meter.   The strength of the source was 1.9 mCi in January 1960, and the meter was calibrated in June 1971.   The detector was placed 2 m from the ground and walls to minimize scattering and obviate the need for scatter corrections.

The following readings were obtained with the survey meter as a function of distance from the source:

| Distance, cm | Exposure rate, mR/hr |
|---|---|
| 30 | 6.2 |
| 50 | 2.3 |
| 100 | 0.7 |
| 150 | 0.3 |

Plot exposure rate as read with the survey meter versus exposure rate as calculated from the source activity and hence prepare a calibration curve for the meter.   If high accuracy were required, how would you revise the calibration procedures?   (Ref.: part IV, section 4.5, fig. 4.20; part II, section 13.2)

22.   An exercise in the interpretation of counting data.

A patient is given 5 $\mu$Ci of $^{131}$I in a thyroid uptake test.   Twenty hours later, the patient's neck is counted with a scintillation detector.   A cup containing a potion identical to the one given to the patient is counted in a phantom at the same time and at the same distance.

The data obtained are as follows:

| Distance from end of crystal to front of source | 35 cm |
|---|---|
| Counting time of patient | 2 min |
| Counts from patient | 2734 |
| Counting time of administered solution | 2 min |
| Counts from solution | 5734 |
| Counting time for background | 10 min |
| Counts from background | 3670 |

(a) Calculate the net thyroid count rate and its standard deviation.

(b) Calculate the fractional uptake in the thyroid and its standard deviation.

(c) Express the fractional uptake with limits at the 95-percent confidence interval.

(d) What would be the percent error introduced in the uptake values if the true distance to the patient was 1.5 cm less than the value recorded? (Ref.: part IV, sections 6.6, 6.7)

23.   Determining the significance of the release of a radioactive gas to the air in terms of radiation standards.

A curie of $^{85}$Kr is released to a room 12 ft × 15 ft × 8 ft.

(a) Calculate the average concentration of $^{85}$Kr in the room in $\mu$Ci/cc, assuming all the $^{85}$Kr remains in the room.

(b) How many times maximum permissible concentration is this, based on occupational exposure for a 40-hour week?

(c) How long could a worker remain in the room without the maximum weekly exposure being exceeded?

(d) How long could a member of the public remain in the room without the maximum weekly exposure being exceeded? (Ref.: part V, section 7, table 5.2.)

24.   Calculating the permissible release rate of a radioactive gas through a hood.

An investigator is interested in releasing 200 mCi of $^{133}$Xe through a hood. The air velocity into the hood is 50 ft/min, through an opening 15 in. high and 3 ft wide. Determine the permissible release rate so that the concentration in the effluent from the hood stack does not exceed maximum allowable concentrations averaged over a 24-hr period. (Ref.: part V, section 18.1, table 5.2)

25.   Monitoring a contaminated area with a G-M counter.

An end window G-M tube with the cap off gave a counting rate of 10,800 c/min in a survey of a contaminated area. The counting rate with the cap on, at the same location, was 7000 c/min. The background counting rate

was 50 c/min.  What was the counting rate due to beta contamination?
(Ref.: part V, section 21.1)

## Answers to Problems

1. 0.51 MeV.

2. 0.41 cm.

3. 35 cm (based on HVL = 5.4 cm, "good geometry").

4. 3.6 cm (based on HVL = 3.15 cm for concrete and 0.57 cm for lead; "good geometry").

5. 2.5 cm (based on HVL = 0.57 cm, "good geometry").  NCRP 1976, Report 49, fig. 11, gives a value of about 2.8 cm for an attenuation factor of 0.045 in broad beam geometry.

6. (a) 45.9 mr/hr (rule of thumb); 48.4 mr/hr, $\Gamma$ (b) AF = 0.63; 0.63 × 48.4 = 30.5 mr/hr.

7. Assume activity is point source at center of container.  Distance from source to surface (hand) is 1.95 cm.  $\Gamma$ = 18.4 r-cm$^2$/hr-mCi.  HVL = 1.5 cm.  (a) 27.8 R/hr; 232 mR (approx. 232 mrad); (b) 27,800 mrem/hr × $(1.95)^2/(30)^2$ = 117 mrem/hr.

A more accurate result is obtained by considering each photon energy separately.  From fig. 2.18, part II, $\Gamma$ = 11.9 for 2.754 MeV and 7.2 for 1.37 MeV.  The half-value layers are 1.48 cm and 1.13 cm respectively and the attenuation factors 0.55 and 0.46 respectively.  The surface dose rate is 25.9 R/hr and the dose in 30 sec = 216 mR.

8. Dose rate is 379 mR/hr, permissible weekly dose is 1250/13 = 96 mR, giving a permissible working time of 96/378 = 0.254 hr or 15 min.

9. 266 cm.

10. 6.95 ml.

11. (a) 15.0 $\mu$Ci deposited; (b) 75.9 rad $\beta$ dose plus an additional 10 percent $\gamma$ dose, or 83.5 rad total.

12. (a) 120 min; (b) 0.215 mrad.

13. (a) 63.3 mrad/hr; (b) 24.4 rad based on effective average life of 15.9 day.

14. Assume 1 mCi administered.  Then dose in first week is 1.53 rad to skin and 0.153 rad whole body.  Thus 300/1530 × 1000 $\mu$Ci = 196 $\mu$Ci max. dose based on skin; also 100/153 × 1000 = 654 $\mu$Ci based on whole body. 196 $\mu$Ci = max tracer dose.

15. 0.688 rad.

16. (a) 1.57 $\mu$Ci; (b) 0.77 $\mu$Ci; (c) number of effective half-lives to give fractional decay of 0.385 =1.37.  $T_e^{\frac{1}{2}}$ = 21.9 day; $T_b^{\frac{1}{2}}$ = 29.3 day.

17. Consider each energy separately, as if the $^{99}$Mo - $^{99m}$Tc generator were composed of several different sources.  Set up a routine calculation procedure.  Every problem, no matter how complex it appears, may be broken up into a sequence of simple operations.  These can be performed in a minimum amount of time if they are organized properly.

| (1) Photon energy, MeV | (2) Mean number/ disintegration | (3) Source Strength, S $3.7 \times 10^9 \times$ (2) photons/sec | (4) Flux density at 30 cm $0.885 \times 10^{-4} \times$ (3) | (5) Energy flux density (1) × (4) |
|---|---|---|---|---|
| 0.78 | 0.048 | $0.178 \times 10^9$ | $0.158 \times 10^5$ | $0.123 \times 10^5$ |
| .74 | .14 | .518 | .458 | .339 |
| .37 | .014 | .058 | .051 | .019 |
| .18 | .067 | .248 | .220 | .040 |
| .14 | .90 | 3.33 | 2.95 | .413 |
| .018 | .104 | 0.385 | .341 | .006 |
| | | | $4.18 \times 10^5$ | $0.940 \times 10^5$ |

(a) See column (3).

(b) See column (4). Total flux density is $4.18 \times 10^5$/cm²-sec.

(c) Tissue dose rate at 30 cm = 0.00172 × (flux density) × (photon energy). Sum up contributions of (flux density) × (photon energy) at each energy, since different energy photons may be considered as separate sources. Tissue dose rate = $0.00172 \times 0.940 \times 10^5$ = 162 mrad/hr.

18. $\bar{g} = 3 \pi r = 56.55$; blood specific gravity = 1.056. $\beta$ dose = 0.44 rad; $\gamma$ dose = 0.47 rad.

19. (a) 0.14 mR/hr; (b) 130 mrad.

20. 5355/min-ml.

22. (a) 1000 ± 26.8/min; (b) 0.40 ± 0.012; (c) 0.40 ± 0.024; (d) 35 cm recorded, actual distance 33.5 cm. Since patient uptake is measured with reference to 35 cm, patient reading must be reduced by $(33.5/35)^2$ or patient uptake is too high by $(35/33.5)^2$ or 9.2 percent.

23. (a) $2.45 \times 10^{-2}$ μCi/cc; (b) 2450; (c) 0.98 min; (d) 7.5 sec.

24. 2300 μCi/day.

25. 3800 c/min.

# Appendix II  Data on Selected Radionuclides

| Radionuclide | Half-life and type of decay | Major radiations, energies (MeV), percent of disintegrations and equilibrium dose constant, Δ (g-rad/μCi-hr) | | | | Γ(R-cm²/hr-mCi); Pb HVL(cm) |
|---|---|---|---|---|---|---|
| | | $\beta_{max}$ (%); $\beta_{av}$; $e^-$; x (np) | Δ | γ, x-ray | Δ | |
| ³H | 12.3 yr, $\beta^-$ | 0.0186 (100%): 0.0057 av | 0.0121 | | | |
| ¹¹C | 20.3 min, $\beta^+$ | .980 (100%); .394 av | .838 | 0.511 (200%) | 2.1725 | |
| ¹⁴C | 5730 yr, $\beta^-$ | .156 (100%); .0493 av | .1050 | | | |
| ¹³N | 10.0 min, $\beta^+$ | 1.19 (100%); .488 av | 1.0395 | .511 (200%) | 2.1768 | |
| ¹⁵O | 124 sec, $\beta^+$ | 1.70 (100%); .721 av | 1.5349 | .511 (200%) | 2.1768 | |
| ¹⁸F | 109 min, EC, $\beta^+$ | .633 (97%); .250 av | .5157 | .511 (194%) | 2.1115 | |
| ²²Na | 12.60 yr, EC, $\beta^+$ | 1.821 (0.06%); .836 av | .0010 | 1.275 (100%) | 2.7148 | 12.0 R/hr; 1.0 cm |
| | | .546 (91%); .216 av | .4163 | .511 (181%) | 1.9735 | |
| | | $e^-$ (Auger) | .0001 | | | |
| ²⁴Na | 15.0 hr, $\beta^-$ | 1.392 (100%); .555 av | 1.1805 | 3.860 (0.08%) | 0.0065 | 18.4 R/hr; 1.5 cm |
| | | | | 2.754 (100%) | 5.8610 | |
| | | | | 1.369 (100%) | 2.9149 | |
| ³²P | 14.3 day, $\beta^-$ | 1.71 (100%); .695 av | 1.4799 | | | |
| ³⁵S | 87.0 day, $\beta^-$ | .167 (100%); .0488 av | .1039 | | | |
| ⁴⁰K | 1.270 × 10⁶ yr, EC, $\beta^-$ | 1.30 (89.5%); .556 av | 1.0591 | 1.46 (10.3%) | .3214 | |
| | | $e^-$ (Auger) | .0003 | | | |
| ⁴²K | 12.4 hr, $\beta^-$ | 3.52 (82%); 1.56 av | 2.7036 | 1.52 (18%) | .5845 | 1.4 R/hr; 1.2 cm |
| | | 2.00 (18%); .284 av | .3160 | .313 (0.17%) | .0011 | |
| | | 1.68 (0.18%) .699 av | .0026 | | | |
| ⁴³K | 2.44 hr, $\beta^-$ | 1.2–1.4 (12.4%); 0.67 av | .6935 | 0.167 (73%) | | 5.6 R/hr |
| | | .825 (82%); .297 av | | .373 (90%) | | |
| | | $e^-$ 0.37 (0.04%) | .0004 | All (191%) | 1.9777 | |
| ⁴⁵Ca | 163 day, $\beta^-$ | .257 (100%); .077 av | .1645 | | | |

**Appendix II** (continued)

| Radionuclide | Half-life and type of decay | β_max (%); β_av; e⁻; x (np) | Δ | γ, x-ray | Δ | Γ(R-cm²/hr-mCi); Pb HVL(cm) |
|---|---|---|---|---|---|---|
| $^{47}$Ca | 4.53 day, $\beta^-$ | 1.985 (18%); .816 av | .7303 | 1.30 (75%) | 2.2675 | |
| | | .688 (82%); .240 av | | | | |
| $^{51}$Cr | 27.7 day, EC | e⁻ (Auger) | .0080 | All (89%) | | 0.16 R/hr; 0.2 cm |
| | | x (np) | .0021 | .32 (10.2%) | .0694 | |
| $^{54}$Mn | 312 day, EC | e⁻ 0.83 (.02%) | .0004 | .835 (100%) | 1.7777 | 4.7 |
| | | e⁻ (Auger) | .0087 | | | |
| | | x (np) | .0027 | | | |
| $^{55}$Fe | 2.70 yr, EC | e⁻ (Auger) | .0092 | | | |
| | | x (np) | .0031 | | | |
| $^{59}$Fe | 45.0 day, $\beta^-$ | .467 (52%); .150 av | .2508 | 1.292 (44%) | 1.2168 | 6.4 R/hr; 1.1 cm |
| | | .273 (46%); .081 av | | 1.099 (55%) | 1.2987 | |
| | | e⁻ (IC) | .0003 | .1922 (2.9%) | .0166 | |
| $^{57}$Co | 270 day, EC | e⁻ 0.1 (3.51%) | .0089 | .136 (10.4%) | .0326 | .9 R/hr |
| | | e⁻ (IC) | .0133 | .122 (86%) | .2233 | |
| | | e⁻ (Auger) | .0177 | | | |
| | | x (np) | .0099 | | | |
| $^{58}$Co | 71.3 day, EC, $\beta^+$ | .474 (16%); 0.201 av | .0664 | .811 (99%) | 1.7461 | 5.5 R/hr |
| | | e⁻ (IC) | .0005 | .511 (31%) | .3374 | |
| | | e⁻ (Auger) | .0081 | | | |
| | | x (np) | .0031 | | | |
| $^{60}$Co | 5.26 yr, $\beta^-$ | .313 (100%); .0941 av | .2022 | 1.33 (100%) | 2.8378 | 13.2; 1.1 cm |
| | | | | 1.17 (100%) | 2.4935 | |
| $^{65}$Zn | 243 day, EC, $\beta^+$ | .325 (1.5%); .141 av | .0047 | 1.11 (51%) | 1.2019 | 2.7 R/hr; 1.0 cm |
| | | e⁻ (Auger) | .0106 | .511 (3%) | .0326 | |
| | | x (np) | .0061 | | | |

| Nuclide | Half-life, decay | Radiation | | | | |
|---|---|---|---|---|---|---|
| ⁶⁷Ga | 78.1 hr, EC | e⁻ 0.2 (0.4%) | .0013 | .394 (4%) | .0410 | 1.1 R/hr |
| | | e⁻ (IC) | .0606 | .300 (16%) | .1031 | |
| | | e⁻ (Auger) | .0148 | .185 (24%) | .1049 | |
| | | x (np) | .0095 | .092 (41%) | .0817 | |
| ⁶⁸Ga | 68.3 min, EC,β⁺ | 1.8980 (88%); 0.835 av | 1.5629 | 1.0774 (3.2%) | .0828 | |
| | | .8200 (1.3%); .352 av | .0097 | .5110 (178%) | 1.9417 | |
| | | e⁻ (Auger) | .0010 | | | |
| | | x (np) | .0006 | | | |
| ⁷⁵Se | 120 day, EC | e⁻ 0.1–0.4 (3%) | .0096 | .400 (11%) | .0998 | 2.0 R/hr |
| | | e⁻ (IC) | .0073 | .265 (57%) | .4776 | |
| | | e⁻ (Auger) | .0126 | .136 (54%) | .2093 | |
| | | x (np) | .0121 | | | |
| ⁸⁵Kr | 10.7 yr, β⁻ | .672 (99.6%); .246 av | .5218 | .514 (0.42%) | .0046 | .04 R/hr |
| | | .150 (0.4%); .041 av | .0003 | | | |
| | | e⁻ (Auger) | | | | |
| | | x (np) | | | | |
| ⁸⁶Rb | 18.6 day, β⁻ | 1.7720 (91%); .710 av | 1.3789 | 1.0766 (8.8%) | .2007 | .5 |
| | | .6920 (8.8%); .230 av | .0429 | | | |
| ⁸⁵Sr | 65.1 day, EC | e⁻ .5 (0.01%) | .0082 | .514 (99%) | 1.0862 | 3.0 R/hr |
| | | e⁻ (Auger) | .0113 | | | |
| | | x (np) | .0172 | | | |
| ⁹⁰Sr | 28.1 yr, β⁻ | .546 (100%); .196 av | .4177 | | | |
| ⁹⁰Y | 64 hr, β⁻ | 2.273 (100%); .931 av | 1.9836 | | | |
| ⁹⁹Mo | 66.7 hr, β⁻ | 1.234 (80%); 0.452 av | .8321 | .778 (4.8%) | .0840 | 0.89 R/hr; 0.74 cm |
| | | .456 (19%); .140 av | | .740 (13.7%) | .2154 | |
| | | e⁻ 0.1–0.2 (2%) | .0054 | .366 (1.4%) | .0122 | |
| | | e⁻ (IC) | .0022 | .181 (6.6%) | .0253 | |
| | | e⁻ (Auger) | .0006 | .141 (5.6%) | .0179 | |
| | | | | .018 (3.8%) | .0015 | |
| ⁹⁹ᵐTc | 6.03 hr, ISOM | e⁻ 0.1 (12%) | .0312 | .1405 (88%) | .2631 | .60 R/hr; 0.03 cm |
| | | e⁻ (IC) | .0035 | .0183 (6.6%) | .0029 | |
| | | e⁻ (Auger) | .0022 | | | |

**Appendix II** (continued)

| Radionuclide | Half-life and type of decay | Major radiations, energies (MeV), percent of disintegrations and equilibrium dose constant, Δ (g-rad/μCi-hr) | | | | Γ(R-cm²/hr-mCi); Pb HVL(cm) |
|---|---|---|---|---|---|---|
| | | $\beta_{max}$ (%); $\beta_{av}$; e⁻; x (np) | Δ | γ, x-ray | Δ | |
| ¹¹¹In | 2.81 day, EC | e⁻ 0.1–0.2 (16%) | .0615 | .2470 (94%) | .4942 | |
| | | e⁻ (Auger) | .0151 | .1720 (90%) | .3282 | |
| | | x (np) | .0007 | .0230 (70%) | .0345 | |
| | | | | .0263 (14%) | .0079 | |
| ¹²³I | 13 hr, EC | e⁻ 0.1 (16%) | .0440 | .159 (84%) | .2831 | |
| | | e⁻ (Auger) | .0160 | .2–.8 (2.3%) | .0245 | |
| | | x (np) | .0010 | .0273 (71%) | .0415 | |
| | | | | .0313 (15%) | .0101 | |
| ¹²⁵I | 60.2 day, EC | e⁻ (IC) | .0151 | .035 (6.7%) | .0050 | .7; 0.0037 cm |
| | | e⁻ (Auger) | .0266 | .027 (115%) | .0671 | |
| | | x (np) 22% | .0017 | .031 (25%) | .0163 | |
| ¹³¹I | 8.06 day, β⁻ | .806 (0.8%); 0.284 av | .0048 | .723 (1.7%) | .0267 | 2.2 R/hr; .3 cm |
| | | .606 (90%); .192 av | .3666 | .637 (6.5%) | .0906 | |
| | | .25–.333 (9.3%); .090 av | .0177 | .364 (82%) | .6430 | |
| | | .1–.6 (2.1%) | .0144 | .284 (5.8%) | .0371 | |
| | | e⁻ (IC) | .0042 | .080 (2.6%) | .0044 | |
| | | e⁻ (Auger) | .0008 | .030 (3.8%) | .0028 | |
| ¹¹³Sn | 115 day, EC | e⁻ .2 (.08%) | .0003 | .2550 (2.1%) | .0112 | 1.7 R/hr; .3 cm |
| | | e⁻ (Auger) | .0131 | .0241 (61%) | .0312 | |
| | | x (np) | .0006 | .027 (1.3%) | .0073 | |
| ¹³³Xe | 5.31 day, β⁻ | .1006 (98%) | .2132 | .0809 (36%) | .0632 | .1 R/hr |
| | | e⁻ (IC) | .0696 | .0308 (39%) | .0318 | |
| | | e⁻ (Auger) | .0093 | | | |
| | | x (np) | .0007 | | | |

| | | | | | | |
|---|---|---|---|---|---|---|
| { ¹³⁷Cs | 30 yr, β⁻ | 1.1760 (5%); 0.427 av | .0491 | [.6616(85%)]ᵃ | | 3.3 R/hr; 0.5 cm |
| | | .5140 (95%); .175 av | .3520 | | | |
| ¹³⁷mBa | 2.55 min, ISOM | e⁻ 0.6 (10.2%) | .1366 | .6616 (89.8%) | 1.2658 | |
| | | e⁻ (Auger) | .0013 | .032 (5.9%) | .0048 | |
| | | x (np) | .0001 | | | |
| ¹⁹⁸Au | 2.69 day, β⁻ | .9612 (99%); .316 av | .6667 | .6758 (1.1%) | .0207 | 2.3 R/hr; .3 cm |
| | | e⁻ .3–.6 (4.2%) | .0312 | .4117 (96%) | .8380 | |
| | | e⁻ (Auger) | .0006 | .0708 (1.4%) | .0042 | |
| | | x (np) | .0002 | | | |
| ¹⁹⁷Hg | 65 hr, EC | e⁻ .1–.2 (1.5%) | .0053 | .1915 (0.29%) | .0016 | .4 R/hr |
| | | e⁻(IC) | .1056 | .0773 (25%) | .0417 | |
| | | e⁻ (Auger) | .0336 | .068 (56%) | .0811 | |
| | | x (np) | .0013 | .079 (16%) | .0264 | |
| ²⁰³Hg | 46.5 day, β⁻ | .2120 (100%); .0577 av | .1229 | .2792 (82%) | .4860 | 1.3 R/hr |
| | | e⁻ .2–.3 (18%) | .0829 | .083 (2.9%) | .0050 | |
| | | e⁻ (Auger) | .0038 | .072 (9.9%) | .0152 | |
| | | x (np) | .0013 | | | |

*Sources:* Dillman and Van der Lage, 1975; ICRU 1979, report 32; Jaeger et al., 1968 (for specific gamma-ray constants, except ⁹⁹Mo and ⁹⁹mTc, which were calculated from MIRD data); Martin and Blichert-Toft, 1970 (for average beta energies); Quimby, Feitelberg, and Gross, 1970 (for lead half-value layers).

*Notes:* $\beta_{max}$ is maximum beta-particle energy. $\beta_{av}$ is average beta-particle energy. Percentage given in parentheses is for beta-particles or photon energy listed, 2 principle energies given. Percentage given for group of energies, including those not listed, where sum of dose constants gives dose for all particles or photons emitted per disintegrations. Photons less than 0.015 MeV classified as nonpenetrating (np). Percentage of disintegrations given only for beta particles and internal conversion (IC) electrons with energies equal to or greater than 0.1 MeV (range 14 mg/cm²). All Auger electrons and IC listings without stated percentages are less than 0.1 MeV. HLV is approximate half-value layer (cm) for lead. ISOM = isomeric transition. EC = electron capture.

a. ¹³⁷Cs is normally listed as emitting a 0.66 MeV gamma ray in 85 percent of the disintegrations, but the gamma ray is actually emitted in 89.8 percent of the disintegrations of its decay product, ¹³⁷mBa ($T^h$ = 2.55 min), which results from 95 percent of the ¹³⁷Cs disintegrations.

# Appendix III

# Anatomical and Physiological Data for Dose Calculations

## A. Masses of Organs and Tissues for Reference Adult

|  | ICRP 1975 (Report no. 23) | | ICRP 1959 |
|---|---|---|---|
|  | Adult male | Adult female | Standard man |
| Mass of total body (g) | 70,000 | 58,000 | 70,000 |
| Total body water (ml) | 42,000 | 29,000 | 43,000 |
| Total blood volume (ml) | 5,200 | 3,900 | |
|   Red blood cells | (2,200)[a] | (1,400) | |
|   Plasma | (3,000) | (2,500) | |
| Total blood mass (g) | 5,500 | 4,100 | 5,400 |
|   Red blood cells | (2,400) | (1,500) | |
|   Plasma | (3,100) | (2,600) | |
| Total body fat (g) | 13,500 | 16,000 | 10,000 |
|   Essential constituents of cells | (1,500) | (1,000) | |
|   Nonessential (separable) | (12,000) | (15,000) | |
| Adrenal glands | 14 | 14 | 20 |
| Bladder | 45 | 45 | 150 |
|   Normal capacity (ml) | 200 | 200 | |
| Brain | 1,400 | 1,200 | 1,500 |
| Breasts | 26 | 360 | |
| Eyes | 15 | 15 | 30 |
| Gallbladder (without contents) | 10 | 8 | |
|   Bile | 62 | 51 | |

**Appendix III**   (continued)

| | ICRP 1975 (Report no. 23) | | ICRP 1959 |
| | Adult male | Adult female | Standard man |
|---|---|---|---|
| G. I. tract | | | 2,000 (excluding contents) |
| Esophagus | 40 | 30 | |
| Stomach + contents | 150 + 120 | 140 | 250 |
| Small intestine | 640 + 400 | 600 | 1,100 |
| Upper large intestine | 210 + 220 | 200 | 135 |
| Lower large intestine | 160 + 135 | 160 | 150 |
| Heart (without blood) | 330 | 240 | 300 |
| End of diastole | 570 | 470 | |
| End of systole | (425) | (350) | |
| Kidneys | 310 | 275 | 300 |
| Liver | 1,800 | 1,400 | 1,700 |
| Lungs | 1,000 | 800 | 1,000 |
| Pulmonary blood | (530) | (430) | |
| Lung tissue or parenchyma | (440) | (360) | |
| Bronchial tree | (30) | ~(25) | |
| Lymphatic tissue (fixed) | 700 | 580 | 700 |
| Lymphocytes | 1,500 | 1,200 | |
| Muscle, skeletal | 28,000 | 17,000 | 30,000 |
| Ovaries | | 11 | 8 |
| Pancreas | 100 | 85 | 70 |
| Parathyroids (4) | 0.12 | 0.14 | 0.15 |
| Pituitary | 0.6 | 0.7 | 0.6 |
| Prostate | 16 | | 20 |
| Salivary glands | 85 | 70 | 50 |
| Skeleton | | | |
| Excluding bone marrow | 7,000 | | 7,000 |
| Red marrow | 1,500 | 1,300 | 1,500 |
| Yellow marrow | 1,500 | 1,300 | 1,500 |
| Skin | 2,600 | 1,790 | 2,000 |
| Spinal cord | 30 | 28 | 30 |
| Spleen | 180 | 150 | 150 |
| Teeth | 46 | 41 | 20 |
| Testes or ovaries | 35 | 11 | 40 |
| Thymus | 20 | 20 | 10 |
| Thyroid | 20 | 17 | 20 |

**Appendix III   (continued)**
**B. Physiological Data**

|  | Adult man | Adult woman | Child (10 yr) | Infant (1 yr) | Newborn |
|---|---|---|---|---|---|
| Volume air breathed (m³) | | | | | |
| 8-hr working, "light activity" | 9.600 | 9.100 | 6.240 | 2.500 (10 hr) | 0.090 (1 hr) |
| 8-hr nonoccupational activity | 9.600 | 9.100 | 6.240 | | |
| 8-hr resting | 3.600 | 2.900 | 2.300 | 1.300 (14 hr) | .690 (23 hr) |
| Total | 23 | 21 | 15 | 3.8 | 0.8 |
| Water intake (ml/day) | | | | | |
| Milk | 300 | 200 | 450 | | |
| Tap water | 150 | 100 | 200 | | |
| Other | 1,500 | 1,100 | 750 | | |
| Total fluid intake | 1,950 | 1,400 | 1,400 | | |
| In food | 700 | 450 | 400 | | |
| By oxidation of food | 350 | 250 | 200 | | |
| Totals | 3,000 | 2,100 | 2,000 | | |

*Sources:* ICRP, 1975 (report 23).

*Note:* Values used in 1959 ICRP Committee II report (ICRP, 1960) are: volume of air breathed, 10 m³ (8-hr working day) and 20 m³ (24-hr); water intake, 1.1 l (8-hr working day) and 2.2 l (24-hr).

a. Numbers in parentheses pertain to constituents of organs or tissues whose masses are given separately, usually in the lead entry.

# Appendix IV

# Some Constants and Conversion Factors

| | |
|---|---|
| Electron mass | $m_e = 9.109 \times 10^{-31}$ kg; 0.511 MeV. |
| Proton mass | $m_p = 1.67252 \times 10^{-27}$ kg; 938.256 MeV. |
| Neutron mass | $m_n = 1.67482 \times 10^{-27}$ kg; 939.50 MeV. |
| Alpha particle mass | $m_\alpha = 6.6443 \times 10^{-27}$ kg; 3,727 MeV. |
| Mass unit, unified mass scale | $\mu = 1.66043 \times 10^{-27}$ kg; 931.478 MeV. |
| Electron charge | $e = 1.602 \times 10^{-19}$ coulomb (C). |
| Energy expended by $\alpha$ particles per ion pair in air | $W(\alpha) = 34.98$ eV. |
| Energy expended by $\beta$ particles per ion pair in air | $W(\beta) = 33.73$ eV. |
| Avogadro's number | $N_a = 6.023 \times 10^{23}$/mole. |
| Planck's constant | $h = 6.626 \times 10^{-34}$ joule-second. |
| Boltzmann constant | $k = 1.381 \times 10^{-23}$ J °K$^{-1}$. |
| Velocity of light in vacuum | $c = 2.998 \times 10^8$ m/sec. |

Density of dry air at 0°C, 760 mm Hg = 0.001293 g/cc.
Density of dry air at 20°C, 760 mm Hg = 0.001205 g/cc.

| Multiply | By | To Obtain |
|---|---|---|
| feet | 30.48 | centimeters |
| cubic feet | $2.832 \times 10^4$ | cubic centimeters |
| gallons | 3.785 | liters |
| pounds | 453.5 | grams |
| British thermal units | $2.931 \times 10^{-4}$ | kilowatt hours |
| British thermal units | 251.8 | calories |
| million electron volts | $1.603 \times 10^{-13}$ | joules |

# Appendix V

# Calculations Using Powers of Ten

Large numbers may be written as a product of a number between 1 and 10 and the factor 10 raised to a positive exponent. The exponent gives the number of places the decimal is moved to the right.

Numbers smaller than 1 may be written as a product of a number between 1 and 10, and the factor 10 raised to a negative exponent. The exponent gives the number of places the decimal is moved to the left.

$$1 \text{ microcurie} = 2{,}220{,}000 \text{ disintegrations per minute.}$$
$$= 2.22 \times 10^6 \text{ dpm.}$$
$$1 \text{ mrad} = 62{,}500 \text{ MeV/g.}$$
$$= 6.25 \times 10^4 \text{ MeV/g.}$$

The maximum level for tritium in drinking water
$$= 0.00000020 \ \mu\text{Ci/cc.}$$
$$= 2.0 \times 10^{-7} \ \mu\text{Ci/cc.}$$

To multiply two numbers expressed as coefficients times 10 raised to a power, express the result as (product of the coefficients) × (10 raised to the sum of the exponents):

$$6 \times 10^{16} \times 2 \times 10^{13} = 12 \times 10^{29}$$
$$6 \times 10^{16} \times 2 \times 10^{-13} = 12 \times 10^{3}.$$

To divide two numbers expressed as coefficients times 10 raised to a power, express the result as (quotient of the coefficients) × (10 raised to the difference of the exponents):

$$\frac{6 \times 10^{16}}{2 \times 10^{13}} = 3 \times 10^{3}.$$

$$\frac{6 \times 10^{16}}{2 \times 10^{-13}} = 3 \times 10^{29}.$$

A number may be inverted if the sign of the exponent is changed.

$$10^6 = \frac{1}{10^{-6}} \qquad 10^{-6} = \frac{1}{10^6}$$

Example: The radius of the earth is 3960 miles. What is the radius in centimeters?

$$r = 3.96 \times 10^3 \text{ miles} \times 5.280 \times 10^3 \frac{\text{ft}}{\text{mile}} \times 12 \frac{\text{in}}{\text{ft}} \times 2.54 \frac{\text{cm}}{\text{in}}$$
$$= 3.96 \times 5.28 \times 12 \times 2.54 \times 10^6$$
$$= 637 \times 10^6$$
$$= 6.37 \times 10^8 \text{ cm.}$$

The above example also illustrates the crossing out of units. In this procedure, each value is given with its units, and units are divided or multiplied algebraically to determine the units of the final result of the calculation. The application of this procedure prevents errors from use of wrong units, or the incorrect use of conversion factors.

# Selected Bibliography

The following titles are recommended, but the list is by no means exhaustive, and the reader is urged to investigate the many volumes on subjects related to radiation protection that are on the shelves of a good library. The reader is also referred to the literature of manufacturers and suppliers of commercial equipment, which often includes not only information on the availability of equipment but extensive educational material and practical information on methods and applications.

## Radiation Protection and Dosimetry

Attix, F. H., and W. C. Roesch, eds. 1968. *Radiation Dosimetry*, vol. I, *Fundamentals*. New York: Academic Press. *See also, Radiation Dosimetry*, vol. II, *Instrumentation* (1966); *Radiation Dosimetry*, vol. III, *Sources, Fields, Measurements, and Applications* (1969); *Topics in Radiation Dosimetry, Supplement* (1972).
Cember, H. 1983. *Introduction to Health Physics*. Oxford: Pergamon Press.
Knoll, G. F. 1979. *Radiation Detection and Measurement*. New York: John Wiley.
Price, W. J. 1964. *Nuclear Radiation Detection*. New York: McGraw-Hill.
Tsoulfanidis, N. 1983. *Measurement and Detection of Radiation*. New York: McGraw-Hill.

## Nuclear Radiation Physics

Evans, R. D. 1955. *The Atomic Nucleus*. New York: McGraw-Hill.
Kaplan, I. 1963. Nuclear Physics. Reading, Mass.: Addison-Wesley.
Lapp, R. E., and H. L. Andrews. 1972. *Nuclear Radiation Physics*. Englewood Cliffs, N.J.: Prentice-Hall.

## Radiobiology

Hall, E. 1984. *Radiation and Life*. New York: Pergamon Press.
Hall, E. 1988. *Radiobiology for the Radiologist*. Philadelphia: J. B. Lippincott.
Pizzarello, D., and R. Witcofski. 1982. *Medical Radiation Biology*. Philadelphia: Lea and Febiger.

## Medical Radiation Physics

Curry, T., et al. 1984. *Christensen's Introduction to the Physics of Diagnostic Radiology*. Philadelphia: Lea and Febiger.
Hendee, W. R. 1978. *Medical Radiation Physics*. Chicago: Year Book Medical Publishers.
Johns, H. E., and J. R. Cunningham. 1982. *The Physics of Radiology*. Springfield, Ill.: Charles C Thomas.
Meredith, W. J., and J. B. Massey. 1972. *Fundamental Physics of Radiology*. Baltimore: Williams and Wilkins.
Webster, E. W. 1988. Radiologic Physics. Chapters 1–35 in volume 1 of *Radiology*, ed. J. Taveras and J. Serrucci. Philadelphia: J. B. Lippincott.

## Nuclear Medicine

Gottschalk, A., P. Hoffer, and J. Potchen. 1988. *Diagnostic Nuclear Medicine*. Baltimore: Williams and Wilkens.
Harbert, J., et al. 1984. *A Textbook of Nuclear Medicine*. Philadelphia: Lea and Febiger.
Mettler, F., and M. Guiberteau. 1986. *Essentials of Nuclear Medicine Imaging*. Orlando, Fla.: Grune and Stratton.
Sorenson, J., and M. Phelps. 1987. *Physics in Nuclear Medicine*. Orlando, Fla.: Grune and Stratton.

## Handbooks

*Radiological Health Handbook*. 1970. Compiled and edited by the Bureau of Radiological Health and the Training Institute, Environmental Control Administration. Washington, D.C.: Government Printing Office.
Brodsky, A. 1978. *CRC Handbook of Radiation Measurement and Protection*, sect. A, vol. 1, *Physical Science and Engineering Data*. Boca Raton, Fla: CRC Press, Inc.
Shlein, B., and M. Terpilak. 1984. *The Health Physics and Radiological Health Handbook*. Olney, Md.: Nucleon Lectern Associates, Inc.
Wang, Y., ed. 1969. *Handbook of Radioactive Nuclides*. Cleveland: Chemical Rubber Co.

The Medical Internal Radiation Dose Committee (MIRD) of the Society of Nuclear Medicine publishes a series of pamphlets giving methods and data for absorbed dose calculations. The first pamphlets were issued as supplements to the *Journal of Nu-*

*clear Medicine.* Starting with pamphlet 10, they were issued in looseleaf binder format. Pamphlet 10 (1975) gives extensive data on radionuclide decay schemes for use in radiation dose calculations. Pamphlet 11 (1975) gives "S" factors for many radionuclides. The pamphlets may be purchased from MIRD Committee, 404 Church Ave., Suite 15, Maryville, Tenn. 37801.

The National Council on Radiation Protection and Measurements (NCRP) issues reports providing information and recommendations based on leading scientific judgment on matters of radiation protection and measurement. The following reports are available from NCRP Publications, 7910 Woodmont Ave., Suite 800, Bethesda, Md. 20814.

| Number | Title and Date |
|---|---|
| 99 | Quality Assurance for Diagnostic Imaging Equipment, 1988. |
| 97 | Measurement of Radon and Radon Daughters in Air, 1988. |
| 96 | Comparative Carcinogenesis of Ionizing Radiation and Chemicals, 1988. |
| 95 | Radiation Exposure of the U.S. Population from Consumer Products and Miscellaneous Sources, 1987. |
| 94 | Exposure of the Population of the United States and Canada from Natural Background Radiation, 1987. |
| 93 | Ionizing Radiation Exposure of the Population of the United States, 1987. |
| 91 | Recommendations on Limits for Exposure to Ionizing Radiation, 1987. |
| 89 | Genetic Effects of Internally Deposited Radionuclides, 1987. |
| 87 | Use of Bioassay Procedures for Assessment of Internal Radionuclide Deposition, 1986. |
| 86 | Biological Effects and Exposure Criteria for Radiofrequency Electromagnetic Fields, 1986. |
| 85 | Mammography—A User's Guide, 1986. |
| 84 | General Concepts for the Dosimetry of Internally Deposited Radionuclides, 1985. |
| 83 | The Experimental Basis for Absorbed-Dose Calculations in Medical Use of Radionuclides, 1985. |
| 80 | Induction of Thyroid Cancer by Ionizing Radiation, 1985. |
| 79 | Neutron Contamination from Medical Electron Accelerators, 1984. |
| 78 | Evaluation of Occupational and Environmental Exposures to Radon and Radon Daughters in the United States, 1984. |
| 77 | Exposures from the Uranium Series with Emphasis on Radon and Its Daughters, 1984. |
| 76 | Radiological Assessment: Predicting the Transport, Bioaccumulation, and Uptake by Man of Radionuclides Released to the Environment, 1984. |
| 74 | Biological Effects of Ultrasound: Mechanisms and Clinical Implications, 1983. |
| 73 | Protection in Nuclear Medicine and Ultrasound Diagnostic Procedures in Children, 1983. |
| 72 | Radiation Protection and Measurement for Low Voltage Neutron Generators, 1983. |

| | |
|---|---|
| 71 | Operational Radiation Safety—Training, 1983. |
| 70 | Nuclear Medicine—Factors Influencing the Choice and Use of Radionuclides in Diagnosis and Therapy, 1982. |
| 69 | Dosimetry of X-Ray and Gamma-Ray Beams for Radiation Therapy in the Energy Range 10 keV to 50 MeV, 1981. |
| 68 | Radiation Protection in Pediatric Radiology, 1981. |
| 67 | Radiofrequency Electromagnetic Fields—Properties, Quantities and Units, Biophysical Interaction, and Measurements, 1981. |
| 66 | Mammography, 1980. |
| 65 | Management of Persons Accidentally Contaminated with Radionuclides, 1979. |
| 63 | Tritium and Other Radionuclide Labeled Organic Compounds Incorporated in Genetic Material, 1979. |
| 62 | Tritium in the Environment, 1978. |
| 61 | Radiation Safety Training Criteria for Industrial Radiography, 1978. |
| 59 | Operational Radiation Safety Program, 1978. |
| 58 | A Handbook of Radioactivity Measurements Procedures, 1978. |
| 57 | Instrumentation and Monitoring Methods for Radiation Protection, 1978. |
| 55 | Protection of the Thyroid Gland in the Event of Releases of Radioiodine, 1977. |
| 54 | Medical Radiation Exposure of Pregnant and Potentially Pregnant Women, 1977. |
| 53 | Review of NCRP Radiation Dose Limit for Embryo and Fetus in Occupationally-Exposed Women, 1977. |
| 51 | Radiation Protection Design Guidelines for 0.1–100 MeV Particle Accelerator Facilities, 1977. |
| 50 | Environmental Radiation Measurements, 1976. |
| 49 | Structural Shielding Design and Evaluation for Medical Use of X Rays and Gamma Rays of Energies up to 10 MeV, 1976. |
| 48 | Radiation Protection for Medical and Allied Health Personnel, 1976. |
| 47 | Tritium Measurement Techniques, 1976. |
| 46 | Alpha-Emitting Particles in Lungs, 1975. |
| 42 | Radiological Factors Affecting Decision-Making in a Nuclear Attack, 1974. |
| 38 | Protection against Neutron Radiation, 1971. |
| 37 | Precautions in the Management of Patients Who Have Received Therapeutic Amounts of Radionuclides, 1970. |
| 36 | Radiation Protection in Veterinary Medicine, 1970. |
| 35 | Dental X-Ray Protection, 1970. |
| 34 | Medical X-ray and Gamma-Ray Protection for Energies up to 10 MeV —Structural Design and Use, 1968. |
| 33 | Medical X-Ray and Gamma-Ray Protection for Energies up to 10 MeV —Equipment Design and Use, 1968. |
| 32 | Radiation Protection in Educational Institutions, 1966. |
| 31 | Shielding for High-Energy Electron Accelerator Installations, 1964. |
| 30 | Safe Handling of Radioactive Material, 1964. |
| 29 | Exposure to Radiation in an Emergency, 1962. |

22            Maximum Permissible Body Burdens and Maximum Permissible Concentrations of Radionuclides in Air and in Water for Occupational Exposure, 1959.

The International Commission on Radiation Units and Measurements (ICRU) issues reports concerned with the definition, measurement, and application of radiation quantities in clinical radiology and radiobiology. The following reports are available from ICRU, 7910 Woodmont Ave., Suite 800, Bethesda, Md. 20814.

| Number | Title and Date |
|--------|----------------|
| 43 | Determination of Dose Equivalents from External Radiation Sources —Part 2, 1988. |
| 40 | The Quality Factor in Radiation Protection, 1986. |
| 39 | Determination of Dose Equivalents Resulting from External Radiation Sources, 1985. |
| 37 | Stopping Powers for Electrons and Positrons, 1984. |
| 36 | Microdosimetry, 1983. |
| 35 | Radiation Dosimetry: Electron Beams with Energies between 1 and 50 MeV, 1984. |
| 34 | The Dosimetry of Pulsed Radiation, 1982. |
| 33 | Radiation Quantities and Units, 1980. |
| 32 | Methods of Assessment of Absorbed Dose in Clinical Use of Radionuclides, 1979. |
| 31 | Average Energy Required to Produce an Ion Pair, 1979. |
| 30 | Quantitative Concepts and Dosimetry in Radiobiology, 1979. |
| 28 | Basic Aspects of High Energy Particle Interactions and Radiation Dosimetry, 1978. |
| 26 | Neutron Dosimetry for Biology and Medicine, 1977. |
| 25 | Conceptual Basis for the Determination of Dose Equivalent, 1976. |
| 22 | Measurement of Low-Level Radioactivity, 1972. |
| 20 | Radiation Protection Instrumentation and Its Application, 1971. |
| 17 | Radiation Dosimetry: X-Rays Generated at Potentials of 5 to 150 kV, 1970. |
| 16 | Linear Energy Transfer, 1970. |
| 14 | Radiation Dosimetry: X Rays and Gamma Rays with Maximum Photon Energies between 0.6 and 50 MeV, 1969. |
| 13 | Neutron Fluence, Neutron Spectra and Kerma, 1969. |
| 10c | Radioactivity, National Bureau of Standards Handbook 86, 1963. |
| 10b | Physical Aspects of Irradiation, Natural Bureau of Standards Handbook 85, 1964. |

The International Commission on Radiological Protection (ICRP) issues reports dealing with the basic principles of radiation protection. The reports may be obtained from Pergamon Press, Maxwell House, Fairview Park, Elmsford, N.Y. 10523. The following reports provide practical information and recommendations for radiation users.

| Number | Title and Date |
|--------|----------------|
| 54 | Individual Monitoring for Intakes of Radionuclides by Workers: Design and Interpretation, 1988. |
| 53 | Radiation Dose to Patients for Radiopharmaceuticals, 1987. |
| 52 | Protection of the Patient in Nuclear Medicine, 1987. |
| 51 | Data for Use in Protection against External Radiation, 1987. |
| 50 | Lung Cancer Risk from Indoor Exposures to Radon Daughters, 1987. |
| 49 | Developmental Effects of Irradiation on the Brain of the Embryo and Fetus, 1986. |
| 48 | The Metabolism of Plutonium and Related Elements, 1986. |
| 46 | Radiation Protection Principles for the Disposal of Solid Radioactive Waste, 1985. |
| 45 | Quantitative Bases for Developing a Unified Index of Harm, 1985. |
| 44 | Protection of the Patient in Radiation Therapy, 1985. |
| 43 | Principles of Monitoring for the Radiation Protection of the Population, 1985. |
| 40 | Protection of the Public in the Event of Major Radiation Accidents: Principles for Planning, 1984. |
| 39 | Principles for Limiting Exposure of the Public to Natural Sources of Radiation, 1984. |
| 38 | Radionuclide Transformations: Energy and Intensity of Emissions, 1983. |
| 36 | Protection against Ionizing Radiation in the Teaching of Science, 1983. |
| 35 | General Principles of Monitoring for Radiation Protection of Workers, 1982. |
| 34 | Protection of the Patient in Diagnostic Radiology, 1982. |
| 33 | Protection against Ionizing Radiation from External Sources Used in Medicine, 1982. |
| 32 | Limits of Inhalation of Radon Daughters by Workers, 1981. |
| 31 | Biological Effects of Inhaled Radionuclides, 1980. |
| 30 | Limits for Intakes of Radionuclides by Workers, 1979. |
| 29 | Radionuclide Release into the Environment: Assessment of Doses to Man, 1979. |
| 28 | The Principles and General Procedures for Handling Emergency and Accidental Exposures of Workers, 1978. |
| 27 | Problems Involved in Developing an Index of Harm, 1977. |
| 26 | Recommendations of the International Commission of Radiological Protection, 1977. |
| 25 | The Handling, Storage, Use and Disposal of Unsealed Radionuclides in Hospitals and Medical Research Establishments, 1977. |
| 24 | Radiation Protection in Uranium and Other Mines, 1977. |
| 23 | Reference Man: Anatomical, Physiological and Metabolic Characteristics, 1975. |
| 22 | Implication of Commission Recommendations that Doses Be Kept as Low as Readily Achievable. |
| 17 | Protection of the Patient in Radionuclide Investigations, 1971. |
| 16 | Protection of the Patient in X-Ray Diagnosis, 1970. |
| 15 | Protection against Ionizing Radiation from External Sources, 1970. |

13          Radiation Protection in Schools for Pupils up to the Age of 18 Years, 1970.

The International Atomic Energy Agency issues many publications pertaining to the nuclear science field, including the proceedings of symposia (Proceedings Series, Panel Proceedings Series), a Safety Series covering topics in radiation protection, a Technical Reports Series, a Bibliographical Series, and a Review Series. A complete catalog of publications may be obtained from the Publishing Section, International Atomic Energy Agency, Karnter Ring 11, P.O. Box 590, A-1011 Vienna, Austria. Publications may be ordered from UNIPUB, Inc., P.O. Box 433, New York, N.Y. 10016. Examples are:

Technical Report Series No. 133.  Handbook on Calibration of Radiation Protection Monitoring Instruments, 1971.
Technical Report Series No. 109.  Personnel Dosimetry Systems for External Radiation Exposures, 1970.
Safety Series No. 46.  Recommendations.  Monitoring of Airborne and Liquid Radioactive Releases from Nuclear Facilities to the Environment, 1978.
Safety Series No. 1.  Safe Handling of Radionuclides, 1973 Edition.  Code of Practice Sponsored by IAEA and WHO, 1973.
Safety Series No. 38.  Radiation Protection Procedures, 1973.

National consensus standards relating to radiation protection provide valuable information and guidance, and are often incorporated into the regulations of the Nuclear Regulatory Commission. The major national organization issuing such standards is the American National Standards Institute (ANSI), 1430 Broadway, New York, N.Y. 10018. The following ANSI standards were also issued as handbooks of the National Bureau of Standards:

Safety Standard for Non-Medical X-Ray and Sealed Gamma-Ray Sources (NBS Handbook 93, ANSI std. Z54.1-1963).
Radiological Safety in the Design and Operation of Particle Accelerators (HB 107, ANSI N43.1-1969).
Radiation Safety for X-Ray Diffraction and Fluorescence Analysis Equipment (HB 111, ANSI N43.2-1971).

The U.S. Nuclear Regulatory Commission issues guides that describe methods acceptable to the NRC staff for implementing specific parts of the Commission's regulations. They are published and revised continuously; interested persons should request current information from the U.S. Nuclear Regulatory Commission, Washington, D.C. 20555, Attention: Director, Office of Nuclear Regulatory Research. Following are some guides of interest to users of radioactive materials licensed by the NRC.

| Number | Title and Date |
|--------|----------------|
| 1.86 | Termination of Operating Licenses for Nuclear Reactors, 1974. |
| 8.10 | Operating Philosophy for Maintaining Occupational Radiation Exposure as Low as Reasonably Achievable, 1975. |

| 8.13 | Instruction Concerning Prenatal Radiation Exposure, 1975. |
| 8.18 | Information Relevant to Insuring that Occupation Radiation Exposures at Medical Institutions Will Be as Low as Reasonably Achievable, 1977. |
| 8.20 | Applications of Bioassay for I-125 and I-131, 1979. |
| 8.21 | Health Physics Surveys for Byproduct Material at NRC-Licensed Processing and Manufacturing Plants, 1978. |
| 8.23 | Radiation Safety Surveys at Medical Institutions, 1981. |
| 10.2 | Guidance to Academic Institutions Applying for Specific Byproduct Material Licenses of Limited Scope, 1984. |
| 10.3 | Guide for the Preparation of Applications for Special Nuclear Material Licenses of Less than Critical Mass Quantities, 1977. |
| 10.4 | Guide for the Preparation of Applications for Licenses to Process Source Material, 1985. |
| 10.5 | Guide for the Preparation of Applications for Type A Licenses of Broad Scope for Byproduct Material, 1985. |
| 10.6 | Guide for the Preparation of Applications for Use of Sealed Sources and Devices for the Performance of Industrial Radiography, 1984. |
| 10.7 | Guide for the Preparation of Applications for Licenses for Laboratory Use of Small Quantities of Byproduct Material, 1984. |
| 10.8 | Guide for the Preparation of Applications for Medical Programs, 1987. |

*Health Physics,* the official journal of the Health Physics Society, is an extremely valuable source of information in radiation protection.

# References

Abelson, P. H. 1987. Municipal waste. Editorial in *Science*. *Science*, 236:1409.

Abrams, H. L. 1978. Factors underlying the overutilization of radiologic examinations. Paper presented at the National Conference on Referral Criteria for X-Ray Examinations. Summarized in the weekly news bulletin issued by the Harvard University News Office for the Medical Area, *Focus*, Nov. 30, 1978.

ACGIH 1983. *Air Sampling Instruments for Evaluation of Atmospheric Contaminants*, 6th ed. Cincinnati: American Conference of Governmental Industrial Hygienists.

Adams, J. A. S., and W. M. Lowder, eds. 1964. *The Natural Radiation Environment*. Chicago: Univ. Chicago Press.

AEC 1972. *The Safety of Nuclear Power Reactors (Light-Water Cooled) and Related Facilities*. U.S. Atomic Energy Commission Report WASH-1250. Washington, D.C.: National Technical Information Service.

Ahearne, J. F. 1987. Nuclear power after Chernobyl. *Science*, 236:673–679.

Ahrens, L. H. 1965. *Distribution of the Elements in Our Planet*. New York: McGraw-Hill.

Alcox, R. W. 1974. Patient exposures from intraoral radiographic examinations. *J. Amer. Dent. Assn.*, 88:568–579.

Altshuler, B., N. Nelson, and M. Kuschner. 1964. Estimation of lung tissue dose from the inhalation of radon and daughters. *Health Phys.*, 10:1137–1161.

Altshuler, B., and B. Pasternack. 1963. Statistical measures of the lower limit of detection of a radioactivity counter. *Health Phys.*, 9:293–298.

Anderson, T. T. 1978. Radiation exposures of Hanford workers; a critique of the Mancuso, Stewart and Kneale report. *Health Phys.*, 35:739–750.

Andersson, I. O., and J. Braun. 1963. *A Neutron Rem Counter with Uniform Sensitivity from 0.025 eV to 10 MeV. Neutron Dosimetry*. International Atomic Energy Agency Proceedings Series STI/PUB/69. Vienna: IAEA.

Angevine, D. M., and S. Jablon. 1964. Late radiation effects of neoplasia and other diseases in Japan. *Ann. N.Y. Acad. Sci.*, 114:823–831.

ANSI 1975. *Radiation Protection Instrumentation Test and Calibration.* American National Standards Institute Standard N323. New York: ANSI.

ANSI 1978. *Control of Radioactive Surface Contamination on Materials, Equipment, and Facilities to Be Released for Uncontrolled Use.* Draft American National Standard N13.12 (issued on trial basis). New York: ANSI.

Anspaugh, L. R., R. J. Catlin, and M. Goldman. 1988. The global impact of the Chernobyl reactor accident. *Science,* 242:1513–19.

Archer, V. E., J. D. Gillam, and J. K. Wagner. 1976. Respiratory disease mortality among uranium miners. *Ann. N.Y. Acad. Sci.,* 271:280–293.

Arraj, H. A. 1969. Ruling, Richard Crowther et al., plaintiffs, vs. Glenn T. Seaborg et al., defendants. Reprinted in *Nuclear Explosion Services for Industrial Applications,* pp. 734–739. See JCAE 1969.

Attix, F. H., and W. C. Roesch, eds. 1966. *Radiation Dosimetry,* vol. II, *Instrumentation.* New York: Academic Press.

Attix, F. H., and W. C. Roesch, eds. 1968. *Radiation Dosimetry,* vol. I, *Fundamentals.* New York: Academic Press.

Ayres, J. W. 1970. *Decontamination of Nuclear Reactors and Equipment.* New York: Ronald Press.

Baedecker, P. A. 1971. Digital methods of photopeak integration in activation analysis. *Analyt. Chem.,* 43:405–410.

Bair, W. J., C. R. Richmond, and B. W. Wachholz. 1974. *A Radiobiological Assessment of the Spatial Distribution of Radiation Dose from Inhaled Plutonium.* U.S. Atomic Energy Commission Report WASH-1320. Washington, D.C.: U.S. Government Printing Office.

Bair, W. J., and J. M. Thomas. 1975. Prediction of the health effects of inhaled transuranium elements from experimental animal data. In *Transuranium Nuclides in the Environment.* Proceedings of a symposium. Vienna: IAEA.

Bair, W. J., and R. C. Thompson. 1974. Plutonium: biomedical research. *Science,* 183:715–722.

Bale, W. F. 1951. *Hazards Associated with Radon and Thoron.* Memorandum to files, Division of Biology and Medicine, Atomic Energy Commission, March 14.

Bale, W. F., and J. Shapiro. 1955. Radiation dosage to lungs from radon and its daughter products. *Proceedings of the U.N. International Conference on Peaceful Uses of Atomic Energy,* 13:233.

Barkas, W. H. 1963. *Nuclear Research Emulsions.* New York: Academic Press.

Bathow, G., E. Freytag, and K. Tesch. 1967. Measurements on 6.3 GeV electromagnetic cascades and cascade-produced neutrons. *Nucl. Phys.,* B2:669–689.

Baum, J. W., A. V. Kuehner, and R. L. Chase. 1970. Dose equivalent meter designs based on tissue equivalent proportional counters. *Health Phys.,* 19:813–824.

Baxt, J. H., S. C. Bushong, S. Glaza, and S. Kothari. 1976. Exposure and roentgen-area-product in xeromammography and conventional mammography. *Health Phys.,* 30:91–94.

Beck, H. L., W. M. Lowder, and B. G. Bennett. 1966. *Further Studies of External Environmental Radiation.* U.S. Atomic Energy Commission Report HASL 170.

Beck, T. J., and M. Rosenstein. 1979. *Quantification of Current Practice in Pediatric Roentgenography for Organ Dose Calculations.* U.S. Department of Health, Education, and Welfare Publication (FDA) 79-8078. Washington, D.C.: U.S. Government Printing Office.

Becker, K. 1966. *Photographic Film Dosimetry*. London and New York: Focal Press.

Becker, K. 1973. *Solid State Dosimetry*. Cleveland: CRC Press.

Beckmann, P. 1976. *The Health Hazards of Not Going Nuclear*. Boulder, Colo.: Golem Press

Beierwaltes, W. H., M. T. J. Hilger, and A. Wegst. 1963. Radioiodine concentration in fetal human thyroid from fallout. *Health Phys.*, 9:1263–1266.

Bennett, B. G. 1974. *Fallout* $^{239}Pu$ *Dose to Man*. U.S. Department of Energy Environmental Measurements Laboratory Report HASL 278, pp. 41–63. Springfield, Va.: National Technical Information Service.

Bennett, B. G., and C. S. Klusek. 1978. Strontium-90 in the diet—results through 1977. Environmental Measurements Laboratory (Department of Energy) Report EML-342. *Envir. Quart.*, July 1.

Blatz, H. W. 1970. Regulatory changes for effective programs. *Second Annual National Conference on Radiation Control*. U.S. Department of Health, Education, and Welfare Report BRH/ORO 70-5.

Boice, J. D., and C. E. Land. 1979. Adult leukemia following diagnostic x-rays? *Am. J. Pub. Health*, 69:137–145.

Boice, J. D., and R. R. Monson. 1977. Breast cancer in women after repeated fl>oscopic examinations of the chest. *J. Natl. Cancer Inst.*, 59:823–832.

Bond, V. P. 1979. *The Acceptable and Expected Risks from Fast Neutron Exposure*. Position paper to National Council on Radiation Protection and Measurements, Nov. 27.

Bond, V. P., E. P. Cronkite, S. W. Lippincott, and C. J. Shellabarger. 1960. Studies on radiation-induced mammary gland neoplasia in the rat III. Relation of the neoplastic response to dose of total-body radiation. *Radiat. Res.*, 12:276–285.

Bond, V. P., and L. E. Feinendegen. 1966. Intranuclear $^3H$ thymidine: dosimetric, radiological and radiation protection aspects. *Health Phys.*, 12:1007–1020.

Braestrup, C. B. 1969. *Past and Present Status of Radiation Protection. A Comparison*. U.S. Department of Health, Education, and Welfare, Consumer Protection and Environmental Control Administration Report, Seminar Paper 005.

BRH 1969. *Population Dose from X-Rays U.S. 1964*. U.S. Department of Health, Education, and Welfare, Bureau of Radiological Health Report, Public Health Service Publication no. 2001. Washington, D.C.: U.S. Government Printing Office.

BRH 1970. *Radiological Health Handbook*. Compiled and edited by the Bureau of Radiological Health and the Training Institute, Environmental Control Administration. Washington, D.C.: U.S. Government Printing Office.

BRH 1973. *Population Exposure to X-Rays U.S. 1970*. Public Health Service x-ray exposure study conducted under the direction of the Bureau of Radiological Health. Department of Health, Education, and Welfare Publication (FDA) 73–8041. Washington, D.C.: U.S. Government Printing Office.

BRH 1974. *Suggested Optimum Survey Procedures for Diagnostic X-Ray Equipment*. Prepared by the Conference of Radiation Control Program Directors and the Bureau of Radiological Health, U.S. Department of Health, Education, and Welfare. Washington, D.C.: Bureau of Radiological Health.

BRH 1976. *Gonad Doses and Genetically Significant Dose from Diagnostic Radiology, U.S., 1964 and 1970*. Report of the Bureau of Radiological Health. Washington, D.C.: U.S. Government Printing Office.

BRH 1978. *Ninth Annual National Conference on Radiation Control. Meeting*

*Today's Challenges. June 19–23, 1977.* Proceedings issued as HEW Publication (FDA) 78–8054. Washington, D.C.: U.S. Government Printing Office.

BRH 1978a. X-ray referral conference could establish pattern for future action. News item on National Conference on Referral Criteria for X-Ray Examinations. *BRH Bulletin,* 7(20):1–4.

BRH 1978b. Bureau of Radiological Health, unpublished information. Personal communication from A. B. McIntyre, Chief, Nuclear Medicine Studies Staff, Division of Radioactive Materials and Nuclear Medicine.

Brill, A. B., M. Tomonaga, and R. M. Heyssel. 1962. Leukemia in man following exposure to ionizing radiation. *Ann. Internal Med.,* 56:590–609.

Bross, I. D. J., M. Ball, and S. Falen. 1979. A dosage response curve for the one rad range: adult risks from diagnostic radiation. *Am. J. Pub. Health,* 69:130–136.

Bross, I. D. J., and N. Natarajan. 1972. Leukemia from low-level radiation. *New Eng. J. Med.,* 287:107–110.

Bross, I. D. J., and N. Natarajan. 1977. Genetic damage from diagnostic radiation. *J. Am. Med. Assn.,* 237:2399–2401.

Brown, R. F., J. W. Shaver, and D. A. Lamel. 1980. *The Selection of Patients for X-ray Examinations.* U.S. Department of Health, Education, and Welfare Publication (FDA) 80–8104. Rockville, Md.: Bureau of Radiological Health.

Buckton, K. E., P. A. Jacobs, W. M. Court Brown, and R. Doll. 1962. A study of the chromosome damage persisting after x-ray therapy for ankylosing spondylitis. *Lancet,* 2:676–682.

Burchsted, C. A., J. E. Hahn, and A. B. Fuller. 1976. *Nuclear Air Cleaning Handbook.* Oak Ridge National Laboratory Report ERDA 76–21. Springfield, Va.: National Technical Information Service.

Burgess, W. A., and J. Shapiro. 1968. Protection from the daughter products of radon through the use of a powered air-purifying respirator. *Health Phys.,* 15:115–121.

Bustad, L. K., ed. 1963. The biology of radioiodine. Proceedings of the Hanford Symposium held at Richland, Wash., June 17–19. *Health Phys.,* 9:1081–1426.

Butts, J. J., and R. Katz. 1967. Theory of RBE for heavy ion bombardment of dry enzymes and viruses. *Radiat. Res.,* 30:855–871.

Cameron, J. R., N. Suntharalingam, and G. N. Kenney. 1968. *Thermoluminescent Dosimetry.* Madison: Univ. Wis. Press.

Carter, J. 1978. Radiation protection guidance to federal agencies for diagnostic x-rays. Presidential memorandum. *Fed. Reg.,* 43(22):4377–4380.

Carter, L. J. 1976. National environmental policy act: critics say promise unfulfilled. *Science,* 193:130–139.

Carter, M. W., and A. A. Moghissi. 1977. Three decades of nuclear testing. *Health Phys.* 33:55–71.

CFR 1975. *Analysis of Effects of Limited Nuclear Warfare.* Report of Committee on Foreign Relations, U.S. Senate.

CFR 1987. Standards for protection against radiation. United States Nuclear Regulatory Commission rules and regulations. *Code of Federal Regulations, Title 10, Part 20.* Washington, D.C.: USNRC.

Chamberlain, A. C., and E. D. Dyson. 1956. The dose to the trachea and bronchi from the decay products of radon and thoron. *Brit. J. Radiol.,* 29:317–325.

Chilton, A. B., and C. M. Huddleston. 1963. A semiempirical formula for differential dose albedo for gamma rays. *Nucl. Sci. Eng.,* 17:419.

Clark, H. M. 1954. The occurrence of an unusually high-level radioactive rainout in the area of Troy, N.Y. *Science,* 119:619.

Clarke, R. H. 1988. *Statement of Evidence to the Hinkley Point C Inquiry.* Statement by the director of the National Radiological Protection Board (United Kingdom), Report NRPB-1.

Clayton, R. F. 1970. *Monitoring of Radioactive Contamination on Surfaces.* International Atomic Energy Agency Technical Reports Series no. 120. Vienna: IAEA.

Cloutier, J. R., J. L. Coffey, W. S. Synder, and E. E. Watson, eds. 1976. *Radiopharmaceutical Dosimetry Symposium.* Proceedings of a conference held at Oak Ridge, Tenn., April 26–29. U.S. Department of Health, Education, and Welfare Publication (FDA) 76–8044. Washington, D.C.: U.S. Government Printing Office.

Cohen, B. L. 1976. Impacts of the nuclear energy industry on human health and safety. *Am. Scientist,* 64:550–559.

Cohen, B. L. 1977. Hazards from plutonium toxicity. *Health Phys.,* 32:359–379.

Cohen, B. L. 1977a. High-level radioactive waste from light-water reactors. *Rev. Mod. Phys.,* 49:1–20.

Cohen, S. C., S. Kinsman, and H. D. Maccabee. 1976. *Evaluation of Occupational Hazards from Industrial Radiation: A Survey of Selected States.* U.S. Department of Health, Education and Welfare Publication (NIOSH) 77–42. Washington, D.C.: U.S. Government Printing Office.

Comar, C. L., ed. 1976. *Plutonium: Facts and Inferences.* Palo Alto, Calif.: Electric Power Research Institute.

Commoner, B. 1958. The fallout problem. *Science,* 127:1023–1026. Reprinted in *Fallout from Nuclear Weapons Tests,* pp. 2572–2577. See JCAE 1959.

Conard, R. A. 1976. Personal communication, reported in UNSCEAR 1977. See also Conard, R. A., et al., 1975. *A Twenty-Year Review of Medical Findings in a Marshallese Population Accidentally Exposed to Radioactive Fallout.* Brookhaven National Laboratory Report BNL 50424. Springfield, Va.: National Technical Information Service.

Conlon, F. B., and G. L. Pettigrew. 1971. *Summary of Federal Regulations for Packaging and Transportation of Radioactive Materials.* U.S. Department Health, Education, and Welfare Report BRH/DMRE 71–1. Washington, D.C.: U.S. Government Printing Office.

Conti, E. A., G. D. Patton, and J. E. Conti. 1960. Present health of children given x-ray treatment to the anterior mediastinum in infancy. *Radiology,* 74:386–391.

Court Brown, W. M., and R. Doll. 1965. Mortality from cancer and other causes after radiotherapy for ankylosing spondylitis. *Brit. Med. J.,* no. 5474(Dec. 4): 1327–1332.

Court Brown, W. M., R. Doll, and A. B. Hill. 1960. Incidence of leukaemia after exposure to diagnostic radiation in utero. *Brit. Med. J.,* no. 5212(Nov. 26):1539–45.

Cowan, G. A. 1976. A natural fission reactor. *Sci. Am.,* 235:36–48.

Cowser, K. E., W. J. Boegly, Jr., and D. G. Jacobs. 1966. $^{85}Kr$ *and Tritium in an Expanding World Nuclear Industry.* U.S. Atomic Energy Commission Report ORNL 4007, pp. 35–37.

Crawford, M. 1987. Hazardous waste: Where to put it? *Science,* 235:156–157.

CRCPD 1988. *Average Patient Exposure Guides 1988.* Conference of Radiation Control Program Directors, Inc. Publication 88-5. Available from Office of Executive Secretary, 71 Fountain Place, Frankfort, Ky. 40601.

Curtis, R., and E. Hogan. 1969. The myth of the peaceful atom. *Natural Hist.,* 78:6.

Dahl, A. H., R. Bostrom, R. G. Patzer, and J. C. Villforth. 1963. Patterns of $^{131}I$ levels in pasteurized milk network. *Health Phys.,* 9:1179–1186.

Davies, S. 1968. Environmental radiation surveillance at a nuclear fuel reprocessing plant. *Am. J. Pub. Health,* 58:2251.

Davis, H. L. 1970. Clean air misunderstanding. *Phys. Today,* 23(May):104.

Davis, R. K., G. T. Stevenson, and K. A. Busch. 1956. Tumor incidence in normal Sprague-Dawley female rats. *Cancer Res.,* 16:194–197.

DCPA 1973. What the planner needs to know about fallout. *DCPA Attack Environment Manual.* Defense Civil Preparedness Agency Manual CPG 2-1A6.

DeBeeck, J. O. 1975. Gamma-ray spectrometry data collection and reduction by simple computing systems. *Atom. Energy Rev.,* 13:743–805.

DeLawter, D. S., and T. Winship. 1963. Follow-up study of adults treated with roentgen rays for thyroid disease. *Cancer,* 16:1028–1031.

Dennis, R., ed. 1976. *Handbook on Aerosols.* U.S. Energy Research and Development Administration Report TID-26608. Springfield, Va.: National Technical Information Service.

Dertinger, H., and H. Jung. 1970. *Molecular Radiation Biology.* New York: Springer-Verlag.

DeVoe, J. R., ed. 1969. *Modern Trends in Activation Analysis,* vols. 1 and 2. National Bureau of Standards Special Publication 312. Washington, D.C.: U.S. Government Printing Office.

Dillman, L. T. 1969. Radionuclide decay schemes and nuclear parameters for use in radiation dose estimation. Medical Internal Radiation Dose Committee Pamphlets no. 4 and 6. *J. Nucl. Med.,* vol. 10, suppl. no. 2 (March 1969) and vol. 11, suppl. no. 4 (March 1970).

Dillman, L. T., and F. C. Van der Lage. 1975. *Radionuclide Decay Schemes and Nuclear Parameters for Use in Radiation-Dose Estimation.* NM/MIRD Pamphlet no. 10. New York: Society of Nuclear Medicine.

DiNunno, J. J., et al. 1962. *Calculation of Distance Factors for Power and Test Reactor Sites.* U.S. Atomic Energy Commission Report TID-14844. Washington, D.C.: Office of Technical Services.

DOE 1987. *Health and Environmental Consequences of the Chernobyl Nuclear Plant Accident.* Department of Energy Report DOE/ER-0332. Springfield, Va.: NTIS.

Doida, Y., T. Sugahara, and M. Horikawa. 1965. Studies on some radiation induced chromosome aberrations in man. *Radiat. Res.,* 26:69–83.

Donn, J. J., and R. L. Wolke. 1977. The statistical interpretation of counting data from measurements of low-level radioactivity. *Health Phys.,* 32:1–14.

DOT 1983. *A Review of the Department of Transportation (DOT) Regulations for Transportation of Radioactive Materials.* Compiled and edited by A. W. Grella. Washington, D.C.: Department of Transportation, Office of Hazardous Materials.

Edsall, J. T. 1976. Toxicity of plutonium and some other actinides. *Bull. Atom. Sci.,* 32:27–37.

Eisenbud, M. 1963. *Environmental Radioactivity.* New York: McGraw-Hill.

Eisenbud, M. 1968. Sources of radioactivity in the environment. In *Proceedings of a Conference on the Pediatric Significance of Peacetime Radioactive Fallout. Pediatrics,* suppl. 41:174–195.

Elkind, M. M., and G. F. Whitmore. 1967. *The Radiobiology of Cultured Mammalian Cells.* New York: Gordon and Breach.

EPA 1974. *Plutonium Accidents.* Supplemental information from the Atomic Energy Commission Division of Biomedical and Environmental Research to Environ-

mental Protection Agency Plutonium Standards Hearings, Washington, D.C., Dec. 10–11.

EPA 1976. *Radiation Protection Guidance for Diagnostic X-Rays*. Report of the Interagency Working Group on Medical Radiation, U.S. Environmental Protection Agency. Federal Guidance Report no. 9 EPA 520/4–76–019.

EPA 1977. *Radiological Quality of the Environment in the United States, 1977*, ed. K. L. Feldman, U.S. EPA Report EPA 520/1–77–009. Washington, D.C.: EPA.

EPA 1978. *Provisions for Hazardous Waste Regulation and Land Disposal Controls under the Resource Conservation Act of 1976.* Summary (SW-644) prepared by the Office of Solid Waste, United States Environmental Protection Agency.

EPA 1988. *Limiting Values of Radionuclide Intake and Air Concentration and Dose Conversion Factors for Inhalation, Submersion and Ingestion.* Federal Guidance Report No. 11. Washington, D.C.: Office of Radiation Programs, EPA.

Epp, E. R., and H. Weiss. 1966. Experimental study of the photon energy spectrum of primary diagnostic x-rays. *Phys. Med. Biol.*, 11:225–238.

Etherington, H., ed. 1958. *Nuclear Engineering Handbook.* New York: McGraw-Hill.

Evans, R. D. 1955. *The Atomic Nucleus.* New York: McGraw-Hill.

Evans, R. D. 1963. Statistical fluctuations in nuclear processes. In *Methods of Experimental Physics*, vol. 5B, ed. L. C. Yuan and C-S. Yo. New York: Academic Press.

Evans, R. D. 1967. The radiation standard for boneseekers—evaluation of the data on radium patients and dial painters. *Health Phys.*, 13:267–278.

Evans, R. D. 1968. X-ray and $\gamma$-ray interactions. In *Radiation Dosimetry*, vol. 1, ed. F. H. Attix and W. C. Roesch. New York: Academic Press.

Evans, R. D. 1974. Radium in man. *Health Phys.*, 27:497–510.

Evans, R. D., and C. Goodman. 1940. Determination of the thoron content of air and its bearing on lung cancer hazards in industry. *Journal Ind. Hyg. Toxicol.*, 22:89.

Evans, R. D., A. T. Keane, and M. M. Shanahan. 1972. Radiogenic effects in man of long-term skeletal alpha-irradiation. In *Radiobiology of Plutonium*, ed. B. J. Stover and W. S. S. Jee. Salt Lake City: J. W. Press.

Fabrikant, J. I. 1980. *The BEIR-III Report and Its Implications for Radiation Protection and Public Health Policy.* Lawrence Berkeley Laboratory (University of California) Report LBL-10494.

Failla, G. 1960. Discussion submitted by Dr. G. Failla. *Selected Materials on Radiation Protection Criteria and Standards: Their Basis and Use.* Printed for the use of the Joint Committee on Atomic Energy, 86th Congress, 2d sess. Washington, D.C.: U.S. Government Printing Office.

Feely, H. W., and L. E. Toonkel. 1978. Worldwide deposition of $^{90}$Sr through 1977. Environmental Measurements Laboratory (Department of Energy) Report EML-344. *Envir. Quart.*, October 1.

Findeisen, W. 1935. Uber das Absetzen Kleiner, in der Luft suspendierter-Teilchen in der menschlichen Lunge bei der Atmug. *Arch. Ges. Physiol. (Pflugers)*, 236:367.

Fish, B. R. 1967. *Surface Contamination.* Proceedings of a symposium held at Gatlinburg, Tenn. June 1964. New York: Pergamon Press.

Fish, B. R. 1969. The role of nuclear energy in the control of air pollution. *Nucl. Safety*, 10:119–130.

Fitzgerald, J. J. 1969. *Applied Radiation Protection and Control.* New York: Gordon and Breach.

Fleischer, R. L., P. B. Price, and R. M. Walker. 1975. *Nuclear Tracks in Solids.* Berkeley: Univ. Calif. Press.

Focht, E. F., E. H. Quimby, and M. Gershowitz. 1965. Revised average geometric factors for cylinders in isotope dosage I. *Radiology,* 85:151.

Foderaro, A. 1971. *The Elements of Neutron Interaction Theory.* Cambridge, Mass.: MIT Press.

Fowler, E. B., R. W. Henderson, and M. F. Milligan. 1971. *Proceedings of Environmental Plutonium Symposium.* Los Alamos Scientific Laboratory Report LA-4756 (UC-41).

Fraumeni, J. F., Jr., and R. W. Miller. 1967. Epidemiology of human leukemia: recent observations. *J. Natl. Cancer Inst.,* 38:593–605.

FRC 1961. *Background Material for the Development of Radiation Protection Standards.* Federal Radiation Council Report no. 2. Washington, D.C.: U.S. Department of Health, Education, and Welfare.

FRC 1963. *Estimates and Evaluation of Fallout in the United States from Nuclear Weapons Testing Conducted through 1962.* Report of the Federal Radiation Council, FRC Report 4. Washington, D.C.: U.S. Government Printing Office.

FRC 1964. *Background Material for the Development of Radiation Protection Standards.* Federal Radiation Council Report no. 5. Washington, D. C.: U.S. Department of Health, Education, and Welfare.

Frigerio, N. A., and R. S. Stowe. 1976. Carcinogenic and genetic hazard from background radiation. In *Biological and Environmental Effects of Low Level Radiation.* International Atomic Energy Agency Proceedings Series, STI/PUB/409. Vienna: IAEA.

Fyfe, W. S. 1974. *Geochemistry.* London: Oxford Univ. Press.

Gamow, G. 1961. *The Creation of the Universe.* New York: Bantam Books.

Geiger, K. W., and C. K. Hargrove. 1964. Neutron spectrum of an $^{241}$Am-Be $(\alpha, n)$ source. *Nucl. Phys.,* 53:204–208.

Gesell, T. F., G. Burke, and K. Becker. 1976. An international intercomparison of environmental dosimeters. *Health Phys.,* 30:125–133.

Gilkey, A. D., and E. F. Manny. 1978. *Annotated Bibliography on the Selection of Patients for X-Ray Examination.* U.S. Department of Health, Education, and Welfare Publication (FDA) 78-8067.

Gitlin, J. N., and P. S. Lawrence. 1964. *Population Exposure to X-rays.* U.S. Public Health Service Publication no. 1519. Washington, D.C.: U.S. Government Printing Office.

Glasstone, S., ed. 1962. *The Effects of Nuclear Weapons.* Washington, D.C.: U.S. Government Printing Office.

Goldman, M. I. 1968. United States experience in management of gaseous wastes from nuclear power stations. *Treatment of Airborne Radioactive Wastes* (Proceedings of a symposium held by the International Atomic Energy Agency). Vienna: IAEA.

Goldsmith, W. A., F. F. Haywood, and D. G. Jacobs. 1976. Guidelines for cleanup of uranium tailings from inactive mills. In *Operational Health Physics. Proceedings of the Ninth Midyear Topical Symposium of the Health Physics Society,* ed. P. L. Carson, W. R. Hendee, and D. C. Hunt. Boulder: Health Physics Soc.

Graham, S., et al. 1966. Preconception, intrauterine and postnatal irradiation re-

lated to leukemia. *Epidemiological Approaches to the Study of Cancer and Other Chronic Diseases.* National Cancer Institute Monograph no. 19. Washington, D.C.: U.S. Government Printing Office.

Gray, H. 1977. *Anatomy, Descriptive and Surgical,* ed. T. P. Pick and R. Howden. New York: Bounty Books, rev. American, from the 15th English, ed.

Grodstein, G. W. 1957. *X-ray Attenuation Coefficients from 10 KeV to 100 MeV.* U.S. National Bureau of Standards Report, NBS Circular 583. Washington, D.C.: U.S. Government Printing Office.

Grove, R. D., and A. M. Hetzel. 1968. *Vital Statistics Rates in the United States, 1940–1960.* National Center for Health Statistics publication. Washington, D.C.: U.S. Government Printing Office.

Grubner, O., and W. A. Burgess. 1979. Simplified description of adsorption breakthrough curves in air cleaning and sampling devices. *Am. Ind. Hyg. Assn. J.,* 40:169–179.

Halitsky, J. 1968. Gas diffusion near buildings. In *Meteorology and Atomic Energy,* ed. D. H. Slade. U.S. Atomic Energy Commission Document, TID-24190. Springfield, Va.: National Bureau of Standards.

Hammond, S. E. 1971. Industrial-type operations as a source of environmental plutonium. *Proceedings of Environmental Plutonium Symposium.* Los Alamos Scientific Laboratory Report LA-4756.

Hanford, J. M., E. H. Quimby, and V. K. Frantz. 1962. Cancer arising many years after irradiation of benign lesions in the neck. *J. Am. Med. Assn.,* 181:404–410.

Hankins, D. E. 1968. *The Multisphere Neutron-Monitoring Technique.* Los Alamos Scientific Laboratory Report LA-3700. Available from Clearinghouse for Federal Scientific and Technical Information, Springfield, Va. 22151.

Haque, A. K. M. M., and A. J. L. Collinson. 1967. Radiation does to the respiratory system due to radon and its daughter products. *Health Phys.,* 13: 431–443.

Hardy, E. P. 1978. Sr-90 in diet. Environmental Measurements Laboratory Report EML-344 (UC-11). *Envir. Quart.,* Oct. 1.

Hardy, E. P., Jr., ed. 1970. *Fallout Program Quarterly Summary Report.* U.S. Atomic Energy Commission Report HASL-227.

Hardy, E. P. Jr., and J. Rivera, eds. 1965. *Fallout Program Quarterly Summary Report.* U.S. Atomic Energy Commission Report HASL-161.

Harley, J. H., ed. 1972. *EML Procedures Manual.* Contains the procedures used currently by the Environmental Measurements Laboratory of the Department of Energy. EML Report EML-300. [27th edition will be published in 1989.] New York: EML.

Harley, J. H., and B. S. Pasternack. 1972. Alpha absorption measurements applied to lung dose from radon daughters. *Health Phys.,* 23:771–782.

Harrison, E. R. 1968. The early universe. *Physics Today,* 21:31–39.

HASL 1970. *Fallout Program Quarterly Summary Report, July 1.* U.S. Atomic Energy Commission Health and Safety Laboratory Report HASL-223.

Hatcher, R. B., D. G. Smith, and L. L. Schulman. 1979. *Building Downwash Modeling—Recent Developments.* Paper presented at Air Pollution Control Association 72nd annual meeting. Lexington, Mass: Environmental Research and Technology.

Hayden, J. A. 1977. Measuring plutonium concentrations in respirable dust. *Science,* 196:1126.

Hayes, E. T. 1979. Energy resources available to the United States, 1985–2000. *Science,* 203:233–239.

Healy, J. W. 1971. *Surface Contamination: Decision Levels.* Los Alamos Scientific Laboratory Report LA-4558-MS. Springfield, Va.: National Technical Information Service.

Healy, J. W. 1975. The origin of current standards (plutonium). *Health Phys.,* 29:489–494.

Healy, J. W. 1977. *An Examination of the Pathways from Soil to Man for Plutonium.* Los Alamos Scientific Laboratory Report (informal) LA-6741-MS. Springfield, Va.: National Technical Information Service.

Heath, R. L. 1964. *Scintillation Spectra Gamma Spectrum Catalog.* U.S. Atomic Energy Commission Report IDO 16580, vol. I.

Hempelmann, L. H. 1968. Risk of thyroid neoplasms after irradiation in childhood. *Science,* 160:159–163.

Hempelmann, L. H., W. J. Hall, M. Phillips et al., 1975. Neoplasms in persons treated in x-rays in infancy: fourth survey in 20 years. *J. Natl. Cancer Inst.,* 55:519–530.

Hemplemann, L. H., J. W. Pifer, G. J. Burke et al. 1967. Neoplasms in persons treated with x-rays in infancy for thymic enlargment. *J. Natl. Cancer Inst.,* 38: 317–341.

Hendee, W. R., E. L. Chaney, and R. P. Rossi. 1977. *Radiologic Physics, Equipment and Quality Control.* Chicago: Year Book Medical Publishers.

Hine, G. J., and G. L. Brownell, eds. 1956. *Radiation Dosimetry.* New York: Academic Press.

Hine, G. J., and R. E. Johnston. 1970. Absorbed dose from radionuclides. *J. Nucl. Med.,* 11:468.

Hoenes, G. R., and J. K. Soldat. 1977. *Age-Specific Radiation Dose Commitment Factors for a One-Year Chronic Intake.* USNRC Report NUREG-0172. Springfield, Va.: National Technical Information Service.

Holtzman, R. 1977. Comments on "Estimate of natural internal radiation dose to man." *Health Phys.,* 32:324–325.

HPA 1961. Depth dose tables for use in radiotherapy. A survey prepared by the scientific subcommittee of the Hospital Physicists Association. *Brit. J. Radiol.,* suppl. no. 10.

HPS 1973. *Health Physics in the Healing Arts.* Proceedings of the Seventh Midyear Topical Symposium of the Health Physics Society. Washington, D.C.: U.S. Government Printing Office.

HPS 1988. *Surface Radioactivity Guides for Materials, Equipment and Facilities to Be Released for Uncontrolled Use.* Standard developed by the Health Physics Society, 8000 Westpark Drive, Suite 400, McLean, Va. 22102.

Hubbell, J. H. 1969. *Photon Cross Sections, Attenuation Coefficients, and Energy Absorption Coefficients from 10 keV to 100 GeV.* National Bureau of Standards Report NSRDS-NBS 29. Washington, D.C.: U.S. Government Printing Office.

Hubbell, J. H. 1974. *Present Status of Photon Cross Section Data 100 eV to 100 GeV.* Invited keynote paper presented at the International Symposium on Radiation Physics, Calcutta, India. Reprint available from author, National Bureau of Standards, Washington, D.C. 20234.

Hubbell, J. H. 1977. Photon mass attenuation and mass energy-absorption coeffi-

cients for H, C, N, O, Ar, and seven mixtures from 0.1 keV to 20 MeV. *Radiat. Res.*, 20:58–81.

Hubbell, J. H., W. H. McMaster, N. Kerr Del Grande, and J. H. Mallett. 1974. X-ray cross sections and attenuation coefficients. In *International Tables for X-Ray Crystallography*, vol. 4, ed. J. A. Ibers and W. C. Hamilton. Birmingham, Eng.: Kynoch Press.

Hubbell, J. H. et al. 1975. Atomic form factors, incoherent scattering functions, and photon scattering cross sections. *J. Phys. Chem. Ref. Data*, 4:471–538.

Huda, W., and K. Gordon. 1989. Nuclear medicine staff and patient doses in Manitoba (1981–1985). *Health Phys.*, 56:277–285.

Hughes, D. J., and R. B. Schwartz. 1958. *Neutron Cross Sections*. Brookhaven National Laboratory Report BNL 325. (Supplements were issued in 1965 and 1966.) Washington, D.C.: U.S. Government Printing Office.

Hutchison, G. B. 1968. Leukemia in patients with cancer of the cervix uteri treated with radiation. *J. Natl. Cancer Inst.*, 40:951–982.

IAEA 1962. *Safe Handling of Radioisotopes*. Vienna: International Atomic Energy Agency.

IAEA 1967. *Basic Safety Standards for Radiation Protection*. International Atomic Energy Agency Safety Series no. 9. STI/PUB/147. Vienna: IAEA.

IAEA 1971. *Handbook on Calibration of Radiation Protection Monitoring Instruments*. International Atomic Energy Agency Technical Reports Series no. 133. Vienna: IAEA.

IAEA 1971a. *Rapid Methods for Measuring Radioactivity in the Environment*. Proceedings of a Symposium. Vienna: IAEA.

IAEA 1973. *Radiation Protection Procedures*. International Atomic Energy Agency Safety Series no. 38. Vienna: IAEA.

IAEA 1979. *Manual on Decontamination of Surfaces*. International Atomic Energy Agency Safety Series no. 48. Vienna: IAEA.

Ichimaru, M., and T. Ishimaru. 1975. Leukemia and related disorders. *A Review of Thirty Years Study of Hiroshima and Nagasaki Atomic Bomb Survivors. Research Supplement, 1975* (Japan). Chiba: Japan Radiation Research Society.

ICRP 1960. Report of ICRP committee II on permissible dose for internal radiation (1959), with bibliography for biological, mathematical and physical data. *Health Phys.*, 3:1–233.

ICRP 1963. Report of the RBE committee to the International Commission on Radiological Protection and on Radiological Units and Measurements. *Health Phys.* 9:357–386.

ICRP 1964. *Recommendations of the International Commisssion on Radiological Protection* (as amended 1959 and revised 1962). ICRP Publication 6. New York: Pergamon Press.

ICRP 1966. *The Evaluation of Risks from Radiation*. ICRP Publication 8. Oxford: Pergamon Press.

ICRP 1966a. *Radiation Protection; Recommendations . . . Adopted September 17, 1965*. ICRP Publication 9. Oxford: Pergamon Press.

ICRP 1966b. Deposition and retention models for internal dosimetry of the human respiratory tract. Report of the Task Group on Lung Dynamics of the International Commission on Radiological Protection. *Health Phys.*, 12:173–207.

ICRP 1968a. *A Review of the Radiosensitivity of the Tissues in Bone*. ICRP Publication 11. New York: Pergamon Press.

ICRP 1969. *Radiosensitivity and Spatial Distribution of Dose.* ICRP Publication 14. New York: Pergamon Press.

ICRP 1970. *Protection of the Patient in X-Ray Diagnosis.* ICRP Publication 16. New York: Pergamon Press.

ICRP 1971. *Protection of the Patient in Radionuclide Investigations.* ICRP Publication 17. New York: Pergamon Press.

ICRP 1972. *The Metabolism of Compounds of Plutonium and Other Actinides.* ICRP Publication 19. New York: Pergamon Press.

ICRP 1975. *Report of the Task Group on Reference Man.* ICRP Publication 23. New York: Pergamon Press.

ICRP 1976. *Limits for Intakes of Radionuclides by Workers.* Dosimetric data for uranium. Report of ICRP Committee II.

ICRP 1976a. *Protection against Ionizing Radiation from External Sources.* Republication in one document of ICRP Publications 15 (1969) and 21 (1971). New York: Pergamon Press.

ICRP 1977. *Recommendations of the International Commission on Radiological Protection.* ICRP Publication 26. New York: Pergamon Press.

ICRP 1977a. *The Handling, Storage, Use and Disposal of Unsealed Radionuclides in Hospitals and Medical Research Establishments.* ICRP Publication 25. New York: Pergamon Press.

ICRP 1979a. *Limits for Intakes of Radionuclides by Workers.* Report of Committee II. ICRP Publication 30. New York: Pergamon Press.

ICRP 1980. *Biological Effects of Inhaled Radionuclides.* ICRP Publication 31. Annals of the ICRP, vol. 4, no. 1/2. New York: Pergamon Press.

ICRP 1981. *Limits for Inhalation of Radon Daughters by Workers.* ICRP Publication 32. New York: Pergamon Press.

ICRP 1985. Statement from the 1985 Paris meeting of the International Commission on Radiological Protection. *Health Phys.,* 48:828.

ICRP 1987. *Protection of the Patient in Nuclear Medicine.* ICRP Publication 52. New York: Pergamon Press.

ICRP 1987a. *Radiation Dose to Patients from Radiopharmaceuticals.* ICRP Publication 53. New York: Pergamon Press.

ICRP 1988. *Individual Monitoring for Intakes of Radionuclides by Workers: Design and Interpretation.* ICRP Publication 54. New York: Pergamon Press.

ICRU 1962. *Physical Aspects of Irradiation.* Recommendations of the International Commission on Radiological Units and Measurements (ICRU) Report 10b. Published by National Bureau of Standards as Handbook 85. Washington, D.C.: U.S. Government Printing Office.

ICRU 1969. *Neutron Fluence, Neutron Spectra and Kerma.* International Commission on Radiation Units and Measurements Report 13. Washington, D.C.: ICRU.

ICRU 1970. *Linear Energy Transfer.* ICRU Report No. 16. Washington, D.C.: ICRU.

ICRU 1971. *Radiation Protection Instrumentation and Its Application.* ICRU Report 20. Washington, D.C.: ICRU.

ICRU 1971a. *Radiation Quantities and Units.* ICRU Report 19. A Supplement to Report 19 was issued in 1973. Washington, D.C.: ICRU.

ICRU 1976. *Conceptual Basis for the Determination of Dose Equivalent.* ICRU Report 25. Washington, D.C.: ICRU.

ICRU 1979. *Methods of Assessment of Absorbed Dose in Clinical Use of Radionuclides.* ICRU Report 32. Washington, D.C.: ICRU.

ICRU 1980. *Radiation Quantities and Units.* ICRU Report 33. Washington, D.C.: ICRU.

Iinoya, K., and C. Orr, Jr. 1977. Filtration. In *Air Pollution,* vol. 4, *Engineering Control of Air Pollution,* ed., A. C. Stern. New York: Academic Press.

ISS 1978. *The Military Balance 1978–1979.* London: The International Institute for Strategic Studies.

Jablon, S., and H. Kato. 1970. Childhood cancer in relation to prenatal exposure to atomic bomb radiation. *Lancet,* Nov. 14:1000–1003.

Jacobi, W. 1964. The dose to the human respiratory tract by inhalation of short-lived $^{222}$Rn- and $^{220}$Rn-decay products. *Health Phys.,* 10:1163–1174.

Jacobi, W. 1972. Relations between the inhaled potential alpha energy of $^{222}$Rn and $^{220}$Rn daughters and the absorbed alpha-energy in the bronchial and pulmonary region. *Health Phys.,* 23:3–11.

Jacobi, W., and K. Eisfeld. 1981. Internal dosimetry of Radon-222, Radon-220 and their short-lived daughters. *Proceedings of the Special Symposium on Natural Radiation Environment, 19–23 January 1981.* Bombay, India: Bhabha Atomic Research Centre.

Jacobs, D. G. 1968. *Sources of Tritium and Its Behavior upon Release to the Environment.* U.S. Atomic Energy Commission Report in Critical Review Series. Reprinted in *Environmental Effects of Producing Electric Power,* pp. 500–592. See JCAE 1969a.

Jaeger, R. G., E. P. Blizard, A. B. Chilton et al., eds. 1968. *Engineering Compendium on Radiation Shielding,* vol. 1, *Shielding Fundamentals and Methods.* Berlin: Springer-Verlag.

James, A. C., J. R. Greenhalgh, and A. A. Birchall. 1980. A dosimetry model for tissues of the respiratory tract at risk from inhaled radon and thoron daughters. In *Radiation Protection: A Systematic Approach to Safety. Proceedings of the 5th Congress of the International Radiation Protection Association. Jerusalem, March 1980,* vol. 2, 1045–1048. Oxford: Pergamon Press.

Jaworowski, Z. 1969. Radioactive lead in the environment and in the human body. *Atom. Energy Rev.,* 7:3–45.

JCAE 1959. *Fallout from Nuclear Weapons Tests: Hearings.* U.S. Congress, Joint Committee on Atomic Energy, 86th Congress, 1st sess., May 5-8. Washington, D.C.: U.S. Government Printing Office.

JCAE 1959a. *Biological and Environmental Effects of Nuclear War: Hearings.* U.S. Congress, Joint Committee on Atomic Energy, 86th Congress, 1st sess., June 22–26. Washington, D.C.: U.S. Government Printing Office.

JCAE 1969. *Nuclear Explosion Services for Industrial Applications: Hearings.* U.S. Congress, Joint Committee on Atomic Energy, 91st Congress, 1st sess., May 8, 9, and July 17; 2d sess., Jan. 27–30, Feb. 24–26. Washington, D.C.: U.S. Government Printing Office.

JCAE 1969a. *Environmental Effects of Producing Electric Power: Hearings.* U.S. Congress, Joint Committee on Atomic Energy, 91st Congress, 1st sess., Oct. 28–31, Nov. 4–7. Washington, D.C.: U.S. Government Printing Office.

Johns, H. E. 1969. X-rays and teleisotope $\gamma$ rays. In *Radiation Dosimetry,* vol. III. ed. F. H. Attix and E. Tochilin. New York: Academic Press.

Johnson, C. J., R. R. Tidball, and R. C. Severson. 1976. Plutonium hazard in respirable dust on the surface of soil. *Science,* 193:488–490.

Johnson, D. W., and W. A. Goetz. 1986. Patient exposure trends in medical and dental radiography. *Health Phys.* 50:107–116.

Jones, A. R. 1962. Pulse counters for $\gamma$ dosimetry. *Health Phys.,* 8:1–9.

Kahn, B., R. L. Blanchard, H. L. Krieger et al. 1970. *Radiological Surveillance Studies at a Boiling Water Nuclear Power Reactor.* U.S. Department of Health, Education, and Welfare Report BRH/DER 70–1.

Kahn, H. 1959. Major implications of a study of nuclear war. Statement for *Hearings on Biological and Environmental Effects of Nuclear War,* pp. 908–922. See JCAE, 1959a.

Katz, R., S. C. Sharma, and M. Homayoonfar. 1972. The structure of particle tracks. *Topics in Radiation Dosimetry. Radiation Dosimetry, Suppl. 1,* ed. F. H. Attix. New York: Academic Press.

Kellerer, A. M., and H. H. Rossi. 1972. The theory of dual radiation action. *Curr. Top. Radiat. Res. Quart.,* 8:85–158.

Kellerer, A. M., and H. H. Rossi. 1978. A generalized formulation of dual radiation action. *Radiat. Res.,* 75:471–488.

Kelley, J. P., and E. D. Trout. 1971. Physical characteristics of the radiations from 2-pulse, 12-pulse, and 1000-pulse x-ray equipment. *Radiology,* 100:653–661.

Kemeny, J. G., chairman. 1979. *Report of the President's Commission on the Accident at Three Mile Island. The Need for Change: The Legacy of TMI.*

Kenny, P. J., D. D. Watson, and W. R. Janowitz. 1976. Dosimetry of some accelerator produced radioactive gases. *Radiopharmaceutical Dosimetry Symposium.* See Cloutier et al., eds. 1976.

Kereiakes, J. G., et al. 1976. Pediatric radiopharmaceutical dosimetry. *Radiopharmaceutical Dosimetry Symposium.* Proceedings of a conference held at Oak Ridge, Tenn., April 26–29. U.S. Department of Health, Education, and Welfare Publication (FDA) 76–8044. Washington, D.C.: U.S. Government Printing Office.

Kernan, W. J. 1963. *Accelerators.* Booklet in a series entitled "Understanding the Atom." Available from United States Atomic Energy Commission, P.O. Box 62, Oak Ridge, Tenn.

Kobayashi, Y., and D. V. Maudsley. 1974. *Biological Applications of Liquid Scintillation Counting.* New York: Academic Press.

Kohn, H. I., J. C. Bailar III, and C. Zippin. 1965. Radiation therapy for cancer of the cervix: its late effect on the lifespan as a function of regional dose. *J. Natl. Cancer Inst.,* 34:345–361.

Korff, S. A. 1955. *Electron and Nuclear Counters.* New York: Van Nostrand.

Krey, P. W. 1974. Plutonium-239 contamination in the Denver area. *Health Phys.,* 26:117–120.

Krey, P. W. 1976. Remote plutonium contamination and total inventories from Rocky Flats. *Health Phys.,* 39:209–214.

Krey, P. W., and E. P. Hardy. 1970. *Plutonium in Soil around the Rocky Flats Plant.* Health and Safety Laboratory Report HASL-235.

Krey, P. W., E. P. Hardy, and L. E. Toonkel. 1977. *The Distribution of Plutonium and Americium with Depth in Soil at Rocky Flats.* Report HASL-318, issued by the Environmental Measurements Laboratory, Department of Energy, New York, N.Y. 10014

Krey, P. W., et al. 1976. Interrelations of surface air concentrations and soil char-

acteristics at Rocky Flats. *Atmosphere Surface Exchange of Particulate and Gaseous Pollutants (1974)*. Proceedings of a symposium held at Richland, Wash., Sept. 4–6, 1974. R. J.Engelmann and G. A. Sehmel, coordinators.

Krey, P. W., et al. 1976a. *Plutonium and Americium Contamination in Rocky Flats Soil—1973*. Report HASL-304 issued by the Environmental Measurments Laboratory, Department of Energy, New York, N.Y. 10014.

Krzesniak, J. W., O. A. Chomicki et al. 1979. Airborne radioiodine contamination caused by [131]I treatment. *Nuklearmedizin*, 18:246–251.

Kuehner, A. V., J. D. Chester, and J. W. Baum. 1973. Portable mixed radiation dose equivalent meter. *Neutron Monitoring for Radiation Protection Purposes*, vol. 1, pp. 233–246. Vienna: International Atomic Energy Agency.

Landahl, H. D. 1950. Removal of air-born droplets by the human respiratory tract. The lung. *Bull. Math. Biophys.*, 12:43.

Langham, W. H. 1971. Plutonium distribution as a problem in environmental science. *Proceedings of Environmental Plutonium Symposium*. Los Alamos Scientific Laboratory Report LA-4756.

Lanza, F., O. Gautsch, and P. Weisgerber. 1979. *Contamination Mechanisms and Decontamination Techniques in Light Water Reactors*. Report EUR 6422 EN. Ispra, Italy: Commission of the European Communities.

Lanzl, L. H. 1976. State and federal regulatory measurement responsibilities around medical facilities. *Symposium on Measurements for the Safe Use of Radiation*. See NBS 1976.

Lanzl, L. H., J. H. Pingel, and J. H. Rust. 1965. *Radiation Accidents and Emergencies in Medicine, Research, and Industry*. Springfield, Ill.: Charles C Thomas.

Lapp, R. E. 1971. How safe are nuclear power plants? *New Republic*, 164:18–21.

Lassen, N. A. 1964. Assessment of tissue radiation dose in clinical use of radioactive gases, with examples of absorbed doses from $^3$H, $^{85}$Kr, and $^{133}$Xe. *Minerva Nucl.*, 8:211–217.

Laws, P. W., and M. Rosenstein. 1978. A somatic dose index for diagnostic radiology. *Health Phys.*, 35:629–642.

Laws, P. W., and M. Rosenstein. 1980. *Quantitative Analysis of the Reduction in Organ Doses in Diagnostic Radiology by Means of Entrance Exposure Guidelines*. U.S. Department of Health, Education, and Welfare Publication (FDA) 80–8107. Washington, D.C.: U.S. Government Printing Office.

Lea, D. E. 1955. *Actions of Radiations on Living Cells*. Cambridge, Eng.: Cambridge Univ. Press.

Lewis, E. B. 1970. Ionizing radiation and tumor production. *Genetic Concepts and Neoplasia*. Baltimore: Williams & Wilkins.

Lewis, F. 1967. *One of Our H-Bombs Is Missing. . . .* New York: McGraw-Hill.

Libby, W. F. 1955. *Radiocarbon Dating*. Chicago: Univ. Chicago Press.

Libby, W. F. 1959. Statement to *Hearings on Biological and Environmental Effects of Nuclear War*, pp. 923–932. See JCAE, 1959a.

Lindell, B. 1968. Occupational hazards in x-ray analytical work. *Health Phys.*, 15:481–486.

Lindop, P. J., and J. Rotblat. 1961. Long term effects of a single whole body exposure of mice to ionizing radiations. *Proc. Roy. Soc. (London)*, B154:332–360.

Lister, B. A. J. 1964. *Health Physics Aspects of Plutonium Handling*. A series of lectures given during a visit to Japan, March. Atomic Energy Research Establishment Report AERE-L 151. London: H. M. Stationery Office.

Lorenz, E., J. W. Hollcroft, E. Miller et al. 1955. Long-term effects of acute and chronic irradiation in mice. I. Survival and tumor incidence following chronic irradiation of 0-11 R per day. *J. Natl. Cancer Inst.*, 15:1049–1058.

Lowder, W. M., and W. J. Condon. 1965. Measurement of the exposure of human populations to environmental radiation. *Nature*, 206:658–662.

Machta, L. 1963. Meteorological processes in the transport of weapon radioiodine. *Health Phys.*, 9:1123–1132.

MacMahon, B. 1962. Prenatal x-ray exposure and childhood cancer. *J. Natl. Cancer Inst.*, 28:1173–1191.

Mancuso, T., A. Stewart, and G. Kneale. 1977. Radiation exposures of Hanford workers dying from cancer and other causes. *Health Phys.*, 33:369.

Mancuso, T., A. Stewart, and G. Kneale. 1978. Reanalysis of data relating to the Hanford study of the cancer risks of radiation workers. *IAEA International Symposium on the Late Biological Effects of Ionizing Radiation.* Vienna: International Atomic Energy Agency.

Mancuso, T. F. 1978. *Study of Lifetime Health and Mortality Experience of Employees of ERDA Contractors.* Testimony prepared for hearing of the Subcommittee on Health and Environment of the House of Representatives on Feb. 8 (U.S. Congress).

Mark, J. C. 1976. Global consequences of nuclear weaponry. *Ann. Rev. Nucl. Sci.*, 26:51–87.

Marks, H. S., ed. 1959. *Progress in Nuclear Energy, Series X. Law and Administration.* New York: Pergamon Press.

Martin, M. J., and P. H. Blichert-Toft. 1970. Radioactive atoms, auger electron, $\alpha$-, $\beta$-, $\gamma$-, and x-ray data. *Nucl. Data Tables*, 8:1–198.

Masse, F. X., and M. M. Bolton, Jr. 1970. Experience with a low-cost chair-type detector system for the determination of radioactive body burdens of M.I.T. radiation workers. *Health Phys.*, 19:27–35.

Maxon, H. R., S. R. Thomas, E. L. Saenger, C. R. Buncher, and J. G. Kereiakes. 1977. Ionizing irradiation and the induction of clinically significant disease in the human thyroid gland. *Am. J. Med.*, 63:967–978.

Mayneord, W. V., and C. R. Hill. 1969. Natural and manmade background radiation. In *Radiation Dosimetry*, vol. 3, ed. H. H. Attix and E. Tochilin. New York: Academic Press.

Mays, C. W. 1976. Estimated risk from $^{239}$Pu to human bone, liver, and lung. *Biological and Environmental Effects of Low-Level Radiation.* Symposium proceedings. Vienna: International Atomic Energy Agency.

McBride, J. P., R. E. Moore et al. 1978. Radiological impact of airborne effluents of coal and nuclear plants. *Science*, 202:1045–1050.

McClenahan, J. L. 1976. A radiologist's view of the efficient use of diagnostic radiation. In *Assuring Radiation Protection. Proceedings of the 7th Annual National Conference on Radiation Control.* Washington, D.C.: U.S. Government Printing Office.

McCullough, E. C., and J. R. Cameron. 1971. Exposure rates from diagnostic x-ray units. *Health Phys.* 20:443–444.

McCullough, E. C., and J. T. Payne. 1978. Patient dose in computed tomography. *Radiology*, 129:457–463.

McDonnel, G. M. 1977. Computerized axial tomographic scanners—use, potential, and control. In *Eighth Annual National Conference on Radiation Control.*

*Radiation Benefits and Risks: Facts, Issues, and Options*, May 2–7, 1976.  HEW Publication (FDA) 77–8021.  Rockville, Md.: Bureau of Radiological Health.

McDowell, W. J., F. G. Seeley, and M. T. Ryan.  1977.  Penetration of HEPA filters by alpha recoil aerosols.  In *Proceedings of the Fourteenth ERDA Air Cleaning Conference*.  Springfield, Va.: National Technical Information Service.

McGregor, D. H., et al.  1977.  Breast cancer incidence among atomic bomb survivors, Hiroshima and Nagasaki, 1950–1969.  *J. Natl. Cancer Inst.*, 59:799–811.

McGregor, R. G., et al.  1980.  Background concentrations of radon and radon daughters in Canadian homes.  *Health Phys.*, 39:285–289.

McKlveen, J. W.  1980.  X-ray exposures to dental patients.  *Health Phys.*, 39:211–217.

McLaughlin, J. E., Jr., and H. Blatz.  1955.  Potential radiation hazards in the use of x-ray diffraction equipment.  *Ind. Hyg. Quart.*, 16:108–112.

Mercer, T. T.  1973.  *Aerosol Technology in Hazard Evaluation*.  New York: Academic Press.

Mercer, T. T.  1976.  The effect of particle size on the escape of recoiling RaB atoms from particulate surfaces.  *Health Phys.*, 31:173–175.

Mettler, F.  1987.  Diagnostic radiology: usage and trends in the United States.  *Radiology* 162:263–266.

Miller, W. B., and V. D. Baker.  1973.  The low exposure capabilities of electronic radiography.  See HPS 1973, pp. 399–402.

Millman, J., and C. C. Halkias.  1972.  *Integrated Electronics: Analog and Digital Circuits and Systems*.  New York: McGraw-Hill.

MIRD 1975.  *Radionuclide Decay Schemes and Nuclear Parameters for Use in Radiation Dose Estimation*.  Medical Internal Radiation Dose Committee Pamphlet 10.  New York: Society of Nuclear Medicine.

Modan, B., D. Baidatz, H. Mart et al.  1974.  Radiation induced head and neck tumors.  *Lancet*, 1:277–279.

Moeller, D. W., and D. W. Underhill.  1976.  *Final Report on Study of the Effects of Building Materials on Population Dose Equivalents*.  Prepared for U.S. Environmental Protection Agency by Department of Environmental Health Sciences, Harvard University School of Public Health.

Moeller, D. W., J. M. Selby, D. A. Waite, and J. P. Corley.  1978.  Environmental surveillance for nuclear facilities.  *Nucl. Safety*, 19:66–79.

Moore, H. E., E. A. Martell, and S. E. Poet.  1976.  Sources of polonium-210 in atmosphere.  *Envir. Sci. Technol.*, 19:586–591.

Moore, H. E., and S. E. Poet.  1976. Background levels of $^{226}$Ra in the lower troposphere. *Atmos. Envir.*, 10:381–383.

Morgan, K. Z.  1967.  Reduction of unnecessary medical exposure. *Radiation Control for Health and Safety Act of 1967: Hearings on S. 2067*.  U.S. Congress, Senate, Committee on Commerce, 90th Congress, 1st sess., part 1, Aug. 28–30.

Morgan, K. Z.  1975.  Suggested reduction of permissible exposure to plutonium and other transuranium elements.  *Am. Ind. Hyg. Assn. J.*, 36:567–575.

Morgan, K. Z., and J. E. Turner, eds.  1967.  *Principles of Radiation Protection*.  New York: Wiley.

Morgan, R. H.  1972.  Radiological research and social responsibility (editorial).  *Radiology*, 102:459–462.

Murray, R., P. Heckel, and L. H. Hempelmann.  1959.  Leukemia in children exposed to ionizing radiation.  *New Eng. J. Med.*, 261:585–589.

Nachtigall, D. 1967. Average and effective energies, fluence-dose conversion factors and quality factors of the neutron spectra of some (α, n) sources. *Health Phys.*, 13:213–219.

Nachtigall, D., and G. Burger. 1972. Dose equivalent determinations in neutron fields by means of moderator techniques. In *Topics in Radiation Dosimetry. Radiation Dosimetry*, suppl. 1, ed. F. H. Attix. New York: Academic Press.

Najarian, T., and T. Colton. 1978. Mortality from leukemia and cancer in shipyard nuclear workers. *Lancet*, 1:1018.

NAS-NRC 1956. *The Biological Effects of Atomic Radiation.* Summary Reports from a Study by the National Academy of Sciences. Washington, D.C.: NAS.

NAS-NRC 1961. *Long-Term Effects of Ionizing Radiations from External Sources.* National Academy of Sciences-National Research Council Publication 849. Washington, D.C.: NAS.

NAS-NRC 1961a. *Effects of Inhaled Radioactive Particles.* NAS-NRC Publication 848. Washington, D.C.: NAS.

NAS-NRC 1980. *The Effects on Populations of Exposure to Low Levels of Ionizing Radiation.* Report of the Advisory Committee on the Biological Effects of Ionizing Radiations (BEIR Committee), NAS-NRC. Washington, D.C.: NAS.

Nathan, O., and H. Norden, eds. 1960. *Einstein on Peace,* p. 521. New York: Simon and Schuster.

NBS 1957. *Protection against Neutron Radiation up to 30 Million Electron Volts.* National Bureau of Standards Handbook 63. Washington, D.C.: U.S. Government Printing Office.

NBS 1964. *Safe Handling of Radioactive Materials.* National Bureau of Standards Handbook 92. Washington, D.C.: U.S. Government Printing Office.

NBS 1968. *Modern Trends in Activation Analysis.* Proceedings of an international conference. National Bureau of Standards Special Publication 312, vols. 1 and 2.

NBS 1976. *Symposium on Measurements for the Safe Use of Radiation,* ed. S. P. Fivozinsky. National Bureau of Standards Report SP 456. Washington, D.C.: NBS.

NCRP 1960. *Protection against Radiation from Sealed Gamma Sources.* National Council on Radiation Protection and Measurement. Report 24.

NCRP 1964. *Safe Handling of Radioactive Materials.* NCRP Report 30. Issued by National Bureau of Standards as Handbook 92. Washington, D.C.: U.S. GPO.

NCRP 1968. *Medical X-Ray and Gamma-Ray Protection up to 10 MeV. Equipment Design and Use.* NCRP Report 33.

NCRP 1970. *Medical X-Ray and Gamma-Ray Protection for Energies up to 10 MeV. Structural Shielding Design and Evaluation Handbook.* NCRP Report 34.

NCRP 1971. *Basic Radiation Protection Criteria.* NCRP Report 39.

NCRP 1971a. *Protection against Neutron Radiation.* NCRP Report 38.

NCRP 1975. *Natural Background Radiation in the United States.* Recommendations of the National Council on Radiation Protection and Measurements. NCRP Report 45.

NCRP 1976. *Structural Shielding Design and Evaluation for Medical Use of X-Rays and Gamma Rays of Energies up to 10 MeV.* NCRP Report 49.

*Note: All NCRP Reports are published by the National Council on Radiation Protection and Measurement, now located in Bethesda, Maryland.*

NCRP 1977. *Medical Radiation Exposure of Pregnant and Potentially Pregnant Women.* NCRP Report 54.

NCRP 1978. *A Handbook of Radioactivity Measurements Procedures.* NCRP Report 58.

NCRP 1978a. *Instrumentation and Monitoring Methods for Radiation Protection.* NCRP Report 57.

NCRP 1979. *Tritium and Other Radionuclide Labeled Organic Compounds Incorporated in Genetic Material.* NCRP Report 63.

NCRP 1979a. *Tritium in the Environment.* NCRP Report 62.

NCRP 1980. *Radiation Protection in Nuclear Medicine.* A report of NCRP SC #32. Issued in 1982 under the title *Nuclear Medicine—Factors Influencing the Choice and Use of Radionuclides in Diagnosis and Therapy.* NCRP Report 70.

NCRP 1986. *Mammography—A User's Guide.* NCRP Report 85.

NCRP 1987. *Recommendations on Limits for Exposure to Ionizing Radiation.* NCRP Report 91.

NCRP 1987a. *Exposure of the Population in the United States and Canada from Natural Background Radiation.* NCRP Report 94.

NCRP 1989. *Exposure of the U.S. Population from Diagnostic Medical Radiation.* NCRP Report 100.

Nelson, J. L., and J. R. Divine. 1981. *Decontamination Processes for Restorative Operations and as a Precursor to Decommissioning: A Literature Review.* NRC report NUREG/CR-1915; PNL 3706.

Nelson, N. 1988. Letter from Norton Nelson, Chairman, Executive Committee, Science Advisory Board, to Lee M. Thomas, Administrator, U.S. Environmental Protection Agency, File SAB-RAC-88-041.

NEXT 1976. *Suggested Optimum Survey Procedures for Diagnostic X-Ray Equipment.* Report of the Nationwide Evaluation of X-ray Trends task force, cosponsored by Conference of Radiation Control Program Directors and Bureau of Radiological Health, U.S. Department of Health, Education, and Welfare. Washington, D.C.: Bureau of Radiological Health.

NIRP 1969. *Straldoser fran radioaktiva amnen i medicinskt bruk-information till sjukhusens isotopkommitteer.* Report of the National Institute of Radiation Protection, Stockholm.

NRC 1975. *Reactor Safety Study. An Assessment of Accident Risks in U.S. Commercial Nuclear Power Plants.* Study sponsored by the U.S. Atomic Energy Commission and performed under the independent direction of Professor Norman C. Rasmussen of the Massachusetts Institute of Technology. U.S. Nuclear Regulatory Commission Report WASH-1400 (NUREG 75/014).

NRC 1981. *Radiation Protection Training for Personnel at Light-Water-Cooled Nuclear Power Plants.* USNRC Regulatory Guide 8.27.

NRC 1984. *Radiation Protection Training for Personnel Employed in Medical Facilities.* USNRC Draft Regulatory Guide.

NRC 1987. *Guide for the Preparation of Applications for Medical Programs.* NRC Regulatory Guide 10.8, Rev. 2.

NRC 1988. *Standards for Protection against Radiation.* Final rule (proposed). Nuclear Regulatory Commission paper SECY-88-315. November 10, 1988.

O'Brien, K., H. Sandmeier, G. Hansen, and J. Campbell. 1980. Cosmic ray induced neutron background sources and fluxes for geometries of air over water, ground, iron, and aluminum. *J. Geophys. Res.*, 83:114–120.

Okada, S., et al. 1975. *A Review of Thirty Years of Study of Hiroshima and Nagasaki Atomic Bomb Survivors.* *J. Radiat. Res.,* suppl. (Japan), 164 pp. Chiba: Japan Radiation Research Society.

O'Kelley, G. D., ed. 1963. *Application of Computers to Nuclear and Radiochemistry.* National Academy of Sciences Report NAS-NS-3107.

ONRR 1976. *Safety Evaluation Report Related to Operation of Three Mile Island Nuclear Station, Unit 2.* Office of Nuclear Reactor Regulation (USNRC) report NUREG-0107. Springfield, Va.: National Technical Information Service.

Orvis, A. L. 1970. *Whole-Body Counting. Medical Radionuclides: Radiation Dose and Effects,* ed. R. J. Cloutier, C. L. Edwards, and W. S. Snyder, 115–132. USAEC Symposium Series 20, Report CONF-691212. Springfield, Va.: National Technical Information Service.

Osterhout, M., ed. 1980. *Decontamination and Decommissioning of Nuclear Facilities.* New York: Plenum Press.

OTA 1979. *The Effects of Nuclear War.* Office of Technology Assessment, U.S. Congress. Washington, D.C.: U.S. Gov. Printing Office.

Palmer, H. E., and W. C. Roesch. 1965. A shadow shield whole-body counter. *Health Phys.,* 11:1913–1919.

Parker, G. W., and C. J. Barton. 1973. Fission-product release. In *The Technology of Nuclear Reactor Safety,* vol. 2, *Reactor Materials and Engineering,* ed. T. T. Thompson and J. G. Beckerley. Cambridge, Mass.: M.I.T. Press.

Pauling, L. W. 1958. Letter to the *New York Times,* May 16, 1958. Reprinted in *Hearings on Fallout from Nuclear Weapons Tests,* p. 2462. See JCAE, 1959.

Pearson, E. S., and H. O. Hartley, eds. 1966. *Biometrika Tables for Statisticians,* vol. 1, p. 227. Cambridge, Eng.: Cambridge University Press.

Pendleton, R. C., C. W. Mays, R. D. Lloyd, and A. L. Brooks. 1963. Differential accumulation of $^{131}$I from local fallout in people and milk. *Health Phys.,* 9:1253–1262.

Peterson, H. T., Jr., J. E. Martin, C. L. Weaver, and E. D. Harward. 1969. Environmental tritium contamination from increasing utilization of nuclear energy sources. *Hearings on Environmental Effects of Producing Electric Power,* appendix 13, p. 765. See JCAE 1969a.

Petrosyants, A. M. 1969. The peaceful profession of the nuclear explosion. Reprinted in *Hearings on Nuclear Explosion Services for Industrial Applications,* p. 696. See JCAE 1969.

Pfeiffer, S. W. 1965. Mandan milk mystery. *Scientist & Citizen,* 7(September): 1–5.

Phillips, L. A. 1978. *A Study of the Effect of High Yield Criteria for Emergency Room Skull Radiography.* U.S. Department of Health, Education, and Welfare Publication (FDA) 78–8069.

Podgorsky, E. B., P. R. Moran, and J. R. Cameron. 1971. Thermoluminescent behavior of LiF (TLD-100) from 77° to 500 °K. *J. Appl. Phys.,* 42:2761.

Poet, S. E., and E. A. Martell. 1972. Plutonium-239 and Americium-241 contamination in the Danver area. *Health Phys.,* 23:537–548.

Poet, S. E., and E. A. Martell. 1974. Reply to ''Plutonium-239 contamination in the Denver area'' by P. W. Krey. *Health Phys.,* 26:120–122.

Price, B. T., C. C. Horton, and K. T. Spinney. 1957. *Radiation Shielding.* London: Pergamon Press.

Price, W. J. 1964. *Nuclear Radiation Detection.* New York: McGraw-Hill.

Quimby, E. H., S. Feitelberg, and W. Gross. 1970. *Radioactive Nuclides in Medi-*

*cine and Biology,* vol. 1, *Basic Physics and Instrumentation.* Philadelphia: Lea and Febiger.

Quittner, P. 1972. *Gamma-Ray Spectroscopy.* London: Adam Hilger.

Raloff, J. 1979. Abandoned dumps: a chemical legacy. *Sci. News,* 115:348–351.

Reddy, A. R., A. Nagaratnam, A. Kaul, and V. Haase. 1976. Microdosimetry of internal emitters: a necessity? In *Radiopharmaceutical Dosimetry Symposium.* See Cloutier et al., 1976.

Reissland, J. A. 1978. *An Assessment of the Mancuso Study.* National Radiological Protection Board (England) Report NRPB-R 79. Harwell: NRPB.

RERF 1987. *US-JAPAN Reassessment of Atomic Bomb Radiation Dosimetry in Hiroshima and Nagasaki, Final Report.* Radiation Effects Research Foundation, Hiroshima, Japan. Available from W. H. Ellett, RERF Office, National Research Council, 2101 Constitution Ave. NW, Washington, D.C. 20418.

Ricci, J. L., and D. Sashin. 1976. Radiation exposure in clinical mammography. In *Operational Health Physics.* Proceedings of the Ninth Midyear Topical Symposium of the Health Physics Society. Boulder, Colo.: Health Physics Society.

Richards, A. G. 1969. Trends in radiation protection. *J. Mich. Dent. Assn.,* 51: 18–21.

Roberts, L. 1987. Atomic bomb doses reassessed. *Science,* 238: 1649–50.

Robinson, A. L. 1978. The new physics: quarks, leptons, and quantum field theories. *Science,* 202:734–737.

Rockwell, T., III, ed. 1956. *Reactor Shielding Design Manual.* New York: McGraw-Hill.

Rodger, W. A. et al. 1978. *"De Minimus" Concentrations of Radionuclides in Solid Wastes.* Atomic Industrial Forum Report AIF/NESP-016. Washington, D.C.: Atomic Industrial Forum.

Roesch, W. C., and H. E. Palmer. 1962. Detection of plutonium in vivo by whole-body counting. *Health Phys.,* 8:773–776.

Rogovin, M. 1980. *Three Mile Island. A Report to the Commissioners and to the Public.* Nuclear Regulatory Commission Special Inquiry Group. M. Rogovin, director. Springfield, Va.: National Technical Information Service.

Rosenstein, M. 1976. *Organ Doses in Diagnostic Radiology.* U.S. Department of Health, Education, and Welfare Publication (FDA) 76–8030. Washington, D.C.: U.S. Government Printing Office.

Rosenstein, M. 1976a. *Handbook of Selected Organ Doses for Projections Common in Diagnostic Radiology.* U.S. Department of Health, Education, and Welfare Publication (FDA) 76–8031. Washington, D.C.: U.S. Government Printing Office.

Rosenstein, M., T. J. Beck, and G. G. Warner. 1979. *Handbook of Selected Organ Doses for Projections Common in Pediatric Radiology.* U.S. Department of Health, Education, and Welfare Publication (FDA) 79–8078. Washington, D.C.: U.S. Government Printing Office.

Rossi, H. H. 1968. Microscopic energy distribution in irradiated matter. In *Radiation Dosimetry,* vol. 1, ed. F. H. Attix and W. C. Roesch. New York: Academic Press.

Rossi, H. H. 1976. Interrelations between physical and biological effects of small radiation doses. *Biological and Environmental Effects of Low Level Radiation.* Proceedings of a symposium organized by the International Atomic Energy Agency and World Health Organization. Vienna: IAEA.

Rossi, H. H., and C. W. Mays. 1978. Leukemia risk from neutrons. *Health Phys.*, 34:353–360.

Rowland, R. E., A. F. Stehney, and H. F. Lucas, Jr. 1978. Dose-response relationships for female radium dial workers. *Radiat. Res.*, 76:368–383.

Rundo, J., F. Markun, and N. J. Plondke. 1979. Observations of high concentrations of radon in certain houses. *Health Phys.*, 36:729–730.

Russell, W. L. 1967. Factors that affect the radiation induction of mutations in the mouse. *An. Acad. Brasileira de Ciencias*, 39:65–75. Reprinted in*Hearings on Environmental Effects of Producing Electric Power*, pp.624–634. See JCAE 1969a.

Ryan, M. T., K. W. Skrable, and G. Chabot. 1975. Retention and penetration characteristics of a glass fiber filter for $^{212}$Pb aggregate recoil particles. *Health Phys.*, 29:796–798.

Saenger, E. L., ed. 1963. *Medical Aspects of Radiation Accidents*. Washington, D.C.: U.S. Government Printing Office.

Saenger, E. L., F. N. Silverman et al. 1960. Neoplasia following therapeutic irradiation for benign conditions in childhood. *Radiology*, 74:889–904.

Saenger, E. L., G. E. Thoma, and E. A. Thompkins. 1968. Incidence of leukemia following treatment of hyperthyroidism. *J. Am. Med. Assn.*, 205:855–862.

Sakharov, A. D. 1978. Nuclear energy and the freedom of the west. *Bull. Atom. Sci.*, June, pp. 12–14.

Sanders, B. S. 1978. Low-level radiation and cancer deaths. *Health Phys.*, 34: 521–538.

Sanders, S. M., Jr., and W. C. Reinig. 1968. Assessment of tritium in man. In *Diagnosis and Treatment of Deposited Radionuclides*, ed. H. A. Kornberg and W. D. Norwood. Amsterdam: Excerpta Medical Foundation.

Sanford, J. R. 1976. The Fermi National Accelerator Laboratory. *Ann. Rev. Nucl. Sci.*, 26:151–198.

Sashin, D. E., J. Sternglass, A. Huen, and E. R. Heinz. 1973. Dose reduction in diagnostic radiology by electronic imaging techniques. In HPS 1973, pp. 385–393.

Schwarz, G. S. 1968. Radiation hazards to the human fetus in present-day society. *Bull. N. Y. Acad. Med.*, 44:388–399.

Seltser, R., and P. E. Sartwell. 1965. The influence of occupational exposure to radiation on the mortality of American radiologists and other medical specialists. *Am. J. Epidemiol.*, 81:2–22.

Shambon, A. 1974. *CaSo$_4$: Dy TLD for Low Level Personnel Monitoring*. U.S. Atomic Energy Commission Health and Safety Laboratory Report HASL 285.

Shapiro, J. 1954. *An Evaluation of the Pulmonary Radiation Dosage from Radon and Its Daughter Products*. Ph. D. thesis, University of Rochester. Issued as University of Rochester Atomic Energy Project Report UR-298.

Shapiro, J. 1956. Radiation dosage from breathing radon and its daughter products. *A.M.A. Arch. Ind. Health*, 14:169–177.

Shapiro, J. 1956a. *Studies on the Radioactive Aerosol Produced by Radon in Air*. University of Rochester Atomic Energy Project Report UR-461.

Shapiro, J. 1980. The development of the American National Standard, "Control of radioactive surface contamination on materials, equipment and facilities to be released for uncontrolled use." *Proceedings of the 5th International Congress of the International Radiation Protection Association*. Oxford: Pergamon Press.

Sheline, G. E., S. Lindsay et al. 1962. Thyroid nodules occuring late after treatment of thyrotoxicosis with radioiodine. *J. Clin. Endocr. Metab.*, 22:8–18.

Shleien, B. 1973. *A Review of Determinations of Radiation Dose to the Active Bone Marrow from Diagnostic X-Ray Examinations.* U.S. Department of Health, Education, and Welfare, Bureau of Radiological Health, Report (FDA) 74–8007. Washington, D.C.: U.S. Government Printing Office.

Shore, R. E., L. H. Hempelmann et al. 1977. Breast neoplasms in women treated with x-rays for acute postpartum mastitis. *J. Natl. Cancer Inst.*, 59:813-822.

Silverman, L., C. E. Billings, and M. W. First. 1971. *Particle Size Analysis in Industrial Hygiene.* New York: Academic Press.

Sisefsky, J. 1960.*Autoradiographic and Microscopic Examination of Nuclear Weapon Debris Particles.* Forsvarets Forskningsanstalt Avdelning 4 (Stockholm) Report A 4130–456 (FOAY Rapport).

Slack, L., and K. Way. 1959, *Radiations from Radioactive Atoms in Frequent Use.* U.S. Atomic Energy Commission Report.

Slade, D. H., ed. 1968. *Meterology and Atomic Energy, 1968.* Available as TID-24190 from Clearinghouse for Federal Scientific and Technical Information, National Bureau of Standards, U.S. Department of Commerce, Springfield, Va. 22151.

Smisek, M., and S. Cerny. 1970. *Action Carbon.* Amsterdam: Elsevier.

Smith, D. G. 1975. *Influence of Meteorological Factors upon Effluent Concentrations on and near Buildings with Short Stacks.* Paper presented at Air Pollution Control Association 69th annual meeting. Boston: Harvard School of Public Health.

Smith, D. G. 1978. *Determination of the Influence of Meteorological Factors upon building Wake Tracer Concentrations by Multilinear Regression Analysis.* Paper presented at Air Pollution Control Association 71st annual meeting. Boston: Harvard School of Public Health.

Smith, E. M., G. L. Brownell, and W. H. Ellett. 1968. Radiation dosimetry. In *Principles of Nuclear Medicine*, ed. H. N. Wagner, Jr. Philadelphia: Saunders.

Snyder, W. S., B. R. Fish et al. 1968. Urinary excretion of tritium following exposure of man to HTO—a two exponential model. *Phys. Med. Biol.*, 13:547–559.

Snyder, W. S., H. L. Fisher, Jr., M. R. Ford, and G. G. Warner. 1969. Estimates of absorbed fractions for monoenergetic photon sources uniformly distributed in various organs of a heterogeneous phantom. Medical Internal Radiation Dose Committee Pamphlet 5. *J. Nucl. Med.*, suppl. 3, August.

Snyder, W. S., M. R. Ford, G. G. Warner, and S. B. Watson. 1975. *"S," Absorbed Dose per Unit Cumulated Activity for Selected Radionuclides and Organs.* Medical Internal Radiation Dose Committee Pamphlet 11. New York: Society of Nuclear Medicine.

Song, Y. T., and C. M. Huddleston. 1964. A semiempirical formula for differential dose albedo for neutrons on concrete. *Trans. Am. Nucl. Soc.*, 7:364.

Spiers, F. W. 1968. *Radioisotopes in the Human Body; Physical and Biological Aspects.* New York: Academic Press.

Spiers, F. W., and J. Vaughn. 1976. Hazards of plutonium with special reference to skeleton. *Nature*, 259:531–534.

Sterlinski, S. 1969. The lower limit of detection for very short-lived radioisotopes used in activation analysis. *Nucl. Inst. Meth.*, 68:341–343.

Stewart, A., and G. W. Kneale. 1970. Radiation dose effects in relation to obstetric x-rays and childhood cancers. *Lancet,* June 6, pp. 1185–1187.

Storm, E., and H. I. Israel. 1970. Photon cross sections from 1 KeV to 100 MeV for elements Z = 1 to Z = 100. *Nucl. Data Tables, Sect. A,* 7:565–681.

Swindell, W., and H. H. Barrett. 1977. Computerized tomography: taking sectional x-rays. *Phys. Today,* Dec., pp. 32–41.

Tamplin, A. R., and H. L. Fisher. 1966. *Estimation of Dosage to the Thyroids of Children in the United States from Nuclear Tests Conducted in Nevada during 1952–1955.* U.S. Atomic Energy Commission Report UCRL-14707.

Tamplin, A. R., and J. W. Gofman. 1970. ICRP publication 14 vs the Gofman-Tamplin report. *Hearings on Environmental Effects of Producing Electric Power,* p. 2104. See JCAE 1969a.

Taylor, L. S. 1961. Report of interview with Dr. L. S. Taylor entitled, "Is fallout a false scare? Interview with the leading authority on radiation." *U.S. News & World Report,* Nov. 27.

Telegadas, K. 1959. Announced nuclear detonations. Reprinted in *Hearings on Fallout from Nuclear Weapons Tests,* pp. 2517–2533. See JCAE, 1959.

Telegadas, K. 1977. An estimate of maximum credible atmospheric radioactivity concentrations from nuclear tests. Health and Safety Laboratory Report HASL-328. *Envir. Quart.,* Oct.1.

Ter-Pogossian, M. 1967. *Physical Aspects of Diagnostic Radiology.* New York: Hoeber.

Thompson, T. T. 1978. *A Practical Approach to Modern X-Ray Equipment.* Boston: Little, Brown.

Till, J. E., et al. 1980. *Tritium—An Analysis of Key Environmental and Dosimetric Questions.* Oak Ridge National Laboratory Report ORNL/TM-6990. Oak Ridge, Tenn.: Technical Information Center.

Trout, E. D., and J. P. Kelley. 1965. Scattered radiation in a phantom. *Radiology,* 85:546–554.

Trout, E. D., J. P. Kelley, and A. C. Lucas. 1960. Determination of half-value layer. *Am. J. Roentgenol. Radium Ther. Nucl. Med.,* 84:729–740.

Trout, E. D., J. P. Kelley, and A. C. Lucas. 1962. The effect of kilvoltage and filtration on depth dose. In *Technological Needs for Reduction of Patient Dosage from Diagnostic Radiology,* ed. M. L. Janower. Springfield, Ill.: Charles C Thomas.

UNSCEAR 1969, 1966, 1964, 1962, 1958. *Report of the United Nations Scientific Committee on the Effects of Atomic Radiation.* General Assembly, Official Records. 1969, 24th sess., supp. no. 13 (A/7613); 1966, 21st sess., supp. no.14 (A/6314); 1964, 19th sess., supp. no. 14, (A/5814); 1962, 17th sess., supp. no. 16 (A/5216); 1958, 13th sess., supp. no.17 (A/3838). New York: United Nations.

UNSCEAR 1977. *Sources and Effects of Ionizing Radiation.* United Nations Scientific Committee on the Effects of Atomic Radiation 1977 Report to the General Assembly, with annexes. New York: United Nations.

UNSCEAR 1988. *Sources, Effects and Risks of Ionizing Radiation.* United Nations Scientific Committee on the Effects of Atomic Radiation 1988 Report to the General Assembly, with annexes. New York: United Nations.

UNSG 1968. *Effects of the Possible Use of Nuclear Weapons and the Security and Economic Implications for States of the Acquisition and Further Development of*

*these Weapons.* Report of the Secretary General transmitting the study of his consultation group. United Nations Document A/6858. New York: United Nations.

Upton, A. C., J. Furth, and K. W. Christenberry. 1954. Late effects of thermal neutron irradiation in mice. *Cancer Res.,* 14:682–90.

USAEC 1959. Quarterly statement on fallout by the U.S. Atomic Energy Commission, September. Reprinted in *Hearings on Fallout from Nuclear Weapons Tests,* pp. 2188–2191. See JCAE 1959.

USAEC 1965. *AEC Licensing Guide, Medical Programs.* Division of Materials Licensing, United States Atomic Energy Commission. Washington, D.C.: U.S. Government Printing Office.

USPS 1983. *Radioactive Materials.* United States Postal Service Publication 6. Washington, D.C.: Government Printing Office.

Vennart, J. 1969. Radiotoxicology of tritium and $^{14}C$ compounds. *Health Phys.,* 16:429–440.

Villforth, J. C. 1978. Report on federal activities in meeting today's challenges. *Ninth Annual National Conference on Radiation Control.* June 19–23, 1977. Proceedings, HEW Publication (FDA) 78–8054. Washington, D.C.: U.S. Government Printing Office.

Volchok, H. C. 1967. Strontium-90 deposition in New York City. *Science,* 156:1487–1489.

Volchok, H. L., M. Schonberg, and L. Toonkel. 1977. Plutonium concentrations in air near Rocky Flats. *Health Phys.,* 33:484–485.

Wagner, E. B., and G. S. Hurst. 1961. A Geiger-Mueller γ-ray dosimeter with low neutron sensitivity. *Health Phys.,* 5:20–26.

Wagoner, J. K., V. E. Archer, F. E. Lundin et al. 1965. Radiation as the cause of lung cancer among uranium miners. *New Eng. J. Med.,* 273:181–188.

Wanebo, C. K., K. G. Johnson, K. Sato, and T. W. Thorslund. 1968. Breast cancer after exposure to the atomic bombings of Hiroshima and Nagasaki. *New Eng. J. Med.,* 279:667–671.

Warren, S., and O. M. Lombard. 1966. New data on the effects of ionizing radiation on radiologists. *Arch. Envir. Health,* 13:415–421.

Watt, D. E., and Ramsden, D. 1964. *High Sensitivity Counting Techniques.* Oxford: Pergamon Press.

Webster, E. W., N. M. Alpert, and C. L. Brownell. 1974. Radiation doses in pediatric nuclear medicine and diagnostic x-ray procedures. In *Pediatric Nuclear Medicine,* ed. A. E. James, Jr., H. N. Wagner, and R. E. Cooke. Philadelphia: W. B. Saunders.

Weeks, J. L., and Kobayashi, S. 1978. Late biological effects of ionizing radiation. Report on the international symposium held in Vienna. *At. Ener. Rev.,* 16:327–337.

Weibel, E. R. 1963. *Morphometry of the Human Lung.* Berlin: Springer-Verlag, p. 139.

Weigensberg, I. J., C. W. Asbury, and A. Feldman. 1980. Injury due to accidental exposure to x-rays from an x-ray fluorescence spectrometer. *Health Phys.,* 39:237–241.

Weinberg, S. 1977. *The First Three Minutes.* New York: Basic Books.

Weisskopf, V. F. 1978. Debate on the arms race. Letter to the editor by V. F. Weisskopf, Professor (emeritus) of Physics, Massachusetts Institute of Technology. *Phys. Today,* Dec. 1, p. 13.

Wilkening, M. H., W. E. Clements, and D. Stanley. 1972. Radon-222 flux measurements in widely separated regions. In *The Natural Radiation Environment II*, ed. J. A. S. Adams, W. M. Lowder, and T. F. Gesell. U.S. Energy Research and Development Administration Report CONF-720805–P2.

Wilson, R., and W. J. Jones. 1974. *Energy, Ecology, and the Environment*. New York: Academic Press.

Wilson, R. R. 1977. The tevatron. *Phys. Today,* Oct., pp. 23–30.

Wilson, R. 1987. A visit to Chernobyl. *Science,* 236:673–679.

Winkler, K. G. 1968. Influence on rectangular collimation and intraoral shielding on radiation dose in dental radiography. *J. Am. Dent. Assn.,* 77:95–101.

Wood, V. A. 1968. *A Collection of Radium Leak Test Articles.* U.S. Department of Health, Education, and Welfare Report MORP 68–1.

Wooton, P. 1976. Interim report: mammographic exposures at the breast cancer detection demonstration project screening centers. *Am. J. Roentgenol.,* 127:531.

Wrenn, M. E. 1974. *Environmental Levels of Plutonium and the Transplutonium Elements.* Paper presented as part of the AEC presentation at the EPA Plutonium Standards Hearings, Washington, D. C., Dec. 10–11.

York, H. F. 1970. *Race to Oblivion. A Participant's View of the Arms Race.* New York: Simon and Schuster.

York, H. F. 1976. The nuclear "balance of terror" in Europe. *Bull. Atom. Sci.,* May, pp. 9–16.

Zumwalt, L. R. 1950. *Absolute Beta Counting Using End-Window Geiger-Mueller Counters and Experimental Data on Beta-particle Scattering Effects.* U.S. Atomic Energy Commission Report AECU-567.

# Index